Art Therapy Practices for Resilient Youth

Art Therapy Practices for Resilient Youth highlights the paradigm shift to treating children and adolescents as "at-promise" rather than "at-risk." By utilizing a strength-based model that moves in opposition to pathology, this volume presents a client-allied modality wherein youth are given the opportunity to express emotions that can be difficult to convey using words. Working internationally with diverse groups of young people grappling with various forms of trauma, 30 contributing therapists share their processes, informed by current understandings of neurobiology, attachment theory, and developmental psychology. In addition to guiding principles and real-world examples, also included are practical directives, strategies, and applications. Together, this compilation highlights the promise of healing through the creative arts in the face of oppression.

Marygrace Berberian is a clinical assistant professor at New York University. Ms. Berberian has invested her 25 year career establishing community-based art therapy initiatives for children and families at-promise.

Benjamin Davis is a psychotherapist, educator, and consultant in New York City, focusing on non-pathologizing treatment models for LGBTQ individuals across the lifespan.

Art Therapy Practices for Resilient Youth

A Strengths-Based Approach to At-Promise Children and Adolescents

Edited by Marygrace Berberian and Benjamin Davis

Routledge
Taylor & Francis Group

NEW YORK AND LONDON

First published 2020
by Routledge
52 Vanderbilt Avenue, New York, NY 10017

and by Routledge
2 Park Square, Milton Park, Abingdon, Oxon, OX14 4RN

Routledge is an imprint of the Taylor & Francis Group, an informa business

© 2020 Taylor & Francis

The right of Marygrace Berberian and Benjamin Davis to be identified
as the authors of the editorial material, and of the authors for their
individual chapters, has been asserted in accordance with sections 77 and
78 of the Copyright, Designs and Patents Act 1988.

Trademark notice: Product or corporate names may be trademarks
or registered trademarks and are used only for identification and
explanation without intent to infringe.

Library of Congress Cataloging-in-Publication Data
Names: Berberian, Marygrace, editor. | Davis, Benjamin, editor.
Title: Art therapy practices for resilient youth : a strengths-based
 approach to at-promise children and adolescents / Marygrace
 Berberian and Benjamin Davis.
Description: New York, NY : Routledge, 2020. | Includes bibliographical
 references and index.
Identifiers: LCCN 2019051070 (print) | LCCN 2019051071 (ebook) |
 ISBN 9781138293502 (hardback) | ISBN 9781138293519 (paperback) |
 ISBN 9781315229379 (ebook)
Subjects: LCSH: Art therapy for children. | Art therapy for youth.
Classification: LCC RJ505.A7 A788 2020 (print) | LCC RJ505.A7 (ebook) |
 DDC 618.92/891656—dc23
LC record available at https://lccn.loc.gov/2019051070
LC ebook record available at https://lccn.loc.gov/2019051071

ISBN: 978-1-13829-350-2 (hbk)
ISBN: 978-1-13829-351-9 (pbk)
ISBN: 978-1-31522-937-9 (ebk)

Typeset in Minion
by Apex CoVantage, LLC

Visit the eResource: www.routledge.com/9781138293519

MIX
Paper from
responsible sources
FSC
www.fsc.org FSC™ C013985

Printed in the United Kingdom
by Henry Ling Limited

Dedicated to Madeline and Ella. Your love, creativity, and courage have inspired my continued cultivation of community support in this ever-changing world. Your bright, passionate spirits lift me. I love you always.

–Mommy

Immense gratitude to my parents, grandparents and great grandparents whose survival and lives modeled unswerving resiliency amidst life's most adverse blows.

Special thanks to my husband, Ken Hutchinson who has tirelessly supported my work.

–Marygrace

Contents

Contributors

Ikuko Acosta, PhD, LCAT, ATR-BC
Director, Graduate Art Therapy Program, New York University, New York, NY

Lauren Adelman, MA
Co-founder & Board Member, Artistic Noise, New York, NY

Asli Arslanbek, MA, ATR-P
Art Therapist, Yusra Community Center, Istanbul, Turkey
PhD Student and Research Fellow, Drexel University, Philadelphia, PA

Yasmine Awais, MAAT, MA, MPhil, ATR-BC, ATCS, LCAT, LPC
Associate Clinical Professor, Drexel University, Philadelphia, PA
Member, Critical Pedagogies in the Arts Therapies Think Tank

Rawan Bajsair, MA, ATR-BC
Art Therapist/Psychotherapist, Adult & Child Therapy Center,
Jeddah, Saudi Arabia

Marygrace Berberian, MA, MSW, ATR-BC, LCAT, LCSW
Clinical Assistant Professor, New York University, New York, NY
PhD Candidate, Drexel University, Philadelphia, PA

Annie G. Bonz, MA, LCAT, ATR-BC
Director, Resilience Programs, HIAS, Silver Spring, MD
(Based remotely in Jordan)

Nicole Brandstrup, MA2, ATR-BC, LPCC
School-Based Therapist, Unison Health, Toledo, Ohio

Kimberly Bush, MFA, ATR-BC, LCAT, LP
Director of Creative Arts Therapy, The League Education and Treatment Center,
Brooklyn, NY
Adjunct Faculty, Pratt Institute, Brooklyn, NY
Private Practice, Brooklyn, NY

Marcia Sue Cohen-Liebman, PhD, ATR-BC, LPC
Adjunct Faculty, Drexel University, Philadelphia, PA

Benjamin Davis, MA, ATR-BC, LCAT
Adjunct Faculty, New York University, New York, NY
Private Practice, New York, NY

Mia de Bethune, MA, ATR-BC, LCAT, SEP
Adjunct Faculty, New York University, New York, NY
Art Therapy on Hudson, Private Practice, Hastings-on-Hudson, NY
Hospice and Palliative Care of Westchester, White Plains, NY

Sofia del Carmen Casas, MA, ATR-BC, LCAT
Mental Health Technical Advisor, Humanity & Inclusion, South Sudan

Christina A. Grosso, MA, ATR-BC, LCAT, BCETS
Adjunct Faculty, New York University, New York, NY
Private Practice: Mind+Body= ONE, Westchester, NY

Chelsey Gutierrez, MAAT
Visitation Supervisor, Olive Crest, Silverdale, WA

Lucía Cristina Hernández, MA, ATR-BC, LCAT
Creative Arts Therapist/Psychotherapist, Independence Outpatient Treatment
Program, Samaritan Daytop Village, Bronx, NY

Tami Herzog- Rodriguez, PhD, ATR-BC, LCAT
Adjunct Faculty, New York University, New York, NY
Adjunct Faculty, School of Visual Arts, New York, NY

Maria Kondratiev Sossi, MA, ATR-BC, LCAT
Senior Art Therapist, NYU Art Therapy in Schools Program, New York, NY

Patricia Landínez González, MA
Child Protection in Emergencies Specialist, UNICEF

Kelley Linhardt, MA, ATR-BC, LCAT
Art Therapist/ Psychotherapist; Director of Continuing Education Program; Dancing
Dialogue LCAT LMHC PLLC; Cold Spring and New York, NY

Christopher Major, DAT, ATR-BC, LCAT
Psychosocial Rehabilitation Therapist, NY
Presbyterian Payne Whitney Clinic, New York, NY

Eileen P. McGann, MA, ATR-BC, LCAT
Director, Arts and Creative Therapies, MercyFirst, New York, NY
Adjunct Faculty, New York University, New York, NY
Adjunct Faculty, School of Visual Arts, New York, NY
Adjunct Faculty, Molloy College, Rockville Center, NY

Gretchen M. Miller, MA, ATR-BC, ACTP
Visiting Instructor, Ursuline College Counseling and Art Therapy Department, Pepper Pike, OH
Art Therapist, Art Therapy Outreach Services, Cleveland, OH
Art Therapist, Intensive Services, Akron Children's Hospital, Akron, OH

Elsa Pelier, MA, ATR-BC, LCAT
Psychotherapist, Private Practice, New York, NY
Adjunct Faculty, New York University, New York, NY
Psychotherapist and Coordinator, Johnson Counseling Center School Based Satellite Clinic, Union Settlement Association, New York, NY

Jordan S. Potash, PhD, ATR-BC, REAT, LCAT, LCPAT
Associate Professor, The George Washington University, Washington, DC
Editor in Chief, Art Therapy: Journal of the American Art Therapy Association

Sarah Pousty, MA, ATR-BC, LCAT
ARTogether Supervisor and Lead Facilitator, Children's Museum of the Arts, New York, NY

Lauren Dana Smith, MPS, ATR-BC, LCAT, CCLS
Senior Creative Arts Therapist and Child Life Specialist, The Lilian and Benjamin Hertzberg Palliative Care Institute and Brookdale Department of Geriatrics and Palliative Medicine at Icahn School of Medicine at Mount Sinai, New York, NY

Robyn Spodek-Schindler, MA, MS, ATR-BC, LCAT, LPC, NCC
Private Practice, Paint the Stars Art Therapy, Manalapan , NJ
Adjunct Faculty, Long Island University, Brookville, NY

Maria K. Walker, MFA, MA, ATR-BC, LCAT
Director of Ancillary Therapeutic Services, Four Winds Hospital, Katonah, NY

Ashley Claire Wood, MA, ATR-BC, CIMI
Art Therapist, Texas Children's Hospital, Houston, TX

Sarah Yazdian Rubin, MA, ATR-BC, LCAT, CCLS
Creative Arts Therapist and Child Life Specialist, SYR Art Therapy, Nashville, TN

Acknowledgments

Most importantly, we would like to thank the young people depicted in this volume for sharing their authentic selves and creative processes with us. We will continue to learn with them and from their journeys. Thank you to the chapter authors and editors who have tirelessly worked to describe their successes and frustrations, as well as their home institutions for allowing their permission to participate. Thank you to our incredible team, subjected to multiple revisions; late-night fact finding; and sometimes circular, existential wonderings: Ikuko Acosta, Nicole Avallone, Susan Beachy, Amanda Devine, Jackie Ehrlich, Elizabeth Graber, Christina Grosso, Nina Guttapalle, Ken Hutchinson, Rohita Kilachand, Clare Smith Marash, Olivia Powers, Christopher Teja, and Jess White. This project would not have been possible without the thorough and tireless eyes of Kristin Winter, who helped to unify our chapter authors' many voices.

Foreword

Children and youth, by nature, are far more resilient than adults tend to believe. The common assumption that children are helpless and totally dependent on adults for their survival is belied by clinical case studies illustrating amazing resilience under adverse circumstances. While children do require a great deal of caretaking to thrive, they nonetheless possess innate resilience for managing psychological difficulties. The resilience, however, often remains a dormant potential, especially under severe adversity. The most effective and natural way to awaken this capacity is through play and creative activities, yet this can be blocked and overwhelmed by trauma. With the support of an attuned art therapist, children can awaken creative problem-solving skills and develop resiliency in managing internal psychological problems as well as externally imposed adversity.

Based on my cross-cultural work with children, I would like to share an apropos anecdote. In Sydney, Australia, at a government agency providing after-school programs for aboriginal children, we offered a three-week art therapy session. On the first day, a seven-year-old boy greeted us by screaming and kicking the furniture around the room. After some hapless observation, an art therapy intern took out a pack of origami paper and began to fold it in a casual manner. Catching this act, the boy stopped kicking and slowly walked toward the intern. Eventually the boy grabbed a sheet of paper and started his own random folding project. This led to a nonverbal and interpersonal exchange, with the boy mirroring the intern's origami pieces, fold by fold. At the end, the boy was amazed that he had actually created an origami puppy. This was like a magic to him; he was ecstatic. Fortified and nurtured by the mirroring relationship, which he successfully internalized, he began to work independently, from start to finish, creating his very own origami artworks. The destructive energy within him had been channeled into problem solving in the domain of art. As he progressed, the problem-solving skills became a kind of reservoir or template for working through personal problems. To the extent that he was insistently destructive on the first day, he became persistently constructive, able to refashion himself with tremendous resiliency.

The book *Art Therapy Practices for Resilient Youth: A Strengths-Based Approach to At-Promise Children and Adolescents*, edited by Marygrace Berberian and Benjamin Davis, beautifully highlights this theme. The diverse chapters contain a multiplicity of viewpoints that collectively elucidate how art therapists help children find personal and unique ways of creative problem solving as a way of awakening and strengthening resilience. The editors have recruited an impressive group of art therapists, each with extensive experience working with children and youth impacted by a broad spectrum of biopsychosocial problems. This includes poverty, familial conflict, abuse, homelessness, immigration, and war. The aftereffects include anxiety disorders, PTSD, depression, and substance abuse, as well as external stressors such as incarceration. The primary emphasis uniting the chapters is to help children shift from being "at-risk" to being "at-promise."

The book is divided into four sections. In the first section, the editors address the general principles of art therapy practice and describe how and what art therapy offers in promoting creative problem-solving abilities and resilience. The second section deals with the theme of disruptions in early individual development, which can be caused by trauma, physical disability, developmental disorders, medical illness, psychiatric illness, and substance abuse. This section examines the nature of problem-solving styles for

children whose normal development is disrupted and interrupted. The third section spotlights dysfunctional family systems, which include divorce, sexual and physical abuse, and ineffectual social agencies and foster care systems. Often children become the victims of systemic failure. It is essential for them to develop coping skills and resiliency to deal with these horrific betrayals by the adults from whom they expected safety and protection. The fourth section addresses the negative effects of socioeconomic and political issues, globally and locally. This includes the impact of war and terrorism, poverty and migration, loss and bereavement, child trafficking, school violence, and incarceration.

In addition to these themes, the editors emphasize the importance of linking creative activity to neuroscience. It is well established that creative experience positively affects the human brain in many different ways. The editors cite various relevant articles written by psychologists and art therapists to stimulate future research ideas.

Each chapter in the book examines different types of trauma and stress impacting the lives of children today, with a positive and proactive theme, namely, the development of resilience through art therapy. In the words of Berberian:

> As a conduit for accessing and mitigating conflicted memories and affect, visual expression can organize cognitions and memories. The attuned relationship with the art therapist aids in the mirroring and repair of disruptions in attachment, and rewards gained from engagement in art-making lead to both pleasure and mastery. Taken together, these support creative problem solving: a theoretical construct of art therapy's promotion of resilience.
>
> (p. 14)

Ikuko Acosta, PhD, LCAT, ATR-BC

1

Introduction

MARYGRACE BERBERIAN AND BENJAMIN DAVIS

For centuries, violence and deprivation have hindered the lives of developing young people in communities most affected by poverty and inaccess. Systems continue to reinforce outdated power structures, and clinical paradigms have shifted without comprehensive practice guidelines. Despite well-intended clinicians and institutions, children and adolescents have often resorted to their internal, strength-based survival instincts to heal and grow. Activated as a response to trauma and unmet need, the young person's extraordinary ability to persevere has captivated clinical audiences over the past few decades. Resilience, a dynamic interplay of developmental stages involving both threatening and protective factors, is nested in a historical, ecological, and cultural context known to influence individual and communal development over time (Jain & Cohen, 2013). Clinical psychologist Norm Garmezy conceived the scientific study of resilience, which "transformed the science and practice of multiple disciplines, from the molecular level to the global ecosystem, infusing a strength-based and recovery-oriented approach into psychology, education, social work, and psychiatry" (Masten, Nuechterlein, & Wright, 2011, p. 141). Garmezy (1983) noted, "children are not strangers to stress. Over a significant span of human history, they have been more often the victims of slings and arrows of an uncaring society than recipients of its beneficent protection" (p. 49). Nearly four decades after Garmezy's work began, we sadly continue to see our youngest members of society often suffering the most.

Across the literature, demographics track patterns and trends among groups. Age, wealth, gender, location, and ability provide general guidelines to classify circumstance, risk, and repair. The specific condition, be it homelessness, war, or medical fragility, bring expected developmental concerns. Yet scholars also acknowledge massive heterogeneity in the responses to psychosocial and physical environmental hazards. Protective factors that buffer and modify the impact of risks over time and support positive adaptation can diminish vulnerabilities to environmental stressors, aid in the recovery of adversity, and ultimately yield more positive outcomes (Rutter, 2012). A socioecological perspective has examined the continuum of risk and protective factors to domains inclusive of culture, society, community, gender, race, ethnicity, and historical period (Bronfenbrenner, 1977; Garbarino, & Haslam, 2005; Garmezy, 1987). In this vein, a young person is examined in a bidirectional relationship within the continuum of environmental micro to macro systems contributing to adaptation and well-being. The bidirectional relationship of the young person within a communal system of support underscores the proverb

"it takes a village to raise a child" (Henderson, DeCuir-Gunby, & Gill, 2016, p. 480). The "experience within" the domain, rather than the domain itself, is what ultimately influences the young person (Siperstein & Favazza, 2008). Social, cognitive, economic, and cultural contexts will affect the potential and risk inherent in the transactional, experiential relations between the young person and their world. The "experience within" the domain therefore becomes highly personalized, and effective clinical intervention becomes more complex.

Many clinicians find themselves searching to determine causality from a single variable responsible for developmental outcomes (Horowitz, 2000). But without an intersectionally informed approach, the nuance of a young person's "experience within" a domain is quickly lost, and an opportunity to bolster resilience becomes less attainable. This reductive stance also risks the clinician becoming complicit in seeing deficits and thereby wrongfully placing blame within the individual, family, and community, rather than the institutional structures that create and maintain inequality (Arnold & Swadener, 1993; Lubeck & Garrett, 1990; Swadener & Lubeck, 1995).

Case material in this book showcases profound resiliency evident despite micro and macro experiences of adversity. Authors use the framework of "at-promise" rather than "at-risk" to dispel the assumptions of pathology for young people managing systems that are inherently detrimental and oppressive. This compilation recognizes that pathologizing young people "at-risk" for negative outcomes based on their race, primary language, family structure, gender, or class, results from a deficit model that parallels the persistent social stratification in the U.S. (Swadener & Lubeck, 1995). The "at-risk" label, disproportionately classified through sociodemographic data for many marginalized groups, appears more detrimental and stigmatizing than the internal and external factors in causal relationship to negative outcomes themselves (Franklin, 2013). The classification of being "at-risk" is not one of neutrality and comes with the potential to damage, disempower, and further marginalize (Swadener, 1995). Franklin (2013) adds:

> History clearly shows that when these labels were used for poor or minority children, they served as immutable referents that spoke only to inadequacies in the child and his or her family. The psychological character, physiological makeup, and cultural patterns of students were often called into question and labeled deficient, as if competence, achievement, and motivation manifested and developed solely in the home.
>
> (p. 3)

Examining adversity broadly, this compilation reviews the impact of communal, familial, and interpersonal stressors as variables in the expansive constellations of young people's psychology and sense of self. The ideology of an "at-promise" framework offers complimentary concepts for further discussion in the field of art therapy. The concept of "at-promise" has been most largely embraced by educational reform for students who are economically disadvantaged (Henderson et al., 2016; Rios, 2011), stigmatized by institutional racism (Franklin, 2013; Whiting, 2006), physically challenged (Leifield & Murray, 1995), twice-gifted (gifted students with learning disabilities) (Nielsen, 2002), and underachieving (Boykin, 2000). Similar goals intrinsic to the field of art therapy illuminate a vision to "see beyond 'what is' into a more democratically just and humane world of 'what might' be" (Lake & Kress, 2017). Paolo Freire upheld principles for democratic education that would emancipate people from oppression and transform society

through a sense of personal agency (Rennick, 2015). For revolutionaries John Dewey and Maxine Greene, the nurturance of imagination propagated new thinking, actively reconstructing current understanding and sustaining receptivity to novel problem solving (Mayer, 2017). Embedded in the theory and practice of art therapy is the opportunity to promote creative play and problem solving while engendering new aspects of personal agency. Throughout history we have witnessed young people, despite the circumstance, access these vital developmental building blocks through art-making.

During World War II, Anna Freud and Dorothy Burlingham (1943) observed young children in wartime nurseries separated from their parents. In these accounts, a range of responses were noted:

> Children may therefore go apparently unharmed through experiences that would produce grave results in people of another age. On the other hand, they may break down completely under strain which to the ordinary adult person seems negligible. The peculiarities of the psychological make-up of the child may account on the one hand for the astonishing robustness of children, on the other hand for most of the problems of behavior and symptoms to which all the war nurseries complain.
>
> (p. 64–65)

While Freud and Burlingham were tending to children's reactivity to war in England, Friedl Dicker-Brandeis artistically engaged children imprisoned in the Terezín ghetto in former Czechoslovakia. Despite her tragic death in Auschwitz, Dicker-Brandeis' safely guarded collection of approximately 5,000 drawings created by children of the Holocaust survived and provide an example of legacy for vitality summoned in the face of annihilation (Makarova, Makarov, & Kuperman, 2004). In a letter in 1940, Dicker-Brandeis wrote, "Today only one thing seems important—to rouse the desire towards creative work, to make it a habit, and to teach how to overcome difficulties that are insignificant in comparison with the goal to which you are striving," (Dicker-Brandeis, as cited in Makarova, 2001, p. 151). Dicker-Brandeis, a teacher and mentor for art therapy pioneer Edith Kramer, demonstrated the undebatable therapeutic potential for art-making in the face of engulfing anguish. In reference to Dicker-Brandeis' contributions, John-Steiner (2010) described:

> They understood that for the minutes or hours during which they drew with a pencil on scraps of paper or performed or listened to music, they were alive in the deepest sense of what it is to be human. To create is to go beyond restrictions of habit, pain, terror and the known. It requires a continuity of concern, an absorption in shaping experience in a novel and moving manner.
>
> (p. ix)

Kramer referenced and credited Dicker-Brandeis for her influences on her foundational theories of art as therapy (Makarova, 2001). Kramer (2010), commenting on the work of Dicker-Brandeis, wrote that she "allowed children to depict the sanity and beauty of their past lives while permitting comfort amid present nightmares. In this sense she formed a kind of therapeutic community that sustained the many children who endured unimaginable fear, loss and the threat of annihilation" (p. 2).

In the presence of adversity, coping (and healing) through creative play and artistic exploration has paralleled the established, pathology-driven, "medical model" of mainstream child psychiatry and laid the foundation for a more holistic understanding of the

child in a resilience-oriented approach (Ludwig-Körner, 2017). Observation of the child engaged in their natural setting, while the clinician restrains preemptive judgment, will enable a more precise assessment of strengths. Freud and Burlingham's (1943) observations also highlight the increased resilience of children when caregivers maintained expected routines and positive interactions. These protective factors include active coping skills, self-efficacy, social support, and the maintenance of stable relationships with adults that encourage adaptive practices (Garbarino & Kostelny, 1993, p. 29).

Almost 80 years later, clinicians and community leaders continue to identify, systematize, and strengthen a framework of protective factors in pursuit of childhood resilience. To encapsulate the state of young people today, one is tasked with understanding complex experiences of identity and self. Bracketed by community norms, economic conditions, geographic location, family structure, and psychological idiosyncrasies, each young person's voice carries with it a unique fingerprint of personal history; a snapshot of time and place; self-definition; and their particular, often nonlinear, experiential perceptions. Understanding the global context and the experience of youth today would take many lifetimes of inquiry. Here, we provide only a brief snapshot of demographic information to ground readers with the trends and patterns exemplified in literature to date.

Young people today make up the largest youth population in history, and half of the global population is now under 30 years old (Sharma, 2017). By 2020, the under-18 population is expected to grow to 73.9 million (Vespa, Armstrong, & Medina, 2018). As a group, they face unprecedented technological, social, environmental, and economic challenges. The experience of being a young person varies drastically based on age, sex, religion, ethnicity, location, level of ability or disability, racial minority status, gender identity, and sexual orientation, among many other factors. As clinicians, therapeutic interventions designed at engaging young people have needed to adapt to technological advances, communication styles, and evolving relational dynamics as children and adolescents prepare themselves to manage an increasingly volatile world.

The International Youth Foundation, a cumulative source for global trends in youth welfare, defines well-being as a "multidimensional concept that includes a person's physical and mental health, educational status, economic position, physical safety, access to freedoms and ability to participate in civic life. It is, in a sense, the abundance or scarcity of opportunities available to an individual" (Sharma, 2017, p. xiv). Under the domain of health, in 2017 The International Youth Foundation ranked the U.S. twelfth globally behind Saudi Arabia, Spain, the United Kingdom, China, Morocco, Germany, Colombia, Ghana, Vietnam, Sweden, and Jordan (Sharma, 2017). Several factors contribute to the low health ranking, including a high rate of adolescent fertility (21 per 1,000 births for women ages 15 to 19 versus an average of 9 per 1,000 births in European countries) and high rates of youth self-harm fatalities (23 deaths per 100,000 youth). Currently the U.S. ranks twenty-third globally in youth interpersonal violence, accounting for 20 deaths per 100,000 youth (Sharma, 2017).

Despite advances in the field, The National Institute of Mental Health reports an estimated 49.5% of adolescents live with a mental disorder; of those, an estimated 22.2% are severely impaired based on DSM-IV criteria (Merikangas et al., 2010). ADHD, behavior problems, anxiety, and depression are the most commonly diagnosed mental disorders in children, whereby 9.4% of children aged 2–17 years (approximately 6.1 million) have received an ADHD diagnosis (Danielson et al., 2018), and, of children aged 3–17, 7.4% (approximately 4.5 million) have a diagnosed behavior problem, 7.1% (approximately 4.4 million) have diagnosed anxiety, and 3.2% (approximately 1.9 million)

have diagnosed depression (Ghandour et al., 2019). Depression and anxiety diagnostic rates have increased over time among youth (Bitsko et al., 2018). A multitude of factors impact access to care, treatment options, and outcomes. The Centers for Disease Control and Prevention (2019) acknowledged that age and poverty-level were strong predictors in the treatment of mood and behavioral problems.

In the U.S. 20% of all children ages 0–17 lived in poverty in 2015, down from 21% in 2014 (Federal Interagency Forum on Child & Family Studies, 2017). In 2015, approximately 13.1 million children (18% of all children in the U.S.) lived in households that were classified as food insecure (Federal Interagency Forum on Child & Family Studies, 2017). While socioeconomic class correlates with health, wellness, and educational markers of success, strongly held racism and other discriminatory ideologies have had devastating consequences, particularly on youth of color and LGBTQ (Lesbian, Gay, Bisexual, Transgender and/or Queer) individuals. For example, despite an overall decline in youth incarceration rates, as of 2015, African-American youth were five times as likely as white youth to be detained or committed to youth facilities (The Sentencing Project, 2017). Black students, who comprise 16% of students in U.S. public schools, make up over a quarter of students referred to law enforcement from schools and 31% of those arrested for school-related incidents (U.S Department of Education, Department of Civil Rights, 2014). Additionally, LGBTQ young people had a 120% higher risk of reporting homelessness compared to youth who identified as heterosexual and/or cisgender (Morton, 2018), and 73% of LGBTQ youth have received verbal threats because of their actual or perceived LGBTQ identity (Human Rights Campaign, 2018).

Young people who have been silenced, isolated, victimized, and rejected are often asked in treatment to intellectually understand their circumstances and begin to heal from them. Art-making, through limitless opportunities to engage in tactile experiences, access symbolic meaning, and promote personal agency, has the capacity to help process not only the painful emotions endured by systemic trauma, but also a young person's unique ability to self-define and find truth and meaning with power and celebration. In the book *The Courage to Create*, Rollo May (1975) propositioned the existential choice to either withdraw in panic or apathy or "move ahead in spite of the despair" in the face of extreme adversity and destruction (p. 12). Art therapists, creative cultivators of human potential, naturally practice in "at-promise" frameworks through the active employment of imaginative realms to challenge limitations, birth new thinking, and provide agency. Within a therapeutic frame, hope and courage are channeled to engage, create, and reflect through creative practice. Unlike verbal modalities, art therapists are able to capitalize on the protections gained using metaphor and the novel problem solving afforded by the creative processes, often increasing a client's tolerance to sustain treatment despite painful realizations.

For these reasons, art therapists frequently reference their alignment with a strength-based approach (Sarid, Cwikel, Czamanski-Cohen, & Huss, 2017; Malchiodi, 2015; van Lith, Fenner, & Schofield, 2011). Kelly and Gates (2017) credited the early settlement house movement of the 1880s as the start of the strength-based model of intervention. Contrary to the Charity Organization Society, which feared charity would perpetuate greater poverty, settlement houses served to empower the functioning of families through literacy, work skills, and childcare. Strength-based therapy, gaining momentum in the mid-1900s through advancements in the fields of psychology, social work, and counseling, is defined as a "client-directed approach that invites people to participate in every aspect of care and apply their indigenous strengths and resources towards

personally meaningful goals" (Murphy & Sparks, 2018, p. 3). A strength-based practice counters the problem-focused medical model that perpetuates blame for the "at-risk" etiology, a model where the most cost-effective form of treatment—a focus on individual strengths—is overlooked (Edwards, Young, Nikels, & Standefer, 2017).

Dr. Shawn Ginwright, a leading national expert on African American youth, youth activism, and youth development, advocates for an asset-driven approach to therapy, focused on increasing well-being rather than suppressing symptoms. "A healing centered approach to addressing trauma requires a different question that moves beyond 'what happened to you' to 'what's right with you' and views those exposed to trauma as agents in the creation of their own well-being rather than victims of traumatic events" (Ginwright, 2018). Treatment based in a secure, non-blaming, and attuned therapeutic relationship can consider alternative narratives based in strengths, acceptance, and understanding, cultivating new regulation and mastery (Bianco, 2017). Strength-based approaches may be more aligned with cultural norms and better in accessing the confidence to transcend hardship (Ho et al., 2014). For Ginwright (2018), healing is experienced collectively, and therapeutic interventions should be culturally grounded and promote building a health identity and sense of belonging. He wrote:

> The pathway to restoring well-being among young people who experience trauma can be found in culture and identity. Healing centered engagement uses culture as a way to ground young people in a solid sense of meaning, self-perception and purpose. This process highlights the intersectional nature of identity and highlights the ways in which culture offers a shared experience, community and sense of belonging.
>
> (Ginwright, 2018)

In the promotion of strength-based practices, Estrella (2011) listed the dictates of creative therapeutic intervention as follows:

> Follow the image. Follow the client and the community. Meet the client and community where they are, and facilitate an environment in which arts-based inquiry and connection can take place, trusting that the process will take you to a place where suffering can be experienced, where feeling can be given form, and where the whole self (personal and collective, body, mind, spirit, and imagination) can be enlisted in the service of healing.
>
> (p. 47)

The practices of art therapy interventions for micro and macro level stressors, as outlined in this book, highlight the human potential for creative adaptation and resilience. The concept of "resilience" has been described broadly as both an outcome and a process, thereby producing complex and multifaceted definitions and measures (McClearly & Figley, 2017). Notable mediating factors contribute to the "process of resilience" to champion a "resilient" individual (van Breda, 2018, p. 3). Participatory in nature and action oriented, art therapy treatment, as a collaboration between client and therapist, yields a shared vision for recovery and growth. Communities can be empowered through emancipatory action through creative arts therapies. Practitioners can begin to reconceptualize the transformative action necessary to enable resilience through arduous commitment to curricular, structural, personal, and

relational work (Swadener, 1995). Sajnani (2012) acknowledged the value of honoring lived experiences through collaborative engagement by adding, "creative arts therapists enable an embodied, affective, and interpersonal responsiveness to change, amidst suffering, against oppression, and as an experience of social justice" (p. 186). Similarly, visionary Maxine Greene (2007) shared:

> I think I want mostly to argue for a centrality of imagination because of its power to enable persons to reach towards alternatives, to reach beyond; and I want to argue for the arts because of the ways in which they open windows in experience, provide moments of freedom and presence, enable us to break with terrible moments of apathy and numbness keeps us, in our ongoing conversations with the young, ardently in the changing and problematic world.
>
> (p. 2)

Positive outcomes in the face of adversity have resulted in adaptive functioning through optimism and resilience (Maholmes, 2014). Authors in this compilation showcase art therapy interventions that provide new, imagined possibilities for youth "at-promise."

The first section of the book lays a theoretical foundation. A neurobiological framework examines creative problem solving as a protective factor and an adaptive response in the pursuit of resilience. Art, a natural communicative tool, is comprehensively discussed through a developmental lens. Section II examines the art therapy practices with individuals experiencing disruptions related to trauma, physical functioning, illness, substance abuse, and problematic sexual behaviors. A broader view of stressors in family systems is explored in Section III. Art therapy interventions for young people experiencing parental separation as a result of death, divorce, abuse, and neglect are considered through systems that both hamper and aid optimal coping. Section IV expands the lens of inquiry to examine macro stressors that propagate communal stress. Art therapy treatment for young people exposed to war, terrorism, and migration offer effective interventions for the persistent global unrest of this era. The amelioration of the systemic injustices against the liberties of young people are also reflected through art therapy practices to engage clients who identify as transgender and those who face incarceration. As we hope to remain teachable and primed for growth, we have ended this compilation with a chapter acknowledging the clinical mistakes evident in art therapy practices with young people.

Artwork included in this anthology amplifies young people's voices, unmodified and unedited by the adult clinician. Art engenders a nuanced recognition of perspective, conveying meaning and depth that often falls flat in written word. Each symbol, stroke of a brush, color wash, and hue gradient serve as a fingerprint of time and place, allowing the artist's intent and emotionality to influence viewers' interpretation and understanding of meaning. Case studies present a sample of current research as it relates to each subpopulation as well as critical practical considerations for clinicians in the field. Client vignettes capture the nuances of personhood and resilience. Despite catastrophic circumstances, youth prevail with the ability to orient toward the future.

Contributing to this collection are clinicians from various backgrounds across the globe sharing in a collective belief. The universal qualities of art-making are affirmed through a diverse range of client populations and clinician positionalities. These authors have witnessed and cultivated creative engagement through strength-based creative art therapy approaches with young people internationally. Art therapy approaches are varied in theoretical underpinnings and applications.

The words within the volume have been assembled by chapter authors, leaders in their respective fields, using the language most attuned to their client population and current best practice standards. Translating nonverbal therapeutic art techniques into the written word has its challenges, particularly when we come to understand that language itself has a long history of creating and upholding systems of oppression. As art therapists, we continue to interpret our client's artistic creations, filtering their work through screens of our own biased language to communicate their intention to treatment teams, parents, and in reflecting back to the artists' themselves. The language we use to communicate, describe, and define is therefore of utmost importance.

Language, like culture, lives and breathes, evolving as we work to better grasp and articulate the lived experiences of diverse individuals across the globe. As such, we are confident that the language used here will soon be read as dated or archaic, perhaps even pejorative, as we continue to better understand community-based standards and respectful, strength-based care. As editors, we are grateful for the opportunity to highlight the groundbreaking art therapy approaches and techniques depicted here. We ask our readers to allow themselves to be inspired by the passages within, while also holding accountability for continued cultural awareness attuned to the time and place in which they work.

We urge practitioners in the field to not underestimate the power of their words and to take responsibility to change and adapt in the best interest of their clients. As Swadener (1995) explained:

> As deceptively simple as it may seem, we need to treat all children like human beings, without "at-risk," "doomed to fail," or other adjectives or qualifiers- limiters-added. "Human beings at promise," needing our care, confidence and faith. This may indeed by the only way to begin to transform a "nation at risk" to a future generation "at promise."
>
> (p. 41)

We look forward to continued redefinition, conversation, and evolution.

References

Arnold, M. S., & Swadener, B. B. (1993). Savage inequalities and the discourse of risk: What of the white children who have so much green grass? *Educational Review, 15*, 261–272.
Bianco, M. (2017). At-risk youth and attachment-based therapy: Implications for clinical practice. *Canadian Journal of Counselling and Psychotherapy, 51*(1), 81–96.
Bitsko, R. H., Holbrook, J. R., Ghandour, R. M., Blumberg, S. J., Visser, S. N., Perou, R., & Walkup, J. T. (2018). Epidemiology and impact of health care provider—diagnosed anxiety and depression among U.S. children. *Journal of Developmental & Behavioral Pediatrics, 39*(5), 395–403.
Boykin, A. W. (2000). The talent development model of schooling: Placing students at promise for academic success. *Journal of Education for Students Placed at Risk (JESPAR), 5*(1–2), 3–25. doi:10.1080/10824669.2000.9671377
Bronfenbrenner, U. (1977). Toward an experimental psychology of human development. *American Psychologist, 32*(7), 515–531
Centers for Disease Control and Prevention. (2019). *Data and statistics on children's mental health.* Retrieved from www.cdc.gov/childrensmentalhealth/data.html#ref

Danielson, M. L., Bitsko, R. H., Ghandour, R. M., Holbrook, J. R., Kogan, M. D., & Blumberg, S. J. (2018). Prevalence of parent-reported ADHD diagnosis and associated treatment among U.S. children and adolescents, 2016. *Journal of Clinical Child & Adolescent Psychology*, 47(2), 199–212.

Edwards, J., Young, A., Nikels, H., & Standefer, S. (2017). Strengths-based counseling 2.0. In J. Edwards, A. Young, & H. Nikels (Eds.), *Handbook of strengths-based clinical practices: Finding common factors* (pp. 3–18). New York, NY: Routledge.

Estrella, K. (2011). Social activism within expressive arts "Therapy". In *Art in action: Expressive arts therapy and social change* (pp. 42–52). London, England: Jessica Kingsley Publishers.

Federal Interagency Forum on Child, & Family Studies (U.S.) (Eds.). (2017). *America's children: key national indicators of well-being 2017*. Government Printing Office. Retrieved from www.childstats.gov/pdf/ac2017/ac_17.pdf

Franklin, W. (2013). Students at promise and resilient: A historical look at risk. In M. G. Sanders (Ed.), *Schooling students placed at risk: Research, policy, and practice in the education of poor and minority adolescents* (pp. 3–16). New York, NY: Routledge.

Freud, A., & Burlingham, D. (1943). *War and children*. New York, NY: Ernst Willard.

Garbarino, J., & Haslam, R. H. (2005). Lost boys: Why our sons turn violent and how we can save them. *Paediatrics & Child Health*, 10(8), 447–450.

Garbarino, J., & Kostelny, K. (1993). Children's response to war: What do we know? In L. Leavitt & N. Fox (Eds.), *The psychological effects of war and violence on children* (pp. 23–40). Hillsdale, NJ: Lawrence Erlbaum Associates, Inc.

Garmezy, N. (1983). Stressors of childhood. In N. Garmezy & M. Rutter (Eds.), *Stress, coping, and development in children*, Ctr for Advanced Study in the Behavioral Sciences, Inc (pp. 43–84). Baltimore, MD: Johns Hopkins University Press.

Garmezy, N. (1987). Stress, competence, and development: Continuities in the study of schizophrenic adults, children vulnerable to psychopathology and the search for stress-resistant children. *American Journal of Orthopsychiatry*, 57, 159–174.

Ghandour, R. M., Sherman, L. J., Vladutiu, C. J., Ali, M. M., Lynch, S. E., Bitsko, R. H., & Blumberg, S. J. (2019). Prevalence and treatment of depression, anxiety, and conduct problems in U.S. children. *The Journal of pediatrics*, 206, 256–267.

Ginwright, S. (2018). The future of healing: Shifting from trauma-informed care to healing centered engagement. *Occasional Paper*, 25.

Greene, M. (2007). *Imagination and becoming*. Retrieved from https://maxinegreene.org/uploads/library/imagination_bbcs.pdf

Henderson, D., DeCuir-Gunby, J., & Gill, V. (2016). "It Really Takes a Village": A socio-ecological model of resilience for prevention among economically disadvantaged ethnic minority youth. *Journal of Primary Prevention*, 37(469–485). doi:10.1007/s10935-016-0446-3

Ho, R. T. H., Potash, J. S., Lo, P. H. Y., & Wong, V. (2014). Holistic interventions to trauma management for teachers following disaster: Expressive arts and integrated body-mind-spirit approaches. *Asia Pacific Journal of Social Work and Development*, 24(4), 275–284. doi:10.1080/02185385.2014.92581

Horowitz, F. (2000). Child development and the PITS: Simple questions, complex answers, and developmental theory. *Child Development*, 71(1), 1–10.

Human Rights Campaign. (2018). *LGBTQ youth report 2018*. Retrieved from https://assets2.hrc.org/files/assets/resources/2018-YouthReport-0514-Final.pdf

Jain, S., & Cohen, A. K. (2013). Fostering resilience among urban youth exposed to violence: A Promising area for interdisciplinary research and practice. *Health Education & Behavior*, 40(6), 651–662. https://doi.org/10.1177/1090198113492761

John-Steiner, V. (2010). *Through a narrow window: Friedl Dicker-Brandeis and her Terezín students*. Albuquerque, NM: University of New Mexico Press.

Kelly, B., & Gates, T. (2017). Strengths=based approaches: An interdisciplinary historical account. In J. Edwards, A. Young, & H. Nikels (Eds.), *Handbook of strengths-based clinical practices: Finding common factors* (pp. 19–32). New York, NY: Routledge.

Kramer, E. (2010). On Friedl. In V. John-Steiner (Ed.), *Through a narrow window: Friedl Dicker-Brandeis and her Terezín students* (pp. 1–3). Albuquerque, NM: University of New Mexico Press.

Lake, R., & Kress, T. (2017). Mamma don't put that blue guitar in a museum: Greene and Freire's duet of radical hope in hopeless times. *Review of Education, Pedagogy, and Cultural Studies, 39*(1), 60–75. doi:10.1080/10714413.2017.1262166

Leifield, L., & Murray, T. (1995). Advocating for Aric: Strategies for full inclusion. In B. B. Swadener & S. Lubeck (Eds.), *SUNY series, the social context of education: Children and families "at promise": Deconstructing the discourse of risk* (pp. 238–261). Albany, NY: State University of New York Press.

Lubeck, S., & Garrett, P. (1990). The social construction of the 'At-Risk' child. *British Journal of Sociology of Education, 11*(3), 327–340. Retrieved from www.jstor.org/stable/1392846

Ludwig-Körner, C. (2017). Anna Freud and observation: Memoirs of her colleagues from the Hampstead war nurseries. *Journal of Infant, Child, and Adolescent Psychotherapy, 16*(2), 131–137. doi:10.1080/15289168.2017.1307072

Maholmes, V. (2014). *Fostering resilience and well-being in children and families in poverty: Why hope still matters.* Oxford: Oxford University Press.

Makarova, E. (2001). *Friedl Dicker-Brandeis, Vienna 1898-Auschwitz 1944.* Los Angeles: CA: Tallfellow Press.

Makarova, E., Makarov, S., & Kuperman, V. (2004). *University over the abyss: The story behind 520 lecturers and 2,430 lectures in KZ Theresienstadt 1942-1944.* Jerusalem, Israel: Verba Publishers.

Malchiodi, C. (2015). Calm, connection, and confidence: Using art therapy to enhance resilience in traumatized children. In D. Crenshaw, R. Brooks, & S. Goldstein (Eds.), *Play therapy interventions to enhance resilience* (pp. 126–145). New York: Guilford Publications.

Masten, A. S., Nuechterlein, K. H., & Wright, M. O. (2011). Norman Garmezy (1918–2009). *American Psychologist, 66*(2), 140–141. http://dx.doi.org/10.1037/a0021246

May, R. (1975). *The courage to create.* New York, NY: W.W. Norton.

Mayer, S. J. (2017). The social world, the creative self, and the ongoing achievement of freedom. *Review of Education, Pedagogy, and Cultural Studies, 39*(1), 7–17. doi:10.1080/10714413.2017.1262155

McClearly, J., & Figley, C. (2017). Resilience and trauma: Expanding definitions, uses, and contexts. *Traumatology, 23*(1), 1–3. http://dx.doi.org/10.1037/trm0000103

Merikangas, K. R., He, J. P., Burstein, M., Swanson, S. A., Avenevoli, S., Cui, L., . . . Swendsen, J. (2010). Lifetime prevalence of mental disorders in U.S. adolescents: results from the National Comorbidity Survey Replication—Adolescent Supplement (NCS-A). *Journal of the American Academy of Child & Adolescent Psychiatry, 49*(10), 980–989.

Morton, M. H., Samuels, G. M., Dworsky, A., & Patel, S. (2018). *Missed opportunities: LGBTQ youth homelessness in America.* Chicago, IL: Chapin Hall at the University of Chicago.

Murphy, J., & Sparks, J. (2018). *Strengths-based therapy: Distinctive features.* New York, NY: Routledge.

Nielsen, M. E. (2002). Gifted students with learning disabilities: Recommendations for identification and programming. *Exceptionality, 10*(2), 93–111. doi:10.1207/S15327035EX1002_4

Rennick, J. B. (2015). Learning that makes a difference: Pedagogy and practice for learning abroad, teaching & learning inquiry. *The ISSOTL Journal, 3*(2), 71–88. Retrieved from www.jstor.org/stable/10.2979/teachlearninqu.3.2.71

Rios, V. (2011). *Street life: Poverty, gangs and a PhD.* California: Five Rivers Press.

Rutter, M. (2012). Resilience as a dynamic concept. *Development and Psychopathology, 24,* 335–344. doi:10.1017/S0954579412000028

Sarid, O., Cwikel, J., Czamanski-Cohen, J., & Huss, E. (2017). Treating women with perinatal mood and anxiety disorders (PMADs) with a hybrid cognitive behavioural and art therapy treatment (CB-ART). *Archives of Women's Mental Health, 20*(1), 229–231. doi:10.1007/s00737-016-0668-7

Sajnani, N. (2012). Response/ability: Imagining a critical race feminist paradigm for the creative arts therapies. *The Arts in Psychotherapy, 39*(3), 186–191. doi.org/10.1016/j.aip.2011.12.009.

Sentencing Project. (2017). *Black disparities in youth incarceration*. Retrieved from www.sentencing project.org/wp-content/uploads/2017/09/Black-Disparities-in-Youth-Incarceration.pdf

Sharma, R. (2017). *Global youth wellbeing index*. Retrieved from www.iyfnet.org/sites/default/files/library/2017YouthWellbeingIndex.pdf

Siperstein, G. N., & Favazza, P.C. (2008). Placing children "At Promise": Future trends for promoting social competence. In W. H. Brown, S. L. Odom, & S. R. McConnell (Eds.), *Social competence of young children: Risk, disability, and intervention* (pp. 321–332). Baltimore, MD: Paul H Brookes Publishing.

Swadener, B. B. (1995). Children and families "at promise": Deconstructing the discourse of risk. In B. B. Swadener & S. Lubeck (Eds.), *Children and families "at promise": Deconstructing the discourse of risk* (pp. 17–49). New York, NY: State University of New York Press.

Swadener, B. B., & Lubeck, S. (1995). *Children and families "at promise": Deconstructing the discourse of risk*. New York, NY: State University of New York Press.

U.S. Department of Education Office for Civil Rights. (2014). *Civil rights data collection data snapshot: School discipline*. Retrieved from https://ocrdata.ed.gov/downloads/crdc-school-discipline-snapshot.pdf

Van Breda, A. D. (2018). A critical review of resilience theory and its relevance for social work. *Social Work/Maatskaplike Werk, 54*(1), 1–18. doi:10.15270/54-1-611

Van Lith, T., Fenner, P., & Schofield, M. (2011). The lived experience of art making as a companion to the mental health recovery process. *Disability and Rehabilitation, 33*(8), 652–660. doi:10.3109/09638288.2010.505998

Vespa, J., Armstrong, D. M., & Medina, L. (2018). *Demographic turning points for the United States: Population projections for 2020 to 2060*. Washington, DC: U.S. Department of Commerce, Economics and Statistics Administration, U.S. Census Bureau.

Whiting, G. W. (2006). From at risk to at promise: Developing scholar identities among Black males. *Journal of Secondary Gifted Education, 17*(4), 222–229. https://doi.org/10.4219/jsge-2006-407

2

Creative Problem Solving in Art Therapy
An Overview of Benefits to Promote Resilience

MARYGRACE BERBERIAN

Resilience

Resilience, a constellation of internal processes and external behaviors, has been widely examined in the fields of psychology, psychiatry, sociology, and biology (Herrman et al., 2011). Broadly defined, resilience can be understood as "multi-dimensional characteristics and processes of time and context-specific resistance, leading to positive adaptation in the face of adversity" (Ebersöhn, Nel, & Loots, 2017, p. 147). It encompasses both reactive recovery from adverse events and the proactive management of stressors through reliance on protective factors. Resilience is influenced by temperament, psychosocial development, genetic factors, and other environmental protective elements (Herrman et al., 2011; Osório, Probert, Jones, Young, & Robbins, 2017; Ungar, 2015).

The proximal and distal effects of chronic adversity can manifest widely throughout the body (Kendall-Tacket, 2009). The longitudinal impact of acute stress responses in the face of chronic abuse, trauma, and violence in early development is still often misunderstood, minimized, and misdiagnosed (Chapman, 2014). Early adversity has increasingly been shown to have extensive and enduring effects on the neuroregulatory systems that mediate illness and behavior from childhood into adult life. Adverse childhood experiences that often go unrecognized as trauma can have a negative influence on emotional states, health, sexual behavior, and medical care costs decades later (Felitti & Anda, 2010). Systematic factors such as family, school, and community can account for variance in the outcomes for childhood resilience (Ungar, 2013). As threats to individual and community safety become more complex, there is increasing interest in how systematic resources can be linked through a translational framework to apply the multidisciplinary inquiries into resilience (Abramson et al., 2015).

Art Therapy and Resilience

Since its inception, the practice of art therapy has been shown to promote resilience in children. As acclaimed child art therapist Judith Rubin wrote, "Creating helps children define themselves and their experiences, through forming unformed media, developing their own themes and styles, and discovering and delineating their identities" (2005, p. 312).

Art therapists frequently bear witness to the transformative, astounding results of treatment, but outcomes have been difficult to measure empirically (Regev & Cohen, 2018). A decade ago, Johnson (2009) suggested that linking the long-held qualitatively driven theories of creative arts therapy to neuroscience constructs would help the profession gain legitimacy within the dominant mental health culture. More recently, Kapitan (2014) endorsed the adoption of brain science in art therapy, noting:

> When it comes to the complex beauty of the human brain, art has much to tell us about how the mind and the brain work. Despite the fact that there is so much more to learn and to discover, we enrich art therapy by adding a new dimension to its study and opening ourselves to its great potential.
>
> (p. 51)

Researching outcomes in art therapy is challenging, as the practice involves more than just measurable, structured interventions; art-making is conducted in tandem with the attuned therapeutic relationship and the inherent rewards of its processes. Advances in neuroscience research have ignited more informed discussions within the profession. Recent neuroscientific research in art therapy has begun to better explain how and why art therapy helps to strengthen a child's adaptive response to adversity (Chapman, 2014; Hass-Cohen & Findlay, 2015; King, 2016). Intervention methods presented in the Art Therapy Trauma Protocol (Talwar, 2007), Intensive Trauma Therapy (Gantt & Tripp, 2016), and the Neurodevelopmental Model of Art Therapy Treatment (Chapman, 2014) have innovatively considered the neurological underpinnings of art therapy and its ability promote psychological health in the face of adversity. New paradigms are being developed to examine how pervasive stress responses can be alleviated in art therapy through affect regulation, cognitive processing, and the rewards of mastery (Hass-Cohen & Findlay, 2015). Neurobiologically, these mechanisms, which have in the past been oversimplified, are now understood as different, complex processes (Hass-Cohen & Findlay, 2015; Johnson, 2009).

The creative processes and production of art—the substance of art therapy treatment—is complex to fractionate and measure, as skill (both learned or established), talent (inborn or promoted), and aesthetics are intertwined (Zaidel, 2014). Regarding the promotion of resiliency, three key, dynamically operative mechanisms of change have emerged from current art therapy research:

1. As a conduit for accessing and mitigating conflicted memories and affect, visual expression can organize cognition and memories.
2. The attuned relationship with the art therapist aids in the mirroring and repair of disruptions in attachment.
3. The rewards gained from engagement in art-making lead to both pleasure and mastery.

Theoretically, these three broad functions work interdependently. For example, the tolerable access of traumatic memories via art processes is encouraged by the trusting, empathic relationship with the therapist and the reward derived from the sensorially pleasurable creative process. Further, by safely re-encoding terrorizing memories through art therapy, the child can construct new options for safety through mirroring from the art therapist and reap the rewards of feeling validated. In this structural

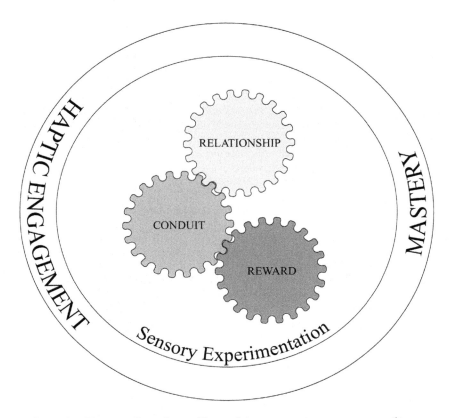

Figure 2.1 Diagram of creative problem-solving components to support resilience

framework, this interdependent tripartite construct operates in the context of sensory experimentation, which allows for both haptic engagement and mastery. Figure 2.1 illustrates this concept.

The effectiveness of art therapy in promoting resiliency in young people is summarized in the next section of this chapter. It outlines the outcomes of art therapy witnessed in practice and described in the literature, presenting a framework for the creative problem solving that can promote resiliency in young people. Although the term "creative problem solving" has appeared in art therapy research as a targeted outcome, it has not been operationalized (Carolan & Backos, 2017; Malchiodi, 1999; Rubin, 2011). Creative problem solving in art therapy can be defined as the constellation of creative processes, supported by the therapist, that enables sensory, experimental, and often metaphoric exploration to devise new ways to cope with past and chronic experiences of adversity. Emotions and thoughts are expressed and rehearsed through graphic communication as novel, possible realities. Through paced reflections, the child can develop a sense of agency, gaining mastery over the process and product.

Belfiore (2016) acknowledged the widespread belief that the impact of arts engagement on the mind and body is not borne out by scientific evidence. The art therapy

profession has begun to change that view. Schore (2015) suggested the constructs linking the instrumental theories of psychoanalysis (Kramer, 1958; Naumburg, 1947) and developmental psychology are engaged in novel cross-fertilizing for research. Advances in neuroscience have expanded the breadth of the profession, including practices understood to be proactive, protective proponents of wellness (Chapman, 2014; Czamanski-Cohen & Weihs, 2016; Gantt & Tinnin, 2007; Hass-Cohen & Findlay, 2015; King, 2016). This broad spectrum of treatment requires understanding the mechanisms of change that strengthen the capacity of complex young people to navigate contextual systems of unpredictability and injustice.

Five broad, observable benefits illustrate how art therapy promotes creative problem solving and resilience. These observations of clinical practice link early concepts of art therapy to expanding advances in neuroscience.

1. Art therapy utilizes art-making as an accessible and developmentally suitable means of communication.
2. Art therapy promotes a range of sensory-based experiences that are often rewarding to children at promise.
3. Art therapy activates the preverbal and body memories of stored experiences and can provide less-threatening venues for expression through creation and metaphor.
4. Art therapy provides structured opportunities to explore overwhelming psychological distress and mitigate tensions into more tolerable expression.
5. Art therapy allows for the witnessing of emotional expression through attuned presence and support for creative aspirations.

Collectively, these benefits can foster creative problem solving, which is believed to be essential to resilience.

1. Art Therapy Utilizes Art-making as an Accessible and Developmentally Suitable Means of Communication

As a method of communication, art therapy taps into the liminal world of the child, translating inner processes into visual narratives that reflect the developmental stages of the child. Acceptance of ambiguity, propensity for nonlinear thinking, and receptivity to fantastical ideas are the essential, creative assets of childhood (Narayan, 2005). These assets promote novel ideas; the combination of novelty and utility is considered the hallmark of creativity (Bilder & Knudsen, 2014). McNiff (2015) wrote that "those of us who stay close to children witness the wonder and curiosity that is the wellspring of creative imagination" (p. 9). Playful, creative exploration in normal development also provides mastery and acceptance of existing realities (Erickson, 1963). Curiosity—the impetus for creativity and positivity—is the neural default of children in the absence of adversity (Hass-Cohen & Findlay, 2015).

Art-making engages the imaginal, playful realm, capitalizing on innate creativity to reveal alternatives to maladaptive ways of coping. Art therapy broadens the range of expressed affect, often enabling the individual to communicate what is internally withheld or externally oppressed. In the playful, iterative process of creation, possibilities are limitless, and solutions thereby become realized. Art therapy encourages the rehearsal of creative exploration without judgment, allowing children to problem

solve and self-regulate while investigating their inner anxieties (Gil, 1991). As Winn-icott (1971) wrote, "It is in playing and only in playing that the individual child or adult is able to be creative and to use the whole personality, and it is only in being creative that the individual discovers the self" (p. 54). Play and creativity, thought to be adaptive, evolutionary mechanisms in the mammalian brain, allow for growth, flexibility, tolerance, and experimentation (Schore & Marks-Tarlow, 2018). Immersion in creative exploration and imaginal realms also provides distraction and soothing (Chapman, 2014).

While art and play share many characteristics, the images formed in the imagi-nal experience are thought to require deeper cognitive integration and organization; thus, art is distinguished as a "goal directed form of play" (Gardner, 1973, p. 166). Mark making and symbolic representations play important roles in development, as drawing supports the child's generation of ideas that latter manifest themselves in sentences (Yang & Noel, 2006). Interestingly, von Petzinger (2016) classified a total of 32 specific graphic signs discovered in caves across a 30,000-year time span across Europe, which predated the early forms of writing such as Egyptian hieroglyphics. She speculated that drawing preceded writing as the oldest system of graphic com-munication. Along similar lines, Kellogg (1969) identified the 20 basic scribbles from over one million children's drawings and theorized that these scribbles were the ear-liest developmental attempts to construct gestalts that would lead to both images and letters.

Drawings are the primary modes of graphic communication for children. Dialogue is captured in visual form, serving as a point of reflection for future reference. Lowenfeld and Brittain (1987) wrote that:

> Young children use art as a means of learning, through the development of concepts which take visible form, through the making of symbols which capture and are an abstraction of the environment, and through the organization and positioning of these symbols together in one configuration.
>
> (p. 2)

Gardner (1980) also noted the developmental importance of art-making, writing that "creative works are the means, the artist's necessary means, of expressing his being and those feelings that are often inarticulate and inexpressible in other media" (p. 268). For "it is through the process of art that art itself unfolds" (Lowenfeld & Brittain, 1987, p. 11). As a translator of imagination, art-making is the first graphic communication for a growing child, and a prime means of idea generation and emo-tional expression. Developmentally suited for therapeutic intervention (Gardner, 1980; Kellogg, 1969; Lowenfeld & Brittain, 1987) and culturally appropriate (Ber-berian, 2015), art helps the individual access inner states of consciousness (Kramer, 1993; Naumburg, 1947).

2. Art Therapy Promotes a Range of Sensory-Based Experiences That Are Often Rewarding to Children at Promise

Art therapy invites exploration of a range of media, from highly controlled to more expressive materials. The entry point for artistic expression is generally chosen by the child, cultivating greater ease and security as more difficult feelings may arise.

Empowered with the autonomy to choose art materials, children are likely be less defended in their engagement. Dissanayake (2000) noted:

> [B]oth love and art have the power to grasp us utterly and transport us from ordinary sweating, flailing, imperfect "reality" to an indescribable realm where we know and seem known by the sensibility of another, united in a continuing present, our usual isolation momentarily effaced.
>
> (p. 4)

This has been described as a period of "incubation," the immersive experience of working without conscious deliberation (Rubin, 2011, p. 15). Csikszentmihalyi's (1990) flow theory described the optimal experience of artistic immersion:

> Yet we have all experienced times when, instead of being buffeted by anonymous forces, we do feel in control of our own actions, masters of our own fate. On the rare occasions that it happens, we feel a sense of exhilaration, a deep sense of enjoyment that is long cherished and becomes a landmark in memory for what life should be like. This is what we mean by optimal experience. It is what the sailor holding a tight course feels when the wind whips through her hair, when the boat lunges through the waves like a colt—sails, hull, wind and sea humming a harmony that vibrates the sailor's veins. It is what a painter feels when the colors on the canvas begin to set up a magnetic tension with each other, and a new thing, a living form, takes shape in front of the astonished creator.
>
> (p. 3)

The writings of early philosophers can help us understand the immersive rapture of discovery. Expressive therapists who have referenced Aristotle's early work emphasize the ways of knowing as: 1) theoria, knowing by observing; 2) praxis, knowing by doing or acting; and 3) poesis, knowing by making (Levine, 2004; McNiff, 2011). Therapeutic practices that involve poesis encourage engagement with the imaginal world to achieve "decentering," in which actions remove the problem from the "center" of focus to reveal unknown possibilities (Levine, 2015, p. 17).

The sensory experience of art-making has been linked to pleasure (Carafoli, 2016; Chatterjee, 2014). Art therapy literature has largely focused on the visual experience rather than tactile engagement, downplaying the potential for treating trauma through the specificities of touch (Elbrecht & Antcliff, 2014). Earlier studies have noted the role of sensory stimulation in developmental art therapy but failed to recognize the benefits of tactile engagement for other populations (Aach-Feldman & Kunkle-Miller, 1987; Henley, 1992, Malchiodi, Kim, & Choi, 2003). More recently, art therapy literature has highlighted the sensory qualities of art-making as a means to activate the amygdala via the somatosensory primary cortex (Czamanski-Cohen & Weihs, 2016; Hass-Cohen & Findlay, 2015; Lusebrink & Hinz, 2016). Touch is linked to the earliest body memories, to sexuality, and to experiences of physical violations or injuries and is thus related to the release of oxytocin, serotonin, and endorphins (Elbrecht & Antcliff, 2014; Hass-Cohen & Findlay, 2015). In the manipulation of art media, exteroceptors and interoceptors are stimulated, and the hands signal information back to the brain. The engagement of sensory stimulating materials can result in haptic pleasure. The exploration of malleable material through iterative doing and undoing offers the potential to repair attachment through experiences of mastery.

3. Art Therapy Activates the Preverbal and Body Memories of Stored Experiences and Can Provide Less Threatening Venues for Expression Through Creation and Metaphor

The use of symbol and metaphor is essential in art therapy. Hagman (2010) wrote that "art is one of the means by which human communities extend and infiltrate these archaic interpersonal processes of shared experiences of self, relationship, community and world" (p. 16). The process of evoking metaphors, the created image, and the responses to the final product are understood as reflections of development, ambitions, and conflicts. Chronic distress can impair verbal expression as these experiences decrease the functioning of the left hemisphere, home to both language and declarative memory (Perry, 2009; Vogel & Schwabe, 2016). Schore (2015) stressed that "the right hemisphere-to-right hemisphere dialogue is the primordial wellspring" for the meaning making that is generated across development through coherent systems, culminating in a personal narrative (p. 482). Further, the characteristic "speechless terror" of alexithymia, a possible outcome of trauma, complicates the efforts of those in distress to use language for both processing the experiences and advocating for resolutions (Tripp, 2016; van der Kolk, 2014). In a study of the relationship between post-traumatic stress disorder and symbolic representation, participants demonstrated greater capacities for symbolic representation, thereby freeing themselves from the pressure to process difficult memories using verbal methods alone (Miller & Johnson, 2012).

The nonverbal, sensory-based qualities of material manipulation have been found to aid recall and encourage symbolization for psychic distancing (Rubin, 1984). Van der Kolk (2014) explained that extreme stress inhibits the hippocampus so that stress-inducing memories are stored as somatic sensations or images through sensory motor functions. Trauma is often encoded as a nonverbal sensation and retained as implicit memory (Lusebrink & Hinz, 2016). Implicit memory can be impaired by adverse events; in the more extreme stress experiences of PTSD, memories are intrusive and experienced involuntarily (Siegel, 2017).

In trauma recovery, clients are encouraged to process memories by externalizing autobiographical details and constructing a new narrative (Collie, Backos, Malchiodi, & Spiegel, 2006; Smith, 2016; van der Kolk, 2014). Accessing implicit memory, reflexive mentalizing, and transforming conflicted memories are part of effective contextual trauma processing in art therapy (Hass-Cohen & Findlay, 2015, 2019). Newer studies suggest that creating a more tolerable and less emotionally disturbing account of trauma may be more crucial to recovery than the accurate, consolidated retelling of the associated memories (Bedard-Gilligan, Zoellner, & Feeny, 2017; Engelhard, McNally, & van Schie, 2019). In art therapy, the retelling and reformulation of the terrorizing memories through pictorial, nonverbal iterations is generally less threatening and more tolerable than verbal disclosure because much is mitigated through visual symbolism (Harris, 2009). The brain functions that allow language to verbalize creative and innovative processes aid the formation of body memories into a self-narrative (Hass-Cohen & Findlay, 2015; van der Kolk, 2014).

Empowered by creative confidence, the child has command over the narrative, embracing or surrendering the protective veil of the metaphor while sharing the lived experience. Using metaphor, art-making accesses "the depth where deep, but opposite, truths are, paradoxically valid, and are reconciled, producing a transcendent experience" (Gorelick, 1989, p. 152). The use of symbols reveals new perspectives, "shedding light on and at times obscuring the view of a polyvalent perspective of self, culture,

and history" (Dean, 2016, p. 22). This concept of simultaneity in art, introduced by Gadamer, is described in this way:

> Simultaneity allows for the representation of past and present realities at the same time, which unearths, preserves and narrates our collective and individual histories. Simultaneity also implies the coexistence of multiple realities and truths, some apparent and others concealed, which are revealed and re-experienced within the emergent iterative arts process.
>
> (Gerber & Myers-Coffman, 2018, p. 591)

Metaphors add dimension to language, conveying and bridging old constructs to meet novelty, ultimately supporting self-actualization and transcendence (Gorelick, 1989).

4. Art Therapy Provides Structured Opportunities to Explore Overwhelming Psychological Distress and Mitigate Tensions

The establishment of safety and stabilization is crucial to responding effectively to crises and treating trauma (Greenwald, 2005; Yaeger & Roberts, 2015; Rothschild, 2017). An assurance of predictability and a feeling of competency are protective factors for resilience (Osório et al., 2017). Uncontrollable stress can lead to "learned helplessness," a belief in the inability to change the circumstances of one's situation, which can severely affect cognition and mood and reduce future coping skills (Wu et al., 2013).

Predictability in the stress-system activation can have greater influence than the actual intensity of the stressor (Perry & Szalavitz, 2017). In art therapy sessions, the malleability of the materials, the decisions made, and the static dimensions of the finished product provide high levels of both predictability and control, generating a sense of competency in periods of distress. Art therapy provides for the supported negotiation of creative tensions and the successful completion of sequential, goal-driven tasks. Art can pictorially map what cannot be examined verbally; order can be established visually in the midst of psychological chaos (Berberian, 2017). Through sequenced actions, the child becomes immersed in a process with media "which do[es] not talk back" (Rubin, 2005, p. 358). The child gains a sense of agency amidst feelings of powerlessness. Art therapy offers a way to expose intolerable internal experiences. In trauma treatment, where triggering content is often avoided, the externalized creation of an image allows for the "internal world to become fixed, external, and unavoidable" (Skeffington & Browne, 2014, p. 119). The child often attempts to apply a cognitive-based causation explanation to "tame and attenuate" the trauma to master what is incomprehensible (Bohleber, 2018, p. 111). Kramer (1993) believed art therapy opened a door to "a new order of experiences wherein ideas can be told and retold in many different guises" (p. 33). The reconstructed representation of the distressful experience can also dissolve the false cognitions and guilt often embedded in the processing (Bohleber, 2018; Gantt & Tripp, 2016; Greenwald, 2005; Herman, 1992).

Creative processes are divided into divergent and convergent phases. Divergent thinking generates ideas and possible solutions, while convergent thinking analyzes, recognizes, and selects concepts (de Buisonjé, Ritter, de Bruin, ter Horst, & Meeldijk, 2017). Neurology links cognitive flexibility to creative achievement, as divergent problem solving is implicit in the artistic process (Boccia, Piccardi, Palermo, Nori, & Palmiero, 2015, Heinonen et al., 2016). The balance of stability and flexibility in creative practice can be a protective factor in resiliency for those with a genetic predisposition to mental illness

(NEA, 2015). The intentional actions demanded by creative processes invite cognitive structuring. This gives the individual who may in the past have been victimized more control over future decision making (Hass-Cohen & Findlay, 2015). Art-making allows for the continual discovery of creative solutions. Creativity is a multifaceted process, supported by high-level mental operations including executive functions (planning, working memory, attention, semantic memory retrieval) and associative modes of processing (Boccia et al., 2015). Art therapy sessions offer an abundance of choices, inviting rehearsal and successful execution of cognitive functioning. The constellation of decisions, most of which are made without conscious awareness, includes choosing media; whether to sit or stand at a preferred position at the table, easel, or floor; the subject of the work; the linear steps in the production; and the verbalization of the associations.

Psychology research has long noted dual process models of decision making, which posit that choices stem from either analytical or experiential/emotional processing systems (Epstein, Pacini, Denes-Raj, & Heier, 1992). The Unconscious Thought Theory (Dijksterhuis & Nordgren, 2006) examined conscious deliberation in making choices and found that less consciousness, and less deliberation and more distraction, yielded more effective decision making in complex tasks. The inclusion of drawing, as a more emotional and experimental practice for decision making was found to be more effective in discerning factors for decision making than a more deliberated rational/analytic mindset (Usher, Russo, Weyers, Brauner, & Zakay, 2011).

Garrison and Handley (2017) have since proposed that unconscious thought is independent of the two modes of processing previously described. This third dimension of decision making operates "outside of conscious awareness but does so over a period of time (i.e., not quickly and automatically), and in a goal-directed manner" (p. 2). Complex information is thought to be analyzed through goal-directed unconscious thought during periods of distraction rather than deliberation. Further, the benefits are derived not from the unconscious thinking per se but rather the emotional experience during the distraction period. More empirical art therapy research is needed to determine how art-making enhances decision making skills.

Vasanth Sarathy (2018), an engineer and cognitive scientist in the field of artificial intelligence, developed the Real World Problem-Solving (RWPS) method, a model involving both internal neural processes (conscious and unconscious thought) and external environmental influences. The RWPS model theorizes that problem solving, creativity, and insight help to manage the likely impasses inherent in the iterative discoveries achieved through involvement with the environment. It suggests that interaction with the environment triggers potentially useful memories and adds novel, informed linkages from observations to the problem-solving process (Sarathy, 2018). The cognitive/neural mapping of this model as it pertains to both the art therapy process and the role of the art therapist presents extensive areas for research.

The potential of art therapy as a less analytical yet goal-directed and engaged arena for decision making offers another opportunity for study. Clinicians have observed novel discoveries and informed decisions in children as they emerge from the immersive creative process.

Additionally, individuals can gain psychic distance from traumatic experiences by viewing the completed art works. Rubin (2010) suggested:

> Viewing and showing the finished product(s) can be a wonderful source of pride and enhanced self-esteem. Creating something unique with materials facilitates much more, however, than a sense of accomplishment. Having an effect on even

a small piece of material reality is a powerful antidote for feelings of shame and helplessness.

(p. 91)

Through art-making, the child is encouraged to release tension through a discharge of conflicted energy. Nondirected art-making can lower negative affect and improve positive affect and self-efficacy (Kaimal & Ray, 2016).

The literature has explored art therapy's role in successful activation of creative energy, honoring regressive and aggressive states (Kramer, 1993; McNiff, 2015; Rubin, 2005). Kramer (1993) described the psychodynamic similarities of art and imaginative play as "islands wherein the reality principle is partly suspended" to enable the expression of forbidden wishes and impulses, the tempered reliving of painful experiences, and the safe discharge of affect (p. 26–27). Lured by the emotional pull of regression, cognition can manage the tensions in the aesthetic process (Rubin, 1984). The dialectic between the art and artist, thought to be the "engine of creativity," enables the art to come into being (Hagman, 2005, p. 75). Through the transformation of malleable materials, the artist also relies on symbolism as a protective barrier to both distance and reintegrate the destructive content (van Westrhenen et al., 2017).

5. Art Therapy Allows for the Witnessing of Emotional Expression Through Attuned Presence and Support for Creative Aspirations

The attuned presence of the art therapist can provide a reparative experience for children who have experienced disruptions in primary relationships. Early disruptions in parent-child attachment can have long-lasting influences on physical and mental health (Bosch & Young, 2017). Self-regulation develops within the early experiences with a primary caregiver (Siegel, 2017). Known as "parental social buffering," the mere presence of an empathic caregiver can moderate the activation of a stress response when an infant expresses behavioral distress (Gunnar, Hostinar, Sanchez, Tottenham, & Sullivan, 2015, p. 474).

Blaustein and Kinniburgh (2018) summarized the colossal developmental expectations in early, normative childhood as:

The child is learning that he exists as a separate entity from those individuals surrounding him; he is acquitting the foundations of connection in building his earliest relationships within the dyad and familial system; he is building early affect tolerance and regulations strategies through the coregulation provided by his caregivers; he is exploring his world and establishing the foundational understanding that will serve in problem solving and awareness of objects and space; and he is developing a basic sense of agency, or the awareness that he has the capacity to have an impact upon the world.

(p. 11)

Disruptions to this course of development can result in diminished self-regulation and interpersonal relatedness. In disrupted attachment, children may show excessive help-seeking, dependency, social isolation, and disengagement (Cook et al., 2005).

A supportive social emotional environment, in addition to an optimally developing brain, will lead to expanding adaptive functional capacities (Schore, 2001). There is much greater plasticity in the brain than previously thought. The plasticity of the

prefrontal cortex, specifically in areas involved in affect regulation, extends for longer periods, lengthening the opportunity to learn from the environment (Schlegel et al., 2015; Tottenham, 2017). Of course, the quality and nature of such learning will affect outcomes for the child. In normative development, childhood growth and development are optimized in the context of relationships with people and places reflective of familial, cultural and community ties (Field, 2016).

For chronically traumatized children, attentive regard, creativity, and play are essential not only for repair but also for regulation and problem solving in times of distress (Schore & Marks-Tarlow, 2018). The ability to soothe becomes impaired when early adverse experiences result in attachment deficiencies (Schore, 2015). The therapeutic alliance provides a haven within the child's chaotic external surroundings and overloaded intrapsychic structure. The child-centered art therapist encourages freedom of exploration without intrusion (Gil, 1991). The therapist offers concentrated attention to support "the realization of selfhood via one's own map" in creative exploration (Guerney, 1980, p. 21).

The calm, paced, attuned interventions of the therapist support the release of oxytocin, inhibiting arousal patterns to cultivate "optimal arousal" for the client (Ogden & Fisher, 2015, p. 69). For clients exposed to chronic stress, Perry and Szalavitz (2017) suggest that the therapist pay greater attention to the "dosing" of intervention to aid long-term potentiation, the strengthening of synaptic connections for new learning and memory reconsolidation (p. 308). The growing child relies on the caregiver for social referencing to regulate emotions and receive emotional knowledge (Tottenham, 2017). Research of mirror neurons analogizes this early exchange to the therapeutic process whereby the patient learns to identify emotions by "'observing' them as they are reflected in the therapist's attuned response" (Gallese, Eagle, & Migone, 2007, p. 160). Buk (2009) described the "embodied simulation" of mirror neurons evident in art therapy practices in the exploration of images, art-making, and later interpersonal discussion of the art. The art therapist generates empathy through the careful observation of the process and the later review of the mechanics of the created work (e.g., brushstrokes). Artistic experiences offer multilevel connectedness and reciprocity among individuals (Piechowski-Jozwiak, Boller, & Bogousslavsky, 2017).

Art therapists enhance their presence by providing art materials. The commodity of the art materials is critical in the relational experience of art therapy. Offering art materials in the space cultivates a dialogue between artist and the media (Snir & Regev, 2013). Rubin (1984) noted that nurturance is frequently sensed as the art therapist "feeds" the client art materials, engages in playful manipulation, and admires the art with the maternal "gleam-in-the-eye" (p. 59). The trust in the relationship and safety felt in the therapeutic space fosters resiliency as positive interpersonal relations is a protective factor (Hass-Cohen & Findlay, 2019; Herrman et al., 2011; Klorer, 2016).

Art therapists also offer technical support for the creative expression cultivated in the trusted space. Described as the "Third Hand" (Kramer, 1986), the attuned art therapist aligns with the child to achieve artistic aspirations. The "Third Hand" is the "hand that helps the creative process along without being intrusive, without distorting meaning or imposing pictorial ideas or preferences alien to the client" (Kramer, 2000, p. 48). Dannecker (2018) elaborated upon the "third hand" as a distinctive competency of the art therapist, noting "the art therapist's empathetic supporting presence facilitates and unburdens the patient's resurfacing feeling and experiences, and he is able to develop greater self-awareness" (p. 144–145).

The therapist may direct the use of materials with intentionality toward treatment goals. The versatility of controlled to expressive materials offers wide opportunities for engagement. Preliminary research has explored attachment styles with preference for and avoidance of specific media, suggesting further studies are needed (Snir, Regev, & Shaashana, 2017). Those with higher scores in avoidance showed aversion to more expressive materials such as finger paint and oil pastels. Ultimately, the empathic presence of the trained art therapist witnesses, validates, and aids artistic expression.

Art Therapy Activates Creative Problem Solving

The World's Largest Lesson, a child-friendly animated film for the United Nations Global Goals for Sustainable Development, contained this statement:

> Human beings have a power that other creations don't. We are the most creative creatures ever. Our heads are full of ideas and we're great at making things too. With that power, we can change the world over and over and can solve thousands of problems.
>
> (Robinson, 2015)

This idea, while arguably naïve, suggests the potential for sustainable development through harnessing the creative potential of young people. The World Economic Forum (2016) stated that creative problem solving and processing skills (active listening and convergent thinking) are core skill requirements for future industries. In envisioning technological advancements in education, the U.S. Department of Education (2017) defined creative problem solving "as a capacity to respond to non-routine situations to achieve their potential as constructive and reflective citizens" (p. 59).

Often misunderstood, the concept of creativity is neurologically different from the processes involved in creating art (Zaidel, 2014). The standard, bipartite definition of creativity dates back to the 1930s (Patrick, 1937) and can be summarized as "creativity requires both originality and effectiveness" (Runco & Jaeger, 2012, p. 92). Expanding on this definition, Corazza (2016) also considered how both contextual interplay and iterative processes generate creativity. He noted "cognitive and affective energy is required in the decision to engage in creative activity, and dynamic relationships with the environment bear fundamental influences on the process" (2016, p. 265). This dynamic definition of creativity is echoed in Csikszentmihalyi's (1996) systems approach, which says that creativity results from the interaction of three elements: a culture imbued with symbolic rules, a person contributing novelty to the symbolic realm, and a field of experts validating the innovation. More recently, there has been debate about whether the innovation of creative works must be measured by societal value, perhaps raising broader questions of art's role in society (Harrington, 2018; Heilman & Acosta, 2013; Weisberg, 2015). With the exception of thoughtfully planned exhibits, the art produced in therapy sessions is infrequently shown in public, let alone judged on its merits. The current controversy about this criterion for creative work does, however, underscore the importance of the work being valued by another. In art therapy sessions, the therapist engages the client in reflection, examining the work as an endpoint of the dynamic creative process. It can be argued that the intimate dialogue of validation and the therapist's witnessing and cultivating the process place value on the innovation of the work.

Creating art requires different neural pathways than simply being creative. Neuroscientific research postulates creativity engrosses convergent and divergent thinking, perception, memory, and learning. By uniting discrete areas of the brain, convergent and divergent thinking inhibits fixed ways of thinking and activates flexible memory combination (Benedek et al., 2014; Boccia et al., 2015; Zaidel, 2014, 2016). In a working model, Nadal (2013) outlined at least three functionally distinct sets of brain regions to understand how art-making is tracked in the brain:

> (i) prefrontal, parietal, and temporal cortical regions support evaluative judgment, attentional processing, and memory retrieval; (ii) the reward circuit, including cortical, subcortical regions, and some of its regulators, is involved in the generation of pleasurable feelings and emotions, and the valuation and anticipation of reward; and (iii) attentional modulation of activity in low-, mid-, and high-level cortical sensory regions enhances the perceptual processing of certain features, relations, locations, or objects.
>
> (p. 135)

Making art, with all the symbolic and metaphoric concepts and abstractions it entails, is a synthesis of multiple systems functions that is still not largely understood (Nadal, 2013; Benedek et al., 2014; Zaidel, 2016). Eureka moments, the phenomena of novel discoveries coupled with affect, are the result of widespread activation of bilateral areas of the brain and cognitive processes that vary by individual (Sprugnoli et al., 2017). The iterative engagement with conscious and unconscious thought processes may explain how creative immersion aids complex problem solving.

Neuroscience continues to untangle the processes of creativity and the production of creative works. Yet the question arises as to what inspires creative action. Indeed, the ability to create art is unique to humans (Zaidel, 2009). The propensity to create art is less easy to decipher, as explored in recent research (Boccia et al., 2015; Zaidel, 2014). Zaidel (2016) explained there is a void of assessment of visual art innovation in neurology:

> The alphabetical primitives in visual art consist of forms, shapes, patterns represented with various angles, perspective lines, convergence, vanishing points, overlap, gray-scale gradations, canonical views, disembedding, texture, medium, colors, shadows, and edges. These examples do not all have ready interpretations within existing neuropsychological tools or models.
>
> (p. 206)

In *The Courage to Create*, May (1994) examined the laws of nature in which "the acorn becomes an oak," a majestic outcome of automatic growth. Conversely, he adds, the individual becomes "fully human only by his or her choices and his or her commitment to them. People attain worth and dignity by the multitude of decisions they make from day by day. These decisions require courage" (p. 14).

In the supportive art therapy space, rich with opportunities for exploration, children are encouraged to create courageously with paced support for the neural processes that unfold. They can express emotions and have them validated as the visual narrative develops. The therapist bears witness to assure that risks are mitigated to rehearse new possibilities. Media use is regulated to moderate sensory stimulation. When such creative advances expose memories or inaccurate cognitions, the nature of the visual communication as a concrete form allows for distancing and reformulation. The simultaneous

mitigation of creating, bearing witness, and empathy of another reinforces affect regulations skills (Hass-Cohen & Findlay, 2015).

Art-making also mitigates the adrenal response to stress. The neurological circuits of reward (the catecholamine system—namely dopamine, norepinephrine, and adrenaline) work in tandem with the cortisol system (Hass-Cohen & Findlay, 2015). This dynamic circuit is highly susceptible to adverse conditions, chronically dysregulating neurochemical responses, altering brain structures, and increasing vulnerability to damage (Hass-Cohen & Findlay, 2015). Acute stress causes a circuitous neuroendocrine (flight or fight) response, activating hormones and neurochemical systems, most notably those involved with the productions of adrenaline and cortisol (Richter-Levin & Jacobson-Pick, 2010). Produced under normal circumstances, adrenaline and cortisol prepare the body for stress, mobilizing energy and altering blood flow. In chronic stress, the response is never turned off, and long-term effects include the suppression of the immune system, memory, and metabolic syndromes (National Scientific Council on the Developing Child, 2014).

Through complementary alternation of tonic and phasic dopamine signaling (e.g., participating in paced art-making processes), stability and flexibility can be mediated through cortical networks. Engaging in visual expression was found to activate blood flow in the prefrontal cortex, part of the brain's reward circuit (Kaimal et al., 2017). Using functional magnetic resonance imaging ([fMRI], Lacey et al., 2011) found images engaged the reward circuity of the ventral striatum, hypothalamus, and orbitofrontal cortex. Additionally, the excitation of paced novel experiences can balance cortisol to provide benefits (Hass-Cohen & Findlay, 2015). In a quasi-experimental pilot study, art therapy reduced cortisol levels in 75% of the sample and produced positive qualitative responses (Kaimal, Ray, & Muniz, 2016). Greater use of biomarker data in research will illuminate other potential physiological benefits.

Conclusion

Robinson (2015) wrote that "creativity is putting your imagination to work. It is applied imagination. Innovation is putting new ideas into practice" (p. 118). Art therapy activates creativity and uncovers innate problem-solving abilities that are often oppressed, stigmatized, and hindered by chronic adversity. Creative problem solving is both a protective factor and an adaptive response in the pursuit of resilience. Creating art fosters experimentation and innovation, reflecting emotional and cognitive flexibility (Zaidel, 2016). The paced rehearsal of new possibilities, combined with the attuned presence of another, can provide a "stress inoculation," affirming that challenges can be mastered (Wu et al., 2013).

As a conduit for accessing and mitigating conflicted memories and affect, visual expression can organize cognitions and memories. The attuned relationship with the art therapist aids in the mirroring and repair of disruptions in attachment, and the rewards gained from engagement in art-making lead to both pleasure and mastery. Taken together, these mechanisms support creative problem solving: a theoretical construct of art therapy's promotion of resilience.

References

Aach-Feldman, S., & Kunkle-Miller, C. (1987). A developmental approach to art therapy. In J. A. Rubin (Ed.), *Approaches to art therapy: Theory and technique* (pp. 251–274). New York, NY: Brunner and Mazel.

Abramson, D. M., Grattan, L. M., Mayer, B., Colten, C. E., Arosemena, F. A., Bedimo-Rung, A., & Lichtveld, M. (2015). The resilience activation framework: A conceptual model of how access to social resources promotes adaptation and rapid recovery in post-disaster settings. *The Journal of Behavioral Health Services & Research*, *42*(1), 42–57. doi:10.1007/s11414-014-9410-2

Bedard-Gilligan, M., Zoellner, L. A., & Feeny, N. C. (2017). Is trauma memory special? Trauma narrative fragmentation in PTSD: Effects of treatment and response. *Clinical Psychological Science*, *5*(2), 212–225. https://doi.org/10.1177/2167702616676581

Belfiore, E. (2016). The arts and healing: the power of an idea. In S. Clift & P. Camic (Eds.), *Oxford textbook of creative arts, health and wellbeing* (pp. 11–18). Oxford, UK: Oxford University Press.

Benedek, M., Beaty, R., Jauk, E., Koschutnig, K., Fink, A., Silvia, P. J., . . Neubauer, A. C. (2014). Creating metaphors: The neural basis of figurative language production. *NeuroImage*, *90*, 99–106. doi:10.1016/j.neuroimage.2013.12.046

Berberian, M. (2015). Art therapy with Chinese American children in New York city. In S. L. Brooke & C. E. Myers (Eds.), *Therapists creating a cultural tapestry: Using the creative therapies across cultures* (pp. 25–56). Springfield, IL: Charles C. Thomas Publishers.

Berberian, M. (2017). Standing tall: Students showcase resiliency through body tracings (Standing Tall: la résilience en vitrine dans les tracés corporels d'étudiants). *Canadian Art Therapy Association Journal*, *30*(2), 88–93. http://dx.doi.org/10.1080/08322473.2017.1375734

Bilder, R., & Knudsen, K. (2014). Creative cognition and systems biology on the edge of chaos. *Frontiers in Psychology*, *5*, 1104. https://doi.org/10.3389/fpsyg.2014.01104

Blaustein, M. E., & Kinniburgh, K. M. (2018). *Treating traumatic stress in children and adolescents* (2nd ed.). New York, NY: Guilford Press.

Boccia, M., Piccardi, L., Palermo, L., Nori, R., & Palmiero, M. (2015). Where do bright ideas occur in our brain? Meta-analytic evidence from neuroimaging studies of domain-specific creativity. *Frontiers in Psychology*, *6*, 1195. https://doi.org/10.3389/fpsyg.2015.01195

Bohleber, W. (2018). Trauma and its consequences for the body and mind. In C. Charis & G. Panayiotou (Eds.), *Somatoform and other psychosomatic disorders* (pp. 107–120). Cham, Switzerland: Springer International Publishing. doi.org/10.1007/978-3-319-89360-0_6

Bosch, O. J., & Young, L. (2017). Oxytocin and social relationships: From attachment to bond disruption. In R. Hurlemann & V. Grinevich (Eds.), *Behavioral pharmacology of neuropeptides: Oxytocin. Current topics in behavioral neurosciences* (Vol. 35, pp. 1–21). https://doi.org/10.1007/7854_2017_10

Buk, A. (2009). The mirror neuron system and embodied simulation: Clinical implications for art therapists working with trauma survivors. *The Arts in Psychotherapy*, *36*(2), 61–74.

Carafoli, E. (2016). The creativity process: freedom and constraints. *Rendiconti Lincei*, *27*. doi:10.1007/s12210-015-0499-x

Carolan, R., & Backos, A. (Eds.). (2017). *Emerging perspectives in art therapy: Trends, movements, and developments*. New York, NY: Routledge.

Chapman, L. (2014). *Neurobiologically informed trauma therapy with children and adolescents: Understanding mechanisms of change*. New York, NY: W.W. Norton & Company, Inc.

Chatterjee, A. (2014). *The aesthetic brain: How we evolved to desire beauty and enjoy art*. Oxford: Oxford University Press.

Collie, K., Backos, A., Malchiodi, C., & Spiegel, D. (2006). Art therapy for combat-related PTSD: Recommendations for research and practice. *Art Therapy: Journal of the American Art Therapy Association*, *23*(4), 157–164. https://doi.org/10.1080/07421656.2006.10129335

Cook, A., Spinazzola, J., Ford, J., Lanktree, C., Blaustein, M., Cloitre, M., . . van der Kolk, B. (2005). Complex trauma in children and adolescents. *Psychiatric Annals*, *35*(5), 390–398. https://doi.org/10.3928/00485713-20050501-05

Corazza, G. E. (2016). Potential originality and effectiveness: The dynamic definition of creativity. *Creativity Research Journal*, *28*(3), 258–267. https://doi.org/10.1080/10400419.2016.1195627

Csikszentmihalyi, M. (1990). *Flow*. New York, NY: HarperCollins Publishers.

Csikszentmihalyi, M. (1996). *Creativity*. New York, NY: Harper Perennial.

Czamanski-Cohen, J., & Weihs, K. L. (2016). The bodymind model: A platform for studying the mechanisms of change induced by art therapy. *The Arts in Psychotherapy, 51*, 63–71.

Dannecker, K. (2018). Edith Kramer's third hand intervention: Intervention in art therapy. In L. Gerity & S. Anand (Eds.), *The legacy of Edith Kramer* (pp. 141–147). New York, NY: Routledge.

Dean, M. (2016). *Using art media in psychotherapy: Bringing the power of creativity to practice*. New York, NY: Routledge and ProQuest Ebook Central. Retrieved from http://ebookcentral. proquest.com/lib/nyulibrary-ebooks/detail.action?docID=4355078

De Buisonje, D. R., Ritter, S. M., de Bruin, S., ter Horst, J. M-L., & Meeldijk, A. (2017). Facilitating creative idea selection: The combined effects of self-affirmation, promotion focus and positive affect. *Creativity Research Journal, 29*(2), 174–181. https://doi.org/10.1080/10400419. 2017.1303308

Dijksterhuis, A., & Nordgren, L. F. (2006). A theory of unconscious thought. *Perspectives on Psychological Science, 1*(2), 95–109. https://doi.org/10.1111/j.1745-6916.2006.00007.x

Dissanayake, E. (2000). *Art and intimacy: How the arts began*. Seattle, WA: University of Washington Press.

Ebersöhn, L., Nel, T., & Loots, T. (2017). Analysing risk and resilience in the first sand tray of youth at a rural school. *The Arts in Psychotherapy, 55*, 146–157. https://doi.org/10.1016/j. aip.2017.04.007

Engelhard, I., McNally, R., & van Schie, K. (2019). Retrieving and modifying traumatic memories: Recent research relevant to three controversies. *Current Directions in Psychological Science*. https://doi.org/10.1177/0963721418807728

Elbrecht, C., & Antcliff, L. (2014). Being touched through touch: Trauma treatment through perception at the clay field: A sensorimotor art therapy. *International Journal of Art Therapy, 19*(1), 19–30. http://dx.doi.org/10.1080/17454832.2014.880932

Epstein, S., Pacini, R., Denes-Raj, V., & Heier, H. (1992). Individual differences in intuitive-experiential and analytical-rational thinking styles. *Journal of Personality and Social Psychology, 71*(2), 390–405. doi:10.1037/0022-3514.71.2.390

Erickson, E. (1963). *Childhood and society*. New York, NY: W. W. Norton & Company.

Felitti, V. J., & Anda, R. F. (2010). The relationship of adverse childhood experiences to adult health, well-being, social function, and healthcare. In R. Lanius, E. Vermetten, & C. Pain (Eds.), *The hidden epidemic: The impact of early life trauma on health and disease* (pp. 77–87). Cambridge, UK: Cambridge University Press.

Field, M. (2016). Empowering students in the trauma-informed classroom through expressive arts therapy. *In Education, 22*(2), 55–71.

Gallese, V., Eagle, M., & Migone, P. (2007). Intentional attunement: Mirror neurons and the neural underpinnings of interpersonal relations. *Journal of the American Psychoanalytic Association, 55*(1), 131–175. https://doi.org/10.1177/00030651070550010601

Gantt, L., & Tinnin, L. (2007). Intensive trauma therapy of PTSD and dissociation: An outcome study. *The Arts in Psychotherapy, 34*(1), 69–80. https://doi.org/10.1016/j.aip.2006.09.007

Gantt, L., & Tripp, T. (2016). The image comes first: Treating preverbal trauma with art therapy. In J. King (Ed.), *Art therapy, trauma and neuroscience* (pp. 157–172). New York, NY: Routledge.

Gardner, H. (1973). *The arts and human development*. New York, NY: John Wiley & Sons.

Gardner, H. (1980). *Artful scribbles*. New York, NY: Basic Books.

Garrison, K. E., & Handley, I. M. (2017). Not merely experiential: Unconscious thought can be rational. *Frontiers in Psychology, 8*(1096). doi:10.3389/fpsyg.2017.01096

Gerber, N., & Myers-Coffman, K. (2018). Translation in arts-based research. In P. Leavy (Ed.), *Handbook of arts-based research* (pp. 587–607). New York, NY: The Guilford Press.

Gil, E. (1991). *The healing power of play*. New York, NY: Guilford Press.

Gorelick, K. (1989). Perspective: Rapprochement between the arts and psychotherapies: Metaphor the mediator. *The Arts in Psychotherapy, 16*(3), 149–155.

Greenwald, R. (2005). *Child trauma handbook: A guide for helping trauma-exposed children and adolescents*. Abingdon, Oxon: Routledge.

Guerney, L. F. (1980). Client-centered (non-directive) play therapy. In C. Shaefer & K. O'Connor (Eds.), *Handbook of play therapy* (pp. 21–64). New York, NY: Wiley.

Gunnar, M. R., Hostinar, C. E., Sanchez, M. M., Tottenham, N., & Sullivan, R. M. (2015). Parental buffering of fear and stress neurobiology: Reviewing parallels across rodent, monkey, and human models. *Social Neuroscience, 10*(5), 474–478.

Hagman, G. (2005). *Aesthetic experience: Beauty, creativity, and the search for the ideal.* Amsterdam, Netherlands: Rodopi.

Hagman, G. (2010). *The artist's mind: A psychoanalytic perspective on creativity.* New York, NY: Routledge.

Harrington, D. M. (2018). On the usefulness of "value" in the definition of creativity. *Creativity Research Journal, 30*(1), 118–121. https://doi.org/10.1080/10400419.2018.1411432

Harris, D. A. (2009). The paradox of expressing speechless terror: Ritual liminality in the creative arts therapies' treatment of posttraumatic distress. *The Arts in Psychotherapy, 36*(2), 94–104. https://doi.org/10.1016/j.aip.2009.01.006

Hass-Cohen, N., & Findlay, J. C. (2015). *Art therapy & the neuroscience of relationships, creativity, & resiliency.* New York, NY: W. W. Norton & Company, Inc.

Hass-Cohen, N., & Findlay, J. C. (2019). Recovery from grief and pain: Results from an art therapy relational neuroscience four-drawing art therapy trauma and resiliency protocol. In D. Elkid-Abuhoff & M. Gaydos (Eds.), *Art and expressive therapies within the medical model* (pp. 132–152). New York, NY: Routledge.

Heilman, K. M., & Acosta, L. M. (2013). Visual artistic creativity and the brain. *Progress in Brain Research, 204,* 19–43. doi:10.1016/b978-0-444-63287-6.00002-6

Heinonen, J., Numminen, J., Hlushchuk, Y., Antell, H., Taatila, V., & Suomala, J. (2016). Default mode and executive networks areas: Association with the serial order in divergent thinking. *PLoS One, 11*(9), e0162234. https://doi.org/10.1371/journal.pone.0162234

Henley, D. (1992). *Exceptional children: Exceptional art.* Worcester, MA: David Publications.

Herrman, H., Stewart, D., Diaz-Granados, N., Berger, E., Jackson, B., & Yuen, T. (2011). What is resilience? *The Canadian Journal of Psychiatry, 56*(5), 258–265. https://doi.org/10.1177/070674371105600504

Herman, J. (1992). *Trauma and recovery: The aftermath of violence.* New York, NY: Basic Books.

Johnson, D. R. (2009). Commentary: Examining underlying paradigms in the creative arts therapies of trauma. *The Arts in Psychotherapy, 36*(2), 114–120. https://doi.org/10.1016/j.aip.2009.01.011

Kaimal, G., Ayaz, H., Herres, J., Dieterich-Hartwell, R., Makwana, B., Kaiser, D. H., & Nasser, J. A. (2017). Functional near-infrared spectroscopy assessment of reward perception based on visual self-expression: Coloring, doodling, and free drawing. *The Arts in Psychotherapy, 55,* 85–92. http://dx.doi.org/10.1016/j.aip.2017.05.004

Kaimal, G., & Ray, K. (2016). Free art-making in an art therapy open studio: Changes in affect and self-efficacy. *Arts and Health, 9*(2), 154–166. https://doi.org/10.1080/17533015.2016.1217248

Kaimal, G., Ray, K., & Muniz, J. M. (2016). Reduction of cortisol levels and participants' responses following artmaking. *Art Therapy: Journal of the American Art Therapy Association, 33*(2), 74–80. https://doi.org/10.1080/07421656.2016.1166832

Kapitan, L. (2014). Introduction to the neurobiology of art therapy: Evidence based, complex, and influential. *Art Therapy: Journal of the American Art Therapy Association, 31*(2), 50–51. https://doi.org/10.1080/07421656.2014.911027

Kellogg, R. (1969). *Analyzing children's art.* Palo Alto, CA: National Press Books.

Kendall-Tackett, K. (2009). Psychological trauma and physical health: A psychoneuroimmunology approach to etiology of negative health effects and possible interventions. *Psychological Trauma: Theory, Research, Practice, and Policy, 1*(1), 35–48. https://doi.10.1037/a0015128

King, J. L. (Ed.). (2016). *Art therapy, trauma, and neuroscience: Theoretical and practical perspectives.* New York, NY: Routledge.

Klorer, P. G. (2016). Neuroscience and art therapy with severely traumatized children: The art is the evidence. In J. L. King (Ed.), *Art therapy, trauma, and neuroscience: Theoretical and practical perspectives* (pp. 139–156). New York, NY: Routledge.

Kramer, E. (1958). *Art therapy in a children's community.* Springfield, IL: Charles C Thomas Schocken Books.

Kramer, E. (1986). The art therapist's third hand: Reflections on art, art therapy, and society at large. *American Journal of Art Therapy, 24*(3), 71–86.

Kramer, E. (1993). *Art as therapy with children.* Chicago, IL: Magnolia Street Publishers.

Kramer, E. (2000). *Art as therapy: Collected papers.* London, UK: Jessica Kingsley Publishers.

Lacey, S., Hagtvedt, H., Patrick, V. M., Anderson, A., Stilla, R., Deshpande, G. . . . Sathian, K. (2011). Art for reward's sake: visual art recruits the ventral striatum. *NeuroImage, 55*(1), 420–433. doi:10.1016/j.neuroimage.2010.11.027

Levine, S. K. (2004). The philosophy of expressive arts therapy: Poiesis as a response to the world. In P. Knill, E. G. Levine, & S. K. Levine (Eds.), *Principles and practice of expressive arts therapies: Toward a therapeutic aesthetics* (pp. 15–73). London, UK: Jessica Kingsley Publishers.

Levine, S. K. (2015). The Tao of poiesis: Expressive arts therapy and Taoist philosophy. *Creative Arts Education Therapy, 1*, 15–25. https://doi.org/10.15534/CAET/2015/1/4

Lowenfeld, V., & Brittain, W. M. (1987). *Creative and mental growth* (7th ed.). New York, NY: Palgrave Macmillan.

Lusebrink, V. B. (2004). Art therapy and the brain: An attempt to understand the underlying processes of art expression in therapy. *Art Therapy: Journal of American Art Therapy Association, 21*(3), 125–135.

Lusebrink, V., & Hinz, L. (2016). The expressive therapies continuum as a framework in the treatment of trauma. In J. L. King (Ed.), *Art therapy, trauma, and neuroscience: Theoretical and practical perspectives* (pp. 42–66). New York, NY: Routledge.

Malchiodi, C. A. (1999). *Medical art therapy with children.* London, UK: Jessica Kingsley Publishers.

Malchiodi, C. A., Kim, D. Y., & Choi, W. S. (2003). Developmental art therapy. In C. A. Malchiodi (Ed.), *Handbook of art therapy.* New York, NY: Guilford Press.

May, R. (1994). *The courage to create.* New York, NY: W. W. Norton & Company, Inc.

McNiff, S. (2011). Artistic expressions as primary modes of inquiry. *British Journal of Guidance & Counselling, 39*, 385–396. https://doi.org/10.1080/03069885.2011.621526

McNiff, S. (2015). *Imagination in action: Secrets for unleashing creative expression.* Boston, MA: Shambala.

Miller, R. J., & Johnson, D. R. (2012). The capacity for symbolization in posttraumatic stress disorder. *Psychological Trauma: Theory, Research, Practice, and Policy, 4*(1), 112–116. https://doi.org/10.1037/a0021580

Nadal, M. (2013). The experience of art: Insights from neuroimaging. *Progress in Brain Research, 204*, 135–158.

National Endowments for the Arts. (2015). *How creativity works in the brain: Insights from a Santa Fe institute working group.* Washington, DC: National Endowment for the Arts. Retrieved from www.arts.gov/sites/default/files/how-creativity-works-in-the-brain-report.pdf

National Scientific Council on the Developing Child. (2014). *Excessive stress disrupts the architecture of the developing brain* (Working Paper No. 3). Updated Edition. Retrieved from www.developingchild.harvard.edu

Narayan, O. P. (2005). *Harnessing child development.* New Delhi, India: Isha Books.

Naumburg, M. (1947). *Studies of the "free" expression of behavior problem children as a means of diagnosis and therapy* (Nervous and Mental Disease Monographs, No. 71). New York, NY: Coolidge Foundation.

Ogden, P., & Fisher, J. (2015). *Sensorimotor psychotherapy: Interventions for trauma and attachment.* New York, NY: W. W. Norton & Company, Inc.

Osório, C., Probert, T., Jones, E., Young, A., & Robbins, I. (2017). Adapting to stress: Understanding the neurobiology of resilience. *Behavioral Medicine, 43*(4), 307–322. https://doi.org/10.1080/08964289.2016.1170661

Patrick, C. (1937). Creative thought in artists. *Journal of Psychology, 5*, 35–73.

Piechowski-Jozwiak, B., Boller, F., & Bogousslavsky, J. (2017). Universal connection through art: Role of mirror neurons in art production and reception. *Behavioral Sciences, 7*(2), 29, doi:10.3390/bs7020029

Perry, B. D. (2009). Examining child maltreatment through a neurodevelopmental lens: Clinical applications of the neurosequential model of therapeutics. *Journal of Loss and Trauma: International Perspectives on Stress & Coping, 14*(4), 240–255. https://doi.org/10.1080/15325020903004350

Perry, B. D., & Szalavitz, M. (2017). *The boy who was raised as a dog: And other stories from a child psychiatrist's notebook: What traumatized children can teach us about loss, love, and healing* (2nd ed.). New York, NY: Basic Books.

Regev, D., & Cohen-Yatziv, L. (2018). Effectiveness of art therapy with adult clients in 2018—What progress has been made? *Frontiers in Psychology, 9*, 1531. https://doi.org/10.3389/fpsyg.2018.01531

Richter-Levin, G., & Jacobson-Pick, S. (2010). Differential impact of juvenile stress and corticosterone in juvenility and in adulthood, in male and female rats. *Behavioural Brain Research, 214*(2), 268–276. https://doi.org/10.1016/j.bbr.2010.05.036

Robinson, K. (2015). *The world's largest lesson* [Video]. Retrieved from http://sirkenrobinson.com/the-worlds-largest-lesson-written-by-sir-ken-robinson

Rothschild, B. (2017). *The body remembers Vol. 2: Revolutionizing trauma treatment.* New York, NY: W. W. Norton & Company, Inc.

Rubin, J. A. (1984). *The art of art therapy.* Levittown, PA: Taylor & Francis.

Rubin, J. A. (2005). *Child art therapy* (25th anniversary ed.). New York, NY: John Wiley & Sons.

Rubin, J. A. (2010). *Introduction to art therapy: Sources & resources* (2nd ed.). New York, NY: Routledge.

Rubin, J. A. (2011). *The art of art therapy* (2nd ed.). New York, NY: Routledge,

Runco, M. A., & Jaeger, G. (2012). The standard definition of creativity. *Creativity Research Journal, 24*(1), 92–96. https://doi.org/10.1080/10400419.2012.650092

Sarathy, V. (2018). Real world problem-solving. *Frontiers in Human Neuroscience, 12*, 1–14. doi:10.3389/fnhum.2018.00261

Schlegel, A., Alexander, P., Fogelson, S., Li, X., Lu, Z., Kohler, P., . . Meng, M. (2015). The artist emerges: Visual art learning alters neural structure and function. *NeuroImage, 105*, 440–451. doi:10.1016/j.neuroimage.2014.11.014

Schore, A. N. (2001). Effects of a secure attachment relationship on right brain development, affect regulation, and infant mental health. *Infant Mental Health Journal, 22*(1–2), 7–66. https://doi.org/10.1002/1097-0355(200101/04)22:1 < 7:AID-IMHJ2 > 3.0.CO;2-N

Schore, A. N. (2015). *Affect regulation and the origin of the self: The neurobiology of emotional development.* New York, NY: Taylor & Francis.

Schore, A., & Marks-Tarlow, T. (2018). How love opens creativity, play, and the arts through early right-brain development. In T. Marks-Tarlow, M. Solomon, & D. J. Siegel (Eds.), *Play and creativity in psychotherapy* (pp. 64–91). New York, NY: W. W. Norton & Company, Inc.

Siegel, D. J. (2017). *Mind: A journey to the heart of being human.* New York, NY: W. W. Norton & Company, Inc.

Skeffington, P. M., & Browne, M. (2014). Art therapy, trauma and substance misuse: Using imagery to explore a difficult past with a complex client. *International Journal of Art Therapy, 19*(3), 114–121. https://doi-org.proxy.library.nyu.edu/10.1080/17454832.2014.910816

Smith, A. (2016). A literature review of the therapeutic mechanisms of art therapy for veterans with post-traumatic stress disorder. *International Journal of Art Therapy, 21*(2), 66–74. https://doi.org/10.1080/17454832.2016.1170055

Snir, S., & Regev, D. (2013). A dialog with five art materials: Creators share their art making experiences. *Arts in Psychotherapy, 40*(1), 94–100. doi:10.1016/j.aip.2012.11.004

Snir, S., Regev, D., & Shaashana, Y. (2017). Relationships between attachment avoidance and anxiety and responses to art materials. *Art Therapy, 34*(1), 20–28. https://doi.org/10.1080/07421656.2016.1270139

Sprugnoli, G., Rossi, S., Emmendorfer, A., Rossi, A., Liew, S-L., Tatti, E., . . . Santarnecchi, E. (2017). Neural correlates of Eureka moment. *Intelligence, 62*, 99–118. https://doi: 10.1016/j.intell.2017.03.004

Talwar, S. (2007). Accessing traumatic memory through art making: An art therapy trauma protocol (ATTP). *Arts in Psychotherapy, 34*(1), 22–35.

Tottenham, N. (2017). The brain's emotional development. *Cerebrum: The Dana forum on brain science. 2017*, cer-08-17.

Tripp, T. (2016). A body-based bilateral art protocol for reprocessing trauma. In J. L. King (Ed.), *Art therapy, trauma, and neuroscience: Theoretical and practical perspectives* (pp. 173–194). New York, NY: Routledge.

Ungar, M. (2013). Resilience, trauma, context and culture. *Trauma, Violence, & Abuse, 14*(3), 255–266.

Ungar, M. (2015). Practitioner review: Diagnosing childhood resilience—a systemic approach to the diagnosis of adaptation in adverse social ecologies. *Journal of Child Psychology and Psychiatry, 56*(1), 4–17. https://doi.org/10.1111/jcpp.12306

U.S. Department of Education. (2017). *Reimagining the role of technology in education: 2017 national education technology plan update.* Retrieved from https://tech.ed.gov/files/2017/01/NETP17.pdf

Usher, M., Russo, Z., Weyers, M., Brauner, R., & Zakay, D. (2011). The impact of the mode of thought in complex decisions: intuitive decisions are better. *Frontiers in Psychology, 2*(37). doi:10.3389/fpsyg.2011.00037

van der Kolk, B. (2014). *The body keeps the score: Brain, mind, and body in the healing of trauma.* New York, NY: Penguin Books.

van Westrhenen, N., Fritz, E., Oosthuizen, H., Lemont, S., Vermeer, A., & Kleber, R. (2017). Creative arts in psychotherapy treatment protocol for children after trauma. *The Arts in Psychotherapy, 54*, 128–135. https://doi.org/10.1016/j.aip.2017.04.013

Vogel, S., & Schwabe, L. (2016). Learning and memory under stress: Implications for the classroom. *Science of Learning, 1*, 16011. https://doi.org/10.1038/npjscilearn.2016.11

von Petzinger, G. (2016). *The first signs: Unlocking the mysteries of the world's oldest symbols.* New York, NY: Atria Books.

Weisberg, R. W. (2015). On the usefulness of "value" in the definition of creativity. *Creativity Research Journal, 27*, 111–124. doi:10.1080/10400419.2015.1030320

Winnicott, D. W. (1971). *Playing and reality.* New York: Basic Books.

World Economic Forum. (2016, January). *The future of jobs: Employment, skills and workforce strategy for the fourth industrial revolution.* Global Challenge Insight Report. Retrieved from http://www3.weforum.org/docs/WEF_Future_of_Jobs.pdf

Wu, G., Feder, A., Cohen, H., Kim, J., Calderon, S., Charney, D., & Mathé, A. (2013). Understanding resilience. *Frontiers in Behavioral Science, 7*(10). doi:10.3389/fnbeh.2013.00010

Yaeger, K., & Roberts, A. (2015). *Crisis intervention handbook: Assessment, treatment, and research* (4th ed.). New York, NY: Oxford.

Yang, H-C., & Noel, A. M. (2006). The developmental characteristics of four- and five-year-old pre-schoolers' drawing: An analysis of scribbles, placement patterns, emergent writing, and name writing in archived spontaneous drawing samples. *Journal of Early Childhood Literacy, 6*(2), 145–162. https://doi.org/10.1177/1468798406066442

Zaidel, D. W. (2009). Art and brain: Insights from neuropsychology, biology and evolution. *Journal of Anatomy, 216*(2), 177–183.

Zaidel, D. W. (2014). Creativity, brain, and art: Biological and neurological considerations. *Front Hum Neurosci, 8*,389. doi:10.3389/fnhum.2014.00389

Zaidel, D. W. (2016). *Neuropsychology of art: Neurological, cognitive, and evolutionary perspectives* (2nd ed.). New York, NY: Routledge.

3

Art as Communication for Young People

ASHLEY CLAIRE WOOD

> Children respond rapidly, perhaps unconsciously, to the invitation to reveal themselves through a creative modality. They do so in a variety of ways, sending messages at many levels and in many guises. If one wishes to understand these messages, it is necessary to determine what children are saying by looking both at what they say and how they communicate.
> —Irwin & Rubin, 1976, p. 169

The power of art as a language for young people rests in its dynamic, communicative potential and its accessibility across the span of development. As the developmental level of young people greatly influences the capacity for verbal expression and abstract reflection, complex experiences and emotionally laden conflicts become particularly difficult to articulate (Malchiodi, 1999a). Providing an alternative or complimentary means for externalizing these experiences in addition to verbal language allows for a natural and developmentally sensitive avenue of communication. Through the fundamental qualities of art—the ease of nonlinguistic expression, the richness of pictorial narrative, the promotion of mastery and containment, and the encouragement of exploration and imagination—young people are given an opportunity to freely articulate inner sensations, thoughts, perceptions, and needs with uninhibited depth and authenticity (Councill, 2012; Moon, 2016).

This chapter explores the role of art in facilitating communication and building on innate strengths of individuals, specifically within the scope of children and youth. First, literature on child development and art therapy theory is presented to review underlying mechanisms of art-making that support growth and communicative needs of young people. Consideration is then given to how properties of art materials and creative processes, and, thereafter, art within art therapy practice, can foster and elicit meaningful expression. Throughout the chapter, three case examples are provided to highlight clinical application and further demonstrate the vast range of ways in which artistic expression gives voice to experiences.

Art Expression and Childhood

The human need for aesthetic expression, meaning-making experiences, and communication of self is intrinsic and biological (Dissanayake, 1992). From the sensory-kinesthetic pleasure of early childhood to purposeful and symbolic imagery of youth,

self-expression through creative form manifests within the earliest stages of life and spans the developmental continuum. Throughout each stage and area of development—cognitive, affective, perceptual, physical, social, and spiritual—art and creative expression not only have the ability to reflect young people's growth and functioning but also to delineate and facilitate this growth (Brown, 2009; Malchiodi, 2012). Understanding art's integral role within development allows for a comprehensive approach to working with young people, as it provides an imperative foundation for art intervention and capitalizes on developmentally effective techniques for communication (Malchiodi, 2012). A summary is offered to underscore how art-making may be incorporated in the work of childhood development to promote positive functioning and self-expression for children in varying stages and life circumstances.

Developmental Applications

Within infancy and toddlerhood (one to three years), children utilize senses to increase their understanding of self in relation to the external world. Through exploratory learning and tactile contact with their surroundings, children gradually discover and organize new information into coherent, integrated mental representations (Levine & Munsch, 2011). As a source of kinesthetic-sensory stimulation, art expression during this stage promotes spontaneous yet meaningful environmental encounters. From exploration and manipulation of pre-art materials to scribbling, art engages and strengthens formative skills for development (Ach-Feldman & Kunkle-Miller, 2016). With the advent of scribbling—a natural achievement in the sequence of emerging cognitive and fine-motor abilities—art begins to function as a "record of movement" and basis for pictorial expression (Kellogg, 1969, p. 173). The evolution of the child's scribble from primitive linear and dotted markings, to the repetition of these marks, to the formation of basic gestalts, and, lastly, to the creation of shape can promote control over visual dimensions and reflect cognitive capacities (Lowenfeld & Brittain, 1987). As children begin coordinating sensory perceptions with physical activity, they gain greater "perceptual expectations," motoric control, and mastery over these processes (Santrock, 2011, p. 178).

During early childhood (three to seven years), developmental systems continue to strengthen with maturation. Perceptual and fine-motor abilities evolve, including shape perception and the transition from primitive, entire hand grasping to more optimal finger grasps. With egocentric logic and transductive reasoning, children conceptualize of single ideas at a time and consideration for "all parts in terms of the whole" proves challenging (Hockenburry & Wilson, 2015, p. 525). As a result of this preoperational thinking, children are most receptive to engagement in concrete problem-solving activities. Accordingly, art-making can play a significant role in the way children in early childhood learn information and communicate to others, primarily through art's capacity for symbolic activity and expression in concrete visual form (Klorer, 2017). Marking the "beginning of graphic communication," children in this stage begin combining action-focused scribbles and geometric shapes to convey more intentional representations (Lowenfeld & Brittain, 1987, p. 220). Although original meaning of representations often shift throughout their art process, graphic depictions—free-floating images, tadpole figures, exaggerated proportions, and centralized self-representations—capture inner logic and developing perceptions of their environment (Golomb, 2004).

In middle and late childhood (7 to11 years), or the school age, establishing useful skills is prioritized with a high focus on achievement and competency. Children's perspectives expand from egocentric to inclusion of others, during which forming close friendships and peer acceptance become primary concerns (Levine & Munsch, 2011). Through the development of concrete operations, children more effectively conceptualize reality versus fantasy and derive observations grounded in personal knowledge and reason. Art-making during middle and late childhood can offer a valuable context for engaging in "meaningful, socially useful" experiences and gratification from mastery of creative materials (Hockenburry & Wilson, 2015, p. 570). Parallel to children's expanding, outward-shifting perspectives, art compositions increasingly capture atmospheric details with attention to the relationship of objects within space (Kellogg, 1969). Schemas, or individualized repeating symbols, begin to emerge and exhibit the young person's active assimilation and interpretation of figures, objects, and the environment; notably, modifications of standard schematic symbols can communicate important information, including the ability to consolidate new concepts or potential emotional conflicts (Lowenfeld & Brittain, 1987; Malchiodi, 2012).

Throughout adolescence (11–18 years), a period characterized by intensified experimentation and formation of one's identity, young people are prone to adopt new ideals. Arising impulses and developmental changes are often met with psychological vulnerability and pressure to integrate these changes within a cohesive sense of self (Levy-Warren, 1996). The transition toward idealistic thought, higher-order logic, and abstract reasoning increases adolescents' ability to critically deduct conclusions and formulate independent perspectives (Santrock, 2011). With the opportunity for individualized expression and testing the views of their world, art effectively supports developmental focuses of adolescence. Art provides a "socially acceptable release for emotions and tensions" during a stage of transition and heightened self-expectation (Lowenfeld & Brittain, 1987, p. 395). Furthermore, art's permission for ranging themes and styles offers acceptance for their own developing identity and style; whether expression remains realistic—converting perceptions into naturalized images—or kinesthetically focused and expressionistic—reflecting perceptions through form and size relationships—art encompasses and respects all creative types (Lowenfeld & Brittain, 1987; Riley, 1999).

Art Intervention and Resiliency

For many children and youth, adverse biological and environmental circumstances in childhood interfere with movement along an optimal developmental trajectory, and the previously discussed progression of positive growth and development becomes challenging. Young people's exposure to familial crisis, violence, economic deprivation, substance abuse, loss, and illness are often linked with increasing developmental and psychological disruptions. Experiencing multiple adverse circumstances, the severity of the circumstance, and the timing of the circumstance within development further compound the likelihood of poor adaptive or integrative responses. For effective intervention and support, it is imperative to address how the negative impact of trauma and adversity can be buffered and, equally, what therapeutic resources are essential in facilitating adaptation and coping for the child (Masten, 2014; Rak & Patterson, 1996).

A number of studies have reported children's internal and external protective resources as powerful indicators for successful adjustment and resilience in the face of threat (Cohen, 1999; Commission on Children at Risk, 2003). Research on resilience

and "at-risk" populations has identified consistent variables connected with positive outcomes for young people: family and community support systems, social connectedness and belonging, proactive problem-solving and adaptive skills, self-regulatory abilities, self-efficacy and autonomy, and a sense of hope (Masten, 2014; Rak & Patterson, 1996). Significantly, these fundamental factors are accessible to therapeutic work and can be repaired, protected, and developed through creative expression (Ach-Feldman & Kunkle-Miller, 2016; Brown, 2009). The utilization of art expression as intervention has proven especially beneficial in cultivating communicative resources and inner strengths of young people as well as fostering their ability to thrive (Malchiodi, 1999a). With "opportunity to revisit critical periods in development" and meet individuals where they are presently, artistic expression in intervention can equip children with the necessary tools for continued positive growth and development (Chapman, 2014, p. 86).

Case Vignette: Andrew

For Andrew, a 16-year-old adolescent who was blind, art offered an opportunity to reexamine developmental and sensory integration milestones. Throughout early childhood, tactile exploration of Andrew's environment was discouraged for sanitation and safety purposes. His caregivers largely approached experiences through sight and "visually oriented" descriptions, such as emphasizing colors and the visual appearance of objects versus other sensorial properties (Herrmann, 2012, p. 314). With this limited connection to his external world, Andrew grew accustomed to having visual perceptions of his surroundings translated and described to him rather than encountering his environment through tactile or auditory means—senses through which he could relate and establish personal environmental understandings. As a result, Andrew lacked meaningful, connected engagement with his environment as well as awareness for how to function with increased agency.

Early in his nine-month period of individual art therapy sessions, Andrew created an all-yellow sculpture that he titled "Yellow House" (Figure 3.1). Efforts to construct the house were marked with frequent requests for assistance and attempts at assimilation, where Andrew tried to make meaning of his sculpture similar to sighted culture, predominantly through the use of only yellow materials. Although the intrinsic meaning of yellow was never clearly articulated, the color yellow seemed symbolic of the larger visual world for Andrew; its role within the artwork may be understood as his wish for pictorial control over the color and, respectively, control over visual experience.

For several months, Andrew's art continued to evidence visual themes with the addition of yellow fabric, yellow paper, yellow cellophane, and yellow shells. The house remained inaccessible in its lack of openings, such as windows and doors, which seemingly mirrored Andrew's feelings of inaccessibility and restriction within his environment in reality. During this process, I began introducing tactilely rich materials and hand-over-hand guidance to provide increased sensory-focused connections in Andrew's art-making. When Andrew requested yellow paper, for example, I presented options with distinct textural, movement, and weight differences for Andrew to feel. In efforts to bring understanding to materials and how Andrew planned to engage them, I also guided his hands along surfaces of his artwork and chosen media while simultaneously describing aloud his interactions with their physical and aesthetic properties. Through my own tactile modeling and simultaneous verbal connections, I intended to help shift external interactions from disconnected to active understanding and

Figure 3.1 Andrew's "Yellow House" sculpture

gratification, both within his art and within his everyday environment. This gradually did occur and helped transform Andrew's isolated behaviors, so his inner experience was more inclusive of his encounters with the external world.

As Andrew started seeking supplementary ways for interacting with art materials and his environment, he chose to create a second house focused on personal meaning-making experiences—in his words, a house with "accessibility mode" and "just for me" (Figure 3.2). The second house was circular and organic, where Andrew included "rooms divided by ribbon, a living room filled with accessible games, and kitchen with a warm oven." Exploring and selecting materials through touch, Andrew built spaces and surfaces with consideration of sensory-based properties, including cellophane for its smooth quality and packaging tape for its stickiness. He executed his artistic vision in an increasingly independent manner, seeming to evidence growing agency. Concluding this project, Andrew sculpted and placed a plant in the doorway of his new, safe, and accessible environment (Figure 3.3), which I believed to signify his own growth manifesting through his artwork.

In this case, art was utilized to attune to Andrew as an individual, who is blind, and to provide him more relatable meaning-making experiences. Developing specific tactile and verbal descriptive techniques to present information in accessible ways to Andrew was essential in this process. As I guided Andrew in navigating and integrating external stimuli in a manner relatable to his sensory culture, the disconnect between his internal and external world was bridged. The three-dimensionality of sculpture also lent to tactile perception between Andrew and his artwork, which provided an opportunity for

Figure 3.2 Andrew's second, more accessible sculpture

Figure 3.3 Andrew's plant sculpture

increased initiative and independent expression. In these ways, art-making and expressive processes enabled Andrew to rework ineffective patterns established in early development, while positively fostering adaption, learning, and growth within his current stage and moving forward.

Art as a Communicative Tool

For individuals in all facets of development, art invites active, original expression. Whether an intricate painting or spontaneous experimentation of marks and colors, each visual creation becomes a direct manifestation of the artist and holds significant meaning (Franklin, 2013). The array of art materials and art-making combinations can be utilized to support expansive expression for diverse abilities. Through its self-expressive qualities, visible nature, and multimodal potential, art naturally connects to how children relate and communicate about their world. Various elements of art, such as color and line, allow children to present and express themselves in nonverbal, authentically descriptive ways. A growing awareness for art's universal expressive capacities as well as its links to communicative works of children are pivotal in both appreciating and employing the modality in its most effective forms for young people.

An Expression of Self

When children begin to create, art reflects purposeful information about individuals and their ways of encountering the world. Pictorial expression allows children to "discover, develop, and define their uniqueness, creating in and through art a sense of themselves" (Rubin, 2005, p. 360). Through choice and use of materials, integrating personal themes and imagery, and externalizing thoughts and perceptions, visual statements give dimension to children within that moment in time (Rogers, 2016). All young people express material differently and often illustrate what is most present, which communicates meaningful content regarding their reality, inner logic, pressures, feelings, and wishes in the process. Why specific subject matter is selected, how it is interpreted, and the way unformed materials take shape are each influenced by the child's subjective experience, making art expression individualized and distinct to who is creating the work (Lowenfeld & Brittain, 1987).

Attunement to how and what children express during the art-making experience is of significant value in determining content being shared. Materials that they are drawn to (i.e., collage or pastels) and the range of their expression through those materials—lightly shaded marks or heavily layered strokes—provide a wealth of information about a child, from aesthetic preferences to the child's internal state (McNiff, 2004). Similar self-expressive material is communicated through the selection of fluid, spontaneous making versus more controlled making or gravitation toward line and form versus color dominance (Landgarten, 1987). Certain children may steadily pace their creative process or engage in an impulsive, sporadic style, whereas others may develop personal patterns or themes from image to image (Irwin & Rubin, 1976). Children's pictorial vocabularies are further evidenced in their own quality of mark making, order of material application, and organization of composition. As these aesthetic dynamics reveal children's inner workings transparently and accurately, the art of children can serve as a window into their emotional, social, and physical selves (Franklin, 2013; Lowenfeld & Brittain, 1987).

Visible Nature of Art

The visible nature of art provides a way to transcend words or communicative barriers, helping children visually articulate information to themselves and others. As children externalize experiences into imagery, they generate a visible record within their art: a visible record of thoughts and emotions, exploration and discovery, regression and progression, and adaption and change. Once this expression is visible and, thereby, more tangibly accessible, the young person can begin to relate to the content in a new way and give order to that expression through material interaction (Franklin, 2013). For children and youth whose language and socioemotional skills are still maturing, the ability to communicate nonverbally and concretely through visible form is central to art's efficacy as a communicative tool. As art allows children to express thoughts and emotions visually, they are given a safe way to convey content that may be too difficult to openly state. Bringing communication into visible form also extends others an entrance into the young person's world and provides a starting point for approaching personal expression in the safe boundaries and comfortable mediator of the artwork (Riley, 1999).

The visible art form simultaneously functions as a container of the young person's lived experience and a catalyst for discussion. Multiplicities or emotionally charged experiences that may be flattened by words can be complexly represented in the art, which affords a more comprehensive view of the young person and their relationship to the material expressed (Kramer, 1979). As inner material becomes visible through form, art gives shape, color, motion, and rhythm to that experience or feeling; the interplay of these visual qualities and the resulting imagery capture experience often at levels other communicative approaches do not. Through "what is present in the image itself and through their own responses to the image," the visible form can also stimulate new insights and facilitate reflection on the work (Malchiodi, 1999b, p. 175). The young person may access and apply meaning to parts of the artwork within the present moment and return to the imagery for continued discovery and derivation of new insights over time (Gravell, 2015). As such, the lasting visual product permits pictorial definition to take place in the child's timing—creating when desired, holding progress, and allowing for modifications and meaning-making as ready.

Dynamic Expression

The dynamic properties of art and its processes offer opportunity for endless aesthetic experiences. Art materials and creative processes range in technical abilities, expressive qualities, intrinsic effects, and method of application (Penzes, van Hooren, Dokter, Smeijsters, & Hutschemaekers, 2014). Given the breadth and scope of art media and tools, children can engage in a way that is most suitable to their level of functioning. Specifically, paint may allow one child to express themselves through active spreading, or the kinesthetic and sensory-based manipulation of the material; the same medium of paint can enable complex metaphoric representation and symbolism through portraits, scenic landscapes, or abstract paintings. Traditional materials of paint, clay, charcoal, oil pastels, wood, wire, and collage can also "take on new dimensions" based on individual interpretation and engaged accordingly (Moon, 2002, p. 178). With limitless permission for expression and the versatility of art media, children can interpret and apply materials beyond their customary use. One individual may select tape for its familiar adhesive property to secure a sculpture, while another child incorporates tape as a primary medium and element of design within the artwork. As art is inherently complex and

adaptable in nature, the modality offers countless avenues for young people to navigate their experiences and communicate in ways that best meet their expressive needs.

Therapeutic techniques may be integrated within art to enhance, access, or release expression. With ability to function as a parallel process or an extension of art-making, the use of many "nonverbal modes allows [young people] an alternate path for self-exploration and communication" (Rogers, 2016, p. 231). Whether natural overlap or purposeful pairing, introducing one or more creative structures, such as narrative, storytelling, drama, and play, can broaden how information is expressed and explored (Yasenik & Gardner, 2017). These creative structures allow for a representational framework, where children can interact with their creations at a comfortable distance and in multilayered, expressive ways. For example, the incorporation of a symbolic narrative within the creative process may further allow for the projection of personal fantasies, fears, and self-perceptions. Creating a story can constructively provide context and characters for a child who is testing themes or roles perceived as dangerous (Henderson & Thompson, 2011). When modalities organically intersect during a child's creative process, or a child could benefit from the introduction of such modality, openness to dynamic modes of expression can be essential in supporting children in the fullness of their communication (Rubin, 2005).

Case Vignette: Leah

Within a Creative Arts and Child Life Program in an urban medical center, I began to work with Leah, an insightful and creative 15-year-old with cystic fibrosis. Throughout her life, Leah experienced frequent, prolonged hospitalizations for vacillating impacts of her disease, including lung infections, gastrointestinal complications, and bone and muscle weakness. Her cystic fibrosis diagnosis required isolation from other patients during these stays, which heightened her feelings of social isolation and the inability to engage in activities typical for her age. Upon first meeting Leah, she showed me her personal sketchbook filled with detailed renderings of underwater scenes and sea creatures. She passionately described the freedom mermaids have to swim and explore the expansive sea, appearing to desire this type of freedom and ability to live without restriction for herself. As we discussed what she might be interested in creating during our time together, Leah decided to use three-dimensional materials to bring form to her current artwork—specifically, through the creation of a "mermaid doll" (Figure 3.4, Figure 3.5).

In her art-making process, Leah selected and repetitively wound teal yarn around a bandana fabric to shape her mermaid. She layered multicolored yarn to fashion a rainbow tail followed by the application of long, golden yarn for hair. However, several strands of golden yarn became unglued, to which Leah mumbled, "It keeps falling out." As she stared at the fallen strands of yarn, Leah reflected on how her own hair was previously long like her mermaid's hair but thinned with the progression of her illness. Transitioning, Leah shared that certain "words" continuously provided strength during difficult periods of living with cystic fibrosis and undergoing medical treatment. In response, I wondered how she would feel about incorporating these personal words within her art in some way. I thought this intervention could integrate Leah's verbal and visual means of self-expression and coping, while also empowering her through the physical and emotional complexities of her illness. Eagerly, Leah wrote, "It's going to be okay" and "Just keep swimming" within the tail of her mermaid. The inclusion of personal mantras prompted ideas for other personalizing qualities—blue hair highlights, jewels, and facial features—that were then added. Thereafter, Leah proudly held up the

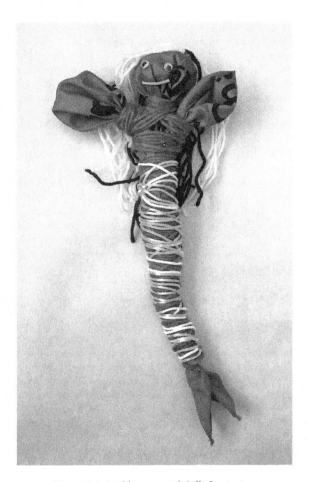

Figure 3.4 Leah's mermaid doll, front view

mermaid and voiced, "Now she's a rad mermaid! That is all I want to say, though; I like how she speaks for herself."

Through Leah's symbolic character of the mermaid doll, art offered form and a point of connection to her illness experience. The natural unfolding of art processes allowed Leah to project onto the doll, eliciting experiences of her disease that otherwise may not have been communicated. The visible nature of art expression also captured multifaceted aspects of her illness and adolescent life stressors that she was not ready to discuss. Rather, as Leah phrased, her artwork spoke for itself: the chosen self-representation of a mermaid descriptively conveyed feelings of isolation, as someone who is human but faces a very different reality; engaging with soft materials and soothing, repetitive wrapping processes described her need for comfort in the sterile hospital environment; and lastly, the addition of more individualized features and mantras evidenced her ability for positive self-expression and resilience in the face of internal and external restrictions of

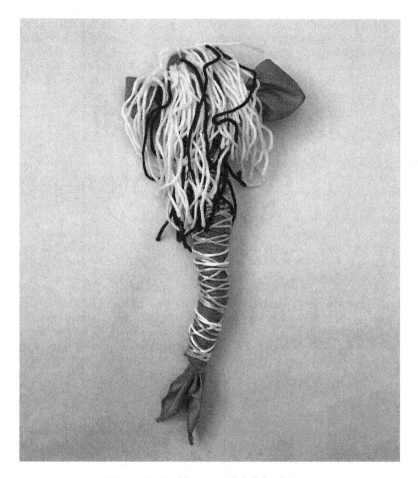

Figure 3.5 Leah's mermaid doll, back view

cystic fibrosis. The ease with which art themes, processes, and media enabled Leah to express her story exemplifies the modality's larger communicative potential and how art may be used to achieve similar, fluid, and natural expression for children in widespread circumstances.

Art Within Art Therapy

When the natural expressive ability of art is brought into the context of art therapy, potential for communication and reparative work are maximized. Art therapy draws on art's developmentally attuned nature and its capacity for diverse expression to help young people communicate in comfortable yet meaningful and therapeutic ways. Tools for creative expression are taken beyond the independent use of art media and processes to include the art therapy relationship and the therapeutic space. Within the safe

"growing grounds" of the therapeutic relationship and therapeutic environment, art therapy's specialized use of art offers opportunity for communication, self-discovery, and the change-instilling effects that stem from having one's expression witnessed and accepted (Axline, 1974, p. 16). Distinguishing factors of art therapy practice are highlighted to clarify these specialized applications of art and ways in which visual communication is nurtured in art therapy with young people.

Art Media and Processes

Art media and processes are understood and distinctly applied in art therapy for clinical and expressive purposes. When selecting materials or creative processes, art therapists consider components of each that aid in children's psychological, affective, and physiological well-being. Attention is given to ranging variables from physical characteristics of materials—malleable, transparent, organic, and smooth—to the degree of emotional liberation or structure particular materials evoke (Moon, 2002). All art mediums and processes have distinct properties and effects, which can be introduced to elicit imagery and support cathartic expression in a manner most effective to the young person. Art therapy approaches may exercise art-making in a directed manner or in open-ended, non-directive forms; art can be engaged for collaboration within a group and community setting or to provide personal growth and empowerment for an individual. With awareness for the aesthetic and psychological impact of art and its applications, art therapists can help determine how specific media and processes and, likewise, their sequence, frequency, and combination may benefit diverse population or individual needs.

Art therapy utilizes art media and processes to address psychosocial goals and rehearse more adaptive ways of being. From assessment to intervention, the modality may be employed to increase autonomy and a sense of mastery for children with little control, improve fine motor skills for individuals with rehabilitation needs, and deliver pain management and stress reduction for those experiencing medical illness (Councill, 2012). Art media and processes can offer a tactilely soothing experience to children who are overstimulated or pictorially establish boundaries for other children who feel unsafe or need containment. Drawing on art itself as a tool, art therapy frequently uses visual and expressive properties as access points for connection and means of coping (Moon, 2016). By inviting children to make adaptions or equip themselves with resources through art, coping and problem-solving skills can be introduced pictorially. Creating armor to battle a current fear or giving order to chaotic experiences by storyboarding, for example, promotes ways to pictorially manage feelings. As art therapy interventions are provided and coping skills harvested, art therapy's applications of art can immensely affect how children communicate through creative expression and use the modality as an "agent of change" (Moon, 2010, p. 194).

Therapeutic Relationship

Creating art in the presence of an art therapist can enrich and expand expression for children in substantial ways. With extensive knowledge of development and psychology theories paired with dynamics of art elements and principles, art therapists are attuned to the psychological and pictorial components of children's expression (Yasenik & Gardner, 2017). Accordingly, art therapists can engage children with both words and images, while drawing on therapeutic qualities of each, to support communication in diverse

visual and nonverbal forms. Art therapists may adapt the function of materials to build on children's individual sensory cultures, corresponding properties, and effects of art media to their communicative styles (Herrmann, 2012). With the objective of helping children achieve their desired creation, art therapists gauge when and what tools or interventions best facilitate expression. Art therapists often pace or regulate creative processes, model artistic techniques, introduce relevant art utensils, and provide physical assistance to visually transfer intentions into art form (Kramer, 1986). Throughout art interventions, the art therapist understands children's vision for the art and uses their "handwriting," or personal artistic style, as opposed to the art therapist's own, to assist them in furthering that vision (Kramer, 1986, p. 76).

The ability of art therapists to receive and reciprocate what has been visually articulated plays a vital role in processing material created (McNiff, 2004). During art-making or discussion afterward, art therapists help children bridge expression with understanding in a way that aids in deeper identification and awareness. Art therapists may sensitively name aesthetic qualities observed in imagery or reflect pictorial dynamics back to a child, dependent on what is most useful to the individual (Chapman, 2014; Winnicott, 1989). Engaging in dialogue and viewing artwork within the therapeutic relationship enables children to develop personal meaning for their images; this joint processing can also illuminate additional layers of content contained, reframe adverse perceptions, or approach depictions from alternate perspectives (Moon, 2016). When art therapists accompany children in traversing feelings and experiences, children are helped to derive personal truths from their artistic communications and gain fuller understanding of themselves through the process.

Therapeutic Space

Cultivating a space—physical and emotional—for expression to unfold is fundamental to art-making within art therapy. As the external environment affects a child's psychological environment, the physical workspace becomes an essential consideration for both creative and therapeutic aspects of art expression. An environment of safety, consistency, and freedom promotes internal needs of security and trust while signifying the value of the work (McNiff, 2004; Riley, 1999). Consistent arrangement of the room, a reliable session schedule, and familiar therapeutic rituals can also establish predictability. By presenting art materials in a readily accessible fashion, young people are able to navigate the therapeutic environment with independence and uninhibitedly access tools to execute projects of their choice. This nonrestrictive, agency-building framework serves as a valuable learning environment for children to test, practice, and form their emotional and aesthetic voices alike (Rubin, 2005).

As a sustained and supportive presence, art therapists play an equally integral role in ensuring a space conducive to authentic and creative expression. Meeting young people with a warm attitude, empathy, and compassion for their presenting spectrum of experiences helps children feel seen and heard (Malchiodi, 1990). When art therapists demonstrate unconditional acceptance in children for who they are and as they are, clinicians instill inner acceptance that is deeply rooted. In art therapy practice, artwork provides a unique, secondary means for art therapists to convey or reinforce these messages of support; more precisely, the art therapist's positive regard and respect for the art, an extension of the young person, can communicate respect for that individual (Klorer, 2017). Through opportunity for supported expression and power to initiate change in a secure, reciprocally valued relationship, art therapists empower children to be themselves and

openly create (Rubin, 2005). As these nurturing environmental and relational conditions lay the groundwork for clinical activity and artistic expression, children feel comfortable sharing experiences and, ultimately, processing these experiences in the space cultivated (Axline, 1974).

Case Vignette: Sara

For Sara, a bright and inquisitive eight-year-old, art-making within the context of art therapy provided the nonverbal expression and therapeutic support necessary to foster communication surrounding a difficult life experience. Sara was referred to art therapy within a children's bereavement program due to minimal outward expression of grief in the two years following her father's death. During our first art therapy group session, Sara and other group members were asked to sculpt a clay piece representing the person in their family who died. Sara immediately reached for the clay and shared that she was going to create a memory of her family camping—a special tradition before the loss of her father.

Sara worked in a wholehearted, deeply invested manner throughout her art-making process. Initially, she constructed a winding hiking path along a cardboard circle, where each member of her family was sculpted and placed (Figure 3.6). As Sara lengthened the path, she attached a second, smaller circle leading to "camping grounds," which she equipped with sleeping bags, pillows, a campfire, and small rocks. Becoming fixated on the rocks, Sara began increasing their number and size. The large rocks were inserted along her family's hiking path with the largest being placed between the path and campsite; notably, this appeared symbolic of growing, escalating obstacles for her family and the magnitude of disruption that this loss caused within their lives.

Figure 3.6 Sara's camping grounds and hiking path sculpture

As Sara paused and examined her sculpture, I reflected the appearance of many rocks along the hiking trail and within the camping area. Nodding, Sara confirmed, "it's really long and rocky" and "there is a mountain too!" By diagonally positioning a third cardboard circle, Sara extended the hiking trail up the side of a "mountain" and then declared her work complete. As I offered the opportunity for Sara to share, she explained, "My family is hiking, but there's a big mountain we have to climb over." Reference to the steep, uphill climb of a mountain seemed reflective of her family's own "mountain" of the mourning process, as they attempted to "process the pain of grief" and acclimate to life without her father (Worden, 2018, p. 45). Staying in line with her explanation, I wondered if Sara wanted to add anything to help her family climb this mountain; however, Sara decided it was "too tall and scary" and "nothing could help," which I honored.

The following session Sara ran in exclaiming, "I know what can help my family get over the mountain! I am going to give them hiking sticks!" My inquiry during the previous session appeared to prompt this consideration of personal coping strategies. Sara selected toothpicks and gave a "hiking stick" to each member of her family. Concluding the session, Sara observed it was still a *really* big mountain.

After several sessions of working on additional, bereavement-focused art therapy projects, Sara returned to her camping ground, requested markers, and specified she would need every color. "It's now going to be a rainbow path because it doesn't seem so scary anymore," Sara clarified; since rainbows are often regarded as symbols of transformation and hope, I imagined this suggestive of Sara's own hope and transforming experience. While Sara colored her path, she noticed the path ended at the mountain's peak and the downward climb looked dangerous. Extending a similar invitation for problem solving as before, I inquired if there was something she could create to help her family continue safely. "I know—a ladder!" Sara suggested and drew (Figure 3.7). When the

Figure 3.7 Sara's ladder along the mountainside

ladder was finished, Sara remarked with equal pride and relief, "My family will be able to climb the mountain and keep hiking after all!" Thereafter, she began reshaping her previously named "rocks" and declared each one's new function as camping equipment. From tools and a flashlight to roasted marshmallows and toys, shifting each rock from obstacles into enjoyable, helpful items seemed to demonstrate Sara's continued adaptive functioning and ability to access inner resources. At the end of session, Sara practiced the hike several times with a clay figure, appearing to test, integrate, and master this winding but now colorful path.

Art expression within the context of art therapy provided Sara an entrance into the deep reflection and communication of her father's death. The modality of art comfortably held difficult memories and overwhelming emotions, while giving Sara language to communicate the enormity of her internal experience. Creating her circular hiking path, large mountain, and the later addition of rainbow colors poetically paralleled the cyclical process of grief, its accompanying pain and struggle, and the evolving process of coping with loss. The use of clay allowed Sara to undo and redo elements of her sculpture, which promoted a sense of control and mastery over the content represented. Art coupled with factors inherent in the therapeutic relationship—including my open-ended reflections and invitations for coping pictorially—further supported Sara in processing her grief through imagery and fostered inner resources. As Sara found a way to externalize her emotions and tangibly work through grief in the artwork, she began to "adjust" to life without her father while also establishing a lasting connection to him through the memory of camping (Worden, 2018, p. 47). Similar to the emotional and pictorial benefit experienced by Sara, art therapy can afford other children the therapeutic environment, specialized use of media, and supportive presence of the art therapist to achieve rich, meaningful communication through art and creative processes.

Conclusion

Throughout childhood and adolescence, young people's processes of communication will continually evolve in light of developmental growth and life circumstances. Each child has a unique "developmental rhythm," and it is important to offer a communicative tool that accounts for the degree of variability among individuals (Rubin, 2005, p. 50). With capacity for diverse expression and meeting ranging sensory, linguistic, cognitive, affective, and creative needs, art serves as a principal communicative approach that enables young people to visually speak the complexity of their experience. As freedom for expression and safe exploration are offered through art-making, young people can connect and respond through creative materials, define themselves within a tangible representation, and begin to access art as a source of communication for themselves and others.

Being both developmentally appropriate and adaptive to the individual, art serves to reach the total child in her or his own language. By attuning to individual expressive needs and what makes a difference for each child, children are helped to feel seen, understood, and valued. Beyond creative expression, art therapy intervention in childhood can nurture innate strength and resilience that has lasting effects on young people's ability to cope and grow. In the face of both normative and adverse life experiences, art therapy's ability to support inner resources, self-expression, and adaptive functioning allows for continued positive development. As the modality is recognized and utilized with such awareness, art therapy and the communicative nature of art can serve an integral role in meeting needs in the lives of children and, indeed, foster their potential for promise.

References

Ach-Feldman, S., & Kunkle-Miller, C. (2016). A developmental approach to art therapy. In J. Rubin (Ed.), *Approaches to art therapy* (3rd ed., pp. 435–451). New York, NY: Routledge.

Axline, V. (1974). *Dibs in search of self*. New York, NY: Ballantine Books.

Brown, C. (2009). Therapeutic play and creative arts: Helping children cope with illness, death, and grief. In A. Armstrong-Dailey & S. Zarbock (Eds.), *Hospice care for children* (3rd ed., pp. 305–338). London, UK: Oxford University Press.

Chapman, L. (2014). *Neurobiologically informed trauma therapy with children and adolescents*. New York, NY: W. W. Norton & Company, Inc.

Cohen, M. S. (1999). Families coping with childhood chronic illness: A research review. *Family, Systems, & Health, 17*(2), 149–164.

Commission on Children at Risk. (2003). Hardwired to connect: The new scientific case for authoritative communities. In K. Kline (Ed.), *Authoritative communities: The scientific case for nurturing the whole child* (pp. 3–68). New York, NY: Springer.

Councill, T. C. (2012). Medical art therapy with children. In C. Malchiodi (Ed.), *The handbook of art therapy* (2nd ed., pp. 222–240). New York, NY: The Guilford Press.

Dissanayake, E. (1992). *Homo aestheticus: Where art comes from and why*. New York, NY: Free Press.

Franklin, M. (2013). Know thyself: Awakening self-referential awareness through art-based research. In S. McNiff (Ed.), *Art as research: Opportunities and challenges* (pp. 85–93). Chicago, IL: Intellect Ltd.

Golomb, C. (2004). *The child's creation of a pictorial world* (2nd ed.). Mahwah, NJ: Lawrence Erlbaum Associates, Inc.

Gravell, K. (2015). *Breastless landscape: An arts-based enquiry into my lived experience of breast cancer* (Unpublished doctoral dissertation), Ikon Institute, Australia.

Henderson, D., & Thompson, C. (2011). *Counseling children* (8th ed.). Belmont, CA: Brooks/Cole.

Herrmann, U. (2012). *Art psychotherapy and congenital blindness: Investigating the gaze* (Doctoral dissertation). Retrieved from ProQuest Dissertations Publishing. (U598839)

Hockenburry, M., & Wilson, D. (2015). *Wong's nursing care of infants and children* (10th ed.). Canada: Elsevier, Inc.

Irwin, E., & Rubin, J. (1976). Art and drama interviews: Decoding symbolic messages. *Art Psychotherapy, 3*(3–4), 169–175.

Kellogg, R. (1969). *Analyzing children's art*. Palo Alto, CA: National Press Books.

Klorer, P. G. (2017). *Expressive therapy with traumatized children* (2nd ed.). Lanham, MD: Rowman & Littlefield.

Kramer, E. (1979). *Childhood and art therapy: Notes on theory and application*. New York, NY: Schocken Books Inc.

Kramer, E. (1986). The art therapist's third hand: Reflections on art, art therapy and society at large. *American Journal of Art Therapy, 24*, 71–86.

Landgarten, H. (1987). *Family art psychotherapy: A clinical guide and casebook*. New York, NY: Brunner and Mazel.

Levine, L., & Munsch, J. (2011). *Child development: An active learning approach*. Canada: SAGE Publications, Inc.

Levy-Warren, M. (1996). *The adolescent journey*. Northvale, NJ: Jason Aronson, Inc.

Lowenfeld, V., & Brittain, W. (1987). *Creative and mental growth* (8th ed.). Upper Saddle River, NJ: Prentice Hall, Inc.

Malchiodi, C. (1990). *Breaking the silence*. New York, NY: Brunner and Mazel.

Malchiodi, C. (1999a). Introduction to medical art therapy with children. In C. Malchiodi (Ed.), *Medical art therapy with children* (pp. 13–32). London, UK: Jessica Kingsley Publishers.

Malchiodi, C. (1999b). Understanding somatic and spiritual aspects of children's art expressions. In C. Malchiodi (Ed.), *Medical art therapy with children* (pp. 173–196). London, UK: Jessica Kingsley Publishers.

Malchiodi, C. (2012). Developmental art therapy. In C. Malchiodi (Ed.), *The handbook of art therapy* (2nd ed., pp. 114–129). New York, NY: The Guilford Press.

Masten, A. (2014). *Ordinary magic: Resilience in development*. New York, NY: The Guilford Press.

McNiff, S. (2004). *Art heals: How creativity cures the soul*. Boston, MA: Shambhala.

Moon, B. (2010). *Art-based group therapy: Theory and practice*. Springfield, IL: Charles C. Thomas.

Moon, B. (2016). *Introduction to art therapy: Faith in the product* (3rd ed.). Springfield, IL: Charles C. Thomas.

Moon, C. H. (2002). *Studio art therapy: Cultivating the artist identity in the art therapist*. Philadelphia, PA: Jessica Kingsley.

Penzes, I., van Hooren, S., Dokter, D., Smeijsters, H., & Hutschemaekers, G. (2014). Material interaction in art therapy assessment. *The Arts in Psychotherapy, 41*(5), 484–492.

Rak, C., & Patterson, L. (1996). Promoting resilience in at-risk children. *Journal of Counseling and Development, 74*(4), 368–373.

Riley, S. (1999). *Contemporary art therapy with adolescents*. London, UK: Jessica Kingsley Publishers.

Rogers, N. (2016). Person-centered expressive arts therapy. In J. Rubin (Ed.), *Approaches to art therapy* (3rd ed., pp. 230–248). New York, NY: Routledge.

Rubin, J. (2005). *Child art therapy* (25th ed.). Hoboken, NJ: John Wiley & Sons, Inc.

Santrock, J. (2011). *Child development* (13th ed.). New York, NY: McGraw-Hill Companies, Inc.

Winnicott, D. W. (1989). *Playing and reality*. London, UK: Routledge.

Worden, J. W. (2018). *Grief counseling and grief therapy* (5th ed.). New York, NY: Springer Publishing Company.

Yasenik, L., & Gardner, K. (2017). Counseling skills in action. In E. Prendiville & J. Howard (Eds.), *Creative psychotherapy* (pp. 59–80). New York, NY: Routledge.

Part I
Disruptions in Early Individual Development

4

"My Passed!!!"
A Case Study in the Efficacy of Art Therapy With Adolescents With Complex Trauma and Attachment Disruptions

MARIA K. WALKER

In the treatment of early childhood and relational trauma, art therapy provides a dynamic, flexible, and non-threatening means for traumatized youth to begin to heal. This chapter reviews neuroscience research regarding the fragmented, nonverbal coding of trauma in the brain as well as the role of stress hormones in post-trauma symptoms, including maladaptive behaviors and the inability to self-regulate. It also outlines the profound impact of early attachment on a child's ability to self-regulate and develop healthy relationships.

The chapter follows with a literature review of the efficacy of art therapy in the treatment of early life trauma and attachment disruptions. This includes bridging the mind-body disconnect, improving self-regulation, and addressing past trauma visually. The rituals of art-making, the sensory qualities of the art materials, and the mirroring and co-regulation of the art therapist allow youth to connect with, tolerate, and express their feelings and experiences while remaining grounded in the present. Artistic release provides emotional distance from overwhelming content that may arise in the artwork and can help an individual begin to visualize the past as having truly passed.

A detailed case study of Carmela, a youth with a history of complex and relational trauma, exemplifies the dimensional power of art therapy in softening defenses, connecting the mind to the body through ritual and physical interaction with the materials, as well as the powerful use of metaphor in helping a young person speak. With the help of attuned mirroring and support, Carmela was able to develop feelings of security in the therapeutic relationship, allowing her to explore the depths of her ambivalence regarding relationships and begin to address her past trauma.

Trauma, the Brain, and Trauma Symptoms

The Neuroscience of Trauma

Extensive neuroscientific research details the ways that the developing brain responds to early life trauma and stores the traumatic experience nonverbally in the body (Perry, 2014; Schore, 2013; van der Kolk, 2014). After the corpus collosum forms around the age of three, connecting the two hemispheres of the brain, the brain stores a verbal narrative of an individual's experiences in the left hemisphere and a nonverbal, sensory script in the right hemisphere (Gant & Tripp, 2016). When a trauma occurs, the left brain surrenders

its customary verbal dominance while the right brain continues to record the experience nonverbally through sense and feeling (Tinnin & Gantt, 2013). Faced with threat, the individual surrenders to the physiological mechanisms of fight, flight, or freeze in an instinctual self-protection response (Duros & Crowley, 2014). When the trauma ends, and the person recovers from the survival response, the experience is remembered as fragments of feelings and images without verbal coding, beyond the articulation of words (Tinnin & Gantt, 2013). The imprint of the trauma is not accessible as a logical narrative but as pieces of sensory experience and emotion (van der Kolk, 2014).

Post-Trauma Symptoms

The physiological and neurological responses to trauma can result in numerous post-trauma symptoms that impact an individual's ability to live freely and presently without fear. Ford (2009, p. 32) describes the neurological changes that take place after extreme early trauma as a shift from a "learning brain" to a "survival brain." The victim no longer feels safe enough to maintain an open mind and explore the surrounding environment; instead, the person focuses on defending against potential danger and threat and becomes accustomed to a constant state of low-level fear (Perry, 2001). The stress hormones spike disproportionately and take longer to return to baseline in response to even mildly stressful stimuli (Duros & Crowley, 2014). Continuously high levels of stress hormones can result in memory and attention problems, irritability, sleep problems, hyperarousal, feelings of imminent danger, dissociation, and paralyzing fear (Straus, 2017; van der Kolk, 2014). The traumatized person may also detach from the body and become desensitized to the nuances of physical experiences, which can lead to periods of dissociation or seemingly inexplicable bursts of anger (van der Kolk, 2014).

Other common post-trauma symptoms include a vicious cycle of intrusive memories and overwhelming negative emotions and cognitions, consolidating feelings of imminent fear and further fragmenting memory (Ehlers & Clark, 2000; Lane, Ryan, Nadel, & Greenberg, 2014). As a result, the individual may struggle all the more to contextualize the trauma as a past event. The victim may become hypervigilant, with a heightened sensitivity and reactivity to any change in the environment, which can lead to the misinterpretation of nonverbal cues and impulsive responses without the benefit of cognitive processing (Klorer, 2016).

Trauma and Self-Regulation

Ultimately, these symptoms, focused on survival and on suppressing inner chaos, inhibit the individual from spontaneous, sustained life engagement and the ability to self-regulate (van der Kolk, 2014). Young people suffering from post-traumatic stress disorder lose the ability to "consciously control their thoughts, feelings, and behaviors" (McClelland & Tominey 2014, p. 2) and struggle to manage their attention and emotions well enough to set goals, complete tasks, control impulses, and engage in stable relationships (Hofmann, Schmeichel, & Baddeley, 2012; Murray, Rosanbalm, Chrisopoulos, & Hamoudi, 2015). Such youths may be unable to control their reactions to stress, sustain focus, or understand and interpret the mental states of themselves and others, resulting in emotional reactivity, strained relationships, and an inability to self-soothe (Fonagy & Target, 2002). Self-regulation is further inhibited by decreased self-efficacy

resulting from the helplessness and terror of having lived through their trauma (Benight, Kotaro, & Delahanty, 2017).

Trauma Reenactment

As part of the impact of trauma on relational dynamics, the survivor and caregivers may fall into maladaptive patterns of reenacting the roles of rescuer, victim, and persecutor (Bloom & Farragher, 2013). In these instances, the traumatized individual unconsciously plays out trauma-based interpersonal dynamics, such as feeling victimized by loved ones in one moment and maltreating the same loved ones in the next. The survivor reenacts these roles in response to residual feelings of profound helplessness, anger, and threat. The hope of gaining mastery over past traumatic events can lead to the recreation of the very dynamics that led to the initial suffering (Bloom & Farragher, 2013). The individual may also unintentionally play out these roles due to a habituation to arousal, a desire to mask pain by creating conflict, or even as a pursuit of punishment because of feelings of guilt and shame.

Sexual Trauma

Sexual trauma can result in symptoms of impaired attachment, poor interpersonal connection, feelings of unworthiness, inability to comprehend aspects of sexuality, and a need for affection and acceptance, all of which increase vulnerability to re-victimization (Lalor & McElvaney, 2010). Studies link a history of sexual abuse with distortions of sexuality that may include heightened sexual activity and permissiveness, anxiety around sexual behaviors, sexual avoidance, and sexual dysfunction (Zoldbrod, 2015). Sexual abuse survivors are more likely to become pregnant as teenagers, experience sexual assault, and have multiple partners; they are also more susceptible to high-risk sexual behavior including exploitation (Lalor & McElvaney, 2010).

Relational Stress and Attachment Theory

The relational stress associated with neglect, emotional or physical abuse, witnessing domestic violence, parental drug use, or untreated parental mental health disorders disrupts the development of future healthy attachments. Trauma professionals increasingly focus on the need to consider interpersonal dynamics and the impact that trauma has had on attachment relationships and have sought out terms and language to account for this dimension of the field (Crenshaw, 2014). Bessel van der Kolk (2014) writes about the impact of complex trauma during early childhood with the term "developmental trauma." Allan Schore (2001) uses the term "relational trauma" to address the influence of early trauma and attachment disruptions on development.

Secure Attachment and Co-Regulation

A person's level of resilience in the face of stressful life events is significantly determined by the attachment style experienced during childhood (Hooper, 2007). Bowlby's (1982) attachment theory asserts that an infant's early experiences with a primary caregiver are internalized as an inner working model for relationships later in life. Infant attachment

can affect patterns of relating, social competence, expressions of anger and play, and anxiety (Armstrong, 2013).

Attachment with a caregiver directly affects a child's ability to cope with stress, impacting brain development and the ability to regulate emotions (Bowlby, 1982). Winnicott (1987) describes the "good enough" parent as the caregiver who provides predictability and safety, thereby ensuring a child's feelings of security and allowing for confident growth, exploration, and independence. Caregivers who provide this secure attachment are available and attuned to their child. They also provide safety in times of distress and help the child understand the surrounding environment (Zilberstein, 2013).

In infancy and early childhood, a child's ability to self-regulate is limited at best; children are therefore dependent on their caregivers to help them learn to "understand, express, and modulate their thoughts, feelings, and behaviors" through co-regulation (Murray et al., 2015, p. 14). The caregiver accomplishes this by mirroring and validating feelings, modeling and supporting management of those feelings, and responding to the cues of the child with consistent sensitive responses (Gillespie, 2015; Zilberstein, 2013). With this support, the child eventually learns to independently self-regulate and is able to draw on internalized skills to manage stress, integrate experiences, and function socially (Zilberstein, 2013).

Insecure Attachment and Dysregulation

When caregivers are unable to respond attentively to the needs of the child or are unreliable, inconsistent, or, most especially, rejecting or terrifying, a child does not receive the needed co-regulation that is essential to their development (Gant & Tripp, 2016). Without the caregiver there to mirror and provide a secure base, the child develops only a fragmented understanding of needs, feelings, and experiences (Fonagy & Target, 2002). The young person may learn to ignore emotions in a desperate attempt at self-preservation and connection (van der Kolk, 2014). The lack of predictable co-regulation in infancy and early childhood leads to insecurely attached adolescents who cannot manage their feelings and consequently struggle with either hyperactivity or shutting down (Straus, 2017). Language development, the capacity to verbally access memories, and IQ can also be affected by the absence of supportive scaffolding and attention from caregivers (Appelbaum, Uyehara, & Elin, 1997; Zilberstein, 2013).

Adoption

In the case of adoption, a history of neglect and abuse within the original birth family can affect future attachment patterns. Despite this, adoption can be reparative and protective, with the adoptive parent(s) playing a vital role in the child's development of secure attachment (Piermattei, Pace, Tambelli, D'onofrio, & Di Folco, 2017). Siegel and Strolin-Goltzman (2017) recognize that every adoption involves loss. Verrier (1993) theorizes that if the adoption takes place in infancy or very early childhood, the adopted child may later act out, without conscious awareness of the impact of the original loss. Verrier believes that even when adopted into a loving, secure home, the child may perceive being "given up" as a rejection, making it difficult to develop loving or trusting new relationships. However, other research, including Feeney, Passmore, and Peterson (2007), shows that adoptive parents who establish positive, supportive relationships

with their adopted children can lessen the likelihood of feelings of rejection and insecurity in these youth.

Parentification

In both secure and insecure families, there are circumstances in which a child takes on the role of a parent (Saha, 2016). "Parentification" was first defined by Boszormenyi-Nagy, Nagy, and Spark (1973) as a parental figure's expectation that a child fulfill the role of a parent within the family subsystem. Parentification can be either adaptive or maladaptive. When the child's parental role is age-appropriate, reasonable, and validated by family members, the youth may develop healthy feelings of responsibility, accountability, and psychological well-being (Levine, 2009). Hetherington (1999) asserts that within certain contexts, such as divorce or illness, parentification can help ensure family cohesion, although at times at a cost to the child's social and emotional functioning.

Pathology may result if a child must take on excessive parental responsibilities within an unsupportive family environment (Saha, 2016). Studies increasingly show that parentification often takes place within families experiencing major stressors or family dysfunction (Earley & Cushway, 2002). In these families, boundaries amongst family members can become "distorted, rigid, or nonexistent" (Hooper, 2007, p. 220). Some research suggests a correlation between child sexual abuse and parentified roles, particularly in relation to incest, intrafamilial abuse, and chronic abuse, although other research counters this correlation (Fitzgerald et al., 2008; Hooper, 2007).

Treatment Approaches and Art Therapy

Establishing Safety: Rituals, Art Engagement, and Affect Regulation

Many trauma treatment approaches stress the foundational importance of establishing actual and perceived safety before proceeding with further trauma processing (Hass-Cohen, 2016). The Sanctuary Model of treatment, which outlines a method for creating an organizational culture for trauma treatment with a structured language and approach, follows the compass of S.E.L.F., an acronym for four key components of healing: safety, emotional regulation, loss, and future (Bloom & Farragher, 2013). Treatment begins with the securement of safety in order to then increase emotional intelligence, address loss, and move toward a better-adapted future. Some research, however, emphasizes that focusing on grounding and relaxation techniques too early in treatment may be experienced by the patient as a demand for change, unintentionally eliciting the survival freeze response (Porges, 2013). Therefore, it is vital that the individual undergoing treatment experiences a *felt* rather than merely a cognitively *perceived* sense of safety (Hass-Cohen, 2016).

In art therapy, this sense of security can develop within the holding environment of the physical and interpersonal space, the rituals of art-making, and the interactions with the art materials. The art therapist can approach all aspects of a client's art-making experience—from the preparation of projects to the physical interaction with materials to the titling of the finished artwork, to the clean-up—with therapeutic awareness and purpose. Actions such as laying paper out on a table, picking up a paintbrush, and putting materials away become "purposeful movements" and provide a sense of security felt interpersonally alongside the art therapist (Hass-Cohen, 2016, p. 113). The sensory and

kinesthetic aspects of art-making, which can come from blending oil pastels, cutting felt, smoothing clay, or splattering paint, have shown to help with integration of brain function, subsequently facilitating the individual's ability to learn how to regulate affect (Hass-Cohen & Carr, 2008). The art therapist's parallel guidance in cognitive processing and the client's experience of mastery further support a coherent sense of self for the survivor, helping to alleviate the stress response (Hass-Cohen, 2016). This balancing of the internal self becomes an expression of resilience (Sapolsky, 2004). Development of mastery as well as the art therapist's support through scaffolding and third-hand mediation, as described by Edith Kramer (1990), can help build feelings of self-efficacy that counterbalance post-traumatic feelings of worthlessness and helplessness (Hass-Cohen, 2016).

The Therapeutic Relationship, Mirroring, and Attachment Security

The therapeutic relationship can also be used to provide a sense of safety, an experience of secure attachment, and an assessment of any interpersonal trauma reenactments that may arise (Hass-Cohen, 2016; Bloom & Farragher, 2013). Straus (2017, p. 26) writes:

> Much of what will be healing [within art therapy] will have little or nothing to do with cognitively processed material. It is preverbal experience that makes up the core of the developing self. To believe that this relationship is different, [the client will] have to feel differently, in real time, with us.

Providing a secure base from which a child can experience emotional communication and affect attunement can help the client learn to organize feelings and experiences (Fonagy & Target, 2002). Within art therapy, this security arises from sitting alongside the client, witnessing the art-making, reflecting on the process, and providing structure and containment for the creation, as well as for what the creation reveals. Klorer (2016) reflects that rather than interpreting artwork directly, which may feel threatening, the art therapist can address current behavior and struggles while the client experiences attachment realignment through the genuine therapeutic relationship.

Art-making within art therapy also provides an avenue for positive mirroring, valuable for survivors who only know how to perceive threatening gestures and insecure attachment (Hass-Cohen, 2016). The mirror neurons in the brain support empathic attunement, such that the therapist experiences emotional and physical feelings parallel to the client's (Straus, 2017). A therapist's self-awareness can increase understanding of the nuances of the client's experience, allowing the art therapist to mirror the client's feelings through artistic expression, material intervention, verbalization, and tone of voice. This kind of mirroring, essential to secure attachment in infancy, is unknown to the child of disrupted attachments (Straus, 2017). The interchange helps to develop the client's self-awareness, and also enables the client to "feel felt" (Siegel, 2010, p. 57).

Mind-Body Engagement

Art therapy also allows for the engagement of the entire organism and restoration of the connection between the body and mind (van der Kolk, 2014). The art therapist guides the client not only to create artwork but to mindfully recognize and name internal experiences. Van der Kolk (2014) reflects that healing depends on experiential knowledge; a

person can only take full charge of life by acknowledging the reality of the body. Coholic (2011) notes that art is especially effective for developing mindfulness in young people who may not respond to tradition talk therapies or may not be able to grasp traditional mindfulness practices. Traumatized youth are often not comfortable enough with their bodies to sit quietly in meditation with their eyes closed. Instead, through basic experiences of breathing, moving, and touching, stimulated through the tactile and visual rituals of art therapy, survivors slowly gain awareness of their internal experiences and learn to regulate their physiology, including supposedly involuntary functions (van der Kolk, 2014). This engagement of both mind and body eventually allows an individual to access stored traumatic memories while remaining grounded and focused in the present (Tripp, 2016).

Accessing and Expressing the Nonverbal

The neurological understanding of nonverbal coding of trauma in the brain offers a framework for the powerful efficacy of art therapy in treating severely traumatized children with attachment disruptions (Klorer, 2016). The intrinsically visual nature of art therapy provides a means for the brain to release its withheld emotional and sensory experience without the censorship of the verbal, conscious mind (Tinnin, 1990). This externalization of inner images, thoughts, and dialogue also allows some distance for the patient's observing ego, which helps with maintaining emotional regulation and preventing a spiraling of reexperiencing symptoms (Tinnin & Gantt, 2013). Eventually, when addressing the trauma narrative directly, accessing the experience of the nonverbal mind through artistic expression can help the individual create a narrative that is whole rather than fragmented, thereby reuniting the traumatized, dissociated self with the survivor in present time and space (Tinnin & Gantt, 2013).

Carmela: A Case Vignette

Carmela, a bubbly, kind, and child-like 13-year-old Latina youth, was referred to art therapy after residing for 3 months at a residential treatment facility (RTF), which provided intensive, team-based psychiatric and trauma-based treatment for adolescents. The facility followed the Sanctuary Model of trauma treatment, with the goal of helping the residents and their families further stabilize over a period of six months to two years before integrating back into the community. All clients at the RTF received individual therapy with a social worker, and some were referred to art therapy for additional support. At the time of Carmela's treatment, residents who received art therapy participated for a time-limited average of 12 sessions so that an increased number of individuals could benefit from the adjunctive treatment.

Since her admission, Carmela had worked with her treatment team—consisting of her social worker, psychiatrist, team leader, and milieu staff—who felt discouraged with Carmela's lack of evident progress. While Carmela attended individual therapy regularly and could identify triggers and positive coping skills, she continued to be easily agitated by peers and staff. She regularly had tantrums in her unit or left the building without permission; at times, she ran away from the agency altogether. She often became hyper-aroused and could be seen yelling for hours in a stream of anger and anxiety, making threats to peers and staff, cursing, and banging her hands against walls and windows in anger. At times these fits veered into tangential, fantastical rants,

leaving her social worker surmising a possible psychosis. When she was not upset, Carmela was caring, cheerful, and thoughtful and often asked for hugs from any staff happening to pass by.

Carmela came to the RTF from inpatient state hospitalization. This was one of several hospitalizations in Carmela's history, beginning at age 11. In infancy, Carmela had been removed from her biological mother's care due to reports of physical abuse and emotional neglect, exposure to substance abuse, and what her intake material labeled as exposure to "adult sexual behavior," with no further details. Given her mother' drug use, it is possible Carmela was born with a positive toxicology; Carmela also had a below-average IQ. After leaving her birth mother, Carmela was placed in foster care with Ms. Torres, a sweet-tempered Spanish-speaking elderly woman who adopted Carmela when she was six, along with her biological sister.

At the age of 11, Carmela began to display disruptive behaviors including aggression, impulsivity, and self-harm. She also began to have auditory hallucinations, leading to her first hospitalization. While in the hospital, Carmela reported that she had been physically and sexually abused by her "stepfather," meaning her birth mother's boyfriend, with whom she had occasional visits throughout her childhood. In addition to her trauma history of physical and sexual abuse, neglect, exposure to substance use, and subsequent removal from her mother, Carmela also reported having been harshly bullied by peers in school.

Carmela's discharge plan from the RTF was to return to her adopted mother, Ms. Torres, with whom she had maintained regular home visits and family therapy sessions. Carmela often took on a motherly, caretaker role with Ms. Torres, whom she viewed as elderly and sickly, and Ms. Torres readily accepted this attention. Ms. Torres expressed fierce loyalty to her adopted daughter but also feared that she couldn't provide the care Carmela needed in her home. Throughout treatment, Ms. Torres repeatedly changed Carmela's discharge plan from her home to a community residence, fearing that she couldn't manage Carmela. Carmela would sadly accept this change but then would pressure her adopted mom to take her back, and Ms. Torres would once again insist that her daughter return straight home.

Carmela's team referred her to art therapy due to her love of art and in the hope that a different therapeutic modality could help her better internalize the skills and insights she seemed to possess but struggled to practice.

Art Therapy Assessment

When I first approached Carmela about meeting for an initial art therapy assessment, she was shy, agreeable, and excited. She talked continuously, moving rapidly from topic to topic.

As a way to begin to know her, I invited Carmela to create a drawing that told a story. After a pause, she asked if it should be a happy story; I assured her she could create any kind of story she would like. Carmela drew two cartoon-like round faces with a sharp pencil (Figure 4.1). She commented that she didn't feel confident drawing bodies and proceeded to add details to the faces, which she declared to be portraits of the two of us. She drew herself with large eyes and a wide, dimpled smile and me with squinting, smiling eyes and an open, happy mouth. Carmela explained, "It's the story of us meeting today." Behind the two heads she drew the art therapy bulletin board, and used colored pencils to add in the postcards that hung on the board. She added speech bubbles to the figures introducing themselves to each other.

Figure 4.1 Art therapy assessment

After working quietly for a while, Carmela began to talk again in a steady stream. She spoke about her dog, her aunt who passed away and used to be an artist, her adoption, and her family. She alternately used the present and past tense to speak about her aunt, and she talked about her aunt's spirit living on in the dog. She referred to both her birth mother and her adopted mother as "Mom," often having to clarify about whom she was speaking. She expressed anxiety about being bullied in school and about an upcoming extended home visit, saying, "I hope it goes well." She made several self-doubting comments about her artistic talents and appeared relieved when I reflected back her strengths.

Eventually, Carmela expressed satisfaction with her drawing and signed it. She agreed that she was interested in starting regular art therapy as soon as a space opened up.

Family Portrait

Two months after her assessment, Carmela started regular individual art therapy. When she returned to my office, she was calm and happy and provided me with updates on her family and her dog, who had given birth to a litter of puppies. She agreed to draw a portrait to help me learn more about her family and chose to draw a bouquet of flowers.

Carmela drew a very large vase, again using pencil, and carefully added individual flowers inside, labeling each with the name of a specific family member (Figure 4.2). In the left half of the vase, she drew the stems, one after another. The tops of the flowers spread out above the vase making it appear full, but the right side of the vase remained

Figure 4.2 Family Portrait

empty. When I asked about this, Carmela said, "That's where my future family will go. My children." Carmela described her wish to give her children "a better experience" than her own, expressing a desire to stay in their life, unlike her birth mother.

When I reflected that Carmela had not labeled any of the flowers as herself, she responded, "I'm not a flower. I'm the vase. I hold everyone." She wrote her name on the vase, adding a heart and a simple flower with a cartoon angry face next to it, saying playfully, "It's an angry flower! It's angry about having to take care of everyone!" Carmela signed her drawing and added a couple of other details.

It would be five weeks before Carmela returned to art therapy. During this time, she ran away twice from the program and was subsequently hospitalized for aggression and lability.

Color Check-In

Carmela resumed art therapy when she returned from the hospital. I initiated each session with a structured "Color Check-In" activity. We started by resting our feet on the floor, sitting comfortably, and taking three deep breaths. I then quietly prompted Carmela to check in with her mind and body to see how each was feeling. Then I asked, "If those feelings were a color, what color would they be?" Carmela engaged well with the exercise. She listed several colors, and, with minimal prompting, she named the feelings she associated with each of the colors. I encouraged her to be as specific as possible to help her connect with the nuance of her feelings and to distinguish between the intensity of her feelings, such as irritability versus anger versus rage.

After a few sessions, Carmela began initiating and facilitating the activity herself. During one color check-in, she identified she was "teal sky-blue" because she was feeling "great!" even though the day before, she had felt "dark cherry brown red" because she felt "really angry" with her peers. Carmela eventually taught this check-in process to her social worker, therapeutic team, residential unit, and yoga class as a way for her to share her feelings and help her peers do the same. Sometimes we used the exercise to check out at the end of session as well, which helped increase Carmela's awareness of shifts in her mood, her internal body experience, and the impact of working with the art materials.

Spirit Animal

As Carmela progressed, I invited her to use plaster strips to make a spirit animal who could be a trusted companion and friend, helping her reflect on her own needs and self-care. At this time, Carmela expressed feeling shades of "bright red and dark blue," and she presented as stressed, depressive, and withdrawn. She was increasingly frustrated with her residence at the RTF, arguing frequently with peers and staff and continuing to make attempts to run away from the program. She focused on leaving to either rejoin Ms. Torres or to run away to her new boyfriend, Eduardo, a 20-year-old young man whom she said she loved.

Working on her spirit animal seemed to help ground Carmela and provided an avenue for her to further reflect on romantic and familial relationships. On her first day with the project, Carmela laid down strips of plaster over a plastic mask base; as she worked with the material, her flat affect softened. After some quiet experimenting, Carmela became more present in her work, declaring, "I'm going to make a wolf." Carmela reflected that wolves are "adventurous" and "like a dog but wilder and more dangerous." Carmela decided that her spirit animal would be a "baby wolf boy" because "I'm a baby." At the end of the session, Carmela reflected that she felt better. Her check-out reflected a decrease in her affect intensity, with her colors changing from bright red to pink and from dark to light blue.

Carmela continued to work on her spirit animal over four sessions (Figure 4.3), and as she worked she continued to reflect on her growth, ambivalence about treatment, and her longing for home. She also began to reflect on deeper layers of her past. As she added ears to her wolf, she spoke about her childhood dog, who, she said, "knew when I was being hurt," and "sensed something about my dad," referring to her stepfather who had sexually abused her without anyone knowing. When asked from where her spirit animal drew his support and strength, Carmela determinedly said, "from family."

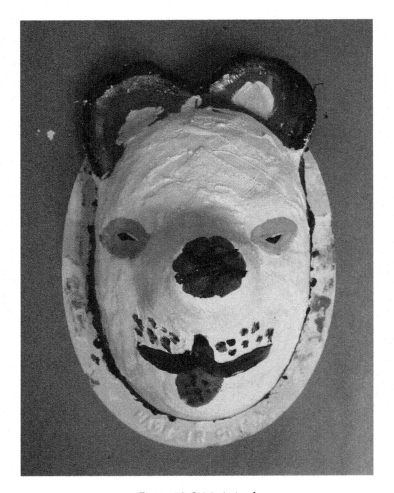

Figure 4.3 Spirit Animal

Carmela initially chose to name her spirit animal Eduardo, after her boyfriend. When Carmela talked about her boyfriend, she became very calm, stating that they had a "real connection and real caring," although she expressed anxiety about her mother finding out about Eduardo's age. I reflected back to Carmela that her spirit animal was there to provide her with safety, strength, support, and feelings of pride. The creature was meant to love and accept her unconditionally, serving as a companion with whom she could be fully honest in return. As Carmela reflected on this, she began to question the stability and safety of her relationship with Eduardo. She decided to change her animal's name to "Hal," because she liked the playful, friendly tone of the name. A few weeks later, Carmela shared that Eduardo had cheated on her with her best friend. Carmela said she was "taking it slow" in other relationships and that she wanted to proceed with caution.

My Peace!!!

For her next project, Carmela chose to work with clay. She created a small flat slab with a stick person laying down on it and explained that the slab was a park "somewhere in the world" where "someone is relaxing and happy." Carmela added a figure of herself walking her dog, but then decided the figure was her sister, and the person lying down was her older brother. When asked about her own location in the scene, Carmela said, "I am the park" and, as with her vase of flowers, said it was her role to hold her family and provide a calming place for them. She reflected that the park could expand further into space but that she wasn't in it and that there wasn't a place for her there. Carmela ultimately decided not to paint her sculpture. She coated it with clear glaze, preserving the white color of the fired clay (Figure 4.4). She wrote out the title "My Peace!!!" and wrote underneath, "Calm and Peaceful! Come Join!!!" (Figure 4.5).

As she worked in our weekly sessions, Carmela continued to verbally explore her ambivalence about relationships. She talked about new boyfriends and being "swept off her feet" but also asserted that the only reason to have sex "is to have a baby and to get custody money." She made references to her sexual abuse, verbalizing, "I had a bad experience with sex," and seemed relieved to talk through the complexity of her combined aversion to and longing for relationships. Together we also discussed ways of setting limits, maintaining safety, and building trust.

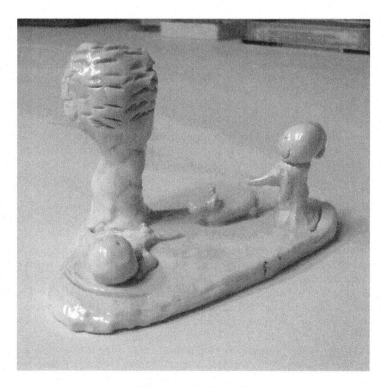

Figure 4.4 My Peace!!!

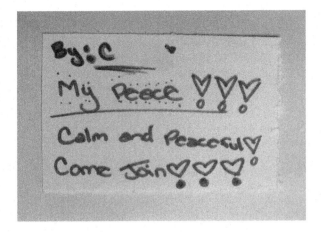

Figure 4.5 My Peace!!! title card

Past, Present, Future

Carmela's art therapy extended a month past the originally planned 12 sessions. In that time she had improved her emotional regulation, was visiting her family regularly, and was working toward discharge. She had been at the RTF for just under a year.

For her final art therapy project, Carmela decided to create works on canvas on the theme of past, present, and future. For the "Past" artwork, she drew in pencil what she identified as a self-portrait, showing her eyes lowered, a small smile on her lips, and a halo of curly hair encompassing her head. She surrounded the portrait with harsh words, including "You're a Nobody," "Dumb Bitch," and "Die!!!" along with the figure's response of "I know!!!" While drawing, she became perfectionistic, frustrated, and self-critical, but when she finished her drawing, she was still and thoughtful. She decided to title the drawing "My Passed!!! >0<" (Figure 4.6). With emotion in her voice, she quietly reflected that the drawing re-awakened feelings of anger from when she had been harshly bullied as a child. After some thought she added: "This was in the past." With emphasis she said, "I wouldn't allow words like that to hurt me now."

For her "Present" drawing, created in the next session, Carmela drew a line down the middle of the canvas. Using charcoal, she scribbled the left half of the canvas black, with the word "depressed" written underneath. On the right side, she drew half of a face with a small smile, similar to in her Past drawing but with more confidence and darker lines. Around the face, in thin colored Sharpie marker, she wrote positive words, including "Happiness," "Faith!" and "Hope!" (Figure 4.7). Carmela shared that the drawing reflected her current ambivalent feelings, combining darkness with the belief that "things'll be okay." She talked about feeling both depressed and loved and described a growing feeling of happiness, expressing both hopefulness and longing for the future.

In discussion of her "Present" drawing, Carmela disclosed that she thought she was pregnant after having had sex with her boyfriend during a home visit. The thought of having her own family seemed to fill Carmela with hope and longing. She reiterated that

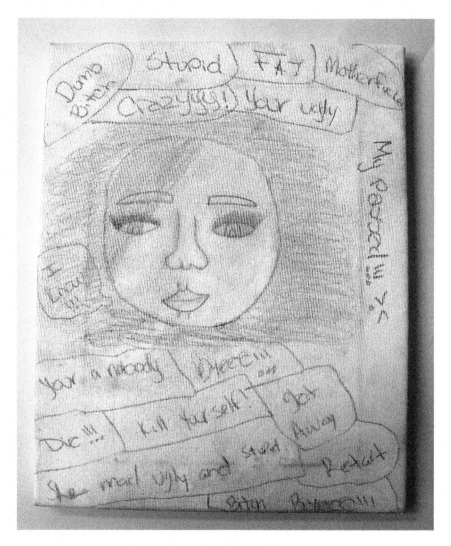

Figure 4.6 My Passed!!

she wanted a better life for her potential child; she expressed sadness about not knowing her birth mother better, and anger at her birth mother for not keeping her.

In the next session, as Carmela brainstormed for her "Future" artwork, she played with the markers on the art therapy table and became involved in arranging them in a rainbow. She asked to take a photograph of the markers and decided that she would use this image to represent her future. She glued the photo onto her canvas, and she sampled each of the marker colors on a paper, titled "My Colors," which she also attached to her canvas. At the bottom of the canvas, she wrote "HOW I AM & HOW I'M Going to Be"

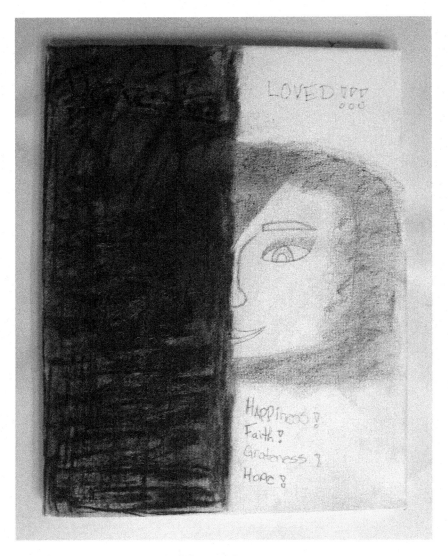

Figure 4.7 Present

(Figure 4.8). Carmela connected her artwork to her weekly color check-ins, which she continued to self-initiate. She stated that she wanted her future to be full of color—not just the bright and beautiful colors but a whole range of color, and with that a whole range of feelings.

Laying out her three canvases together, Carmela reflected that she felt proud of herself because "I had never let myself put it outside of me like that" (Figure 4.9). Although our art therapy time was ending, she appeared relieved, strong, and calm. She expressed gratitude for having had the space to express herself.

Figure 4.8 My Colors

Figure 4.9 Past, Present, and Future

Discussion

Throughout her time in art therapy, Carmela was able to center herself through the art materials and the art therapy space, develop a trusting relationship with me, and slowly develop the self-regulating skills that allowed her to discuss relationships and revisit parts of her past while remaining grounded in the present.

Introductions and Connections

Carmela's art therapy assessment (Figure 4.1) provided a lucid window into her symptom picture and treatment needs. In both her verbalizations and her artwork, she expressed her relational longings and desire to connect. Carmela's choice to draw the "happy" story of our meeting allowed her to communicate her hope that our relationship would be a safe and friendly one and also reflected a self-protective need to focus on positive affect. Her discussion of her two mothers gave insight into Carmela's focus on her present and past family; her adoption; and the confusion, longing, and disorganization that resulted.

Carmela's assessment also helped illuminate her current trauma symptoms. Her tangential thinking and somewhat disorganized and fantastical thoughts (such as her aunt's spirit living on in her dog) easily jumped from present to past. In her artwork, Carmela's happy story suggested a low tolerance for, and subsequent avoidance of, negative affect. Her dark hair, which cut across the forehead of her self-portrait in a jagged line, suggested possible internal dissonance cutting through her thoughts, and the predominance of white space surrounding the drawn image seemed to relate to concurrent feelings of isolation, which also contrasted to the happy, relational story she was telling. Carmela's drawing also raised themes of dissociation and a freeze response. While the faces in the picture smiled, Carmela's self-portrait stared out with glassy, frozen eyes and a toothy grimace. The bodiless heads suggested disconnection between mind and body, creating further feeling of isolation.

In counterbalance to these aspects, Carmela's artwork also revealed her desire for connection and grounding. She situated our portraits together, trying to ensure a secure relationship. She also situated the figures in the context of the art therapy space. The drawn detail of the bulletin board behind the figures provided a grounding in the midst of the white space of the page. Carmela used the greatest amount of color when drawing the art therapy board, reflecting the potential for the safe expression of affect within the boundaries of artwork. She carefully drew the shapes of the collage at the center of the board, which read "Every Artist Needs a Safe Space to Create." Her connection with these words seemed to reflect Carmela's hope, and her initial experience, that art therapy could provide a safe, expressive space for her.

Familial Attachment and Loss

Carmela's initial feelings of security and acceptance during her assessment may have helped her express more complex and ambivalent feelings regarding family in our subsequent sessions. In Family Portrait (Figure 4.2), the deceptively full vase of flowers reflected Carmela's great appreciation of her large family, while also revealing underlying complex feelings of absence and loss. Carmela identified the unfilled space at the right of the vase as being reserved for her future family, yet the space also evoked the absence of Carmela's birth mother and the void Carmela carried, often unnoticed, from this loss. Projecting her future family into the empty part of the vase, Carmela filled the

void left by her birth mother. She seemed to hope to create a corrective experience by having her own child who could provide her with the unconditional love, co-regulation, and security she lacked as a young person. With this longing, however, Carmela created unrealistic expectations for her future child, exchanging their proper roles and resulting in another potential generation of attachment insecurity.

Carmela visualized her own parentification in "Family Portrait" and "My Peace!!!" (Figure 4.4). She represented herself as an outsider, separated from her family yet burdened with the responsibility of caring for them by serving as the metaphorical holding vessels of the vase and the park. Carmela's feeling of not belonging to her family may have resulted from her adoption, as well as from time spent living in a facility. Carmela succinctly depicted feelings of resentment about her parentified role with the cartoon flower face on the vase that was "angry about having to take care of everyone." Ms. Torres's repeated changes to Carmela's discharge plan further played out a cycle of acceptance and rejection, unintentionally enforcing attachment insecurity and reenacting Carmela's removal from her birth mother.

Seeking Love and Attachment

Carmela's "Spirit Animal" (Figure 4.3) brought to light her eager, indiscriminate longing for affirmation and love, symptomatic of her traumas of neglect and sexual abuse. Carmela chose to make her companion an animal she described as adventurous, wild, and dangerous: all adjectives descriptive of the high-risk nature of her romantic relationships. Additionally, she described the wolf as a baby, reflecting her own infantile need for love and attention. Having not received this as a child, she now sought that attention from older men.

Carmela did not initially recognize these dynamics and did not understand the implications of naming her spirit animal after her older boyfriend, who, like a wolf, preyed on the thirteen-year-old girl. The dark pink nose of the wolf, emblazoned with a black star, was a burst of color that appeared sexual, calling to mind Carmela's history of abuse and her vulnerability to revictimization. Throughout her processing, however, Carmela questioned what it is to be loved and supported and eventually changed the identity of her animal to a neutral, playful companion who provided understanding and safety. Carmela's protective spirit animal harkened back to her childhood dog, who she believed recognized the signs that she was being sexually abused when no one else did, including Ms. Torres.

Affect Tolerance, Self-Regulation, and Mind-Body Connection

Over the course of her art therapy, Carmela strengthened her ability to connect with her body and her internal experiences. Each session's color check-in and check-out provided a contained, sensory means for her to connect to her internal emotional states. Through the ritualized structure and the incorporation of subjective color association, Carmela began to recognize a wider range of affect, while maintaining composure under the ongoing threat of becoming upset beyond control. As she increasingly found that she could tolerate these feelings without spiraling into dysregulation, her self-awareness and emotional intelligence increased.

Carmela's use of her art materials also aided in her self-regulation. From the start of her art therapy, Carmela favored using a sharp pencil with little, if any, added color. The control and precision of the pencil allowed Carmela to safely infuse her artwork with

symbolism while restricting the range of affect. After she became more familiar with art materials, the cool, soothing physicality of the plaster and clay helped her experience further internal regulation. As she began to reconnect with her body and bridge the dissociative split that she so powerfully represented in her first drawing, Carmela found that she could explore feelings of ambivalence, anger, and fear without losing control of her emotions and, as a result, her behaviors.

Telling Her Story

Carmela's improved self-connection and affect regulation empowered her to create her past, present, and future artworks at the end of her course of art therapy. Throughout the project, she stayed grounded in the present, allowing her to reflect as she externalized her experiences. In the first two artworks in this final series, Carmela used her habitual limited color range, which may have helped her maintain a sense of affect control while expressing such potentially overwhelming content.

In "My Passed!!!" (Figure 4.6) Carmela infused her self-portrait with the kind of complex, nuanced expression that she had notably avoided in her initial assessment. In the drawing, the swirl of hair surrounding the head contrasted to the calm sadness of the face and evoked Carmela's racing thoughts and continued anxiety. The title, "My Passed!!!"— unintentionally misspelled—reflected the way that Carmela could now experience her past: as, in fact, passed.

Carmela expressed the greatest amount of affect in the left side of her "Present" drawing (Figure 4.7). Here she used the materials kinetically for the first time to express the intensity of her feelings. The face on the right side of the drawing was easily over-powered by the potency of the dark scribble on the left; the words on the right side, although written in color in an attempt to elicit positive feelings, were thin and timid in relation to the rest of the drawing, like tiny voices in the midst of a powerful storm. This honestly reflected the ways that Carmela was earnestly trying to instill hope and faith in her current situation yet still struggled with an overwhelming veil of darkness and depression.

Carmela introduced the greatest range of color in her Future drawing, "My Colors" (Figure 4.8). Having avoided color throughout most of her art therapy, Carmela here found a creative way to incorporate a rainbow while still choosing controlled and removed media. By creating a sculpture out of the markers and using the distance of the camera, Carmela maintained a safe detachment from expressing this affect firsthand. These materials also gave her the strength and means to project her feelings more heartily and confidently into her future.

Looking at the three canvases together side-by-side (Figure 4.9), Carmela expressed relief and pride in having visualized her story without disconnecting or losing control. She appeared truly surprised by the strength and honesty of her artwork, and she expressed feelings of liberation and empowerment. Carmela stood whole before her artwork, which looked back at her in turn, affirming her experience and her story.

Conclusion

It was clear over the course of Carmela's art therapy that the structured framework of art therapy, the sensory and symbolic qualities of making art, and the steady development of our relationship helped her to develop the confidence and regulatory skills to safely acknowledge and express herself. Carmela came to art therapy desperate to connect

through "happy" stories. She left art therapy not only having articulated nuanced, complex feelings that arose from her chronic history of abuse; she also gained the experience of a unified, empowered self who could tell her story without falling into the spiral of re-experiencing and decompensation.

Neuroscientific trauma and attachment research illuminate the connections between Carmela's behaviors and the chronic spike of her stress hormones, her dissociation, and her nonverbal fragmentation of memory. Carmela's fight and flight response, her need for affection and acceptance, her hypervigilance and lability, and her unconscious trauma reenactments developed from her complex history of loss and abuse. Art therapy allowed Carmela to set aside verbal processing and instead develop mastery and self-efficacy while engaging the nonverbal part of her brain and experiencing her mind and body as whole and united. Her artwork provided self-affirmation, a safe distance for her ego, and a space to have a felt experience rather than merely a cognitively processed one. By sitting with her as a supportive witness, I established a secure relationship with Carmela in which she was seen and allowed to safely express herself. Ultimately, Carmela's initial relinquishment of words led her to find the strength, through art-making, to speak the nuances of her ambivalence, longing, hurt, and hopes.

Carmela continued at the RTF for a total of a year and a half. Shortly after she finished art therapy, Carmela's social worker left the agency, and I assumed this role. Carmela and I proceeded to work together for another five months, until I left on maternity leave. My pregnancy evoked further transference for Carmela, in particular around her longing to have a baby, and her idealizations of me in a maternal role. When possible, I continued to incorporate art-making to aid in her processing. In one family session, she and Ms. Torres collaborated to create an artwork for their home. In another series of sessions, Carmela visualized her fears and hopes about her future and used symbolism to connect her current struggles with her childhood sexual abuse.

Carmela was discharged from the RTF to her home with Ms. Torres a few months after I went on leave. A year after her discharge, Carmela called me at the RTF. She shared that her relationship with her mother was going well and that she was attending school regularly. After her discharge from the RTF, she continued to struggle with unsafe relationships and eventually was involved with a man who became physically abusive. She expressed aversion to any new romantic relationships. She said, "I'm staying away from that right now. I'm focusing on me." She told me that she continued to make art and that she won an art prize recently in school. She asked about her favorite staff and wanted to return to visit. After months of anger and resentment for her time at the RTF away from home, she expressed positive memories and gratitude for her time there.

The Dynamic Flexibility of Art Therapy

Treatment Recommendations and Interventions

In the treatment of youth who have suffered early life trauma and attachment disruptions, the dynamic flexibility of art therapy allows the art therapist to finely adjust treatment approaches to compassionately address the client's needs. The art therapy space also provides a respite from the extensive verbal processing that often accompanies intensive trauma treatment, especially in a residential setting. By staying attuned to all dimensions of the session, including how materials are used, what is created, what is said, and how a youth leaves, the art therapist gains rich insight into the nuances of the young person's mental state, struggles, needs, and strengths. Once the youth fully

engages, the art helps move the client past the fragmentation and disconnection caused by the trauma and allows for a more thorough integration of the self. As Klorer (2016) writes, the psychological safety created by the art therapy room and the therapeutic relationship provides the space for children and adolescents to find their own path.

In order to kindle and support this healing, it is important for the art therapist to possess a dynamic range of materials available for the youth's exploration, experimentation, and self-expression. Different youth will respond very differently to the same material. Colored pencils may allow one adolescent to poignantly express the self with a symbolic drawing or color blending; for another with a frail self-esteem, perfectionist expectations, and little artistic experience, this material may feel confining and abstract and only highlight feelings of failure and frustration.

The art therapy room should be arranged so that materials are appealing, accessible, and contained. Supplies should include paper of all sizes, weight, and patterns so that both delicate, layered feelings and powerful splatters and smears can be held. A collection of boxes should be available for use in containing projects, such as a memory box for a loved one, a sensory box for self-soothing, or a safety box to hold upsetting journal entries. Structured, controlled materials, such as stencils, a wide variety of beads, and coloring pages, may help especially guarded youth engage in an activity that feels safe and attainable. Pre-cut collage images (best organized by categories to facilitate a less overwhelming search) provide ego support, metaphor, and help with more cognitive-based projects, such as exploring "What do I love about my family, and what do I wish I could change?" Soft materials including felt, fleece, and stuffing should be available to help soften a constructed home or to sew a pillow or doll, allowing the youth to experience focus and mastery and create a transitional object. Sculptural materials with a range of tactile intensity (from clay to Model Magic to blocks) can help youths assert themselves more physically into space.

In addition to a range of materials, it is also important for the art therapist to utilize the flexibility of art therapy approaches to accommodate the needs and defenses of the youth. One child may use the modality to concretely visualize a problem. Another may draw on the power and protection of personal symbolism and metaphor. Another youth may benefit most from working experientially and tactically. Within one session, a client's needs may dramatically shift. Affect attunement, careful observation, and consideration of transference dynamics will help the therapist sensitively determine how to best mirror, scaffold, intervene, or verbally respond to the youth.

At times it will be necessary for the art therapist to develop a specific directive to help break patterns of avoidance or to guide toward further expression. I always come to a session with a directive or material in mind to help address the client's current treatment needs. However, I have also found that once safety is established and youths are given supportive space and time, clients begin to intuitively select materials and projects that poignantly address their needs beyond any project I may conceive. One boy with whom I worked, who struggled with intense anger that he hid by becoming the "class clown," determinedly came to session asking to paint with his basketball outside. I followed his lead, providing the support to make sure we had paper large and strong enough to receive and contain his action. What resulted were explosive abstract paintings in blood red and yellow ochre that at once resembled wounds and flowers. The artwork served as an incredible catharsis for him. He was thrilled with the visually potent results, and his community saw him with a renewed respect as a powerful artist when he shared his artwork in the annual art show.

Despite the depth of hurt and damage caused by early life trauma and attachment disruptions, trauma therapy helps to frame these life experiences as events that have happened to the individual, rather than as a core aspect of identity (Bloom & Farragher, 2013). Art therapy helps trauma survivors connect with the life and potential inside of them, with the act of creating serving as an antithesis to destruction. After art therapy work ends—regardless of the challenges, unknowns, and losses an individual still faces—the client can carry this life, and ability to create, into the future.

References

Appelbaum, P., Uyehara, L., & Elin, M. (Eds.). (1997). *Trauma and memory*. New York, NY: Oxford University Press.

Armstrong, V. G. (2013). Modelling attuned relationships in art psychotherapy with children who have had poor early experiences. *The Arts in Psychotherapy, 40*(3), 275–284. https://doi-org.ezproxy2.library.drexel.edu/10.1016/j.aip.2013.04.002

Benight, C. C., Kotaro, S., & Delahanty, D. L. (2017). Self-regulation shift theory: A dynamic systems approach to traumatic stress. *Journal of Traumatic Stress, 30*(4), 333–342.

Bloom, S. L., & Farragher, B. (2013). *Restoring sanctuary: A new operating system for trauma-informed systems of care*. New York, NY: Oxford University Press.

Boszormenyi-Nagy, I., Nagy, I. B., & Spark, G. M. (1973). *Invisible loyalties: Reciprocity in intergenerational family therapy*. Hagerstown, MD: Medical Department, Harper & Row.

Bowlby, J. (1982). *Attachment and loss, Volume 1: Attachment*. (2nd ed.). New York, NY: Basic Books.

Coholic, D. A. (2011). Exploring the feasibility and benefits of arts-based mindfulness-based practices with young people in need: Aiming to improve aspects of self-awareness and resilience. *Child & Youth Care Forum, 40*(4), 303–317. doi:10.1007/s10566-010-9139-x

Crenshaw, D. A. (2014). Play therapy approaches to attachment issues. In C. Malchiodi & D. Crenshaw (Eds.), *Creative arts and play therapy for attachment problems* (pp. 19–32). New York, NY: The Guilford Press.

Duros, P., & Crowley, D. (2014). The body comes to therapy too. *Clinical Social Work Journal, 42*(3), 237–246. doi:10.1007/s10615-014-0486-1

Earley, L., & Cushway, D. (2002). The parentified child. *Clinical Child Psychology and Psychiatry, 7*(2), 163–178.

Ehlers, A., & Clark, D. M. (2000). A cognitive model of post-traumatic stress disorder. *Behavior Research and Therapy, 38*(4), 319–345.

Feeney, J. A., Passmore, N. L., & Peterson, C. C. (2007). Adoption, attachment, and relationship concerns: A study of adult adoptees. *Personal Relationships, 14*(1), 129–147.

Fitzgerald, M., Schneider, R., Salstrom, S., Zinzow, H., Jackson, J., & Fossel, R. (2008). Child sexual abuse, early family risk, and childhood parentification: Pathways to current psychosocial adjustment. *Journal of Family Psychology, 22*(2), 320–324. Retrieved from PsycARTICLES, Ipswich, MA.

Fonagy, P., & Target, M. (2002). Early intervention and the development of self-regulation. *Psychoanalytic Inquiry, 22*(3), 307–335.

Ford, J. (2009). Neurobiological and developmental research: Clinical implications. In C. A. Courtois & J. Ford (Eds.), *Treating complex trauma stress disorders: Scientific foundations and therapeutic models* (pp. 31–58). New York, NY: Guilford Press.

Gant, L., & Tripp, T. (2016). The image comes first: Treating preverbal trauma with art therapy. In J. King (Ed.), *Art therapy, trauma and neuroscience* (pp. 67–99). New York, NY: Routledge.

Gillespie, L. (2015). It takes two: The role of co-regulation building self-regulation skills. *YC: Young Children, 70*(3), 94–96.

Hass-Cohen, N. (2016). Secure resiliency: Art therapy relational neuroscience trauma treatment principles and guidelines. In J. King (Ed.), *Art therapy, trauma and neuroscience* (pp. 100–138). New York, NY: Routledge.

Hass-Cohen, N., & Carr, R. (2008). *Art therapy and clinical neuroscience*. London: Jessica Kingsley.

Hetherington, E. M. (1999). Should we stay together for the sake of the children? In E. M. Hetherington (Ed.), *Coping with divorce, single parenting, and remarriage: A risk and resiliency perspective* (pp. 93–116). Mahwah, NJ: Erlbaum.

Hofmann, W., Schmeichel, B. J., & Baddeley, A. D. (2012). Executive functions and self-regulation. *Trends in Cognitive Sciences, 16*(3), 174–180. doi:10.1016/j.tics.2012.01.006

Hooper, L. M. (2007). The application of attachment theory and family systems theory to the phenomena of parentification. *The Family Journal, 15*(3), 217–223. https://doi-org.ezproxy2.library.drexel.edu/10.1177/1066480707301290

Klorer, P. G. (2016). Neuroscience and art therapy with severely traumatized children. In J. King (Ed.), *Art therapy, trauma and neuroscience* (pp. 138–156). New York, NY: Routledge.

Kramer, E. (1990). *Art therapy in a children's community*. New York, NY: Schocken Books.

Lalor, K., & McElvaney, R. (2010). Child sexual abuse, links to later sexual exploitation/high-risk sexual behavior, and prevention/treatment programs. *Trauma, Violence, & Abuse, 11*(4), 159–177. https://doi-org.ezproxy2.library.drexel.edu/10.1177/1524838010378299

Lane, R. D., Ryan, L., Nadel, L., & Greenberg, L. (2014). Memory reconsolidation, emotional arousal, and the process of change in psychotherapy: New insights from brain science. *The Behavioral and Brain Sciences*. http://dx.doi.org/10.1017/S014052X14000041

Levine, A. (2009). *Parentification and adult psychosocial life distress* (Order No. 3376850). Available from ProQuest Dissertations & Theses Global; ProQuest One Academic. (305038773). Retrieved from http://ezproxy2.library.drexel.edu/login?url=https://search-proquest-com.ezproxy2.library.drexel.edu/docview/305038773?accountid=10559

McClelland, M. M., & Tominey, S. L. (2014). The development of self-regulation and executive function in young children. *Zero to Three, 35*(2), 2–8.

Murray, D. W., Rosanbalm, K., Chrisopoulos, C., & Hamoudi, A. (2015). *Self-regulation and toxic stress: Foundations for understanding self-regulation from an applied developmental perspective* (OPRE Report #2015-21). Retrieved from www.acf.hhs.gov/sites/default/files/opre/report_1_foundations_paper_final_012715_submitted_508.pdf

Perry, B. D. (2001, October 25). *Violence and childhood: How persisting fear can alter the developing child's brain*. Retrieved from www.ChildTrauma.org

Perry, B. D. (2014). The neurosequential model of therapeutics: Application of a developmentally sensitive and neurobiology-informed approach to clinical problem solving in maltreated children. In K. Brandt, B. Perry, S. Seligman, & E. Tronick (Eds.), *Infant and early childhood mental health: Core concepts and clinical practice* (pp. 21–54). Arlington, VA: American Psychiatric Publishing.

Piermattei, C., Pace, C. S., Tambelli, R., D'onofrio, E., & Di Folco, S. (2017). Late adoptions: Attachment security and emotional availability in mother-child and father-child dyads. *Journal of Child and Family Studies, 26*(8), 2114–2125. http://dx.doi.org.ezproxy2.library.drexel.edu/10.1007/s10826-017-0732-6

Porges, S. W. (2013). A psychophysiology of developmental disabilities: A personal and historical perspective. *American Journal on Intellectual and Developmental Disabilities, 118*(6), 416–418.

Saha, A. (2016). Parentification: Boon or bane? *Journal of Psychosocial Research, 11*(2), 289–301. Retrieved from http://ezproxy2.library.drexel.edu/login?url=https://search-proquest-com.ezproxy2.library.drexel.edu/docview/1868276586?accountid=10559

Sapolsky, R. M. (2004). *Why zebras don't get ulcers: An updated guide to stress, stress-related diseases, and coping* (3rd ed.). New York: W.H. Freeman & Co.

Schore, A. N. (2001). The effects of early relational trauma on right brain development, affect regulation, and infant mental health. *Infant Mental Health Journal, 22*(1–2), 201–269.

Schore, A. N. (2013). Relational trauma, brain development, and dissociation. In J. D. For & C. A. Cartois (Eds.), *Treating complex traumatic stress disorders in children and adolescents: Scientific foundations and therapeutic models* (pp. 3–23). New York, NY: Guilford Press.

Siegel, D. (2010). *The mindful therapist: A clinician's guide to mindsight and neural integration.* New York, NY: W. W. Norton & Company, Inc.

Siegel, D. H., & Strolin-Goltzman, J. (2017). Adoption competency and trauma-informed practices with adoptive families. *Families in Society: The Journal of Contemporary Social Services, 98*(3), 167–168. doi:110.1606/1044-3894.2017.98.22

Straus, M.B. (2017). *Treating trauma in adolescents: Development, attachment, and the therapeutic relationship.* New York, NY: The Guilford Press.

Tinnin, L. (1990). Biological processes in nonverbal communication and their role in the making and interpretation of art. *American Journal of Art Therapy, 29*(1), 9–13.

Tinnin, L., & Gantt, L. (2013). *The instinctual trauma response & dual brain dynamics: A guide for trauma therapy.* Morgantown, WV: Gargoyle Press.

Tripp, T. (2016). A body-based bilateral art protocol for reprocessing trauma. In J. King (Ed.), *Art therapy, trauma and neuroscience* (pp. 173–194). New York, NY: Routledge.

Van Der Kolk, B. (2014). *The body keeps score.* New York, NY: Penguin Books.

Verrier, N. N. (1993). *The primal wound: Understanding the adopted child.* Baltimore: Gateway Press.

Winnicott, D. (1987). *The child, the family, and the outside world.* Reading, MA: Addison-Wesley Pub. Co.

Zilberstein, K. (2013). Neurocognitive considerations in the treatment of attachment and complex trauma in children. *Clinical Child Psychology and Psychiatry, 19*(3), 336–354. https://doi-org.ezproxy2.library.drexel.edu/10.1177/1359104513486998

Zoldbrod, A. P. (2015). Sexual issues in treating trauma survivors. *Current Sexual Health Reports, 7*(3), 3–11. https://doi-org.ezproxy2.library.drexel.edu/10.1007/s11930-014-0034-6

5

Promoting Resilience Through Attachment in Early Childhood Art Therapy Intervention

KIMBERLY BUSH

In two decades as a preschool educator and art therapist, this author has developed a firm philosophy: there is no single approach that can be applied universally when working with children. Instead, an openness to various theories, materials, and practices is essential for therapists and educators to shape fruitful therapeutic experiences for young students. While therapeutic principles and methods may change to suit each student, one certainty is that children can exhibit cognitive and emotional growth when offered a safe environment and opportunities to form meaningful attachments. Indeed, it is usually through strong attachments, rather than prescribed art therapy directives or techniques, that children with special needs demonstrate progress. Art therapy materials and activities can be vehicles for children to form attachments, but the process whereby students interact meaningfully with others is much more significant than any finished art product.

Attachment between instructional/therapeutic staff and students is particularly important when those students are at-promise, for example, due to disability, minority status, early trauma, or socioeconomic standing. When teachers and clinicians are deeply invested in the care of the children they serve, they can create an environment that nurtures secure attachments. Through these mutually caring therapeutic interactions, students can develop skills to help them cope and thrive in difficult circumstances.

The following account of art therapy used with preschool students conveys how vulnerable children can overcome challenges associated with their disabilities. A review of literature outlines fundamental concepts related to disabilities and art therapy; case vignettes illustrate art therapy and attachment in action; discussion of specific techniques provides practical advice for art therapists and educators who aim to cultivate students' resilience through their work.

Developmental Disabilities

Developmental disabilities in young children can stem from a range of sources: neurological disorders such as autism spectrum disorders, auditory processing disorders, or expressive language disorders; neuro-behavioral disorders such as attention deficit disorder; and early emotional trauma such as abuse or neglect, medical and surgical interventions, and social events leading to disruption of attachments with primary caregivers.

When children show signs of developmental delay, they demonstrate overt behaviors such as social isolation, sensory integration problems, and affect regulation difficulties. Affect regulation is often linked to sensory regulation (Foley, 2018). For example, when children with autism are experiencing an overload of sensation due to environmental factors such as bright lights and loud noises, their anxiety rises because the amount of sensory stimulation is greater than tolerable. Such phenomena can also affect children who have witnessed domestic abuse or environmental violence. They may become hyper-vigilant and overly alert to unexpected movements, sounds, or sensations. Some children even learn to expect chaotic experiences and may try to induce them in order to get the necessary internal rush of adrenaline that previous chaotic experiences have provided.

Environmental stressors such as poverty can deeply impact young children's development by making it difficult for a parent to provide protection and encourage exploration. Basic parenting skills can be severely affected by daily struggles due to a lack of safe housing options and play spaces, direct access to educational opportunities, adequate healthcare, healthy food sources, and decent jobs:

> The role of severe environmental stressors and traumatic events in derailing parental competence should not be underestimated. Exposure to traumatic situations in infancy and early childhood shatters the developmentally appropriate protective shield, engendering traumatic helplessness and prematurely confronting the child with the realization that the parent is unable to protect them from danger.
>
> (Lieberman & Van Horn, 2008, p. 19)

Many children with developmental disabilities are also members of at-promise racial and socioeconomic groups, increasing the burden of disability for children and parents alike.

Early detection of disabilities by developmental pediatricians and early screening by psychologists can support treatment options for preschool children as young as two years of age. Therapeutic preschool programs that provide services for a broad range of delays and disorders in children use a range of models of therapeutic interventions from applied behavioral analysis to cognitive behavioral therapy. However, it is through the lens of attachment theory that a secure foundation for growth and development is provided.

Attachment and Art Therapy

Attachment forms the basis of all human development. Bowlby (1982, 1988) noted that attachment is a biologically necessary element of the human infant's ability to thrive. Physical, emotional, and psychological survival depend on forming attachment bonds with other human beings. Ainsworth, Blehar, Waters, and Wall's (1978) research suggested that secure and insecure attachment adaptations are determined through nonverbal communication between infants or young children and their caregivers. The character of this communication, as well as the ways children use these nonverbal mental representations to process their own feelings as they grow, become the foundation of a child's maturational development. While attachment to primary caregivers is highly influential to development, research in current attachment theory suggests that relationships are flexible and can offer "second chances" to establish secure relational

connections with others beyond primary experiences with parents and caregivers (Fonagy, Steele, & Steele, 1991; Main, 1985; Wallin, 2007).

Therapeutic services may also be founded on attachment relationships such as those between parents and children:

> The patient's attachment relationship to the therapist is foundational and primary. It supplies the secure base . . . for exploration, development, and change. This sense of secure base arises from the attuned therapist's effectiveness in helping the patient to tolerate, modulate, and communicate difficult feelings. By virtue of the security generated through such affect-regulating interactions, the therapeutic relationship can provide a context for accessing disavowed and dissociated experiences within the patient that have not—and perhaps cannot—be put into words.
>
> (Wallin, 2007, pp. 2–3)

The content of therapeutic activities can be delivered only with the foundation of an attachment relationship.

A child's attachment style and primary relationship with parents and caregivers is the single most important factor in assessing and treating mental health issues in young children (Bowlby, 1982; Lieberman & Van Horn, 2008). Adults must provide the necessary emotional, psychological, and physical support to serve as protectors for young children, whether or not they have been diagnosed with a developmental delay. Caregivers must also be sensitive enough to know when to encourage age-appropriate exploration and when to let go of this protective shield in order to support independence.

A developmental approach may be most useful when working with delayed preschool children. In particular, it can be helpful to consider the primary stages of development (Aach-Feldman & Kunkle-Miller, 2016) for typically developing children from birth to age two, even when working with children who may be chronologically older. Art materials are often provided for the child to explore "the body, trial-and-error process, and object permanence" (Piaget, 1951, 1954). Pre-art experiences may include "manipulation and mouthing" (Rubin, 2005). Sometimes it can be beneficial to use edible materials in case the child uses his mouth to explore the texture and taste like an infant does. Quite often, children with disabilities impulsively grab materials and attempt to put them in their mouth during the process of exploring something new. Using the body in art-making is a child's first impulse.

Relational and environmental exploration begins with movement and the engagement of the five senses; touch, sight, smell, sound, and taste. Young children diagnosed with global developmental delays often have very little capacity to separate and differentiate their external environment from their internal self. The body is a child's first art tool. Art materials are often smelled, tasted, kinesthetically engaged with, and spread on their bodies. It is through the body ego that textural, tactile qualities of the world are explored, experienced, integrated, and known.

Typically developing babies under two years of age seem to "delight in action [and show] interest in how material moves and feels" (Golomb, 1974), "respond to the environment with pleasure" (Williams & Wood, 1977), and engage in "exploration, experimentation, manipulation" (Hartley, Frank, & Goldsenson, 1952). However, children with developmental delays due to autistic spectrum disorders or early trauma may not show signs of delight or interest in the outside world at all. They may seem stagnant in their exploration of their environment and appear lost as they self-protect and withdraw from the world around them. Art therapy interventions can wake up the body

to help align the child with his surroundings and help him connect and relate with others.

In art therapy sessions, some children with developmental delays are able to focus better when overhead fluorescent lights are dimmed and loud noises are avoided. When a peer becomes dysregulated and disrupts the group by screaming or crying, behavioral support often needs to be provided to prevent other children from becoming triggered. By designating a "safe space" in every classroom, an overwhelmed child can request to take a break to lie on a bean bag, where the child can experience a secure, calm place to help regulate his or her body.

Visual containment devices, such as trays to designate children's workspaces, are also helpful in providing focus, security, and clear boundaries. Forms such as pre-drawn circles on paper can also act as targets for supporting hand and eye coordination when exploring mark making and 3D materials. Art therapy materials are always presented slowly and with repetition to allow children to move from one-step processes, such as exploring shaving cream directly on a table or using a marker on a piece of paper to multistep processes such as watercolor painting that requires children to wet the brush, wiggle it in the desired color, spread the color on the paper, rinse, and repeat.

Greenspan and Weider (2006) suggest that the key to art therapy is not to fit the child to the intervention program but rather to fit the intervention program to the child. These authors note that although every child on the autism spectrum has a sensory disorder, every child with a sensory disorder is not autistic. Trauma and early loss of attachment to a significant caregiver can also cause children to exhibit affect regulation difficulties, communication disorders, misbehavior, and social isolation.

To help caregivers connect to children with autism, Greenspan and Weider (2006) developed the "Families First" initiative, which outlines seven stages of playful interaction to develop stronger attachments and build relational skills. These stages can be adapted and utilized in forming relationships with all young children who have developmental delays and disabilities. The stages are meant to scaffold connections between caregivers and children. Beginning with the first initiative, *shared attention and regulation*, caregivers notice and engage through the use of the senses. In the second stage, *engagement and relating*, touch, rhythm, and interactive games such as peek-a-boo offer ways to tune in and follow the child's interests. Using the third initiative, *purposeful emotional interactions*, caregivers engage children by exchanging expressive facial and auditory reactions to shared experiences. Stage four includes *shared problem solving*, in which children are encouraged to show interest and wonder in dramatic play scenarios beginning with simple problems such as how to roll a ball. Stages five, six, and seven incorporate language in *creating ideas* and using *logical thinking* so that children will begin to communicate their wants and needs to others in understandable and comprehensive ways. The aim of therapeutic interventions is to support adaptive behaviors and communication to promote improved socialization and day-to-day functioning.

Resilience and Attachment

Researchers at the American Psychological Association state that resilience is "the process of adapting well in the face of adversity, trauma, tragedy, threats, or significant sources of stress" (American Psychological Association [APA], 2017). Resilience is the ability to bounce back from adversity, and "research has shown that resilience is ordinary, not extraordinary" (APA, 2017). Rather than being an inborn trait or disposition

that one either has or does not have, resilience can be developed through learned thoughts and actions.

Heise (2014), an art educator who looks to art therapy and psychodynamic theory to inform her work with children, discussed how resilience can be viewed as a developmental process:

> Children learn to mobilize assets and resources as they are exposed to adversity. As youth overcome low levels of risk, they become more prepared to face increasing risk. As individuals continue to overcome adversity, their capacity to thrive despite risks increases.
>
> (p. 28)

While environmental challenges can prompt children to "bounce back," interpersonal supports and role models are usually necessary for children to develop effective coping strategies.

Researchers Masten, Gewirtz, and Sapienza (2006) discuss the protective processes that shape resilience in young children:

> Problems in learning and self-control often begin in the preschool years and are related to the quality of available parenting. Effective preventive intervention programs during infancy and preschool years support parenting in multiple ways and provide enriched learning environments for children. Early success in school—related to effective care, positive home-school connections and effective classroom practices—appears to be a key segue to resilience, particularly for very disadvantaged children.
>
> (p. 3)

Thus, caring connections are critical to the development of resilience. In order to feel capable of facing challenges, young children require the protection conferred by a strong bond with caregivers who show love and concern (e.g., through limit-setting and provision of nutrition and cognitive stimulation). With the support of caring attachments, children can master new skills, develop self-control, and respond constructively to setbacks.

Teachers and therapists engaged in caring attachments with young students tend to "focus on building competence and strengths in young children and their families, along with reducing risk and addressing problems early" (Masten et al., 2006, p. 3). By using a strengths-based approach, educators recognize students' competence, thereby fostering resilience. It is generally caring attachments that engender such a positive approach. Psychotherapists, creative arts therapists, and educators (Aach-Feldman & Kunkle-Miller, 2016; Bayley, 2010; Wallin, 2007) all point to evidence that, of the many ways that resilience may be fostered in young children, having positive relationships and secure attachments with supportive adults feature as the most important component:

> The single most common factor for children who develop resilience is at least one stable and committed relationship with a supportive parent, caregiver, or other adult. These relationships provide the personalized responsiveness, scaffolding, and protection that buffer children from developmental disruption. They also build key capacities—such as the ability to plan, monitor, and regulate behavior—that

enable children to respond adaptively to adversity and thrive. This combination of supportive relationships, adaptive skill-building, and positive experiences is the foundation of resilience.

(Center for the Developing Child, 2018)

A nurturing environment with secure attachments is critical for children to develop resilience. Yet some educational and therapeutic milieus seem to preclude such caring relationships. Nessie Bayley (2010), a child therapist who employed sensory experiences to help young children connect to self and others, discusses the integration of caring attachments with more traditional concepts of education and therapy:

> Teachers, daycare providers, and other adults whose task it is to care for children or others in need are encouraged to think about bonding and attachment. For some this requires a shift in thinking about the tasks as caregivers and what it means for the way they interact with children. In so many circumstances, infant and early childhood day care professionals are encouraged to "manage" children; teachers study 'classroom management' techniques. There is no contradiction between "bonding" and "re-parenting" principles described herein and current classroom "management" principles. However, bonding and re-parenting reflect a deeper emotional connection and way of thinking about the caregiver's relationship with the child than someone who is being asked to "manage" the child. If the caregiver can think about the child developmentally, emotionally, and intellectually, as he is presenting himself in the caring environment, it will be easier to recognize his needs as they present themselves.
>
> (Bayley, 2010, pp. 19–20)

Resilience Through Art Therapy

Therefore, bonding and fostering resilience through attachment with young children who have experienced adversity and are struggling with delays may be the most important goal in a therapeutic preschool educational program. To prepare children at the youngest age possible with the skills they need to flourish in the community, preschool programs need to include social-emotional learning goals that enhance positive attachments to others. Additionally, programs must encourage developmentally appropriate self-regulation and coping skills to strengthen children's perceived control in their environment to encourage resilience.

In particular, art therapy interventions are poised to support the development of young children through hands-on sensory experiences that enhance regulation of the body, build positive social skills, and promote positive self-esteem. Art therapy modalities offer experiences with materials in which engagement can be in the child's realm of control. Heise (2014) notes that resilient children need to develop "social competence, problem-solving skills, autonomy, and a sense of purpose and future" (p. 27). Art therapists know that engagement in the arts is effective in developing these strengths in children to help them adapt and grow: "Art is a meaning making endeavor that develops creative problem solving, flexibility, and resourcefulness. It addresses a variety of perspectives and requires persistence and vision" (Heise, 2014, p. 28).

Creativity is one manifestation of resilience. Heise (2014) paraphrases the research of Wolin and Wolin (1993), while connecting it to the theory and practice of creative arts therapists:

Art therapists use the creative process to promote mental health. . . . Creative activity can provoke a safe haven for people in times of stress. Other types of resilience that can be addressed through the creative arts: insight, independence, relationships, initiation, humor, and morality.

(Heise, p. 28)

With its emphasis on emotional processing and affective learning, art therapy can build resilience by helping students respond constructively to challenges arising from environmental and internal stimuli. To engage in a creative process is, by definition, to work with what is at hand, adapt, and create something transcendent. Many times, that transcendence—rising above—resilience—lies in the process itself. The following vignettes highlight effective art therapy practices within a supportive milieu setting.

Case Vignette: Marco

Marco came to a therapeutic preschool in New York City at age three. His family placed him in the school after a pediatric mental health screening and evaluation by the Department of Education. Marco was being raised by his first-generation American teenage mother and his immigrant maternal grandparents, who spoke only Spanish. The cultural and generational gap between caregivers may have contributed to misunderstandings about Marco's language development and unmet milestones. By age two and a half, he was still not talking, and as communication was extremely difficult for him, he began exhibiting severe behaviors, including tantrums and inconsolable crying, biting, withdrawal, and throwing himself onto the floor.

The school Marco attended uses a child-centered approach to learning. Educational and therapeutic staff work together to support children's developmental needs. While the school complies with common core standards of learning, it also works from a strong social-emotional curriculum; therapists engage principles developed by early childhood educator and expert in developmental psychology, Dr. Becky Bailey (2015), in her book *Conscious Discipline*. These strategies support children to identify emotions, process experiences through the lens of "helpful" versus "hurtful" choices, and use "safe spaces" to work on emotional regulation (p. 24). The school primarily serves the needs of developmentally delayed children between the ages of three and five years, while also providing childcare for a handful of typically developing children in inclusion classrooms. Classrooms are typically comprised of six to eight children with a lead teacher and at least two assistants. Class groups are divided by the diverse special needs and diagnoses of the children, such as emotional issues, behavioral delays, autism spectrum disorders, and typically developing inclusion children. Beyond the teaching staff, clinicians such as occupational and physical therapists, speech and language pathologists, social workers, and psychologists engage in therapy sessions with children, alone and pushing in to the art therapy sessions to provide additional support for the specific needs of a child.

At the beginning of his first day in preschool, three-year-old Marco approached the building cautiously, his facial expression blank yet wide-eyed. He had been greeted at the door of the bus by several unfamiliar adults, each speaking, gesturing, and physically guiding him. It took several minutes and much cajoling to walk to the building from the bus. Perhaps one of his family members had read him the social story that was sent home by the school to prepare him for this experience. Social stories, originally created by Carol Gray (2010) and used by early childhood educators, speech pathologists, and

therapists, are social learning tools that provide cues for helping children with processing disorders such as autism to understand and establish basic expectations regarding unfamiliar situations and events. With a sequence of pictures rather than words telling the events of the day, he might have been preliminarily prepared for these transitions. But he appeared tense and distrustful.

By the time he arrived in the art therapy studio with his class group, Marco had been offered breakfast, toys to play with, and welcoming words and songs from his teachers. However, he continued to appear distant and blank as he was positioned at the art table. While others in his class resisted the new environment by vocalizing loudly or wiggling in their seats, Marco sat passively as tears streamed silently down his cheeks.

The art therapy session began with a simple song to say hello and present images of faces with different emotions to suggest the different ways that each child might be feeling. While promoting joint attention, the goal was to help the children look and listen together and engage their bodies rhythmically in auditory and visual tracking of the leader. Next, a deep tray with dry rice was placed before each child. The therapist and teachers helped by gently shaking the tray to make noise in the hope that each child would turn toward the sound and independently reach in. The adults scooped some rice in their hands and sprinkled it over the hand of each child to encourage tactile exploration.

Marco cried without making any sound. However, when the rice fell gently onto his hand, his affect appeared to shift slightly. He began to notice the tactile sensation and seemed to connect a positive internal feeling with the outside action. He made eye contact with the art therapist as she continued to scoop and pour the rice over his hand. His body seemed to relax a bit. Maybe the material felt soothing, or maybe the sound of the falling rice resonated with a kinesthetic feeling in his body. The nonverbal invitation to engage with rice in a tray seemed to produce a momentarily integrated experience for Marco that regulated and settled his body. His teacher stated that this was the first moment of relational eye contact he made that day.

In the initial stages of therapeutic work, young children's abilities, strengths, and interests are often unclear. Even a child's diagnosis may not be clearly defined. In Marco's case, he entered the program due to global speech and language delays with a history of aggressive behaviors such as biting, hitting, and scratching. Impulsive with little sense of danger, his communication abilities, daily living skills, and fine-motor coordination were extremely low for his chronological age of three years old. He often appeared withdrawn and made little eye contact. He was placed in a class with a group of children diagnosed with autism spectrum disorders.

As the therapeutic team worked with Marco, his skills increased. Over time, it became clear that he did not have autism. In art therapy, he presented with highly attuned receptive language, as he could follow directions and point to colors, animals, and shapes when asked. In one session, while working with clay, an impromptu game of peek-a-boo emerged as the art therapist placed a piece of clay on a picture book to cover an image of a cow. Since his desire to communicate was so strong, Marco learned that he could use gestures, facial expressions, and minimally articulated sounds to express his desire to continue with the game. As the therapist said the name of the next animal to hide, he used the clay to cover that animal. His enthusiasm for this type of playful connection with others was acknowledged through nonverbal cueing and engaging in meaningful play. Through social-emotional experiences like these, he began to establish a stronger sense of purpose and find power in communication. Over time, he withdrew less, and his frustration seemed to be better managed. As his fine-motor skills increased, drawing

also became a way for him to express thoughts and feelings. Initially, he explored mark making with finger paint and then moved on to felt-tipped pens, chalk, and craypas. His ability to control his scribbling developed throughout the year with exposure to new materials that increased his hand-eye coordination.

Marco began to show signs that he wanted to communicate through symbolic visual imagery when working with clay and collage materials during his second year of the program. As each group session began with ritualized songs, visual aids, and routines for identifying feelings, Marco had become familiar with labeling feelings such as happy, sad, tired, and angry. While his language skills were still significantly delayed, he learned to point to the image that he wished to associate with his internal feeling. During a group session, Marco spontaneously created a face using bits of clay on a background sheet of bubble wrap (Figure 5.1).

This image was positively received by the art therapist and teachers. The adults in the room noticed and responded with excitement. Marco's image was held up for others to see and applaud. The teachers recognized that Marco's communication had facilitated a *purposeful emotional interaction* and allowed this child to *create an idea* where he was able to share a feeling state through the production of a symbolic art piece (Greenspan & Weider, 2006, p. 60).

Figure 5.1 Face on bubble wrap

Figure 5.2 Face within a face

As Marco increased his hand and eye coordination, he began to attempt to express himself through drawing on paper as well (Figure 5.2). His inspiration continued to be focused on communicating feeling states that were reinforced daily in art therapy sessions. He initially identified this image as a "sad face," and then he turned the paper. He drew a second face inside the eye of the first drawing with more fine-motor control as he continued to practice skills of communicating through symbolic art-making. By this point in the school year, Marco was using an iPad with voice activation. His use of artistic symbols coincided with linguistic development.

By the time Marco was ready to move on to kindergarten, he was communicating consistently through drawing and his iPad. Expressing his feelings had become routine, and he was able to clearly communicate his wants and needs through visual means. His fluency had expanded from simple requests to expressing complicated feelings about saying goodbye to his teachers and therapists. He continued to use both his digital device and the visual literacy of drawing lines and forms.

Case Vignette: Johnny

Johnny was a five-year-old child diagnosed with autism spectrum disorder. Like many children with ASD, he exhibited self-stimulatory behaviors, anxiety, and isolating behaviors such as poor eye contact and withdrawal from the activities of peers and teachers. He demonstrated little expressive language and very limited age-appropriate

social-emotional skills. It often appeared that he was "daydreaming," as he was extremely internally preoccupied. He received speech and occupational therapy services and was referred for individual art therapy services. He often wore a weighted vest to help him stay focused while at school. The pressure of the weight seemed to help him to feel more grounded in his body and supported physical awareness.

When Johnny began individual art therapy, he was still warming up to his new classroom teachers and was being seen in art therapy groups twice weekly. In these groups, he did not usually exhibit any behavioral issues, but he seemed distracted in the environment due to the lights, sounds, and movements in the room. Like his peers, Johnny was also often distracted and overwhelmed by choosing between too many materials, so art therapy directives were appropriately simplified to help while exposing the children to new sensory experiences.

When Johnny began individual sessions, the art therapist started by offering him playdough, a familiar material, to help him feel safe, expand his sensory integration skills, and provide a vehicle to aid in his interaction with the therapist. However, Johnny often engaged in non-functional use of the play dough such as "stimming" with the material by bouncing it on the back of his hands in a repetitive manner. Self-stimulatory behaviors are common in people with ASD or developmental disabilities and involve the repetition of sounds and movements of the body and/or objects.

To address these behaviors, the art therapist used another piece of playdough to mirror Johnny's actions and model more functional behavior. Through this, Johnny began to become aware of the art therapist's presence. He moved his body closer to her, began to look at what she was doing, and then started to look into her eyes. Joint attention was increasing, and he was able to share the experience of the playdough with another person.

Additionally, the art therapist quietly narrated her mirroring and modeling actions by saying, "up, down," when playdough was gently thrown into the air. Johnny began to tap on the art therapist's wrist to indicate that he wanted her to do the action again. This is when she became aware that he wanted to and had the ability to communicate with her. It seemed that he wanted to engage to further the social relationship. It should be noted that Johnny is a child who, prior to this experience, did not even point at things that he wanted to play with. The therapist would also say "squeeze, squeeze, squeeze" when having Johnny hold the dough in his hands as she cupped her hands around his to help him feel the material more fully. This seemed to help the child self-regulate and calm down during moments when he became overly excited or anxious.

For the first few months of weekly individual sessions, the art therapist needed to initiate the art and play by developing a repetitious routine. Over time, Johnny was able to initiate activities and engage with the art therapist on his own. This began with him offering a small piece of his dough to the therapist. Eventually, this changed to him giving the art therapist the entire piece of playdough and engaging in turn-taking by passing the material between them.

One of Johnny's goals was to expand his sensory integration skills. A handprinting activity was offered to provide a pressure-touch experience, which was used to facilitate attention and awareness and to reduce overall arousal. In time, Johnny was able to initiate and use the art therapist's hands to create handprints. He would often explore the material by guiding her hands and then eventually by using his own.

After the progress with playdough, painting materials were offered to Johnny but seemed to be too distracting for him. He spilled the paint without intention and

became overly stimulated, bouncing the paintbrush on the back of his hand. However, after eight months of individual and group art therapy, Johnny was able to choose paints and use a paintbrush appropriately without stimming. He finally had begun to gain control over the painting process and mastery of his body. He was able to choose a color of paint and pour it in the tray. He then took the paintbrush and appropriately used it on the paper, brushing it back and forth with good hand and eye coordination. He appeared calm and in control of the process. Sequentially, he was able to paint and then stop painting, without stimming or throwing the brush as he had done in previous sessions. Although Johnny needed to take breaks during the session, the art therapist did not see any self-stimulation behaviors. Instead, Johnny engaged with the therapist by appropriately playing a game of "tag," in which he would make full eye contact and take her by the hand, nonverbally requesting that she follow him. Children on the spectrum often have difficulty staying focused on tasks that require sustained interaction with another person. To compensate for feeling uncomfortable, children may engage in stimming activities to reduce their anxiety and disengage from the interaction. The art therapist needs to learn to become aware of the moment when a child has reached their limit during a session. It is at this time that she should offer the child a sensory break such as jumping up and down; running; or, in some way, moving away from the current task.

In the case of Johnny, the art therapist made emotional and social contact by expanding the child's curiosity through sensory and kinesthetic art-making and play. Mirroring and modeling through primarily nonverbal engagement expanded his range of interest, keeping him focused and calm while encouraging increased social relating. This case demonstrates that the dance between the child and therapist takes patience and a tolerance for the repetitive quality of the work as it develops slowly, with only slight variations from week to week. Each interaction builds upon the previous and reflects a sense of hope and resilience in the face of the communication gaps that exist for a child with autism.

Discussion

Art therapy provides sensory experiences and bonding with caregivers that can support progress in children with special needs. Marco and Johnny's stories illustrate how pre-art materials can serve as a bridge for the use of traditional art materials with developmentally delayed children. It is important to provoke interest in experimentation with sensory-based materials. Writing about her work with preschool children with autism spectrum disorders, Scanlon (1993) describes the need to orient children to the use of art materials by beginning with pre-art materials such as sand, dough (made from flour and water), rice, shaving cream, and soap bubbles:

> The therapeutic intervention made by the art therapist at this stage of development is sensory stimulation. She seeks to help the autistic child to experience the environment as a safe, pleasurable place. In a psychodynamic model this first developmental stage is an undifferentiated state; therefore the art therapist focuses on the body level in her interventions, to help create body boundary awareness and develop the self/ego. Pre-art materials are sensory experiences. Stay with feeling, tasting, smelling, hearing, seeing the materials and do not move yet to asking, "What can be made with this material?"
>
> (p. 37)

In groups, children are offered opportunities to make imagery alongside others and encouraged to enter a shared experience. Engaging in rich sensory interactions using pre-art materials alongside others develops a shared focus and builds connections—to materials and to one another. By creating relationships that are both interpersonal and therapeutic, we seek to understand the latent content that physical movement, interactive encounters, and eventually works of art communicate about a child's feelings, thoughts, and ideas. Through the processes of mirroring, modeling, and attunement, we form relationships.

Nonverbal communication has obvious importance in art therapy work, particularly when children do not have expressive language skills. For example, we observe and record the emotional content that may be embedded in actions, such as ripping paper, squeezing dough, or scribbling. We notice when children appear anxious or overly sensitive to a particular material. We choose specific materials in an attempt to soothe and calm. We watch when children use materials in inappropriate ways and seek to reinforce appropriate engagement while recognizing that children with developmental delays will often explore materials through more than their visual sense as they use tactile, auditory, taste, and kinesthetic means.

The artwork created by the young children who attend the therapeutic preschool in the case vignettes is not remarkable or special. It looks similar to other preschool artwork: scribbles, finger paintings, and simple sculptures of glued pompoms on cardboard. Although school staff hang paintings in the hallways and send home drawings and sculptures to families, art materials used in art therapy sessions are primarily chosen to engage children in experiential processes that have therapeutic value. The final art product often becomes secondary to the experience of the art-making itself. Based on principles of the expressive therapies continuum (Hinz, 2009), materials offered are often *sensory* to provide soothing experiences, *kinesthetic* to promote tension release, *perceptual* to support control and containment, or *affective* to aid in emotional expression. It is common for artwork to be created and destroyed in a single session. Additionally, as children grow and develop, materials used can promote increasing age-appropriate *cognitive* skills such as planning and following simple steps, as well as exploration of *symbolic* images embedded with personal meaning.

Evans and Dubowski (2001) developed a model of art therapy interventions to support children with autism and other communication disorders to increase their capacity for imagination and symbolization. Considering typical childhood development, particularly development in infancy, the authors suggest that relationships with parents and caregivers provide a stable foundation for children to experience reciprocal cueing, develop proto-conversations, seek attention and sensitivity to emotional needs, and engage in rhythm and body language. These foundational skills form the basis of social interaction and relationships. The authors describe how art therapists must use *reciprocal cueing* when working with children who have autism:

> In much the same way that both mother and infant are actively seeking cues from each other, the therapist needs to be aware that even the most severely affected child with autism may nevertheless be "cueing" in barely perceptible ways for some communicative contact.
>
> (Evans & Dubowski, 2001, p. 50)

Thus, therapists must be sensitive to and respond to cues from children with communication impairments. Such sensitivity and attunement require a close attachment.

Additionally, *proto-conversations* in therapeutic encounters reflect the way a mother responds to a baby's vocalizations to imbue them with meaning:

> Any expression made by an individual, such as a vocalization or an action, is in direct response to the individual's environment, including the people within it. The therapist's responses to such expressions are designed to help the child to find some shape or form for meaning concerning the nature of such expressions.
>
> (Evans & Dubowski, 2001, p. 51)

As children engage in therapeutic activities with pre-art or traditional art materials, the sensitive caregiver or educator will use their actions as a platform for attachment and communication.

Overall, art therapists who work with children with developmental disabilities that impair communication must provide undivided attention and sensitivity in therapeutic relationships to overcome the difficulty of picking up on nonverbal cues. By emphasizing reciprocal engagement in nonverbal language during the art-making process, therapists watch children begin "to develop a kind of 'vocabulary' of marks [that can be used to] create representational drawings. . . . In this way, we see that drawing in many ways mirrors language" (Evans & Dubowski, 2001, pp. 32–33). Engaging in art activities side by side with students, or observing and commenting on students' actions, art therapists encourage relational thinking and feeling. In the cases of Marco and Johnny, art therapy was a vehicle for forming meaningful attachments and, thus, developing resilience and skills that improved each child's level of functioning and emotional well-being.

Art Therapy Recommendations/Interventions

Art therapy interventions that support the development of young children with disabilities must include hands-on sensory experiences that enhance regulation of the body, build social skills, and promote positive self-esteem. Art therapy modalities offer experiences with materials where engagement can be in the child's realm of control. Using the body in art-making is a child's first impulse; therefore, sensory and kinesthetic experiences provide the basis of learning. Children with disabilities need support from an adult because they may impulsively grab materials and attempt to put them in their mouth during the process of exploring or reject the material entirely before learning to use it appropriately. Adult support is critical to help the children engage safely and at their own pace. The art therapist must choose materials carefully for this population, present the materials slowly, and use verbal and nonverbal cues to support the children's experience. Through a trial-and-error process, the art therapist learns which materials are best for each child. There is no single approach that can be applied universally when working with young children with disabilities; however, there are some basic guidelines.

1. Preparation of the space

Group and individual art therapy sessions need to be pre-planned to be successful. It is recommended to prepare more than enough materials ahead of time and assume that not everything will be needed. Soft music and low lighting can be helpful to create a calm environment. Once children have transitioned successfully into the room, the art therapist needs to be fully present to the needs of the group. Directives can be shared

through singing. Changing the words to the tunes of familiar lullaby songs can provide children rhythmic guidance and impart instructional messages.

2. Structure of the session

Group sessions need to be structured with beginning, middle, and end sections. The use of visual aids such as a picture schedule can support the introduction of each section by giving children multiple ways to understand the sequence of what is coming next. Hello and goodbye rituals in the form of songs will provide clear distinction between arrival and departure activities. The middle of the session may be focused on the exploration of one or several different materials. It is advisable to offer materials one at a time to avoid overwhelming and overstimulating the children.

3. Choosing materials

Young children with disabilities typically have sensory sensitivities. They may be sensory seeking or sensory defensive which will determine the type of materials provided by the art therapist. It is often best to begin with pre-art materials such as rice, sand, dough, or water inside a small but deep tray. Try to allow for the children to engage at the pace that meets their needs. The art therapist may need to encourage exploration by joining and modeling for each child while establishing a calming presence. It helpful to begin by using simple instructions such as *roll, roll, roll the playdough* as the children engage with dough. Additionally, the use of single-step processes where the sole aim of the experiential is to touch, squeeze, or poke with one's hands provides the greatest accessibility to materials for the most delayed child. Overtime, multistep processes can be introduced slowly.

4. Trial and error

Working with children who have developmental delays challenges the art therapist to continuously think creatively about materials and establishing relationships with young children. The process is slow, and observations of nonverbal cueing need to be examined over time. Interventions need to be tailored to the specific goals of each child.

Acknowledgment

This author would like to thank Nicole Inniss for assistance in the case description of Johnny. Her extraordinary art therapy work with young children who are on the autistic spectrum is visible every day in her practice.

References

Aach-Feldman, S., & Kunkle-Miller, C. (2016). Developmental art therapy. In J. A. Rubin (Ed.). *Approaches to art therapy* (3rd ed., pp. 435–451). New York, NY: Routledge.
Ainsworth, M. D. S., Blehar, M. C., Waters, E., & Wall, S. (1978). *Patterns of attachment: A psychological study of the strange situation.* Hillsdale, NJ: Erlbaum.
American Psychological Association. (2017). *The road to resilience.* Retrieved from www.apa.org/helpcenter/road-resilience.aspx

Bailey, B. (2015). *Conscious discipline: Building resilient classrooms* (2nd ed.). Oviedo, FL: Loving Guidance.

Bayley, A. J. (2010). *In touch again: A primer*. Little Compton, RI: Quabbin.

Bowlby, J. (1982). *Attachment and loss. Vol. I: Attachment* (2nd ed.). New York, NY: Basic Books.

Bowlby, J. (1988). *A secure base: Parent-child attachment and healthy human development*. New York, NY: Basic Books.

Center on the Developing Child. (2018). *Resilience*. Retrieved from https://developingchild. harvard.edu/science/key-concepts/resilience/

Evans, K., & Dubowski, J. (2001). *Art therapy with children on the autistic spectrum: Beyond words*. Philadelphia, PA: Jessica Kingsley Publishers

Foley, G. M. (2018, May). *Sensation: A vital link in development*. Paper presented at the New York Zero-to-Three Spring Conference, New York, NY.

Fonagy, P., Steele, H., & Steele, M. (1991). Maternal representations of attachment during pregnancy predict the organization of infant-mother attachment at one year of age. *Child Development, 62*(5), 891–905.

Golomb, C. (1974). *Young children's sculpture and drawing*. Cambridge, MA: Harvard University Press.

Gray, C. (2010). *The new social story book* (10th anniversary ed.). Arlington, TX: Future Horizons.

Greenspan, S. I., & Weider, S. (2006). *Engaging autism: Using floortime approach to help children relate, communicate, and think*. Philadelphia, PA: Da Capo Press.

Hartley, R., Frank, L., & Goldsenson, R. (1952). *Understanding children's play*. New York, NY: Columbia University Press.

Heise, D. (2014). Steeling and resilience in art education. *Art Education, 67*(3), 26–30. https://doi.org/10.1080/00043125.2014.11519270

Hinz, L. D. (2009). *Expressive therapies continuum*. New York, NY: Routledge.

Lieberman, A. F., & Van Horn, P. (2008). *Psychotherapy with infants and young children: Repairing the effects of stress and trauma on early attachment*. New York, NY: The Guilford Press.

Main, M., Kaplan, N., & Cassidy, J. (1985). Security in the infancy, childhood, and adulthood: A move to the level of representation. In I. Bretherton & E. Waters (Eds.), *Monographs of the Society for Research in Child Development, 50*(1–2), Serial No. 209, 66–106.

Masten, A. S., Gewirtz, A. H., & Sapienza, J. K. (2006). Resilience in development: The importance of early childhood. *Centre of excellence for early childhood development*. University of Minnesota Digital Conservancy. Retrieved from http://hdl.handle.net/11299/53904

Piaget, J. (1951). *Play, dreams, and imitation in childhood*. New York, NY: W. W. Norton & Company, Inc.

Piaget, J. (1954). *The construction of reality in the child*. New York, NY: Basic Books.

Rubin, J. A. (2005). *Child art therapy* (3rd ed.). Hoboken, NJ: John Wiley & Sons.

Scanlon, K. (1993). Art therapy with autistic children. *Pratt Institute Creative Arts Therapy Review, 14*, 34–43.

Wallin, D. J. (2007). *Attachment in psychotherapy*. New York, NY: Guilford Press.

Williams, G., & Wood, M. (1977). *Developmental art therapy*. Baltimore, MD: University Park Press

Wolin, S. J., & Wolin, S. (1993). *Bound and determined: Growing up resilient in a troubled family*. New York, NY: Villard.

6

The Mind, the Body, and the Creative Process
Embodied Representations in Art Therapy

ELSA PELIER

The Role of Art Therapy in Children's Emotional Development

How do children differentiate and make sense of who they are in relation to others and the world around them? How do they navigate the interplay of internal experiences and external stressors? These developmental tasks are particularly complicated for children faced with adversity such as illness, domestic violence, and familial separation. Such events can be physical, emotional, and psychological assaults on children's development. Yet for children confronted by trauma and loss, art therapy has repeatedly showcased the restorative power of creativity. This chapter considers perspectives in psychodynamic, attachment, object relations, and trauma theories to gain insight to questions surrounding child development in the face of traumatic stress. It explores the therapeutic effects of art-making for children. In particular, it examines artistic representations of body image, body ego, and the membrane of the skin, as the physical body symbolizes psycho-emotional elements of children's development and well-being. Case vignettes illustrate the layered therapeutic process, which includes symbolic representations, the art-making process, and the therapeutic alliance.

Theoretical Underpinnings: The Membrane as a Container and the Emergence of Self

Sigmund Freud described the ego as, first and foremost, a "body ego," meaning that "the ego is ultimately derived from bodily sensations, chiefly from those springing from the surface of the body" (Freud, 1923, p. 3). In this view, tactile sensation—in particular, touch on the skin—is the origin of identity. Ego, or sense of self, evolves within the context of the original relationship with a caregiver and through a thinking, feeling, and moving body. The dyad between child and caregiver, as the origin of self-representation for the infant, develops through experience. Over time, the child differentiates from caregivers. Mahler, Pine, and Bergman (1975) posited a differentiation process in which physical understanding gives way to intellectual understanding and "establishment of mental representations of the self . . . paves the way for identity formation" (p. 117). Childhood is a time of exploration, when developmental tasks help a child to build a sense of self as an individual, separate from primary caregivers. The child has unique

thoughts and feelings, encased in his or her own mobile body. A child must perceive and differentiate himself physically before he can incorporate the idea of an inner self, the ego, or the mind's picture of the body. In infancy, the primary caregiver nurtures individuation within the holding environment. Throughout infancy and toddlerhood, the child strives to attain "proximity to some clearly defined individual who is conceived as better able to cope with the world" (Bowlby, 1988, p. 7). This dyad is central to the child's perception of the world and establishes the relational sense of self and other, as well as "emotional regulation, social relatedness, access to autobiographical memory, and the development of self-reflection and narrative" (Siegel, 2012, p. 67).

> The child internalizes both the skin and the mothering environment. Perceptions from the surface of the body become internalized as the skin ego, a containing psychic envelope, while the mothering environment becomes internalized as the internal world of thoughts, images, and affects. The skin ego is not only a containing envelope but also the vehicle of exchange between the mind and the outside world.
>
> (Aron & Anderson, 1999, p. 22)

In addition, the boundaries of the body and the skin provide the limited membrane between what is "me" and "not me." This concept, what Winnicott termed "personalization," derives from the mother's efficacious handling of the infant's body, and this environment allows for the emergence of a sense of self, or "the psyche indwelling in the soma" (Caldwell & Robinson, 2017, p. 226). "Personalisation," per Winnicott, is the opposite of depersonalization, or a split between the body and the mind, which can occur when the infant cannot sense such cohesion (Caldwell & Robinson, 2017, p. 226). Thus, through physical connection with caregivers, infants and children develop a mental understanding of self.

As children grow and develop physical skills, so too will they develop cognitive and emotional capacities, among which is the ability to identify and express one's identity. In his seminal article "Body Ego and Creative Imagination," Gilbert Rose (1963) noted that kinesthetic sense extends thought and feeling through bodily expression: "Art may be inspired by feeling and conceived in thought, but it is executed through the body. Thus, the body is the creative instrument through which the creative process occurs" (p. 782). Despite its loftier origins in the abstract realm of thought and feeling, art relies ultimately on the body for expression. According to Rose (1963):

> [T]he artist's inborn heightened sensitivity to bodily sensations and rhythm as well as to the outer world causes a continual searching for harmony of balance between the two; the force of his own body feelings responds to and causes a kind of amalgamation of body imagery with outer forms in the world and leads to a state of mutual permeability or sense of fusion with the outer world.
>
> (p. 778)

Thus, fluid projections of the self derive from physical intake of and response to external stimuli. Artists may recognize "their motions, posturing and retreats from the canvas as a kind of ballet" and use kinesthetic sensations to determine if a creation "feels right" (Rose, 1963, p. 786). Rose cites the example of Matisse, who, when asked how he gauged the value of his works, answered, "Well, one feels it in the hand" (Rose, 1963, p. 786). By this logic, a worthwhile piece of art is one that feels "right" to create.

The case examples shared in this chapter illuminate the focal premise that chronically ill children have a spontaneous need to create art. This need originates from an innate impulse to represent themselves by means of the membrane of the skin. They reenact mental intrusions symbolically and express them through movement. In this process, the canvas may be understood as the ultimate projection of the self: "While the work of art may represent the body image of the artist, projected via the hand, the canvas may sometimes be a representation of the skin" (Rose, 1963, p. 781).

Identity: Mind-Body Symbols and Self-Representations in Art

> The true texture, color, and drama of a child's lived experience involve actively animating and creating her environment with her imagination
>
> (Birch, 1997 p. 59).

Drawings can provide insight into a child's body image and unfolding personality, which develops "through the kinesthetic sense" or "movement, feeling, and thinking of a specific body" (Machover, 1980, p. 4). The art process and product also express one's bodily needs and conflicts and help us to understand these areas of concern (Hammer, 1958; Machover, 1980). As the young child moves from egocentric forms of play to more symbolic ones, "an object such as a simple piece of string can mean many things to the child and can be used in make believe," (Petrillo & Sanger, 1980, p. 99). Everyday objects, toys, and simple art media can become useful devices of self-expression.

Edith Kramer (1986) noted, "the serious quality of art seems to hinge on the purposeful making of symbols" (p. 63) "since all art therapy deals mainly with visual rather than verbal orientation, art therapists . . . learn to see their patients' productions with a 'third eye'" (p. 71). Kramer (2000) posited that the art therapist's central purpose is to "support processes whereby feelings take on visual form" and to develop clients' faculties related to expression and processing of emotions (p. 48). Kramer's theory advanced from the psychoanalyst Reik's (1948) metaphor of the "third ear," a sensory organ attuned to the most subtle, nonverbal, and unconscious gestures (p. 146). The hypothesis is that the therapist must train the "third eye" in order to "perceive the multifaceted embodied messages produced in the course of art therapy—messages that may defy translation into words" (Kramer, 2000, p. 48). The art therapist fosters the child's creative efforts by attending to the child's creations, increasing the client's depth and breadth of emotions explored to yield novel discoveries. Winnicott's (2005) concept of "holding" can be applied to the art-making process and the boundaries of the paper, canvas, or clay. The therapeutic relationship and environment can provide a transitional space for healing to occur. Josephine Klein (2006) addressed this idea of being contained by a skin, writing that, "as anyone knows who has glued things, the things to be stuck together need to be held firmly in a kind of a frame until the glue holds" (p. 361). The boundaries formed within the therapeutic work are like such a frame.

While many child therapists include art-making as part of play therapy, the *purposeful* nature of art therapy differentiates it from more recreational creative practices. Both the client and the therapist recognize the meaning infused in the object created. The child, therapist, and art object can be regarded as a therapeutic triad, an inclusive framework for relating in art therapy. Images may be viewed as a "bridge between body and mind, or the conscious level of information processing and the physiological changes in

the body" (Lusebrink, 2004, p. 218). Engaging in art production can also elicit change without conscious insight. The object born within the therapeutic alliance has permanency and is thus cathartic. As Tinnen (1990) noted:

> [T]he picture or sculpture in art therapy provides evidence of the resolution of traumatic memories, the neutralization of affect, the soothing of pain, or the resolution of conflict or confusion in the unconscious mind. Calming or resolution may occur entirely within the unconscious without the necessity of conscious involvement.
>
> (p. 69)

Thus, the production of art can connect the client with the unconscious psyche by corporeal means.

Disorganized Attachment

Children who are separated from home and family, neglected or abused, or repeatedly hospitalized experience traumatic disruptions that affect their emerging personalities. They may show signs of an attachment disorder and lack a cohesive sense of self because of such disorganization. Psychoanalyst Anne Alvarez (1992) emphasized respecting and protecting the therapeutic process for such children, as they are in dire need of gentle, carefully considered intervention. She offered Winnicott's premise of the "intermediate area of experience between the pure narcissistic illusion that everything belongs to oneself [and] the mature awareness of separateness and indebtedness to the object" as an area that may need to go unchallenged (Alvarez, 1992, p. 167). This transitional space exists as "a resting place," where the first "not me possession," such as the child's blanket or stuffed animal, may need to be accepted without interpretation to allow the child a much-needed defense in the face of harsh realities and to permit healthier developmental progression (Winnicott, 2005, p. 1). Thus, emphasis is shifted from a medical or pathology-based model toward rehabilitation, empowerment, and hopefulness, especially when working with children who have experienced deep deprivation and trauma.

Described as the "one primary issue," the struggle with relatedness reflects the need for these children to oppose and undo "feelings of vulnerability, insecurity, lack of safety, helplessness, shame, and hunger" (Gonick & Gold, 1992 p. 435). Especially for children who suffer from a shattered sense of self, talking about painful emotions and experiences may be too much to bear. Attempting to understand the meaning of the child's art process and art expressions in treatment is central to the art therapist's quest for insight. It is not the child's responsibility to provide the answers. Art therapists can gain insight by asking themselves and facilitating clients' articulation of issues as needed. Our presence and attunement promote resiliency in children.

Art therapy directives can also be experienced as imposing to children when they are aimed at uncovering traumatic memories: "When we force children prematurely into compliance with our fixed idea about reality, we destroy the future" (Birch, 1997, p. 60). Asking a child to draw his or her family can be crushing when the child has suffered separation and loss (Malchiodi, 1990). Changing such a directive to one that allows for some control and choice, such as "draw a favorite person in your family," can empower the child (Pelier & Grosso, 2007, p. 8). The goal is to express and process some elements of experience, not to confront the most painful phenomena directly and immediately.

Trauma and Art Therapy

Physical self-awareness is the first step in releasing the tyranny of the past.

(van der Kolk, 2014, p. 103)

Current theories on attachment, neurobiology, and trauma validate art therapy as an appropriate treatment modality. For many clients, "traumatic events are almost impossible to put into words. . . . We can get past the slipperiness of words by engaging . . . sensations, tone of voice, and body tensions. Being able to perceive visceral sensations is the very foundation of emotional awareness" (van der Kolk, 2014, p. 233). For instance, handling clay can help art therapy clients to feel grounded and better able to release emotions. Drawing, painting, modeling with clay, and building structures can be viewed as reparative processes through which children can tell their stories symbolically and represent their inner selves within their creations, grounded in the power of human touch.

Researchers in the area of trauma and neurobiology have established the brain as "sculpted by our early experiences. Maltreatment is a chisel that shapes a brain to contend with strife, but at the cost of deep, enduring wounds" (Teicher, 2002). The National Child Traumatic Stress Network identifies trauma as "a frightening, dangerous, or violent event that poses a threat to a child's life or bodily integrity. Traumatic experiences can initiate strong emotions and physical reactions that can persist long after the event" (NCTSN, n.d.). Trauma can also be defined as an experience that is "too overwhelming for a child's ego to assimilate" (Malchiodi, 1999, p. 5). The term "developmental trauma" as a specific pediatric diagnostic classification demonstrates concern about the ways in which diagnosis and treatment affect understanding of children with complex trauma histories (van der Kolk, 2017). Unfortunately, trauma may result in neurologic disruption, as the brain is "organized around the issue of triggered dysregulation in response to traumatic reminders, stimulus generalization, and the anticipatory organization of behavior to prevent the recurrence" (van der Kolk, 2014, p. 406). Breaking these dysfunctional patterns requires attention to three principal areas: "establishing safety and competence, dealing with traumatic reenactments, and integration and mastery of the body and mind" (van der Kolk, 2017, p. 407). Given the plasticity of children's neural networks, the brain—and, therefore, the psyche—can unlearn harmful patterns and relearn more adaptive responses, but it requires significant practice to overcome deeply rooted trauma.

Within the field of neuroscience, the concept of the mirror neuron system (MNS) has deepened our understanding of interpersonal neurobiology (Bucci, 2011; Buk, 2009; Gallese, 2007, 2009, 2014; van der Kolk, 2014). The mirror neuron system is the physiological basis of empathy and embodied communication within the therapeutic context. On account of the MNS, an observer's neurological response to another's action is the same as the neurological response in the actor herself. Gallese (2009) advances the concept of "embodied simulation" and "our capacity to share the meaning of actions, intentions, feelings, and emotions with others. Social identification, empathy, and 'we-ness' are the basic ground of our development and being" (p. 519). The relational process of creation in art therapy "allows an embodied 'as if' understanding between the observer and the observed, which accesses the mind and feeling states of others" (Franklin, 2010, p. 161). Empathic attunement is understood as "an intersubjective, imaginal practice of entering the world of another" (Franklin, 2010, p. 151). This complex process in which art therapists sense and witness the creative space for the client within ourselves, while we extend a third hand as needed, is essential and requires an attuned eye. Through such empathic attunement, Buk (2009) informs us that therapists

can guide clients "on both physiological and psychological levels, [in] the bodily and life-affirming activities of . . . making art [to] remediate the feelings of helplessness, passivity, and annihilation experienced during the trauma" (p. 62).

From a relational psychoanalytic approach to trauma, Kurfirst (2016) described the dynamic perception: "me, not me, new me" (p. 2). The "me" represents a patient's account of the problem; "not me" is a way to defend against the uncovering of trauma and the relational bind within the family that reinforces patients to keep themselves at bay; and the "new me" is "the dissolving of the 'not me' dissociative structures as a newly individuated self emerges" (Kurfirst, 2016, p. 2). The "new me" can also be understood as "*revisioning* . . . the attuning process within the portraits which create a new vision of self-identity" (Carr, 2014, p. 58).

Art Therapy as Relationship

We need symbols for sunsets but also for new mornings.

(Alvarez, 1992, p. 168)

A child's perception of self is realized in relation to caregivers (Bowlby, 1988; Mahler et al., 1975; Spelman & Thomson-Salo, 2014; Winnicott, 1953, 2005). The primary relationship, or the caregiver-infant dyad, can be expanded to a triad when considering the therapeutic relationship: the art-making process and object created within the therapeutic space, along with the client and therapist. Aron and Anderson (1999) noted, "The nature of thirdness is that it is an ever-shifting, dynamic process. Intersubjectivity consists of a dialectic process of mutual recognition and breakdown into complementarity" (p. 222). This triangular configuration gives birth to an idea realized as an image and a projection of the self in the presence of the observing and empathically attuned therapist "in an attempt to share the feeling and possible meaning that its making may hold . . . as it joins up the vertices of the triangle between patient, image, and therapist, enabling the structure of the art therapeutic relationship" (Isserow, 2008, p. 34). The art-making process in art therapy treatment is realized as an embodied experience of emotions that fosters awareness of meaning and development of interpersonal relatedness. Lusebrink (2004) informs us that "interaction with art media in art therapy can proceed from the peripheral stimulation of the different sensory modalities or from spontaneous expression of emotions, or both" (p. 125).

Thus, classical body ego theories, interpersonal attachment constructs, and current neurobiological discoveries inform and validate art therapy treatment. If we view the surface of the paper as the membrane of the skin, then art therapists need to be thoughtful in our positioning within a triadic relationship. Respecting the process during creation of the art object and the manner in which art therapists observe and empathize can offer a holding space for children. Providing the container, envelope, or skin for a child's work is a means of validating the child's creation and, thereby, the child's presence, experience, and ego. The power of art therapy to effect positive change for stressed children is exemplified in the case vignettes below.

Joey: A Case Vignette

Joey was nine years old when he was referred for long-term psychiatric care in an inpatient setting. He had been hospitalized after exhibiting aggressive, oppositional, and psychotic behaviors, including fighting with peers, head banging, and hearing voices.

He had placed a pillow over his newborn brother's head, bit his three-year-old brother, and set a fire at home. Joey had been diagnosed with a psychotic disorder and was considered to be on the autism spectrum. He tended to express feelings through physical complaints. He often became paranoid in social situations, misinterpreting events and feeling threatened by others. The noise level of group situations agitated him, and he found it difficult to self-soothe or accept comfort from others when he was in an agitated state. This was especially true outside the structure of the psychiatric facility, such as during home visits and when he interacted with his siblings and family.

Both of Joey's parents, who lived apart, had a history of drug abuse. His mother admitted to smoking crack while pregnant; she had a history of depression and borderline personality disorder and often felt overwhelmed by Joey's illness and saddened by his necessary separation from home. She had a live-in boyfriend who also had psychiatric health issues and was intermittently hospitalized during the period of time when Joey needed intensive treatment. Joey's mother's problems dominated the family therapy sessions, overshadowing Joey's needs. In sessions with his mother, Joey mirrored her every mood. Joey's biological father cared for his son but was not consistently available to him. He had a history of alcohol and drug abuse as well as depression and phobias and had difficulty leaving the house.

During a carefully planned holiday weekend, Joey became highly aggressive during an outing with his mother. He initially had not wanted to leave home, feeling that he needed quiet time. Needing to run errands, Joey's mother took the three children along. Sensing his agitation, she then offered Joey the choice to visit his father at his psychiatric program, which was in the vicinity. When Joey returned from visiting his father, he became insistent that he go back to stay with him and could not comprehend that he would be going there the next day for an overnight visit. Once again out shopping with his mother, Joey became agitated and broke a fixture in the store. The police were called, and Joey required restraint. The police reported that Joey said he wanted to kill himself. When Joey was brought back to the psychiatric facility, he was evaluated and given a sedative, and he slept. He was calm for the rest of the weekend, with no further outbursts.

Reflecting on the incident, Joey stated that his mother had hit him on the head while they were in the store. On the telephone, his mother expressed how very upsetting this incident was for her and for the children. She described how Joey ran into the street and she went after him, endangering his younger brothers as well as herself. She denied having hit him. She was also wounded by Joey's expression of rage at her and his repeated wish to be with his father; she felt rejected. She asked to take a break from family therapy and to have Joey's father attend family sessions at this time. She also said that her partner did not want Joey at home with his siblings due to his aggression, and he was urging the suspension of all contact between Joey and his mother. Suspending home visits until Joey and his family were able to reconnect seemed appropriate. Joey's mother expressed her sadness that her family could not seem to stay together; things had seemed better to her and then "it all blows up," she stated.

After four weeks without contact with his mother, Joey shared that he missed his mother. He described the feeling inside as being "like my heart is being ripped." He called his mother, who was also ready to speak to him; with the therapist's support, he was able to express his feelings to her. She responded empathetically and let her son know that she missed him as well and that she loved him. A family session was scheduled, which she later cancelled and rescheduled. Two months after the holiday incident, Joey's mother arrived one hour late to meet with the therapist for a family session. Joey and his mother had visited prior to meeting with the therapist. During this time, Joey

became very upset and angry and was not able to tolerate when his mother offered to share the candy that she brought for him with the other children. He broke a window and required restraint. This seemed precipitated by his anxiety over powerful feelings in their previous encounter that resulted in his loss of control and subsequent separation from his mother.

Around the time of this second incident, Joey's mother's boyfriend went into the hospital, after which she also admitted herself to a mental health facility. Thereafter, both parents failed to come to appointments. The mother's phone number was disconnected. Joey expressed that "they [his parents] ought to be giving me more support." After scratching his face and requiring restraint, Joey was placed on suicide alert.

As an art therapist, I had the opportunity to work with Joey at the inpatient psychiatric facility. Joey was reluctant to talk about the severance from his parents when we met because, he said, it made him feel sad. At one session, I presented art-making materials, and Joey said, "I know, let's do art." He decided to work with clay and chose to create a figure (Figure 6.1). Joey explained, as he worked, how his figure had lost one arm. As if to compensate, Joey created a clay gun-arm for the figure to defend itself. He poked a hole where the arm was missing, gouged at it repeatedly, then took the water in a nearby cup and poured it over the wound, saying, "This is the blood." He scratched the figure carefully, which seemed a reenactment of what he had done to himself earlier. Joey named him, "Clay Face, The Bad Guy."

Joey told this story about the figure: "He died millions and millions of years ago. He got stopped by the cops. They blew him up because he was destroying the city. This is his clay gun arm."

Art therapy interventions during this session included supporting Joey's efforts in the process of his creation and witnessing his expression of a personally symbolic story. It was painful to realize that he had hurt himself. This became evident when I attempted to help him stop gouging at the figure by suggesting that Joey keep him solid so that the figure would withstand the firing process needed to harden the material. I wondered out

Figure 6.1 Clay Face

Figure 6.2 Clay Face after glazing and firing

loud if the figure felt pain. Joey smiled and said the figure was "just clay and couldn't feel any pain." Continuing to rely upon the metaphor of art, which gave him distance from such powerful emotions, Joey stated that he was going to paint Clay Face brown (Figure 6.2). His own skin was light in color, and his choice of brown seemed to express an urge to regress with a symbol of anal fantasies and primitive functioning. He added azure blue, which may be interpreted as a split, per Caldwell and Robinson (2017), between "personalization" and "depersonalization" and "between the body and the mind, which can occur when the infant cannot sense cohesion" (p. 226). The contrasting colors may have been expressive of Joey's conflict and opposing feelings regarding mother and self.

Witnessing the process and creation of the figure, I recognized it as an external representation of Joey's sense of self and his own wounding. Joey's scratching at the area surrounding each eye is reminiscent of Oedipal fantasies and subsequent self-negation and self-blame, with the severed limb a symbol of castration and powerlessness (Freud, 1913). The figure's gun-arm was a compensation for his loss and a defense from further harm. Joey's loss of control was tied in to the loss of his mother, and his scratching, as if to gouge his eyes, self-recrimination. Through the act of creation, Joey could contend with a deep trauma that was too painful to articulate and, in a symbolic way, reconnect with what he had lost:

> A child's ability to enter into art-making may be linked to the child's ability to enter into a transitional space between internal and external reality. . . . The creative act gratifies the wish to be one with mother. The lost object and the self are for the moment recreated together.
>
> (Stronach-Buschel, 1992, p. 49)

Through the metaphor of art, Joey was able to tell his story and have the art therapist understand his experience more powerfully than his words could express. His clay figure was fired and glazed and fired again until it solidified as an enduring art piece.

Owen: A Case Vignette

What happens to a child's psyche when the body is threatened by a serious disease such as cancer? How does the child cope with intrusive medical procedures, drugs with painful internal side effects, and dramatic changes in outward appearance? What mechanisms are used to help defend against the overwhelming anxiety evoked by the possibility of death?

> When children are diagnosed with cancer they are thrust into a world filled with uncertainty. Pain and treatment separate them from the routine of daily living; the possibility of death looms. Children employ necessary defenses to psychologically negotiate the various stressors of the illness, to help them feel more secure while integrating their experience of cancer and healing potentials.
>
> (Jacobs, Pelier, & Larkin, 1998, p. 139)

The case of Owen probes these challenging issues and provides an example of a young child's resilience, highlighted through art therapy.

Owen was diagnosed with acute lymphoblastic leukemia (ALL) just a few days after his sixth birthday. At the time, he and his ten-year-old brother lived with their mother; all were undocumented immigrants. Owen's brother returned to his native South America to live with his father because his mother could not take care of him and tend to Owen during his illness. Owen and his mother moved many times subsequent to his diagnosis, due to financial hardship. Thus, the medical condition was associated with upheaval of family routines. After the initial stabilizing treatments for cancer, Owen completed two years of maintenance therapy, followed by an indeterminate period of monthly visits to monitor his ongoing remission.

As an art therapist providing services in a medical facility, I met Owen and his family a few months after Owen's diagnosis, when he was receiving treatment in the hospital. (We continued to meet for art therapy sessions throughout the two-year course of Owen's maintenance treatments.) When she met with me, Owen's mother, Sandra, acknowledged feeling depressed and surviving only on her will to care for her ill son. She stated that she would collapse emotionally when Owen was asleep and that if it weren't for her child, she didn't know what she might do. She described standing outside in the rain crying so that Owen would not see her in despair. Sandra thought that Owen felt responsible for everything that happened, including his brother's departure and his mother's distress, and he voiced that things might be better if he were dead.

Owen would not speak to me at our first few meetings. At age six, a patient on the medical unit due to medication side effects, Owen was huddled in his bed, tearful and anxious. It had been just a few months since his cancer diagnosis. Several meetings took place in which I introduced myself and attempted to engage him. At first, Owen barely spoke. It seemed that he limited communication to regain some sense of control in a frightening, isolating environment. I often left art supplies by his bedside and assured him of my return. After a few such introductions, Owen began to draw in the evenings when his mother was there with him. During the day, I viewed his efforts, commented on them, and hung the artwork on the wall of his room. Speaking with him, and

Figure 6.3 Drawing of home

especially with his grandfather (who frequently stayed in Owen's room), in their native Spanish language inspired the beginning of our connection. Eventually, Owen began to trust me enough and produced his first drawing in my presence, a picture of his native country (Figure 6.3).

Owen described the scene in vivid detail, despite the fact that he had left his native country when he was only three years old. His animated description contrasted with the isolated, barren, and depressed feeling of his artwork. The icy blue-peaked mountains seem to be a barrier to the nurturance and protection he longed for and an expression of separation anxiety, as they block the small house from the sun. The house floats on the paper far below where Owen placed his name. The line quality seems fragile around the house, a tenuous representation of home and of self.

The fragility and loss of a stable home, family, and identity were recurring themes in Owen's art. As Owen continued maintenance chemotherapy on a weekly basis, he often appeared frightened and mistrustful in the hospital environment. When separated from his mother for a treatment or procedure, Owen was inconsolable until Sandra reappeared and soothed him. Their connection was reflected in therapeutic art activities. Sometimes, the activity itself served as a means of strengthening their bond and fostering a sense of protection and comfort for the ill child. When Sandra sat at the table to draw, Owen would quietly slide into place beside her and work on the same drawing. When Owen worked on a drawing, Sandra would respond to his signal and work along with him. Frequently, a scene of their native country evolved (Figure 6.4). It was often difficult to tell where Sandra's drawing ended and Owen's began or who had colored in which area. It became apparent that Sandra provided much of Owen's rich understanding of what "home" was like. It also became clear that Owen identified with Sandra in her longing for their native home, impossible for now because of his illness.

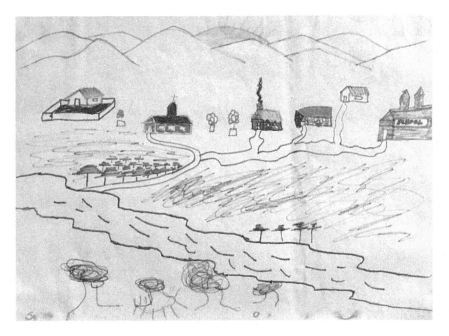

Figure 6.4 Joint drawing of home

Owen and Sandra's love of drawing together laid the groundwork for subtle inter-ventions in which I joined them in order to foster the therapeutic relationship. Weekly, I offered them materials and commented about how well they worked together on an art piece. They began to talk about their art and allowed me to join them as they drew. When we had developed rapport and Owen seemed to trust and even welcome my presence, both Owen and his mother were offered separate drawing paper to create individual artwork. Over time, Owen emerged as more autonomous in his art-making. Despite Owen's initial reservations, I was able to foster a therapeutic relationship within an environment supported by the parent and child's mutual love of art. As Owen was encouraged to do his own work, he produced more material that expressed his emo-tional states.

Anticipation of the Halloween holiday ostensibly allowed Owen to safely portray scary feelings. He drew his first portrait, reflecting his depressed state and concern about death (Figure 6.5). A ghost-like Owen floats to the right of the larger figure. The smiling and benign little ghost pales against the hair-raising and large-headed figure, whose face is contorted in anguish. With the addition of the heart, cross, and flower, which add to the emotional quality of this piece, Owen depicts feelings that he could not put into words. He is honoring his image with symbols of the cemetery, lamenting his own death with a sad visage. Only the ghost is happy: is he enjoying tormenting the human figure, or is this Owen's own ghost, glad to be free from the confines and discomfort of bodily illness? This image illustrates the way in which "metaphoric language can serve as the link to the patient's unconscious material and simultaneously offer the patient a safety valve by means of which optimum distance can slowly be created and preserved"

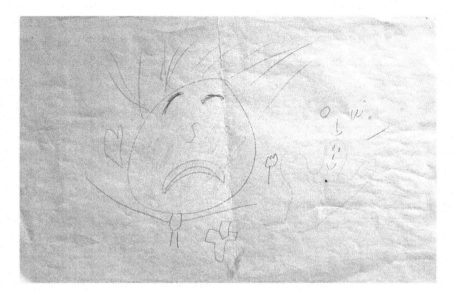

Figure 6.5 Halloween portrait

(Eckstein, 1983, p. 159). This drawing, created with me by Owen's side and encouraging his effort, allowed Owen to simultaneously express troublesome feelings in the permissible context of Halloween and to gain a sense of mastery through his art; he was proud of his creation.

As Owen became more comfortable in art therapy, he worked more readily on his own, although he also continued to work with Sandra. When separated from his mother, Owen made a series of split-image portraits. They depict the idea that "the physical fact of separation can lead to even more panic-stricken disavowal of the fact of separateness and to the delusion of symbiotic union" (Mahler et al., 1975, p. 8). In describing Figure 6.6, the drawing he called "a monster," Owen voluntarily explained that the green side on the left was "the bad monster" and the blue side on the right was the "the good one." He also stated that the left side was his mother and the right side was himself. This image suggests splitting as a defense against the regressive pull to the mother: since Owen desperately needed his mother for his own survival, he was forced to maintain the symbiotic relationship even though there was much inner need to separate, perhaps to prove his independence and strength in the face of illness or maybe to distance himself from the sadness he caused his mother. Owen defended against angry feelings toward Sandra, who could not protect him from his illness or from the invasive medicines and intrusive procedures, by splitting mother into good mother and bad monster. Owen also merged mother with monster and tells us, in his art, that mother had a monster aspect, the depressed and overwhelmed woman who would cry when she thought that Owen could not hear her. Owen was burdened with responsibility for his mother's depression; perhaps his drawing acknowledges the hardship that Sandra herself experienced. Sandra's solution of breaking up her sons and sending one back to South America gave way to Owen having his mother all to himself. If Owen unconsciously regarded this turn of

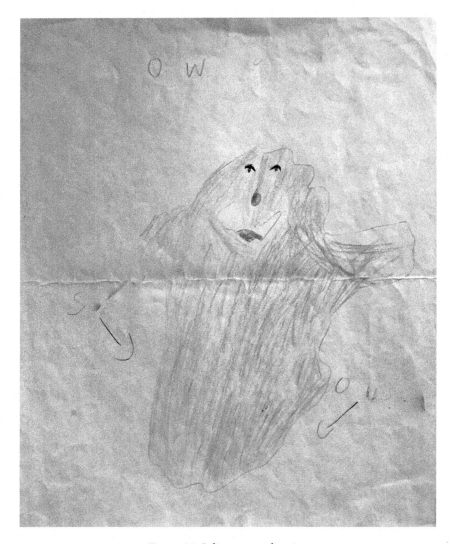

Figure 6.6 Split monster drawing

events as an Oedipal wish partially fulfilled, then in Owen's understanding his illness was a grave consequence for his forbidden fantasies.

In another split-image portrait, Owen imagines himself alongside a female figure, most likely his mother (Figure 6.7). His lips are straight, and tears flow from his eye toward his pallid cheek. In contrast, his blond-haired, rosy-cheeked other half (mother) appears to be smiling. Is Owen identifying with his mother, recognizing their allied wishes to safeguard his health, or separating from her to acknowledge his unique struggle and the fact that, ultimately, it is his body and not hers that must confront the illness? Eckstein (1983) notes that "the challenge of the psychotherapist is to convince the child

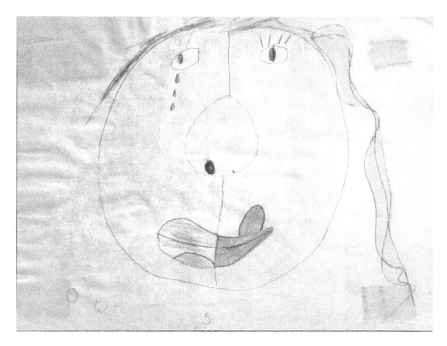

Figure 6.7 Owen-Mother drawing

of an emotional situation that allows for separation leading to individuation rather than to annihilation" (p. XXII). As evidenced in these split-image portraits, Owen used the art-making process to express his struggles and fears surrounding illness, separation, and death. These images also indicate confusion regarding body imaging, potentially brought on by conflict and by the regressive pull to merge with his mother (Figure 6.7). Sigmund Freud (1913) described "the more complete Oedipus complex, which is two-fold, positive and negative, and is due to the bisexuality originally present in children" (p. 33). Not only does Owen wish to be with his mother, he also wants to be her: the protective authority rather than the ill, helpless child.

In later drawings, Owen began to conceive of himself as separate from his mother. On one occasion, Owen made two portraits on two separate pieces of paper (Figure 6.8). On the left, Owen's self-portrait is bald and somewhat monster-like, indicated by the stump-like protrusions rendered in different colors on either side of the head where the ears would be. In reality, he did appear bald and sickly as a result of chemotherapy and other cancer treatments. On the right, the figure has feminine attributes but is still very much like Owen; it has Owen's hair color rather than the light-colored hair he used to represent his mother. Owen continued to co-create with Sandra but began to use her more as an auxiliary ego to help develop his own ideas.

Feeling damaged by his illness and the side effects of treatment seemed to make Owen regard himself as a monster, a theme he explored and attempted to resolve throughout two years of art therapy. In Figure 6.9, Owen appears with alien or animal-like ears and a tiny, deformed, stump-like body. For the first time, he stated his feelings

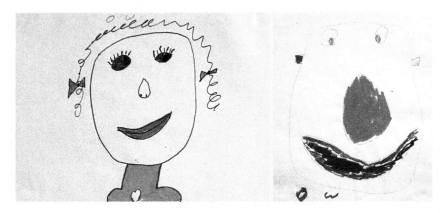

Figure 6.8 Double portraits

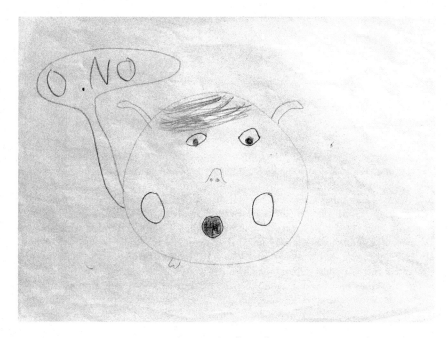

Figure 6.9 "O, no"

in written words, a plaintive "O, no." These words appear to be coming from the side of his face in the drawing, rather than from his mouth, as if even in a drawing it is too dangerous to speak aloud what he is really feeling. In reality, Owen typically maintained silence regarding his most troubling thoughts and feelings.

In another drawing from around the same time (Figure 6.10), Owen portrayed a pathetic figure whose blackened skull-shaped head appears to reflect depression and

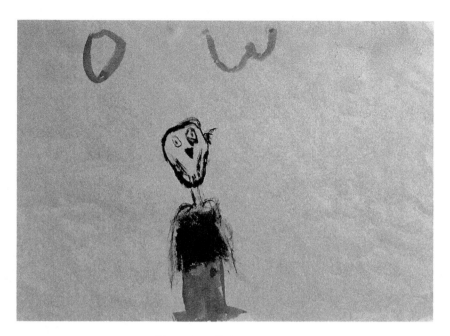

Figure 6.10 Skeleton portrait

fear of death. The arms seem empty and limp, showing Owen's loss, helplessness, and disfigurement as they seem to melt away where the hands should be. With the black eye and exaggerated false smile, Owen appears to be showing that he feels like a victim whose only choice is to stand still and wait for more abuse. This is reflective of his experience with having submit to treatments and procedures; indeed, he was typically a compliant patient and did not resist medical treatments performed upon or administered to him, although many were clearly painful and saddening for him. His use of watercolor in this image gives the figure a fluid, melting quality that poignantly unveils the dissolving experiences of Owen's body image and his sense of self. As his body endured more pain and damage, so did his ego.

Owen continued and concretized the monster theme by introducing Frankenstein in his work. Frankenstein, the literary and film character, seemed to serve as an apt metaphor for Owen's experiences. Pieced together from dead bodies by a doctor, Frankenstein's monster is scarred and different, frightening and considered inhuman to others, and therefore misunderstood. He longs to be accepted but is instead persecuted and destroyed. Owen's identification with Frankenstein is disclosed in a benign portrait, where the two are merged together (Figure 6.11). The surgical placement of an indwelling intravenous catheter, a thin tube inserted in a vein in the neck and then pushed downward to extend out of the chest, helped to alleviate Owen's anxiety of repeated needle sticks by providing a long-term port for medication administration and blood draws. The initial surgery and the tubing that is permanently placed and easily visible to others contribute to the child's sense of himself as different and scarred. Reference to Owen's catheter can be seen in his depiction of the two protuberances from the monster's cheeks

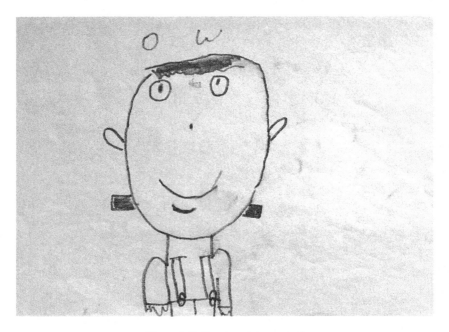

Figure 6.11 Frankenstein portrait

as well as the two long appendages that appear to emerge from incisions in the neck area. The image also suggests the gender identity confusion brought about by the catheter protruding from the chest; having a tube that both gives and receives "nurturance" (that is, blood and medications) may cause the child to believe that he has been given a breast and may be turning into a woman. Owen continued to experiment with the theme of disfigurement as he later drew multiple versions of Frankenstein.

Due to the immaturity of children's thought processes, even the simplest yet accurate explanations by adults cannot prevent fantasies such as "fear of disfigurement . . . fear of all the blood running out . . . fear of bursting like an overfilled balloon" (Brunquell & Hall, 1982, p. 43). Thus, the imagination and anticipation of medically induced harm can compound the physical pain and material reality of medical and surgical procedures. Invasive procedures on a male child's body can act "like a seduction to passivity to which the child either submits with disastrous results for his masculinity, or against which he has to build up permanent pathologically strong defenses" (Freud, 1952, p. 75). Especially in a typically gendered social environment, boys can experience illness and attendant treatments as an insult to the masculine persona. Children might experience painful and intimidating procedures as punishment for "exhibitionistic desires, for aggressive penis envy, above all for masturbatory practices and oedipal jealousies" (Freud, 1952, p. 74). Children conflate physical pain and emotional/spiritual punishment.

Self-concept and body image consumed Owen's attention. His involuntarily changed appearance drove him to continually reaffirm his physicality and manage the angst regarding his altered self. The loss of hair, including eyebrows and eyelashes, cannot be overemphasized in its traumatic effect on the child.

Figure 6.12 Pirate portrait

Over time, Owen seemed to be feeling less overwhelmed as he became acclimated within the hospital environment. After several months, he began to draw animals rather than monsters, which seemed a progression in his self-concept. With a developing sense of mastery through self-expression, Owen gained some control in spite of his illness. The hospital became a constant, secure environment in Owen's destabilized world. He felt safe there as he realized that his art productions were a safe area for him to explore, re-experience, and define his emotions.

In the spring of his second year of treatment, Owen drew a portrait of a pirate (Figure 6.12) and introduced a healthier human being in his images. The pirate, with his cynical sneer, is a symbolic identification with the aggressor. He is a fighter and also a wounded figure, as the eye patch marks him as scarred and "other." The sword that is cut off from the frame, along with the figure that ends above the genital area, suggest castration anxiety. The arms are held tight to the sides of the body and, without hands, make the figure appear powerless and unable to carry thought into action. Indeed, the placement of the skull and crossbones over the forehead indicates Owen's probable pre-occupation with thoughts of death. Surrounded by water, the pirate seems to be sinking, while his weapon—the broken sword—floats uselessly behind him. Yet this portrait also illustrates Owen's valiant efforts to mature and survive as he struggles with the over-whelming feelings heroic, brave, and fiercely independent.

Owen turned his attention to drawing underground tunnels and the activity occurring below the surface of the earth (Figure 6.13). Anna Freud (1965) described the child concerned with tunnels as being interested in the internal workings of the body. The tiny ants Owen has drawn are carrying all the necessities from a house above ground to their multilevel home below. This intellectually sophisticated concept depicts a number

Figure 6.13 Ants underground

of concerns. The image drawn looks like a sick person lying in bed whose intravenous catheter appears to be extending up, which addresses Owen's concern for what is being put in the body and how the body is being affected. With the house a metaphor for the body, Owen may also be wondering about what is being taken out and why, such as the blood extracted through that tubing. Owen's investigation into the world underground may also be correlated to his thoughts of death and interment.

As his treatment period came to a close, Owen chose a large piece of paper and said that he was going to make "something funny that's going to make you laugh." He asked for my assistance in drawing the form of a Mets baseball player and then filled in the stadium around him. He cut and measured and finally placed his own head through the paper, laughing. The following week he made a second version of this picture, again relying on my assistance. This time he included cut-out circles for arms (Figure 6.14). He then asked for help from Sandra and me to color in the large scene. Asking both his mother and his art therapist to assist him seemed an appropriate manner to process termination issues since Owen's two years of treatment (art therapy and cancer treatment) were about to end and joining the child and his mother in making art was how I had initiated our art therapy sessions. The stadium advertisements drawn in the picture were those he remembered from the baseball game he had gone to the previous summer. To the right of the baseball player appears the little ghost, along with the other symbols Owen often displayed in his drawings. When Owen finished coloring the large green ground area, he pulled the paper over his head and put on a Mets cap. Pushing his arms through the circles, Owen became the living embodiment of his portrait. This brought his work in art therapy closer to consciousness: he revealed awareness that his portraits were versions of him. His living portrait also demonstrates the application of the defense mechanism of sublimation: Owen had been ill, but he placed himself in the position of the virile athlete. He may also have been expressing his concern with death, as the picture requires his physical presence to bring it to life. Without Owen to animate

Figure 6.14 Baseball player

it, it looks like a baseball player whose head and hands have been ripped away at a peak moment in the game—an empty uniform.

For Owen, art was a natural medium of expression, originating from art-making with his mother, which allowed him to deal with his relationship to her. Over time, and with increased comfort in the art therapy (as well as the hospital) environment, Owen was able to gain autonomy from symbiotic dependence with his mother exacerbated by his chronic illness. He explored a range of ideas, fantasies, and emotions through the safer metaphors of art: "Like the dream, the metaphor enables the patient to maintain the necessary distance with the feeling that the meaning of the dream/metaphor is ego-dystonic and not meant by him really" (Eckstein, 1983, p. 159). In his art, Owen illustrated the effects of family separation, illness, and invasive treatments on his body image and sense of self. This process also allowed Owen to gain a sense of mastery and competence that was unavailable to him by other means. He intuitively joined the embodiment of his illness with his self-portraits (Carr, 2014). As his art therapist, I paced with his need to express himself symbolically, and I believe that he felt my presence and acceptance. Art became the central process through which Owen neutralized his anxiety in the clinical setting. His case illustrates how physical illness may affect the developing personality of the child. As art therapists, we must understand our role in working with these children, aptly stated by Edith Kramer (1979):

> The art therapist's most important function may be to help the physically ill child reach whatever stage of psychosexual and ego development he seems to be striving to attain, even while illness exerts its regressive pull. Symbolic living in art, which

normally complements the child's actual life experiences, can also compensate for enforced deficiency of such experiences.

<div align="right">(p. 141)</div>

That is, art therapy can offer a rich symbolic world, giving stressed children access to experiences that are materially impossible for them. For Owen, art served as a bridge to home, family, and his own ego, vital elements from which the child had been separated on account of his sickness. In the face of life-threatening illness, Owen exemplified courageous resilience and "continued movement towards health and life . . . accomplished within the shaky context of ever-present doom" (Van Dongen-Melman & Sanders-Woodstra, 1986, p. 149). Through imaginative experiences of places, people, and events, Owen coped with a menacing reality.

Conclusion

The case examples of Joey and Owen demonstrate the traumatic impact of separation for children, whether due to social and environmental stressors or medical illness. In each case, art therapy served as a vehicle for expression so necessary because using words was unbearable. The art therapist can create a sphere of safety within the therapeutic bond of shared attention and appreciation for the birth of the art object: "The act of looking together at the object is of vital importance for art therapy as it joins up the vertices of the triangle between patient, image and therapist, enabling the structure of the art therapeutic relationship" (Isserow, 2008, p. 34). With a caring witness to validate the creative act and the artifact—itself an extension of the ego—art therapy can promote resilience among children with emotional concerns.

References

Alvarez, A. (1992). *Live company*. London, England: Routledge.

Aron, L., & Anderson, F. (Eds.). (1999). *Relational perspectives on the body*. New York, NY: Routledge.

Birch, M. (1997). In the land of counterpane: Travels in the realm of play. *The Psychoanalytic Study of the Child*, *52*(1), 57–75. https://doi.org/10.1080/00797308.1997.11822454

Bowlby, J. (1988). *A secure base*. London, England: Routledge.

Brunnquell, D., & Hall, M. D. (1982). Issues in the psychological care of pediatric oncology patients. *American Journal of Child Psychology & Psychiatry*, *27*(2), 145–180. https://doi.org/10.1111/j.1939-0025.1982.tb02662.x

Bucci, W. (2011). The role of embodied communication in therapeutic change: A multiple code perspective. In W. Tschacher & C. Bergomi (Eds.), *The implications of embodiment: Cognition and communication* (pp. 209–228). Exeter: Imprint Academic.

Buk, A. (2009). The mirror neuron system and embodied simulation: Clinical implications for art therapists working with trauma survivors. *The Arts in Psychotherapy*, *36*(2), 61–74. https://doi.org/10.1016/j.aip.2009.01.008

Caldwell, L., & Robinson, H. T. (Eds.). (2017). *The collected works of D. W. Winnicott*. Oxford, England: Oxford University Press

Carr, S. M. (2014). Revisioning self-identity: The role of portraits, neuroscience and the art therapist's "third hand". *International Journal of Art Therapy*, *19*(2), 54–70. https://doi.org/10.10 80/17454832.2014.906476

Eckstein, R. (1983). *Children of time and space, of action and impulse*. New York, NY: International Universities Press.

Franklin, M. (2010). Affect regulation, mirror neurons, and the third hand: Formulating mindful empathic art interventions. *Art Therapy, 27*(4), 160–167. https://doi.org/10.1080/0742165 6.2010.10129385

Freud, A. (1952). The role of bodily illness in the mental life of children. *Psychoanalytic Study of the Child, 7*, 69–81.

Freud, A. (1965). *Normality and pathology in childhood: Assessments of development.* New York, NY: International Universities Press.

Freud, S. (1913). *The interpretation of dreams* (3rd ed.). (A. A. Brill, Trans.). New York, NY: Palgrave Macmillan.

Freud, S. (1923). *The ego and the id.* London, England: Hogarth Press.

Gallese, V., Eagle, M. N., & Migone, P. (2007). Intentional attunement: Mirror neurons and the neural underpinnings of interpersonal relations. *Journal of the American Psychoanalytic Association, 55*(1), 131–175 https://doi.org/10.1177/00030651070550010601

Gallese, V. (2009). Mirror neurons, embodied simulation, and the neural basis of social identification. *Psychoanalytic Dialogues, 19*(5), 519–536. https://doi.org/10.1080/10481880903231910

Gallese, V. (2014). Bodily selves in relation: embodied simulation as second-person perspective on intersubjectivity. *Philosophical transactions of the Royal Society of London. Series B, Biological sciences, 369*(1644), 20130177. doi:10.1098/rstb.2013.0177

Gonick, R., & Gold, M. (1992). Fragile attachments: Expressive arts therapy with children in foster care. *The Arts in Psychotherapy, 18*(5), 433–440. https://doi.org/10.1016/0197-4556(91) 90055-F

Hammer, E. F. (1958). *The clinical application of projective drawings.* Springfield, IL: Charles C. Thomas.

Isserow, J. (2008). Looking together: Joint attention in art therapy. *International Journal of Art Therapy, 13*(1), 34–42. https://doi.org/10.1080/17454830802002894

Jacobs, E., Pelier, E., & Larkin, D. (1998). Ericksonian hypnosis and approaches with pediatric hematology and oncology patients. *American Journal of Clinical Hypnosis, 41*(2), 139–154. https://doi.org/10.1080/00029157.1998.10404201

Klein, J. (2006). *Our needs for others and its roots in infancy.* New York, NY: Routledge.

Kramer, E. (1979). *Childhood and art therapy.* New York, NY: Schocken Books.

Kramer, E. (1986). The art therapist's third hand: Reflections on art, art therapy, and society at large. *American Journal of Art Therapy, 24*(3), 71–86.

Kramer, E., & Gerity, L. A. (2000). *Art as therapy: Collected papers.* London, England: Jessica Kingsley Publishers.

Kurfirst, J. (2016). *This Me, Not Me, New Me.* (Unpublished paper).

Lusebrink, V. B. (2004). Art therapy and the brain: An attempt to understand the underlying processes of art expression in therapy. *Journal of the American Art Therapy Association, 21*(3), 125–135. https://doi.org/ 10.1080/07421656.2004.10129496

Machover, K. (1980). *Personality projection in the drawing of the human figure.* Springfield, IL: Charles C. Thomas.

Mahler, M. S., Pine, F., & Bergman, A. (1975). *The psychological birth of the human infant: Symbiosis and individuation.* New York, NY: Basic Books.

Malchiodi, C. A. (1990). *Breaking the silence: Art therapy with children from violent homes.* Philadelphia, PA, US: Brunner and Mazel.

Malchiodi, C. A. (1999). *Medical art therapy with children.* London, England: Jessica Kingsley Publishers.

National Child Traumatic Stress Network. (n.d.). *About child trauma.* Retrieved from www.nctsn. org/what-is-child-trauma/about-child-trauma

Pelier, E., & Grosso, C. A. (2007). *Trauma work within the residential milieu: An innovative parallel process.* Paper presented at the Annual Conference of the American Association Children's Residential Centers, Chicago, IL.

Petrillo, M., & Sanger, S. (1980). *Emotional care of hospitalized children: An environmental approach.* Philadelphia, PA: Lippincott Williams & Wilkins.

Reik, T. (1948). *Listening with the third ear: The inner experience of a psychoanalyst.* New York, NY: Farrar, Straus, & Giroux.

Rose, G. J. (1963). Body ego and creative imagination. *Journal of the American Psychoanalytic Association, 11*(4), 775–789. https://doi.org/10.1177/000306516301100405

Siegel, D. J. (2012). *The developing mind: How relationships and the brain interact to shape who we are.* New York, NY: Guilford Press.

Spelman, M. B., & Thomson-Salo, F. (2014). *The Winnicott tradition: Lines of development.* London, England: Karnac Books.

Stronach-Buschel, B. (1992). Trauma, children, and art. *American Journal of Art Therapy, 29*(11), 48–52.

Teicher, M. H. (2002). Scars that won't heal: The neurobiology of child abuse. *Scientific American, 283*(3), 68–74. https://doi.org/10.1038/scientificamerican0302-68

Tinnen, L. (1990). Obligatory resistance to insight. *American Journal of Art Therapy, 28*, 68–70.

van der Kolk, B. A. (2014). *The body keeps the score: Brain, mind, and body in the healing of trauma.* New York, NY: Viking.

van der Kolk, B. A. (2017). Developmental trauma disorder: Toward a rational diagnosis for children with complex trauma histories. *Psychiatric Annals, 35*(5), 401–408. https://doi.org/10.3928/00485713-20050501-06

Van Dongen-Melman, J., & Sanders-Woodstra, J. (1986). Psychological aspects of childhood cancer: A review of the literature. *Journal of Child Psychology and Psychiatry, 27*(2), 145–180. https://doi.org/10.1111/j.1469-7610.1986.tb02328.x

Winnicott, D. W. (1953). Transitional objects and transitional phenomena. *International Journal of Psychoanalysis, 34*(2), 1–25. https://doi.org/10.1093/med:psych/9780190271411.003.0052

Winnicott, D. W. (2005). *Playing and reality.* London, England: Routledge.

7

Building a Therapeutic Relationship With Children Who Have Severe and Multiple Disabilities

TAMI HERZOG-RODRIGUEZ

This chapter addresses the role of the therapeutic relationship in art therapy with children who have severe and multiple disabilities (SMD). A focus on the therapeutic relationship is necessary when introducing art materials and processes to children facing numerous challenges: delays in intellectual functioning, social functioning, and verbal engagement, as well as possible neurological, physical, or sensory impairments (Bellamy, Croot, Bush, Berry, & Smith, 2010). New objects and textures may be met with resistance in the form of outward aggression or withdrawal unless the art therapists are highly attuned to children's unique preferences (MacLean & Dombush, 2012). As part of a collaborative team of professionals who treat the medical, physical, educational, and social-emotional challenges of children with SMD, art therapists support the development of an alternate, visual means of communication.

The study described in this chapter investigates art therapists' unique approaches to building therapeutic relationships with children who have SMD. Openness, flexibility, and attunement positively impact the selection and adaptation of art materials in the therapeutic space. Guidelines for establishing a therapeutic relationship with children who are preverbal or nonverbal will also be discussed.

Obstacles to Developing a Therapeutic Relationship

In children with severe disabilities, obstacles to developing a therapeutic relationship may take the form of outward aggression, self-injury, or withdrawing behaviors (Oliver, Petty, Rudick, & Barcarese-Hamilton, 2012; Arron, Oliver, Moss, Berg, & Burbidge, 2011; Snell, Chen, Allaire, & Park, 2008; MacLean & Dornbush, 2012). Previous research has brought to light the prevalence of self-injurious behaviors in children with severe disabilities such as head banging, head hitting, eye poking, hair pulling, and self-biting (MacLean & Dombush, 2012). In children with limited movement, some less aggressive behaviors consist of crying or stiffening of the body (Snell et al., 2008). Many of these behaviors have been linked to disabilities such as the absence of speech; deficits in adaptive behavior; and ritualistic, repetitive behavior (Arron et al., 2011). Art therapy interventions develop an alternate means of communication for children who experience difficulty with augmentative communication systems or other technology (Harding, Lindsay, O'Brien, Dipper, & Wright, 2011). This visual conversation between the therapist and child develops through mindful, empathic art interventions (Franklin, 2010).

Therapeutic Attunement and Presence

In response to the mindful interventions of a caregiver, individuals with disabilities often demonstrate decreased aggression, as well as an overall increase in compliance (Snell et al., 2008; Singh et al., 2006;. Mclaughlin & Carr, 2005). In his characterization of the "mindful therapist," Seigel (2010) defines interpersonal attunement as "how we focus our attention on others" (p. 34). Geller and Greenberg (2011) describe the practice of "*being* with the client rather than *doing* to the client" with mindful, focused attention, as a determinant of the success of a therapeutic experience (p. 85). This statement has significant implications for art therapy, where the focus is on *the doing*, specifically the introduction of new art media and processes. With roots in Buddhist traditions of mindfulness and meditation, attunement within the art-making process calls for the therapist's open, present-moment awareness (Kabat-Zinn, 1994). The practice of present-moment awareness is also a part of therapeutic presence (Geller & Greenberg, 2011; Seigel, 2010). Connections between the two concepts are most clearly defined through Geller and Greenberg's (2011) model outlining three major components of therapeutic presence: preparation, process, and experience.

The Preparation for Art Therapy

According to Geller and Greenberg's (2011) research, "preparing the ground for presence" (p. 75) is a process that takes place before each therapy session as well as on a continuous basis in the therapist's daily life. Productive physical and mental pre-session preparation for art therapy is based on an in-depth knowledge of the art materials, art tools, and art processes (Kramer, 1998; Rubin, 1984). The art therapist's "artist-self" (p. 108) paints, draws, sculpts, or reflects on art materials and tools independent of therapy sessions (Rubin, 1984). When the "artist-self" is actively participating in the meditative process of making art, as described in Abbot, Shanahan, and Neufeld's (2013) study of stress reduction tasks, the art therapist's stress is greatly reduced, further supporting the clinician's mental preparation for therapy.

The Process of Art Therapy

After laying the groundwork for therapeutic presence, Geller and Greenberg's (2011) study outlines the "process of presence," or "what a therapist *does* when in session with a client" (p. 76–77), beginning with receptivity to the client's experience. As children begin interacting with potentially overwhelming textures, smells, and sounds associated with art-making, therapists who respond by mirroring back movements or sounds begin to develop a unique repertoire based on "these exchanges (Aach-Feldman & Kunkle-Miller, 2001; Evans & Dubowski, 2001; Henley, 1992; Malchiodi, Kim, & Choi, 2003). Yet it is the combination of receptivity to the client and "inwardly attending" (Geller & Greenberg, 2011, p. 79), understanding the clients' reactions through the therapists' own inner experiences, that also fits Seigel's (2010) description of the term *interpersonal attunement*. Attunement enables art therapists to develop their "third hand" skills, specifically the ability to "subordinate personal style" and "adapt to the style and imagery of their clients" (Kramer, 1986, p. 71).

Kramer's (1986) definition of *third-hand services* correlates to another component of the process of presence, "extending oneself and making contact with the client" (Geller &

Greenberg, 2011, p. 79). Although some third-hand services, such as setting up a productive environment and offering good quality art materials, fall under the heading of "preparing the ground for presence" (p. 76), other interventions within the process of presence involve direct contact (Geller & Greenberg, 2011). Art therapists may assist with adapting art tools as needed or actually "function as the patient's auxiliary hand" (p. 72) by physically painting for someone with an illness or disability (Kramer, 1986). However, these interventions could be counterproductive if the art therapist is not attuned to subtle positive or negative reactions since "intuitive responding" (p. 76) is necessary to counteract a child's physical and emotional withdrawal (Geller & Greenberg, 2011).

The Experience of Art Therapy

There is overlap between the therapist's "experience of presence" (p. 80) in-session, the third domain of Geller and Greenberg's (2011) model of therapeutic presence, and Baer's (2007) elements of mindfulness. For instance, in both studies the aware therapist is someone who takes notice of intense feelings arising in a session yet does not react with judgment. If children in session are acting out strong emotions visually and kinesthetically through the hitting, pounding, tearing, or throwing of art materials, a mindful art therapist resists getting caught up in the turmoil. Instead the preferred response is to safely handle and contain aggression through adapted, individualized art interventions—interventions such as clay for hitting, pounding, tearing, or a sturdy bin for tossed items (Williams & Wood, 1977). Through the experience of "grounding" (p. 81), art interventions take the form of calm, centered therapeutic support (Geller & Greenberg, 2011). Baer's (2007) mindful therapist "tends to internal and external experiences" (p. 239) in ways that do not intensify negative reactions experienced in sessions, thereby reinforcing the healing process through therapeutic presence.

The Evolving Role of the Art Therapist

"People who are 'self-determined' act in such a way to show evidence that their actions and behaviors are *self*-caused, as opposed to *other*-caused" (Wehmeyer, 2005, p. 117). Laying the groundwork for creative and personal expression, art therapists "provide multiple opportunities and design responsive environments for choice and decision making" (p. 29), adapting art materials and the therapeutic space (Erwin et al., 2009). The art therapist's role evolves to promote greater independence and communication as outlined by Williams and Wood's (1977) five stages of developmental art therapy.

During the first stage in developmental art therapy, "responding to the environment with pleasure" (Williams & Wood, 1977, p. 19), the art therapist's role is to establish a trusting relationship by sufficiently responding to the child's basic need for sensory activities within consistent routines, in conjunction with verbal or physical intervention and feedback. Aach-Feldman and Kunkle-Miller (2001) refer to this initial phase of "extreme dependency and disorientation" (p. 231) as a therapeutic period of touch, listening, and observation, described as a complete reliance on the art therapist for physical support and direction. Physical support may take the form of gently guiding a child's hand over a tray of sand or textured paper as a way of introducing new materials. As therapy progresses through subsequent phases of development, the selection of

materials and approach to the session guide children toward a phase of "relative independence" (Aach-Feldman & Kunkle-Miller, 2001, p. 231).

Therapeutic Engagement: Rachel and Mia

Rachel and Mia were part of a larger study of art therapists working with children who have SMD (Herzog-Rodriguez, 2015). Data was collected from a series of in-depth interviews with art therapists who discussed their professional challenges and distinct methods. An artist and former Montessori teacher, Rachel was an art therapist in a school setting for children with visual impairments and additional disabilities. Mia worked at an inpatient pediatric long-term nursing facility that offers services for medically fragile children requiring long-term or palliative care. An analysis of the interview transcripts provided insight into each art therapist's unique experiences of developing therapeutic relationships with children experiencing self-injury, outward aggression, and resistance to engaging with art materials.

Mia: Addressing Outward Aggression and Self-Injurious Behavior

Transition From Throwing Art Materials to Painting

By remaining receptive to the child's preferred movements, Mia accepted behaviors in the art room of inpatient pediatric nursing facility, such as throwing, which were frequently met with a negative response in different settings. After offering an assortment of art materials to a 12-year-old boy, all of which were repeatedly thrown onto the floor during sessions, Mia took note of his interest in the falling objects. In addition to a complex physical disability, the child's ability to communicate was limited to a few vocalizations and gestures.

A gradual process of building a therapeutic relationship preceded any painting. Initially she observed, mirrored, and verbally reflected his reactions to the art materials.

> In the first session I demonstrated how particular materials worked to see what he would gravitate towards. We started off with clay and he was able to manipulate it with his hand. I validated that verbally by saying, "Wow, wow. You're really squeezing that clay hard. What does that feel like?" Even though I knew I wasn't going to get a verbal response, this was what the child was expressing and I was making him feel heard.

The child was drawn to working with Model Magic clay: a soft, self-hardening, non-toxic modeling material. Mia encouraged him by providing additional verbal feedback and manipulating a piece of her own clay.

> He would engage for about 10 minutes with the Model Magic, really squeezing the clay, stretching the clay, and I was working alongside him with my own piece of clay. Showing him different ways to manipulate and roll it, I was comparing: "Oh look, it kind of looks like the ball you have on your chair." And, "So maybe you don't really want to work with these materials because I see they are on the floor." It wasn't like he was acting out. It seemed like he did get some release from throwing these balls.

Using the information gathered through the preliminary sessions, adaptations can be made to foster communication through art-making. This boy always had a comfort object with him, a ball attached to his wheelchair with a string. She incorporated his favorite object with his desire to throw, while also introducing paint into the sessions.

> This child wants to work on the floor and he's in a wheelchair. So how do you adapt that to suit his needs and make use of the materials? How can he see the balls of clay fall on the ground and hear them fall on the ground? That is when I introduced the paint to see how he would respond to touching the paint . . . seeing how that stimulated him. Again through body language, [I wanted to see] if he moved towards the paint, if he pushed it away. All of those were indications of what he wanted, telling me his wants, his needs. I definitely utilized different tactile balls. There were balls that you could squeeze, there were balls that lit up when you threw them, there were balls that had little plastic ends and almost looked like a spider. So having him feel the paint, touch the paint, also feel the balls, and saying, "This kind of looks like your ball a little bit, doesn't it?" It was something familiar, and I think working with something familiar was definitely a way to connect with this child.

Even as Mia began to introduce painting on a large surface, exploring the textured balls continued to be a major component of the sessions: "To have them be in control of materials they do want to explore and materials they don't want to explore," to understand "why it is they may not want to explore." She would begin with a container of balls, modeling how to touch and squeeze each one in order to see what resonated with the child. "This ball has glitter. Is this something you want to feel?" Mia would wait to see if there was an attempt to reach for the ball or withdraw completely.

The painting process encompassed mirroring and taking turns dipping the balls in the paint and tossing them onto the mural paper. At first Mia modeled the process, but soon "he wanted to throw the [paint dipped] balls where they made a certain splat. And we would look at the mark that he made." Yet as the therapeutic "relationship was being built through the nonverbal process," Mia explained, "he was able to tell me where he wanted the balls to be placed and how he wanted to use me in the creative process. . . . If he threw a ball I would say, 'Do you want me to move the ball with my foot this way?' And he would be able to point that way."

Ultimately Mia found a way to communicate with this boy through the art, without focusing on the art product. Since Mia noticed his tendency to throw was not aggressive, the ball evolved into a sensory object and, when combined with paint, led to expressive, creative work.

TRANSITION FROM SELF-HARM TO SELF-SOOTHING

Finding an effective art intervention was critical in Mia's work with an eight-year-old girl who had cerebral palsy and cognitive impairments. Though she could not verbalize her needs, she was vocal and knew a handful of signs. Tube braces on her arms kept her from certain self-injurious behavior. After losing sight in one eye, she continued to poke at that eye or bang her head when frustrated.

Safety concerns led to this child spending time in front of the nurses' station when not involved with school or related activities. Despite her close proximity to the nurses, she would regurgitate as a way of attracting attention, even if the attention was negative.

After observing these repeated interactions, Mia introduced art materials to break the cycle of regurgitating, play, and clean up.

> She would regurgitate and people would stop to say, "Oh, well, you're really dirty right now." So what happens? The nurse has to go back with her to her room. She gets that kind of one-on-one attention that she was looking for, even though it was in a negative way. I noticed that when she would regurgitate, she had a ball playing with what was on her tray. Well, we can substitute that with art materials. Being aware of what she gravitated towards, as far as certain textures and incorporating them into the art, was really important.

Mia believed that "the exploration of materials was really important for her because of what she was doing. She was comforted by playing with her own vomit." As various materials were introduced through a trial and error process, "paintbrushes just ended up everywhere" and finger painting was overstimulating. Ultimately, the soothing process of moving hands in glue replaced the manipulation of vomit.

> With her regurgitation, there was something soothing about playing with what was on her tray, and this was something she created, right? She created this. So to replicate that in the creative process. . . . Well, what kind of material feels like that? Paint and glue feel like that. What else? What other materials have that kind of familiar sensation? I noticed that it [spreading her hands in paint] did over stimulate her to the point where she actually had an accident in her pants. So that was definitely something that I was aware of as far as regulating the appropriate amount that is tolerable. She loved the texture of glue. She was very tactile, because she would play with her vomit, so the glue was attractive for her, as far as being able to spread her hands in it. So instead of playing with her vomit, I was giving her materials when she was waiting in front of the nurse's station, things that she was able to use outside of the art therapy session.

In this case, Mia found that white glue in a plastic bottle moved the child away from a damaging, self-injurious behavior toward a more creative solution. The tactile properties of the glue held her interest long enough to receive positive feedback from the therapist and nursing staff. This shift opened to the door to further art exploration.

Rachel: Addressing Resistance to Art Materials

FACILITATING INDEPENDENT EXPLORATION

Art therapists hold insight about the experimental nature of the creative process. Rachel noted, "I don't feel like I have a sequence of materials. I have a sequence of my actions." During the first session with a seven-year-old girl who was completely blind, Rachel noticed that she could "explore very purposefully" but did not have the language to talk about any discoveries. Nearly half of the room was explored by using both hands and mouth. Rachel remained nearby without intruding in the child's process.

> She came into the room for the first time, and I let her feel around the edges of the room. In the first session I think we got about halfway through. I was just watching

her, what she was attracted to feeling, how she explored it. She was using her teeth, not to eat, but to feel the vibration against the teeth. She has hearing, but she seemed to like that vibration. She also found a cup that somebody had actually used to make an elevator on a sculpture and she kept trying to drink out of it even though it didn't have anything in it. I was just watching how she responded to familiar things, unfamiliar things, how she made her way around the room. Then she finally found me. I was there next to her the whole time, but she really didn't care. She was independent enough that she knew that I was there. If I moved it didn't startle her. She was able to reach out and touch me if she needed to.

Once Rachel was "found," further introductions continued through movement and turn taking. "I work a lot with repetition and variation; letting them get into a routine and then changing it and seeing if they can add to their routine, creating more fluency in their vocabulary."

Standing back and giving children enough space to gain independence whenever possible is critical. Rachel found her greatest challenge lay in creating an environment that encouraged children to reach out, rather than to passively accept what was given.

A lot of our kids tend to be passive. They require so much assistance that they don't learn to do things for themselves, or they don't have the opportunity to feel, "I'm in control of my body." And when they do need a tool of resistance, the only thing that they have is to be passive. "I will just completely resist by not doing anything." Because they can't get up and tell people, "No." They can't get up and be angry. They can't storm out of the room. It's their most effective tool. So instead of going into their space, I try stand back as much as possible and get them to come out.

Additional assistance was given to children who were not able to physically reach out. Rachel used the technique of massaging children's shoulders to relax the muscles in their arms and hands to gently encourage a bit more movement. Then she gave them time to touch the art materials independently.

Kids who are not as mobile need a certain amount of warm-up time and very gentle stimulation before they can even reach out. I have a couple of kids whose movement is very, very restricted. Their muscles are very tense. So I found they need a lot of sensory [stimulation], like stroking their arms. Rubbing their shoulders will encourage their fingers to move out. Maybe a good 15 or 20 minutes, then they'll start moving their own hands. They signal so gently, I try to stay away from their hands as much as possible. I want them to feel like they're reaching outward.

The time allotted for massage and preparation ultimately had a positive impact on the latter part of the session, touching, holding, and reaching for art materials.

FACILITATING CREATIVE EXPRESSION

A range of creative interventions can be employed to build rapport. In her work with a six-year-old boy with visual impairments, Rachel found that using her singing voice in combination with colored shapes led to a unique form of creative expression. The boy

was unable to speak due to damaged vocal cords, and his fluency in sign language was also limited. While able to move and walk around on his toes, there was not a great deal of exploration as he "resisted most materials" and "had a very low tolerance for interaction." They worked together over a period of three years with a set of translucent colored plastic shapes to produce a musical dialogue.

The musical dialogue developed in response to his intense interest in a light box sitting on one of the art tables, a plastic box with a translucent white Plexiglas surface illuminated from behind. Light filtering through the box could be adjusted with a dimmer knob to create contrast or brighten colored transparent objects with strong lights. A container of transparent colored shapes may be used with this type of light box. During sessions in which the light box and shapes were used, Rachel assigned each plastic shape a high, medium, or low musical note and encouraged the child to arrange them independently. Rachel would either sing the notes or wait for the shapes to be rearranged until they resulted in a satisfying composition.

> We had those little plastic shapes on the light box. I was trying to think of something that we could do with them. "What's one little thing we could do differently?" And we started arranging them in a line. Then I gave each shape a note. A circle would be low. A triangle would be high. A square would be medium, and so I would sing the notes. If he liked it, he would take my hand and we would do it again. And we'd do it again, and we'd do it again. And if he didn't like it, he'd sweep them all off and make a new arrangement. So he got to compose for me, and I would sing. I let him communicate to me the way he wanted.

Although some sessions were spent testing new materials and drawing, he generally preferred Rachel to sing a new composition at the light box. "We just gained rapport because I wasn't forcing him to do anything. I was giving him some space. I would initiate, or I would model, and every once in a while I would ask him, 'I'd like you to try this.'"

Longer interactions were also punctuated with breaks, providing more space with an opportunity to turn away from the activity.

> Every once in a while he'd stop and turn and take a break. And I would stay connected by telling a story about him and what he was doing. And he would turn and smile. So that was our routine. We would work, and then he would take a break. And it was okay for him to take a break. And he would come back on his own. That just became our pattern.

The key to developing a therapeutic relationship included Rachel's respect for breaks from the art, further developing the child's feelings of trust in the creative work.

Discussion

Therapeutic Presence With Children Who Are Preverbal or Nonverbal

Art therapists demonstrate therapeutic presence by providing children with physical space and time to explore either the studio space or wheelchair trays before creating

art. The literature on therapeutic presence integrates ideas about mindfulness, or being present, as an "actively receptive state," rather an overly reactive or passive (Seigel, 2010, p. 24; Geller & Greenberg, 2011). A receptive approach to art therapy sessions does not use fixed plans created for specific disabilities and instead focuses on the children's subtle cues and body language.

Rachel's description of "sitting and watching" is also a common thread linking the therapists' diverse approaches to building therapeutic relationships. "We just gained rapport because I wasn't forcing him to do anything. I was giving him space." Present-moment awareness as described by Kabat-Zinn (1994) is practiced through the process of stepping back, observing, and allowing even challenging behaviors to provide insight into children's preferences and individual styles of communication.

Remaining Receptive and Flexible Through the Use of Multisensory Art Therapy Techniques

Art therapists may support children who depend on them for new sensory information with multisensory activities: exploring colors, textures, or playing with sound. Visual, auditory, and tactile techniques can take the form of lights, bright colors, noise-making materials, and verbal narrative. Art therapists are able to gauge levels of sensitivity to each new material by paying particular attention to children's reactions, including withdrawing or acting out behaviors.

Mia and Rachel share the same goal, noticing and responding to nonverbal attempts at communication. They use gradual exposure to new textures and sensations as preparation for the next stages of developmental art therapy, incorporating skill building and communication using art (Williams & Wood, 1977). For instance, Rachel combines brightly colored translucent shapes with song while Mia narrates the experience of manipulating Model Magic clay. They also emphasize the significance of physical responses within the art therapy space, mindfully positioning their own bodies to face children at eye level.

Self-Awareness Through the Art of Art Therapists

Nurturing strong connections to visual arts outside of the art therapy sessions is a foundation for presence in therapeutic relationships with children who have SMD. Edith Kramer (1998) underscores the importance of "true engagement in the arts and the pleasures and satisfaction it brings [as a way to] help art therapists maintain the distance necessary for empathetic understanding" (p. 276). Whether the art therapist is experimenting with pre-art and art media on their own or surrounding themselves with other professional artists and their work, artistic expression guides the therapist toward self-knowledge and self-compassion (Kramer, 1986; Seigel, 2010).

For Rachel and Mia, the process of personal art-making is informative. In art reaction pieces created after sessions, Mia reflects on times when her attention begins to drift. "Why was I drifting away in session? Probably in that moment it was really difficult to be in the session. It was really difficult to be in a session with a child who was not responding and be okay with that." This self-knowledge enables Mia to return her attention to supporting the children's creative expression in sessions.

Recommended Art Therapy Interventions

As the therapeutic relationship develops, specific art therapy interventions for children with SMD may include:

1. **Pairing new materials with familiar objects and textures to decrease resistance.** Moving beyond traditional art materials, children can transition into art-making by exploring sensory-based pre-art materials alone or in combination with everyday items.
2. **Balancing verbal feedback and physical support with time and space for independent exploration.** If the studio space and art materials are prepared for safe exploration prior to the session, the art therapist can remain closely behind to provide guidance when needed.
3. **Using potentially challenging behaviors, including outward aggression and withdrawing, to begin to build rapport.** Art therapists build rapport with children by learning their communication styles, allowing children's aversions to certain tools and textures to guide the therapeutic interventions.
4. **Reserving time for self-reflection and personal artwork.** Art therapists' ongoing personal connections to the art materials and art processes are a source of empathy and self-awareness (Kramer, 1998).

Conclusion

Art therapists must attend to subtle, nonverbal forms of communication, which may be misinterpreted in children with SMD. For children who use withdrawal or passivity as a tool for coping with overwhelming stimuli, therapeutic presence is needed to interpret those communication cues. Yet the components of therapeutic presence and developmental art therapy are often understood in isolation. By combining the two in an open, flexible approach, attuned art therapists may shift potentially destructive behavior patterns into productive art experiences.

Removing the focus on the specific disabilities in favor of individualizing therapeutic interventions strengthens the therapeutic relationship. By tuning in to the children's mannerisms and preferences, art therapists can uncover art materials and art processes used to increase engagement. As children gain mastery over the art materials, confidence and excitement over the art process provides endless opportunities to extend those creative connections.

References

Aach-Feldman, S., & Kunkle-Miller, C. (2001). Developmental art therapy. In J. Rubin (Ed.), *Approaches to art therapy: Theory and technique* (pp. 226–239). Philadelphia, PA: Brunner-Routledge.

Abbot, K., Shanahan, M., & Neufeld, R. (2013). Artistic tasks outperform non-artistic tasks for stress reduction. *Art Therapy: Journal of the American Art Therapy Association, 30*(2), 71–78.

Arron, K., Oliver, C., Moss, J., Berg, K., & Burbidge, C. (2011). The prevalence and phenomenology of self-injurious and aggressive behavior in genetic syndromes. *Journal of Intellectual Disability Research, 55*, 109–120.

Baer, R. (2007). Mindfulness, assessment, and the transdiagnostic processes. *Psychological Inquiry, 18*(4), 238–271.

Bellamy, G., Croot, L., Bush, A., Berry, H., & Smith, A. (2010). A study to define profound and multiple learning disabilities (PMLD). *Journal of Intellectual Disability, 14*(3), 221–235.

Erwin, E., Brotherson, M., Palmer, S., Cook, C, Weigel, C., & Summers, J. (2009). How to promote self-determination for young children with disabilities. *Young Exceptional Children, 12*, 27–37.

Evans, K., & Dubowski, J. (2001). *Art therapy on the autistic spectrum: Beyond words.* London: Jessica Kingsley Publishers.

Franklin, M. (2010). Affect regulation, mirror neurons, and the third hand: Formulating mindful empathic art interventions. *Art Therapy: Journal of The American Art Therapy Association, 27*(4), 160–167.

Geller, S., & Greenberg, L. (2011). Therapeutic presence: Therapists' experience of presence in the psychotherapy encounter. *Person-Centered and Experiential Psychotherapies, 1*(1 & 2), 71–86.

Harding, C., Lindsay, G., O'Brien, A., Dipper, L., & Wright, J. (2011). Implementing AAC with children with profound and multiple learning disabilities: a study in rationale underpinning intervention. *Journal of Research in Special Educational Needs, 11*(2), 120–129.

Henley, D. (1992). *Exceptional children exceptional art.* Worchester: MA: Davis Publications Inc.

Herzog-Rodriguez, T. (2015). Art therapists' perceptions of their work with children who have severe and multiple disabilities. (Doctoral dissertation). Retrieved from ProQuest Dissertations & Theses Global, (Accession No. 1688758182).

Kabat-Zinn, J. (1994). *Wherever you go, there you are.* New York, NY: Hyperion.

Kramer, E. (1986). The art therapist's third hand: Reflections on art, art therapy, and society at large. *American Journal of Art Therapy, 24*, 71–86.

Kramer, E. (1998). *Childhood and Art Therapy.* Chicago, IL: Magnolia Street Publishers.

MacLean, W., & Dornbush, K. (2012). Self-injury in a statewide sample of young children with developmental disabilities. *Journal of Mental Health Research in Intellectual Disabilities, 5*(3–4), 236–245.

Malchiodi, C., Kim, D., & Choi, W. (2003). Developmental art therapy. In C. Malchiodi (Ed.), *Handbook of art therapy* (pp. 93–105). New York, NY: Guildford Press.

McLaughlin, M., & Carr, E. (2005). The quality of rapport as a setting event for problem behavior: Assessment and intervention. *Journal of Positive Behavioral Interventions, 7*(2), 68–91.

Oliver, C., Petty, J., Rudick, L., & Barcarese-Hamilton, M. (2012). The association between repetitive, self-injurious and aggressive behavior in children with severe intellectual disability. *Journal of Autism Dev Discord, 42*, 910–919.

Rubin, J. (1984). *The art of art therapy* (p. 209). New York, NY: Brunner and Mazel.

Seigel, D. (2010). *The mindful therapist: A clinician's guide to mindsight and neural integration.* New York: W. W. Norton & Company, Inc.

Singh, N., Lancioni, G., Winton, A., Curtis, W., Wahler, R., Sabaawi, M., Singh, J., & McAleavey, K. (2006). Mindful staff increase learning and reduce aggression in adults with developmental disabilities. *Research in Developmental Disabilities, 27*, 545–558.

Snell, M., Chen, L., Allaire, J., & Park, E. (2008). Communication breakdown at home and at school in young children with Cerebral Palsy and severe disabilities. *Research and Practice for Persons with Severe Disabilities, 33*, 25–36.

Wehmeyer, M. (2005). Self-determination and individuals with severe disabilities: Re-examining meanings and misinterpretations. *Research and Practice for Persons with Severe Disabilities, 30*(3), 113–120.

Williams, G., & Wood, M. (1977). *Developmental art therapy.* Maryland: University Press.

8

On Becoming Whole
Paul's Journey Through Heart Transplant

SARAH YAZDIAN RUBIN AND LAUREN DANA SMITH

An honorable human relationship—that is, one in which two people have the right to use the word "love"—is a process, delicate, violent, often terrifying to both persons involved, a process of refining the truths they can tell each other. It is important to do this because it breaks down human self-delusion and isolation. It is important to do this because in doing so we do justice to our own complexity. It is important to do this because we can count on so few people to go that hard way with us.

—Adrienne Rich

Wholeness is understood as the state of forming a complete and harmonious entity, being unified, unbroken, or undamaged. Illness can threaten wholeness, integrity, and the intactness of one's personhood and self (Cassel, 1982), rendering a person emotionally, socially, spiritually, and physically in pieces. Illness that requires solid organ transplantation involves both loss and gain and requires the patient to be in relationship with their donor. In childhood, a time when the self and body is rapidly developing, illness and transplant may be especially challenging to integrate into a self-concept. What does it mean for a child to feel whole or become whole again when the central part of their body has been removed, discarded, and replaced? How does that child integrate loss and life simultaneously, physically, psychologically, emotionally, socially, and spiritually? How can art therapists, through a loving relationship, support a child's journey in becoming whole?

Overview

This chapter focuses on medical art therapy in the inpatient hospital setting within pediatrics, as it relates to emotional recovery and cultivating resilience in vulnerable children. Psychosocial stressors, prolonged hospitalization, developmental vulnerability, medical trauma, and the impact of pain will be discussed. Specific challenges associated with cadaveric organ transplantation, including the demarcation line of life and death, loss rituals, constitutions of identity and the bodily self, suicidal ideation, and survivor guilt, will be highlighted. Post-traumatic growth in relation to medical trauma will also be explored.

Through a case analysis, we will explore a child's experience of serious illness and his unique journey of coping through integrative art therapy treatment. We will introduce Paul, who was eight years old when he was hospitalized for a year with cardiomyopathy

that culminated in heart transplantation. Through art, play, and creative writing, Paul wrestled with uncertainty, fantasies, and fears that marked his time of "waiting," which helped him adjust to life post-transplant. The symbolism and metaphoric communication in his creative processes and products—including cooking, writing poems to his heart, tie-dyeing his doctor's white coat, and painting earth and sky—will be explored as interventions that enhanced coping, and ultimately, healing.

Medical Art Therapy

Established over 25 years ago as the "specific use of art therapy with individuals who are physically ill, experiencing trauma to the body, or undergoing aggressive medical treatment such as surgery or chemotherapy" (Malchiodi, 1993 as cited by Rode, 1995), medical art therapy plays a vital role in pediatric medicine, supporting the psychosocial needs of children and families when physiological and biological states are compromised. Medical art therapists are frequently embedded within interdisciplinary team models. The medical art therapist can introduce adaptive interventions that incorporate and normalize medical equipment (such as gauze, tape, syringes, etc.) into art-based play, in order to bolster ego strength, mastery, and control over self, body, and environment.

Art therapy services are frequently referred in cases where a patient or family member is experiencing symptoms of anxiety, depression, or—commonly—adjustment disorder, as a child may not have met the criteria for a full diagnosis of depression but may experience depression-like symptoms secondary to difficulties adjusting with the seriousness of the diagnosis, course of treatment, or length of hospitalization. Many patients who have experienced serious, chronic, or life-limiting medical illnesses have undergone invasive treatments or surgical procedures, which may make them more susceptible to post-traumatic stress disorder (PTSD) or medical trauma, a constellation of physiological and psychological responses to illness and invasive or frightening medical procedures. Symptomology associated with medical trauma is akin to other trauma responses: hyper-arousal, re-experiencing or flashbacks, or avoidance of the triggering event or memory (National Child Traumatic Stress Network, 2017). Anxiety is known to heighten the experience of pain and other symptoms while depleting perceived levels of esteem, which has a direct bearing on quality of life.

In an environment where medical treatment itself may be painful or generate discomfort, art therapy can provide an essential component of a patient's multidisciplinary treatment plan that, while not medically curative, may be fundamentally restorative and does not trigger a physical pain response. Themes of loss, isolation, fear, anger, confusion, and misconception around illness are frequently explored through a variety of art media and within the therapeutic alliance. Many children and families receiving medical art therapy are confronting the concept of death and dying for the first time, often an unexpected and ill-prepared for reality confronting the young person. A skilled clinician is able to bridge such fears and anxiety with interventions that support memory making, legacy building, and the ongoing nature of familial bonds, even in the face of serious or life-limiting illness.

So frequently, in a hospital-setting, great emphasis is placed on what a child cannot do: physical limitations, such as fine- or gross-motor impairments, environmental limitations due to spending prolonged periods in a confined space, and developmental interruptions such as restrictions to attendance in school or extra-curricular activities. The benefit of utilizing a strengths-based philosophy in

delivering art therapy treatment in a medical setting is that the child is not defined by their illness, nor pathologized, but rather acknowledged for their internal and generative resource: creativity. Children possess a great capacity for cognitive and emotional flexibility. From a humanistic viewpoint, medical art therapy recognizes these traits within the context of illness and supports a child in constructing alternative narratives of self that integrate a very personal understanding of the scope of human experience and potential.

Culture of Pediatric Medical Illness

For many families, receiving the news of a serious childhood illness signals a sea change in family life. Once normal routines of school, friends, family, spirituality, and community are interrupted in the name of treatment. Families and children must quickly adapt to the unknowable when navigating the features of the modern western healthcare system. In many ways, serious, chronic, or life-limiting illness is a culture unto itself, bringing with it new and unfamiliar experiences, unique power dynamics, medical terminology, modes of behavior, and communication. These stressors extend beyond the impact of initial diagnosis or treatment plan and impact the physical, emotional, psychosocial, cultural, spiritual, and environmental life of the child and family (Malchiodi, 1999; Thompson, 2009; Smith & Yazdian, 2017). Therefore, clinicians functioning within this environment must also cultivate a humanistic approach and "[weave] interventions into the fabric of the environment, including the patient's relationships with hospital staff, the place of the medical unit and the illness itself" (Rode, 1995, p. 105).

The hospital environment, disorienting and unfamiliar, may cause distress and developmental regression. Infants and toddlers may slip into to earlier stages of development and attachment patterns, developing an acute separation/stranger anxiety or regressing from previously attained developmental milestones (speech, fine/gross motor, toilet training, behavioral patterns such as sleep and feeding routines). School age children may internalize their illness, projecting themselves into the world as bad or wrong, or having caused the illness itself due to a perceived bad deed, thought, or action. Adolescents and young adults struggle to interpret their illness within the context of identity formation and individuation. It is typical of teens to grapple with dependence on others and non-compliance of treatment. Themes of isolation, attachment, and mortality may surface. Regression, self-blame, misconceptions, punishment, and fear often pervade a child's relationship to illness (Thompson, 2009). Likewise, the family system is interrupted and experiences a shift in dynamics that can include but are not limited to role reversal and role fluidity, separation anxiety, ambiguous loss, and parent and sibling stress.

To mitigate distress within the family structure, utilizing a family-centered approach has become best practice in the field of medical art therapy. Family-centered care is based on the belief that the most effective way to ensure a child's sense of safety and well-being is to provide supportive services that engage, involve, and strengthen families. Key components of family-centered practice include: information sharing; respecting and honoring differences (cultural, linguistic, care preferences); partnership and collaboration including medical decisions that best fit the family's values; negotiation and recognition that medical care plans are flexible and not always absolute, and that care is provided in the context of the patient's family, home, daily activities; and quality of life within the community (Kuo et al., 2011).

Pediatric Heart Transplant

As will be discussed in the subsequent case, pediatric cardiac transplant patients are amongst some of the most psychologically vulnerable children receiving medical care. The most prevalent indications for heart transplantation in children are cardiomyopathy and congenital cardiomyopathies. The amount of time from initial listing with an organ transplant network to the transplant itself may vary. Depending on the severity of the child's condition, they may wait for transplant at home or in the hospital, under constant medical surveillance. According to the Registry of the International Society for Heart and Lung Transplantation (Rossano et al., 2017), there were 684 pediatric heart transplants that were reported to the registry in 2015.

While any experience of diagnosis and illness presents challenges for families, heart transplantation, "including the diagnosis and decision-making stage, the waiting period, transplantation and hospitalization stage, and the follow-up and recovery periods may subject children and adolescents to additional stressors more problematic than those experienced by open-heart surgery recipients" (Todaro, Fennell, Sears, Rodrigue, & Roche, 2000, p. 568). Todaro et al. note impaired social, developmental, and cognitive functioning in pediatric transplant recipients (p. 568). Extensive literature exploring the pre-transplant, peri-transplant, and post-transplant phases identify specific stressors, particularly around the waiting period and adjustment to diagnosis, medication compliance, familial stress, and psychosocial factors that may impact long-term psychological functioning and outcomes (Anthony, Nicholas, Regehr, & West, 2014; Parent et al., 2015; Copeland et al. 2017; Dipchand et al., 2013; Todaro et al., 2000; Anthony, Annunziato et al., 2014; Dew et al., 2015). It is believed that psychosocial factors may have a predictive relationship to post-transplant outcomes, including morbidity and mortality (Coglianese, Samsi, Liebo, & Heroux, 2015). In a 2001 study, prevalence of depression and anxiety in patients awaiting heart transplantation was recorded at 23.7%; additional studies reflect persistent depressive symptoms in the first year post-transplant and in long-term follow-up (Coglianese et al., 2015, p. 43).

Prior to heart transplant, pediatric patients undergo a multidisciplinary assessment, which includes a psychosocial evaluation of anticipated compliance to medical treatment and to identify social support systems (Coglianese et al., 2015). Psychosocial evaluations, though variable, share a common goal to identify patient and family strengths and risk factors that may impact post-transplant outcomes such as non-adherence; intellectual, academic, and neurocognitive function; psychological functioning; coping and adjustment of child and parent; family dynamic; age; and developmental level (Lefkowitz, Fitzgerald, Zelikovsky, Barlow, & Wray, 2014). Creative arts therapists may provide vital information throughout this assessment period. It should be noted that the consideration of and attunement to cultural characteristics such as race, ethnicity, socioeconomics, gender identity, and religion require ongoing assessment throughout the transplant experience. Lefkowitz et al. (2014) notes that these issues have not been well studied in the literature, however they may "impact families' knowledge and beliefs about transplant, health behaviors and relationships with medical providers" (p. 332).

Illuminated in the subsequent case, Anthony, Annunziato et al. (2014) identified the waiting period for transplant as "the most stressful stage of the transplant journey" (p. 423) and offers that adopting a "holistic and multidimensional" (p. 424) view of psychosocial health and quality of life during the waiting period itself may be an opportunity to foster formative therapeutic relationships between patients, family members, and care teams.

Heart Symbolism

It is important to briefly explore heart symbolism and to emphasize the biopsychosocial and spiritual dimensions of heart transplantation. Essential to life, the heart is anatomically central in the vertical schema of the human body that supplies blood and oxygen to the rest of the body. Across cultures, the heart is synonymous with love, compassion, and charity and connotes the soul. A living symbol, the heart's physical centrality to our existence corresponds with emotions—pleasure, desire, affection, rage, fear, and vulnerability (Ronnberg, 2010, p. 392). The "spiritual and emotional core," the heart represents the "central wisdom of feeling as opposed to the head-wisdom of reason" (Cooper, 82 as cited in Crenshaw, 2008). Siegel's (1999) neurobiological research posits that neural networks around the heart are responsive to attachments, relationships, and feelings toward others. Life giving, vital, and considered the unique essence of a human being, the idea of heart transplant can be met with powerful resistance (Ronnberg, 2010, p. 394).

All transplants involve both concrete and intangible losses and gains. The relationship between the recipient and the donor—a related donor; a stranger; or, in the subsequent case example, a deceased donor—adds complexity to an already sensitive scenario. Patients may feel that they "owe" something to a related donor, or may experience survivor's guilt if the recipient of an organ from a deceased donor. The success or failure of the transplanted organ may evoke depression or anxiety, impacting the patient psychologically, socially, emotionally, and spiritually.

Case Example

Paul

I met Paul when he was hospitalized at the age of six. He was a loving, rambunctious, and charming little boy who was strongly bonded to his parents and nurses. He loved creating art and playing games and enjoyed the company of others. Paul and his family immigrated to America from Ecuador when he was four years old. Soon after their arrival, Paul presented to an emergency room with two days of congestion, cough, decreased appetite, vomiting, and lethargy. In cardiogenic shock, Paul's body began decompensating, and he was resuscitated and intubated. He was diagnosed with dilated cardiomyopathy, a condition in which the heart becomes enlarged and cannot pump blood efficiently. Paul was placed emergently on extracorporeal membrane oxygenation (also known as ECMO, a machine that takes over the work of the lungs and the heart due to organ dysfunction) and was listed for a heart transplant.

Although relatively stable, Paul would experience a recurrence of symptoms that required invasive interventions over the next three years of his life. At various points post-surgery, Paul was intubated and required ventilator dependence, compromising his ability to communicate. After one cardiac surgery, his chest remained open but covered; allowing doctors access, before a final sternal closure. At the age of six, Paul was diagnosed with paroxysmal ventricular tachycardia, a rapid heartbeat that develops when the normal electrical impulses of the heart are disrupted, and underwent surgery to receive an implantable cardioverter defibrillator (ICE) to prevent sudden death. At the age of seven, Paul was again admitted to the pediatric cardiac intensive care unit with worsening congestive heart failure. He received several medications and catheter-based procedures to support heart function.

At the age of eight, Paul again became symptomatic and was hospitalized for a year, culminating in heart transplant. Upon this admission, Paul was diagnosed with heart failure and cardiogenic shock. He underwent several painful and invasive procedures during his year of "waiting," including a left ventricular assistance device (also known as an LVAD, a mechanical pump that is implanted inside the chest to help pump blood) and a tracheostomy (a surgical procedure that creates an opening through the neck into the trachea to create an airway using a tracheostomy tube), among other procedures.

Paul's psychological, emotional, and behavioral responses to hospitalization impacted his parent's decision-making around communicating treatment plans with him. Because Paul experienced unexpected and emergent medical care beginning at the age of four, Paul initially presented as fearful and anxious. His significant fear appeared to be related to his acute decompensation requiring an emergent LVAD placed without preparation. His mother shared that Paul's scars frightened him and that he suffered traumatic mutism, not speaking for one month after his first hospitalization.

While Paul was fluent in both English and Spanish and at times served as the translator for his family, his parents were reluctant to share information related to upcoming procedures with Paul for fear that medical information might trigger anxiety. Following Paul learning that he would require a heart transplant, his primary medical team noted a change in Paul's mood, appetite, and level of anxiety, noting that he was less active and smiling less. He began to resist sleep because he was scared that medical interventions might be performed without his knowledge if he did not remain awake. These presenting symptoms, coupled with isolation in the intensive care unit, put Paul at risk for adjustment issues that warranted mental health services. As such, Paul was followed by several mental health services throughout his hospitalization including psychiatry, social work, and art therapy, which he was most receptive to. In art therapy, Paul coped with pain, uncertainty, environmental challenges, fantasies, and fears that marked his time "waiting."

Several notable life events, behaviors, and feelings arose for Paul throughout this hospitalization. Three months into Paul's hospitalization, Paul's mother became pregnant (his baby brother would be born two weeks before Paul's heart transplant). As Paul's mother was pregnant throughout Paul's transplant waiting period, his relationship to becoming a sibling and preparing for major changes within his family had a distinct impact on his level of coping and adjustment. This also impacted his mother's availability to Paul, at times.

The following case study highlights art and play-based interventions facilitated by a dual-certified creative arts therapist and child life specialist. The profession and practice of child life is rooted in the frameworks of developmental psychology, education, play theory, stress and coping theory, attachment theory, social learning, and family systems theory (Thompson, 2009). Fundamentally, child life specialists utilize "evidence-based, developmentally-appropriate interventions including therapeutic play, preparation and education to reduce fear, anxiety and pain" to assist children and families through challenging events related to healthcare (Association of Child Life Professionals, 2017). Dually certified child life creative arts therapists are able to integrate an understanding of medical illness, medical environments, and treatments within the psychodynamic principles of creative arts therapy practice.

ART THERAPY ASSESSMENT AND TREATMENT PLAN

This chapter reviews art therapy treatment while Paul was hospitalized for one year waiting for heart transplant and short-term art therapy treatment post-transplant.

Paul was seen for inpatient art therapy on average 3 times per week for 10 minutes to 1.5 hours, depending on his ability and level of distress. Sessions were primarily non-directive, and, at times, the therapist collaborated with other practitioners. His mother was often present during sessions and would participate when appropriate. Various art- and play-based therapy interventions were utilized, including medical play and procedural support, emotional containment, kinesthetic movement, communicating and integrating trauma, coping with isolation/environmental challenges, exploring surgical enactments, loss rituals, exploring death, spiritual grounding, and post-traumatic growth.

Art therapy sessions were oftentimes scheduled before blood draws, tracheostomy tube changes, dressing changes, and adjusting settings related to the ventilator so that Paul could learn about the upcoming procedure in developmentally appropriate ways. Sometimes this involved educational books or art-making. The therapist used developmentally appropriate language to explain the upcoming procedure or event. Information gathering and decision-making were important coping skills for Paul, and having a dedicated time for him to ask questions and make choices positively impacted his experience. He was also given the opportunity to manipulate medical items like gauze and syringes (without needles), "play out" his experiences with the medical items (called "Medical Play" in child life literature), and create art with them, with the goal to increase familiarity and neutralize negative associations. Filling syringes with paint and releasing the paint on a large sheet, for example, was one such intervention. Paul frequently chose to hold his therapist's hand, requested a count down when certain parts of the procedure would conclude, or engaged in distraction activities (video games, reading a book). He responded well when the art therapist objectively narrated the procedure experience, which was grounding for Paul.

Paul was also receptive to art-based mindfulness exercises to self-sooth and emotionally regulate post-procedure. After traumatic or frightening procedures, Paul commonly requested a 3D wooden dinosaur skeleton puzzle that he and the therapist would build together and paint. Piecing together the wooden pieces of the puzzle mitigated Paul's usual response of "freezing" and retreating. Predictable yet still challenging, the puzzle allowed for relational support and shifted his focus into problem-solving mode, which helped to re-establish a sense of safety. He often worked silently but diligently, only speaking to request technical help or to thank God aloud for the procedure going well. It was not a time that Paul used to verbally explore his experience but rather orient him to his now calmer surroundings. This specific kind of support proceeding, during and after procedures, offered Paul a sense of control and predictability while helping to support trust between Paul and his care team.

CONTAINING SPACES, CONTAINING EMOTIONS

Art therapy at a child's bedside can provide a safe, containing space for meaningful therapeutic relationship and engagement. Paul attached strongly to art therapy as a holding space to explore emotions and gravitated toward literal containers to cope with anxiety. Early on in art therapy, Paul stated that he wanted to create a "secret box," which morphed into "worry box." He painted this box pink and commented that the color reminded him of his heart. The therapist wondered how Paul might use his box while hospitalized and suggested that he write down thoughts and feelings to keep inside. Each day following, Paul wrote down worries, wishes, and feelings and selected one to share aloud. Some wishes included: "I wish I never had heart problems," "I wish for all children to be healthy," "I wish to protect animals by making everyone an [herbivore]." This intervention

supported Paul to build emotional intelligence and facilitated conversation around difficult, abstract topics, including where his new heart would come from. As Paul identified, labeled, and expressed feelings, his anxiety began to lessen. Safely storing thoughts and wishes in his "worry box" helped to provide much needed containment.

This intervention strengthened the therapeutic relationship between Paul and his therapist as well as the relationship between Paul's mother and the therapist. His mother observed that Paul responded well to the therapist's containing presence and how the worry box increased communication, and helped Paul feel relaxed. She began to share her own worries and wishes with the therapist privately. She confided that she felt Paul was "the sickest kid in the hospital" and expressed existential pain and feelings of failure in being unable to "protect him." Reframing ways his mother could "protect" Paul from an emotional standpoint proved to be helpful for both mother and child.

SUPPORTING KINESTHETIC MOVEMENT THROUGH ART AND PLAY

At various times throughout hospitalization, Paul showed more restricted physical movement that stemmed from both psychological and physical barriers. Art interventions that encouraged movement, like the "feelings bull's-eye," motivated Paul to explore ways to move his body safely (see Figure 8.1). In each bull's-eye ring, Paul

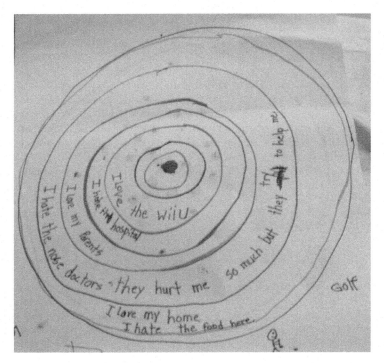

Figure 8.1 "Feelings" Bulls-eye. Paul explored physical abilities, likes, and dislikes using his "Feelings" bulls-eye.

wrote down a feeling or thought he had in this past week. He balanced these statements with hopeful, future-oriented statements such as activities he was looking forward to doing post-transplant. Once the bull's-eye was complete, Paul rolled up pellets of model magic and threw them toward the bull's-eye, shifting his body position to hit different targets.

Laughing and smiling when he would hit the bull's-eye, Paul momentarily escaped the hospital walls and entered a space where he felt unconfined and untethered. Other times, Paul filled syringes with paint to target the bull's-eye. The goal of this intervention was to help Paul shift his perception of abilities, as well as his relationship to and perception of his body through art. Employing a strengths-based approach amplified the well parts of Paul. Playful movement that allowed for kinesthetic release emphasized his "aliveness," abilities, and resilience.

Working with the body through art-making can have a profound impact for hospitalized children. In transition with the relationship to their bodies, Paul used these active interventions to explore his embodied experience of illness and what his ill body could, and could not, do. Grieving the loss of activities like running, Paul could smash clay or rip paper to feel the feelings of freedom and release he may have felt previously. Working with the body using art materials provided Paul with disarming ways to explore and perhaps awaken newfound faculties.

COMMUNICATING AND INTEGRATING TRAUMA THROUGH PERSONAL IMAGERY

Many hospitalized patients have communication impediments secondary to medical illness, despite normative or partially normative levels of cognition. These seriously ill patients experience times when they are unable to speak due to ventilator dependence, pain, or general weakness. Medical trauma may also render individuals speechless. From a neurobiological perspective on trauma, we understand that Broca's area shuts down when confronted by trauma, as "subcortical regions of the brain, the primitive parts that are not under conscious control and have no linguistic representation, have a different way of remembering than the higher levels of the brain, located in the prefrontal cortex" (van der Kolk, Burbridge, & Suzuki, 1997, p. 24).

Paul experienced many emotions associated with the loss of communication, including grief, inadequacy, anger, guilt, vulnerability, and confusion, all of which compounded his communication efforts. Developmentally vulnerable, Paul sometimes lacked the language necessary to describe his inner emotional experience. Medical trauma also exacerbated challenges Paul experienced in verbalizing feelings. When Paul was dependent on a ventilator and unable to speak, he used a dog's squeaky toy his family brought in from home to express his needs. While helpful in communication efforts, this communication system impacted Paul's sense of dignity, as he later shared feeling self-conscious and embarrassed by this. During times when Paul could not speak, mixing paint colors became a self-soothing ritual.

Many of Paul's initial paintings referenced outdoor landscapes with a ground line and skyline (see Figures 8.2A, 8.2B, and 8.2C). The center of the image remained vacant, with a gap, hole, or empty space in the center of the page. This was a repetitive theme for roughly eight consistent sessions. There are several potential interpretations of the

Figure 8.2A, 8.2B, 8.2C Compilation of landscapes. Landscapes with an absent middle ground became a repetitive theme in Paul's artwork and symbolized feelings of loss and uncertainty.

Figure 8.2A, 8.2B, 8.2C (Continued)

meaning of this middle space—to communicate loss, absence, emptiness, fear, and the unknown. In addition to alluding to the eventual loss of his heart, these holes and gaps potentially reflected his compromised body boundary—Paul's center of his chest and center of his neck had been punctured or opened for medical treatment and sometimes remained exposed. Through nonverbal avenues, Paul was able to express the trauma related to his bodily self.

Paul's compositions slowly began to shift, as he filled the middle space between the ground line and skyline. Perhaps representing the threshold between earth and sky/heavens, this space was significant to explore. Themes of explosion, danger, conflict, and fear were contained in the middle space. Sometimes Paul filled the space with houses that allowed the viewer to see the inner workings of the house from the outside, also potentially reflecting his experience of his body and living with an LVAD, his "external organ" (Figure 8.3). Other times, Paul filled the middle of the page with treacherous weather conditions—swirling tornados, erupting volcanoes, and fallings meteoroids (Figures 8.4A, 8.4B, 8.4C, and 8.4D).

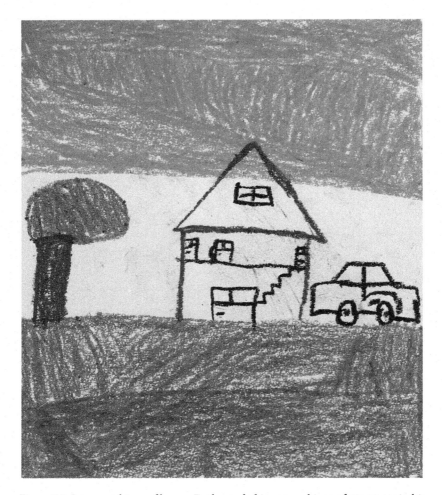

Figure 8.3 Inner workings of house. Paul revealed inner workings of structures in his drawings, potentially reflecting feeling exposed in the hospital setting and processing medical equipment placed inside and outside of his body.

Paul's paintings would often be saturated with a swirl of colors, succumbing to all of the globs of paint on the canvas that swirled into a muddy "white wash." Personal symbology reflected inner conflicts, bodily experience, and grappling with an awareness of critical, life-threatening health concerns. His narratives reflected constitutions of his reality, and even when he was rendered voiceless, art became an important vehicle in his communication and in healing.

Figure 8.4A, 8.4B, 8.4C, 8.4D Meteoroid, volcano, and other weather imagery. Paul
utilized explosive and chaotic weather imagery to communicate inner conflicts.
Periodically, Paul's images would resemble his sick organ, heart chambers, and disease.
The black, erupting volcano image may reference a dying internal organ.

Figure 8.4A, 8.4B, 8.4C, 8.4D (Continued)

COPING WITH ISOLATION

For the greater part of one year, Paul was isolated and unable to leave his room due to medical fragility and dependence on life-sustaining equipment. In his drawings of outer space, during Minecraft video gaming (where he was fascinated by the fact that the world "would never have an end") and visiting his "magic world" under his blanket, Paul experienced pain-free, imaginary environments that proved to be sustaining. He also created companions in hospital staff and developed a friendship with a tree outside of his window that he named Trevor. Paul occasionally drew pictures of Trevor the Tree and wondered how many other children Trevor helped while they were hospitalized. He wondered if they, too, were waiting for organs, missing their friends, or feeling lonely.

Remaining connected to existing support networks also thwarted isolation. Paul's teacher had coordinated for his peers to periodically write notes and draw pictures for Paul. Reading these letters became a ritual that Paul would begin sessions with, as if to symbolically fill his space with friends and classmates. The therapist and Paul taped the letters around his window, and the therapist would encourage Paul to compose messages to his friends in response. Creating a schedule also helped Paul see who would be visiting him at what time, giving a semblance of structure to an otherwise indistinct day in the hospital, and served as a visual representation of his community while hospitalized.

Building a new community within the PCICU became paramount to Paul's experience and mental health. To build rapport and non-medical interaction with medical staff, the therapist suggested group art-making and card games with staff. Tie-dying was a novel experience for Paul that inspired him to make art for others. Paul shared that he wanted to make something for his heart surgeon, and he and the doctor agreed that tie-dying the white coat would be fun. Seeing his doctor wear his colorful "white" coat emphasized Paul harboring value with the capacity to give something, even as he grappled with the knowledge that part of himself (his heart) was "broken," devalued, and replaceable. The act of making original art and gifting his creations fostered playful connection and intimacy and allowed Paul to participate in meaningful relationships. He also tie-dyed blankets for his baby brother, who would be born later in the year, and t-shirts he would later gift to his parents and nursing staff (Figures 8.5A and 8.5B).

Figure 8.5A Tie-dye clothing. Paul enjoyed the process of mixing to create tie-dye clothing for loved ones.

Figure 8.5B

Exploring Enactments Through Sensory Materials

Finding mastery in multisensory materials supported Paul's need to explore his bodily experience and, eventually, enact surgeries. Mixing buckets of dye for tie-dying projects reminded him of blood and other bodily fluids. Squishing model magic reminded Paul of organs and prompted questions about how his heart functioned. An organic material—food—enabled Paul to slice, cut, and carve, allowing him to reverse his passive stance of patient to an active one.

Using a plastic knife and wearing surgical gloves, gown, and a mask, Paul cut the heads of lettuce down the middle and then carefully cut each half systematically, as if he were performing a surgery. The act of cutting helped Paul to externalize unconscious emotional experiences and process his impending heart transplant through art and symbolic play. Eventually, Paul would create tacos and other traditional dishes with the lettuce, tomatoes and onions that he cut, sublimating his desire to cut into productive activities. Paul would often create tacos for visitors, doctors, and himself. He even filmed a cooking show of how to make the perfect taco.

Eating his creations allowed Paul to control what entered his body at a time where he had very little choice and provided a pleasurable experience, as well as a much needed and delicious break from hospital food. Coming from a culture where food is used to care for others, Paul was participating in important work of caring for himself, and showing gratitude towards those he loved.

Loss Rituals and Exploring Death

Patients with serious illness experience multiple losses including independence, control, health, functional ability, relationships, and, sometimes, life itself. Anticipatory grief refers to the reaction that occurs before an impending loss. Grieving can be a

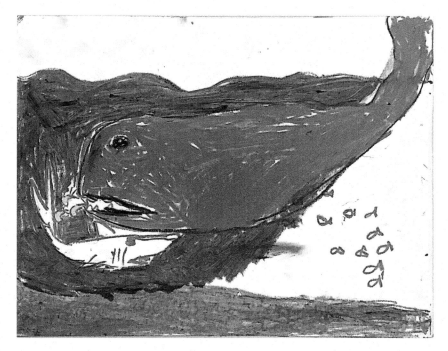

Figure 8.6 Food chain image. The emotional struggle of hoping for a transplant, understanding that a child would die for his new organ to become available, was difficult for Paul to reconcile. Paul's art and play provided nonverbal opportunities to process feelings related survivors guilt and often included characters in two groups: "survivors" and those who were "doomed."

difficult task in a medical setting, where sorrow may be viewed as a problem to be solved, privacy is compromised, and the overwhelming focus is on recovery or "getting well." As Paul waited, art therapy provided space to grieve many losses including the loss of life necessary for Paul to receive his donor organ and his impending loss of his own heart.

Survivor's guilt can be a significant issue for both patients receiving organ transplants, as well as their families. The emotional struggle of hoping for a transplant, knowing that a child will die in order for the organ to become available, was challenging for both Paul and his parents to reconcile. While Paul rarely spoke about his organ donor, providing honest answers when Paul verbalized questions about where his heart was coming from supported his efforts to grieve. Images that highlighted the death of an animal to ensure survival of another began to emerge (Figure 8.6).

Paul also created several masks over the course of art therapy that held opposing feelings related to loss. Paul's "Dead Face" mask had X's for eyes with his tongue sticking out. "Future Paul" wore glasses and had children. Paul used the masks to "try on" different identities and outcomes safely. This kind of metaphoric play was both intrapersonal and interpersonal with the therapist and allowed for release, understanding, and an opportunity for Paul to observe his own grief.

Because Paul endured significant losses throughout his hospitalization, one important function of art therapy was to "chart growth" by providing Paul with a tangible item that reflected living. Each piece of art that Paul created would be placed inside his art therapy journal, a container that safely stored and allowed access to past experiences. Paul would often look through the journal in its entirety and would comment on how far he had come. He noticed changes in his artwork and would comment on the art pieces he was particularly proud of. He left blank pages inside for future artwork. Seeing his art in relation to his larger body of work symbolically represented his own journey, focusing on the present moment, reviewing the past, and cultivating hope for the future.

SPIRITUAL GROUNDING PRE-TRANSPLANT

Spirituality has received increased attention in health-related literature over the past decade, and spiritual care is widely recognized as a key component in providing care to the *whole person*. Defined as an "inner sense of a living relationship to a higher power" (Miller, 2015, p. 6), or whomever or whatever gives one a transcendent meaning in life (relationship with God, nature, energy, family, or community), exploring spirituality in therapy is an important ingredient in becoming more whole (Renzenbrink, 2012). One's beliefs and values affect how a person copes with illness, and spirituality plays a prominent role in experiences of loss and dying (Puchalski, 1999).As shared by Fenton (2008), "art therapy provides a way for patients to go home or return to the center of being, a process that gives these individuals a chance to rediscover essential aspects of their creative selves and find sanctuary in their arduous journeys towards wholeness."

The role of ritual in art therapy is significant in relation to spirituality. Rutenberg (2008) cites a quote by Seftel (2006): "Rituals provide a focal point of awareness that we are moving through an obstacle, transitioning to a new sense of self, or letting go of something lost" (Rutenberg, 2008, p. 109). Art-making became an important ritual for Paul, one that contained conflicting emotions and liminal experiences, created legacy pieces, and held hope for an organ that would arrive and function properly. Art therapy became a time for Paul to reflect, reminisce, and reaffirm the continuity of his identity despite the many transitions he was going through.

Aside from using art to search for meaning, Paul often incorporated his faith in art therapy. He would frequently request to pray for other hospitalized children with his therapist, and the family welcomed visits from their church community, where they would form prayer circles at his bedside. When Paul learned that a heart had arrived for his transplant, he turned to his faith, expressing his desire to talk with God. Visibly nervous, Paul was able to state that he felt "fearful, excited, happy, and nervous all at the same time."

Paul decided to write a prayer for his new heart to "work and increase his energy" and asked this therapist to read his prayer aloud to him. He closed his eyes, and as he listened to his words read aloud, Paul's breathing regulated and and he appeared visibly less anxious. His body appeared more relaxed, and his ability to engage in conversation increased as we prayed together. This self-directed writing intervention provided Paul with much needed spiritual grounding. The arrival of an organ is usually a surprise after many days or months of waiting and disrupts the normalized routine of hospitalization. Paul's choice to write a prayer indicated to the therapist that he had grown in his capacity to identify activities that would assuage anxieties and prepare him for existential questions. Paul decided to place this prayer on the front page of his art

therapy binder. Incorporating aspects of Paul's spiritual foundation during art therapy supported a strengths-based approach that highlighted pre-existing coping strategies, community support, and strengths.

PERI-OPERATIVE SUPPORT

As is common following most heart transplant surgeries, Paul remained intubated and sedated several days after his transplant. The family, having recently welcomed Paul's baby brother, needed support despite feeling extremely grateful for the two "miracles" they experienced within the same week.

Although still intubated, the therapist continued to employ similar techniques when providing procedural support, stating that Paul was safe, narrating what nurses were doing, and stating how much longer the doctors thought he would be intubated. The therapist modeled for his family ways to interact with Paul through therapeutic touch and comforting words. The day Paul was extubated, he felt weak but welcomed the therapist's presence, reaching out to hold hands. Days later, Paul felt strong enough to sit up and engage in art therapy. He spontaneously created a drawing of his "old heart," wondered where it was now, and stated that it was "too big." He spoke of "loving" both of his hearts as he began to process the loss of his old heart and life with his new heart. Paul tearfully admitted feeling sad and missing his old heart.

Before his transplant, Paul had written to his new heart. This therapist suggested that Paul now write a letter to his old heart to cope with feelings of loss. In his letter addressed to "Old Heart Jones," Paul thanked his heart for working the past eight years. He shared that he missed his heart, loved his heart, and would never forget him. Paul placed this letter beside his letter about his new heart in his art therapy binder. As he began to integrate the loss of his heart into his life story, Paul requested his mother bring in his baby pictures from home. Paul expressed a desire to engage in life review, a reminiscing process where individuals explore and ascribe meaning to life experiences, events, and relationships and reconcile challenges (Haber, 2006, p. 154), as part of this integration process. It seemed important for Paul to share childhood memories from Ecuador, and review his life pre-transplant. With the date of transplant commonly considered a new "birthday," the timing of life review and Paul's need to remember where he came from was significant. Paul also shared pictures of deceased pets that he missed.

Once Paul was medically cleared to leave the hospital, the art therapy journal was reviewed as part of the termination process. He left blank pages inside to create drawings at home and to add pictures of his baby brother. Although excited ("Today is the day that I leave the hospital!"; "My new heart works great! I can walk without a walker and do a lot of pranks!"), Paul admitted feeling nervous to leave a place where caregivers were available at any given moment. This therapist validated and normalized feelings, and a plan was made to meet during his next outpatient visit.

POST-TRANSPLANT ADJUSTMENT

The first year following transplant is oftentimes difficult for both patients and their family members. With follow-up visits, different medication protocols, post-transplant limitations, and challenges including immunosuppression, patients and families learn that "they have traded a life threatening illness for a chronic

condition" (Stuber, 2010). Months after transplant, Paul returned home and began to experience depressive symptoms. Paul's mother began to notice that he would cry and hide under tables after interacting with other children. The psychological toll of rehabilitating post-transplant, coupled with physical restrictions that prevented him playing with other children, impacted Paul's overall quality of life. In his journal, Paul described profound sadness and a wish to not live any longer. He drew pictures of a tombstone with his name on it. He began seeing a counselor weekly for suicidal ideation and was occasionally able to meet with his art therapist during outpatient doctor's visits.

Paul re-engaged quickly in art therapy due to the pre-established therapeutic relationship. Because the therapist bore witness to some of his traumatic medical events, Paul could easily reference prior medical experiences. Paul would also reference several art projects he created while he was hospitalized, using art as a demarcation of experience. During outpatient art therapy sessions, Paul created characters with Model Magic. His imagery and play mimicked themes present in earlier artwork. He manipulated the Model Magic in a similar way as before, eliciting this therapist's assistance to poke the slab of Model Magic and then stretching the model magic to create a marbling color effect. Before creating his Model Magic characters, he would trace the Model Magic slab on a sheet of paper, perhaps to indicate where his characters came from and to visualize transformation.

"Mr. Angry Monster," the first character Paul created, had a large hole in the middle of his face, reminiscent of the vacant spaces in his earlier drawings. Eventually, the large whole morphed into a mouth, giving "Mr. Angry Monster" a voice to express feelings (Figure 8.7). "Mr. Jones" and "Mr. Smarty Pants" were two snowmen that required devices made out of blue pipe cleaners to "be alive." A shell with a face drawn on with marker was an unnamed character that vacillated between being a "good guy" who saved other characters when they were in danger, and a "mean guy" who afflicted pain to other characters to get revenge. Paul also constructed and deconstructed worlds where these characters would interact.

Paul began reenacting traumatic experiences through his characters and asked the therapist to video-record their interactions. Themes of danger, losing body parts, and returning to safety were prevalent. In Paul's play, "Mr. Angry Monster," "Mr. Jones," and "Mr. Smarty Pants" all experienced similar hardships—not being able to eat, losing a part of their body, and requesting help for their body to be "healed" or "whole again." Sometimes the characters were displaced and separated from one another due to "epic earthquakes." The question "Where am I?" was verbalized repeatedly by all characters, perhaps speaking to experiences of disorientation as well as identity issues, along with fears of annihilation. Through play, the characters repaired and ultimately found safety while Paul worked through feelings of loss, anger, fear, and frustration. Because these scenes were recorded, Paul was able to re-watch these life events over and over, as a way to process and understand his experience.

Paul was also able to work through feelings of guilt post-transplant. There were three main sources of guilt—receiving an organ from a deceased child; thinking that he "caused" health issues in his baby brother, who was born with minor cardiac issues; and the effect his hospitalization had on his family. While these issues were explored pre-transplant, Paul was able to explore more deeply post-transplant as he began to reestablish relationships with others and his relationship with himself. The therapist also supported his mother as she recalibrated her overprotective relationship with Paul as he grew stronger post-transplant.

Figure 8.7 Mr. Angry Monster. Paul created Mr. Angry Monster and other characters out of Model Magic and used them in play. In Paul's play, themes of danger, losing body parts, requesting to be "whole again," and returning to safety were prevalent.

Post-Traumatic Growth and New Narratives

Paul was later seen by his art therapist when psychiatric symptoms subsided. It was a celebratory time for Paul, near the anniversary of his transplant, his "second birthday," and his brother's birthday. At this time, Paul's artwork appeared more contained and organized and less emotionally charged. Planets revolved in solar systems and cars raced along racetracks (see Figure 8.8).

His subjects had clear paths, and while there were still obstacles in his art, they were far less threatening. Paul began to verbally reflect upon the traumas he endured during his hospitalization, without feeling flooded. He was no longer hyper-reactive when recalling past events. He also showed an increased capacity to reflect on positive events including his Make-A-Wish trip to Disneyland and his efforts in learning how to ride a bike: "I keep practicing and didn't give up." Paul also reflected on the relationships

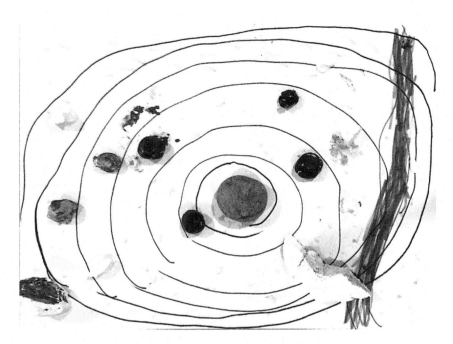

Figure 8.8 Solar System. A year following transplant, Paul's images were more contained and organized and less emotionally charged. Although not completely void of danger, Paul's images revealed restored order, and he began to verbally reflect on the many traumas he endured, indicating adjustment to life post-transplant.

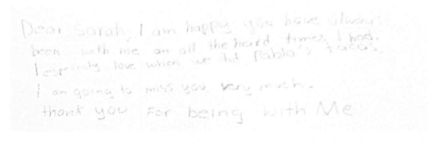

Figure 8.9 Note to therapist. During the last art therapy session, Paul spent time writing letters of gratitude. Paul was able to reflect on the relationships he built during hospitalization. His participation in these relationships was inherently hopeful, an act of living, and brave given his medical condition.

he built during hospitalization with his doctors, child life specialist, art therapist, and others. His participation in these relationships was inherently hopeful, an act of living, and brave given his medical condition. During our last session together, Paul spent time writing letters of gratitude (Figure 8.9). When asked what helped him most about his relationship with his art therapist, Paul simply stated, "just being with me."

Discussion

Paul's case depicts a child grappling with existential questions of self and human connection. Although greatly supported by his well-bonded family and through a consistent therapeutic attachment, Paul was deeply troubled by the prospect of losing a part of himself and acquiring a part of someone else. For an eight year old, and likely for many individuals faced with the reality of undergoing heart transplant, this is an abstract concept. In Paul's case, his internal psychological struggles were evidenced through art imagery and symbolic play, revealing a portrait of moral and spiritual distress. From a strengths-based viewpoint, Paul was able to re-author his personal trauma narrative and claim his self using art and other creative modalities.

Art therapists are invested in the field of traumatology and trauma-focused care. Paul's extensive medical history and invasive, life-threatening medical procedures leading up to and culminating in heart transplant manifested in symptomology consistent with post-traumatic stress syndrome (PTSS) or post-traumatic stress disorder (PTSD). Much of his trauma experience was not verbally expressed or processed but rather addressed in art therapy through a strengths-based psychotherapeutic approach supporting the discovery of alternate modes of expression, enabling post-traumatic growth and resilience. Paul demonstrated mastery, problem-solving skills, impulse control, and alternate modes of expression that bolstered esteem and helped to integrate his experience of heart transplant.

Medical Trauma and Art Therapy

As explored above, art therapists practicing in a pediatric healthcare setting must be attuned to the unique emotional vulnerabilities in patients brought about by traumatic medical experiences and evidenced by regressive art-making, perseveration or repetition of an event or experience, and the inability to verbally externalize the traumatic event. These and other post-traumatic stress symptoms (PTSS) include, "re-experiencing the event or intrusive thoughts, avoidance of trauma reminders, hyper-arousal, dissociation, and negative changes in mood or cognition" (Marsac et al., 2016, p. 71). The term medical traumatic stress is used to identify similar psychological manifestations such as PTSS but in response to medical injury or illness in patients and families.

Traumatology is fundamentally compatible with art therapy study and practice. It is commonly understood across mental health disciplines, thanks to advances in neuroscience, that the experience of trauma is largely nonverbal. In crisis, "higher verbal regulatory functions in the cerebral cortex are out of reach" (Hass-Cohen & Carr, 2008, p. 33). Van der Kolk supports this concept of sensory-somatic experiencing of trauma by stating that traumatic memories are experienced as "fragments of the sensory components of the event" (van der Kolk et al., 1997, p. 103). This inability to integrate felt experience into a larger whole becomes the main problem of trauma and thereby primary treatment goal for trauma-focused treatment and recovery. For children, particularly those who have not yet developed language skills, the impact of trauma may endure somatically and manifest throughout childhood development, adolescence, and adulthood. Paul's landscape paintings helped to give voice despite trauma.

Art therapists, naturally versed in the practice of utilizing diverse material and modalities, are uniquely suited to address the symptoms of trauma by unlocking a channel of communication, made possible by exploring the tangible, textural, multisensory stimulating art materials and processes, which then become symbolic extensions, representations, and externalizations of experience and identity (King, 2016). Van der Kolk

et al. (1997) supports this concept of sensory-somatic experiencing of trauma by stating that traumatic memories are experienced as "fragments of the sensory components of the event" (p. 103). This inability to integrate felt experience into a larger whole becomes the main problem of trauma and thereby primary treatment goal for trauma-focused treatment and recovery.

Post-Traumatic Growth and Resilience

Herman (1992) describes the stages of recovery from trauma as first establishing safety, then reconstructing the traumatic story, and finally restoring the connection between the survivor and community. Psychosocial clinicians engaged in trauma-focused work may employ a family-systems-based resiliency model (Disability-Stress-Coping Model; Transactional Stress and Coping Model; Social Ecological Model) to promote enhanced coping with chronic medical conditions (Mullins et al., 2015). Earlier concepts of Post-Traumatic Growth (PTG) theory suggested that an individual's "assumptive world" must be destroyed entirely by traumatic events in order to move into a phase of growth. Writers Picoraro, Womer, Kazak, and Feudtner (2014) describe the concept of "threatened schemas" whereupon trauma either overwhelms or integrates into the schema, forcing an alternative outcome and reshaped worldview. This evolution will vary greatly and will elicit either decreased resilience, an acute PTSD presentation, or enhanced capacity as in PTG (p. 211).

PTG is believed to include five domains, all of which Paul demonstrated over time: "greater appreciation of life; improved interpersonal relationships; greater personal strength; recognition of new possibilities in one's life course; spiritual and religious growth" (Picoraro et al., 2014, p. 211). Although there is limited literature regarding the study of PTG, children, and art therapy, current models suggest that "enhanced capacity" for the integration of trauma into reformulated schemas of self may contribute to traits of resilience. Although Paul's early childhood included illness and trauma, he was able to remain connected to himself, cultivate meaning out of his experiences, and define his self beyond the role of ill person or patient. Utilizing symbolic art and play effectively to convey fears and anxieties, nurture spirituality, and experience connection with others, Paul faced heart transplant actively, compassionately, and with dignity. In situations where Paul's health were out of his control, the power of shaping his own narrative offered seeds of agency.

Recommendations and Conclusions

Providing art therapy services in the inpatient medical setting presents a unique set of challenges and considerations. Importantly, the work is contingent upon the patient's hospitalization, as the therapeutic services and therapeutic relationship typically terminate once the patient is discharged. Although the therapist described in this chapter was able to occasionally see Paul post-transplant, more consistent long-term psychosocial follow-up is recommended. Connecting families to community-based resources and supporting the child's re-entry into school is also recommended. Interdisciplinary support is crucial in addressing the multifaceted needs of children with serious illness. Ongoing psychosocial assessment is also critical as a patient and family's experience and understanding of the illness will shift over time, as will the available resources.

For the therapist, boundaries and the level of intimacy involved are also unique in the hospital setting. Therapists see more than they are traditionally exposed to in

other clinical settings. For example, vomiting, nakedness, and sleeping behaviors are unique to art therapy practiced at the bedside. Therapists may also meet various family members and friends who visit the patient. Whereas most patients visit the therapist's office at a specific time, the therapist meets the patient at a time that is not always determined ahead of time to work around medical care.

Involving family is integral in working with children in the hospital setting. Trusting that caretakers know the child the best, healthcare professionals involve families in all aspects of care. Operating from a family-centered care philosophy that recognizes that the family is the prevailing constant in the life of the child, therapists may tailor their approach to the specific needs of a child and his family. Responding to specific caregivers needs also strengthens overall well-being of the family unit, which invites mutually beneficial relationships and optimized health outcomes.

Art therapists in the hospital setting must adhere to rigid infection control guidelines. All art materials must be new and unused or disinfected prior to use. Universal hand-washing precautions are also required. If the child has any lines or open wounds on hands or arms, as well as other disabilities or limitations, the therapist must first ensure the safety of the child. For example, some children may be unable to use their arm or hand if movement is prohibited. Creativity, flexibility, and working with and adapting to abilities rather than disabilities are standard practice.

Medical art therapists may add an additional material—medical equipment or supplies—for reasons mentioned earlier in the chapter. As with clients recovering from sexual trauma, some fluid or amorphous art materials, as well as clay, may be triggering, invite regression, or mimic bodily fluids or feces. Incorporating natural or organic elements may jeopardize the sterile hospital environment. Since patients are "stuck" in the hospital setting, medical art therapists might encourage families to bring in reminders of home to be used in art or for environmental enhancement. Finally, since sessions are typically facilitated bedside with the child sometimes remaining in the hospital bed, the art therapist should consider ways to ensure a clean and safe space once art-making concludes, as the patient spends the majority of the day there, eating and sleeping. Humanistic art therapy interventions that acknowledge the whole person, engaging physical, psychological, social, and spiritual aspects of self are recommended.

As explored throughout this chapter, medical art therapy with children can provide meaningful and foundational resources that a child may continue to access long after the illness or hospitalization itself. These interventions, which enhance and cultivate internal resources, have the potential to improve long-term emotional and psychological outcomes. Children, who develop the ability to utilize a wide range of coping tools through art and play, may retain this level of cognitive and emotional flexibility when coping with future anticipatory anxiety, loss, relational conflicts, and symptoms of posttraumatic stress. It is our hope that individualized art-based interventions and thoughtfully established therapeutic relationships may significantly improve quality of life for patients and their families as they journey through the experience of medical illness and construct personal definitions of wholeness.

A Final Note on Paul

Since writing this chapter, Paul has celebrated four transplant anniversaries and has adjusted to life post-transplant. He continues to create art and enjoys fishing with his dad. He continues to be followed by his cardiac team on an outpatient basis.

References

Anthony, S. J., Annunziato, R. A., Fairey, E., Kelly, V. L., So, S., & Wray, J. (2014). Waiting for transplant: Physical, psychosocial, and nutritional status considerations for pediatric candidates and implications for care. *Pediatric Transplantation, 18*(5), 423–434. https://doi.org/10.1111/petr.12305

Anthony, S. J., Nicholas, D. B., Regehr, C., & West, L. J. (2014). A struggle to survive: The experience of awaiting pediatric heart transplantation. *Pediatric Transplantation, 18*(8), 868–874. https://10.1111/petr.12368

Association of Child Life Professionals. (2017). *Mission, values and vision statements.* Retrieved from www.childlife.org/child-life-profession/mission-values-vision

Cassell, E. J. (1982). The nature of suffering and the goals of medicine. *New England Journal of Medicine, 307*(12), 758–760. https://doi.org/10.1056/NEJM198203183061104

Coglianese, E. E., Samsi, M., Liebo, M. J., & Heroux, A. L. (2015). The value of psychosocial factors in patient selection and outcomes after heart transplantation. *Current Heart Failure Reports, 12*(1), 42–47. https://doi.org/10.1007/s11897-014-0233-5

Copeland, H., Razzouk, A., Beckham, A., Chinnock, R., Hasaniya, N., & Bailey, L. (2017). Social framework of pediatric heart recipients who have survived more than 15 post-transplant years: A single-center experience. *Pediatric Transplantation, 21*(2). https://doi.org/10.1111/petr.12853

Crenshaw, D. (2008). *Therapeutic engagement of children and adolescents: Play, symbol, drawing, and storytelling strategies.* Plymouth, England: Jason Aronson.

Dew, M. A., Rosenberger, E. M., Myaskovsky, L., DiMartini, A. F., Dabbs, A. J. D., Posluszny, D. M., . . . Greenhouse, J. B. (2015). Depression and anxiety as risk factors for morbidity and mortality after organ transplantation: A systematic review and meta-analysis. *Transplantation, 100*(5), 988–1003. https://doi.org/10.1097/TP.0000000000000901

Dipchand, A. I., Kirk, R., Mahle, W. T., Tresler, M. A., Naftel, D. C., Pahl, E., . . . Kirklin, J. K. (2013). Ten year of pediatric heart transplantation: A report from the pediatric heart transplant study. *Pediatric Transplantation, 17*(2), 99–111. https://doi.org/10.1111/petr.12038

Fenton, J. F. (2008). "Finding one's way home": Reflections on art therapy in palliative care. *Art Therapy: Journal of the American Art Therapy Association, 25*(3), 137–140. https://doi.org/10.1080/07421656.2008.10129598

Haber, D. (2006). Life review: Implementation, theory, research and therapy. *International Journal on Aging and Human Development, 63*(2), 153–171. https://doi.org/10.2190/DA9G-RHK5-N9JP-T6CC

Hass-Cohen, N., & Carr, R. (Eds.). (2008). *Art therapy and clinical neuroscience.* London, England: Jessica Kingsley Publishers.

Herman, J. (1992). *Trauma and recovery.* New York, NY: Basic books.

King, J. L. (Ed.). (2016). *Art therapy, trauma, and neuroscience: Theoretical and practical perspectives.* New York, NY: Routledge.

Kuo, D. K., Houtrow, A., Arango, P., Kuhlthau, K., Simmons, J., & Neff, J. (2011). Family-centered care: Current applications and future directions in pediatric health care. *Maternal and Child Health Journal, 16,* 297–305. https://10.1007/s10995-011-0751-7.

Lefkowitz, D. S., Fitzgerald, C. J., Zelikovsky, N., Barlow, K., & Wray, J. (2014). Best practices in the pediatric pretransplant psychosocial evaluation. *Pediatric Transplantation, 18*(4), 327–335. https://doi.org/10.1111/petr.12260

Malchiodi, C. A. (1999). *Medical art therapy with children.* London, England: Jessica Kingsley Publishers.

Marsac, M. L., Kassam-Adams, N., Hildenbrand, A. K., Nicholls, E., Winston, F. K., Leff, S. S., & Fein, J. (2016). Implementing a trauma-informed approach in pediatric health care networks. *JAMA Pediatrics, 170*(1), 70–77. https://doi.org/10.1001/jamapediatrics.2015.2206

Miller, L. (2015). *The spiritual child.* New York, NY: St. Martin's Press.

Mullins, L. L., Molzon, E. S., Suorsa, K. I., Tackett, A. P., Pai, A. L., & Chaney, J. M. (2015). Models of resilience: Developing psychosocial interventions for parents of children with chronic health conditions. *Family Relations, 64*(1), 176–189. https://doi.org/10.1111/fare.12104

The National Child Traumatic Stress Network. (2017). *Medical trauma*. Retrieved from www.nctsn. org/trauma-types/medical-trauma

Parent, J. J., Sterrett, L., Caldwell, R., Darragh, R., Schamberger, M., Murphy, D., & Ebenroth, E. (2015). Quality of life following paediatric heart transplant: Are age and activity level factors? *Cardiology in the Young, 25*(3), 476–480. https://doi.org/10.1017/S1047951114000134

Picoraro, J. A., Womer, J. W., Kazak, A. E., & Feudtner, C. (2014). Posttraumatic growth in parents and pediatric patients. *Journal of Palliative Medicine, 17*(2), 209–218. https://doi. org/10.1089/jpm.2013.0280

Puchalski, C. M. (1999). Taking a spiritual history: FICA. *Spirituality and Medicine Connection, 3*(1), 748.

Renzenbrink, I. (Ed.). (2012). Voices. *Illness, Crisis & Loss, 20*(4), 397–397.

Rode, D. C. (1995). Building bridges within the culture of pediatric medicine: The interface of art therapy and child life programming. *Art Therapy: Journal of the American Art Therapy Association, 12*(2), 104–110. https://doi.org/10.1080/07421656.1995.10759140

Ronnberg, A. (2010). *The book of symbols: Reflections on archetypal images*. Cologne, Germany: Taschen.

Rossano, J. W., Cherikh, W. S., Chambers, D. C., Goldfarb, S., Khush, K., Kucheryavaya, A. Y., . . . Stehlik, J. (2017). The registry of the international society for heart and lung transplantation: Twentieth pediatric heart transplantation report—2017, Focus theme: Allograft ischemic time. *The Journal of Heart and Lung Transplantation, 36*(10), 1060–1069. https://doi. org/10.1016/j.healun.2017.07.018

Rutenberg, M. (2008). Casting the spirit: A handmade legacy. *Art Therapy: Journal of the American Art Therapy Association, 25*(3), 108–114.

Seftel, L. (2006). *Grief unseen: Healing pregnancy loss through the arts*. Philadelphia: Jessica Kingsley.

Siegel, D. (1999). *The developing mind: How relationships and the brain interact to shape who we are*. New York, NY: The Guilford Press.

Smith, L. D., & Yazdian, S. R. (2017). Can you help me say goodbye: Sibling loss & bereavement support in the healthcare environment. In B. MacWilliam (Ed.), *Complicated grief, attachment, and art therapy: 14 ready-to-use protocols* (pp. 249–262). London, England: Jessica Kingsley Publishers.

Stuber, M. L. (2010). Psychiatric issues in pediatric organ transplantation. *Child & Adolescent Psychiatric Clinics of North America, 19*(2), 285–300. https://doi.org/10.1016/j.chc.2010.02.002

Thompson, R. H. (2009). *The handbook of child life: A guide for pediatric psychosocial care*. Springfield, IL: Charles C. Thomas Publisher.

Todaro, J. F., Fennell, E. B., Sears, S. F., Rodrigue, J. R., & Roche, A. K. (2000). Cognitive and psychological outcomes in pediatric heart transplantation. *Journal of Pediatric Psychology, 25*(8), 567–576.

van der Kolk, B. A., Burbridge, J. A., & Suzuki, J. (1997). The psychobiology of traumatic memory. *Annals of the New York Academy of Sciences, 821*(1), 99–113. https://doi.org/10.1111/ j.1749-6632.1997.tb48272.x

9
Strength-Based Art Therapy With Adolescent Psychiatric Patients

CHRISTOPHER MAJOR

While therapeutic intervention with adolescents has historically emphasized treatment of pathologies, development of strengths has become a more prominent treatment focus and often yields more sustainable and perceived beneficial short- and long-term outcomes (Cook et al., 2017). Development of narcissism, regression, and attachment are considered factors in the etiology of borderline personality structure (Scott & Saginak, 2016). Reflection within the context of narrative process has been found lacking in persons with borderline traits (Górska & Soroko, 2017), and self-harm and diffuse sense of self are risk factors for borderline personality disorder (American Psychiatric Association, 2013). The case of a 16-year-old African American cisgender young woman named Janelle will be considered in terms of these phenomena.

I had the pleasure of working with Janelle in a psychiatric outpatient art therapy group setting. Because Janelle had received a tentative primary diagnosis of borderline personality disorder (BPD), I will review literature pertaining to developmental aspects of narcissism, self-concept, attachment, regression, borderline personality traits, and personal narrative in order to provide background for consideration of Janelle's case (American Psychiatric Association, 2013).

It should be noted that certain aspects of "disordered" behaviors, such as attention deficit hyperactivity disorder, might be attributed to anxiety associated with the typical development of an adolescent brain and psyche (Ziobrowski, Brewerton, & Duncan, 2018). I suggest here that borderline personality traits might also be worthy of this conceptualization. Perhaps borderline traits, exacerbated by adverse childhood events, could be considered part of the adolescent personality profile; this in contrast to BPD, which is characterized by such symptoms as immature coping, impulsivity, interpersonal hypersensitivity, self-harm, anxiety, depression, and diffuse self-concept and persists into adulthood or, at minimum, for over a year (American Psychiatric Association, 2013). Although Janelle certainly exhibited many of these traits, it should be acknowledged that they often affect adolescents, whether associated with borderline traits or not, and warrant treatment (Polanczyk, Salum, Sugaya, Caye, & Rohde, 2015).

Whether Janelle met the criteria for borderline personality disorder, or exhibited borderline traits secondary to adolescent development, art therapy was deemed by her treatment team as a viable and appropriate treatment modality. Because creative process is its central mechanism, art therapy can provide opportunities for clients to learn new ways of thinking, feeling, behaving, and being (Stepney, 2017, p. 161). Art-making can support community relatedness, creativity, and ability to solve problems. Coping

skills, conflict resolution, and resilience may also be enhanced (Rosal, 2016), all of which temper aspects of borderline pathology.

Relevant Constructs for Treatment With Adolescents

Narcissism

Healthy narcissism is linked to pro-social behavior in at-risk adolescents, whereas a vulnerable or fragile narcissistic structure is not (Kauten & Barry, 2016). Vulnerable narcissism, or a self-concept that is prone to narcissistic injury, correlates with erratic parental supervision, intervention, and reinforcement. This concept is of particular salience in the case of Janelle, who had experienced inconsistent parenting throughout her young life and who presented in art therapy as grandiose yet extremely fragile. Increased narcissism can function in adolescents as a defense against the anxiety (Barry & Kauten, 2014) that might result from increasing autonomy or, in more dire cases, the lack of familial base, as we will see with Janelle. The narcissism of many adolescents is tenuous because it is bifurcated so as to represent an all-or-nothing state of self-regard. Resulting artistic self-representations can therefore take on an ambivalent quality of enhanced prominence combined with anxious uncertainty (Linesch, 2013, p. 15).

Among the narcissistic tasks confronting the adolescent clients are the integration of their grandiose and worthless self-concepts and attenuation of their self-concept from what they believe are others' perceptions of them (Kohut, 2013). In other words, a maturing adolescent must transition from vulnerable narcissism, which is characterized by a two-pole system of fragile grandiosity and underlying devastating worthlessness, to a more resilient state of flexible self-regard. Further, as a young person turns away from the family in favor of their peer group, the perceptions of others, either real or projected, become more important; this is especially the case in context of heightened interpersonal sensitivity. In short, self-esteem correlates strongly with perceptions of the social group (Rosenberg, 2015).

Development between puberty and young adulthood entails emphasis on traits such as focus on the self, power struggles with adults, and establishment of values that may be held as independent of those of the family or authoritative systems. All of these traits can be can be expressed through art-making (Malchiodi, 2011).

Regression

In the case vignette presented here, an adolescent who is experiencing multiple stressors, including a fractured family structure, reacts to the anxiety of joining a new art therapy group by retracting into her own world via her cell phone. In later sessions, she resorts to acting out physically (as represented in her narrative artwork) as a way of coping with conflict and finally removes herself from the narrative altogether by allowing herself to be annihilated. If we interpret Janelle's behavior as corresponding to immature defenses such as denial, acting out, splitting, or turning against the self (Vaillant, 1992), then we might consider an overall pattern of regression (Laczkovics et al., 2018). Janelle's ability to utilize more mature defenses at times, while at other times reverting back to an immature defensive style, could be considered further evidence of regression (Vaillant, 1992). It should be noted that regression itself is considered a defense mechanism, suggesting that defense mechanisms may not be discrete phenomena but more likely a complex web of interrelated, and in some cases nested, intrapsychic patterns.

Linesch (2013) saw regression, or a behavioral return to a previous stage of development, as an adolescent's attempt to defend against the anxiety of separation from the family and movement toward the autonomy of adult life. Others have theorized that existential anxiety can also be caused by family disintegration or turmoil, resulting in use of regression as a defense (Landgarten, 2013). Family disintegration due to divorce, death of a parent, relational conflict, or abuse can also result in false and premature maturation, which might take the form of parentification and possibly contribute to a propensity for behaviors such as substance use, premature sexual activity, self-harm, and/or disregard for social norms (Sang, Cederbaum, & Hurlburt, 2014). If we consider these behaviors to correspond to immature coping mechanisms, then it seems the premature maturity is fragile, incomplete, and prone to breaking down, leaving the prematurely mature adolescent more susceptible to precipitous regression.

The adolescent's desire for autonomy conflicts with their early attachments, potentially leading to ambivalence in the necessary transition from family bonds to peer relationships. A young person may therefore employ regression periodically as a defense against separation anxiety (Linesch, 2013, p. 15). Kramer (2001) observed that adolescent art evidences pressure from two opposing forces, presenting at times as stiff, lifeless, and stereotyped and an opposing chaotic, regressive force that, if left unchecked, would result in the destruction of the artwork. After taking an active role in a group narrative, the young artist "Janelle" under consideration in this chapter symbolically destroys her artwork by allowing her character "Darka" to be annihilated by group members in a collaborative narrative. We will see Janelle regress suddenly from an organized, ethically clear self-state with the ability to influence others to being "blown up," resulting in absence from the group narrative and psychic nothingness. However, we will see her in partial regression, characterized by briefly aligning with the group's baser instincts. Janelle is only able to contain her regression briefly, as she occupies a self-state between total control and total regression. Regression can provide a release of creative energy, necessary for artistic expression (Kramer, 2001). Here, it occurs as a disruption of organized functioning that inhibits effective expression of affect (Rubin, 2011).

Self-Harm

Janelle experienced, as do many adolescents, difficulties such as intense emotional turmoil, identity confusion, and inordinate anxiety. These issues might be expressed naturally in chumship, sublimation, or identification with positive objects, but they might also be manifested in such ways as self-harm, acting out, substance use, or isolation (Case & Dalley, 2014). Although non-suicidal self-injury (NSSI) disorder and suicidal behavior disorder (SBD) present with unique features, such as age of onset, they also appear to be associated with common risk factors, such as being female and diagnosed with an affective disorder. NSSI does appear to be a predictor of greater occurrence of SBD. Therefore, psychiatric adolescent patients should always be assessed for suicide when NSSI is present (Groschwitz et al., 2015) with an instrument such as the Columbia-Suicide Severity Rating Scale (C-SSRS) to assess suicide risk at the time of treatment (Posner et al., 2011) or the Self-Injurious Thoughts and Behaviors Interview (SITBI), which provides more historical data (Nock, Holmberg, Photos, & Michel, 2007). In all cases, practitioners should use a suicide assessment tool that is prescribed by their practice, institution, and/or jurisdiction.

Motivation for NSSI might be seen as an attraction to physical stimulation as a way of escaping or blocking out negative emotions. It might also be a way for a patient to gain control of their emotions (Selby, Nock, & Kranzler, 2014). Adolescents have reported they are motivated to self-harm to obtain release or control aversive feelings, to demonstrate feelings they perceive as not being accepted by others, and even to connect with a peer group who have shared similar experiences (Stänicke, Haavind, & Gullestad, 2018). Attitudes toward the lasting marks left by self-harm vary between individuals. Some regard their scars as signifying resilience, in support of a self-narrative that features survival in the face of hardship. Others might come to accept their scars only after going through a period of disgust or shame. Still others express ambivalence toward the visible remnants of self-harm, seeing them as concrete evidence of consolidated identity and deep flaws (Lewis & Mehrabkhani, 2016). I, myself, have worked with adolescents who told me they were ashamed of visible cuts; however, they later felt as if they lost a part of themselves when their self-inflicted cuts healed.

The complex phenomenon of non-suicidal self-injurious behavior also incorporates aspects of coping, albeit maladaptive (Cerdorian, 2005; Laye-Gindhu & Schonert-Reichl, 2005). An adolescent under stress is likely to focus their coping strategy on mediating the internal emotional experience, resulting in avoidance, distancing, and escape. However, a more externalizing coping style, focused on problem-solving and support, has less potential to include self-harming behavior (Guerreiro et al., 2013).

Art interventions have the potential to ameliorate self-harm by increasing self-esteem through a sense of mastery, concretizing emotional experience in a way that can be communicated to others, and sublimating a cathexis of strong emotions into tangible art objects that can be shared, kept private, or even destroyed by the artist. Artistic depiction of problems can help a client conceptualize them as exogenous, as opposed to internal conflicts or flaws, possibly allowing for more externalized coping (Whisenhunt & Kress, 2013).

Attachment

Multiple theoretical models have associated a disordered attachment with vulnerability to BPD and have linked activation of a disordered attachment system to behavioral dysregulation (Mosquera, Gonzalez, & Leeds, 2014). In particular, an approach to attachment objects that vacillates between fear and dependence not only mediates chaotic relationships but could also be a factor in the etiology of identity diffusion or internal split (Liotti, 2013).

A history of mental health issues, aggression, or trauma can correlate with insecure or disorganized attachment in at-promise youth, leading to deficient social understanding and ineffective interpersonal functioning. Raising attachment patterns and perceptions into consciousness can increase mentalizing between clients and therapists, which in turn can support improved self-acceptance and understanding in the client (Bianco, 2017).

Borderline Traits in Adolescents

My patient Janelle, under consideration here, was provisionally diagnosed with borderline personality traits. BPD has been defined in terms of a constellation of symptoms, including pervasive instability in interpersonal relationships, difficulty regulating affect,

undefined self-concept, suicidality, self-harm, and lack of impulse control. Because of the parallels between symptoms of BPD and the vicissitudes of adolescence, a personality disorder cannot be diagnosed until adulthood (American Psychiatric Association, 2013). It has been recently acknowledged that uncertainties of the developmental arc and emotional transitions of childhood and adolescence not only set the stage for the developmental etiology of BPD but can also be the setting for expression of symptoms of BPD. At times, borderline traits are expressed in adolescence that exceed the trajectory of typical development. However, one must be careful to avoid pathologizing expected adolescent developmental challenges or unnecessarily stigmatizing young patients (Kaess, Brunner, & Chanen, 2014).

The Diagnostic and Statistical Manual, Fifth Edition contains two parallel classification systems for defining personality disorders. The categorical diagnostic criteria outlined in the DSM-IV remain, while a dimensional approach addressing traits is described in the Emerging Measures and Models section (American Psychiatric Association, 2013). This bifurcated conceptualization is especially salient to consideration of borderline traits in adolescents.

It has been suggested that diagnosis of BPD in adolescents may be invalid because they naturally exhibit "borderline traits" as a function of their developmental stage. Identity disturbance, poor emotional regulation, sensitivity to social interactions, and impulsivity are consistent with borderline personality, as they are with a typical adolescent level of maturity. However, it has been shown that adolescents who do not show some improvement in these dimensions over a year are likely to be at higher risk for poor long-term outcomes (Paris, 2014).

Borderline personality organization has come to be seen, along with other disorders of personality, in terms of a trait-based dimensional model versus the traditional categorical classification system (Sharp & Fonagy, 2015). The flexibility of this new perspective lends itself to recognition and understanding of problematic personality traits in developing adolescent patients. There is presently a consensus that the dimensional assessment of borderline traits is a valid and useful approach to diagnosing adolescents if the observed symptoms are sufficiently severe, pervasive, and persistent over time (Sharp & Fonagy, 2015). This distinction is particularly important because female adolescents with borderline personality traits have been found to have rates of psychiatric comorbidity higher than those of those with other psychiatric diagnoses. Common among these comorbidities are mood disorders, substance use, dissociative disorders, and eating disorders (Kaess et al., 2013).

Springham and Whitaker (2015) found that art therapists have commonalities in the way they approach the treatment of borderline personality disorder in that they begin by constructing mutual understanding of the disorder and treatment goals with their clients, paying particular attention to attachment throughout the course of treatment. The authors also noted that attachment style has been shown to affect the involvement of clients with trauma histories in group therapy, with regard to therapeutic alliance, and influence clients' interpretation of their relationships within the group.

Personal Narrative

The core issues of adolescence are numerous and must be overlaid onto psychosocial challenges. They include autonomy versus dependence, rejection of oedipal impulses, establishment of sex roles, increased need for privacy, self-definition, self-esteem, and

thoughts about the future—all of which can be disrupted by adversity (Rubin, 2011). Given the complexity of the adolescent experience, it is especially important for the therapist to take an intersectional approach and be willing to address multiple factors, the priority of which is determined by their clients.

Growing up in an environment full of risks certainly presents challenges to the developing adolescent; however, adolescents receiving trauma-focused art therapy have been shown to experience greater reduction in PTSD symptom severity than counterparts receiving treatment as usual (Lyshak-Stelzer, Singer, Patricia, & Chemtob, 2007). Sitzer and Stockwell (2015) noted that art therapy can be useful in preventing the development of psychopathology, as well as treating the multitude of present symptoms in adolescent patients. Further, behavioral changes applied to the process of creative therapies can help adolescents restructure negative or faulty cognitive patterns, thereby allowing the possibility for improved emotional regulation to follow suit (Stepney, 2017). For example, an adolescent beset by overwhelming waves of emotion might find that, in creative therapy, she can delay behavioral reactions that would otherwise have exacerbated her situation.

There is quantitative evidence from controlled studies suggesting that art therapy can be effective in reducing symptoms of post-traumatic stress disorder (PTSD) and increasing self-esteem in adolescents (Slayton, D'Archer, & Kaplan, 2010). Art therapy can be useful in preventing the development of psychopathology, as well as ameliorating present symptoms in adolescent patients (Sitzer & Stockwell, 2015).

Janelle: A Case Vignette

Janelle was 16 years old when I met her. She is an African American girl of low socioeconomic status who attended art therapy groups as an outpatient at a metropolitan psychiatric hospital, after a recent inpatient stay. At the time she was admitted to the outpatient program, Janelle's residence of record was with her father and three younger siblings in public housing. Her mother, who was addicted to opiates, was frequently absent for extended periods of time and would return at unpredictable intervals, hoping to resume normal family relations.

In her pre-teen years, Janelle had been diagnosed with intermittent explosive disorder and attention deficit hyperactivity disorder (ADHD). It was suspected, but not confirmed, that Janelle had been sexually abused by an uncle, so post-traumatic stress disorder (PTSD) was in her differential.

Prior to her time in the outpatient department, she had been admitted as an inpatient three times due to self-harming behavior (cutting), marijuana and alcohol abuse, and a suicide attempt by overdose one year before our first meeting. After each hospitalization, her follow-up had been inconsistent at best. She had been treated in succession with Zoloft, Lamictal, and Lexapro in combination with Clonazepam. She had been restrained in emergency rooms twice due to violent rages. When I saw her, she carried diagnoses of unipolar depression, anxiety, substance use disorder, and borderline traits. She had been involved with law enforcement due to drugs and spent time on probation.

Janelle wore heavy makeup, tight shirts, and jeans. She most often walked in an animated, aggressive manner with her chest thrust forward and spoke loudly. At other times, she would remain silent and still, with her hood up.

While Janelle described her social life as "fine," she also described frequent conflicts with friends, whom she felt would always betray her. She used substances whenever available but was unable to identify benefits of using except to "deal with life." She

described rarely sleeping at home, citing lack of privacy, instead spending nights with a boyfriend or on the street. She had been in a relationship with a 30-year-old man but claimed they had not had sex. It was thought that he supplied her with cannabis and that she continued to see him.

Art Therapy Treatment

Janelle had been referred to the outpatient department due to ongoing SIB and passive suicidal ideation. She had been having difficulty engaging in treatment, expressing opposition to treaters' recommendations, and rejecting home in favor of living with her adult boyfriend. She was started on Prozac and referred for individual and group therapy, including dialectical behavioral therapy and art therapy.

In our first session, Janelle entered the room in an aggressive yet closed-off manner. She sat down abruptly, wearing a hoodie, and refused to put her phone away. Use of devices was not allowed in sessions. An administrator who had been observing entered the room, which proceeded to heighten the conflict. When I reinforced the group norm that phones were not allowed in group, Janelle remained motionless, still staring at her phone. Knowing that Janelle would be extruded from the program otherwise, I proposed that I would hold her phone for 15-minute intervals, between which she would be allowed to check her social media for 15 minutes. After what seemed to me like a very long time, Janelle handed her phone to me, and with the stand-off defused, she began to interact with peers and engage in art-making. The administrator appeared displeased by the "bending of rules," but a compromise, through which Janelle could participate in decision making, seemed important to building a therapeutic alliance. My sense was that this would be in contrast to the all-or-nothing discipline she had likely experienced to date. Fortunately, the alliance did take hold, and Janelle subsequently surprised me by transitioning from isolate to group leader. The sudden nature of Janelle's shift in engagement made me curious, as did her change in demeanor from distant to active and, at times, dominant group member. It struck me that Janelle evidently had reserves of resilience that could be tapped and developed as an objective of her treatment.

In all, I had 12 sessions with Janelle. After our first rough session, Janelle changed in her approach to art therapy. Soon, she would settle down to work after briefly pacing the room, drawing attention from all present—especially the boys. Following her dramatic entrance, she would engage fully in group projects, one of which involved creating characters and a collaborative narrative. Here, Janelle demonstrated remarkable creativity and confidence as she generated and shared a series of original ideas. Of particular interest was a character she named "Darka." This female character was, according to Janelle, taller than all the other characters and possessed super-human strength. Darka could break through brick walls, while at the same time being fashionably dressed. According to Janelle, Darka fought for righteousness and discouraged her peers from engaging in anti-social behavior such as shoplifting. In the group narrative, Darka specifically prevented her peers from stealing a pair of attractive shoes from a store.

Janelle rendered Darka as being very tall, with long arms and legs (Figure 9.1). Darka was dressed in blue and red, with heavy black boots and a long, straight ponytail. Notably, Darka had what appeared to be a void in her abdomen, upon which Janelle declined to elaborate, except to confirm that it was a hole in Darka's body.

As the group developed their narrative, Janelle was always clear that Darka was morally superior and physically more powerful than characters created by her peer group. The group continued to develop their narrative. In one of our final sessions together,

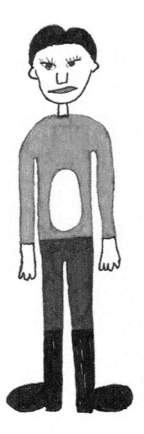

Figure 9.1 Darka—a character created by Janelle during a group narrative activity.

Darka was inside a store, having vanquished all her peers who had turned out to be shoplifters, craving a certain pair of shoes. After admonishing her peers to refrain from breaking the law, Janelle stated that Darka now found herself tempted by the alluring merchandise. She saw the glittering brands on display and contemplated shoplifting them.

Meanwhile, group members, representing the erstwhile shoplifters in the narrative, were gathered outside in the mall parking lot, where they plotted their return. They decided to create tanks, with which they would break through the wall of the store. The group members mounted their tanks, moved forward, and broke through the wall. The first tank to confront Darka aimed its gun at her. Janelle surprised me by deciding to make no attempt to evade the tank. Instead, she stood still and looked directly at it (Figure 9.2). The gun fired, annihilating her. I remember asking Janelle what she would do in this moment. She replied, "Darka is dead."

Recalling that last session, I am not sure if I wanted Janelle to preserve Darka or if I was drawn to the idea that Darka would perish in such a dramatic manner. I said nothing and left it up to Janelle, who seemed unperturbed by the demise of Darka, as

Figure 9.2 Darka and the tank. She makes no attempt to evade annihilation.

if, for her, it was an expected outcome. Janelle explicitly approved of the narrative as it stood and left the session without further comment. At first, I mourned the loss of Darka, as I projected my own meaning onto the character; namely, that I saw Darka as a representation of Janelle herself. This scenario sparked a certain anxiety in me, as I remembered Janelle's history of suicidality. However, I also had a sense that Janelle had grown tired of her creation. Darka had maintained a heroic level of self-control in the face of peer pressure and temptation. Perhaps Janelle was ready to let Darka go, even if I had not done so easily.

I had seen Janelle three times a week for four weeks. She was discharged to the care of a psychiatrist and a female DBT therapist, with whom, I was told, she had difficulty working. The last I heard of Janelle was that she had moved in with her boyfriend and had discontinued therapy.

Discussion

After a brief period of resistance, Janelle engaged in a group narrative that served to normalize her struggles within a therapeutic frame. The group context supported her rehearsal of a more imaginal, powerful character who was morally superior—perhaps an ego ideal. Having created a character to represent her strong ego, Janelle was able to practice restraint from temptation—something she was struggling with in her addiction to cannabis. The role taking in the communal narrative equalized the playing field so Janelle no longer had to prove herself to be superior.

We might conceptualize Janelle as rehearsing functions of adulthood, such as decision making, executive function, and cooperation in contrast to the impulsiveness,

omnipotence, and subjectivity that are characteristic of early childhood. Adolescents maturing out of a stable family base, to which they can return after exploring, making mistakes, and learning, should typically begin developing executive function, cognitive flexibility, and other positive functions. However, kids trying to mature from an unstable family structure are more likely to experience greater challenges as they attempt to develop executive function, emotional regulation, and interpersonal skills.

My first impression of Janelle was that she showed remarkable strength. She was able to work through her initial opposition within one session. In following sessions, she took a leadership role, serving almost as the group's superego. I thought this dramatic transition from nothingness to grandiosity might be an expression of an internal split, but her ability to make the transition was remarkable. I hoped Janelle could get to a point where she could be fallible, without reverting to nothingness. In this case description, Janelle created an idealized imago, and after briefly allowing herself to covet the beautiful shoes her less-than-perfect peers had tried to shoplift, she allowed her imago to be destroyed.

As they mature, adolescents typically move gradually away from family toward their peer group. This transition requires a stable and flexible family environment as well as an accepting and safe social context. Usually, such a move provokes anxiety in the adolescent, even in the presence of a stable family base and benign social environment. Against the backdrop of positive family and social context, transitional anxiety may be mediated by the adolescent's sense that they can move from peers to family and back again, as needed. If the transition progresses effectively, certain developmental objectives can be achieved, such as self-regulation, cognitive flexibility, healthy narcissism, consolidated self-concept, and libidinal functioning.

The transition from family toward a wider social context is made more difficult for the adolescent if the family structure is tenuous and/or if the peer group is hostile. Unfortunately, this is the state of affairs in which Janelle found herself, leaving her with an intensely defensive demeanor that was seemingly the result of a pervasive sense of being unsafe. Having grown up with only her father in the house and taking care of younger siblings, she may have been required to take on a parental and spousal role in her family due to circumstance—even if sexual abuse was not a factor. As a result, Janelle may have experienced accelerated maturation and weak boundaries within the family, increasing her vulnerability to developing BPD traits (Vanwoerden, Kalpakci, & Sharp, 2017). It is possible that the lack of safe transitional attachment figures had led to Janelle's attraction to adult men and sexualized approach to relationships in general, as evidenced by her older boyfriend and approach to boys in the group.

In our first session, Janelle demonstrated a rigidity that one might expect from a much younger child, as she refused to give up her cell phone. Even under threat of discharge from the program—most likely back to an inpatient setting—Janelle remained headstrong and unyielding. Attempts at motivational interviewing, i.e., asking about the perceived benefits of her cell phone, were met with no response. Although the situation highlighted Janelle's difficulty coping and most likely mirrored her previous conflicts with adults, she was able to be flexible when I suggested a compromise. I suggested she hand me her phone for a short period of time. I interpreted Janelle's ability to compromise as a sign of strength and a first step toward participating in art-making and possibly therapy in general.

It seems an adolescent can eventually come to the realization that, in reality, adults are no more omnipotent than children. First, they are likely to play with this concept by devaluing authoritative adults around them. The goal in therapy would be that,

eventually, the adolescent can come to see certain adults as allies. In order to do so, the adolescent must convert their transference to adults from one of authoritarian or oppressor to partner and collaborator. If the parent or caregiver is not able to make this transition, then a safe, non-parental person such as a therapist or other transitional figure might need to play a part (Lamb, 2012, p. 38).

Thus, adults should, and must, ask adolescents to make decisions and ask them to cooperate with those who might oppose their impulses. For the adolescent patient, such a realization most often provokes some level of anxiety in context of an ambivalent desire for autonomy versus the security of adult control. If this is true, striking a compromise with an adult could also evoke anxiety. Many adolescents find fault with, or devalue, the adult who is willing to share some authority as an immature way to defend against the anxiety inherent in increased demand on their own egos. Such a defense could take the form of affect reversal, where the client expresses affection by insulting the therapist. It could also be manifested as regression, acting out, splitting, or any number of immature defenses.

Further, due to their heightened state of interpersonal sensitivity, adolescents tend to over-value emotional cues from those around them, including therapists. It is, therefore, important for the art therapist to be aware of, and manage, countertransferential anxiety when, for instance, an adolescent client refuses to participate in a group directive. Resistance can be seen as coping, so it is important to remember that ego defense is not, in and of itself, maladaptive. Rather, the mechanisms employed may prove more or less effective depending on their level of maturity. Thus, a state of resistance can be seen as an opportunity for therapeutic progress (Shapiro, 2015). When an adolescent client appears to favor immature defenses such as devaluation, withdrawal, projective identification (a combination of acting out and countertransference), or splitting, the therapist does not seek to remove those defense mechanisms but to replace them with more mature and effective mechanisms such as altruism, humor, and—especially salient to art therapy—sublimation.

Janelle presented with an underdeveloped defensive approach, perhaps understandably, given her unstable family base and threatening social environment. When challenged, Janelle resorted to an all-or-nothing strategy characterized by domination or annihilation but without shades in between. One might refer to dialectical behavior as splitting, where all situations and people (including the self) are divided into all-good and all-bad. In our first session, Janelle seemed to feel that the only alternative to keeping her cell phone was to completely disintegrate her relationship with the hospital program, along with the policies and staff who represented it.

Subsequently, Janelle participated in group art-making in a dominant way, thereby stimulating her less motivated peers to participate. She was very specific about how Darka should look, including the void in her abdomen, a feature on which Janelle remained silent and which the group accepted without comment. She designed the shoes that would come to be coveted by the shoplifters, and, in the end, it appeared she made a conscious decision to allow Darka to be destroyed by the tank. It seemed that Janelle found some comfort in this outlook that allowed only for extremes. Perhaps she found some sense of control by implying "I'm in charge or I'm gone."

However, Darka and therefore Janelle came to a point in the group narrative where she had to make a decision. She contemplated taking the beautiful shoes and then using her power to escape. She could have done so because the narrative was completely open. Instead, she decided to metaphorically die.

When treatment began, I was tempted to focus exclusively on Janelle's deficits. In keeping with convention and my institution's approach, I formulated a treatment plan

that focused on making progress in problem areas. However, as I began to know her better, I found Janelle to be strong in many ways. When I first met her, she was largely unable to apply her strengths to her own betterment in purposeful ways. Yet Janelle exhibited great strength, even in the extremes of splitting; this was in contrast to some of her peers whose self-determination was perpetually vague, making them inordinately susceptible to social influences. I began to suspect that Janelle had somehow learned to defend her self-concept, even as she continued to build an understanding of who she was as a person. I began to think that Janelle's defenses were not only causing her problems but were also signs of strength and were holding her together for the moment.

First, I noticed that Janelle was able to engage in a compromise over the cell phone. While others might have seen her as purely troublesome, it seemed to me that her ability to move off of her entrenched position, just a little bit, was indication that she could participate in problem solving, tolerate compromise, and move away from an all-or-nothing stance even when emotions ran high. Next, she took a leadership role after observing me trying to motivate her peers to make art and to engage in the group process, with limited success. Did she identify with me as a frustrated leader? I felt there was very likely a paternal transference where I, a middle-aged male, was concerned. If so, the transference could very well present itself as a conflation of both spousal and father/child relationships given Janelle's experience. In light of this interpretation, I was careful to maintain physical space between Janelle and myself, and I was vigilant against any seductive interactions, although none occurred. Perhaps Janelle was more tolerant of boundaries and therefore better able to form a nuanced multifaceted relationship than I had thought.

Recommendations

There will always be things we don't know about our adolescent clients, so therapists must rely on certain assumptions while prepared to be wrong, realigning our goals and interpretations as we go. Therapists need to remain open and not reductive in their approach. Adolescents can surprise us with their strength and resiliency, and we must consider the frame of our own cultural biases and blind spots. If adherence to assumptions becomes rigid or dogmatic, it is likely to fail to deliver therapeutic benefit. Instead, the therapist should hold theory and experience in reserve. This is especially true when working with adolescents.

Creating art, allowing it to exist, reflecting on it, and sharing it with others can be challenging for a client with borderline personality traits. However, in doing so, the client may increase their ability to tolerate distress, accept their art as a self-imago, and mindfully react to it and the work of others. Representation of emotion through formal artistic elements can help clients contain, reflect on, and regulate emotions in the moment. Multifaceted or layered artwork has the potential to embody conflicting emotional states or seemingly incompatible aspects of self-concept. Collaborative art-making can provide context for development of interpersonal skills, as can creation of characters and imagining interactions between them. Safe role-play fosters creative problem solving and potentiates opposite action outside the heat of emotional experience.

With this population, as with all others, curiosity and understanding are often more important than teaching. Although many adult caregivers will try to reshape their

adolescents' behavior through incentives and punishment, the adolescent will progressively reject such interventions as they mature. Interaction with a therapist who is respectfully curious about the adolescent's experience, able to avoid taking on the emotional charge associated with conflict, and who is open to compromise can afford an adolescent opportunities to develop mature coping skills and resolve a more distinct sense of self (Greene, 2011).

Art therapy has been shown effective in treating personality disorders, specifically by increasing mature coping skills and regulation of emotional self-states (Haeyen, van Hooren, van der Veld, & Hutschemaekers, 2018). In terms of technique, involvement of the art therapist in art-making can demonstrate attention to the client, thereby supporting the therapeutic relationship and potentially engaging clients who might otherwise resist alliance due to disrupted attachment mechanisms (Springham & Camic, 2017).

For the adolescent, the therapeutic alliance is likely to be novel in several ways. First, they have the opportunity to experience something other than an authoritarian relationship. In the case of Janelle, I, as the therapist, tolerated the anxiety inherent when she began to express autonomy. Thus, the child's viewpoint is taken into consideration. Ideally, this situation teaches the child to make decisions, while the consequences continue to be mediated by an adult. My hope is that this happened with Janelle.

How does one establish an alliance with an adolescent? I have tried to ask adolescents this question, and I have attempted it in many ways. In my own practice with adolescents, the harder one tries to connect, the wider the void seems to grow. Adolescents are sometimes able to articulate their needs, but more often they can, and will, provide verbal and behavioral clues. Teens require freedom within certain safe boundaries. Ideally, they will come to know what is allowed and disallowed as part of their own self-regulatory system (Haigh, 2013). Therefore, the authority of the therapist should be implicit and flexible, except in situations where physical and emotional safety are concerned.

Adolescent clients need to know that when seemingly non-negotiable boundaries are tested, the resulting conflicts will be moderated by a caregiver—ideally by a parent but perhaps by the therapist. Here, the caregiver or therapist may act as ego support, moderating conflicts between basic impulses and the superego and teaching more effective coping (Ghuman & Sarles, 2013). If this type of ego support has not been previously present, the adolescent client may have a new kind of relational experience. That is, they have an opportunity to exercise their own judgment in situations with minimal consequences, such as art-making or other activities in the setting of a therapy group.

A common theme of adolescence is isolation. Adolescents intensely want to fit into a peer group but often feel this is impossible or comes at an intolerable cost (loss of self). Projection of negative self-concept onto important others can certainly contribute to an adolescent's unhappiness; however, they can also experience real malicious criticism from others (bullying) which they must process, even at a time when their ego is not fully developed. The developmental period when young people are most vulnerable is also the time when they are likely to engage immature defenses such as projection and regression and less likely to cope through use of such mechanisms as humor, sublimation, or identification (Westen & Chang, 2013).

In the face of this, what is a therapist to do with an adolescent? I suggest stability, safety, unconditional positive regard, facilitation of creativity, respectful curiosity, and willingness to negotiate reasonably. And, of course, validation.

References

American Psychiatric Association. (2013). *Diagnostic and statistical manual of mental disorders* (5th ed.). Washington, DC: American Psychiatric Association.

Barry, C. T., & Kauten, R. L. (2014). Nonpathological and pathological narcissism: Which self-reported characteristics are most problematic in adolescents? *Journal of Personality Assessment, 96*(2), 212–219. https://doi.org/10.1080/00223891.2013.830264

Bianco, M. C. (2017). At-risk youth and attachment-based therapy: Implications for clinical practice. *Canadian Journal of Counselling & Psychotherapy, 51*(1), 81–96.

Case, C., & Dalley, T. (2014). *The handbook of art therapy* (3rd ed.). New York, NY: Routledge.

Cerdorian, K. (2005). The needs of adolescent girls who self-harm. *Journal of Psychosocial Nursing and Mental Health Services, 43*(8), 40–46.

Cook, A., Spinazzola, J., Ford, J., Lanktree, C., Blaustein, M., Cloitre, M., . . . Mallah, K. (2017). Complex trauma in children and adolescents. *Psychiatric Annals, 35*(5), 390–398. https://doi.org/10.3928/00485713-20050501-05

Ghuman, H. S., & Sarles, R. M. (2013). Limit setting with acting-out adolescents. In S. H. Ghuman & R. M. Sarles (Eds.), *Handbook of adolescent inpatient psychiatric treatment* (pp. 224–240). New York, NY: Brunner-Routledge.

Górska, D., & Soroko, E. (2017). Between verbalization and reflection: Referential activity and narrative processes in borderline personality organization. *Psychoanalytic Psychology, 34*(4), 422–433. https://doi.org/10.1037/pap0000117

Greene, R. W. (2011). Collaborative problem solving. In R. C. Murrihy, A. D. Kidman, & T. H. Ollendick (Eds.), *Clinical handbook of assessing and treating conduct problems in youth* (pp. 193–220). New York, NY: Springer.

Groschwitz, R. C., Kaess, M., Fischer, G., Ameis, N., Schulze, U. M., Brunner, R., . . . Plener, P. L. (2015). The association of non-suicidal self-injury and suicidal behavior according to DSM-5 in adolescent psychiatric inpatients. *Psychiatry Research, 228*(3), 454–461. https://doi.org/10.1016/j.psychres.2015.06.019

Guerreiro, D. F., Cruz, D., Frasquilho, D., Santos, J. C., Figueira, M. L., & Sampaio, D. (2013). Association between deliberate self-harm and coping in adolescents: A critical review of the last 10 years' literature. *Archives of Suicide Research, 17*(2), 91–105. https://doi.org/10.1080/13811118.2013.776439

Haeyen, S., van Hooren, S., van der Veld, W., & Hutschemaekers, G. (2018). Efficacy of art therapy in individuals with personality disorders cluster b/c: A randomized controlled trial. *Journal of Personality Disorders, 32*(4), 527–542. https: doi.org/10.1521/pedi_2017_31_312

Haigh, R. (2013). The quintessence of a therapeutic environment. *Therapeutic Communities: The International Journal of Therapeutic Communities, 34*(1), 6–15. https://doi.org/10.1108/09641861311330464

Kaess, M., Brunner, R., & Chanen, A. (2014). Borderline personality disorder in adolescence. *Pediatrics, 134*(4), 782–793. https://doi.org/10.1542/peds.2013-3677

Kaess, M., von Ceumern-Lindenstjerna, I. A., Parzer, P., Chanen, A., Mundt, C., Resch, F., & Brunner, R. (2013). Axis I and II comorbidity and psychosocial functioning in female adolescents with borderline personality disorder. *Psychopathology, 46*(1), 55–62. https://doi.org/10.1159/000338715

Kauten, R. L., & Barry, C. T. (2016). Adolescent narcissism and its association with different indices of prosocial behavior. *Journal of Research in Personality, 60*, 36–45. https://doi.org/10.1016/j.jrp.2015.11.00

Kohut, H. (2013). *The analysis of the self: A systematic approach to the psychoanalytic treatment of narcissistic personality disorders*. Chicago, IL: University of Chicago Press.

Kramer, E. (2001). Art and emptiness: New problems in art education and art therapy. *American Journal of Art Therapy, 40*(1), 6–14.

Laczkovics, C., Fonzo, G., Bendixsen, B., Shpigel, E., Lee, I., Skala, K., . . . Huemer, J. (2018). Defense mechanism is predicted by attachment and mediates the maladaptive influence of insecure attachment on adolescent mental health. *Current Psychology*, 1–9.

Lamb, D. (2012). *Psychotherapy with adolescent girls.* New York, NY: Plenum Press.

Landgarten, H. B. (2013). *Clinical art therapy: A comprehensive guide.* London, England: Routledge.

Laye-Gindhu, A., & Schonert-Reichl, K. A. (2005). Nonsuicidal self-harm among community adolescents: Understanding the "whats" and "whys" of self-harm. *Journal of Youth and Adolescence, 34*(5), 447–457. https://doi.org/10.1007/s10964-005-7262-z

Lewis, S. P., & Mehrabkhani, S. (2016). Every scar tells a story: Insight into people's self-injury scar experiences. *Counselling Psychology Quarterly, 29*(3), 296–310. https://doi.org/10.1080.095 15070.2015.1088431

Linesch, D. G. (2013). *Adolescent art therapy.* London, England: Routledge.

Liotti, G. (2013). Disorganised attachment in the pathogenesis and the psychotherapy of borderline personality disorder. In A. N. Danquah & K. Berry (Eds.), *Attachment theory in adult mental health* (pp. 135–150). New York, NY: Routledge.

Lyshak-Stelzer, F., Singer, P., Patricia, S. J., & Chemtob, C. M. (2007). Art therapy for adolescents with posttraumatic stress disorder symptoms: A pilot study. *Art Therapy: Journal of the American Art Therapy Association, 24*(4), 163–169. https://doi.org/10.1080/07421656.2007. 10129474

Malchiodi, C. A. (Ed.). (2011). *Handbook of art therapy.* New York, NY: The Guilford Press.

Mosquera, D., Gonzalez, A., & Leeds, A. M. (2014). Early experience, structural dissociation, and emotional dysregulation in borderline personality disorder: The role of insecure and disorganized attachment. *Borderline Personality Disorder and Emotion Dysregulation, 1*(15), 1–8. https://doi.org/10.1186/2051-6673-1-15

Nock, M. K., Holmberg, E. B., Photos, V. I., & Michel, B. D. (2007). Self-injurious thoughts and behaviors interview: Development, reliability, and validity in an adolescent sample. *Psychological Assessment, 19*(3), 309–317. https://doi.org/10.1037/1040-3590.19.3.309

Paris, J. (2014). A history of research on borderline personality disorder in childhood and adolescence. In C. Sharp & J. L. Tackett (Eds.), *Handbook of borderline personality disorder in children and adolescents* (pp. 9–17). New York, NY: Springer.

Polanczyk, G. V., Salum, G. A., Sugaya, L. S., Caye, A., & Rohde, L. A. (2015). Annual Research Review: A meta-analysis of the worldwide prevalence of mental disorders in children and adolescents. *Journal of Child Psychology and Psychiatry, 56*(3), 345–365. https://doi. org/10.1111/jcpp.12381

Posner, K., Brown, G. K., Stanley, B., Brent, D. A., Yershova, K. V., Oquendo, M. A., . . . Mann, J. J. (2011). The Columbia—Suicide severity rating scale: Initial validity and internal consistency findings from three multisite studies with adolescents and adults. *American Journal of Psychiatry, 168*(12), 1266–1277. https://doi.org/10.1176/appi.ajp.2011.10111704

Rosal, M. L. (2016). Rethinking and reframing group art therapy. In D. E. Gussak & M. L. Rosal (Eds.), *The Wiley handbook of art therapy* (pp. 231–241). Hoboken, NJ: John Wiley & Sons.

Rosenberg, M. (2015). *Society and the adolescent self-image.* Princeton, NJ: Princeton University Press.

Rubin, J. A. (2011). *Child art therapy.* Hoboken, NJ: John Wiley & Sons.

Sang, J., Cederbaum, J. A., & Hurlburt, M. S. (2014). Parentification, substance use, and sex among adolescent daughters from ethnic minority families: The moderating role of monitoring. *Family Process, 53*(2), 252–266. https://doi.org/10.1111/famp.12038

Scott, S. K., & Saginak, K. A. (2016). Adolescence: Emotional and social development. In D. Capuzzi & M. D. Stauffer (Eds.), *Human growth and development across the lifespan: Applications for counselors* (pp. 347–386). Hoboken, NJ: John Wiley & Sons.

Selby, E. A., Nock, M. K., & Kranzler, A. (2014). How does self-injury feel? Examining automatic positive reinforcement in adolescent self-injurers with experience sampling. *Psychiatry Research, 215*(2), 417–423. https://10.1016/j.psychres.2013.12.005

Shapiro, J. P. (2015). *Child and adolescent therapy: Science and art.* Hoboken, NJ: John Wiley & Sons.

Sharp, C., & Fonagy, P. (2015). Practitioner review: Borderline personality disorder in adolescence—Recent conceptualization, intervention, and implications for clinical practice. *Journal of Child Psychology and Psychiatry, 56*(12), 1266–1288. https://doi.org/10.1111/ jcpp.12449

Sitzer, D. L., & Stockwell, A. B. (2015). The art of wellness: A 14-week art therapy program for at-risk youth. *The Arts in Psychotherapy, 45*, 69–81. https://doi.org/10.1016/j.aip.2015.05.007

Slayton, S. C., D'Archer, J., & Kaplan, F. (2010). Outcome studies on the efficacy of art therapy: A review of findings. *Art Therapy, 27*(3), 108–118. https://doi.org/10.1080/07421656.201 0.10129660

Springham, N., & Camic, P. M. (2017). Observing mentalizing art therapy groups for people diagnosed with borderline personality disorder. *International Journal of Art Therapy, 22*(3), 138–152. https://doi.org/10.1080/17454832.2017.1288753

Springham, N., & Whitaker, R. (2015). How do art therapists structure their approach to borderline personality disorder? *The Arts in Psychotherapy, 43*, 31–39. https://doi.org/10.1016/j.aip.2014.10.013

Stänicke, L. I., Haavind, H., & Gullestad, S. E. (2018). How do young people understand their own self-harm? A meta-synthesis of adolescents' subjective experience of self-harm. *Adolescent Research Review*, 1–19. https://10.007/s40894-018-0080-9

Stepney, S. A. (2017). *Art therapy with students at risk: Fostering resilience and growth through self-expression* (2nd ed.). Springfield, IL: Charles C. Thomas.

Vaillant, G. E. (1992). *Ego mechanisms of defense: A guide for clinicians and researchers*. Washington, DC: American Psychiatric Press.

Vanwoerden, S., Kalpakci, A., & Sharp, C. (2017). The relations between inadequate parent-child boundaries and borderline personality disorder in adolescence. *Psychiatry Research, 257*, 462–471. https://doi.org/10.1016/j.psychres.2017.08.015

Westen, D., & Chang, C. (2013). Personality pathology in adolescence: A review. In A. H. Esman & L. T. Flaherty (Eds.), *Adolescent psychiatry, V. 25: The annals of the American society for adolescent psychiatry* (pp. 69–108). New York, NY: Routledge.

Whisenhunt, J. L., & Kress, V. E. (2013). The use of visual arts activities in counseling clients who engage in nonsuicidal self-injury. *Journal of Creativity in Mental Health, 8*(2), 120–135. https://doi.org/10.1080/15401383.2013.792669

Ziobrowski, H., Brewerton, T. D., & Duncan, A. E. (2018). Associations between ADHD and eating disorders in relation to comorbid psychiatric disorders in a nationally representative sample. *Psychiatry Research, 260*, 53–59. https://doi.org/j.psychres.2017.11.026

DASH©—Draw a Superhero
The Role and Significance of the Superhero in the Art of Children With Trauma

CHRISTINA A. GROSSO

The superhero is a prevalent symbol in pop culture and is familiar to all of us. Fantastical stories of strength, resilience, and power provide the context for their heroism and supernatural mysticism. Due to this familiarity, the superhero can serve as a powerful projective capable of uncovering symbolism from the unconscious and providing insight into the emotional and ideational experiences of the drawer. The superhero serves as an ego ideal for children with trauma and mental illness who can feel the lack or absence of power and control due to their abuse and psychological state. The Draw a Superhero (DASH) directive provides a method in which the art therapist can discern the impact of trauma on the child and further develop coping and mastery of these experiences fostering resiliency and recovery.

Throughout my clinical practice, working with children and adolescents in a variety of treatment settings and from diverse cultural and socioeconomic backgrounds, I was struck by the degree of trauma that complicated and pervaded their lives. Trauma and complex trauma of an interpersonal nature as well traumatic loss were evident. Children often had additional mental health issues, including mood disorders, psychosis, and developmental delays. Trauma was not always known at the onset of treatment due to limited psychosocial histories and non-disclosure from the client. Typically, trauma assessment was conducted through verbal means; therefore, trauma that was not verbally expressed was often unknown, undiagnosed, and untreated.

During my therapy sessions, where I incorporated verbal, play, and art therapies in an integrated manner, I began to see graphic indicators of trauma depicted in the children's play and art that were not present in their verbally administered trauma assessments. As my work progressed, the image of the superhero became distinctly paramount in the artwork of the children. The superhero served as a powerful ego ideal and exemplified characteristics of both strength and vulnerability through the roles of aggressor, protector, survivor, and savior for these children who often felt they had no power and control due to their abuse and psychological state. DASH was created in response to the children's spontaneous artwork and the symbolic interpretations the image offered.

To fully appreciate the powerful role of the superhero in the work of the children, we must first examine the role of trauma, art, and the projective.

Trauma

Trauma can be defined as a shocking and overwhelming event of an actual or perceived threat, loss, or death that can render a person feeling a sense of terror, helplessness, and powerlessness (APA, 2013). Trauma can be directly or indirectly experienced and can continue to impact the person's perception of self, others, world, and development (APA, 2013; Cohen, Mannarino, & Deblinger, 2006). The lasting effects of trauma or post-traumatic stress disorder (PTSD) are characterized by the presence of the following responses: 1) *intrusion*: re-experiencing through nightmares, flashbacks, intrusive thoughts/images; 2) *avoidance responses*: underactivation, emotional numbing, dissociation, denial, thought suppression; 3) *negative cognitions and mood*: maladaptive patterns of thinking about self, others, and situations and persistent negative emotional state (anger, guilt, shame); and 4) *arousal responses*: difficulty concentrating, irritability, and hypervigilance (APA, 2013).

Early trauma can affect children's development, namely attachment. Early attachments dictate what one expects from later relationships and how one deciphers the world and oneself. Complex trauma can emerge when children experience multiple traumas that are severe and persistent, impacting their sense of self and development (Ford & Courtois, 2013). When these traumas occur within the primary caregiver relationship, the lack of consistency in attachment can lead to disorganized attachment, wherein a child can both seek and reject the abusive caregiver and have difficulty initiating and maintaining relationships with others (Bowlby, 1969). Trauma bonding occurs when the child in danger seeks attachment regardless of the safety and consistency of that attachment. The bond with an abuser is strengthened by intermittent reinforcement of both terror and nurturance (van der Kolk, 1989). Hyperarousal and serotonin release further intensifies the bond, driving the child to believe that their survival depends on the abusive attachment. With these complications in attachment, the child is left confused and will find ways to self-protect and survive (Cantor, 2005).

There are many powerful emotions experienced by a child who has been traumatized. Feelings of guilt and responsibility for what has transpired may occur, as well as aggressive behavior, depression, and mistrust of others. The inability to identify and modulate feelings is common; children may not only experience difficulty in labeling and understanding emotion, but they may also lack the coping skills necessary to regulate feeling and behavior (Cohen et al., 2006). Regression, pseudomaturity, seductive behaviors, and social difficulties in sexually abused children has also been observed (Finkelhor and Browne as cited in Malchiodi, 1997) and is referred to as traumatic sexualization. This occurs when a child acquires misconceptions about sexual behavior from the perpetrator, which can be exacerbated through a preoccupation with that area of the body as a way of working through the abuse.

In the event of a traumatic experience, not all children will experience persistent trauma symptoms that lead to a PTSD diagnosis. Van der Kolk (1989) describes that "traumatization occurs when both internal and external resources are inadequate to cope with external threat" (p. 405). When a child's *internal resources*—self-esteem, coping skills, developmental level—along with their *external resources*—support systems such as family/caregivers, community and treatment providers—are adequate, the child can survive the *external threat* of trauma. Essentially, they may never experience lasting trauma symptoms, and recovery may be expedient. These *resources* serve to fuel their resiliency.

Trauma treatment aims to foster resilience in children and provide them with opportunities to increase their mastery and competence. Evidence-based approaches to treatment have proven to be effective in decreasing symptomatology in children through a directive and structured approach, providing skill building during the *safety and stabilization phase*, narrative work during the *remembering phase*, and safety and future orientation work during the *reconnection phase* (Cohen et al., 2006; Herman, 1997). Skill building is an important first step in trauma treatment in that it provides psychoeducation on trauma and coping skills in affect regulation, cognitive restructuring, and embodied stress reduction exercises such as breathing, muscle relaxation, and guided imagery. Trauma memory can be fragmented and confused, and supported narrative work has proven to be effective in offering structure and grounding. Through the supported creation of a trauma timeline and narrative, the child can organize that which was previously jumbled. Art therapy can be particularly helpful in constructing a visual timeline that can be seen and physically reorganized rather than piecing together events in memory alone. Narrative also serves to ground the child and assist them in processing cognitive distortions of shame, blame, and guilt that may have resulted from a traumatic experience. This organization and processing enables the child to transition to the reconnection phase where they can incorporate the trauma into their life timeline and view it as something that "happened to them" rather than what's "wrong with them." During this final stage, resilience is fostered as children are encouraged to look to the future in building healthy relationships, managing triggers, and utilizing coping skills (Cohen et al., 2006; Grosso, 2012).

A critical aspect of trauma treatment is building resiliency wherein a child's strengths and competencies are emphasized and they are provided "opportunities for active choice and empowerment" (Blaustein & Habib, 2017, p. 394). Promoting resilience on an individual level aims to identify a child's strengths and interests through engaging activities such as art, athletics, media, and popular culture (Hornor, 2017). An integrated treatment approach, using both an evidence-based structure coupled with art and play, can be uniquely beneficial to address the multifaceted effects of trauma (Gil, 2016).

Art

[A]rt therapy, a treatment modality that utilizes art expression as its core, has a unique role in the amelioration of violence and its effects. The very nature of image making makes it a powerful means of illiciting [sic] and dissociating painful and frightening images from the self.

(Malchiodi, 1997, p. 5)

Art expression can serve as a primary means of communication for the traumatized child in that it allows for the projection of painful material. Art and play are the primary language of children (Kramer, 1998). Their expression through these mediums are often spontaneous and unfiltered, resulting in a direct and transparent view of their worlds. As traumatic memory can often be locked in the visual spatial center of the brain apart from language, an art-based approach may "provide a greater ability to access implicit memory and types of imagery that are stored in the nondominant hemisphere" (Backos & Samuelson, 2017, p. 58). Art-making can serve as a vehicle to access as well as ground, contain, and organize traumatic memory, enabling a child to make meaning from memory that was previously confused and fragmented (Grosso,

2012). Art allows for a child to fulfill wishes in fantasy; make the passive active; change the outcome; master the previously unmasterable; and assimilate experience through practice of repetition.

The Projective

> Traditionally, a clinical technique qualifies as a projective device if it presents the subject with a stimulus, or series of stimuli, either so unstructured or so ambiguous that their meaning for the subject must come, in part, from within himself.
>
> (Hammer, 1958, p. 169)

According to Buck, the house, tree, and person are familiar objects to everyone and stimulate spontaneous expression (Hammer, 1958). Based on these principles, Buck considered drawings of them to be saturated with significant symbolism from the unconscious. Therefore, the analysis and evaluation of these drawings would provide insight into the emotional and ideational experiences of the drawer (Backos & Samuelson, 2017; Hammer, 1958). The drawing of the person usually elicits a need for "ego-defensive maneuvering" (Hammer, 1958, p. 172) and can be seen as a more conscious projection of self. The person drawing elicits various types of projections, including self-portrait, self-ideal, and perception of significant other and communicates a projection of body image and self-concept.

Expressive aspects are important in analyzing projective drawings because they convey different nuances of meaning. Expressive aspects include sequence, size, pressure, stroke, detailing, symmetry, and placement (Hammer, 1958; Malchiodi, 1997). These expressive qualities can provide insight into the psychodynamic functions of the child. Some argue that distinctive symbolism can be seen in the artwork of clients with trauma (Howard and Jacob as cited in Malchiodi, 1997). Researchers have shown that various themes and symbols emerge in clusters of some of the following: depiction of genitalia, orifices, and phalluses or the lack thereof (Malchiodi, 1997). Elements such as heavy lines and stab marks (Hagood, 1994) and the inclusion of hearts, wedges, circles, and complimentary color schemes may also be evident (Malchiodi, 1997), There may be a disorganization or fragmentation of body parts, and figures may have vacant or blackened eyes and no hands (Malchiodi, 1997; Sidun & Rosenthal, 1987). Children who have been abused may encapsulate their drawings in some type of graphic enclosure, separating the person/object from the surrounding environment (Sidun & Rosenthal, 1987), or castrate body parts in a protective effort to control and contain the abuse (Malchiodi,1997). As we examine the artwork of children, is it important to note that the above referenced symbols can have multiple meanings when viewed in isolation. Artwork needs to be viewed in specific relation to the client and in clustering of symbols.

The Superhero

The superhero is a developmentally appropriate portrayal by children in the latency period and is a symbol of the ego ideal (Kramer, 1998). The superhero is omnipresent and is so familiar to children that it can become internalized, similar to Buck's concept of the house, tree, and person (Hammer, 1958). This familiarity allows a child to identify with the superhero on an unconscious level and project themselves onto the image.

Superheroes are identified by their insignia or crest emblazoned on their chest. This emblem alone can represent the characteristics of strength, resilience, and power pervading cultural and language barriers. Since the definitive superhero, Superman, debuted in 1938 (Siegel & Schuster, 1938), the stories of superheroes have become an entire genre of fiction that has monopolized the comic book world and dominated film and television. Born from ancient symbols in Greek mythology, many modern superheroes have archetypal meaning. From Poseidon (Homer, Verity, & Graziosi, 2011) to Aquaman (DC Comics), generations have been intrigued by their god-like powers and have reinvented their role and presence to compliment human existence. We have seen a rebirth of the superhero in recent blockbuster films from Marvel and DC Comics highlighting roles of woman and people of color, including Wonder Woman, Captain Marvel, and Black Panther. These roles highlight their power, strength, and resilience, an aspect of the superhero universe previously invisible in modern culture. Our children need role models they can relate with to feel seen and heard in a world where they may feel invisible. The superhero fosters hope and resilience. Through these superheroes, they can see their own reflections.

Strength and Vulnerability

Duality often exists in the role of the superhero—strength and vulnerability; aggressor and protector; survivor and savior. Children who have experienced trauma can see the world as all powerful and in turn see themselves as ineffectual (Terr, 1990). In an effort to work through this powerlessness, children can emulate the ego ideal and seek its power (Kramer, 1998). The superhero, as the ego ideal, presents an opportunity for the child to embrace their wish for strength and power, idealizing the superhuman. The "superpowers include flight, speed, invulnerability, acute sensory capacity, telepathy, invisibility, shape shifting, and genius" (Rubin, 2006, p. 12). However, superheroes also possess an "Achilles' heel, a vulnerability that imposes a limit on them" (Rubin, 2006, p. 12), thus unmasking their weakness.

Aggressor and Protector

> Since the aggressive child sees enemies everywhere . . . he is also in constant need of protection. He is preoccupied with ideas about powerful, well defended figures, and to create their images is reassuring
>
> (Kramer, 1993, p. 171).

Through the role of aggressor, children can project anger, shame, and guilt and separate more destructive aspects of self. Children who have experienced being overpowered by a force stronger than them can both fear and idealize that force and identify with the aggressor (Herman, 1997; Kramer, 1993; van der Kolk, 1989). The superhero's use of power and strength can mimic the "overpowering" nature of an abuser and lend itself to processing through traumatic reenactment. However, superheroes transcend the role of aggressor alone and, in their resilience, use their power for "good not evil" as a protector. The superhero can become a metaphorical attachment figure for the child where they can project wished-for attributes of the idealized caregiver (Bowlby, 1969).

Survivor to Savior

Superheroes also present a commonality with the traumatized child in that they have often overcome violence, loss, and abuse (Haen & Brannon, 2002; Ligorski, 1994; Rubin, 2006). Rubin (2006) elaborates:

> Superman's infant arrival from the doomed planet of Krypton and subsequent adoption; violent early childhood traumatization, as in the case of the murder of Batman's (Bruce Wayne's) parents; or is orphaned, as in the case of Spider-Man, who is subsequently adopted and raised by his aunt and uncle. Other superheroes, such as the X-Men, each born a mutant, are raised in a group foster home, where they learn to harness their mutant abilities, or are removed from their parents at birth to protect them, such as Luke Skywalker of the Star Wars saga.
>
> (p. 9)

The trauma, loss, and disrupted attachment experienced by the superhero provides a common ground for the traumatized child. This can assist a child in knowing they are not alone in their traumatic experience and normalize previously experienced stigma, shame, and "otherness." The resiliency modeled can also provide hope for recovery (Cohen et al., 2006; Grosso, 2012). A child can shift from the position of victim to survivor, allowing them to find strength in everyday life as they face adversity and challenges (Haen & Brannon, 2002).

The idea of a savior—an all-powerful figure—to rescue a child from hardship and adversity is a common theme in rescue fantasies. It can serve as an escape from the realities of life and loss and offer an opportunity for wish fulfillment and storytelling (Bettelheim, 1977). The superhero's story of victim-to-survivor-to-savior can provide a child with motivation to create their own trauma narrative and hope for the future. This modeling can illuminate a once dark path from trauma to recovery.

The DASH Directive

Rationale

The Draw a Superhero directive (DASH) is based upon the ideals of the projective in that it seeks to present the client with a directive that is familiar to them, thus promoting a spontaneous response where aspects of self are projected onto the drawing. The intent is that the directive will elicit a self-portrait response and, paired with the ideals of the superhero, offer the child an opportunity for wish and fantasy (Backos & Samuelson, 2017; Hammer, 1958). DASH engages the child's strengths to foster resilience and hopefulness. The strengths depicted often reflect the children's strengths and at other times reflect their vulnerabilities and a desire for specific strengths to counteract their own feelings of helplessness and powerlessness. They can use the strength of the superhero to instill a sense of hope and confidence.

Children can respond to the DASH directive with either a known hero or one they create. A nine-year-old African American boy depicted *Catwoman* as he explored his racial and gender identity. A 13-year-old girl created *Animal Girl*, who found comfort in her therapy dog and created her hero to have the power to talk to animals. *Bliss-master* was created by a 16-year-old girl with severe anxiety and depression whose

hero had the ability to create a state of peace in herself and others with a single close of her eyes.

Procedure

The directive begins by asking the child to "Draw a superhero. Any superhero you want. It can be from your imagination or from a cartoon or story." Once the directive is introduced, the child is asked to use an 8 1/2" × 11" piece of white paper and choice of medium (pencil, colored pencils, crayons, markers, tempera paint).

The ability to choose from a variety of mediums offers achromatic versus chromatic use of color and expressive versus controlled mediums, allowing the child choice. The child can either choose materials they are familiar with or experiment with new ones. The child can also choose more than one medium.

Upon completion of the image, the child is asked the following questions:

Table 10.1 illustrates the DASH Questionnaire, which mirrors the phases of trauma treatment. As this directive can be done at any time during treatment, it can highlight various aspects of a client's progress through trauma recovery. Questions 1 and 2 are identifying characteristics and asking the client to create a name, identity, and developmental stage for their superhero. Question 3 asks about superpowers to identify skills and strengths. The question is strength based and does not directly ask about vulnerabilities. Question 4 begins to illuminate client insight and memory. It is not meant to cue a narrative response but rather indicate a general area of trauma type or trigger/reminder. Question 5 is future based and asks the client to build upon earlier answers and develop an action plan.

Table 10.1 DASH Questionnaire

	Question	Trauma Treatment Connections*	DASH Correlates
1	What is your superhero's name?	Safety & Stabilization -Grounding	Identity
2	Who or what is your superhero?	Safety & Stabilization -Grounding	Identity
3	What superpowers does your superhero have?	Safety & Stabilization -Skill Building -Resiliency	Strength/ vulnerability
4	If your superhero had the power to change absolutely anything, what would it be?	Remembering -Narrative -Restructuring -Resiliency	Aggressor/ protector Survivor/ savior
5	If your superhero was going on an adventure, where would he/she/ they go? What would he/she/they do?	Reconnection -Future Orientation -Resiliency	Aggressor/ protector Survivor/ savior

*Based upon Hermann's Stages of Recovery (1997)

Case Vignettes

Lucas

Lucas was a nine-year-old African American cisgender boy with attention deficit, hyperactivity, mood dysregulation, and a history of sexual abuse. Lucas was a bright and engaging youngster. His biological mother was a multisubstance abuser, and he was born addicted to cocaine. She abandoned him at birth, and Lucas was later adopted by his foster mother as a toddler. When Lucas entered treatment, he had a history of fire setting, temper tantrums, destruction of property, and sexualized behavior. Often, his aggressive behavior was directed toward his adoptive mother, further complicating their relationship and her inability to care for him.

Lucas's drawing began as a portrait of Superman (DC Comics). Lucas spoke of Superman's strength and ability to fly. As he worked, superman transitioned to what Lucas named the *Lonely Boy*, a superhero whose superpower was that "he walked around and looked for people" (Figure 10.1). Lucas often expressed his feelings of loneliness during treatment as he was separated from his family and expressed curiosity about his birth

Figure 10.1 "The Lonely Boy" by Lucas

Table 10.2 DASH Questionnaire: Lucas's Responses

What is your superhero's name?	Lonely Boy
Is it a man, a woman, a boy, or a girl?	Boy
What superpowers does your superhero have?	Walks around and looks for people
If your superhero had the power to change absolutely anything, what would it be?	Find a family
If your superhero was going on an adventure, where would he/she go? What would he/she do?	Travel around until he found his real mom

family. The naming of the superhero shifted this image from Superman to a reflection of self. He further explored self by depicting his hero as a boy and coloring the skin brown using quick, medium-pressured marks with crayon and pencil. He then colored the groin area red and appeared to become overwhelmed as he quickly stopped coloring. The red groin area and the phallus-like shape of the abdominal muscles possibly communicated his anxiety and hyperarousal related to his sexual abuse (Hammer, 1958; Malchiodi, 1997).

Lucas displayed insight into his own perceived sense of *vulnerability* as it related to his loss of family and trauma. However, he created a *strength* in his superhero's ability to find "a family" and ultimately "his real mom." Lucas projected his desires onto this figure, enabling it to be his ideal . . . a boy with a family. The *Lonely Boy* served as a reflection of Lucas' actual and ideal selves combining both his traumatic past and his resiliency in the hope for the future (Herman, 1997).

Rafael

Rafael was a ten-year-old white and African American cisgender boy with a history of depression, psychosis, and PTSD. He was of average height and weight and walked with a pronounced limp. Rafael was born with positive toxicology to cocaine. Both his biological parents were polysubstance abusers, and his mother had a history of prostitution. Rafael was sexually abused by his mother, where she used him and his siblings in her sex work. Rafael reported that he and his siblings sexually acted out with one another and were encouraged to do so by the mother. Upon removal from the mother's care, Rafael and his sister were placed in foster care where they suffered further physical abuse and neglect. One night, in an effort to find food and water after being locked in their room, Rafael and his sister jumped out of their third-story window; he fractured his heels. He planned to jump out of the window "like Superman" and "land" on his feet to run away with his sister.

Rafael often spoke of superheroes and was drawn to Blade (Marvel Comics), Superman (DC Comics), and Megaman (Capcom). He came to session and stated, "I used to fight good before I jumped out the window." He drew this figure quickly, focusing on the superhero's strengths in being able to "jump high and kill everyone really fast" (Figure 10.2). As he worked, Rafael focused on his superhero's *strength and vulnerability* and his roles as *aggressor and protector, survivor and savior.*

Figure 10.2 "One-Eye Jack" by Rafael

Table 10.3 DASH Questionnaire: Rafael's Responses

What is your superhero's name?	One-Eye Jack
Is it a man, a woman, a boy, or a girl?	Man
What superpowers does your superhero have?	Strong, see through walls, jump high, kill everyone really fast
If your superhero had the power to change absolutely anything, what would it be?	Protect people from being hurt
If your superhero was going on an adventure, where would they go? What would they do?	He would go through neighborhoods and apartment buildings looking through walls and protecting kids from being hurt. He would kill all the people that were bad.

Rafael named his superhero *One-Eye Jack* and described him as a man with one eye who could see through walls. His choice of making his hero a man may reflect his belief that adults have more power and strength than a child. Rafael explained that *One-Eye Jack* had "big muscles," was very strong, and was protected by blades on his shoulders and a machine gun in his hand. Despite the *strength* of this superhero, his underlying *vulnerability* was revealed in that he was equipped with a peg leg and appeared off balance, reminiscent of the injury Rafael suffered. The machine gun, as well as the title *One-Eye Jack*, places an element of displaced sexual aggression onto the figure, which is reinforced by the multiple graphic indicators of sexual abuse, such as wedges, phallic representations, and separation of head from body (Malchiodi, 1997; Sidun & Rosenthal, 1987). Despite his gun, Rafael did not give the figure adequate hands to hold it, thus leaving the figure unable to protect himself (Malchiodi, 1997; Sidun & Rosenthal, 1987).

Rafael continued to process his sense of self in relation to his history of severe trauma and feelings of guilt, shame, and confusion. His history of disorganized attachment and the lack of a safe and trusted caregiver appeared to leave Rafael in a suspended position between that of *aggressor* and *protector* (Bowlby, 1969; van der Kolk, 1989). He sought his own protection by creating his superhero who could fight, jump, and "kill people really fast" (Cantor, 2005). The role of the aggressor enabled Rafael to process his trauma through identifying with his perpetrators' strength (Kramer, 1998; van der Kolk, 1989). Despite only having a single eye, *One-Eye Jack* could see through walls and "protect people from being hurt." This enabled *One-Eye Jack* to be a *protector*, not only protecting others from being hurt but also protecting Rafael himself. Through this role of protector, Rafael shifted from a position of *survivor* to *savior*. Rafael was able to begin to restructure his trauma narrative and move into the reconnection phase of trauma recovery as he fostered resiliency (Cohen et al., 2006; Herman, 1997).

Conclusion

Over the course of treatment, Lucas and Rafael continued to create many superheroes appearing to be both ego ideals and projections of self. The superheroes embodied their desires for strength and protection while simultaneously communicating their loss, trauma, and resiliency. The familiar yet indirect projective technique of Draw a Superhero (DASH) allowed Lucas and Rafael to express their complex trauma histories through a strength-based approach of utilizing their interests, capabilities, and choice (Blaustein & Habib, 2017). Beginning with art-making allowed them to have a more spontaneous and contained approach to access trauma memory (Grosso, 2012), possibly increasing their capacity for recall and integration (Backos & Samuelson, 2017). The subsequent pairing of the art with structured and goal-directed questions helped the children create a narrative for their superhero, further organizing cognition and memory (Cohen et al., 2006; Grosso, 2012). Resiliency, the crucial element in trauma recovery, was fostered in Lucas and Rafael as they created a skill set of powers for their superhero where they were able to have both strength and vulnerability. This allowed them to experience safety and stabilization, reconnect to self, and begin a hopeful outlook into the future (Herman, 1997).

Draw a Superhero (DASH) combines foundations in trauma theory and treatment with the projective techniques of art-making and play (Cohen et al., 2006; Hammer, 1958; Kramer, 1998). Through the role of the superhero, the child can explore wish fulfillment and fantasy in an effort to deal with the adversities of everyday life (Bettelheim,

1977; Haen & Brannon, 2002). Continuing to build resiliency in children who have experienced trauma through focusing on their strengths, capabilities, and interests while creating opportunities for choice and control can further empower children through their recovery (Blaustein & Habib, 2017).

Future research and use of DASH includes focus on gender and race. As my work continues, my interest is in exploring how DASH can be used to help empower girls, women, and children of color in their identity and their capacity to be heard and seen—not to be invisible. How can DASH be used as tool for fostering resilience and identity? Future data collection and expanding the scope of the use of DASH with other mental health challenges in both the child and adult populations is of attention. Further analysis is needed to determine the effectiveness and validity of the intervention outside of the case study methodology.

References

American Psychiatric Association. (2013). *Diagnostic and statistical manual of mental disorders* (5th ed.). Arlington, VA: American Psychiatric Publishing.

Backos, A., & Samuelson, K.W. (2017). Projective drawings of mothers and children exposed to intimate partner violence: A mixed methods analysis. *Art Therapy, 34*(2), 58–67. doi:10.10 80/07421656.2017.1312150

Bettelheim, B. (1977). *The uses of enchantment: The meaning and importance of fairy tales.* New York, NY: Vintage Books.

Blaustein, M., & Habib, M (2017). Trauma-impacted children and adolescents. In C. Haen & S. Aronson (Eds.), *Handbook of child and adolescent group therapy: A practitioner's reference* (p. 389–403). New York, NY: Routledge.

Bowlby, J. (1969). *Attachment and loss* (Vol. 1). London, UK: The Hogarth Press.

Cantor, C. (2005). *Evolution and posttraumatic stress.* London, UK: Routledge.

Cohen, J. A., Mannarino, A. P., & Deblinger, E. (2006). *Treating trauma and traumatic grief in children and adolescents.* New York, NY: Guilford Press.

Ford, J. D., & Courtois, C. A. (2013). Conclusion. In J. D. Ford & C. A. Courtois (Eds.), *Treating complex traumatic stress disorders in children and adolescents: Scientific foundations and therapeutic models* (pp. 349–358). New York, NY: Guilford Press.

Gil, E. M. (2016). Using integrated directive and nondirective play interventions for abused and traumatized children. In L. A. Reddy, T. M. Files-Hall, & C. E. Schaefer (Eds.), *Empirically based play interventions for children* (pp. 95–113). Washington, DC: American Psychological Association.

Grosso, C. (2012). Children with developmental disabilities. In J. A. Cohen, A. P. Mannarino, E. Deblinger (Eds.), *Trauma focused CBT for children and adolescents* (pp. 149–174). New York, NY: Guildford Press.

Haen, C., & Brannon, K. (2002). Superheroes, monsters, and babies: The roles of strength, destruction and vulnerability for emotionally disturbed boys. *The Arts in Psychotherapy, 29*, 31–40.

Hagood, M. (1994). Diagnosis or dilemma: Drawings of sexually abused children. *Art Therapy: Journal of the American Art Therapy Association, 11* (1), 37–42.

Hammer, E. F. (1958). *The clinical application of projective drawings.* Springfield, IL: Charles C. Thomas.

Herman, J. L. (1997). *Trauma and recovery.* New York, NY: Basic Books.

Homer, Verity, A., & Graziosi, B. (2011). *The Iliad.* Oxford: Oxford University Press.

Hornor, G. (2017). Resilience. *Journal of Pediatric Health Care, 31*(3), 384–390.

Kramer, E. (1993). *Art as therapy with children.* Chicago, IL: Magnolia.

Kramer, E. (1998). *Childhood and art therapy.* Chicago, IL: Magnolia.

Ligorski, M. (1994). The masked superhero. *Journal of the American Academy of Psychoanalysis, 22*(3), 449–464.

Malchiodi, C. (1997). *Breaking the silence*. Pennsylvania: Brunner and Mazel.

Rubin, L. (2006). Introduction: Look, up in the sky! An introduction to the use of superheroes in psychotherapy. In L. Rubin (Ed.), *Using superheroes in counseling and play therapy* (pp. 3–22). New York, NY: Springer.

Sidun, N. M., & Rosenthal, R. H. (1987). Graphic indicators of sexual abuse in draw-a-person tests of psychiatrically hospitalized adolescents. *Arts in Psychotherapy, 14*, 25–33.

Siegel, J., & Schuster, J (1938). *Action comics, 1*. Detective Comics.

Terr, L. (1990). *Too scared to cry: Psychic trauma in childhood*. New York, NY: Basic Books.

van der Kolk, B. A. (1989). The compulsion to repeat the trauma: Re-enactment, revictimization, and masochism. *Psychiatric Clinics of North America, 12*(2), 389–411.

Finding Safe Spaces in "Jars"
Stamping Containers in Substance Use Treatment

RAWAN BAJSAIR

Adolescence is a time of erratic transformation and identity formation yet a time of desperate preservation of childhood rituals. This chapter introduces an innovative use of jars in art therapy utilizing a jar rubber stamp (Figure 11.5a, 11.5b) as a two-dimensional container to serve as a safe holding environment for clients in treatment for substance use disorders. The concept behind this art-based directive is to provide clients with a visually structured space to hold on to and in which to be held during art therapy treatment. The case vignette highlighted in this chapter examines the therapeutic value of holding, containing, regulating, and mirroring within the frame of the container that could be utilized as a safe space in art therapy.

Jars are known to place a sense of preservation and protection over objects collected from daily life. Historically, the timeless and ubiquitous use of jars speaks to the integral process of canning as a means of transformation and survival. The long cultural history of glass containers, known as jars, conjures one's memories of preserved, canned goods used since early times. The appeal of the iconic jar lies in its transparent, glass material that invokes nostalgic references for clients of many cultures. The current trend and popularity of the jar made it an accessible and novel schema for therapeutic intervention. The jar rubber stamp serves as a metaphoric and symbolic container of holding and safety in art therapy practices with adolescents in treatment for substance use disorders.

For some time now, many have noticed the use of jars in various ways seems to revive the richness and versatility of their fundamental functionality. Jars were invented more than a century ago to preserve perishable produce due to its long-lasting seal and visibility of contents (Martin, 2014). Its metaphoric structure provides a space, allowing enough autonomy for clients to choose how to respond and interact with the inside and outside of the frame within a contained space. As an art therapist working in a context of intense political, social, racial, and cultural conflict, I observed a systemic need for safe containment, holding, and validation. The use of jars in my art therapy practice was cultivated by my curiosity surrounding the use of containers, combined with the exploration of attachment bonds, trauma, and regulation in substance use treatment. I have since used the jar rubber stamp to serve as a therapeutic tool and directive to establish a safe space for clients from diverse populations and demographic backgrounds to explore underlying issues necessitating treatment.

As I analytically observe and explore the process and product of the arts-based directive in this case study, I address the use of the jar rubber stamp as a therapeutic tool in

individual art therapy sessions with Felix. This directive is designed to assist my clients in managing internal and external regulation while in recovery. It also helps to create a visual representation of the idea that the client can choose to "put a lid" on their jars and contain their substance use. In the case presented in this chapter, I asked Felix to create one or more prints of jars using the rubber stamp with paint or ink. I asked Felix to capture what makes him feel safe using the inside and outside of the jar. During processing, I focused on helping my client draw connections between his substance use and journey in recovery. With consideration to attachment and trauma, presenting literature addresses substance use therapeutic frameworks, the use of the container in art therapy, and the creative process of printmaking while highlighting substance use diagnostic implications and theoretical applications in art therapy. The aim of this directive is to reframe the client's relationship to substances while maintaining sobriety and promoting emotional regulation.

Bion's (1962) early concept of the "container/contained" highlights the "container" as a representation of the internal dynamic system that is used in the process and transformation of the client's lived experiences of holding on, being held, and letting go—all in a jar. The frame created by the jar rubber stamp provides a pictorial reference for visualizing internal and external stressors for clients managing intense emotions during their recovery journey.

Containment and Substance Use

With consideration to attachment and trauma, the review of the literature will cover substance use therapeutic frameworks, the use of the container in art therapy, and the creative process of printmaking while highlighting substance use diagnostic implications and theoretical applications. From an attachment theory lens, substance use is considered an artificial reparation of insecure attachments in early life experiences (Cihan, Winstead, Laulis, & Feit, 2014). It is highly prevalent for individuals with insecure attachment bases to resort to substances in order to serve "the missing element" from early caregiver-infant dyadic experiences (Cihan et al., 2014, p. 534). Substances then aid self and affect regulation as well as chemically mimic a sense of security that was missed from unhealthy early attachments (Cihan et al., 2014).

The connection between early experiences and substance use while synthesizing attachment theory have been researched for decades. Examining the theory of self-regulation, attachment, and self-medication suggests that addictive vulnerability to substances reveal the lack of tolerance and understanding of one's emotions (Fletcher, Nutton, & Brend, 2015). Substances can compensate for comfort, contact, and security in individuals who grew up with attachment ruptures in childhood and adolescence. Individuals who cannot recognize, feel, and regulate their own emotions will often rely on substance for avoidance. Being addicted to substances was noted to relieve suffering, aid self-regulation, and repair the sense of self for individuals who present with difficulty in affect regulation and lack emotional awareness. These substances create alternative feelings of security and protection in individuals with addictive behaviors where negative feelings such as anger, shame, and restlessness related to attachment traumas are escaped (Fletcher et al., 2015).

Early childhood attachment ruptures create an insecure attachment that lacks emotional comfort and support. As a result, substance users find security in creating a relationship with one or various substances where they play the role of the compensator for comfort, contact, and security. As such, when feelings of loneliness,

vulnerability, and insecurity arise, they might be repressed by a substance of choice rather than tolerated (Fletcher et al., 2015). Specifically, emotional maltreatment in childhood is a risk factor for impulsive substance use, such as cannabis, characterized by poor affect regulation during adolescence. Negative moods or emotions experienced by adolescents who were subject to trauma, abuse, or neglect in their childhood seem to induce a sense of urgency to seek sensation or alternative emotions (Wardell, Strang, & Hendershot., 2016).

The importance of the interactional experience in the recovery process of individuals diagnosed with substance use disorders was highlighted by Fletcher et al. (2015). One of the fundamental facets of substance use treatment is to explore the need to "seek external emotional support and regulation from a substance" (p. 114). The provision of spaces to revisit early attachment traumas has been shown to help individuals in treatment for substance use disorder to rebuild secure interpersonal attachments in adulthood (Fletcher et al., 2015). Offering clients a safe holding space to explore, feel, and repair conflicting internal experiences through the therapeutic use of art media was a key goal for group art therapy treatment. History of traumatic experiences and feelings such as shame, anxiety, and a lacking sense of self and self-esteem were revealed and explored in an emotionally safe environment during art therapy sessions (Skeffington & Browne, 2014).

The significance of the integrative component of creative arts approaches in the treatment of substance use includes the benefits of the end product as well as the interpretation and feelings attached to the art-making process (Adedoyin, Burns, Jackson, & Franklin, 2014). This approach activates thought and memory recollection processes on a multisensory level, therefore allowing the opportunity to gain a new perspective to their problem. The contained art therapy directive allows self-expression, self-discovery, empathy, and mastery over feelings of shame and worthlessness during recovery.

In an article titled "Relational Holding: Using Winnicott Today," Slochower (2013) examines Winnicott's concept of the maternal metaphor of holding in clinical encounters. Winnicott promoted the integration of the maternal metaphor in the therapeutic process in transitional space and play. Winnicott's notion of holding metaphorically echoed the holding of a situation, giving support, holding contact on every level in relation to the client (Slochower, 2013). The concept of "therapeutic metaphor" was presented as a tool that serves the establishment of a "holding environment" or third area of exploration.

Pedersen, Poulsen, and Lunn (2014) presented *containing* as the "function of receiving, carrying, and transforming," identified as the ability to transform emotional and bodily discomfort while regulating and understanding one's internal process (p. 852). Similarly, the art-making process and product can offer holding through tolerance for polarized emotions and experiences (Pedersen et al., 2014). The holding environment, as postulated by Winnicott (1971), would be a protected space for the psyche to unfold. Farrell-Kirk (2001) promoted the use of boxes in art therapy as framed safe spaces that offer a sense of security and freedom to explore and overcome emotions, thoughts, and fears symbolically. An emphasis was put on the closed and intimate aspect of any container derived from everyday objects in mirroring the human need for secrecy and protection from danger. The role of the box as a holder, container, protector, and preserver places value and protects threatening contents from the viewers as well as the self. Often, containers are used to conceal a "problem" as well as guard a secret from the self and the viewers. The dialectic significance of the protected and preserved contents in an enclosed space would represent a sacred and holding space for "complex

interrelationships" between "inside versus outside," "here versus there," "problem versus solution," and the integration of opposites (Farrell-Kirk, 2001, pp. 90–91). When used in art therapy, the box as a concept of enclosure, space, and contents invites a "limiting context" while providing distance from emotions and thoughts related to the presenting problem (Farrell-Kirk, 2001, p. 89). The object, or the box, becomes a metaphorical space that contains the process of integration, realization, and hope for the client (Farrell-Kirk, 2001).

In light of Bion's early descriptions of the "contained/container," Ogden (2004) reflected upon the concept of the "container" not as an object but as a process that holds the capacity for the conscious and unconscious psychological work to unfold. The "contained" as a variable, like the "container," allows the client's experience, thoughts, and feelings to expand and change in the therapeutic art-making process. Ogden (2004) featured the difference between the function of holding and containing:

> Winnicott's holding and Bion's container—contained represent different analytic vertices from which to view the same analytic experience. Holding is concerned primarily with being and its relationship to time; the container—contained is centrally concerned with the processing (dreaming) of thoughts derived from lived emotional experience. Together they afford 'stereoscopic' depth to the understanding of the emotional experiences that occur in the analytic setting.
>
> (p. 1362)

Pedersen et al. (2014) presented *containing* as the "function of receiving, carrying, and transforming" (p. 852). The ability to transform emotional and bodily discomfort while regulating and understanding one's internal process is connected to the concept of containment (Pedersen et al., 2014). Containment as a function of "sorting-out" entails an integration of conflicting experiences good and bad, as well as anger and compassion (Pedersen et al., 2014; Moss, 2008, p. 189). "The 'container' thinks for the 'contained,'" which helps in bringing sensible meaning to an experience (Moss, 2008, p. 189). Hence, holding and containment can be better delineated as containing describes more verbal and communicative process following the act of holding, which is suggestive of nonverbal engagement (Moss, 2008).

Most importantly, the relational experience of the container/contained lies in the integration of affective states—or parts of the self—and the transformation of more tolerable feelings or states (Malone & Dayton, 2015). The early concept of the "container/contained" coined by Bion was highlighted where the "container" is a representation of the internal dynamic system that is used in the process and transformation of the client's lived experiences. The interactional aspect of the "container/contained" space, where the function of growth and change becomes infused with emotions that underlie the client's lived experience, provides a relational space and process that enables containment and ultimately transformation (Malone & Dayton, 2015). Establishing a safe space in therapy has been highlighted as a key starting point to allow substance users to examine their relationship to their substance of choice (Fletcher et al., 2015). In addition, establishing an empathic therapeutic relationship with a client provides a secure attachment and safe space to explore the affective role of substance use during treatment (Cihan et al., 2014).

Skeffington and Browne (2014) identified several common issues in clients with substance use disorders such as a lack of sense of self, low self-esteem, ambivalence, shame, and guilt. Correspondingly, clients produced imagery that responds to

and reflects deep and overwhelming feelings from complex traumas experienced in childhood. Their research concluded that symbols encourage clients to "unlock" and reflect on traumatic memories, feelings, and imagery from their past and present life experiences in relation to their diagnoses. For the client showcased in this study, difficult emotions rooted in trauma exposure during early childhood development are repressed by altered states using substances later in life. Moreover, Halužan (2012) shed light on various problem areas that are explored in art therapy treatment with individuals that struggle with substance use disorders. In those individuals' artworks, the size and foundation of figures in regard to space were noted to identify feelings of insecurity and powerlessness. Figures commonly drawn in passive positions and distinctive mouths were given as examples for the expression of struggle with interpersonal relationships. Proportions and relation of objects in pictures drawn by individuals who struggle with addiction are often unaligned to mirror their daily functioning, which were highlighted as reflective contents of their environments, internal states, emotional connections, and opinions of change (Halužan, 2012).

As a bridge between art-making and early childhood experiences, White (2014) drew connections between early developmental experimentations of hand and finger printing and the process of printmaking attributable to its similarities with early scribbling stage. Printmaking was noted as more inviting and accessible for resistant clients because of its non-threatening easy steps. Additionally, the symbolic language of the printmaking process is embedded in the stimulating physical gesture during art-making (White, 2014). The stamping and printmaking process was described to be effective in enhancing symbolic and metaphorical expression, meaning, and dialogue during the creative art-making process.

Additionally, printmaking offers a technical, iterative production of the image, placing distance between the artwork, perhaps as the identified problem area, and the artist. Printmaking was further noted to tap into issues regarding control and identity, as well as lack of containment and social skills (White, 2014). White (2014) advocated for the therapeutic aspects of printmaking and its value of the product, process, and person. The use of printmaking in art therapy was emphasized in its unique production process of multiple prints, which highlights the soothing reward of repetition. The involvement of multiple steps to complete the printmaking process is a significant factor of the development and enhancement of therapeutic journey of art therapy (White, 2014).

Case Vignette: Felix

Felix (pseudonym) was a 19-year-old Caucasian American male admitted to a substance use treatment clinic in a metropolitan city. At that time, he was primarily diagnosed with severe cannabis use disorder and moderate sedatives use disorder. Upon admission, Felix was identified to be ambivalent about his substance use and its consequences and presented with a soft-spoken, monotone voice and flat affect. He was referred to a local outpatient mental health clinic by probation and was expected to comply with probation mandate for treatment from substance use and for 12 months. Reportedly, substance use had challenged him and impacted members of his family for generations. Felix primarily relied on cannabis and benzodiazepine to self-medicate in order to manage psychological distress and his chronic pain caused by pectus excavatum, which is a birth defect manifested in sinking of the chest.

As part of his treatment, Felix was referred to psychiatry and chronic pain management in order to obtain proper medical and psychological needs to accommodate

his medical condition. Through evidence of weekly urine test results, Felix was compliant with prescribed medications. Felix reported a history of domestic violence between birth and the age of three and described his parents as "emotionally separated." He reported struggling with co-occurring symptoms of anxiety and depression, as well as social anxiety and low self-worth; however, Felix denied self-harm or suicidal ideation. Additionally, he reported struggling with tooth decay as a symptom of his medical condition, which led him to present with poor hygiene and body image.

Felix was immediately engaged with a polymer modeling material, repeatedly building and destroying in his early sessions. He created a structure of a container-like form that transformed over a few of his early sessions. Initially, Felix described it as "eggs in a nest" (Figure 11.1).

He stated that those eggs belonged to a dinosaur, and in a later session he claimed that it was a "pouch of pearls" you could find at the bottom a deep blue sea (Figure 11.2).

From observation, Felix presented as weary and anxious and spoke in a flat tone for most of the time, which was generally his demeanor in sessions. His art-making process seemed methodical and intuitive and often stimulated a highly intellectualized

Figure 11.1 "Eggs in a Nest" Artwork, 2 × 3, Sculpey medium

Figure 11.2 "Pouch of Pearls" Artwork, 1 × 2, Sculpey medium

conversation that varied from diagnostic labels to systems and coding. He would usually sit across with his eyes seemingly fixated on his fidgety fingers or his artwork more frequently than not. His attendance remained consistent throughout the sessions discussed, and his affect seemed to range between quiet and withdrawn to expressive and insightful.

As Felix seemed to begin feeling safe in the therapeutic space, he expressed his desire for sessions to be geared toward exploring recurring feelings of "emptiness" that commonly surface with abstinence. In response, I introduced the jar rubber stamp in our following sessions to give him structure to explore his feelings of emptiness. After providing him with a demonstration on the different applications of the rubber stamp, I prompted him to explore people, things, or places that allow him a sense of safety. Felix sorted through different colors of construction papers then seemed to make an unmotivated choice of black (Figure 11.3).

He then covered the entire rubber stamp with gold paint including the inside of the jar, which wouldn't print without immense pressure. He slammed the stamp hard on the paper and pressed down with his frail body while standing on his feet for several

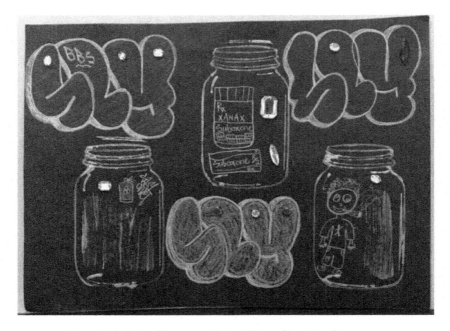

Figure 11.3 Printed Jars artwork, 9 × 12, acrylic paint, rhinestones, and colored pencils on construction paper

seconds. He seemed surprised to see that his weight had left paint impressions on the paper where the markings appeared as scratch marks. He left the jar print on that piece of paper to work on some graffiti sketches while declaring that it was his favorite activity to engage in. As Felix went back to the jar artwork after not working on it for about a month, he started by drawing objects inside the printed jars and later added the graffiti tags on the outside with colored pencils. The decorative jewels were the final touches on his artwork, which he seemed to glue without any forethought.

The first session in which he stamped the jar, the discussion was around feelings of frustration within his recovery process and the challenge in cultivating alternative and healthy coping mechanisms. He stated that the jar could be seen as a "safe place" to store matters that are important, as well as matters one would like to work on and "keep it there." While Felix was working on his printed jars, he expressed that he was expected to refrain from engaging in illegal behaviors involving graffiti and drugs during his time in recovery. He then reflected on the images he created inside of his jar as they corresponded with a time when he felt the need to engage in substance use. When I asked Felix to reflect on his artwork and art-making process, he stated that he had chosen to put images of his substance and himself actively using and spraying graffiti in all three of his jars because they are things that he is not supposed to be engaging in at the moment. Lastly, Felix reflected on how the objects in the jar reflect his past and present life and recovery obstacles. When I asked Felix whether his jar was closed or open, in order to allow him to reflect on his accessibility to safe spaces, he stated "Well, I guess it's closed because I gotta keep a lid on it for now" then laughed.

Attachment and Regulation

As holding and protection are imperative for the containment process required to explore psychic vulnerabilities, the "jar" becomes the clients' safe space (Pedersen et al., 2014). Notably, exploring the states of omnipotence of substance users is a fundamental facet of their treatment, and the "jar" stamp promotes a sense of safety and control over their internal worlds. In my early sessions with Felix, I placed high value on developing an empathic therapeutic alliance during his treatment in order to model for him regulation without the use of substances (Fletcher et al, 2015). When I asked Felix questions about his caregivers, he often described them as detached and neglectful, which is connected to his reliance on substances to replicate feelings of security and repress feelings of emptiness. Felix's history reflected familial addiction and lack of emotional understanding and expression in his upbringing, which is represented in his need to stamp more than one jar as an attempt to create a visual representation of our conversations on the relationship between his emotions and thoughts as well as his substances of choice. Additionally, the range of emotional connections is markedly depicted in Felix's choice of having multiple jars to represent his fragile self that needs to be cared for, preserved, and protected in the safety limits of the container.

For most of Felix's time in art therapy, containers were his primary mode of expression during his recovery process. A reflection of Felix's inner conflict and internal battle with substances can be seen in the characteristics of his jars. He placed metaphoric contents in the supportive and holding environment of the jars while feeling safe in the space and the therapeutic alliance (Skeffington & Browne, 2014). Felix had put his substance of choice inside the stamped jars to reflect the imprisonment caused by his probation mandate. Perhaps this directive allowed him to feel safe to openly reminisce about the activities he used to engage in at the time of his substance use. Specifically, his ambivalence about addiction seemed to be represented in the size of the substances drawn in the middle jar. Yet, Felix seemed to exhibit a decent level of motivation to change and comply with substance use treatment and court mandate by stating that those jars were "closed for now."

Ego Structure and Embodiment

The contents placed inside the jar on the right of Felix's artwork reflect the lack of self-esteem and sense of self combined with recurrent defensiveness and loneliness (Skeffington & Browne, 2014; Johnson, 1990). Similarly, feelings of powerlessness and passivity could be identified in the size of the figure, which mirrors how Felix illustrates himself inside one of the jars and in relation to the joint and the rest of his surroundings outside the jars (Halužan, 2012).

Felix described his bodily discomfort, triggers, and cravings in recovery in many verbal discussions during art therapy sessions, which seemed to bring sensible meaning and further understanding of his experienced recovery process as well as the impact of pectus excavatum in his social life (Pedersen et al., 2014). Also, the residue of the paint from the center of the stamp seemed to print on the paper used in his jars artwork, which signifies the immense pressure he placed on the stamp as a possible embodiment of frustrations regarding his recovery process (Skeffington & Browne, 2014; White, 2014).

Safety, Containment, and Holding

The establishment of safety within the therapeutic framework was the core of my work with Felix, particularly in his early sessions. The containers were used temporarily to supplement the need for security and protection for Felix as he abstained from addictive use and behaviors during recovery (Fletcher et al., 2015). In his prints, he chose to put his substances of choice inside the safe contained space of the stamped jar, which seemed to be a response to his mandated treatment and sobriety. The primary role of substances in Felix's life is depicted in his jars so as to compensate for the empathy and safety he had lacked in early development (Fletcher et al., 2015). Due to substance use in combination with insecure bases, many of the contents chosen to be protected by the jar are manifestations of Felix's substance use, whether literal or symbolic. In particular, his vivid statement about the jar rubber stamp being a "safe place" in one of the sessions seemed a direct response to the concept of containment as a complex, verbal, and communicative process.

The tendency to numb intolerable emotions is a main concern in addiction and one hardest to overcome; hence, the container-based shape of the jar seemed to offer Felix the sense of control and containment to explore difficult emotions rooted in his past trauma that were repressed by altered states using substances. Container-based art-making helped guide him in exploring hidden parts of himself, unlocking past trauma, and finding a space for change during his treatment (Skeffington & Browne, 2014). Additionally, the container-based directive seemed to allow Felix to lay out his lived experiences within the limits of the holding environment as a way to manage interpersonal conflicts and face overwhelming emotions from early development (Malone & Dayton, 2015). In many verbal discussions during his art therapy sessions, Felix tapped on the relational holding by discussing his interpersonal and familial conflicts as well as their search for a supportive network (Slochower, 2013).

The "Contained/Container": Inside and Outside

The motive behind the use of the jar with Felix was to provide both an object and process for conscious and unconscious thoughts, feelings, and experiences to unfold as a necessity for growth and adjustment in his substance use treatment and recovery (Ogden, 2004). Quite a range of metaphoric and symbolic expressions used in the jar stamp artworks could be interpreted as an adaptive conceal for themes that relate to low self-esteem, ambivalence, shame, and trauma (Skeffington & Browne, 2014). The relational and integrative emphasis on containment to stimulate and transform affective states using this art therapy directive laid out the client's lived experiences within the limits of the holding environment (Malone & Dayton, 2015). The dialogue between Felix and I during art therapy sessions tapped into the relational holding by discussing his interpersonal and familial conflicts as well as his attempt to find a supportive network and a sense of belonging (Slochower, 2013).

The Creative Process and Materials

Throughout the art therapy sessions where Felix worked on the jar directive, he seemed to utilize the creative process to shift from appearing emotionally guarded and highly intellectualized to becoming increasingly open to ultimately being able to explore his emotions and thoughts. The limits of the therapeutic frame of the jar prints seemed to

specifically provide him with enough distance to experience his emotional dysregulation during his treatment symbolically. Indeed, Felix literally placed his substances and depictions of his substance use inside the containers, which could also symbolize his progress in managing his substance use since attending art therapy.

The core goal for this directive is to address substance use, triggers, and patterns using the therapeutic printmaking tool and symbolic space of the jar. The process of printmaking and stamping stimulates creative, symbolic, and metaphorical dialogue, expression, and art-making (White, 2014), which seemed to be true in Felix's case as evidenced by his substance use. One of the prevalent themes when observing this directive with these clients is the noticed enthusiasm upon realizing the multiplicity factor of the printmaking process. Felix's art-making process included repetitive stamping and applying of paint, which was observed to be soothing and regulating of his affect (White, 2014). He seemed to experiment with stamping multiple jars as well as exploring composition and placement in his creative process. The connection between addiction and repetition is represented in the number of jars he had stamped, which relates to addictive and compulsive behaviors and vulnerabilities typical in substance use disorders (Fletcher et al., 2015).

The process of printmaking is known to elicit a certain level of regression and impulsivity (White, 2014), which could be highlighted in Felix's observed expression of internalized emotions as an embodied gesture while stamping. The residue of the paint from the center of the stamp seemed to print on the paper used in Felix's artwork, which indicates the immense pressure he placed on the stamp as a possible embodiment of early recovery frustrations (Skeffington & Browne, 2014; White, 2014). The distance and unpredictability of printmaking challenged his resistance and acknowledged his resilience (White, 2014).

Conclusion

The focus of this chapter is to introduce an innovative way of using containers in art therapy in a more informed and advanced intervention that promotes the duality of transparency and protection, particularly in this population. Highlighted themes in this chapter were based on a deep understanding of the clinical framework and diagnostic implications of substance use disorders. With consideration to internal and external facets of substance use, this chapter explored key concepts related to the identity, embodiment, and regulation of substance users.

The symbolic choice of the "jars" through the practical use of the rubber stamp in this art-based directive facilitated a safe space in recovery from substance use. I have witnessed clients utilize the jar rubber stamp in various methods. The ease and versatile engagement with the jar stamp has led to greater curiosities about the imagery and symbolism cultivated. The diverse and creative expressions beyond the boundaries of the container allow space for explorations and value of the self with all its parts and development. In the art therapy sessions where the jar stamp directive took place, Felix seemed to exhibit a distinct creative and symbolic expression of his psychological, interpersonal, and intrapersonal issues as he mitigated the triggers and cravings during the treatment of substance use. In combination with verbal interactions and discussion topics, Felix was able to create symbolic art products that manifested his substance use, emotional states, identities, and past traumas.

The contents of the "jars" seemed to correspond to his vulnerability and need to be contained in a safe space. Through symbolic imagery, metaphors, and colors, Felix

communicated his internal states, modulated emotions, and revealed hidden selves. As symbolic and metaphoric contents were placed inside the jars, Felix was able to share, recognize, and protect his vulnerabilities within the limits of the container and the therapeutic framework. Holding the metaphors safely inside the jars provided Felix with an opportunity for control and mastery over his addiction narrative.

Art Therapy Recommendations and Applications

Literature has examined the therapeutic uses of boxes, vessels, and containers in art therapy (Farrell-Kirk, 2001). The directive highlighted in this chapter introduces a creative way of shifting the use of containers in art therapy to a more informed and advanced intervention that promotes the duality of transparency and protection, particularly in substance use populations. Drawing from the ubiquitous use of jars for over a century, I have facilitated this jar rubber stamp as a therapeutic directive with a multitude of populations and settings.

In art therapy sessions where the jar directive was utilized, artworks seemed to depict a distinct creative and symbolic expression of psychological, interpersonal, and intrapersonal issues that mitigate triggers and cravings during the treatment of substance use. In combination with verbal processing and reflective dialogue, substance users were allowed to create symbolic art products that manifested their emotional states, identities, and past traumas.

There are several ways the jar rubber stamp could be utilized as an art therapy directive for clients who are struggling with depression, attachment issues, relational conflict or trauma, and many other populations. The artwork in Figure 11.4 is created by a

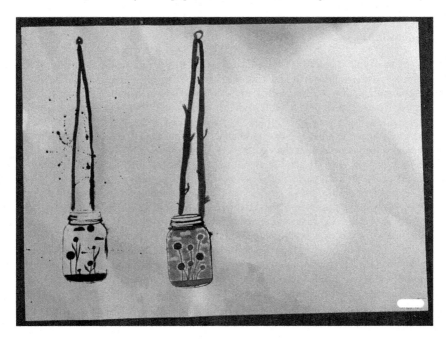

Figure 11.4 Untitled, 14 × 16, acrylic paint, watercolors, and ink on paper

female client, the same age as Felix, who sought to participate in art therapy at a different facility due to severe depression, suicidal ideation, and history of self-harm.

The jar directive was utilized to establish safety within the therapeutic relationship. The frame of the jar provides enough structure and distance for clients from various populations to explore and reflect on the meaning of safe spaces with consideration to attachment, regulation, and emotional triggers and patterns.

A range of art materials to create imagery inside and outside the stamped jars can be utilized including markers, pastels, colored pencils, paint, watercolors, and collage cut-outs. The art therapist facilitating the directive could demonstrate the stamping technique prior to the art-making process. Allowing clients to make a choice of paint or ink for stamping as well as the surface in which they would print on is key to instilling a sense of agency and efficacy. While the jar prints dry after stamping, dialogue about people, places, and things that bring a sense of safety to their life can be initiated as symbolic or metaphoric contents for their jars. Clients would be directed to utilize the jar rubber stamp (Figure 11.5a, 11.5b) to create one or more prints of the jar to represent

Figure 11.5a "Jar" rubber stamp (side A)

Figure 11.5b "Jar" rubber stamp (side B)

safe spaces and are encouraged to utilize the inside and outside of the jar(s) to create a visual representation of "putting a lid" on substance use or any other issue that brought them to therapy. Alternatively, this directive can be easily adapted to a group setting by using multiple rubber stamps or pre-stamped jar prints, depending on the size of the group (Figure 11.6).

When the artwork is completed, the art therapist could facilitate the reflection process by asking whether the jar(s) is open or closed as well as why and when the client has access to the contents. The art therapist could inquire about the decisions behind placing the contents inside versus outside the jar(s). A dialogue about the repetition in the printing process and product(s), especially connected to substance use patterns and addictive behaviors prior and during recovery, is key to facilitating this directive. The art-making as well as the reflection process is guided by the structure established by the

Figure 11.6 Pre-stamped "Jar" template, 2 × 4, ink on paper

qualities of the jar frame and explored in the therapeutic relationship and printmaking serving as symbolic containers.

After assessing nonverbal expressions and analyzing metaphorical meanings, the imagery and symbolism depicted in the jar artworks exhibited in this chapter were categorized in several themes. The chapter highlights themes based on a deep understanding of the diagnostic and treatment implications of substance use disorders. With consideration to internal and external facets of substance use, the discussed themes covered main problem areas that relate to the identity of substance users such as an exploration of the embodiment of the self and ego through the use of jar stamping.

The chapter highlights themes based on a deep understanding of the diagnostic and treatment implications of substance use disorders. After assessing nonverbal expressions and analyzing metaphorical meanings, the imagery and symbolism depicted in the jar artworks exhibited in this chapter were categorized in several themes. Considering the internal and external facets of substance use, the discussed themes covered main

problem areas that relate to the identity of substance users such as an exploration of the embodiment of the self and ego through the use of jar stamping. Creative processes are supported through the held therapeutic space of art therapy practices, using metaphoric containment and symbolic imagery inside and out.

Crucial themes related to the identity of substance users were examined through the use of jar stamping in substance abuse recovery. This can be reflected within the area of regulation; the symbolic choice of the "jars" facilitated a safe space for the emotional and cognitive states of substance users to transpire and integrate. The stamped jars serve as a visual structure for clients and a tool for art therapists to manage all that needs to be contained metaphorically. Most of us, if not all, need to be contained, held, and seen in a safe place where we can feel protected and nourished when vulnerability and shame come into play.

References

Adedoyin, C., Burns, N., Jackson, H. M., & Franklin, S. (2014). Revisiting holistic interventions in substance abuse treatment. *Journal of Human Behavior in the Social Environment, 24*(5), 538–546. https://doi.org/10.1080/10911359.2014.914718

Bion, W.R. (1962). A Theory of Thinking. In E. Bott Spillius (ed.) *Melanie Klein Today: Developments in theory and practice. Volume 1: Mainly Theory.* 1988. London: Routledge.

Cihan, A., Winstead, D. A., Laulis, J., & Feit, M. D. (2014). Attachment theory and substance abuse: Etiological links. *Journal of Human Behavior in the Social Environment, 24*(5), 531–537. https://doi.org/10.1080/10911359.2014.908592

Farrell-Kirk, R. (2001). Secrets, symbols, synthesis, and safety: The role of boxes in art therapy. *American Journal of Art Therapy, 39*(3), 88.

Fletcher, K., Nutton, J., & Brend, D. (2015). Attachment, a matter of substance: The potential of attachment theory in the treatment of addictions. *Clinical Social Work Journal, 43*(1), 109–117. https://doi.org/10.1007/s10615-014-0502-5

Halužan, M. (2012). Art therapy in the treatment of alcoholics. *Alcoholism: Journal on Alcoholism & Related Addictions, 48*(2), 99–105.

Johnson, L. (1990). Creative therapies in the treatment of addictions—The art of transforming shame. *The Arts in Psychotherapy, 17*(4), 299–308. https://doi.org/10.1016/0197-4556(90)90049-V

Malone, J. C., & Dayton, C. J. (2015). What is the container/contained when there are ghosts in the nursery? Joining Bion and Fraiberg in dyadic interventions with mother and infant. *Infant Mental Health Journal, 36*(3), 262. https://doi.org/10.1002/imhj.21509

Martin, C. (2014, August 14). Authenticity, repurposed, in a jar. *The New York Times.* Retrieved from www.nytimes.com/2014/08/17/business/authenticity-repurposed-in-a-mason-jar.html?_r=0

Moss, E. (2008). The holding/containment function in supervision groups for group therapists. *International Journal of Group Psychotherapy, 58*(2), 185–201. https://doi.org/10.1521/ijgp.2008.58.2.185

Ogden, T. H. (2004). *On holding and containing, being and dreaming. International Journal of Psychoanalysis, 85*(6), 1349. https://doi.org/10.1516/T41H-DGUX-9JY4-GQC7

Pedersen, S. H., Poulsen, S., & Lunn, S. (2014). Affect regulation: Holding, containing and mirroring. *The International Journal of Psycho-analysis, 95*(5), 843–864. https://doi.org/10.1111/1745-8315.12205

Skeffington, P. M., & Browne, M. (2014). Art therapy, trauma and substance misuse: Using imagery to explore a difficult past with a complex client. *International Journal of Art Therapy: Inscape, 19*(3), 114–121. https://doi.org/10.1080/17454832.2014.910816

Slochower, J. (2013). Relational holding: Using Winnicott today. *Romanian Journal of Psycho-analysis/Revue Roumain De Psychanalyse, 6*(2), 15–40, 37–55.

Wardell, J. D., Strang, N. M., & Hendershot, C. S. (2016). Negative urgency mediates the relation-ship between childhood maltreatment and problems with alcohol and cannabis in late adolescence. *Addictive Behaviors, 56*, 1–7. https://doi.org/10.1016/j.addbeh.2016.01.003

White, L. M. (2014). *Printmaking as therapy: Frameworks for freedom.* Retrieved from www.ebrary.com

Winnicott, D. W. (1971). *Playing and reality.* London, England: Tavistock Publications.

From Black and White to Color
Staying in the Metaphor Alongside Male Adolescents With Problematic Sexual Behaviors

LUCÍA CRISTINA HERNÁNDEZ

The art of healing is not so much a science, as the intuitive art of wooing nature—and waiting.
(Hall, 2013, p. 160)

Introduction

Working with adolescents who have engaged in problematic sexual behaviors is psychologically challenging. Due to widely acknowledged stigma, many clinicians encounter resistance to working with this population. While the prosecuting act usually mandates treatment, the history and traits of the individual must be considered. This chapter will focus on the underlying characteristics related to youth who present with problematic sexual behaviors, cumulative trauma, attachment, splitting, and integration through treatment within a Sanctuary-based Model. This population demands attention and concern. While often condemned for their problematic behavior, they are also children and adolescents in the midst of development. With this in mind, it is imperative to provide art therapy to these growing individuals who have experienced adverse life events as it allows them opportunities to process trauma, build resilience, and increase self-worth.

This chapter shares the case of Hayden, an adolescent male from Central America who was receiving treatment due to inappropriate sexual behavior toward his young female cousin. It reveals his artistic journey and the way in which his creative process provided an outlet for freedom of expression, while recognizing the challenges associated with treatment. The therapeutic relationship developed will be explored through the artwork created in sessions. Selected sessions highlight Hayden's use of artistic metaphor in integrating the unspoken aspects of his identity.

I think once I found myself in a room with some of these guys, it became perfectly apparent to me that they didn't have horns or breathe fire.
(Scheela, 2001, p. 755)

Working With Adolescents With Problematic Sexual Behaviors

Clinicians who work with adolescents who have displayed problematic sexual behaviors question and explore the complex paths that lead these clients to engage in these

inappropriate acts (Aulich, 1994; Everhart, Falligant, Thompson, Gomez, & Burkhart, 2018; Moulden & Firestone, 2010; Pullman, Leroux, Motayne, & Seto, 2014; Riser, Pegram, & Farley, 2013; Scheela, 2001). Some of the underlying factors that influence these behaviors appear to be child maltreatment, poor social skills and interpersonal relationships, fear of rejection, low self-esteem, and feelings of personal inadequacy. Additional influences include the individual's understanding of consent, what it means to be sexually active, and whether they have experienced healthy sex. This includes, for example, whether they have been sexually abused or have been exposed to sexual or violent encounters (Pullman et al., 2014; Righthand & Welch, 2004; Seto & Lalumière, 2010). While this does not mean that all adolescents struggling with problematic sexual behaviors have a history of sexual abuse or that all individuals who are victims engage in inappropriate sexual behavior toward others, experiences of sexual trauma can have long-term effects on a person's cognitive functioning and mental health (Elias & Haj-Yahia, 2017; Lenkiewicz, 2014; Pullman et al., 2014; Riser et al., 2013; Ryan, Murrie, & Hunter, 2015).

More than a decade ago, Righthand and Welch (2004) noted that 16% of the arrests for forcible sexual acts and 19% of arrests for all other problematic sexual behaviors involved youth under the age of 18 (p. 16). Female adolescents comprised only an estimated 2% to 11% of these arrests. There has not been much change; as noted more recently, 14% and 18% of arrests in North America concern youth under the age of 18 who have engaged in an inappropriate sexual act (Pullman et al., 2014, p. 1249). Given this data, most of the literature on adolescents with problematic sexual behaviors has been focused on males from ages 12 to 17 years old (Boyd & Bromfield, 2006; Felizzi, 2015; Pullman et al., 2014; Righthand & Welch, 2004; Riser et al., 2013; Seto & Lalumière, 2010). Most of the literature on this youth reveals there is a lack of "the social skills necessary to fulfill their sexual and emotional needs in age appropriate consensual relationships" (Pullman et al., 2014, p. 1250). Furthermore, research on the sexually abused/sexual abuser hypothesis indicates how important it is to focus on the prevention of sexual abuse in children and adolescents, given that victims might engage in inappropriate sexual activity in the future (Aebi et al., 2015; Seto & Lalumière, 2010).

The literature on adolescents who present with problematic sexual behaviors indicates that this population reacts positively to treatment because they are still at a developing stage that allows for effective and significant intervention (Aulich, 1994; Righthand & Welch, 2004; Riser et al., 2013; Ryan et al., 2015; Seto & Lalumière, 2010). The goal of treatment is to encourage the clients to perceive themselves as adolescents who engaged in problematic sexual behavior, without defining their action as their sole identity (Righthand & Welch, 2004; Ryan et al., 2015). It is in maintaining focus on the environmental impact in the adolescent's development that efforts toward preventing recidivism can occur (Riser et al., 2013; Sandhu & Rose, 2012).

Given the social and biological changes in their lives, working with adolescents is already a challenge—one further exacerbated when working with those who have engaged in risky sexual activity and who, as such, are so often societally shamed and rejected. In light of the extreme feelings associated with this population, it is important to acknowledge and discuss countertransference within the therapeutic relationship. Countertransference is recognized as the therapist's unconscious reactions to the patient's transference, consisting of all the feelings, conscious and/or unconscious, of the therapist toward the client (Goldstein, 2013; Riley, 2010). While a narrow scope of literature can be found examining the experience of working with adolescents with problematic sexual behaviors, this research is consistent in identifying the effects and

feelings that come to surface when working with this population. Themes that come up in a therapist's experience include loss of trust and innocence, insecurity of the world, and becoming extremely vigilant and scared of people (Aulich, 1994; Collins & Nee, 2010; ; Moulden & Firestone, 2010; Sandhu & Rose, 2012; Scheela, 2001).

Mental health professionals may develop "vicarious trauma," which is caused by the emotional impact of hearing their clients' trauma stories. This occupational challenge, if ignored, can lead to a desensitization of their emotional response. However, therapists note that supervision, support, training, and self-care are effective coping strategies when working with this population. Professionals have shared the ways in which these mechanisms increase feelings of empathy and compassion toward their clients, fostering a deep sense of meaning in their engagement with their work (Collins & Nee, 2010; Sandhu & Rose, 2012; Scheela, 2001).

Disruption of Attachment

Attachment can be understood as a gestalt of experiences, patterns, and interactions with other individuals. "While defining it as a changing, developmental construct, attachment is also seen as a behavioural system, an experience and a trait-like quality" (Campbell, 2007, p. 212). Early childhood attachments, the initial emotional bonds between infant and primary caregiver, hold significant influence throughout one's life; these experiences can impact adolescent self-image, perceptions of others, social relationships, and self-directed behaviors that ultimately affect the individual's sense of safety and self-confidence (Franklin, 2010; Grady, Levenson, & Bolder, 2015; Holmes, 2001; Keogh, 2012; Kossak, 2009).

The role of the environment and family dynamics has been studied in depth when it comes to understanding adolescents with problematic sexual behaviors. In particular, parental absence or inconsistency of care and unhealthy attachments are common risk factors found within this population (Righthand & Welch, 2004; Seto & Lalumière, 2010). Such relational instability can lead to the development of a disorganized or unresolved attachment style, often causing an individual to lack trust, feelings of competence, and self-confidence (Felizzi, 2015). Beyond these initial attachment patterns, family relationships can be further strained when sexual abuse occurs in the individual's childhood; this is particularly detrimental when they, as a victim, are either blamed or ignored (Felizzi, 2015; Riser et al., 2013). Through treatment, it is imperative to reconstruct the human connection, attachment skills, and social relationships that can help the client engage in a lifestyle that does not include recidivism (Grady et al., 2015; Keogh, 2012; Rich, 2006).

Trauma, Splitting, and Integration

Trauma can be described as any event that causes emotional distress and long-lasting effects on one's sense of identity, generating complex and diverse responses. As stated by Herman (1992)" traumatic events overwhelm the ordinary systems of care that give people a sense of control, connection, and meaning" (p. 33). These life-altering moments are known to significantly impact physiological arousal and emotion, as well as processes associated with cognition and memory (Naff, 2014). However, the trauma's effect is dependent on the person's reaction and processing of the experience rather than the event itself (Joseph, 2015; Naff, 2014). Cumulative trauma occurs

when an individual has experienced more than one traumatic event throughout their lifetime. This can interrupt the development of healthy attachments, as the individual's core capacity for self-regulation and interpersonal relatedness becomes affected (Naff, 2014).

The harm caused to an individual's identity by cumulative trauma can lead to splitting of the self. Splitting, also known as black-and-white or all-or-nothing thinking, is a psychoanalytic concept arising from the appearance of dissociative processes. Recognized as a common ego defense mechanism that develops when an individual cannot consciously tolerate the aspects of the self that might be socially unacceptable, splitting can be defined as the individual's action to polarize beliefs, behaviors, objects, or people by categorizing it as good-self and/or bad-self (Howell, 2005).

A primary goal in treatment is to encourage the emotional connection of conflicting experiences, leading to a therapeutic process of integration and acceptance (Wallin, 2007). As such, a space must be created where the opposing feelings and thoughts are safely allowed to emerge (Klein, 2013; Rhyne, 2001). If individuals are understood, valued, supported, and appreciated by their therapist, they could discover, unconsciously and consciously, integration of the two polarized selves by engaging and internalizing their own self-worth (Hall, 2013; Naff, 2014). It is necessary for an individual's mental health to release creative energy, self-regulate, self-balance, and heal the psyche from the split.

A Sanctuary-Based Approach

In the midst of advancements in the field of traumatic stress studies during the mid-1980s, Sandra Bloom, a psychiatrist; Joseph Foderaro, a social worker; and Ruth Ann Ryan, a nurse specialist, began recognizing the overwhelming frequency of childhood trauma experienced by the patients in their hospital's psychiatric unit. The Sanctuary Model was subsequently born, developed as a theory-based, trauma-informed, evidence-supported, whole-culture approach to "teaching individuals and organizations the necessary skills for creating and sustaining nonviolent lives and nonviolent systems" (The Sanctuary Model, n.d.). Rather than delineate a specific treatment, Sanctuary was established to provide a structured methodology for the therapeutic community at every level.

First established for adult inpatient psychiatric settings (Abramovitz & Bloom, 2003), the model quickly expanded to residential care programs for youth suffering from the effects of violence, neglect, and other forms of traumatic experiences (Clarke, 2011). Grounded in a scientific understanding of attachment and adversity, the Sanctuary Model merges four theoretical frameworks: Trauma Theory, espousing the significant impact of stress on human growth and functioning; Social Learning Theory, which promotes the operational use of one's environment as a therapeutic vehicle for change; nonviolence practice that prioritizes attention to safety in daily interactions; and Complexity Theory, which provides a way of understanding adaptive systems and their inherent potential for transformation (Abramovitz & Bloom, 2003; Bloom, 2000).

This conceptual foundation is carried out through the seven Sanctuary Commitments, a value-based guide to everyday conduct, as well as through a shared trauma-informed language of the S.E.L.F. The basic principles of Sanctuary include commitment to nonviolence, emotional intelligence, social learning, democracy, open

communication, social responsibility, growth, and change (Bloom, 2000; Clarke, 2011). Meanwhile, the notion of the S.E.L.F. helps to break down arising dilemmas through the unifying, straightforward, and comprehensive themes of Safety, Emotional Management, Loss, and Future (Clarke, 2011).

At its core, viewing trauma through a Sanctuary lens "shifts the debate about the nature of the problem by changing the definition of institutionalized children from 'bad' kids or 'sick' kids (or both) to children who have sustained physical, psychological, social, and moral insults that lead to developmental injuries" (Abramovitz & Bloom, 2003, p. 131). Rather than being asked, "What's wrong with you?" they are asked, "What happened to you?" (The Sanctuary Model, n.d.). This can be particularly meaningful for adolescents who have engaged in problematic sexual behaviors as it may help to relieve associated feelings of shame and, instead, encourage self-compassion and self-worth. Its emphasis on honoring loss and learning from mistakes while intentionally creating and planning for that which lies ahead permits such adolescents to more readily accept their past, present, and future.

The Sanctuary Model recognizes the importance of integration at both an organizational and personal level. In partnership with individual, group, milieu, family, and medical approaches, the intensive work of a trauma survivor "to integrate memory, affect, and behavior in the context of safe attachment" often requires the use of creative therapies, such as art therapy, "to help bridge the gap between the nonverbal affective experience and the verbal, cognitive, conscious mind" (p. 16).

The Role of Art-making in Treatment

Much of the literature pertaining to the use of arts with this population agrees that many clients who hide their emotions can confront their reality after engaging in art-making as a form of expression (Meekums & Daniel, 2011). Research has shown that art therapy can enhance the cognitive-behavior strategies offered by other disciplines in these clients' assessment and treatment (Aulich, 1994; Hagood, 1994). The process of art-making can help adolescents who have engaged in problematic sexual behavior to access their emotions by expressing themselves. It provides them a chance for self-regulation and an opportunity to decrease the symptoms triggered by aggression, depression, and anxiety (Klein, 2013; Mazloomian & Moon, 2011; Smeijsters, Kil, Kurstjens, Welten, & Willemars, 2011). Art-making also has the potential for increasing their self-awareness and self-esteem, which can prevent them from future inappropriate sexual activity or making harmful choices.

As cited in Hall (2013), Carl Jung pointed to creativity as a significant basic instinct that allows an individual to reach symbolic integration. Jung believed that within an individual's breakdown "there is a creative process at work, trying to heal the split" (p. 161). When the client begins relating to images created in the session, a supportive art therapist may help them to acknowledge and address the unaccepted aspects of their identity (Klein, 2013). Through the experience of art-making, the client can develop an awareness and perception of the "life cycle as an integrated process rather than a sequence of disconnected crises and experiences" (Garai, 1979, p. 179). Art-making allows catharsis, a release of strong or repressed emotions, which provides the client relief from difficult feelings and ultimately allows for a greater acceptance of the whole self (Davis, 2015; Franklin, 2016; Rhyne, 2001). The journey of treatment is different for

each person and, as illustrated in the case below, art-making can support the client in finding their own path.

From Black and White to Color: The Case of Hayden

Hayden was an adolescent male who was born and raised in Central America. He had arrived in the U.S. during his early adolescence and expressed the difficulty of leaving his country, learning the English language, and adapting to the American culture. Hayden was admitted to a Sanctuary'-certified state-run agency in the suburbs of a metropolitan city due to a charge of sexual misconduct against his younger female cousin. He was placed in a unit of adolescent males receiving services that focused on addressing their problematic sexual behaviors. His treatment consisted of Structured Psychotherapy for Adolescents with Recurring Chronic Stress (SPARCS); Trauma Focused Cognitive Behavioral Therapy (TF-CBT), which included individual, group and family therapy; art therapy; educational and recreational services; substance abuse counseling; medical care; and psychiatric medication management. While in treatment, Hayden was diagnosed with Other Specified Disruptive Impulse Control Disorder and Conduct Disorder; Other Specified Depressive Disorder; Other Specified Trauma and Stressor-Related Disorder; and Specific Learning Disorder.

Previous case file information revealed that Hayden had experienced inappropriate sexual behavior toward him as a child. Additionally, he witnessed a family member's murder. While Hayden's biological mother was often referenced throughout our sessions, he appeared to see his grandparents as primary caregivers. As both of Hayden's biological parents were absent during his childhood, he did not seem to hold a healthy attachment to either of them.

Hayden was referred to art therapy because he appeared passionate about art-making and shared how the process helped him focus, decreasing his anxious and depressive symptoms. As complementary treatment, art therapy would provide him a space to address his traumatic experiences prior to arriving in the U.S. in an open and free format. Hayden asked that his individual art therapy sessions be held primarily in Spanish, as a respite from his English-speaking school and residential program. At the initiation of treatment, the Kramer Art Evaluation introduced drawing, painting, and clay materials. The remainder of the art therapy sessions were client led, where Hayden's self-directed inclinations were honored, and explorations of diverse media choices encouraged.

Hayden began his first artwork silently, creating thick and pressured lines in pencil. After he finished each fragment of his drawing patterns, he spoke about his life, the difficulties of the language barrier, and the differences between living in the U.S. and Central America. During the session, I began to mirror what he was drawing on my own sheet of paper as a means of building the therapeutic connection and commented that his patterns were creative but difficult to copy. Hayden looked at me very seriously and stated, "Do not lie to me." I assured him that I had no reason to lie but continued to explore his thoughts on honesty with others. He mentioned that sometimes people lie to spare other people's feelings. This interaction seemed to reflect a lack of trust but perhaps also people pleasing, likely due to a long history of disrupted attachment. As such, honesty became the first and most critical quality of the therapeutic relationship.

As he finished his first drawing (Figure 12.1), titled "Which side you prefer?" Hayden talked about how people have different journeys in life and questioned the ways by

Figure 12.1 "Que lado prefieres?" (Which side you prefer?), 8 × 11, pencil, marker, and paper

which individuals choose a specific path to take while living in this world. Hayden's fragmented and chaotic artwork, comprised of multiple patterns, seemed to reflect the many life experiences that he could not grasp or integrate. Hayden had a guarded approach when speaking to me, but he seemed comfortable while drawing inside the circle of his image, reflecting a nonverbal attempt to build a sense of safety in our work together. While the detailed nature of the artwork's design conveyed a feeling of anxiety, the heavy lines demarcating its boundaries suggested a desire for containment.

Hayden followed his initial drawing with a painting (Figure 12.2), which he worked on for two sessions. He began by drawing three circles and then chose bright

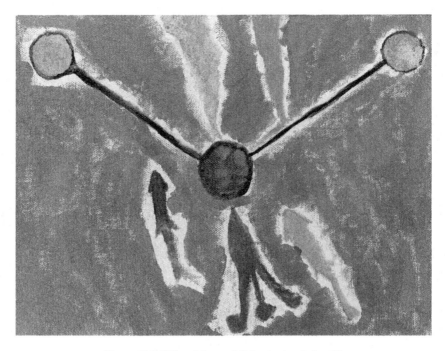

Figure 12.2 "Obra Maestra" (Masterpiece), 8 × 10,
water mix oils, acrylics, and canvas board

colors to fill the shapes. Hayden shared that the middle shape was the world and the
other two circles were suns. He commented that the two suns were created because
the whole world would not see each sun at the same time. While discussing his paint-
ing, he revisited the idea of people having to choose a path, this time adding the
"right path." As Hayden worked on the background of his painting, he stated that,
besides black, red was his favorite color because it represented all the emotions—like
love, hate, anger, and passion. I questioned whether this also included happiness and
sadness, to which he laughingly replied, "Well, maybe it does not represent all the
emotions." Upon further exploration of the color's symbolism, Hayden shared that
red also represented feelings of insecurity. He explained that it was not that he felt
unsafe but that he was uncertain of life and himself. In appearing to feel increasingly
safe within the therapeutic relationship and comfortable in disclosing his worries
and thoughts, Hayden demonstrated a readiness to begin the process of healing his
disrupted attachment.

While Hayden continued creating his painting, he appeared unsettled with the mate-
rial. Hayden requested his painting to be placed in his portfolio because he no longer
wanted to stare at it. The affect-laden medium seemed to reveal emotions connected to
his past trauma, resulting in Hayden's desire to hide the piece in the safety of his port-
folio. This act of containment seemed to demonstrate an awareness of his emotional
capacity, revealing at once his desire to release difficult feelings through art-making as

Figure 12.3 "Sin Nombre" (Untitled), 14 × 11 × 6, clay,
paper board, wood sticks, and felt

well as a need for them to be held by a supportive witness to his trauma, as he was not yet ready to confront them on his own.

After Hayden finished his painting, he decided to build a house with clay (Figure 12.3). While creating bricks for his piece, Hayden mentioned that this form of construction reminded him of the Egyptian pyramids and how, after many years, they had not fallen. He expressed his admiration for such architecture and stated that he wanted his house to be solid. After finishing the piece, he asked if I could put it back in the closet; however, when I picked up the artwork, the back part of the house collapsed. I asked him if he wanted to fix it; smiling, he replied, "It looks better broken." As we were leaving the room to walk to his unit, he reflected, "You know, that house? That's what poverty looks like." This artistic decision and following observation marked a decisive moment in which, for the first time, an element of Hayden's unaccepted past had become both acknowledged and accepted.

The next art piece created was a mask (Figure 12.4). Hayden would place it in front of his face and ask, "Does this scare you?" I understood these moments as an ongoing "test" of my ability to hold and accept the difficult parts of Hayden's identity. After reassuring him that it did not scare me, we explored the various meanings and uses of masks. We discussed the Spanish word for masks, "máscaras" as literally translating to the idea of "more faces." Hayden nodded and said, "That's right, that is why I love masks." While painting the mask, he created an abstract painting from the remaining palette paper. Hayden pointed out that this second piece resembled an abstract face, further emphasizing Hayden's desire to address the split within himself. It appeared to reflect Hayden's representation between the good versus the bad parts of himself; this could be seen during Hayden's art-making process. When he painted the mask, he used the material in a controlled and detailed manner; but with the palette paper, his process was chaotic

Figure 12.4 Untitled, 8 × 11, 7 × 5 × 2, palette paper, cardboard mask, and tempera paints

Figure 12.5 Untitled, 12 × 14 × 2, tempera paint, paintbrushes, cardboard mask, and glue

and impulsive (Figure 12.4). When the mask was completed, Hayden picked up a paper board to spread the paint and create another painting. Once finished, Hayden experimented with various compositions in an attempt to join his mask to the painted board. After gluing the two works together, an artistic act of integration, Hayden added black

Figure 12.6 "Bird on Fire," 12 × 14, paper board, pencil, watercolor pencils, and mark

paint to the background, stood up, pressed his thumb against the board, and stated that his background looked like a tornado (Figure 12.5).

Hayden wanted to create something challenging for his penultimate artwork and asked for a visual reference of the *Hunger Games* symbol, an image of a mockingbird encased by a circular pin. He began by directly copying the image (Figure 12.6) but, once engaged in the process, completed it independently. When I showed him the image of the mockingbird, he appeared to reflect on the figure and asked me, "Don't you think that bird is beautiful?" When the question was reflected back, he answered, "I think the mockingbird is an amazing animal because it can fly, it's free." As he colored the inside of the circle—the background of the mockingbird—it seemed like he was trying to depict an image of a yin and yang, a powerful symbol of two halves creating a whole and another visual nod toward the acceptance of his inner opposing selves.

During the course of eight months, Hayden and I met for 28 individual art therapy sessions. A bittersweet feeling arose as we reached the end of our therapeutic relationship. The termination process was crucial to prevent feelings of abandonment or reenactment of his trauma. To establish a sense of structure and control, we employed the use of a visual calendar that marked our sessions for the remaining month and a half. The art mediums previously used by Hayden to communicate his feelings in treatment were now being used to process what it meant to say goodbye. Hayden began his last painting by choosing an animal that represented his country: the whitetail deer (Figure 12.7). Hayden shared how he identified as the deer and stated that it was crossing the river to a more hopeful future. He

Figure 12.7 Untitled, 8 × 10, paper board, pencil, acrylics, and paintbrushes

expressed that the deer was looking back at the forest, which was dry and damaged because it represented what had happened in the past. Hayden explained that the painting served as a reminder that his past experiences would always be a part of him. As we observed all of the artwork created during his time in art therapy, Hayden acknowledged his emotional growth and shared feeling proud of what he had accomplished.

Metaphor provides a useful distance from raw emotion, while also offering the opportunity for transformation.

(Meekums & Daniel, 2011, p. 233)

Building Human Connection Through Art

Throughout our initial sessions, Hayden's sense of mistrust in me was clear. "How do you want me to trust you if you don't tell me anything about you?" he would ask, his repeated redirecting of conversation likely reflecting a discomfort of his own past experiences. Through an attachment lens theory, Grady et al. (2015) would suggest that the deep distrust marking these initial interactions was indicative of the lack of safety and self-confidence developed in Hayden's early childhood attachment. The fact that Hayden seemed impulsive and angry at the world, his parents, himself, and occasionally even me were likely consequences of what had happened to him and what he had done

in his life. It was important to acknowledge how his family dynamics and environment took part in his development (Felizzi, 2015; Riser et al., 2013).

There appears to be a significant need for external validation, an experienced guardedness, and a lack of trust from adolescents with problematic sexual behaviors (Meekums & Daniel, 2011; Smeijsters et al., 2011). As such, building a strong interpersonal connection to foster a solid working alliance became a crucial aspect of Hayden's treatment (Franklin, 2010; Kossak, 2015). This new and healthy model of attachment within his sessions offered unconditional acceptance and permission of expression, signifying an act of care rarely experienced by Hayden (Klein, 2013; Rhyne, 2001; Wallin, 2007). Hayden also participated in the development of this therapeutic relationship, seeking connection and approval through questions and artistic collaboration. As more of his traumatic history became known, I felt that my role was to support his expression while containing his thoughts and feelings by providing him a safe place to process his past experiences. In doing so, Hayden could explore other experiences that may have previously led him to participate in problematic sexual acts. As Hayden appeared to feel increasingly safe within the therapeutic relationship and comfortable in disclosing his worries and thoughts, he demonstrated a readiness to begin to repair his disrupted attachment.

One of the means by which I attempted to develop trust with Hayden was by maintaining client-led sessions. Hayden's treatment team worked toward addressing his problematic sexual behavior and cycle of abuse, as well as helping him to identify his trauma triggers through structured therapy. Consequently, his art therapy sessions were non-directive because his treatment already required a defined set of rules to be followed. I believe that Hayden's control of the process, as well as his ability to choose the materials and what to create, enabled us to form a trustworthy, therapeutic relationship (Klein, 2013).

Allowing Hayden to dictate the creative process provided the opportunity to create a safe and controlled place, enabling traumatic experiences to surface. This was necessary because he previously had not developed a space to connect with himself, make decisions, and be provided the support and containment that he required through his treatment process. Creating art provided that space (Davis, 2015; Franklin, 2016). This client-led approach served him by supporting his sense of agency, autonomy, self-efficacy, and responsibility (Klein, 2013; Meekums & Daniel, 2011). Moreover, the reason for choosing a non-directed approach allowed Hayden to work on issues he wanted to process; this enabled him to feel supported when being honest about his history and functioning (Collins & Nee, 2010).

The very process of art-making also appeared to be an effective coping strategy to further allow exploration of experiences (Ciornai, 2016; Davis, 2015; Franklin, 2016; Hall, 2013; Klein, 2013; Kossak, 2015; Naff, 2014). Art-making gave Hayden the strength to actively participate in treatment while encouraging greater feelings of self-worth. Ciornai (2016) highlights that it is through the artwork and forms that clients create, without knowing the explanation, that they can understand that everything they make is valuable and real.

Beyond the Unspeakable

Since traumatic events fail to integrate an individual's existing real-life memories, clients may often present themselves as nonverbal (Hass-Cohen, Clyde, Carr, & Vanderlan, 2014; Naff, 2014). During our time together, Hayden never spoke about his problematic sexual

behavior; when discussing his history, any disclosure would be limited to a vague reference of "what I did." The accumulation of Hayden's traumatic childhood experiences seemed to have shaped his identity, and, prior to his treatment, had remained unaddressed.

As clinicians, more specifically those working with traumatized adolescents, there is clear understanding that art-making provides the tools to develop a trustworthy therapeutic relationship through a nonverbal process (Franklin, 2010; Naff, 2014). It is in this way, through artistic and symbolic conversation, that Hayden and I learned to communicate. Using the artwork as metaphor helped to set the structure within the session. Initially, we spoke only through the metaphor of his artwork and what it could represent for the safety of his self-image. The art remained our primary topic of conversation, as Hayden was not yet ready to verbally expose his trauma or his problematic sexual activity.

When the artwork attempted to reveal disclosure, I discussed the metaphors and topics that Hayden wanted to explore. As a result, the pieces created by Hayden serve as powerful visual reminders of his valuable artistic journey throughout his treatment. As Hayden was provided a safe, empathic, and non-judgmental environment, he could explore, identify, and understand the various dimensions of himself without my interpretation of his artwork (Klein, 2013). Hayden would seek assurance of this supported space in examining my reaction to his artwork, such as when he placed his mask in front of his face and asked if it scared me. In those moments, it was necessary to respond with acceptance to allow for continued and uninhibited self-exploration. In this supported state, Hayden grew comfortable relating the artwork to his own life and verbally acknowledging his difficult past. As Smeijsters et al. (2011) would substantiate, by concentrating on the fears, feelings, behavior, and cognition through art-making, Hayden appeared to address his own pain, perspective, and experience.

Healing the Split

Like many adolescents with problematic sexual behaviors grappling with past trauma experiences, Hayden appeared to have created a psychological split as a defensive response against acknowledging the parts of himself he viewed as shameful or prohibited (Howell & Itzkowitz, 2016). The processing of this split, and subsequent journey to acceptance, can be tracked through the artwork created within his art therapy sessions.

In an early session, Hayden's initial musings on possible life paths and subsequent chaotic drawing (Figure 12.1) first hinted to a fragmented sense of self. Later, his response was to hide away a finished painting (Figure 12.2) after being affected by its triggering and affect-laden medium; this further reinforced Hayden's need to deny the difficult emotions associated with his split identity. Nonetheless, by seeking out assistance to contain these unaccepted impulses, he began to show signs of increased trust and a desire to connect.

A turning point in Hayden's therapeutic experience occurred when he chose to leave his house sculpture broken and collapsed (Figure 12.3), reflectively asserting its representation of poverty. In this revealing observation, Hayden seemed to start accepting the "brokenness" he had been feeling but did not want to disclose. In allowing the house to stay broken, he appeared to signify that he was ready to start self-integrating. Hass-Cohen et al. (2014) would support the theory that Hayden's real-life memories were emerging in a non-threatening way and that the art-making process was providing a means of integrating his traumatic memories. Through art-making, he could work toward increased insight while exploring the person he wanted to be.

Hayden's mask work and surrounding discussion revealed a continued emerging self-awareness of his split self, or "many faces," and the ongoing desire to keep the unaccepted parts of his identity hidden (Figure 12.4). In merging his mask and board, he further demonstrated an initial attempt at integration through the creative process. In this way, Hayden may have been symbolically integrating the different parts of himself into one (Hall, 2013). In a secondary act of pressing his finger to the mask board, he left a physical mark on his artwork as a possible attempt to associate and merge with it (Figure 12.5). As Ciornai (2016) described, by using the Gestalt approach, Hayden could endeavor to integrate his own life experiences in an authentic way.

Further attempts at integration were seen through his reproduction of a yin and yang, a celebrated symbol known to represent two halves that together complete wholeness or, at the very least, a starting point for change (Figure 12.6). This artistic metaphor can be considered a reflection of his journey in art therapy and an expression of seeking his own path during treatment. Hayden's final painting (Figure 12.7) was described as a reminder that his past experiences would always be a part of him. This marked an acknowledgment and inclusion of his past traumas and behaviors as part of his complex identity. As such, this image was a meaningful representation of our therapeutic relationship and a true symbol of his journey to integration and self-acceptance.

People are just as wonderful as sunsets if you let them be. When I look at a sunset, I don't find myself saying, 'Soften the orange a bit on the right hand corner.' I don't try to control a sunset. I watch it with awe as it unfolds.

(Rogers, 1995, p. 22)

Conclusion

Through Hayden's art therapy sessions, I witnessed a powerful shift from a cautious adolescent, lacking trust in others and himself, to one who actively sought human connection and understanding through personal disclosure and artistic collaboration. Hayden's artwork reflects the complex trauma of his past, as well as the transformative effects of engaging in a creative experience that allowed for complete freedom of choice. Through client-led art-making and a therapeutic alliance built on honesty and acceptance, Hayden was able to embrace an alternative model of healthy attachment and a newly developed sense of agency. In turn, this prepared him to gradually present, acknowledge, and ultimately accept the many parts of himself and his past that he had previously sought to deny. In this way, Hayden's art therapy treatment was truly an artistic and symbolic journey from black and white to color.

Reflections and Recommendations

Hayden's case study presents several important reflections on the art therapy process. Art-making is often an important creative outlet for many adolescents, as it promotes exploration, healing and integration of the individual's self-image (Briks, 2007; Mazloomian & Moon, 2007; Parisian, 2015). For example, it helped to increase Hayden's self-esteem as he became less critical of his art-making process and final pieces. This expressive modality can be particularly helpful for youth who are struggling with traumatic experiences, as this non-threatening outlet allows them to release and work through unresolved issues (Briks, 2007, ; Naff, 2014). When the adolescent has suffered

trauma, art-making provides a way to integrate their traumatic memories. Through this modality, traumatic memories can first be expressed and organized visually before being processed verbally (Hass-Cohen et al., 2013; Naff, 2014).

When approaching therapeutic treatment with resistant youth, art allows the process to be less threatening and "creates a positive association to therapy through an avenue of personal expression that is often enjoyable for adolescents" (Briks, 2007, p. 4). As such, when adolescents display oppositional behavior, a sense of mistrust, and are verbally withdrawn, "a focus on art may also help alleviate some of the common obstacles in developing a therapeutic relationship" (Briks, 2007, p. 4). The therapeutic alliance may be further developed when the art therapist produces artwork alongside the client, allowing an art dialogue that maintains distance but provides space for identification and effective mirroring of emotional expression (Franklin, 2010; Haeseler, 1989).

Because adolescents with problematic sexual behaviors may have a negative self-image and fear their own conduct, art therapy can provide a chance for the youth to create a safe environment to address their pain, perspective, and experience (Aulich, 1994; Gerber, 1994; Smeijsters et al., 2011). Additionally, a strong therapeutic relationship can be effective when clients are provided a safe and non-judgmental space because it further encourages them to explore their self-image and promotes emotional growth (Sori & Hecker, 2003). When the art therapist uses empathy and intuition through the client's interpretation of symbolic messages in session, it can allow the art therapist a more direct understanding of the client's real emotions. In focusing on the creative power and the art process, the art therapist can experience a deeper connection with the client (Smeijsters et al., 2011). By carefully empathizing while entering their world, the therapist can help the client to feel genuinely seen and move toward experiencing understanding and kindness for others (Franklin, 2010).

References

Abramovitz, R., & Bloom, S. L. (2003). Creating sanctuary in residential treatment for youth: From the "well-ordered asylum" to a "living-learning environment". *Psychiatric Quarterly, 74*(2), 119–135.

Aebi, M., Landolt, M. A., Mueller-Pfeiffer, C., Schnyder, U., Maier, T., & Mohler-Kuo, M. (2015). Testing the "sexually abused-abuser hypothesis" in adolescents: A population-based study. *Archives of Sexual Behavior, 44*(8), 2189–2199.

Aulich, L. (1994). Fear and loathing: Art therapy, sex offenders and gender. In *Art therapy with offenders* (pp. 165–196). London, England: Jessica Kingsley Publishers.

Bloom, S. L. (2000). Creating sanctuary: Healing from systematic abuses of power. *Therapeutic Communities: The International Journal for Therapeutic and Supportive Organizations, 21*(2), 67–91.

Boyd, C., & Bromfield, L. (2006). *Young people who sexually abuse: Key issues* (pp. 1–13). Melbourne: Australian Institute of Family Studies. Retrieved from https://aifs.gov.au/publications/young-people-who-sexually-abuse

Briks, A. (2007). Art therapy with adolescents: Vehicle to engagement and transformation. *Canadian Art Therapy Association Journal, 20*(1), 2–15.

Campbell, K. M. (2007). Attachment and sexual offending: Understanding and applying attachment theory to the treatment of juvenile sexual offenders by P. Rich. *The Howard Journal of Criminal Justice, 46*(2), 211–213. doi:10.1111/j.1468-2311.2007.00467_2.x

Ciornai, S. (2016). Gestalt art therapy: A path to consciousness expansion. In *The Wiley handbook of art therapy* (pp. 47–56). New York: Wiley.

Clarke, A. (2011). Three therapeutic residential care models, the sanctuary model, positive peer culture and dyadic developmental psychotherapy and their application to the theory of congruence. *Children Australia*, *36*(2), 81–87.

Collins, S., & Nee, C. (2010). Factors influencing the process of change in sex offender interventions: Therapists' experiences and perceptions. *Journal of Sexual Aggression*, *16*(3), 311–331.

Davis, B. J. (2015). Art therapy perspectives. In *Mindful art therapy* (pp. 49–62). London, England: Jessica Kingsley Publishers.

Elias, H., & Haj-Yahia, M. M. (2017). Therapists' perceptions of their encounter with sex offenders. *International Journal of Offender Therapy and Comparative Criminology*, *61*(10), 1151–1170.

Everhart, N. J. L., Falligant, J. M., Thompson, K. R., Gomez, M. D., & Burkhart, B. R. (2018). Trauma-focused cognitive behavioral therapy with adolescents with illegal sexual behavior in a secure residential treatment facility. *Children and Youth Services Review*, *91*, 431–438.

Felizzi, M. V. (2015). Family or caregiver instability, parental attachment, and the relationship to juvenile sex offending. *Journal of Child Sexual Abuse*, *24*(6), 641–658.

Franklin, M. A. (2010). Affect regulation, mirror neurons, and the third hand: Formulating mindful empathic art interventions. *Journal of the American Art Therapy Association*, *27*(4), 160–167.

Franklin, M. A. (2016). Essence, art, and therapy. In *The Wiley handbook of art therapy* (pp. 99–111). New York: Wiley.

Garai, J. E. (1979). New horizons of the humanistic approach to expressive therapies and creativity development. *Art Psychotherapy*, *6*(3), 177–184.

Gerber, J. (1994). The use of art therapy in juvenile sex offender specific treatment. *The Arts in Psychotherapy*, *21*(5), 367–374.

Goldstein, W. N. (2013). Larger issues regarding psychotherapy. In *A primer for beginning psychotherapy* (p. 31). Hoboken: Taylor and Francis.

Grady, M. D., Levenson, J. S., & Bolder, T. (2015). Linking adverse childhood effects and attachment: A theory of etiology for sexual offending. *Trauma, Violence, & Abuse*, *18*(4), 433–444.

Haeseler, M. (1989). Should art therapists create artwork alongside their clients? *American Journal of Art Therapy*, *27*, 70–79.

Hagood, M. (1994). Group art therapy with adolescent sex offenders: An American experience. In *Art therapy with offenders* (pp. 197–219). London, England: Jessica Kingsley Publishers.

Hall, P. N. (2013). Art therapy: A way of healing the split. In *Images of art therapy (Psychology revivals): New developments in theory and practice* (pp. 157–187). Hoboken: Taylor and Francis.

Hass-Cohen, N., Clyde, F. J., Carr, R., & Vanderlan, J. (2014). "Check, change what you need to change and/or keep what you want": An art therapy neurobiological-based trauma protocol. *Art Therapy: Journal of the American Art Therapy Association*, *31*(2), 69–78.

Herman, J. L. (1992). *Trauma and recovery*. New York, NY: Basic Books.

Holmes, J. (2001). The six domains of attachment theory. In *The search for the secure base: Attachment theory and psychotherapy* (pp. 6–19). Hove, East Sussex: Brunner-Routledge.

Howell, E. F. (2005). *The dissociative mind* (pp. 161–177). Hillsdale, NJ: Analytic Press.

Howell, E. F., & Itzkowitz, S. (2016). From trauma-analysis to psycho-analysis and back again. In *The dissociative mind in psychoanalysis: Understanding and working with trauma* (pp. 20–32). New York, NY: Routledge.

Joseph, S. (2015). A person-centered perspective on working with people who have experienced psychological trauma and helping them move forward to posttraumatic growth. *Person-Centered & Experiential Psychotherapies*, *14*(3), 178–190.

Keogh, T. (2012). Attachment and juvenile sex offending. In *The internal world of the juvenile sex offender: Through a glass darkly then face to face* (pp. 21–41). London: Karnac Books.

Klein, G. H. (2013). Linking the person-centered approach to the arts: Person-centered expressive arts therapy and empowerment. In *Interdisciplinary applications of the person centered-approach* (pp. 49–56). New York, NY: Springer Science, Business Media.

Kossak, M. S. (2009). Therapeutic attunement: A transpersonal view of expressive arts therapy. *The Arts in Psychotherapy, 36*(1), 13–18.

Kossak, M. S. (2015). Contexts of attunement in the arts and therapy. In *Attunement in expressive arts therapy: Toward an understanding of embodied empathy* (pp. 3–9). Springfield, IL: Charles Thomas Publisher.

Lenkiewicz, J. (2014). Back from the edge: Adolescent sex offenders. In *Sexual diversity and sexual offending: Research, assessment, and clinical treatment in psychosexual therapy* (pp. 217–232). London: Karnac Books.

Mazloomian, H., & Moon, B. L. (2007). Images from purgatory: Art therapy with male adolescent sexual abusers. *Art Therapy: Journal of the American Art Therapy Association, 24*(1), 16–21.

Meekums, B., & Daniel, J. (2011). Arts with offenders: A literature synthesis. *The Arts in Psychotherapy, 38*(4), 229–238.

Moulden, H. M., & Firestone, P. (2010). Therapist awareness and responsibility in working with sexual offenders. *Sexual Abuse: A Journal of Research and Treatment, 22*(4), 374–386.

Naff, K. (2014). A framework for treating cumulative trauma with art therapy. *Journal of the American Art Therapy Association, 31*(2), 79–86.

Parisian, K. (2015). Identity formation: Art therapy and an adolescent's search for self and belonging. *Journal of the American Art Therapy Association, 32*(3), 130–135.

Pullman, L. E., Leroux, E. J., Motayne, G., & Seto, M. C. (2014). Examining the developmental trajectories of adolescent sexual offenders. *Child Abuse & Neglect, 38*(7), 1249–1258.

Rhyne, J. (2001). The Gestalt Approach to experience, art, and art therapy. *American Journal of Art Therapy, 40*(1), 109–120.

Rich, P. (2006). The relationship of attachment to juvenile sexual offending. In *Attachment and sexual offending: Understanding and applying attachment theory to the treatment of juvenile sexual offenders* (pp. 6–18). New York, NY: Wiley.

Righthand, S., & Welch, C. (2004). Characteristics of youth who sexually offend. *Journal of Child Sexual Abuse, 13*, 15–32.

Riley, S. (2010). How therapists get tangled up in adolescent treatment. In *Contemporary art therapy with adolescents* (pp. 218–236). London, England: Jessica Kingsley Publishers.

Riser, D. K., Pegram, S. E., & Farley, J. P. (2013). Adolescent and young adult male sex offenders: Understanding the role of recidivism. *Journal of Child Sexual Abuse, 22*(1), 9–31.

Rogers, C. R. (1995). Experiences in Communication. In *A way of being* (pp. 5–26). Boston, MA: Houghton Mifflin.

Ryan, E. P., Murrie, D. C., & Hunter, J. A. (2015). Changing perceptions of juvenile sexual offending in society and the legal system. In *Juvenile sex offenders: A guide to evaluation and treatment for mental health professionals* (pp. 1–20). Oxford: Oxford University Press.

The Sanctuary Model. (n.d.). Retrieved from http://sanctuaryweb.com/TheSanctuaryModel.aspx

Sandhu, D. K., & Rose, J. (2012). How do therapists contribute to therapeutic change in sex offender treatment: An integration of the literature. *Journal of Sexual Aggression, 18*(3), 269–283.

Scheela, R. A. (2001). Sex offender treatment: Therapists' experiences and perceptions. *Issues in Mental Health Nursing, 22*, 749–763.

Seto, M. C., & Lalumière, M. L. (2010). What is so special about male adolescent sexual offending? A review and test of explanations through meta-analysis. *Psychological Bulletin, 136*(4), 526–575.

Smeijsters, H., Kil, J., Kurstjens, H., Welten, J., & Willemars, G. (2011). Arts therapies for young offenders in secure care—a practice-based research. *The Arts in Psychotherapy, 38*(1), 41–51.

Sori, C. F., & Hecker, L. L. (2003). The "art" of art therapy with adolescents. In *The therapist's notebook for children and adolescents: Homework, handouts, and activities for use in psychotherapy* (pp. 303–308). New York, NY: Haworth Clinical Practice Press.

Wallin, D. J. (2007). The multiple dimensions of the self. In *Attachment in psychotherapy* (pp. 61–83). New York, NY: Guilford Press.

Part II
Disruptions in Family Systems

13
Cultivating Resilience Through Creative Altruism With Institutionalized Youth in Foster Care

MIA DE BETHUNE AND KELLEY LINHARDT

Many institutionalized children have histories of trauma related to neglect, abandonment, or abuse (Briggs et al., 2012; Knoverek, Briggs, Underwood, & Hartman, 2013) and are so focused on basic survival that their ability to give to or think about others is diminished (Mikulincer, Shaver, Gillath, & Nitzberg, 2005; Zhang, Zhang, Yang, & Li, 2017). It is common for early adolescent boys to be self-focused and this can be easily exacerbated in environments like foster care or residential treatment with limited resources that must be shared (Blos, 1962; Levy-Warren, 1996; Riley, 1999). What happens when a group of adult strangers, with similar issues, give generously to young boys living in residential foster care and the boys are asked to give back? Reducing self-focus and exhibiting gentleness might make these young adolescents feel vulnerable. Can they rise to the challenge?

This was the subject of a 2007 participant observer study. Though the exchange between these two groups was informal, the study consists of observed results striking enough to document. In the fall of that year Kelley Linhardt, my co-author, and I were art therapists at a homeless women's shelter and a residential facility, respectively. The homeless shelter served single women in the inner city, many living apart from their children, and the residential facility served youth in foster care in an outlying suburb of the same city. Both populations displayed signs of hopelessness and institutionalized dependence. The women struggled with issues of poverty, loss, mental illness, and substance abuse. They created endless sewn objects such as pillows and dolls, as if seeking comfort. The youth were aggressive; impulsive; and, at times, regressed. They could also be helpless, needy, and self-absorbed.

Kelley hoped that motivating the women to make comfort objects for others would give greater meaning to their repetitive acts of creation. As sewn pillows and dolls piled up, she looked for a group of children to receive the handiwork and found me through an Internet search. I agreed to have the boys create drawings and cards in response and a gift exchange was born.

Though the two groups never met, each group learned a little about the lives and challenges of the other. We hypothesized that making comfort objects and sending them as gifts to strangers might create a symbolic bond that touched on their shared personal experiences of living apart from family and might also positively affect their sense of agency and self-efficacy. In the end, we were struck by the degree to which both groups were motivated to give when they could identify with the people who would receive their gifts.

Our resulting work is a phenomenological and heuristic examination of the effect that altruism can have on institutionalized individuals. Though the story of the women in the shelter is equally compelling, the main focus of this chapter is the experience of the boys in residential care. Composite case studies of two young men will be used to represent the group of boys who participated. The literature review will look at characteristics of youth in residential treatment; effects of parental separation; altruism and its benefits for traumatized youth; emotional resilience; the role of transitional objects in attachment; and the role of art-making in healing attachment-related trauma. A final section will recommend methods and outline clinical considerations for engaging adolescents in altruistic giving and will highlight additional examples of youth-focused art therapy projects that encourage empathy, openness, and generosity.

Youth in Residential Foster Care

Children who are placed in residential care are among those with the greatest need for psychological services (Briggs et al., 2012; James et al., 2006; Knoverek et al., 2013; Weber, Somers, Day, & Baroni, 2016). In 2015, there were 428,000 children in foster care in the U.S. 45% of whom were in institutions or placed with non-related strangers (Child Welfare Information Gateway, 2017). Youth in residential treatment are 25% more likely than those who reside with their families to have experienced multiple traumas such as emotional, physical, or sexual abuse (Knoverek et al., 2013). They are also more likely to have parents with mental illness, substance abuse issues, or violent relationships (Clarizio, 1997; Evans, 2010; Kotler & McMahon, 2005). These types of traumatic experiences in childhood are more likely to result in attachment issues because children tend to organize their behavior, relationships, and choices around the possibility that trauma will reoccur (Green, 1983; Meshcheryakova, 2012; Terr, 1981; van der Kolk, 2005). Problematic behaviors such as running away, self-injury, substance abuse, suicide attempts, and criminal acts can result in multiple foster care placements (Briggs et al., 2012; Hart, 2012; Knoverek et al., 2013; Newton, Litrownik, & Landsverk, 2000; Weber et al., 2016), which further disrupts attachment and can stigmatize a child as difficult. This can make them resistant to treatment and mistrusting of others (Hart, 2012). Longitudinal studies of these children tend to show poor outcomes in mental health and educational attainment (Hart, 2012; McAuley, Pecora, & Rose, 2006; Meltzer, Lader, Corbin, Goodman, & Ford, 2004; Weber et al., 2016).

A certain degree of self-absorption is common in adolescence (Blos, 1962; Levy-Warren, 1996; Riley, 1999), but children in residential treatment often present as more narcissistic and less capable of empathy than their peers (Mikulincer & Shaver, 2007; Zhang et al., 2017). Hart (2012) maintains that children who enter the foster care system experience the trauma of losing their birth family, sometimes leading to the symbolic experience of their parent(s) being dead (Green, 1983). Losing a caregiver, symbolically or otherwise, is likely to lead to expressions of grief through anger, aggression, and emotional detachment, which makes forming new attachments difficult (Conway, Oster, & McCarthy, 2010). Emotional numbing coupled with poor interpersonal skills can result in a lack of empathy and a coercive relational style (Clarizio, 1997; Conway et al., 2010; Evans, 2010), which can be expressed in needy and demanding behaviors toward residential staff and dissatisfaction with their care (Barry & Lee-Rowland, 2015; Herrington, Barry, & Loflin, 2014).

The Power of Altruism to Cultivate Resilience

Attachment theory tells us that repeated contact with supportive and responsive caregivers promotes security, positive self-worth, self-efficacy, and altruistic behavior (Zhang et al., 2017). On the other hand, those with attachment disruption or narcissism, like many of the boys in this study, are less likely to give altruistically than those that are securely attached (Hyun, Park, & Park, 2016). Studies show that individuals whose parents are more nurturing and altruistic tend to be altruistic as well (Clary & Miller, 1986; Hur, 2013), but what about those who are disadvantaged by poor parenting, insecure attachments, and histories of trauma?

Zhang et al. (2017) noted that while secure attachment tends to promote a disposition toward generosity and gratitude, even those with an insecure attachment style can develop a similar disposition with supportive interventions. Despite the corrosive effects of PTSD, common among those with poor attachment, the struggle to come to terms with trauma can also result in greater strength, wisdom, and gratitude. Such gains from difficult experiences are considered "post-traumatic growth" (Zhou & Wu, 2016).

Resiliency is defined as "the ability to respond or perform positively in the face of adversity, to achieve, despite the presence of disadvantages, or to exceed expectations given negative circumstances" (Brennan, 2008, p. 2). Social support and interpersonal relations play a key role in resiliency (Quisenberry & Foltz, 2013). Resolving negative ideas about adults can have a powerful impact on outlook and functioning in young people with a trauma history (Brendtro, Mitchell, & McCall, 2009; Quisenberry & Foltz, 2013). Brendtro et al. (2009) stress the importance of a transparent and collaborative approach among staff working with troubled youth and their parents as a way to develop trust. They also suggest involving youth in residential care, in "service-learning projects" where they can develop problem-solving and social skills and increase "their feeling of connectedness to others and the community outside of residential care." (Quisenberry & Foltz, 2013, p. 284). Positive youth development and strength-based approaches to treatment are shown to increase self-esteem, ameliorate trauma, and build resiliency (Quisenberry & Foltz, 2013).

Lozado, D'Adamo, and Carro (2014) found that even short amounts (10 to 15 minutes) of engagement in becoming aware of others' needs can foster altruism. The psychological and physiological benefits of such pro-social engagement can have an enormous impact on reduction of stress and aggression. Compassion and altruistic behavior can be promoted through what is called "attachment security priming," which is the act of reminding a child about experiences of positive support and secure relationships (Lozado et al., 2014, p. 77). This can be done in conjunction with the modeling of altruistic behavior and can prompt generosity and compassion in children even toward people whom they might consider strangers.

Enright, Rhody, Litts, and Klatt (2014) demonstrated that children who reside in stressful and possibly contentious environments could be taught compassion and forgiveness as coping strategies. They employed a "forgiveness education" curriculum combining journaling and email exchanges between peer groups in conjunction with psychoeducation about forgiveness toward individuals who may have perpetrated aggression against them (p. 2). Results indicated that groups who engaged in the email exchange had increased ability for compassion and empathy and lessened prejudice toward others, while those who only wrote journal entries and did not interact did not show the same effects (Enright et al., 2014).

Art Therapy, Intergenerational Exchanges, and Transitional Phenomena

It is increasingly common to find art therapy practiced in residential programs. Crafts and creative arts have been used for many years with orphans and other displaced and institutionalized peoples (Dvir, Weiner, & Kupermintz, 2012; Mescheryakova, 2012; Phillips, 2003). Social action engagement through art therapy has been shown to increase feelings of personal empowerment (Morris & Willis-Rauch, 2014; Gray, 2012) and to create "islands of competence" amongst marginalized youth (Brooks, in Crenshaw & Hardy, 2006, p. 189).

The majority of documented intergenerational exchanges occurred between children and senior citizens who wrote to each other as pen pals (Dallman & Power, 1996; Kiernan & Mosher-Ashley, 2002). Such programs help children to develop empathy and understand the social needs of another generation (Kiernan & Mosher-Ashley, 2002; Dallman & Power, 1996)and have subsequently been modernized to include video messaging for enabling "cross-cultural" friendships (Du, et al. (2011), p. 290). The unique aspect of our exchange was the choice to use art objects made in a therapeutic setting that could stand in for their creator as the means of communication and connection between the two groups (Buk, 2009; Freedberg & Gallese, 2007; Winnicott, 1953).

Infants learn to self-soothe in the absence of their mother by turning to anxiety-reducing objects, usually stuffed animals, dolls, or blankets. These "transitional objects" represent a mother's nurturance and comfort even in her absence (Winnicott, 1953, 1971). Many art therapists believe that art-making occurs in the "transitional space" between the subjective and objective, like the infant's creative transformation of a loved possession into an object symbolic of their mother (Robbins, 1992; Wilson, 1983). Thus, art therapy is a preferred modality for creating transitional objects that serve as comfort in the absence of an important "other."

McCullough (2009) found that children struggling with loss due to divorce used "transitional objects" created in art therapy to explore their loss and sort out thoughts about their relationships (p. 19). Loss of a parent in childhood, common among children in residential treatment, can have a significant effect on a child's self-esteem, coherence of identity, expression of aggression, and the ability to self-soothe (Conway et al., 2010; Dvir et al., 2012).

Doll making in particular has been identified as having organizing or soothing properties for the artist while also creating an object, which has the capacity to facilitate transitional experiences (Feen-Calligan, McIntyre, & Sands-Goldstein, 2009; Hastings, 2003). Dolls can help build (or rebuild) attachment bonds because they are human-like and allow a child to dialogue in the safety of transitional play (Frey, 2011; Steinhardt, 1994).

Method

The Women in the Shelter

In the fall of 2007, Kelley noticed that women in the urban homeless shelter where she worked as art therapist were repetitively making stuffed animals, dolls, pillows, and blankets for themselves as if to find comfort; however, the overproduction of these crafts caused them to eventually lose their therapeutic value. Whereas the first pillow one of her clients sewed was a personal achievement, the fortieth pillow was simply another of many crammed into her tiny locker. Kelley understood the shelter as a place where personal needs were great and personal space was limited, so in an effort to empower the women and refocus their energies, she suggested they might make things

for others and reached out via a professional list-serve looking for children to receive their "special gifts."

The Boys in Residential Treatment

At the time I was an art therapist at a large residential facility for boys about 30 miles from the shelter. There was already a culture of volunteerism at this facility, and the boys were used to receiving gifts from people other than family. My main concern was that the boys were on the verge of adolescence and might respond negatively to "childish" gifts like dolls and stuffed animals. Nonetheless, I chose 24 boys to be included in the exchange, ages 10 to 13 years old. Most had been removed from their homes due to severe emotional disturbance, abuse, or neglect. Many were regular participants in an open studio I ran, and some were in individual art therapy. I chose to give the gifts right after Thanksgiving rather than wait until Christmas because it was common for residents to receive numerous donated gifts during the holidays. I worried the women's homemade gifts might be underappreciated next to more compelling electronic presents like video games.

Gift Making

At the shelter, 31 women went into a period of purposeful gift creation with the boys in mind. For some, the project brought up memories and fantasies about their own children, but most focused on the altruistic aspects of the project and how "good" and "useful" it made them feel to help children in need.

Kelley suggested that the women might like to write a personal note to be included with their gifts. A woman named Carol sewed a soft doll to a pillow and wrote a note that said, "Please make sure this little doll eats his spinach."

When they had made over 100 gifts, I was invited to the shelter to meet the women and collect the presents.

During my visit, the women asked me specific questions about the boys and what their lives were like; where they went to school and what they ate for breakfast; what they

Figure 13.1 Making gifts at the shelter

Figure 13.2 The gifts waiting to be collected

Figure 13.3 Close up of the gifts waiting to be collected

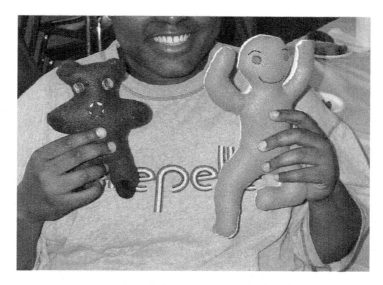

Figure 13.4 Woman with purple dolls

Figure 13.5 Woman with pompom doll

did for fun and where they slept at night. I answered as best I could without revealing anything about the boys individually. Their questions seemed to invoke a story of the children who were about to receive their handiwork. I then offered to photograph any woman who wished to be photographed holding her gifts.

Few declined, and those who were photographed gave written consent. I left them that day with the promise to send the photos so they would have a souvenir to remember their role in the project. I was later told that many of the women were separated from their own children and imagined that these boys could have been their sons.

Receiving and Giving Back

Privately, Kelley and I discussed the evidence of emotional trauma that we, as art therapists, could clearly see in many of the dolls; e.g., a woman who struggled with anorexia left her doll flat and unstuffed; another who had experienced severe physical abuse gave her doll a thick perimeter of protective pompoms; and a third wrapped hers like a mummy for similar protection.

Figure 13.6 Pompom doll

Figure 13.7 Wrapped doll

We agreed that I should sort through the items and remove those that might appear frightening or be rejected by the boys. The rejected gifts were sealed away in a bag in the back of my art studio, while the selected ones were wrapped in paper to equalize them.

On an appointed evening at the end of November, the boys gathered to select their gifts. After telling them a little about my visit to the shelter and the women I met there, I framed the gifts they were about to receive in this way:

These gifts were handmade by women who live in a homeless shelter and have troubles and struggles just like you do. Some of the gifts may seem better than others. It

is possible that you may not like the gifts you choose, and in that case, you may be able to exchange with someone else, but the important thing to remember is that these gifts were made with love.

Each boy then came and selected a few packages out of a large bag and returned to his seat to open them.

Surrounded by their new pillows, blankets, scarves, and dolls, they spontaneously gathered together on the couch and floor, cuddling with their presents as if at a sleepover, demonstrating an unusual, gentle cooperation.

When they had finished with their play, I set up art supplies and asked them to write thank-you notes and draw pictures for the women.

The overwhelming response was positive, with only two children rejecting their gifts outright. However, when they saw the enthusiasm of their peers, they pitched in and made notes, too. Afterward, I collected the cards and drawings to be sent to the shelter along with photos of the boys with their gifts.

Figure 13.8 Receiving gifts at the residence

Figure 13.9 Boys on the couch with their gifts

Figure 13.10 Boys writing thank-you notes and cards

These were presented to the women by Kelley on Christmas Eve. This day was chosen purposefully as it tends to be emotionally difficult for shelter residents separated from loved ones. Initially, Carol, who had written the note to send with her doll, refused to come into the party. She stood outside the shelter gate, smoking and crying, because she had no family to be with. Finally, she was convinced to join the group after

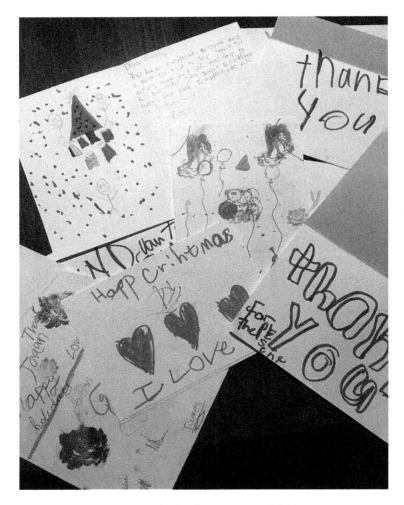

Figure 13.11 The thank-you notes and drawings

much encouragement on the part of her art therapist. As it turned out, there was a note addressed specifically to her from the boy who had received her doll. Opening up the handwritten note, she declared, "This makes my life worth living." Afterward, many of the women taped the cards and photographs of the boys with their dolls on their lockers or kept them in their wallets as if the boys were surrogate children. These small keepsakes seemed to fill up their lockers in a way a slew of craft items could not.

Case Study: Derrick

Derrick was nearly 13 years old at the time of this gift exchange and lived in a cottage for severely emotionally disturbed youth. He had been born to an adolescent mother who

Figure 13.12 Boy with doll pillow

struggled with substance abuse and openly rejected Derrick as an infant. He was lanky and tall, with blond hair cut close to the scalp and pale skin, which showed bruises from where he hit himself or had wrestled with others. Though he had occasional phone calls with his mother, her parental rights were being terminated, and Derrick was unsure where he would be living when he left the residence. He could be argumentative and aggressive and often had trouble sharing.

On the day of the exchange, Derrick appeared shy about taking a gift. When he ripped open the paper, he found a small pillow with a soft doll sewn onto it.

There was a note attached to his gift from a woman named Carol reminding him to feed the doll its spinach. Derrick beamed and held up his pillow, which seemed ten years too young for this early adolescent boy. He requested that his picture be taken with his gift, which led others to ask to have their picture taken, too. The agency has a strict photo release policy, and I was allowed to photograph only those children for whom release was granted.

During the card-making session after the gift exchange, Derrick asked me, "What color do you think Carol likes best?" He drew for a while, stopping to ponder his picture of a Christmas tree and presents, and asked, "Do you think she will like my drawing?"

Case Study: Aaron

Aaron was 12 years old and lived in a "mainstream" cottage for boys who had been temporarily removed from their homes due to neglect or abuse. He had regular weekend home visits with his mother and two younger siblings but would not be discharged until his mother completed parenting classes and a course in anger management. Aaron's father had never been in the home, and, as the oldest child, his mother often took her frustrations out on him. He was a gentle but serious dark-skinned child who was prone to self-harm and often expressed a fear of returning to his neighborhood where he needed to dodge gang violence on his way to school.

On the night of the gift exchange, Aaron and several of his cottage mates took their presents and lay down on the living room floor with pillows from the couch. With their heads up against each other, some with thumbs in their mouths, they appeared to be having a sleepover prompted by receiving the type of objects that they might cuddle with in bed. During the card-making session, Aaron was careful about drawing a bed on which he put a teddy bear. He stated, "My mom and I lived in a shelter once with my baby sister."

The Boys and the "Damaged" Gifts

The Christmas Eve party when the shelter women received their cards and drawings marked the end of our informal gift exchange. However, I still had a substantial number of handmade items that had been deemed too "damaged" to give to the boys.

I did not want to throw them away but had little storage space in my studio.

At that time, I held a regular open studio on Wednesday evenings for many of the same boys who had been included in the exchange. Derrick and Aaron were regular attendees. In late January, two months after receiving their gifts, I briefly reminded the boys of the women from the shelter and then placed the bag in the middle of the studio table to see what they might do.

Their usual repertoire of activities in open studio included making swords, guns, and superhero costumes. It was common to hear them discuss their "hand skills" or fighting ability, as these were necessary tools for survival in both their urban neighborhoods and residential cottages.

Derrick, Aaron, and two other boys opened the bag and, without consulting me, began dividing the rejected dolls among themselves. They then asked for boxes, felt, and cotton batting. My interns and I helped them to cut windows and doors as they carefully created homes outfitted with soft beds or nests for their dolls made by homeless women. At the end of the evening, they packed up their dolls and houses and carried them back to their cottages. Derrick hugged me before he left and said, "This was one of the best days of my life." There are no images of these houses as they remained out of the formal exchange and there was no possibility of written release.

Figure 13.13 Fragile doll

Discussion

In our introduction, we pose a question: what happens when a group of pre-adolescent males living in residential foster care are asked to give back—knowing that such behavior could diminish their protective narcissism? Or more broadly: How does one remain open to new relationships after exposure to trauma? The answer to both, we found, relates to the surprising wells of compassions and resilience found in our clients, which the gift exchange allowed them to access.

The boys accepted not just the physical gifts but also the overture of attachment, no matter how distant or imperfect, that came with them. Their willingness to take this leap from protective self-focus to vulnerable openness was buttressed by the implicit relationship between themselves and the women as well as the protective anonymity between them. They were free to imagine the other as a satisfying object capable of filling a void

left by traumatic losses (Green, 1986; Winnicott, 1953). These imaginings appeared to occur within a "transitional space" prompted by the comforting gifts (Winnicott, 1953). We had our doubts, but both the women and boys proved able to give beyond our expectations and experienced the empowerment and purpose that comes from selfless giving (Crenshaw & Hardy, 2006; Gray, 2012; Morris & Willis-Rauch, 2014).

Motherless Children and Childless Mothers

The participants in this gift exchange never met. They lived in different cities and were different ages but shared poverty, trauma, and separation from family in common. By the time the women had completed the long process of making soft, comforting gifts, a role traditionally undertaken by mothers for their children, many began to understand themselves as surrogates to boys who needed mothers. The boys, on the other hand, did not approach the exchange with the same expectations. The gifts were given to them with little advance notice within the context of regularly receiving holiday presents from a variety of anonymous benefactors. In this case, my "framing" of the gifts, or "attachment priming," allowed them to be open and curious about the handmade items, thus imbuing them with an unusual specialness (Lozado et al., 2014).

Derrick, whose own mother often disappointed him, was able to graciously accept a gift meant for a young child and to create a thoughtful card and picture to give back. It seems likely that the addition of a personal note from Carol could have increased his capacity for empathy toward and feeling of connection with this "stranger," allowing him to imagine the existence of a surrogate mother who might meet his emotional needs through the doll she created (Buk, 2009; Dallman & Power, 1996; Enright et al., 2014; Freedberg & Gallese, 2007; Kiernan & Mosher-Ashley, 2002; Winnicott, 1953).

With their impromptu sleepover and gentle home construction, Aaron and his peers seemed to understand their implicit relationship with the women. They were able to empathize and identify with both the maternal comfort, as well as the trauma embodied in the dolls (Buk, 2009). Rather than rejecting the "damaged" dolls, as we feared, the boys intuited that these toys, which had been made for them by homeless women, needed houses and that the latent trauma embedded in the dolls revealed their need for unconditional love and acceptance.

The boys implicitly understood the intersection between the needs of the doll makers for a home and their own needs for a fulfilling home life. By building homes for the dolls, the boys also created a "potential space" for themselves in which they could imagine a "good enough" mother who could meet their needs for nurturance—no matter how fantastic (Conway et al., 2010; Dvir et al., 2012; Winnicott, 1971). Within this imaginal mother-son holding relationship, the boys felt safe enough to both receive love and to give love to themselves, demonstrating deep wells of resilience within and the possibility of an intact core self (Feen-Calligan et al., 2009; Frey, 2011; Hastings, 2003; Steinhardt, 1994).

The Gift of a Transitional Object

In his seminal work, *Transitional Objects and Transitional Phenomena*, Winnicott (1953) shares a case study of a pre-adolescent boy described as "developing along 'tough-guy' lines" (p. 25). This boy grew up in a loving and intact family, but suffered attachment-related traumas at pivotal moments in his development including several prolonged

maternal absences while she was hospitalized with depression. He privately cared for a family of teddies whom he considered his children by lovingly sewing them trousers. However, he would claim the teddies belonged to his sister if visitors came over. Winnicott (1953) diagnosed this as a symptom of the boy's "maternal identification, based on his own insecurity in relation to his mother" (p. 25).

Derrick, Aaron, and the other boys involved in the gift exchange grew up under more severe circumstances of relational trauma, but similarly presented with 'tough-guy' exteriors to face the social pressures of their cottages and neighborhoods. Their ability to let down their guard and publicly play through some of this trauma, with uncharacteristic gentleness and empathy, showed great courage and provided an opportunity for transformation and reparation within the psychically safe context of communal play and creativity (Conway et al., 2010; Dvir et al., 2012; Feen-Calligan et al., 2009; Gray, 2012; Hastings, 2003; McCullough, 2009; Morris & Willis-Rauch, 2014; Robbins, 1992; Wilson, 1983). Despite insecure relationships with their own mothers, they demonstrated resilience in their ability to love and be loved, which could be considered "post-traumatic growth" (Winnicott, 1953; Zhou & Wu, 2016).

Altruism and Institutionalized Children

One could argue that the truly selfless and altruistic aspect of this exchange happened without adult prompting, during the caretaking of the "damaged" objects in the open studio. The spontaneous choice to create homes seemed to indicate an impulse to show attuned kindness to the dolls and, by proxy, the doll makers. These acts seemed "primed" by the framing I did at the start of the gift exchange in November (Lozado et al., 2014). The secure nature of the group also helped facilitate their relaxed and playful "sleepover." Creating situations that allow closed and traumatized youth to behave generously provides them with an opportunity to expand their sense of self, evidenced by Derrick's statement that making houses for the dolls represented one of "the best days" of his life (Crenshaw & Hardy, 2006; Quisenberry & Foltz, 2013). Other examples of altruism I have witnessed among these youth often revolved around vocational activities like training service dogs, learning to cook and sharing food with each other, and working in the campus barber shop, all of which involve socialization and caregiving. I will give other examples for promoting altruism through art-making further on.

Methods for Implementation

Though we did not set out to conduct research when we planned our gift exchange, certain aspects of its execution appeared to facilitate its success. Among these were:

1. The similarities between the two populations connected them through shared histories, ethnicity, geography, and economic status, which helped lead to a nonverbal emotional connection.
2. The presence of developmental interlocking needs. Pre-adolescent boys may be especially responsive to the attention of mother figures, while homeless women, living apart from their children, may be looking for appropriate means to be generative (Bradley, 1997).
3. The use of attachment priming in the framing of the exchange highlighted that the women weren't typical, anonymous benefactors, but instead were like them.

My introduction seemed to emotionally prepare the boys to be accepting of and generous toward the women's handiwork (Lozado et al., 2014).

4. The use of handmade objects seemed to enhance an empathic bond between the groups. One could hypothesize the presence of mirror neuron connections latent in art objects promoted the connection, which might be less present in pen-pal correspondence or video-chatting (Buk, 2009; Freedberg & Gallese, 2007; Winnicott, 1953).

5. There was a pre-existing culture of volunteerism at the residence in which altruism was frequently modeled. This undoubtedly helped prepare the boys to be generous when it was asked of them (Brendtro et al., 2009; Lozado et al., 2014; Quisenberry & Foltz, 2013)

6. The design of the exchange allowed the boys' altruistic impulses to develop over time and be expressed naturally and without coercion (Lozado et al., 2014). This project could be described as having three distinct stages through which the boys' empathy deepened and developed: 1) The altruism priming by the therapist; 2) the card making in which the boys were asked to connect to the giver as a person; and 3) the house making in which the boys responded empathically when faced with the trauma of others.

Successful implementation of "positive youth development" programming in foster care or residential treatment settings can be enhanced by structuring programming around some of the above-mentioned elements (Quisenberry & Foltz, 2013, p. 283). Below we will consider some of these elements in greater detail and apply them to additional examples of altruistic art therapy projects that can be undertaken with similar populations.

Implied Relationship

Careful thought should be given to which populations children are asked to give to or volunteer with. Children can also be enlisted to research populations that they might like to exchange with, which may increase investment and empathy. The deeper the perceived connection between the groups, the more meaningful the experience may be.

However, by exploring differences between the youth and those they might exchange with, the facilitator can expand flexibility and curiosity, allowing previously unseen points of connection to come to light. An example of this occurred when an orphanage run by an NGO in Rwanda wanted to share art with the youth at my residence. The orphanage sent a short video of the children who had created the art. After watching the video, the drawings my clients received from the orphanage were imbued with a deeper meaning. Not only had they come from across the ocean but were made by children who were orphaned like they were. That my clients were trusted to handle such precious objects, made by children who had survived war and genocide, fed their self-esteem and motivated them to invest in elaborate drawings to give back.

Framing the Project

Psychological framing of gift exchanges can allow empathy to occur even between disparate groups who, on the surface, may appear dissimilar. An example might be traumatized youth pairing up with dementia patients at a nursing home. The key is to create an emotional picture so that the youth not only envision the patients, but also empathize

and see similarities in their experiences, e.g., "The dementia patients wait for visits from family members just like we do" or "My grandma is in a home like that."

Gift exchange framing should consist of a clear expectations and structure, where they know:

1. Who they will be exchanging with.
2. What they will receive.
3. What they will be asked to give.
4. What their benefactors are communicating with their gifts.
5. What message they intend to communicate with their gifts.

Altruistic Art Therapy

Art has the unique capacity to create bridges between disparate and distinct communities because of the powerful emotion expressed in its creation. This can transcend verbal or written language and can be felt at a visceral level by the viewer (Buk, 2009; Freedberg & Gallese, 2007). Examples of other successful altruistic art projects at the residential facility include the creation of paper cranes by the youth in the aftermath of a school shooting and handmade dolls and sketchbooks created for children consigned to shelters after a hurricane flooded their metro area. In this instance, even with the power outages in most cottages, boys came to the recreation center with its generator to work on sewing and collating through the rainstorms.

Clinical Considerations

At the residence where this gift exchange was conducted, the boys were rated each week on a behavioral point system, which involved positive reinforcement through the use of rewards. Within such a motivational system, we endorse an alternative approach when promoting altruism (Brendtro et al., 2009). Rather than coercing youth, we suggest modeling altruism to encourage involvement rather than making it a mandatory (point-earning) activity (Lozado et al., 2014). No punishment or shaming should occur if a child is emotionally unable to engage in altruistic giving (Hart, 2012). An example of this occurred during our gift exchange when one child refused to even choose a package to open. Staff informed me that he had just been approved for discharge home to his mother. Even accepting a gift from a strange woman might constitute betrayal of the parent whom he had worked so hard to rejoin.

If a token economy does exist, the therapist should "frame" an altruistic project for milieu staff to emphasize the intrinsic rewards of giving. One way of assuring that this is understood is to include staff in the creation of gifts and art alongside the youth they care for. Enthusiastic participation by milieu staff can enhance attachment bonds with youth and may have the additional benefit of addressing staff's need to be creative and engage in altruism and self-care (Brendtro et al., 2009).

Additionally, it should be mentioned that although children in foster care tend to be "self-focused" for purposes of survival, I have witnessed a great number of abused and neglected youth who had the opposite tendency: an almost compulsive need to give gifts and their artwork away to others. I understood this as a compensatory behavior, meant to appease a neglectful or abusive parent or attempt to secure a connection to another. This type of compulsive making and giving could also be seen in the art-making behavior

of the women at the shelter for similar reasons. Excessive giving or withholding could both be results of disrupted attachments and should be addressed in the context of art therapy treatment.

Another important consideration during this project was our own countertransference projections and the assumptions that they led us to make about our clients. Kelley worried that the boys would be negatively affected by the presence of the latent traumatic content that she saw embedded in the "damaged" gifts by the women. I feared that my pre-adolescent clients would be too selfish and reject the women's gifts as babyish. Over the course of this project, we became aware that our clients' histories of poverty and trauma could overshadow their capacities for empathy; kindness; and, above all, resilience. Sometimes our most important job is to facilitate an opportunity for clients to exceed expectations and then get out of the way and let them do it.

Limitations

Our decision to write about our anecdotal observations stemmed from the apparent positive benefits of the gift exchange for both groups. Admittedly, it's impossible to draw any firm conclusions from this exchange, as it was not designed as a study and there are numerous limitations. There was no random selection in either population, and there was a clear gender bias in that the gifts were made by adult women for pre-adolescent boys, who may have been inclined to respond positively to their attention (Bradley, 1997; Raihani & Smith, 2015). What might the exchange have been like if the genders were switched? Studies designed to measure the benefits of altruistic art-making and gift giving among institutionalized and traumatized youth might validate our observations.

Other Uses of Art Therapy to Promote Altruism Among Youth in Foster Care

The following suggestions are based on successful interventions I have employed over the years, which helped clients be more curious, generous, and open to their world and others.

ART MATERIALS THAT PROMOTE ALTRUISTIC GIVING

As mentioned above, some youth in residential treatment have a need to make gifts or cards repetitively or spontaneously. For this purpose, I keep small lidded boxes, ribbon, tissue paper, and blank card stock in the studio. The ritual of selecting and wrapping a handmade object formalizes its importance and imbues it with value.

Beading or braiding bracelets or other small items can smack of "craftiness," but the mastery gained from selecting and stringing colored beads should not be underestimated. While it is important to be mindful of color use due to potential "gang" affiliation among some foster care youth, the sequencing and stringing of the beads represents a soothing rhythmic activity that is closely related to the biorhythms of a well-regulated body. Strings of friendship bracelets and lacing lanyards may be seen as ties that bind one person to another, enhancing and mimicking attachment bonds among youth for whom attachment may be fragile.

Activities using fabric, sewing, and yarns can have a similar function. They often evoke an attachment response (e.g., memories of sewing with grandmother or a

nurturing caregiver). Many senior centers look for opportunities with youth where older people can teach them to sew or cook. In a subtle transformation of our gift-giving project, youth could also be encouraged to sew dolls for children younger than they are.

ART ACTIVITIES THAT ENCOURAGE PHYSICAL CONNECTION AND BODILY INTEGRITY

One activity that was popular among youth in my Open Studio groups was the plaster crafting of body parts. This process utilizes the same plaster gauze that doctors use to set broken bones. It also involves the process of touching another person in an intimate way. For this activity, we would set up an area of the studio as a sort of salon. One child at a time would receive the undivided attention of myself or one of their peers while gauze was carefully placed around their hand, arm, or even face. This process depended upon the presence of trust and tolerance on the part of the individual being plastered, especially because many of the boys were victims of physical assault or sexual abuse. Undertaken in a protected group environment, applying a cast evoked not only trust and safety but symbolic healing, which was emphasized by the slow process of witnessing the cast harden and then being removed to reveal their healthy form beneath. I had similar positive results using black ink to create faux tattoos on the arms of older teens, who seemed to feel accepted and seen by my willingness to touch them—again, in a "safe" way.

GROUP INTERVENTIONS THAT BUILD EMPATHY

Group work is a natural forum for promoting altruism as the very nature of group promotes empathic understanding amongst members. The following are two specific projects that promote tolerance and reciprocity.

In the first art therapy group, middle adolescent youth, who had sexually victimized younger children and were enrolled in a juvenile sex offenders' program, were brought together weekly for art-making. Emotions were raw and conflicted as participants struggled to empathize with their victims and one another. They could be hostile and were often filled with shame. Art therapy was one place where they could safely let down their guard and express emotions and vulnerability without having to speak.

A successful intervention for this group was developed by an intern who modified a summer camp activity derived from the children's book *Pinkalicious* (Kann & Kann, 2006). The expression from the book, "You get what you get and you don't get upset," is introduced as each boy chooses a box. All the boxes were differently sized and wrapped in white paper. They contained various items purchased from the Dollar Store such as string, rubber balls, plastic soldiers, balloons, or stickers. In some boxes there were scissors. In others there was tape or glue.

The boys were each given a wooden board on which to work, and they were told to create something with what they found in their box. The mantra "You get what you get and you don't get upset" served to prime or frame the activity as was done in the gift exchange with the shelter women. If the boys did not like what they received in their box, then they could negotiate a trade with the other group members for what they needed. They also had to negotiate the use of the limited supply of scissors, tape, and glue, which were hidden in the boxes. On the surface, this activity was playful and enjoyable, but when done within a therapeutic setting it encouraged creative thinking and deeper connection amongst the members, as well as respectful seeking and

giving. These are all important characterological attributes of an empathic person and a reparative experience for those who had previously struggled to acknowledge the personhood of others.

Another successful group activity employing boxes involved younger adolescents who were encouraged to draw images of their neighborhood. For children in residential care, identification with their home neighborhood can be a source of pride and emotional survival, so this activity was approached eagerly.

After their neighborhood drawings were completed, each child was given boxes covered in white paper just as in the previous activity. In this case, the boxes were used to create buildings from their neighborhood (e.g., apartment buildings, the local bodega, Best Buy, etc.). They decorated them with markers and paint. When all of the boxes were complete, they were brought together on a large base made of foam core with streets and sidewalks. Together they combined their box buildings to form a neighborhood. They then turned soap boxes into cars and toilet paper rolls into trees and jointly built subways and parks. The process of coming together after individual work allowed the boys to have their own space before co-creating a shared space.

Sharing and understanding others' neighborhoods created empathic bonds around common experiences. The neighborhood expanded to include the train ride each boy had taken from his urban home to the residential treatment center where they all lived. What began as an individual depiction of each boys' experience ended up as a concrete representation of their journey from individual to group member.

THINKING ABOUT THE WORLD AROUND US

Youth in residential treatment are often so focused on survival and their narrow world of neighborhood or residence that it is hard for them to see beyond this lens. Art activities that acknowledge our shared stewardship of the environment can allow marginalized populations to see themselves as citizens of the world with a vital mission to care for the planet. With that in mind, every April for Earth Day I promoted recycling awareness by holding "Junk Sculpture" contests. These contests resulted in many delightful experiments from dragons made out of plastic cups and utensils to "Eco-warriors" constructed from tin foil and tuna cans. We also made spider webs out of plastic bags and pulped old t-shirts to make paper. I like to think the boys in my groups came away from these activities with an understanding that they had an ability to help protect the earth's environment—a home that we all share with each other.

Conclusion

Our job as therapists working with children and adolescents in the foster care system is to provide reparative experiences that counteract past trauma and allow for an expansion of personal identity from victim to survivor. In the gift exchange with the homeless women, as well as in the other art therapy interventions listed above, it is clear that when given the smallest opportunity to relate meaningfully to others, youth can rise to the occasion. As therapists, it is easy to let the litany of future obstacles and past traumas obscure wellsprings of resilience and potential buried just below the surface. When youth in foster care are given opportunities to be altruistic, they can define themselves as generous, giving, and kind—transforming personal narratives of loss and lack to ones of agency, strength, and resilience.

References

Barry, C., & Lee-Rowland, L. (2015). Has there been a recent increase in adolescent narcissism? Evidence from a sample of at-risk adolescents (2005–2014). *Personality and Individual Differences, 87*, 153–157. https://doi.org/10.1016/j.paid.2015.07.038

Blos, P. (1962). *On adolescence: A psychoanalytic interpretation.* New York, NY: The Free Press.

Bradley, C. (1997). Generativity-stagnation: Development of a status model. *Developmental Review, 17*(3), 262–290. https://doi.org/10.1006/drev.1997.0432

Brendtro, L., Mitchell, M., & McCall, H. (2009). *Deep brain learning: Pathways to potential with challenging youth.* Albion, MI: Circle of Courage Institute and Starr Commonwealth.

Brennan, M. (2008). Conceptualizing resiliency: An interactional perspective for community and youth development. *Child Care in Practice, 14*(1), 55–64. https://doi.org/10.1080/13575270701733732

Briggs, E. C., Greeson, J., Layne, C. M., Fairbank, J. A., Knoverek, A. M., & Pynoos, R. (2012). Relations between trauma exposure, psychosocial functioning, and treatment needs of youth in residential care: Preliminary findings from the NCTSN core data set. *Journal of Child & Adolescent Trauma, 5*(1), 1–15. https://doi.org/10.1080/19361521.2012.646413

Buk, A. (2009). The mirror neuron system and embodied simulation: Clinical implications for art therapists working with trauma survivors. *The Arts in Psychotherapy, 36*(2), 61–74. https://doi.org/10.1016/j.aip.2009.01.008

Child Welfare Information Gateway. (2017). *Foster care statistics 2016.* Retrieved from www.childwelfare.gov/pubPDFs/foster.pdf

Clarizio, H. (1997). Conduct disorder: Developmental considerations. *Psychology in the Schools, 34*(3), 253–265. https://doi.org/10.1002/(SICI)1520-6807(199707)34:3<253::AID-PITS8>3.0.CO;2-P

Clary, G., & Miller, J. (1986). Socialization and situational influences on sustained altruism. *Child Development, 57*(6), 1358–1369. https://doi.org/10.2307/1130415

Conway, F., Oster, M., & McCarthy, J. (2010). Exploring object relations in hospitalized children with caregiver loss. *Journal of Infant, Child, and Adolescent Psychotherapy, 9*(2–3), 108–117.

Crenshaw, D., & Hardy, K. (2006). Understanding and treating the aggression of traumatized children in out-of-home care. In N. Webb (Ed.), *Working with traumatized youth in child welfare* (pp. 171–195). New York, NY: The Guilford Press.

Dallman, M. E., & Power, S. (1996). Kids and elders: Forever friends. *Teaching PreK—8, 27*(2), 52–54.

Du, H., Inkpen, K., Chorianopoulos, K., Czerwinski, M., Johns, P., Hoff, A., . . . Gross, T. (2011, September 24–28). *VideoPal: Exploring asynchronous video-messaging to enable cross-cultural friendships.* Paper presented at The 12th European Conference on Computer Supported Cooperative Work, Aarhus, Denmark. https://doi.org/10.1007/978-0-85729-913-0_15

Dvir, O., Weiner, A., & Kupermintz, H. (2012). Children in residential group care with no family ties: Facing existential aloneness. *Residential Treatment for Children & Youth, 29*(4), 282–304. https://doi.org/10.1080/0886571X.2012.725368

Enright, R., Rhody, M., Litts, B., & Klatt, J. (2014). Piloting forgiveness education in a divided community: Comparing electronic pen-pal and journaling activities across two groups of youth. *Journal of Moral Education, 43*(1), 1–17. https://doi.org/10.1080/03057240.2014.888516

Evans, D. (2010). The challenge of treating conduct disorder in low-resourced settings: Rap music to the rescue. *Journal of Child and Adolescent Mental Health, 22*(2), 145–152. https://doi.org/10.2989/17280583.2010.528581

Feen-Calligan, H., McIntyre, B., & Sands-Goldstein, M. (2009). Art therapy applications of dolls in grief recovery, identity, and community service. *Art Therapy: Journal of the American Art Therapy Association, 26*(4), 167–173. https://doi.org/10.1080/07421656.2009.10129613

Freedberg, D., & Gallese, V. (2007). Motion, emotion and empathy in esthetic experience. *Trends in Cognitive Sciences, 11*(5), 197–203. https://doi.org/10.1016/j.tics.2007.02.003

Frey, D. (2011). Puppetry interventions for traumatized clients. In L. Carey (Ed.), *Expressive and creative arts methods for trauma survivors* (pp. 181–191). London, England: Jessica Kingsley Publishers.

Gray, B. L. (2012). The babushka project: Mediating between the margins and wider community through public art creation. *Art Therapy: Journal of the American Art Therapy Association, 29*(3), 113–119. https://doi.org/10.1080/07421656.2012.701600

Green, A. (1983). Dimension of psychological trauma in abused children. *Journal of the American Academy of Child Psychiatry, 22*(2), 221–237. https://doi.org/10.1016/S0002-7138(09)60370-8

Green, A. (1986). The dead mother. In *On private madness*. London, England: Hogarth Press. [Reprinted 2005, Karnac Books]

Hart, C. (2012). The "dead mother syndrome" and the child in care: A framework for reflecting on why some children experience multiple placement breakdowns. *Journal of Infant, Child, and Adolescent Psychotherapy, 11*(4), 342–355. https://doi.org/10.1080/15289168.2012.732905

Hastings, P. (2003). *Doll-making as a transformative process.* Saugerties, NY: Self-published.

Herrington, L., Barry, C., & Loflin, D. (2014). Callous-unemotional traits, narcissism, and behavioral history as predictors of discipline problems in an adolescent residential program. *Residential Treatment for Children and Youth, 31*(4), 253–265. https://doi.org/10.1080/08865071X.2014.958341

Hur, Y. (2013). J. P. Rushton's contributions to the study of altruism. *Personality and Individual Differences, 55*(3), 247–250. https://doi.org/10.1016/j.paid.2012.05.016

Hyun, N., Park, Y., & Park, S. (2016). Narcissism and gift giving: Not every gift is for others. *Personality and Individual Differences, 96*, 47–51. https://doi.org/10.1016/j.paid.2016.02.057

James, S., Leslie, L. K., Hurlburt, M. S., Slymen, D. J., Landsverk, J., Davis, I. . . . Zhang, J. (2006). Children in out-of-home care: Entry into intensive or restrictive health and residential care placements. *Journal of Emotional and Behavioral Disorders, 14*(4), 196–298. https://doi.org/10.1177/10634266060140040301

Kann, V., & Kann, E. (2006). *Pinkalicious.* New York, NY: Harper Collins.

Kiernan, H., & Mosher-Ashley, P. (2002). Strategies to expand a pen pal program from simple letters to a full intergenerational experience. *Educational Gerontology, 28*(4), 337–345. https://doi.org/10.1080/036012702753590442

Knoverek, A., Briggs, E., Underwood, L., & Hartman, R. (2013). Clinical considerations for the treatment of latency age children in residential care. *Journal of Family Violence, 28*(7), 653–663. https://doi.org/10.1007/s10896-013-9536-7

Kotler, J., & McMahon, R. (2005). Child psychopathy: Theories, measurement, and relations with the development and persistence of conduct problems. *Clinical Child and Family Psychology Review, 8*(4), 291–325. https://doi.org/10.1007/s10567-005-8810-5

Levy-Warren, M. (1996). *The adolescent journey.* Northvale, NJ: Jason Aronson.

Lozado, M., D'Adamo, P., & Carro, N. (2014). Plasticity of altruistic behavior in children. *Journal of Moral Education, 43*(1), 75–88. https://doi.org/10.1080/03057240.2013.878244

McAuley, C., Pecora, P., & Rose, W. (Eds.). (2006). *Enhancing the wellbeing of children and families through effective intervention: International evidence for practice.* London, England: Jessica Kingsley Publishers.

McCullough, C. (2009). A child's use of transitional objects in art therapy to cope with divorce. *Art Therapy: Journal of the American Art Therapy Association, 26*(1), 19–25. https://doi.org/10.1080/07421656.2009.10129306

Meltzer, H., Lader, D., Corbin, T., Goodman, R., & Ford, T. (2004). *The mental health of children looked after by local authorities in Wales.* London, England: Stationary Office.

Meshcheryakova, K. (2012). Art therapy with orphaned children: Dynamics of early relational trauma and repetition compulsion. *Art Therapy: Journal of the American Art Therapy Association, 29*(2), 50–59. https://doi.org/10.1080/07421656.2012.683749

Mikulincer, M., & Shaver, P. R. (2007). Boosting attachment security to promote mental health, prosocial values, and inter-group tolerance. *Psychological Inquiry, 18*(3), 139–156. https://doi.org/10.1080/10478400701512646

Mikulincer, M., Shaver, P. R., Gillath, O., & Nitzberg, R. A. (2005). Attachment, caregiving, and altruism: Boosting attachment security increases compassion and helping. *Journal of Personality and Social Psychology, 89*(5), 817–839. https://doi.org/10.1037/0022-3514.89.5.817

Morris, F. J., & Willis-Rauch, M. (2014). Join the art club: Exploring social empowerment in art therapy. *Art Therapy: Journal of the American Art Therapy Association, 31*(1), 28–36. https://doi.org/10.1080/07421656.2014.873694

Newton, R. R., Litrownik, A. J., & Landsverk, J. A. (2000). Children and youth in foster care: Disentangling the relationship between problem behaviors and number of placements. *Child Abuse and Neglect, 24*(10), 1363–1374. https://doi.org/10.1016/S0145-2134(00)00189-7

Phillips, J. (2003). The use of art therapy in impacting individual and systemic issues in foster care. In D. J. Betts (Ed.), *Creative arts therapies approaches in adoption and foster care: Contemporary strategies for working with individuals and families* (pp. 143–151). Springfield, IL: Charles C. Thomas.

Quisenberry, C., & Foltz, R. (2013). Resilient youth in residential care. *Residential Treatment for Children & Youth, 30*(4), 280–293. https://doi.org/10.1080/0886571X.2013.852448

Raihani, N., & Smith, S. (2015). Competitive helping in online giving. *Current Biology, 25*(9), 1183–1186. https://doi.org/10.1016/j.cub.2015.02.042

Riley, S. (1999). *Contemporary art therapy with adolescents.* London, England: Jessica Kingsley Publishers.

Robbins, A. (1992). The play of psychotherapeutic artistry and psycho-aesthetics. *Arts in Psychotherapy, 19*(3), 177–186. https://doi.org/10.1016/0197-4556(92)90017-I

Steinhardt, L. (1994). Creating the autonomous image through puppet theatre and art therapy. *The Arts in Psychotherapy, 21*(3), 205–218. https://doi.org/10.1016/0197-4556(94)90050-7

Terr, L. C. (1981). Psychic trauma in children: Observations following the Chowchilla school bus kidnapping. *American Journal of Psychiatry, 138*(1), 14–19. https://doi.org/10.1176/ajp.138.1.14

van der Kolk, B. A. (2005). Developmental trauma disorder: Toward a rational diagnosis for children with complex trauma histories. *Psychiatric Annals, 35*(5), 401–408. https://doi.org/10.3928/00485713-20050501-06

Weber, N., Somers, C., Day, A., & Baroni, B. (2016). Predictors and outcomes of school attachment and school involvement in a sample of girls in residential treatment. *Residential Treatment for Children & Youth, 33*(2), 155–174. https://doi.org/10.1080/0886571X.2016.1188034

Wilson, L. (1983). Symbolism and art therapy: Theory and clinical practice. In J. A. Rubin (Ed.), *Approaches to art therapy: Theory and technique* (pp. 44–62). New York, NY: Brunner, Mazel.

Winnicott, D. W. (1953). Transitional objects and transitional phenomena: A study. In G. H. Pollock (Ed.), *Pivotal papers on identification.* Madison, WI: International University Press.

Winnicott, D. W. (1971). *Playing and reality.* London, England: Tavistock Publications.

Zhang, L., Zhang, S., Yang, Y., & Li, C. (2017). Attachment orientations and dispositional gratitude: The mediating roles of perceived social support and self-esteem. *Personality and Individual Differences, 114*, 193–197. https://doi.org/10.1016/j.paid.2017.04.006

Zhou, X., & Wu, X. (2016). Understanding the roles of gratitude and social support in posttraumatic growth among adolescents after Ya'an earthquake: A longitudinal study. *Personality and Individual Differences, 101*, 4–8. https://doi.org/10.1016/j.paid.2016.05.033

Effects of Art Therapy on Identity and Self-Esteem in Adolescents in the Foster Care System

CHELSEY GUTIERREZ

As of September 2017, there were 437,465 children in foster care throughout the U.S. (Administration for Children and Families, 2017). Despite the overwhelming number of children in care, foster youths are one of the most underserved, vulnerable populations. Adolescents in the foster care system face severe challenges such as repeated trauma, loss of attachment, low self-esteem, and identity fragmented by familial separations. There is extensive data readily available on the common challenges of adolescents in the foster system and no argument against the notion that children in foster care have been exposed to an array of traumas. Foster youths often struggle with identity and esteem issues, traumatic memories, resiliency, goalsetting, issues surrounding relationships, as well as issues related to home and school placement changes (Bruskas, 2008; Collins, Spencer, & Ward, 2010; Fratto, 2016; Kerker & Dore, 2006; Morris, 2007; Stabno & Nagle, 2007; Zetlin, 2006). Fratto (2016) pointed out that "for decades, evidence has shown an undeniable connection between childhood trauma and chronic adverse reactions throughout the lifespan" (p. 439). These adverse reactions tend to manifest the most in adolescence (Bilchik & Nash, 2008).

Art therapy and group work have been anecdotally shown to be ideal treatment options for adolescents (Bazargan & Pakdaman, 2016; Gatta, Gallo, & Vianello, 2014; Jang & Choi, 2012; Malchiodi, 2012; Moon, 2012; Quinlan, Schweitzer, Khawaja, & Griffin, 2015; Riley, 1999). However, to date there has been a limited amount of research in art therapy literature regarding adolescent group art therapy within the foster care system. Art therapy has been shown as effective in trauma work, relationships, goal setting, esteem building, and resiliency (Arrington, 2007; Bazargan & Pakdaman, 2016; Hinz, 2009;Jang & Choi, 2012; Malchiodi, 2012). The non-invasive and developmentally suited aspects of art-making promote art therapy as a key treatment intervention for adolescents (Arrington, 2007; Stabno & Nagle, 2007). Group art therapy work in particular is ideal with the adolescent population, given their developmental needs and focus on peer relationships (Jang & Choi, 2012).

This author conducted a pilot research study seeking to examine the effects of a six-week art therapy group on the self-esteem and sense of self in adolescents in the foster care system, using the Coopersmith Self-Esteem Inventory [SEI] (1981) for data collection. Due to volunteer and participant limitations, only one participant completed the study, engaging in individual sessions rather than an art therapy group. Findings from the implementation of this study are included to showcase both the benefits and challenges of art therapy's use with adolescent youth in foster care.

The Foster Care Experience

Data on foster youth and the subsequent challenges faced is vast and readily available (Administration on Children & Families, 2017; Child Welfare Information Gateway, n.d; Childrens Action Network, n.d; Foster Care & Adoption, 2018; National Foster Care Institute, n.d.) According to the Adoption and Foster Care Analysis and Reporting System's yearly report, there were 437,465 children placed in out-of-home care in the year 2016; of those, 133,280 were between the ages of 12 and 18 years old (Children's Bureau, 2017). Typically, the majority of children were in care due to neglect, abuse, or parental substance abuse. In 2016, neglect was a contributing factor for the removal of 61% of children, while parental drug or alcohol abuse accounted for 40% of those removed. Physical assault was involved in 12% of cases and sexual abuse 4% (Children's Bureau, 2017). The initial trauma and resulting removal from home were not the only events impacting a child in the system but rather the beginning of a string of challenging experiences.

The primary goal of foster care is, typically, reunification of the family unit (Table 14.1). Federal law mandates that a case plan detailing the plans and services that are to be provided in order to improve conditions of the parents' home include plans for the safe care for a child, as well as services for parents, children, and foster families. According to the U.S. Administration for Children and Families (1988), these services are to be provided in such a way as to facilitate the return of the child to "his own safe home" when possible (p. 44). When this is not possible, goals may include placement with family members, long-term foster care, guardianship, or emancipation. Federal guidelines mandate timeliness to expedite and ensure the development of a child's permanence, although many children have spent years in care (Children's Bureau, 2017). Case plans, and parents' progress and compliance records, are to be reviewed at least every six months (Child Welfare Gateway, 2014; Lund & Renne, 2012). These strategies often include hands-on parenting classes, counseling, drug and alcohol abuse treatment, adequate housing, financial planning, and the development of safety plans regarding the care of their children. It should be noted here that while permanency and stability during out-of-home care are desired, there are many reasons children sometimes change placements. These changes can be because of foster home licensing limitations, foster home availability, and behavioral issues, to name a few.

Parents who have not yet had their parental rights terminated and maintain a goal for permanent reunification may engage in weekly supervised visits with children. These family visits usually take place at local social services offices or foster agencies. While visits provide family connection and healing, they also open the possibility for repeated trauma and increased feelings of abandonment. Despite services offered, sometimes parents miss visits, and the child is left disappointed and hurt. In cases where parents use visit time to vent and speak inappropriately, they further damage their children's relationship security. Parents talk negatively about each other, social workers, visitation supervisors, or foster parents. This creates the potential for the child to become confused, torn, and unable to bond with their foster family due to feelings of guilt or a misunderstanding of their situation. Visitations have varied and unpredictable characteristics that can lead to a child's refusing to visit their parents at all. Parents may participate fully in services and regain primary custody of their child, only to return to previous behaviors. Parents' inconsistent compliance and success in services often leads to repeated returns and removals. The uncertainty surrounding visits and a return home is understandably overwhelming and can create a toxic environment of instability and anxiety.

The trauma of abuse, being removed from home, likelihood of repeated trauma while in care, social and cultural stigma of foster status, impact on academic performance, and interruption of routine activities is devastating to children. Feelings of fear, confusion, sadness, anxiety, and loss in childhood can and do directly affect quality of adulthood through educational repercussions, as well as lasting mental health and relationship struggles. Frequent placement changes, physical abuse, and trauma have led foster children to perform at significantly low academic levels when compared to peers and often demonstrated higher rates of behavioral problems and a higher drop-out rate (Bruskas, 2008; Overstreet & Mathews, 2011; Zetlin, 2006). Zetlin (2006) pointed out that the lack of consistent care, support, and advocacy were amongst the determining factors for these deficits.

Years of published research demonstrate that children in foster care left with untreated mental disorders often become young adults who are homeless, imprisoned, or institutionalized. A lack of a strong social support network can increase risks for aggression, suicidality, and sexually transmitted infection (Collins et al., 2010). After ageing out of the foster care system, these young adults also regularly struggle with self-sufficiency, economic independence, housing, basic life skills, and depression (Kerker & Dore, 2006).

The ripples of trauma generated by foster care placement can be transgenerational; 30% of abused and neglected children go on to abuse their own children, 33% of children who age out of foster care live below the poverty line, and girls who have spent time in foster care are two times as likely to get pregnant by the age of 19 (Treehouse, n.d.; National Association of Adult Survivors of Child Abuse, 2011).According to one study through the University of Chicago, 39% of children born to foster care alumni had been the subjects of at least one CPS investigation, 17% had at least one child maltreatment report, and 11% were placed in out-of-home care themselves (Dworsky, 2014). Despite these well-researched and documented needs of foster youth, there is a serious lack of adequate support and treatment that exists due to an absence of funding, fragmented healthcare system, and lack of caregiver responsibility (Kerker & Dore, 2006).

Resilience

While the statistics on the damaging effects of trauma and the foster care experience are overwhelming, foster youth have an unbelievable potential for resilience. The term "resilience" reflects the ability to maintain a stable equilibrium and develop healthy personality characteristics, in spite of exposure to negative life circumstances (Bonanno, 2004). One study measuring the resilience in maltreated youth found that adolescents' ability to see themselves as resourceful and resilient could be useful in interventions aimed at helping them overcome their trauma. It also found that parental acceptance, either biological or adoptive, was key in fostering positive outcomes for the adolescent (Davidson-Arad & Navaro-Bitton, 2015). That was certainly the case for "Sasha," whose case is detailed below. Sasha had immense support from her grandparents and legal guardians. Sasha reported dramatically higher scores on the Coopersmith Self-Esteem Inventory [SEI] (1981), a self-report survey designed to measure a person's level of self-esteem, after six weeks of art therapy targeted at naming and exploring her own strengths and positive characteristics.

Despite extreme trauma, given the proper support and guidance, foster youth can grow into healthy, well-adjusted, successful adults. Programs such as Fostering Healthy Futures have been found to have beneficial impacts on mental health; chronic and

negative trauma symptoms (such as anxiety, anger, and depression); quality of life; and permanency through early mentorship, therapy, and skill building (Child Trends, 2014). Early intervention after entering care is key, with affirming, supportive relationships that focus on strengths. Helping a foster youth realize their positive attributes as well as defining their resiliency can build confidence and establish perseverance. Seeing themselves positively and highlighting that perseverance in overcoming extremely difficult events can vastly improve self-esteem, social abilities with peers, and long-term mental health outcomes.

Self-Esteem and Identity

While adolescents in the foster care system struggle with many different challenges, their self-worth, identity, and esteem greatly affect their well-being (Fratto, 2016; Stabno & Nagle, 2007).Coopersmith (1981) defined self-esteem as "a personal judgment of worthiness expressed in the attitudes a person holds toward the self," referring to how much a person believes themselves to be competent, of value, and significant overall (p. 1). Studies have been conducted regarding the importance and benefits of high self-esteem, such as greater happiness and lowered risk of depression (Baumeister, Campbell, Krueger, & Vohs, 2003); less social anxiety (Greenwald, Belleza, & Banaji, 1988); lowered risk for self-harm (Hawton, Rodham, Evans, & Weatherall, 2002); increased stability (Kernis, 2005); and less risk for physical, mental, and emotional problems (Roghanchi, Mohamad, Mey, Momeni, & Golmohmadian, 2013). Coopersmith (1981) analyzed multiple studies that demonstrate how low self-esteem was closely related to anxiety and that those who doubted their own worthiness struggled with giving and receiving love, tended to avoid closeness, and lived in isolation. These studies also found that individuals with low self-esteem were more likely to live with depression, guilt and/ or shame, and diminished personal accomplishments. Low and unstable self-esteem has also been linked to mental, emotional, and attachment problems, as well as adolescent self-harm and self-destructive behaviors such as substance abuse and risk taking (Hawton et al., 2002; Kernis, 2005). Roghanchi et al. (2013) found that a combination of art therapy and Rational Emotive Behavioral Therapy had a significant positive impact on self-esteem and resilience. Improving the self-esteem of an adolescent in foster care has the potential to impact lifestyle choices and self-concept positively.

Trauma and Adolescence

Trauma stemming from the initial abuse, neglect, and removal from their primary caregivers has a devastating impact on youth. Developmentally, adolescence is a critical time for every child. Adolescence has been seen as challenging and fraught with emotional stressors. The developmental changes of adolescence permeate every part of a teenager's life (Moon, 2012). Aside from infancy, Moon (2012) saw no other growth phase with greater turbulence. Adolescents struggle with normative and developmental challenges of social, educational, and pubertal origins. Navigating these struggles as a foster child with trauma, along with school and home placement changes, can make the resulting social stigma almost unimaginable.

Erikson (1950,1968) believed that the purpose of adolescence was to develop one's own unique identity and sense of self, as well as to settle the conflict between identity and role confusion. He believed that developing a strong identity laid the groundwork

for coping with challenges later in life. This identity conflict often stemmed from disturbances in early childhood or conflicts in adolescence. The adolescent years are critical in developing lasting friendships, concepts of self, values, and goals for adulthood. Erikson (1950,1968) believed that identity confusion could delay maturation into psychological adulthood. Although peers had a powerful impact on an adolescent's development, adolescents have still been seen relying on parental figures in the development of adult identities (Benson & Elder, 2011). A strong base and secure attachment are essential in times of stress and discovery. Adolescents without this base faced finding their identity alone. Further, adolescents who frequently change placements or have been uprooted from their regular school even just once have lost critical social connections. In his in-depth research on neuroscience and development, Perry (2009) noted that "removing children from abusive homes also may remove them from their familiar and safe social network in school, church, and community" (p. 248).He added that unfamiliar settings and caregivers could actually stress these children more, exasperating their symptoms rather than helping them. Aside from this, losing friendships through placement and school changes could be devastating to an adolescent in foster care.

Art Therapy

Art therapy, as any therapy with adolescents, can be difficult to navigate. Adolescents often meet counseling or treatment with resistance. Moon (2012) wrote that adolescent art therapy spans four separate phases: resistance, imagining, immersion, and letting go. However, arguing for the creative modality as an ideal treatment for adolescents, Moon also noted that the most effective art therapy with adolescents is one that engages a sensory component to provide more impactful and lasting therapeutic benefits. Arrington (2007) concurred with Moon and added that art as a language helps to build a healing narrative along with securing a safe way to express and "explore thoughts, feelings, frustrations, and abuse" (p. 63).Art through art therapy can also help the art therapist to assess underlying components of the child's experience.

Many adolescents across cultures and economic levels in the foster care system need and benefit from art therapy. Exploring trauma through artwork provides a safer, less threatening space for adolescent clients than talk therapy alone. Art therapy is inherently suited to the needs of adolescents, and its organic nature gives the flexibility and versatility needed in trauma work.

Sasha

"Sasha," a 13-year-old White cisgender female, was invited to participate in a six-session art therapy group, which would focus on self-esteem. Her social worker recommended it to her, believing the group would benefit Sasha and appeal to her interest in art. Three females aged 13 to 15 originally joined; however, two out of the three initially enrolled discontinued participation due to personal and familial struggles. Accommodations were made throughout the treatment to account for the varied participation that left Sasha as the sole group member participating in all art therapy sessions.

During our time together, Sasha disclosed sexual abuse, family trauma, parental loss, and self-harm. Over six weekly art therapy sessions, Sasha explored feelings associated with her trauma narrative through collage, mask making, painting, drawing, and verbal processing. Each session included a check-in time, an art directive, and processing time.

Art directives were designed to address issues of self-concept, exploring identity, and efficacy. Directives included self-portraits, mask making, positive affirmation collages, scribble drawings, mandalas, and free paintings. During group processing, participants were asked to share as much or as little as they would like. Once the other two participants had left the study, "group" processing included Sasha, a co-facilitator, and me. Sasha was given the Coopersmith SEI (Coopersmith, 1981) during the first and last of the six weekly sessions.

As is common in adolescents, Sasha was an expert in camouflaging her authentic self. She consistently presented with a happy, lighthearted affect. She entered the meeting space smiling each week and chatted easily about subjects she enjoyed learning in school. Even in her first disclosure to us, she smiled, waved her hand lightly, and said she "had been molested and stuff." During sessions, she often stated she "didn't want to bother anyone else" so she rarely told her friends when she was feeling sad or upset. She also said that she rarely showed people she was anything but happy, pretending to be "okay" because she "didn't want to bring them down." Sasha repeatedly minimized her trauma narrative, even when she spoke of her mother passing away from substance abuse. In my experience, youth who have been in foster care tend to minimize their trauma. They don't like to talk about it, and they typically say things are "fine" when asked. I imagine this is a defensive technique and serves them well when wanting to be "normal," especially around peers. Though Sasha typically entered the space somewhat flippantly, during art-making Sasha was quiet, focused, and deeply engaged in the process. When processing her art, she was able to discuss what she called "the dark stuff"; this included her experiences with depression, self-harm, and anxiety.

Moon (2012) asserts that art therapy must engage the senses when working with adolescents. In the first session, Sasha was asked to engage in a scribble drawing. Scribbling exercises can tap into the kinesthetic level of the Expressive Therapies Continuum [ETC] (Hinz, 2009), allowing clients to vent frustration, anger, and pent-up energy by engaging in movement rather than concentrating on a final, artistic product. Hinz (2009) stated, "the healing dimension of the Kinesthetic component of the ETC involves increasing or decreasing clients' amount of arousal and tension" (p. 41) and "media that emphasize movement and enhance the release of energy are often resistive; they require effort to manipulate, and provide resistance to that effort" (p. 43). At first Sasha was hesitant to scribble, stating that she "didn't know what to draw." She laughed anxiously when she was encouraged to scribble without drawing *anything*. Once she began, she continued by making sweeping motions across the paper. As Sasha continued through the six weeks, we added scribble drawings as a warm-up in our sessions. Sasha's scribble drawings eventually became more spontaneous and uncontrolled, and she reported that she enjoyed the freedom of making them.

In almost every session, Sasha chose to blend chalk pastels with her hands. Once she even chose to paint her entire hand with acrylic paint, refusing to wash it off before leaving. While she painted her palm, she said it "felt good" and "was relaxing." Sasha seemed to find great comfort in the art-making process and its kinesthetic properties. Sasha truly demonstrated the benefits of kinesthetic interventions throughout her time with us. Malchiodi (2012) wrote, "making art and engaging in the creative process is a sensory-based approach to safely support, promote, and channel emotional expression of the teen's bottled-up feelings and to set the stage to make sense of its meaning" (p. 248).

One week, Sasha's grandparents called and reported that Sasha had been caught making superficial cuts on her arms while in class at school. In our next session

Figure 14.1 Sasha's free drawing

together, Sasha was invited to create a free piece of art using any media she wished (Figure 14.1). Sasha chose chalk pastels and began making a series of rhythmic slashes across the paper. She worked silently and purposefully, repeating the same angled red slashes. Sasha then added multiple colors and covered the slashes up completely. She used her fingers to blend and scrub the colors together, working quietly for almost an hour. During processing, my co-facilitator and I asked Sasha about the red lines. She raised her eyebrows and stated she hadn't even realized she'd made them. Sasha said she added "bright colors" over the top and enjoyed the physical process of blending the chalk with her hands. We then talked about the similarities between her artwork and the physical action of cutting. While processing her artwork, my co-facilitator asked Sasha to rate her emotional state on a number scale before and after self-harm behavior and compare it to her emotions before and after creating art. Sasha stated that she did not feel better after cutting and that instead it made her feel guilty. She did however note that she felt better after her chalk drawing and that she thought she could try a similar process in a journal she kept at home the next time she felt the urge to cut.

After this self-harm disclosure, referrals were made, and safety was discussed thoroughly with Sasha and her family. Together, they decided to continue counseling for Sasha with a psychologist after the six-week study and stated they would be working with a registered art therapist as well. Sasha reported looking forward to working with referred clinicians and was feeling "better" about her future.

Sasha was invited to create a mask during one of our other sessions, using a pre-formed paper mask and various materials (Figure 14.2). Mask making mimics a common struggle for adolescents in that it perfectly illustrates their decisions about what they show to others and how they feel on the inside (Malchiodi, 2012; Moon, 2006). Somewhat unsurprisingly, Sasha chose bright colors and glitter for the outside of her mask and painted the inside solid black. During processing, she stated that she felt it was an accurate representation of how she presents herself. She was more withdrawn than usual during processing and did not talk about the inside of the mask.

Figures 14.2 and 14.3 Sasha's mask

In another session, Sasha was given lists of positive character traits and qualities. She was asked to choose some that she thought represented herself and to arrange them however she wished around the words "I am" (Figure 14.3). She was encouraged to create a background for the words. Sasha used watercolors for the background and stated that the grey, black, and red areas represented the "dark stuff" inside while the red, yellow, and purple arch represented what she "showed on the outside." She chose the words: "courteous, confident, understanding, selfless, sensitive, caring, focused, gentle, reliable, kind, and loyal." While processing the word "understanding," Sasha made her first disclosure of sexual abuse. She stated that because of her own experiences, she was "understanding" toward a friend. Sasha then waved her hand and said quickly, "you know, 'cuz I was molested and stuff." She then went on to describe how she was able to help a friend confront and deal with her own abuse, as well as help that friend report it for the first time. As we were discussing this event, as well as Sasha's disclosure of abuse, my co-facilitator and I maintained a calm, supportive, positive space for her to process. We used gentle questions and prompts to encourage her to explore her own experience and reactions. While telling us her trauma story, Sasha also pointed out again how it helped her understand and support others. As she spoke and shared with us, Sasha was able to recognize her own strength and resilience. Through her "I Am" painting, Sasha was able to reflect on positive aspects of her character and recognize several strengths.

Figure 14.4 Sasha's "I Am" painting

Processing through artwork offers the unique ability to step back and look at issues in a concrete, tangible way. As discussed previously, Hawton et al. (2002) recognized a connection between low self-esteem and self-harm. By intentionally drawing out strengths and engaging in the sensory process of art-making, adolescents can find a different, safe way of coping.

Though Sasha was not able to participate in an art therapy group, she clearly benefited from engaging in art therapy, scoring significantly higher on the SEI (Coopersmith, 1981) at the end of the six weeks. For Sasha, being able to process her trauma as well as explore her strengths while engaging in a positive, therapeutic relationship with two attentive art therapists allowed her to confront her self-harm behavior and develop some new coping strategies. She was able to express what she called "dark emotions" and talk about her trauma in each of her artworks. As part of termination of our time together, a portfolio review examined Sasha's completed works. Seeing her portfolio from art therapy as a complete body of work was incredibly helpful in processing the gains made in treatment. Through an exploration of the portfolio, notable achievements and setbacks can be reviewed (Moon, 2006; Riley, 1999). Sasha ended her experience with us by identifying her recently developed coping strategies in response to her self-harm. She specifically identified mandala making and chalk drawings as sources of comfort and stated she would be using these mediums in a journal at home.

Sasha consistently demonstrated her strength, resilience, and positive attributes each week. Even though she was supposed to be engaging in an art therapy group with her peers, Sasha ended up the sole participant with two therapists. One client engaging in therapy with two facilitators is generally not recommended as it can make a client feel

overpowered and uncomfortable, but the dynamic seemed to work well for Sasha. Perhaps since she had been looking forward to participating in a group, Sasha responded well to two of us facilitating, instead of an individual therapy model. My co-facilitator and I would often create art alongside Sasha, bringing an element of comfort and familiarity to our sessions. Unlike interviews from social workers and Child Protective Services investigators, or even the individual sessions with a therapist she had seen in the past, Sasha's time with us was more laidback and unguarded. Sasha was able to be more vulnerable and honest while creating and processing her artwork when she didn't feel watched or studied. The mutual art-making afforded a space for Sasha to be witnessed and honored rather than watched and judged.

Scoring the Coopersmith Self-Esteem Inventory (SEI)

The Coopersmith Self-Esteem Inventory [SEI] (Coopersmith, 1981) is used to measure an individual's level of self-esteem. There are 58 statements on the form with the option of selecting "like me" or "not like me" with a lie-scale built into the questions. This lie-scale is designed to measure a client's defensiveness. The score can be used as either a total out of a possible 100 points or, if desired, separate scores for four subscales. These subscales include the General Self, Social Self-Peers, Home-Parents, and School-Academic. These subscales "allow for variances in perceptions of self-esteem in different areas of experience" (Coopersmith, 1981, p. 2).

Coopersmith (1981) noted that there were "no exact criteria" for high, medium, or low levels of self-esteem and that the SEI should be used along with behavioral observations (p. 8). In the SEI however, higher scores correspond to high self-esteem. High scores on the lie scale questions indicate defensiveness or that the examinee thought they understood the "intention" of the questionnaire and attempted to respond positively to all items. The means typically range from 70 to 80 with a standard deviation from 11 to 13. During the first meeting, Sasha scored 48 points out of a possible 100—significantly lower than the normative range. At the end of the six sessions, she scored 74 out of 100, showing a tremendous shift on her self-report survey. She scored seven points higher in the General Self category, three points higher in the Home-Parents category, and doubled her School-Academic score. While Sasha clearly needed continued support through counseling, she had made encouraging progress in a short amount of time.

Discussion

Working with children and adolescents in the foster care system can be challenging for many reasons, but these young people are not lost or hopeless. They hold incredible potential when given attuned and accessible opportunities for self-expression. More research and data that can demonstrate the efficacy of art therapy with foster youth is needed to better serve these adolescents. Studies validating art therapy with this population can lead to more referrals, programs, and opportunities to reduce trauma symptoms and improve long-term outcomes. Art therapists passionate for this population must continue to work toward that end.

That said, the limitations placed on even gaining access to clients can be daunting. The lack of research in art therapy literature for foster care groups may result from the systemic challenges in providing care. The identities of youth in care are fiercely

protected, and typically approval from social workers, foster parents, and case managers is necessary before they can participate in therapy. Art therapy services are not widely offered for many adolescents in foster care. Further, consistent participation in treatment is often thwarted by external factors and/or personal resistance to trust adults. Even with the establishment of a trusted alliance and a willingness to participate, time constraints, limited financial resources, and lack of transportation can prohibit a child in foster care to participate in therapy at all. Over the course of a year, I tried repeatedly to start an expressive arts group through the agency where I worked as a foster care visitation supervisor. I had the support of the agency, the community, and even the local Department of Child and Family Services (DCFS) office. A grant from a local organization generously offered provisions for art supplies. Only one to two clients arrived for sessions. Despite interest, transportation and scheduling conflicts occluded participation.

Aside from the difficulties accessing youth in foster care, this population itself can be a challenge. It is well known that adolescents are often resistant to counseling. Evans (1982) referenced this population as "notoriously difficult" (p. 326). Foster youth, in particular, typically struggle with trust, attachment, and vulnerability, further hindering the therapeutic process. Developing relationships with foster youths is key. Without trust, no progress can be made. Disappointment over broken promises, loss of control, and feelings of being judged are all too familiar to adolescents in care and often leads to being highly suspicious of adults. Repeated interviews by social workers and lawyers can lead to the client becoming apathetic and shutting down to avoid the stigma and fears of being judged and shamed. Therapeutic relationships must consistently uphold trust, encouragement of autonomy, and consistent structure and boundaries. Structure and rules within sessions are important. For example, clients can gain a sense of responsibility and control by cleaning and putting away their own materials. Keeping a familiar routine or structure for each session offers predictability and thereby facilitates expectations for both therapist and client. Within these boundaries, trust can grow, and eventually the client develops trust in their clinician. While time consuming and potentially difficult to build, these relationships with adolescents in the system are not impossible, and clinicians must continue to invest in these goals.

Recommendations

Additional studies are needed to further validate art therapy and to add valuable data to the field of research with this population. This research should introduce an awareness of the importance of art therapy programs for foster youths through DCFS. By accenting resiliency in art therapy, risk-taking behaviors among adolescents in foster care can potentially be reduced. Recommendations for future studies include a more longitudinal approach, as well as different recruitment strategies. A six-week study may not allow enough time for a therapeutic relationship to develop, and clients may not experience the full range of benefit from participating. While there is some data and information to date on art therapy with the foster youth population, the available literature is severely lacking in data on art therapy *groups* for adolescents who are in foster care. Groups, however, can be ideal for adolescents. Group art therapy has been found to provide metaphoric benefits in both boundary maintenance and the expansion of self-image (Gatta et al., 2014).Jang and Choi (2012) noted the value of art therapy with adolescents in groups:

Adolescents share their ideas or experiences with their peers more than they do with their parents or teachers. In the process, they notice that there are other peers who have problems quite similar to their own. They also receive emotional support from their peers while sharing their problems with each other. For these reasons, group-based therapy is often employed with adolescents.

(p. 246)

When working with adolescents experienced in the foster care system, it is important to be well-informed of the wide range of struggles these youths face. Understanding the disappointment from a parent missing a visit can inform the therapist of the heightened importance of maintaining a reliable meeting schedule and good communication with their client. Balancing transference issues is important; engaging in supervision or being part of a supportive treatment team can be extremely helpful. Self-care for the therapist should not be ignored, especially given the trauma histories of their clients and heavy subject matter.

Engaging in art-making with the client during a session can be centering and relaxing for both the client and therapist. It helps take some of the pressure away for the client and helps them not feel quite as "analyzed" or watched. Using pre-made images or magazines for collages can achieve the same type of pressure relief, especially when clients harbor feelings of "not being good artists" or "not knowing what to make." Directives specifically designed to foster confidence and positive regard (such as Sasha's "I Am" painting) can also set the client up for success and add to their experience.

The art therapist working with adolescents in the foster care system must be prepared to be flexible, patient, and creative. Clients within this population are in a constant state of flux, and art directives must be readily adapted to their varying needs from session to session. There is no one formula or technique that works the same for all clients. Riley (1999) describes the practice of art therapy with adolescents beautifully, writing, "Art therapy, in my opinion, is a co-constructed fusion of theory, process, therapeutic relationship, and the client's self-interpreted illustrations of their difficulties" (p. 21). Adolescents in foster care can access their potential, cope with their traumatic experiences, and move forward resiliently through art therapy.

References

Administration for Children and Families. (1998). *Adoption and Safe Families Act* (U.S. Department of Health and Human Services Log No. ACYF-CB-PI-98–02). Washington, DC: U.S. Government Printing Office.

Administration for Children and Families. (2017). *The AFCARS report #24. (U.S. Department of Health and Human Services)*. Washington, DC. Retrieved from www.acf.hhs.gov/sites/default/files/cb/afcarsreport24.pdf

Arrington, D. (2007). *Art, angst, and trauma: Right brain interventions with developmental issues.* Springfield, IL: Charles C. Thomas.

Baumeister, R., Campbell, J., Krueger, J., & Vohs, K. (2003). Does high self-esteem cause better performance, interpersonal success, happiness, or healthier lifestyles? *American Psychological Society, 4*(1), 1–44. https://doi.org/10.111/1529-1006.01431

Bazargan, Y., & Pakdaman, S. (2016). The effectiveness of art therapy in reducing internalizing and externalizing problems of female adolescents. *Archives of Iranian Medicine (AIM), 19*(1), 37–42.

Benson, J., & Elder, G. (2011). Young adult identities and their pathways: A developmental and life course model. *Developmental Psychology, 47*(6), 1646–1657. https://doi.org/10.1037/a0023833

Bilchik, S., & Nash, M. (2008, Fall). Child welfare and juvenile justice: Two sides of the same coin. *Juvenile and Family Justice Today*, 16–20.

Bonanno, G. (2004). Loss, trauma and human resilience: Have we underestimated the human capacity to thrive after extremely aversive events? *The American Psychologist, 59*(1), 20–28. https://doi.org/10.1037/0003-066X.59.1.20

Bruskas, D. (2008). Children in foster care: A vulnerable population at risk. *Journal of Child & Adolescent Psychiatric Nursing, 21*(2), 70–77. https://doi.org/10.1111/j.1744-6171.2008.00134.x

Children's Bureau. (2018). *The AFCARS Report: Preliminary FY 2017 as of August 10, 2018* (#25). Retrieved from https://www.acf.hhs.gov/ch

Child Trends. (2014). Fostering healthy futures. *Programs.* Retrieved from www.childtrends.org/indicators/www.childtrends.org?programs=fostering-healthy-futures

Child Welfare Information Gateway. (2014). *Case planning for families involved with child welfare agencies.* Washington, DC: U.S. Department of Health and Human Services, Children's Bureau.

Child Welfare Information Gateway. (n.d.). Retrieved from www.childwelfare.gov

Children Action Network. (n.d). Retrieved from http://childrensactionnetwork.org/index.htm

Collins, M. E., Spencer, R., & Ward, R. (2010). Supporting youth in the transition from foster care: Formal and informal connections. *Child Welfare, 89*(1), 125–143.

Coopersmith, S. (1981). *SEI self-esteem inventories manual.* Redwood City, CA: Mind Garden.

Davidson-Arad, B., & Navaro-Bitton, I. (2015). Resilience among adolescents in foster care. *Children and Youth Services Review, 59*, 63–70. https://doi.org/10.1016/j.childyouth.2015.09.023

Dworsky, A. (2014). *Child welfare services involvement among the children of young parents in foster care.* Chicago, IL: Chapin Hall at the University of Chicago. Retrieved from www.chapinhall.org/research/children-of-young-parents-in-care-at-higher-risk-of-child-welfare-involvement/

Erikson, E. H. (1950). *The life cycle completed.* New York, NY: W. W. Norton & Company.

Erikson, E. H. (1968). *Identity: Youth and crisis.* New York, NY: W. W. Norton & Company.

Evans, J. (1982). *Adolescent and pre-adolescent psychiatry.* London, England: Academic Press.

Foster Care and Adoption. (2018). Retrieved from https://americanspcc.org/foster-care/

Fratto, C. (2016). Trauma-informed care for youth in foster care. *Archives of Psychiatric Nursing, 30*(3), 439–446. https://.doi/10.1016/j.apnu.2016.01.007

Gatta, M., Gallo, C., & Vianello, M. (2014). Art therapy groups for adolescents with personality disorders. *The Arts in Psychotherapy, 41*(1), 1–6.

Greenwald, A. D., Belleza, F. S., & Banaji, M. R. (1988). Is self-esteem a central ingredient of the self-concept? *Personality and Social Psychology Bulletin, 14*(1), 34–35. https://doi.org/10.1177/0146167288141004

Hawton, K., Rodham, K., Evans, E., & Weatherall, R. (2002). Deliberate self-harm in adolescents: Self-report survey in schools in England. *British Medical Journal, 325*, 1207–1211. https://doi.org/10.1136/bmj.325.7374.1207

Hinz, L. (2009). *The expressive therapies continuum: A framework for using art in therapy.* New York, NY: Routledge.

Jang, H., & Choi, S. (2012). Increasing ego-resilience using clay with low SES (Social Economic Status) adolescents in group art therapy. *The Arts in Psychotherapy, 39*(4), 245–250. https://doi.org/10.1016/j.aip.2012.04.001

Kerker, B. D., & Dore, M. M. (2006). Mental health needs and treatment of foster youth: Barriers and opportunities. *American Journal of Orthopsychiatry, 76*(1), 138–147. https://doi.org/10.1037/0002-9432.76.1.138

Kernis, M. (2005). Measuring self-esteem in context: The importance of stability of self-esteem in psychological functioning. *Journal of Personality, 73*(6), 1–3. https://doi.org/10.1111/j.1467-6494.2005.00359.x

Lund, T., & Renne, J. (2012). The court-ordered case plan. *GPSolo eReport, 1*(10). Retrieved from www.americanbar.org/groups/gpsolo/publications/gpsolo_ereport/2012/may_2012/court-ordered_case_plan.html

Malchiodi, C. (2012). *The handbook of art therapy* (2nd ed.). New York, NY: The Guilford Press.

Moon, B. (2012). *The dynamics of art as therapy with adolescents* (2nd ed.). Springfield, IL: Charles C. Thomas.

Moon, P. (2006). Reaching the tough adolescent through expressive arts therapy groups. *Vistas Online*. Retrieved from www.counseling.org/knowledge-center/vistas/by-subject2/vistas-children/docs/default-source/vistas/vistas_2006_moon2

Morris, R. (2007). Voices of foster youths: Problems and ideas for change. *Urologic Nursing, 27*(5), 419–427. Retrieved from Academic Search Complete, Ipswich, MA.

National Association of Adult Survivors of Child Abuse. (2011). What are the statistics of the abused? *Recovery*. Retrieved from www.naasca.org/2012-Resources/010812-StaisticsOfChildAbuse.htm

National Foster Youth Institute. (n.d). Retrieved from www.nfyi.org

Overstreet, S., & Mathews, T. (2011). Challenges associated with exposure to chronic trauma: Using a public health framework to foster resilient outcomes among youth. *Psychology in the Schools, 48*(7), 738–754. https://doi.org/10.1002/pits.20584

Perry, B. D. (2009). Examining child maltreatment through a neurodevelopmental lens: Clinical applications of the neurosequential model of therapeutics. *Journal of Loss and Trauma, 14*(4), 240–255. https://doi.org/10.1080/15325020903004350

Quilan, R., Schweitzer, R., Khawaja, N., & Griffin, J. (2015). Evaluation of a school-based creative arts therapy program for adolescents from refugee backgrounds. *The Arts in Psychotherapy, 47*, 72–78. https://doi.org/10.1016/j.aip.2015.09.006

Riley, S. (1999). *Contemporary art therapy with adolescents*. London, England: Jessica Kingsley Publishers.

Roghanchi, M., Mohamad, A., Mey, S., Momeni, K., & Golmohmadian, M. (2013). The effect of integrating rational emotive behavior therapy and art therapy on self-esteem and resilience. *The Arts in Psychotherapy, 40*(2), 179–184. https://doi.org/10.1016/j/.aip.2012.12.006

Stabno, C., & Nagle, S. (2007). Foster care: A developmental problem. In D. B. Arrington (Ed.), *Art, angst, and trauma: Right brain interventions with developmental issues* (pp. 63–78). Springfield, IL: Charles C. Thomas.

Treehouse. (n.d.). Taking on challenges with fierce optimism. *Why treehouse*. Retrieved from www.treehouseforkids.org/why-treehouse/foster-care-facts/

Zetlin, A. (2006). The experiences of foster children and youth in special education. *Journal of Intellectual & Developmental Disability, 31*(3), 161–165. https://doi.org/10.1080/13668250600847039

ARTogether
Putting Community at the Center of Family Visits

SARAH POUSTY

Most children living in foster care have experienced abuse, neglect, or maltreatment of some kind, which leads to child welfare investigations that deem it unsafe for the minors to remain in their home. Research suggests that removal from the home increases the risk of long-term vulnerabilities that children of similar socioeconomic backgrounds who stay in the home do not experience (Lawrence, Carlson, & Egeland, 2006). Mental health is a primary area of vulnerability, with children in foster care at increased risk of experiencing emotional and physical disruptions. These disruptions can affect neurocognitive functioning, emotional regulation, and the ability to establish positive relationships (Leve et al., 2012). Furthermore, placement instability, when a child is moved to different homes while in care, heightens vulnerabilities for children in foster care; this, in turn, increases the risk of negative outcomes (Healey & Fisher, 2011).

For most children in foster care, the initial goal is reunification with their legal parents (U.S. Department of Health and Human Services, 2015). While visitation is considered the primary intervention to support the parent-child relationship during foster care separation (Mallon & Leashore, 2002), resources to support enriching visitation experiences are limited. Visits often occur at child welfare agencies. These environments are described by Haight, Kagle, and Black (2003) as "less than ideal: a sterile office with no toys or other amenities, under the watchful eyes of foster parents, caseworkers, or other 'outsiders'" (p. 195). The agency atmosphere might lead the family to feel scrutinized and can trigger memories of the events that brought the family into the child welfare system (Haight et al., 2003). Caseworkers often carry large caseloads and supervise multiple family visits at once. This limits their ability to provide individual guidance and support to caregivers who are struggling to reconnect and repair relationships with their children.

ARTogether is an art therapy-informed, community-based family support program designed to assist parents and children in the foster care system as well as those receiving preventive services through the New York City child welfare system. It is a model that uses a natural community setting to support families who are most often served in isolation. By partnering with agencies to shift family visits into the community, skills learned in therapy and in parenting classes can be put into practice while families also receive the healing benefits of being part of the larger cultural continuum.

Children in Foster Care

For children in foster care, the trauma experienced from maltreatment, abuse, or neglect is compounded by their removal from the home and separation from a primary caretaker. As the removal process has become better understood as a traumatic experience, the national trend since 2002 has moved toward decreasing the number of children removed from the home and providing more preventive interventions (Yaroni, Shanahan, Rosenblum, & Ross, 2014). While there was a nationwide decrease of 15.2% of children in foster care between 2006 and 2015, there still remained 428,000 children in care (U.S. Department of Health and Human Services, 2015). By the end of 2016, the most recent year from which data is available, the number had increased to 437,465 children in care nationally (Child Welfare Information Gateway, 2018).

The terms "over-representation" and "disproportionality" appear frequently when considering the impact of race on the placement of children in foster care in the U.S. with Black and African American families being most affected. While Black and African American children make up 15% of the youth population, they represent 32% of the foster care population (U.S. Department of Health and Human Services, 2008). In the introduction to her book *Shattered Bonds*, Dorothy Roberts (2009) asserts, "Once removed from their homes, Black children remain in foster care longer, are moved more often, receive fewer services, and are less likely to be returned home or adopted than other children" (p. vi). Roberts goes on to weave personal accounts of Black and African American mothers battling to have their children returned to their care with national data and studies that reveal how institutionalized racism and cultural bias influence the child welfare system. Boyd (2014) cites the studies of Harris and Hackett and Tilbury and Thoburn to affirm institutionalized racism as a contributing factor to the disproportionality in the child welfare system, maintaining that "the residual influence of historical events such as the legacy of slavery, legalized discrimination and systematic oppression are acknowledged as having a long-lasting impact that continues to shape the racial/ethnic composition of the current child welfare population" (p. 22).

A modern-day example of how institutionalized racism influences the foster care system can be seen in the February 2018 passing of the Family First Prevention Act. This law is the first major overhaul of the foster care system in four decades and prioritizes keeping families together by increasing funding and access to preventive services (Wiltz, 2018). This act was passed as a response to the current opioid epidemic that disproportionately affects the White population (King & Kolodny, 2017) and is suspected to have led to the recent increase of children in foster care (Baldwin, Crouse, Gherther, Radel, & Waters, 2018). Upon signing the act into law, President Trump stated that it was his administration's response to "families threatened by addiction" (Kelly, 2018). This swift legislative response, compared with decades-long inaction, suggests institutional racism. Funds became more quickly allocated when White families became at risk of separation. Furthermore, in this context, White parents were described as victims of the systemic crisis of opioid addiction as opposed to their non-White counterparts who have been historically categorized as abusers and perpetrators of violence and neglect.

Attachment and Attachment-Focused Therapy

Siegel and Hartzell (2003) described secure attachment as "the sense of well-being that emerges from predictable and repeated experiences of care" (p. 101). In turn, the child internalizes feelings of safety and is able to feel a sense of security in her expectations

of others and the world around her (Bowlby, 1982; Siegel & Hartzell, 2003). Secure attachment is considered a protective factor or "buffer" against risk and adversity (Bryant, 2016; Chesmore, Weiler, Trump, Landers, & Taussig, 2017). Secure attachment positively impacts brain development, social and emotional development, and self-regulation (Blythe, Marsh, McMahon, & Phipps, 2014).

Children in foster care have often experienced maltreatment perpetrated by their primary caregiver, compounded by a physical separation that disrupts the attachment relationship. For children in foster care, the strength of the parent-child bond should not be underestimated. Despite being in an unsafe environment or being exposed to maltreatment, children develop a strong attachment to their primary caretaker (Blythe et al., 2014). Separation from a parent is a major risk factor for children in foster care and has been linked to challenges in their mental health such as depression and anxiety (McWey & Mullis, 2004; Chesmore et al., 2017). While the aim of foster care is to pair children with foster parents who are capable caregivers, children often continue to exhibit distress and a desire for their legal parents even if they are in the care of a nurturing adult (Bowlby, 1982).

Often the legal parents of children in care have their own history of trauma. A parent might have endured abuse or maltreatment as a child and/or might be attempting to manage current stressors such as poverty, homelessness, community violence, domestic violence, and institutionalized racism, which can all influence a parent's ability to serve as a child's protector (Lieberman & Van Horn, 2008). Parents who are trying to cope with their own traumatic experience are less likely to be able to read and/or respond appropriately to their children's cues, leading to difficulty forming healthy attachments (Lieberman, Chu, Van Horn, & Harris, 2011). Parents with unresolved trauma histories might reenact their experiences when in the position of being the parent, leading to trauma being passed on generationally. (Fraiberg, Adelson, & Shapiro, 1975; Chadwick Trauma-Informed Systems Project, 2013). Lieberman, Padrón, Van Horn, and Harris (2005) have noted that parents who have a trauma history can recover by integrating early benevolent memories of their own caregivers, which also has the potential to mitigate the passing on of generational trauma. They name this recovery process of transmitting nurturing experience "angel memories" and describe how these memories give a parent a pathway to identifying with the "protector" as opposed to the "aggressor" when traumatic material is triggered in the parent-child relationship (Lieberman et al., 2005).

Parent-child-dyad art therapy practice has foundations in attachment theory and parallels with child-parent psychotherapy (CPP). CPP is an evidence-based relational treatment model that focuses on the parent-child relationship as a way to prevent child maltreatment (Toth, Gravener-Davis, Guild, & Cicchetti, 2013). Similarly, in parent-child-dyad art therapy, the parent-child pair is the focus and shared creative experiences are used as a way to improve the parent-child bond, attunement, and communication (Proulx, 2003). Through the use of art-based interventions designed to promote successful engagement at the child's developmental level, the child's strengths and needs are validated by the parent. Art-based interventions both motivate parents to support positive engagement with their child and validate their child's success. Engaging in early art and play with their child may simultaneously give parents the opportunity to recapture and heal early moments of their own development (Proulx, 2003). Art directives are designed to be appealing and pleasurable to both the parent and the child. Materials are presented in small amounts and in containers to create a safe holding environment and limit overstimulation. For example, if working on paper, the paper is taped to the table, representing a secure base from which the dyad can explore. The art therapist provides

support through modeling and normalizing age-appropriate behavior and observing successes (Proulx, 2003). The final art product serves as a concrete embodiment of the experience. For a family in foster care, the artwork can serve as a way to maintain connection until the next visit.

Family Visitation and Community Settings

For children in foster care, consistent visitation with legal parents is linked to shorter time in care, reunification, lower levels of depression, and better child behavior (Nesmith, 2015). While visitation is considered the primary intervention to both support the parent-child relationship and attachment during foster care separation (Mallon & Leashore, 2002), the means to effectively support visitation are sparse. As described by Beyer (1999): "Most child welfare systems visits are rarely more than a supervised encounter in an office" (p. 2). While the Adoption Assistance and Child Welfare Act of 1980 requires regular visitation to be part of the plan for families in foster care, visits often occur infrequently and inconsistently. This may be attributed to a range of factors, including, but not limited to, families having difficulty coping with feelings that arise during visits and the triggering of traumatic material in foster care and child welfare settings (Nesmith, 2015).

Haight et al. (2003) highlight the value of visitation in repairing disrupted attachment between children in foster care and their legal parents. They assert that visits should take place in "cultural environments where attachment relationships would normally develop" (p. 201) as opposed to unfamiliar or triggering settings such as child welfare agencies. Community spaces like museums have the potential to fill this gap. Ioannides' (2016) work in museums affirmed the potential of utilizing non-clinical spaces for reducing stigma, increasing self-esteem, and sparking inspiration for clients. According to Carr (2006), cultural institutions such as museums symbolize hope and possibility. He asserts that cultural institutions are made because people want something new to happen and a museum has the ability to facilitate a powerful experience through the individuals' interaction with the space and objects inside. This description parallels the potential of a therapeutic space and alliance. When clients are engaged with a therapist, they are working through challenges with the hope of new understanding and symptom relief. Meanwhile, the therapist is providing a safe emotional and physical environment for this work. Unlike the traditional therapeutic space and appointment time, the museum is public, giving the client increased access and the potential for self-initiated wellness practices by engaging with the objects inside (Treadon, Rosal, & Wylder, 2006). Additionally, the museum, by being a cultural institution, is removed from the legal and social welfare connotations that may negatively affect families in foster care while they engage in their court-ordered visitation.

Children's museums are particularly suited to support family visitation. Children's museums are designed to support child development through play, discovery, and hands-on learning (Mayfield, 2005). While children's museums originally were designed to focus on child-centered learning, they have begun to shift toward a family-centered learning model over the past decade. In the family-centered model, exhibition design and education programming prioritize adult-child interaction in problem solving, making personal connections, and having shared creative experiences (Wolf & Wood, 2012). The priorities of the family-centered learning model reflect the possibilities that can occur when family visitation takes place in the museum space. Family visits have the

potential to help parents increase their understanding of their children's needs as well as practice positive parenting strategies (Beyer, 1999). At a children's museum, parents and children are able to apply skills that are being learned in parenting classes, anger management classes, and individual and family therapy by putting them into practice through art and play activities within a space that is designed to support the parent-child relationship.

Community-based art therapy can be defined as collaborative and therapeutically informed art-making by members of a specific group for the purpose of expressing empowerment, reducing stigma, and nurturing connections between participants (Hocoy, 2007; Ottemiller & Awais, 2016). Kapitan (2008) highlights the possibilities of expanding the reach and application of art therapy-informed work when she asserts that "Community-based settings are uniquely positioned to be incubators for new ideas and practices that will define the professional practice of art therapy in the future" (p. 2). Examples of community settings can range from cultural institutions like museums to neighborhood businesses like laundromats and barbershops. Each community space has the unique potential for people to gather, exchange ideas, and promote connection.

Within the community-based art therapy context, the art therapist's role is defined as "facilitator" rather than therapist. While art therapists in the community context can draw from their therapeutic training to support the emotional and physical safety of participants, they are not using their training to address pathology (Wadeson, 2000). Community-based art therapy practice, paired with the inherent potential of a children's museum, can support families in foster care by providing both an engaging environment for visits as well as, when needed, emotional support from a clinically trained facilitator. In their model of best practices for community-based art therapy, Ottemiller and Awais (2016) have emphasized that the community-based practice should focus on pulling from community strengths and resources with the goals of reducing stigma, encouraging empowerment, and increasing social inclusion. They also highlight the importance of outreach to the community in which the art therapist is working in order to form a relationship with members and service providers (Ottemiller & Awais, 2016). In the case of the child welfare system, establishing and maintaining open communication with caregivers, workers, and therapists involved in the family's case allows service to occur in an overlapping and holistic way.

ARTogether: A Community-Based Family Support Model

The ARTogether Program uses the natural community setting of the Children's Museum of the Arts in New York City to support families navigating the child welfare system. The program pairs participating families with a clinically trained facilitator and hosts family visits at the museum. ARTogether partners with social service agencies to move family visits into the community with the hope of: 1) improving the quality of visits by providing individualized support in a natural setting for children and their legal parents who are working to repair relationships; 2) providing opportunities for families to put into practice in the community the skills they have learned in therapy, parenting classes, and therapy groups; and 3) harnessing the potential of art-making, play, and socialization to connect families with the larger cultural continuum.

ARTogether is not a therapy service. It is a support program that works closely with referring agencies that are either providing or connected to a participating family's therapeutic services. The program connects with service providers by offering monthly

open-house sessions at the museum, providing on-site professional development and information sessions at agency settings, and hosting an annual professional development and worker-appreciation event at the museum. The purpose of these outreach efforts is to make service providers aware of the ARTogether program and model; to develop relationships with referring agencies with the goal of exchanging best practices; and to explore the different ways the museum could function as a resource for the families the providers serve.

The ARTogether program serves legal parents and their children in an effort to focus family visits on the parent-child relationships being monitored by the child welfare system. Often when foster parents, extended family, and friends attend visits, it can be difficult for parents to fully resume their parental role, even though this is an important goal of visitation and at the heart of the process to repair the relationship with their children. ARTogether focuses on relationship goals such as improving communication, parent-child attunement, and the parent-child bond by providing participants individualized support and a natural space to apply the skills learned in therapy.

As part of the referral process, ARTogether facilitators are made aware of a referred family's current therapeutic goals and status of the family's case by the referring worker who is often the family's social worker or therapist. Facilitators are clinically trained to understand the therapeutic goals and techniques families are working on, and they can both acknowledge successes and encourage the use of newly learned techniques during museum visits. Throughout the family's involvement in ARTogether, the facilitator, referring worker, and parent communicate through phone calls and in-person meetings to reflect on progress and connect work being done in the family's child welfare case and therapy settings to the work happening in the museum visits. The program does not ask referring workers or parents for a description of what led the family into the foster care system. This is purposeful as the program aims to work with families based on where they are in the moment and support them on their journey to repair and heal relationships. By not asking, the program attempts to honor the family's right to choose whether or not to share their story. This is in contrast to interactions with the child welfare system during which families are often expected to repeat traumatic stories multiple times despite the negative impact of this retelling on family members.

ARTogether facilitators are clinically trained in the fields of art therapy, social work, early intervention, and counseling. Facilitators use an interdisciplinary approach, pulling from the fields of art therapy, attachment research, and museum education. Facilitators receive case supervision with a licensed art therapist, getting support in their work with the families, while exploring the intersections of oppression, race, privilege, implicit bias, and cultural assumptions that arise throughout their practice. ARTogether facilitators come from diverse backgrounds that reflect the families served in the program. This diversity increases the possibility for families to be paired with facilitators who are able to provide culturally competent care by being bilingual and bicultural. This is particularly significant when considering the impact of institutionalized racism on the child welfare system and how the dynamic of working with a therapist or facilitator from a similar background might help families of color feel better understood and more confident to advocate for their needs.

Before family visits begin, the facilitator, legal parent, and referring worker meet at the museum for an initial intake meeting. This meeting allows participating parents to develop a familiarity traveling to the museum and sense of ownership over the space by observing the museum's public workshops. This experience emphasizes the parent's adult role and parental identity. It also sets a foundation for the parent to feel confident

traveling to the museum with their child and exposing them to the space's offerings, which in turn decreases the parent's expectation that the facilitator will lead the visit. During this meeting, the visit schedule is developed and agreed upon through open communication between the worker, facilitator, and parent. Program goals that align with the family's larger child welfare case are identified. Before each scheduled visit the facilitator reaches out to the parent by phone to confirm attendance, check in on how the parent is feeling in advance of the visit, and discuss possible activities for the family to engage in together. The facilitator remains in communication with the referring worker, providing progress updates and sharing any therapeutic material that may arise and need further exploration.

Each ARTogether visit is two hours long and takes place during open museum hours. During the first hour, the ARTogether facilitator guides the family through available museum workshops, studios, and play spaces. The Children's Museum of the Arts has areas that focus on media, fine arts, and early childhood. Each space has programming that ranges between self-guided experiences, such as painting at an easel, and staff-led workshops inspired by the current exhibition in the museum's central gallery space. The museum teaching-artist staff range in age, ethnicity, and area of artistic expertise. Families are encouraged to develop a relationship with the museum staff and space. As the program progresses, facilitators decrease the amount of time they spend with families during this first hour. Families connect to the museum space through having positive experiences during visits, developing the comfort necessary to engage with one another independently, and socializing with other museum visitors.

The second hour of the visit is reserved for a private art session in the museum's ARTogether Family Room. During the private portion, the facilitator engages the family in an individualized art-making directive to allow for more intimate interactions. Individualized projects are typically developed with the family over the course of the program and reflect the family's interests or may be used to explore a theme. For example, a participating family verbalized their sadness about the Christmas holiday approaching and not being able to have a family meal together because the children were in care. The family spoke in detail about what each person would like to eat together; in response, the facilitator prepared art materials for family members to each create one piece of the family meal. By using playdough, yarn, cardboard, multicolor paper, paper plates, beads, corn husks, and dried beans, the family was able to use the art-making process to create and share a family meal together at the museum.

Family visits are the primary way for families to maintain bonds during foster care separation. Additionally, the quality of visits is regarded by the court as important information for readiness to move forward with reunification. Nesmith (2015) describes issues such as transportation, scheduling, and parental fear of emotional intensity that can arise during visits as barriers to consistent visitation. He also explains how increased contact and engagement of legal parents by providers can help overcome these barriers. As a supportive service, ARTogether facilitators provide additional parent outreach and support to encourage attendance at visits. Facilitators encourage legal parents to communicate when visits are not taking place due to agency or foster parent non-compliance. Lastly, as clinically trained professionals, facilitators are able to provide progress reports and letters for the purpose of advocacy in family court. These reports highlight families' attendance, enjoyment, and sharing of affection during visits. Upon completion of ARTogether, families receive a renewable one-year family membership to continue to independently visit the Children's Museum of the Arts and spend quality time together.

ARTogether Program: Best Practices

PRAISE

By providing praise and encouragement to children and parents, facilitators help families recognize the strengths of each family member. Facilitators model praise and work toward helping family members increase their ability to praise and point out each other's strengths. In a system that often focuses on what parents have done wrong or behaviors that need correcting, self-esteem and hope can be restored in families by highlighting nurturing qualities such as generosity, affection, help, confidence, bravery, and connectivity.

BALANCED SUPPORT

Facilitators may serve as an emotional, behavioral, and cultural translator between parent and child to increase mutual understanding. An example of this is helping a parent more accurately appraise their child's behavior by understanding how the behavior is related to their developmental level. Another example is verbalizing the intention behind a behavior. For example, a parent's frustration about the child not following directions can be reframed by the facilitator as the parent's emotional intention of wanting to see their child succeed and benefit from the activity.

CHILD-LED EXPLORATION

While parents set and maintain the visit structure, children lead the exploration and play in the museum. When parents follow their child's lead, they are able to learn about their child's interests and are encouraged to stay at their child's developmental level. Mirroring can be experienced as an affirmation and acknowledgment of attunement. Working alongside one another while creating artwork or engaging in side-by-side play can serve as a metaphor for mirroring and, as a result, strengthen familial bonds.

STRENGTHENING THE PARENT'S IDENTITY AS CAREGIVER

Parents with children in foster care often have limited access to their children's lives, as well as limited power to make decisions for their children while they are in care. This can deteriorate a parent's identity as the caregiver from the perspective of both the parent and the child. By supporting parents to lead activities, set limits, and engage independently with their children, facilitators send the message that they trust the parents' judgment and ability to care for their children. In turn, children witness their parents being treated with care and respect.

MODELING

As the ARTogether program takes place during public hours, participating families have the opportunity to observe and engage with other families visiting the museum. Facilitators will often encourage parents to observe the behaviors of other children and reflect on what they notice. Parents are frequently surprised at how similar their child's behaviors are to that of their peers. Similarly, parents observe the ways other families interact,

set limits, and manage difficult behavior. Then they reflect with the facilitator on techniques they may want to try or how they may have handled a situation differently.

ARTogether facilitators begin and end each session with a "feeling check-in." Using a visual feeling chart, the facilitator supports family members as they practice both verbalizing their feelings and listening to each other's feelings without judgment or retaliation. When children share difficult emotions such as anger or sadness, they provide caregivers the opportunity to help regulate their emotions or to bear witness to how they feel. Sharing feelings of love and happiness can provide an opportunity to verbalize how much a family enjoys being in each other's company.

The Solar Family

Ms. Solar and her ten-year-old son Edwin were referred to the ARTogether program by Ms. Solar's social worker. The family identified as Mexican American, and the ARTogether facilitator assigned to the case identified as a cisgender, white-presenting woman of color.

Edwin had been placed in foster care with his maternal aunt after a child services investigation. At the time of the ARTogether referral, the family had been living apart for several months and Ms. Solar was in the process of completing a parenting class.

In her initial parent meeting at the museum, Ms. Solar expressed both her excitement about the museum workshops and nervousness about being in crowded spaces. Based on Ms. Solar's affect and verbalizations, the facilitator recognized that Ms. Solar was being triggered by the crowded public space and suggested switching the visit time to a quieter day of the week. This appeared to ease Ms. Solar's nervousness, and she agreed that a time change would be best. During the private intake meeting, Ms. Solar shared her strong motivation to gain custody of her son. She also shared her difficulty setting limits with her son because she feared being a parent her son would not like. With support from her social worker, Ms. Solar set the following goals for the family's participation in the program: 1) to practice better limit setting with her son; 2) to develop new strategies to positively engage with her son; and 3) to use art as a means of shared quality time.

Ms. Solar, Edwin, and Ms. Solar's sister, who was serving as Edwin's kinship foster parent, attended the first visit. The facilitator was surprised to see the aunt, as there was no discussion of her attending. The facilitator greeted the family at the entry and observed the aunt give Edwin several stern directives. Edwin complied with his head down while Ms. Solar stood by quietly. The interaction suggested a power struggle that appeared to diminish Ms. Solar's authority as the parent and placed Edwin in the middle of his mother and aunt. The facilitator reviewed the program goals with the entire family and reminded them that visits were a special time for Ms. Solar and Edwin. The aunt responded with relief, sharing that she needed a break. The facilitator offered that she use the time to relax in the museum's Quiet Room. Once the aunt was settled down in a relaxing corner of the museum, Ms. Solar and Edwin became more animated and engaged in a clay workshop together. Throughout the visit, Ms. Solar and Edwin initiated visiting and checking-in on the aunt and invited her into the private time with the facilitator. In this space, they collaborated to create a family painting. The facilitator followed

Ms. Solar and Edwin's lead and supported their ability to negotiate how involved the aunt would be in the visit.

The aunt attended the second visit and asked to sit in the Quiet Room immediately. During this visit, Ms. Solar and Edwin did not initiate visiting or checking-in on the aunt. After a third visit, during which the aunt immediately walked to the Quiet Room and remained there, Ms. Solar and Edwin began to attend museum visits independently.

Edwin appeared to be aware of his mother's fragility and verbalized being afraid of upsetting her by directly asking for what he needed. At times Edwin would put his mother's ego needs before his own, for example, criticizing his artwork as a way to elevate what his mother was making. While Ms. Solar was able to be attuned, empathic, and affectionate with her son, she would also fluctuate and tease him about his feelings or disclose his confidences without his consent. Edwin appeared to be at ease verbalizing his feelings through his artwork. In the first visit, he sculpted a shark and shared that it was older and had been through more difficulties than the model shark he was using as source material. He added that his shark was angry and expressed this by creating arched eyebrows. When his mother asked why his shark was angry, he responded by saying it was because his mother was moving and giving away his pet. Ms. Solar was able to use this moment to listen to and validate her son's feelings around her recent move to a new home.

Through the museum visits, Ms. Solar was able to practice setting limits with Edwin by collaborating with him to create visit routines. This practice allowed Ms. Solar to be the fun and flexible parent she wanted to be while encouraging Edwin to express his needs and preferences. In the first several visits, Ms. Solar would directly ask the facilitator for help when setting limits and Edwin would turn to the facilitator to meet his needs. By redirecting Edwin back to his mother and engaging with Ms. Solar in open conversation to explore different options and ways to address her son's needs, Ms. Solar's authority as Edwin's caregiver was strengthened. In turn, Edwin became comfortable asking his mother for help and trusting that she would follow through to get his needs met.

As visits continued, the family displayed more ease and ownership over the space. Ms. Solar was able to travel with her son independently, and the family began to check in with the museum's visitor services desk instead of waiting to be led in by the facilitator. The facilitator acknowledged these successes and pulled back during public time, allowing the family to engage independently. During their time in the museum, Ms. Solar and Edwin expressed a strong affinity for the Media Lab, where they participated in clay modeling and sculpting workshops. They developed a relationship with the Media Lab teaching artist, and the experience inspired them to create their own stop-motion animation film. The final four sessions with the facilitator were dedicated to creating the family's film.

Ms. Solar and Edwin wrote a script together between museum visits and used their private session time to sculpt characters, create a set, animate, and record their voices for the film's sound. As both mother and son loved superhero comics, they chose to write their own Batman and Catwoman script with Ms. Solar cast as Catwoman, Edwin as Batman, and the facilitator playing the villain, the Joker. Based on the comic history, Catwoman and Batman's relationship shifts between being adversaries, lovers, and collaborators. In the family's script, Batman and Catwoman have teamed up to capture the Joker, who has just robbed Gotham Bank.

The family took time and care in sculpting their figures. Edwin prioritized creating a figure that could stand on its own and ended with adding details to accentuate Batman's

muscles. Ms. Solar worked with great detail to sculpt a thin, feminine, and delicate Cat-woman figure. The facilitator sculpted the Joker while modeling ways of using the clay to add details and create stable legs, with the purpose of supporting the interests of both mother and son. In the following visit, the family discovered that Ms. Solar's Catwoman was unable to withstand the drying process. Although Ms. Solar reacted with disappoint-ment that her figure had broken, she did not want to sculpt another one, insisting that she would work on the film set and leaving the responsibility of fixing her figure to Edwin. Throughout the sculpting process, Edwin had joked about the possibility of the facilitator being "bad" like the Joker. When the mother's fragile Catwoman figure had crumbled during the drying process, Edwin jokingly maintained this as proof of the facilitator truly being "bad." Despite this, Edwin enlisted the facilitator's help to sculpt a new figure for his mother. The new figure replicated the original figure's color palette and traditionally feminine features but with thicker and stronger arms and legs. As part of the process, Edwin insisted on creating a coffin for the original Catwoman figure and at the end of the session, he carefully placed the broken figure in the coffin and took it home.

The script and final film reflect the dyad's strong connection and desire to work together to overcome challenges. The film begins with Batman seeking out Catwoman to tell her that Joker has robbed the bank. Catwoman responds with concern and sup-ports Batman in coming up with and executing a plan to take down the Joker and put him in jail. Catwoman acknowledges the ambiguity in her trustworthiness by verbaliz-ing that she is on "the Bat's side this time around." The film allowed Edwin to express both his desire to be with his mother as well as his uncertainty around her being a stable caregiver. Through her collaboration with her son, Ms. Solar was able to show Edwin that she could accept and tolerate his expressions and doubts while also developing her character to be a reassuring and strong presence at his side. The animation culminated with the Joker being captured. The script ends with Gotham being safe "for now . . ." suggesting the potentiality of recurring threat that they will need to battle as their rela-tionship continues to strengthen.

Upon completing the film and the ARTogether program, the family was invited to display their work in an upcoming exhibition. The film was featured in the museum's gallery alongside the works of both professional and community artists.

Discussion

Ms. Solar and Edwin's experience in the ARTogether program reflects the potential for community spaces to provide a rich environment in which children in foster care can engage with their parents during their court-ordered visitations. The case also highlights how encounters supported by a clinically trained facilitator can allow for families to use visits to continue the process of repair in their relationships.

While the facilitator was surprised to see the foster parent at the first visit, and observed the obstacle that her attendance appeared to present for the overall goal of visitation, she considered the following possibilities through self-reflection: 1) Ms. Solar might have brought her sister as a support because this might be her first time in the community alone with her son since his removal from the home; she might have had doubts about her ability to keep him safe; 2) Ms. Solar might have brought her sister as a personal support because of her own discomfort when traveling, being in a public space, or perhaps being in a museum space that may reflect the aesthetic of White dominant culture; and 3) the aunt might have insisted on coming to assess the safety of where her sister and nephew would be. In responding to the aunt's presence, the facilitator

also needed to maintain respect for the attachment and bond between Ms. Solar and her sister. If these considerations had not been made, there is the possibility that the family would not have felt safe at the museum and might not have moved forward with the program. By allowing the family the space and authority needed to include the foster parent, the family was able to safely transition to Edwin and his mother attending museum visits independently.

Considering Ms. Solar's discomfort in crowded spaces, one might think she would not be the best candidate for a program that requires subway travel and engaging in an active public space. The facilitator supported Ms. Solar by being attentive to her affect and providing opportunities for her to verbalize if she needed time in quieter spaces. By successfully managing her parental commitments despite personal challenges, Ms. Solar reaffirmed her own growth and dedication for her son, Edwin.

The program also allowed Ms. Solar to apply skills from her parenting class such as limit setting, following through with promises, and validating her son's feelings. This practice contributed to building back Edwin's trust in her ability to parent and care for him. Once the family appeared confident in the museum space, it was essential for the facilitator to pull back her support. In this way, the facilitator communicated her trust in Ms. Solar parental identity and that the museum space itself could be a safe holding environment. Independent exploration of the museum also encouraged the family to form strong bonds with museum's staff. When ARTogether alumni return to the museum with their membership card, it is the staff who personally welcomes the family. This transition from the facilitator to the larger museum parallels how families in foster care transition out of care and can utilize personal and community resources in the place of the foster care institution.

While Ms. Solar was able to make progress strengthening her parental role through her participation in ARTogether, she continued to work on claiming her personal and parental authority. In the script of the family's final film, Batman and Catwoman are paired as equals working together to defeat the Joker. This pairing as equals highlights mom's desire to repair her relationship with her son while reflecting her difficulty accepting her authority as a parent and caretaker. This theme is repeated in Ms. Solar creating a delicate Catwoman figure and then being unable to create another sturdier figure after her first piece crumbled in the drying process. While Ms. Solar took on the responsibility of creating the environment and set for the film, a role she felt more comfortable with, she put her son Edwin in the parental role of taking care of and rebuilding her figure.

Edwin's hesitancy to speak directly to his mother about his feelings and prioritizing her ego needs are common behaviors expressed by children who fear their parent is too fragile to tolerate their needs. The art-making process gave Edwin the space to engage with his feelings creatively and, at times, the ability to verbalize them to his mother, as in the example with his clay shark. It also gave him the space to test his mother's ability to listen, provide assistance, and be consistent. The metaphor of laying to rest his "broken mother" and forging a mother who would not fall apart through the clay process was a strong moment for Edwin both in expressing his desires and perhaps also his increased belief in his mother's ability to be a stable caretaker.

In the process of making the film, Edwin was able to explore his feelings of mistrust in the foster care system by assigning the facilitator the role of "the villain." Through this metaphor, Edwin explored the ambiguity he experienced around workers assigned to help him and whose interventions have also resulted in emotional pain and separation from his mother. While Edwin expressed that he did not fully trust the facilitator or her intentions, he did ask for her help to fix his mother's figure. This enlisting of outside help

to fix his mother parallels the family's involvement in the foster care system and again highlights Edwin's questioning of the necessity of the system for his family to heal or be "fixed." Edwin's mistrust of the facilitator can be considered through the lens of resistance. In her book *Wounds of the Spirit*, Traci C. West (1999) considers the relationship between resistance and healing, stating, "Acts of resistance can open up possibilities for a degree of healing to take place" (p. 152). Edwin expressed his mistrust, and the facilitator, aligning with this identification instead of challenging it, created space for Edwin to lead the exploration of his feelings and experiences through his creative process. The facilitator supported Edwin's lead by providing help and support only when asked.

The gallery at the Children's Museum of the Arts occupies the entire center space of the museum and is the heart of the museum. While Ms. Solar and Edwin enthusiastically agreed that they wanted their work included in the public exhibition, it is unknown if they returned to see the show, and they did not return follow-up calls from the facilitator. The power differential between the facilitator and the client is always present. The facilitator perceived this invitation as a way to further "empower" the family by having their work on display and shared with the public. However, the facilitator did not consider how her authority in asking the family to participate might make it difficult for the family to decline. Dr. Kenneth Hardy (2001) emphasizes the responsibility of the person in the role of authority to make critical distinctions between intention and impact. By operating from her intention and own bias that displaying the work was only a positive next step, the facilitator failed to consider her impact and did not explore with the family what it would mean to have such a personal work on display for all to see, especially because the piece expresses elements of the family's repair process. At the time of this case, the facilitator was the only person in this role in the program and did not have access to case supervision. The need for supervision to be built into the ARTogether program came from experiences such as this. Supervision allows for reflection, planned interventions, and space to challenge both cultural norms and norms in the field practice within the co-construction of the supervisory relationship.

Additionally, the facilitator's decision-making process can be explored through the institution of a museum. While museum spaces may be outside of the child welfare system, they are not exempt from a legacy of White supremacy. As Robinson (2017) describes, "The institutional construct of the museum is often built upon power and privilege—founded and sustained by the wealthy, and shaped by the dominant culture's values and views of the world" (p. 99). With many museum institutions having a history and association with cultural exploitation and cultural appropriation, it is possible the family experienced the facilitator's request and the museum's enthusiasm to display the work as a way of taking it from them for a purpose that is more serving of the museum than the family. With reflective supervision based in anti-racist practice, the facilitator might have been able to explore this possibility with the family.

Recommendations

ARTogether is a unique program that is meant to inspire the potential for utilizing non-traditional and community spaces for therapeutic gains. In ARTogether, the supportive relationship with the facilitator combined with the natural setting of the museum equips and empowers parents with a sense of normalcy that can motivate attendance, decrease visit fears, and provide positive opportunities for engagement during separation. For art therapists, caseworkers, visit coaches, and clinicians who are working with families in foster care, or families otherwise navigating the child welfare system, utilizing the

community as a resource may come in different forms but with similar benefits. Entry fees at many cultural institutions like museums are by donation only and others often have "pay as you wish" access hours, which increase accessibility to the space. During these hours, workers may visit the museum in advance to familiarize themselves and consider how they might engage a family in the space. Access hours also allow for families to test out the museum experience without the financial commitment. While children's museums are ideal in that they have hands-on activities and programming built into the space, traditional museums may also offer scheduled art-making and hands-on experiences, as well as child-oriented tours. With intentional anti-racist and inclusive program development, museums can become allies in creating space and uplifting voices of groups that are marginalized (Ng, Ware, & Greenberg, 2017). For example, art exhibits exploring complex issues of oppression and activism can open critical discussions for visitors who have been historically stigmatized.

Another community resource is the public library. Many libraries are centrally located and have free story time, music time, and arts-and-crafts programming for the public. Libraries often have adult resources that can be shared with parents, including computer literacy classes, ESOL classes, resume-writing support, yoga and mindfulness, parenting support classes, and monthly book clubs. Public libraries also have private spaces that can be requested for use in advance. These free spaces have the potential to host multifamily groups or recognition events. Workers may also consider reaching out directly to a cultural institution in their community; often institutions are interested in supporting families in the community, but they feel ill-equipped to forge a connection.

When considering materials, utilizing a community space could allow families access to engage with a medium that would not typically be available in the traditional therapy space. In the case vignette presented, the Solar family discovered their skill for stop-motion animation at the museum. The stop-motion animation process allowed for the family to create a narrative safely in their newly discovered neutral space of the museum. The process of stopping and slowly doing or redoing a scene allows for deep collaboration, problem solving, and the potential for corrective experiences. The stop-motion animation process beautifully parallels the repair process of the family's relationship. While the museum can provide access to technology like cameras, computers, and specific animation programming, the stop-motion process can be as simple as creating a flipbook with paper and pencil. The Children's Museum of the Arts and the ARTogether program encourage the use of household and upcycled materials for art-making and play. For example, making family sculptures from collected milk cartons, mono-printmaking with the tops of take-out containers, and making homemade play-dough. By utilizing readily available resources, clients are encouraged to value a similar process. Furthermore, the myth that art-making requires expensive or prefabricated materials is dispelled. This upcycling process also creates potential to reinvent value and purpose in material that may otherwise be discarded, which is a powerful metaphor for families that are forging new memories and experiences after a trauma. Greater access to materials also increases the possibility that a family might attempt to engage in similar art-making or play at home, which is evidence of empowerment and independence.

Workers may be deterred from engaging families in the community because of limited time to commit to each family's case and fear of boundary issues arising outside the safety of the therapy room. While time may be limited, this challenge can also be an opportunity to model creative problem solving and encourage clients to think outside the box when planning family visits. If a worker cannot escort a family to a space, perhaps a virtual museum tour can be utilized to encourage a visit or an art piece from

a museum's virtual collection can be observed and inspire an artistic or playful experience. When considering safe boundaries and worker/therapist engagement outside of the therapy room, the role of the facilitator may be taken on. When in the role of facilitator, our work shifts toward supporting families as they are and away from exploring therapeutic material as we do in clinical treatment. Engaging with a family in the community allows workers to see their clients in a different environment and support them in putting therapy skills into practice in a natural setting.

References

Baldwin, M., Crouse, G., Ghertner, R., Radel, L., & Waters, A. (2018). Substance use, the opioid epidemic, and the child welfare system: Key findings from a mixed methods study. *ASPE research brief, U.S. Department of Health and Human Services*. Retrieved from https://aspe. hhs.gov/system/files/pdf/258836/SubstanceUseChildWelfareOverview.pdf

Beyer, M. (1999). Parent-child visits as an opportunity for change. *The Prevention Report: The National Resource Center for Family Centered Practice, 1*, 2–11. Retrieved from www. ocfcpacourts.us/assets/files/list-756/file-1037.pdf

Blythe, M., Marsh, S., McMahon, J., & Phipps, L. (2014). Attachment and child welfare practice. *Children's Services Practice Notes: For North Carolina's Child Welfare Social Workers, 19*(3), 1–10. Retrieved from www.practicenotes.org/v19n3/CSPN_v19n3.pdf

Bowlby, J. (1982). *Attachment and loss, vol. 1: Attachment*. New York, NY: Basic Books.

Boyd, R. (2014). African American disproportionality and disparity in child welfare: Toward a comprehensive conceptual framework. *Children and Youth Services Review, 37*, 15–27. https://doi.org/10.1016/j.childyouth.2013.11.013

Bryant, R. A. (2016). Social attachments and traumatic stress. *European Journal of Psychotraumatology, 7*. https://doi.org/10.3402/ejpt.v7.29065

Carr, D. (2006). *A place not a place: Reflection and possibility in museums and libraries*. Oxford, England: AltaMira Press.

Chadwick Trauma-Informed Systems Project. (2013). *Creating trauma-informed child welfare systems: A guide for administrators* (2nd ed.). San Diego, CA: Chadwick Center for Children and Families.

Chesmore, A. A., Weiler, L. M., Trump, L. J., Landers, A. L., & Taussig, H. N. (2017). Maltreated children in out-of-home care: The relation between attachment quality and internalizing symptoms. *Journal of Child and Family Studies, 26*(2), 381–392. https://doi/10.1007/s10826-016-0567-6

Child Welfare Information Gateway. (2018). *Foster care statistics 2016*. Retrieved from www. childwelfare.gov/pubPDFs/foster.pdf

Fraiberg, S., Adelson, E., & Shapiro, V. (1975). Ghosts in the nursery: A psychoanalytic approach to the problems of impaired infant-mother relationships. *Journal of American Academy of Child Psychiatry, 14*(3), 387–421. https://doi.org/10.1016/S0002-7138(09)61442-4

Haight, W. L., Kagle, J. D., & Black, J. E. (2003). Understanding and supporting parent-child relationships during foster care visits: Attachment theory and research. *Social Work, 48*(2), 195–207. https://doi.org/10.1093/sw/48.2.195

Hardy, K. (2001). African American experience and the healing relationship. In D. Denborough (Ed.), *Family therapy: Exploring the field's past, present and possible futures*. Adelaide, Australia: Dulwich Centre Publications. Retrieved from https://dulwichcentre.com.au/articles-about-narrative-therapy/african-american-experience/

Healey, C., & Fisher, P. (2011). Children in foster care and the development of favorable outcomes. *Children and Youth Services Review, 33*(10), 1822–1830. https://doi.org/10.1016/j.childyouth.2011.05.007

Hocoy, D. (2007). Art therapy as a tool for social change: A conceptual model. In F. Kaplan (Ed.), *Art therapy and social action* (pp. 21–39). Philadelphia, PA: Jessica Kingsley Publishers.

Ioannides, E. (2016). Museums as therapeutic environments and the contribution of art therapy. *Museum International, 68*, 98–109. https://doi.org/10.1111/muse.12125

Kapitan, L. (2008). Not art therapy: Revisiting the therapeutic studio in the narrative of the profession. *Art Therapy: Journal of the American Art Therapy Association, 25*(1), 1–3. https://doi.org/10.1080/07421656.2008.10129349

Kelly, J. (2018, May 2). Donald Trump, family first act fan. *The Chronicles of Social Change.* Retrieved from https://chronicleofsocialchange.org/youth-services-insider/trump-promotes-family-first-act-foster-care-proclamation

King, N., & Kolodny, A. (2017, November 4). Why is the opioid epidemic overwhelmingly white? *National Public Radio.* Retrieved from www.npr.org/2017/11/04/562137082/why-is-the-opioid-epidemic-overwhelmingly-white

Lawrence, C., Carlson, E., & Egeland, B., (2006). The impact of foster care on development. *Development and Psychopathology, 18*(1), 57–76. https://doi.org/10.1017/S0954579406060044

Leve, L. D., Harold, G. T., Chamberlain, P., Landsverk, J. A., Fisher, P. A., & Vostanis, P. (2012). Practitioner review: Children in foster care—vulnerabilities and evidence-based interventions that promote resilience processes. *Journal of Child Psychology and Psychiatry and Allied Disciplines, 53*(12), 1197–1211. https://doi.org/10.1111/j.1469-7610.2012.02594.x

Lieberman, A. F., Chu, A., Van Horn, P., & Harris, W. W. (2011). Trauma in early childhood: Empirical evidence and clinical implications. *Development and Psychopathology, 23*(2), 397–410. https://doi.org/10.1017/S0954579411000137

Lieberman, A. F., Padrón, E., Van Horn, P., & Harris, W. W. (2005). Angels in the nursery: The intergenerational transmission of benevolent parental influences. *Infant Mental Health Journal, 26*(6), 504–520. https://doi.org/10.1002/imhj.20071

Lieberman, A. F., & Van Horn, P. (2008). *Psychotherapy with infants and young children: Repairing the effects of stress and trauma on early attachment.* New York, NY: The Guilford Press.

Mallon, C., & Leashore, B. (2002). Preface. *Child Welfare, 81*, 95–99.

Mayfield, M. (2005). Children's museums: Purposes, practices and play. *Early Child Development and Care, 175*(2), 179–192. https://doi.org/10.1080/0300443042000230348

McWey, L., & Mullis, A. (2004). Improving the lives of children in Foster care: The impact of supervised visitation. *Family Relations, 53*(3), 293.

Nesmith, A. (2015). Factors influencing the regularity of parental visits with children in foster care. *Child & Adolescent Social Work Journal, 32*(3), 219–228. https://doi.org/10.1007/s10560-014-0360-6

Ng, W., Ware, S. M., & Greenberg, A. (2017). Activating diversity and inclusion: A blueprint for museum educators as allies and change makers. *Journal of Museum Education, 42*(2), 142–154. https://doi.org/10.1080/10598650.2017.1306664

Ottemiller, D., & Awais, Y. (2016). A model for art therapists in community-based practice. *Art Therapy: Journal of the American Art Therapy Association, 33*(3), 144–150. https://doi.org/10.1080/07421656.2016.1199245

Proulx, L. (2003). *Strengthening emotional ties through parent-child- dyad art therapy.* London, England: Jessica Kingsley Publishers.

Roberts, D. (2009). *Shattered bonds: The color of child welfare.* New York, NY: Basic Books.

Robinson, C. (2017). Editorial. *Journal of Museum Education, 42*(2), 99–101. https://doi.org/10.1080/10598650.2017.1310485

Siegel, D. J., & Hartzell, M. (2003). *Parenting from the Inside Out.* New York, NY: Penguin Random House.

Toth, S. L., Gravener-Davis, J., Guild, D. J., & Cicchetti, D. (2013). Relational interventions for child maltreatment: Past, present, and future perspectives. *Development and Psychopathology, 25*(4), 1601–1617. https://doi.org/10.1017/S0954579413000795

Treadon, C. B., Rosal, M., & Wylder, V. D. T. (2006). Opening the doors of art museum for therapeutic processes. *Arts in Psychotherapy, 33*(4), 288–301. https://doi.org/10.1016/j.aip.2006.03.003

U.S. Department of Health & Human Services. (2008). *Child maltreatment 2008.* Retrieved from www.acf.hhs.gov/archive/cb/resource/child-maltreatment-2008

U.S. Department of Health & Human Services. (2015). *Child welfare outcomes: 2015 report to congress; Executive summary*. Retrieved from www.acf.hhs.gov/sites/default/files/cb/cwo2015_exesum.pdf

Wadeson, H. (2000). *Art therapy practice: Innovative approaches with diverse populations*. New York, NY: John Wiley & Sons.

West, T. (1999). *Wounds of the spirit: Black women, violence, and resistance ethics*. New York, NY: New York University Press. ProQuest Ebook Central. Retrieved from http://ebookcentral.proquest.com/lib/columbia/detail.action?docID=865954

Wiltz, T. (2018, May 2). This new federal law will change foster care as we know it. *Pew Charitable Trusts*. Retrieved from www.pewtrusts.org/en/research-and-analysis/blogs/stateline/2018/05/02/this-new-federal-law-will-change-foster-care-as-we-know-it

Wolf, B., & Wood, E. (2012). Integrating scaffolding experiences for the youngest visitors in museums. *Journal of Museum Education, 37*(1), 29–37. https://doi.org/10.1080/10598650.2012.11510715

Yaroni, A., Shanahan, R., Rosenblum, R., & Ross, T. (2014). Innovation in NYC health and human services policy. *Vera Institute of Justice*. Retrieved from https://www1.nyc.gov/assets/opportunity/pdf/policybriefs/child-welfare-brief.pdf

16
Drawing to Disclose
Empowering Child Victims and Witnesses in Investigative Interviews

MARCIA SUE COHEN-LIEBMAN

Child sexual abuse has been described as "extraordinary in its characteristics, dynamics, causes and consequences" (Miller-Perrin & Perrin, 2013, p. 96). It has been identified as a common problem that is potentially damaging to the long-term physical and psychological health effects of children and adolescents (Jenny, Crawford-Jakubiak, & Committee on Child Abuse and Neglect, 2013). It has also been characterized as a complex event that children are ill prepared to describe (Everson & Boat, 2002). The lack of a conceptual model and a common definition (Mathews & Collin-Vezina, 2017) are vectors that have contributed to the lack of an objective scientific standard for the determination of child sexual abuse (Brooks & Milchman, 1991). This conundrum has existed since the 1970s, resulting in continued efforts directed toward the achievement of a common definition for this global public health phenomenon as well as a shared understanding (Mathews & Collin-Vézina, 2017) and reliable methods for defining and reporting child sexual abuse (Sapp & Vandeven, 2005).

Typically, there are no witnesses to child sexual abuse and little if any physical or viable evidence. As such, allegations of child sexual abuse are difficult to investigate given that corroborate evidence is often unavailable (Faller, 2014; Lamb & Brown, 2006; Lamb, Hershkowitz, Orbach, & Esplin, 2008; Macleod, Gross, & Hayne, 2013; Myers, 1998; Orbach et al., 2000). Self-reporting by children is often the primary source of information when sexual abuse is suspected (Lamb et al., 2008). Thus, a child's statements factor into the determination of allegations (Faller, 2003). Investigation is often contingent upon information elicited in an investigative or forensic interview. As such, the interview "is the centerpiece of the investigation" (Faller, 2014); albeit, it comprises only a piece or a part of the investigative process (Poole, 2016).

The traumatic factors inherent in disclosure of sexual abuse coupled with the environmental prejudice that pervades this societal ill promote risk factors that mitigate disclosure by youth. The ensuing dynamics and mechanics associated with child sexual abuse as well as the investigation of allegations have been identified as trauma inducing. Investigation should not recapitulate the experienced event. Allegations should not be minimized as a result of investigative efforts directed at identification of child victims and witnesses. The pursuance of justice should foster a salubrious process rather than induce secondary trauma due to investigative methods and fact-finding endeavors. Exploration of personally meaningful or experienced events such as child sexual abuse merit consideration within a platform that promotes resilience and empowerment. As such, a child-centered investigative process is warranted.

This chapter will present an "at promise" approach to the investigation of child sexual abuse allegations. As such, the chapter will focus on the paradigm shift that pervades the text and address a strength-based model of investigative interviewing that fosters resilience and empowerment in child victims and witnesses of experienced events that may be traumatic in nature such as sexual abuse. An art therapy-based investigative interview process, the Common Interview Guideline (CIG), which facilitates information gathering or fact finding through the use of free drawing as an open-ended prompt, is the focus. Disclosure of traumatic events by alleged victims of child sexual abuse and other acts of interpersonal violence is supported by the process, the interviewer, and the team conducting the investigation.

Predicated upon art therapy principles and practices while also rooted in forensic application, the CIG was developed to assist fact finders exploring child sexual abuse allegations and provide support to victims and witnesses during the investigative process. The guideline was developed to provide multidisciplinary team members with a common language and a consistent method for investigating allegations of child sexual abuse in an effort to streamline the process and improve investigative and judicial outcomes (Cohen-Liebman, 1999). Moreover, the CIG was developed to maximize the information that children reveal about experienced events in a manner that is child-centered, child friendly, and empowering for victims and witnesses. In a recent study, this art therapy-based process enhanced disclosure and facilitated fact finding (Cohen-Liebman, 2017).

The use of drawing as a means to facilitate disclosure of information within a relational or dialogical process is central to the CIG. In this art therapy-based process, the locus of control is shifted to the child. The process incorporates expression—be it in words, images, or a combination—that is forensically relevant while at the same time affording emotional support. The CIG promotes empowerment by enabling victims and witnesses *to speak what they cannot say*. The theoretical underpinnings of the CIG will be presented along with practical applications. A composite vignette will demonstrate how drawing, when used as an open-ended prompt in the CIG, facilitates fact finding or information gathering. Relevance regarding the transferability and the modification of the process to other populations will conclude the chapter.

In a recent study of the CIG, the findings suggested that drawing enhanced disclosure of information or fact finding in comparison to a verbal process (Cohen-Liebman 2017). The study explored the use of drawing as a primary resource in an investigative interview process that is based on art therapy principles and practices, The Common Interview Guideline (Cohen-Liebman, 2017). The study explored how drawing facilitates recall and disclosure (evidence) in investigative interviews (a dialogical process) of school-aged children when used as an open-ended prompt (imagery) in a forensic art therapy investigative interview (a relational process) as compared to a verbal process. Three overarching themes emerged from the data: fact finding, imagery, and relationality. The findings, although not generalizable given the small sample size, revealed that free or non-directed drawing enhanced recall and facilitated evidentiary disclosure in the art therapy-based process. Implications for future study emerged, including the use of the CIG with other populations in which fact finding or investigation is warranted such as bullying, interpersonal violence, and elder abuse (Cohen-Liebman, 2017).

The use of prompts and techniques to obtain "rich testimony" (Katz & Hamama, 2013; Lamb et al., 2008; Orbach et al., 2000) and garner reliable and accurate information within an investigative interview format is an area of interest under study (Katz,

2014; Katz & Hamama, 2013; Katz & Hershkowitz, 2010; Lamb et al., 2008; Orbach et al., 2000). The influence of drawing upon children's testimonies within the interview context is another area of interest (Katz & Hershkowitz, 2010). The manner in which drawing may offer provisional emotional support within structured investigative interviews is an additional area of study (Katz, Barnetz, & Hershkowitz, 2014). Although research has been devoted to ascertaining how drawing works within investigative interviewing processes, drawing from an art therapy perspective within the milieu of investigative interviewing has not been addressed. To date, the only known investigative interview process that is predicated upon art therapy principles and practice is the CIG (Cohen-Liebman, 1999, 2016, 2017) which until recently had not been systematically studied (Cohen-Liebman, 2017). In a comparative analogue study pertaining to school-based bullying, study findings revealed that when children drew (CIG with drawing) in an investigative interview, they provided more forensically relevant or qualitatively descriptive information when compared to a verbal investigative interview without the use of drawing (Cohen-Liebman, 2017). Moreover, the study suggested that the facilitative effect of drawing when utilized as a primary resource within the interview process provided support, promoted empowerment, and enhanced disclosure of forensically relevant information.

The CIG emanated in response to the call for a coordinated and cooperative joint investigative process for exploring allegations of child sexual abuse. It was designed to maintain forensic integrity while satisfying objectives identified by frontline investigators that respond to initial reports and are charged with interviewing victims and exploring allegations. A common interview guideline is essential to improve the fact-finding process; eliminate secondary victimization by minimizing repetitive interviews; and the process is known to each discipline and affords consistency (Cohen-Liebman, 1999). The CIG is a Forensic Art Therapy-based process that facilitates elicitation of information within an investigative context. Forensic Art Therapy is sensitive to the parameters of clinical interviewing; however, it adheres to forensic interviewing principles. This is necessary for the process to be acceptable within a court of law. Investigative interviews that derive from Forensic Art Therapy are based on a scientific framework, while subscribing to an art therapy paradigm (Cohen-Liebman, 2016).

Child Sexual Abuse

Child sexual abuse engenders a multidisciplinary response that includes child welfare, child protection, and criminal justice. Each of these factions relies upon disclosure of information by a child victim or witness for fact finding or investigational purposes. As such, it is incumbent upon the various systems that intervene at the initial stages of investigation to engage a child in a manner that is forensically relevant yet emotionally supportive. Research has demonstrated that children are considered capable of providing information that is accurate about experiences; however, the information communicated is impacted by "types of retrieval mechanisms employed and the quality of the communication between them and their interlocutors" (Pipe, Lamb, Orbach, & Esplin, 2004, p. 441). Investigative interviews require the "utilization of innumerable cognitive functions by a child" (Anderson et al., 2010, p. 204). Several cognitive concepts merit consideration when interviewing a child including memory, attention span, and comprehension, as well as simple versus complex ideas and concrete versus abstract concepts (Anderson et al., 2010).

Investigative Interviewing and Child Sexual Abuse

Methods for extracting viable information from children became the focal point of investigation in the late twentieth century given the resurgence of awareness and renewed recognition of child maltreatment including child sexual abuse in the 1960s and 1970s (Faller, 2014; Miller-Perrin & Perrin, 2013). Efforts to understand and address the scope of the problem ensued (Miller-Perrin & Perrin, 2013). As well, the genesis of multiple victim daycare cases sparked media interest and generated attention on interviewer behavior and best practice. As a result, a backlash was fostered with regard to standards of acceptable interviewer practice given questionable techniques such as leading and repetitive questioning (Cheit, 2014). The issue of suggestibility became a matter of concern within the community tasked with exploring allegations of child abuse within the framework of investigative interviewing. Forensic interview practices that currently exist and continue to evolve are based in part on extensive research and study of technique, practice, and method (Cheit, 2014; Poole & Lamb, 2003) that emanated from earlier sensationalized cases.

The literature has addressed many issues, concerns, and controversies associated with the practice of investigative interviewing for more than 40 years (Conte, Sorenson, Fogarty, & Rosa, 1991; Faller, 2014). Many issues continue to garner study. The need for research and data regarding children and investigative interviewing, as well as interviewer behavior, continue to be apparent in the search for best practices. The development of protocols and standards has also contributed to investigative interviewing refinement. State legislation pertaining to the welfare of children and victims emerged in response to the deepening awareness of the pervasive nature of child maltreatment, including child sexual abuse. Resultant to these developments were research efforts to benefit children through applicability, generalizability, and relevance (Poole & Lamb, 2003) on fundamental aspects related to investigative interviewing. Investigative interviewing evolved out of a need "to help avoid false accusations and ensure justice in child sexual abuse cases and to strengthen law enforcement's ability to elicit accurate information from children" (Harris, 2010, p. 12).

Initially, the task of investigative interviewing was assigned to child welfare professionals. Since child sexual abuse is not only a child welfare issue but also a crime, joint investigation between law enforcement and social service agencies was advocated. Joint investigations involving both law enforcement and social services became the standard approach to investigation in the 1980s by most states (Faller, 2014). It was determined that children might be better served through a coordinated and cooperative approach in which law enforcement and child protective services combined their respective skills and expertise (Miller-Perrin & Perrin, 2013). A need for "integrated systems to follow children through the process" was identified (Kempe, 2007, p. 165) including the need to change social and cultural moirés (Kempe, 2007). As such, multidisciplinary collaboration was determined to be a viable approach for identification of victims by agencies and professionals that were mandated to report, protect, investigate, and intervene.

In the U.S. child protection laws were amended to include collaborative investigations given that a myriad of professionals from various disciplines are mandated to respond to reports of child sexual abuse. A multidisciplinary team is comprised of individuals that represent a host of backgrounds, experience, and expertise. Representatives from diverse fields and disciplines including law enforcement, mental health, medicine, prosecution, and social services work together and blend their respective skills (Cohen-Liebman, 1999). It is the combination and integration of these diverse resources that contribute to comprehensive investigations by the systems that intervene.

The disciplines that comprise the multidisciplinary team have distinct and specific investigative needs. Additionally, law enforcement and child protection have specific burdens of proof to substantiate (Cohen-Liebman, 1999). Often, desired information attributed to a particular discipline is correspondent with the investigative needs of other collaborating entities engaged in the fact-finding process.

Prior to the adoption of joint investigation protocols, parallel investigations ensued by the various systems that responded to initial reports of child sexual abuse. A lack of cooperative measures and sharing of information was the norm. Early on attempts to identify victims consisted of multiple interviews conducted by a myriad of interviewers representing a host of disciplines (depending upon the nature of the report and the allegations) often through the use of leading questions and other suggestive techniques (Ceci & Bruck, 1995) that are no longer considered state-of-the-art practice. At the time, any means necessary was used to gather information regarding child maltreatment and sexual abuse allegations (Faller, 2014). These processes were found to be counterproductive and detrimental to the emotional well-being of victims and often impacted recovery. Efforts to obtain credible and reliable accounts from children in a safe and empowering context were advocated. As a result, attention began to focus on interview practices and techniques (Faller, 2014). Specialized training and skills to determine the best method for eliciting information from children that was credible and reliable was advocated, leading to research and reform.

Investigative Interviewing

The goal of investigative interviewing is to elicit factual and detailed information from child victims and witnesses (Faller, 2014; Katz et al., 2014; Malloy, Brubacher, & Lamb, 2011; Patterson & Hayne, 2011). The protection and safety of children, the conviction of perpetrators (Cronch, Viljoen, & Hansen, 2006), and avoidance of wrongful convictions (Salmon, Pipe, Malloy, & Mackay, 2012) are additional objectives associated with investigative or forensic interviewing. According to the American Professional Society on the Abuse of Children (APSAC), the purpose of a forensic (investigative) interview is to "elicit as complete and accurate a report from the alleged child or adolescent victim as possible in order to determine whether the child or adolescent has been abused (or is in imminent risk of abuse) and, if so, by whom" (APSAC, 2002, p. 2). Investigative or forensic interviews are conducted for fact-finding purposes. These processes are directed at facilitating a child's recall following alleged victimization or witnessing of a crime (Lamb & Brown, 2006; Nicol, La Rooy, & Lamb, 2017). Emphasis is directed at attainment of a verbal description that is accurate and detailed for legal and protective purposes (APSAC, 2002; Barlow, Jolley, & Hallam, 2011; Carnes, 2000; Faller, 2014; Hoffman, 2005; Katz et al., 2014; Lamb & Brown, 2006; MacLeod et al., 2013; Malloy et al., 2011; Patterson & Hayne, 2011).

Accuracy is important with regard to the information or memories elicited (Barlow et al., 2011; MacLeod et al., 2013). Types of memory are considered with regard to how a child stores and recalls information. "Forensic interviews with children probe their episodic memory, often for personal episodes with highly emotional content" given that "the ensuing investigative and legal process may be critically dependent on the quality and quantity of the children's memory reports" (Thoresen, Lønnum, Melinder, & Magnussen, 2009, p. 999). In an interview process, information or details regarding an event is needed in an effort to determine event specific or episodic details including who, what, where, how, and when. Episodic details contribute to the assessment and

understanding of a particular experience. Drawing has been demonstrated to enhance reporting of such material (Cohen-Liebman, 2017; MacLeod et al., 2013).

Forensic Relevance

Two types of memory are considered with regard to assessing whether or not information communicated in an investigative interview is forensically relevant to an experienced event: episodic, or event specific memory, and script memory, or generalized knowledge about a particular subject. Whether or not information is episodic (referring to a personal experienced event) or script (generalized knowledge about a topic or previous knowledge about something) is considered and evaluated with regard to determining credibility. Forensic relevance increases and is enhanced with the quantity as well as the quality of the information disclosed by a child within an investigative process. Facts may pertain to core or peripheral information and may include information related to people, places, and activities. Details may relate to central, contextual, or idiosyncratic elements of an event. Facts and details as well as accuracy are critical components associated with forensic relevance. These elements all factor into assessment of forensic relevance in an investigative interview process.

Whether or not drawing influences episodic or script memory and whether or not drawing hinders or helps retrieval of such information has been a matter of study by various researchers (Cohen-Liebman, 2017; Davison & Thomas, 2001; Gross, Hayne, & Drury, 2009; Jolley, 2010). Recent research appears to support that when children draw during the investigative interview process, they recover or retrieve episodic or event specific information while children who do not draw demonstrate a tendency to provide script or information predicated upon generalized or previous knowledge (Cohen-Liebman, 2017). Consideration of forensic relevance distinguishes a fact-finding process (investigative) from a clinical process.

Investigative or forensic interviews strive to achieve a balance between "sensitivity," meaning strategies that correctly identify sexually abused children, and "specificity," which refers to exclusion of children who have not been abused (Faller, 2014). Forensic interviews adhere to rules of evidence in accordance with judicial standards (Gould & Stahl, 2009). The emphasis differs from a clinical process in that the emphasis is on obtaining information or fact finding rather than a subjective focus that is more attuned with feelings. Forensic interviews require the acquisition of accurate information, while mental health processes promote expression of thoughts and feelings (Carnes, 2000). The task of the forensic interviewer is to identify "the most effective means of getting an accurate, complete report" (Everson & Boat, 2002, p. 383). The task of the clinical interviewer is to "match the interview with the individual client in order to maximize the child's ability to convey significant information" (Salmon, Roncolato, & Gleitzman, 2003, p. 65). The clinical process addresses the safety and well-being of the child, including protective, medical, and emotional needs. According to the guidelines of the American Academy of Child and Adolescent Psychiatry (AACAP, 1990), determining whether abuse has occurred is the premise.

Open-Ended Prompts, Non-Directed Drawing and Imagery

Interventions that enhance children's self-report and thus their testimony are topics of importance (Katz et al., 2014). The use of open-ended prompts is gaining acceptance

as best practice for eliciting information in forensic investigative interviews (Lamb et al., 2008). Current literature suggests that the use of open-ended prompts and questions within an investigative interview format is the preferred method to acquire accurate information and evidentiary disclosure from school-aged children (Jolley, 2010; Lamb et al., 2008). An open-ended prompt is an invitational prompt that invites a narrative response. In contrast, a focused or closed prompt implies a specific response. Research studies directed at assessing children's responses to prompts freely given as well as focused reveal that free prompts elicited enhanced information and accuracy while decreasing suggestibility (Lamb et al., 2008; Lyon, Ahern, & Scurich, 2012; Orbach et al., 2000; Sternberg et al., 1996; Sternberg, Lamb, Davies, & Westcott, 2001).

Researchers have studied the use of drawing and its effectiveness in assisting children to communicate and recall information in various contexts in an effort to decipher what drawings do and, more importantly, how drawings work. Empirically sound and forensically relevant research regarding the efficacy of free drawing within investigative interviews is advocated by researchers exploring the context of forensic interviews of children (Everson & Boat, 2002; Olafson, 2012). Increasingly, researchers have identified the need for empirical evaluation of the use of drawing within the process of forensic interviews (Faller, 1993, 2007; Katz et al., 2014; Lamb, Orbach, Hershkowitz, Esplin, & Horowitz, 2007; MacLeod et al., 2013). Researchers who have investigated this topic for many years put forth in 2009 that their primary concern has shifted from "the practical issue of whether drawing works to the more theoretical issue of why it might work" (Gross et al., 2009, p. 967). The rationale for this shift was the belief that "the answer to this theoretically motivated question might, in turn, help us to predict the range of practical situations in which the drawing technique is likely to be effective" (Gross et al., 2009, p. 967). According to Pipe et al. (2004), "a dynamic interchange" is taking place "between researchers exploring questions of applied relevance and those with a more theoretical focus" (p. 457). This is attributed to a confluence in experimental, analogue, and forensic field research (Lamb & Thierry, 2005; Pipe et al., 2004). Giving children the opportunity to draw may moderate the retrieval process. This is achieved through the generation of retrieval cues that are sensory and internally created helping children organize their narratives, which, in turn, allows them to "share their voice" (Driessnack, 2006, pp. 420–421).

The use of imagery allows for other means of communication beyond verbalization because imagery is rooted in preverbal forms of expression. Imagery provides a means of gaining access to preverbal memory that corresponds to the encoding of traumatic memory. Images provide access to preverbal forms of cognition or ways of knowing (Leclerc, 2006, 2012) that include the sensorial and embodied experiences not accessible through traditional language (Harris-Williams, 2010; Hinz, 2009; Lusebrink, 1990; Naumburg, 1987; Robbins & Sibley, 1976), which is intrinsic to the process of information gathering. Acquisition of information at a preverbal level is derived through kinesthetic, sensory, and imaginal means (Lusebrink, 1990). Drawing as an open-ended prompt provides the means for disclosure of the various sensorial as well as logistical aspects in a manner that is congruent with real time experience. Idiosyncratic details that emerge lend credence to a child's disclosure and assist in facilitating additional fact finding (Cohen-Liebman, 2016). Drawing may encompass elements of the experienced event and sensory details that may have occurred simultaneously, which might be difficult to describe linearly. According to Wadeson (2010), "this form of expression more nearly duplicates experience" (p. 13).

Common Interview Guideline

The Common Interview Guideline (CIG) was developed for multidisciplinary team investigations of child sexual abuse allegations (Cohen-Liebman, 1999, 2003; Gussak & Cohen-Liebman, 2001). It is predicated upon the juxtaposition of art therapy principles and practices with legal and forensic tenets (Cohen-Liebman, 1999; Gussak & Cohen-Liebman, 2001). The CIG incorporates non-directed or free drawing as a primary resource. Drawing is used to facilitate free recall and elicit event specific information in a non-threatening manner. The CIG is a child-centered and interactive process that meets the needs of the legal system while safeguarding the emotional well-being of children (Cohen-Liebman, 2016). Artistic skill or talent is not a prerequisite for using the CIG as a means to gather information. As such, drawing functions as an open-ended prompt within the interview process rather than as a secondary support to confirm a verbal statement.

The CIG is predicated upon rapport building, attunement to a child's developmental capabilities, fact finding, and minimization of re-traumatization (Cohen-Liebman, 1999, 2003; Gussak & Cohen-Liebman, 2001). Three central principles underlie the Common Interview Guideline: 1) an open invitational drawing process; 2) the dialogic and relational process; and 3) the encoding, storage, and recall of (traumatic) memory in image form (Cohen-Liebman, 2017).

The CIG melds forensic tenets and clinical practices. The CIG adheres to judicial standards and stems from art therapy principles, resulting in a process that is legally sound yet clinically supportive (Cohen-Liebman, 2016). Each phase of the interview guideline is designed to refute the argument of suggestibility. This means that the interviewer is not leading the child to say or give a particular response nor is the interviewer suggesting a given response. Each element incorporated into the interview process is included for a specific reason and is conceived with the idea that everything within the process must be legally defensible in a court of law.

The CIG is a guideline for facilitating fact finding that advocates fluidity and flexibility with regard to the five phases outlined: rapport building, development assessment, anatomy identification, fact finding, and closure (Cohen-Liebman, 1999). The phases of the CIG may be amended according to the circumstances under investigation such that anatomy identification may be omitted when investigation is not relevant to an allegation of sexual abuse. The CIG is not a scripted interview process. Rather, it is predicated upon open-ended questions that are semi-structured. Although the phases are described sequentially, the process is not mandated to follow a sequence; rather, the interviewer moves in and out of the phases in accord with the child's presentation. The interviewer follows the child's lead while maintaining control of the process (Cohen-Liebman, 1999). The phases are defined and described as follows.

Rapport Building

Rapport building begins at the commencement of the process and concludes at the end of the interview. It is not limited to a particular segment of the CIG; rather, rapport is built and maintained throughout the process and encompasses various elements. Comfort is promoted with the interviewer as well as with the process. Empowerment through various measures, including the promotion of dialogue/exchange of information, is encouraged (Cohen-Liebman, 1999). The purpose of the interview is explained

in developmentally congruent language so that a child understands the premise of the process and the expectations. These so-called "ground rules" are established in an effort to "prepare" a child for their "role as an informant" in the interview process (Nicol et al., 2017, p. 247). The child is asked not to guess but to tell only what they may have personal knowledge about. The child is instructed to say "I don't know" if he or she is unaware of a particular answer. These instructions are designed to increase resistance to suggestion, which is a tenet that underlies the process. The child is advised if the interview process is being observed and by whom. The child is also encouraged to challenge the interviewer in the event the interviewer asks misleading or erroneous questions. An opportunity is provided to practice these instructions by dialoguing about an innocuous subject and to practice with the use of open-ended questions in an effort to facilitate a narrative response and encourage disclosure of event-specific information (episodic material). This serves a myriad of purposes. Dialoguing about a neutral topic cultivates trust with the child and promotes a child-friendly environment as well as connotes a child-centered process. As well, "having children 'practice' responding to open-ended prompts about neutral experienced events has been shown to increase the amount of information produced from recall memory during the substantive phase of the interview" (Toth, 2011, p. 19) or during the fact-finding phase.

Empowerment is also expressed through choice. A child is given the ability to select where to sit and what media to use. Choice is available with regard to materials, including drawing paper and two-dimensional media such as crayons, markers, or colored pencils. Children are invited to use drawing as an open-ended prompt or to create a non-directed drawing using the media (art materials) and to make as many or as few drawings during the interview as they choose. They are also told that they may draw at any time during the process. Children are informed that the drawing(s) that are created during the interview will remain with the interviewer.

Developmental Assessment

Developmental assessment assists the interviewer in comprehending the child's level of functioning in various spheres. This information is used by the interviewer in an effort to adapt language, concepts, and tasks in order to match a child's abilities while promoting and supporting rapport. In order to engage the child and facilitate the fact-finding process, the interviewer has to communicate in a developmentally congruent manner. The interviewer assesses the child's cognitive level, social skills, and emotional state, as well as linguistic skills, expressive-receptive capability, and concept formation (Cohen-Liebman, 1999). During this phase, competency is assessed. Congruency of concepts is also considered in an effort to gather information pertaining to a child's understanding of polarities, such as truth versus lie and real versus pretend (Cohen-Liebman, 1999), and other concepts that may factor into the exploration of allegations.

Anatomy Identification

This phase is applicable when child sexual abuse allegations are explored. If the interview is not directly related to sexual abuse, this phase may be modified or omitted, and, in truth, it is often absorbed within the developmental assessment phase. Sensitivity is warranted and developmental considerations are paramount with how this phase is approached and broached. Often, this phase is not overtly examined. It is typically

reserved for young children in an effort to obtain information pertaining to the labels a child ascribes to body parts. Anatomy identification emanates from the need to refute the argument of suggestibility. Thus, it is an attempt to gather information regarding a child's self-reference regarding body parts. As well, with young children, sensory reference is often addressed since sexual abuse is a sensory-based crime.

Anatomy identification emerged from the need to understand the language that young children associate with body parts. In an effort not to direct attention solely to sexual body parts, an inventory of non-sexual as well as sexual body parts is explored in concert with the child's developmental capabilities and developmental stage. As well, different types of touches are explored in an effort to demonstrate a child's understanding of various polarities such as appropriate/inappropriate, comfortable/uncomfortable, and good/bad that might be discussed during the fact-finding phase of the process. Investigative interviewing is a process that strives for maximizing information gathering while minimizing the use of suggestive techniques. Understanding the terminology that a child associates with body parts and by exploring the child's own words to reference the sensorial nature or functionality of a specific body part eliminates issues associated with suggestibility if a disclosure is made. The emphasis within the process is on the use of open-ended prompts that facilitate a narrative response; however, a question continuum exists in which an interviewer might need to follow an open-ended question with a more structured prompt in an effort to narrow what is being considered and in an effort to mirror the child's patterns of communication. It must be stated that touch is a concept that may be culturally nuanced, which is a factor to consider within the scope of the interview as well as throughout investigation.

This phase garners sensitivity on the part of the interviewer given developmental levels that encompass prepubescent children as well as older teenagers. Asking a child or a teen to demonstrate comprehension and understanding of sexual and non-sexual body parts, whether verbally or demonstratively, may be stress invoking. The use of drawing has been identified as a means of assuaging this piece of the process by providing distance and allowing for discussion of a topic that may be anxiety provoking. Some interview formats incorporate drawing and media in various manifestations, such as schematic drawings or body diagram outlines, to assess what a child calls their body parts. When these types of tools are utilized, children are encouraged to indicate location and names of body parts. These techniques or tools and the manner in which they are introduced may lead to concerns with regard to suggestibility. The CIG incorporates the use of free drawing(s) that provides autonomy and a self-directed process when discussing body parts, location, and functionality as well as sensory reference. Rather than presenting a template for a child to mark, the CIG allows for disclosure of information pictorially or through the use of imagery, which may contribute to verbalization about a particular topic.

Fact Finding

Fact finding entails the elicitation of information pertaining to the experienced event or the reason why the child is being interviewed. Forensically relevant information such as who (people and relationships), what (activity), where (setting/location), as well as collateral (additional or supportive) material are explored in response to a child's verbal and graphic interactions with emphasis on obtaining a narrative. Through a dialogical and interactive process, information, particularly a narrative, is elicited through open-ended

questions or prompts, including the use of free drawing, which functions in the capacity of an open-ended prompt. Core, peripheral, and idiosyncratic details are explored in response to what a child may disclose either verbally, graphically, or in combination. Drawing facilitates fact finding with regard to the elicitation of information including event-specific details. The interviewer attempts to corroborate information by garnering situational and contextual details relative to the experienced/witnessed event, including what, when, where, how, and who. Episodic (event specific) and script (generalized knowledge) memory are assessed with regard to the information provided by a child.

Closure

The child's participation and effort are acknowledged as part of this phase. If the interview proved to be stress provoking for the child or if the child is unable to manage emotional response, the child may need to reconstitute before concluding the interview. The interviewer will review the process with the child and inquire if there is anything else the child wishes to share and whether the interviewer forgot to ask the child something. The process is intended to be concluded positively for the emotional well-being of the child and in the event that a follow-up interview is warranted. Drawings may be reviewed and information recorded on them as necessary, such as child's name, date, and the title ascribed by the child.

The following vignette is a composite interview based upon interviews conducted by the author and based on the CIG interview guidelines. The vignette is not related to a singular or specific interview. In an effort to highlight phase specific elements, components associated with the various phases will be highlighted. Although the phases are discussed independently and in succession, it bears repeating that aspects of the various phases occur simultaneously and are managed as they manifest organically. The interview proceeds in accord with the child's presentation rather than with a script.

Composite Vignette

Referral: An eight-year-old girl was referred for an investigative interview following a report of suspected sexual abuse. Child was referred to explore the allegations further by protective services.

Allegations: Mother was concerned about bruises that the child could not explain on her extremities and face. After questioning by the mother, child stated that the next-door neighbor, a 15-year-old male, tried to hurt her.

Background as provided by the mother during the parent interview:

Disclosure was prompted when the child's mother noticed what she described as relatively fresh bruises on her daughter's legs and arms as well as a less noticeable mark on the child's face. Mom reported that she noticed the bruises when the child changed into her soccer uniform after school. Upon getting into the car for the ride to the field, mom asked the child if she had fallen or something. The child expressed a lack of knowledge with regard to the bruises and said that she probably got them at school during gym class. Mom, who is a pediatric nurse at the local community hospital, continued to ask the child about the bruises or marks. The child became increasingly uncomfortable and said that she did not want to talk about it. The

child exited the car and joined her teammates for the scheduled game. Mom was concerned as she did not remember the child falling or saying that she got hurt at school. Mom described her daughter as outgoing and assertive and mom felt that it was unusual for her child not to tell her what, if anything, had happened to leave bruises or marks.

Mom reported that after the soccer game, the child was quiet and expressed that she did not wish to attend the post-game dinner. The event was being held at the home of her daughter's best friend who lives on the same street. When mom asked why the child did not want to go, the child put her head down and would not speak. Mom was concerned that perhaps the child did not feel well. Mom expressed that nothing remarkable had occurred during the game to warrant the change in her daughter's behavior or her normally sunny disposition. Mom decided that, given the child's presenting behavior, she would skip the dinner. As she and her daughter left the playing field, Mom told some of the other parents that they would not be joining them. Two of the moms whispered to her that they were having second thoughts as well about going to the dinner due to rumors circulating about the teenage son that lived in the home. Upon hearing this, Mom realized that her daughter had gone over to that home to play with her best friend, the sister of the teenage boy, for the past three days because of Mom's work schedule. Mom expressed having a sick feeling. Mom and her daughter left the field and went home. Given the reservations expressed by some of the other parents, and not personally aware of any concerns pertaining to the teen, Mom thought she should try to talk to her daughter to find out what if anything might have occurred while she was spending time at the home during the past week. Mom asked about the boy's sister, who was her child's best friend and teammate. Mom asked if her daughter and the other girl were not speaking or if something had happened that made her not want to go to the dinner. Her daughter said, "I don't want to talk about it" and went into her bedroom. Mom said that she waited a few minutes and then knocked on the child's door. At that time, Mom observed a mark on the child's face. Mom asked her daughter to tell her how she got the bruises. Her daughter did not answer and instead started to cry. Mom asked if something had happened when the child was at the neighbor's house. Her daughter did not answer and looked away. Mom was concerned and asked if the neighbor's brother, who is 15 years old, did anything to her. The child responded by saying "Yes, but I don't want to talk about it. He told me not to tell anyone." Mom asked her to explain what he did. Her daughter said, "He tried to hurt me." Mom took the child to the local emergency room where mom is on staff. The child did not disclose additional information according to Mom. Given the fresh bruises coupled with the child's statements that the teen had tried to hurt her, a report of suspected physical and sexual abuse was filed. The report resulted in a referral for an investigative interview to explore the allegations further.

Interview Synopsis

The child and her mother presented at the designated child-friendly and family-focused setting. The child's mother initially met with the interviewer without the child present. Upon completion of the parent interview, the child was asked to accompany the interviewer into a separate space that was furnished with a table, two chairs, and various art

materials. The art media was openly displayed on the table and included thin and thick markers in an array of colors, a box of 16 crayons, and 2 sizes of white drawing paper.

The child separated easily from her mother and willingly accompanied the interviewer. On the way to the room, the child began to spontaneously discuss her school day. She brought with her a book bag that contained her own supply of art materials, including pencils. Upon entering the meeting space, the child was invited to pick where she wanted to sit. She was informed that the art materials were for her to use as she wished. The child immediately took out her own art supplies and stated that she loves to draw and do art projects. The child asked if she could draw, and she began using her own graphite pencil. The child explained that she uses pencil for her drawings because she likes to make an outline before she colors. The child spontaneously discussed the art project she was working on in class, and she spoke about her favorite things to draw.

Given that the child was easily engaged and invested in talking about her art projects, the interviewer followed the child's lead. As has been stated, the CIG is not a scripted process per se, and, as such, the central elements or components associated with Rapport Building were woven into the conversation. An initial rapport-building dialogue devoted to the child's fondness for drawing and making pictures led to an open-ended inquiry with regard to ascertaining the child's understanding of the interview.

The following excerpts are based upon the interview format and are offered in tandem with material culled from this process for demonstration purposes. Given the constraints associated with relaying the entire interview, the following vignette incorporates dialogical exchanges as well as a narrative summation of the composite process.

The essential components or elements associated with the individual phases are addressed. Excerpts showcasing the process are included; however, as previously noted, the phases are not stages, and as such the phases may happen simultaneously rather than in a prescribed order. Also, the process is not linear, so the phases and the associated components may overlap or intersect. For example, with this composite illustration, the child began to establish rapport immediately upon meeting the interviewer and was actively engaged and talking when the interview process began.

Rapport Building

The child was receptive immediately to the use of the media and began to draw upon being seated. She began to talk to the interviewer without hesitation and spoke about her love of art and coloring. The interview expectations were explained. The child responded positively with regard to understanding and accepting them. The opportunity to diffuse misconceptions was addressed, and the child was instructed to correct the interviewer if the interviewer misunderstood something or stated something incorrectly. The child was also told to inform the interviewer if she needed to take a break or if she did not understand something the interviewer was asking or saying. The child was responsive and expressed that she understood the instructions regarding the interview. The child expressed her pleasure at finding art materials and being able to use them as she chose. She offered her explanation for why she was being interviewed, and she acknowledged the need to speak about real events rather than make-believe or pretend. The child made a few drawings spontaneously. Her self-directed drawings included a picture that she identified as her dog's face. She reported that her dog had recently died because of old age. She discussed that she missed her dog but that she liked to draw pictures of her. She

made two additional drawings and talked as she drew, engaging with the interviewer and providing explanation with regard to her drawings. She utilized the various media and titled one drawing "Uniwitch." The child explained that the drawing is just something that she likes to make, and she repeated the schema in a subsequent drawing.

Rapport building, which began prior to the actual interview commencing, continued in the following manner. Excerpts are provided to illustrate the process.

I: You like to use art materials. I see that you are already using them.
C: Well, I like to draw, and I like to talk. I'm so happy that I brought my own art supplies, but I will probably use the ones that are here, too.

The purpose of the interview was explored with the child. She was asked to offer her thoughts as to why she was meeting with the interviewer. The expectations of the interview were explained to the child, and she was asked to explain her understanding of the process as well. The role of the interviewer was clarified as someone who talks to children about real life, not pretend things/events.

I: Thank you so much for coming to talk to me.
C: My mom said I was going to draw and talk. She knows I talk a lot, and my favorite thing is to do art and make things. I take art lessons after school, and we go to the paint-your-own-pottery studio. I draw all the time.
I: It sounds like you really like to be creative and make things. You can use any of the art materials that you like. I might ask you to tell me about your drawings.
C: Ok. I'll probably let you know what I'm thinking as I draw. I like to talk out loud.
I: I want to explain to you what I do when I meet with children or teenagers.
C: Ok.
I: I talk to kids about all kinds of things. I want you to know that it is very important that we only talk about real things not pretend or make-believe. I want you to know that we can talk about anything, ok?
C: I get it.
I: Just talk about what you know, ok. The kids I talk to are not in trouble.
C: Ok.
I: I ask kids to tell the truth about whatever we discuss.
C: Ok.
I: If I ask something that you do not know or if you do not understand what I am asking or saying, just say so. I will not be upset.
C: Ok.
I: You can just say "I don't know." I'd rather you tell me that you don't know rather than guess or make up an answer.
C: Ok. No lying or making up a story. I get it.
I: Also, if I misunderstand what you are telling me, please feel free to correct me, ok? When I talk to kids, I tell them that they can help me to understand and if I don't, then they should tell me if I get something wrong.
C: Ok. Do you like to color?
I: I do but today I'm just going to write things down as we talk, and you can use the art materials to draw whatever you want while we talk.
C: Ok.
I: I might ask you to tell me what you are drawing if I don't know what you are making.
C: Ok. I like to talk, so I will probably talk about what I am making while I draw it.

I: That is okay. Is that a marker you are using right now?

C: No, it's my pencil. I brought it with me.

I: Oh, ok but if I said that it was a marker, would that be right?

C: No, of course not.

I: Ok, so I am glad that you corrected me. That's important. As we talk, please tell me if I get something wrong. It's ok to correct me if I forget something or if I make a mistake. Everyone makes mistakes, and it's ok.

C: I'll tell you if I make a mistake, too.

I: That sounds good. We'll both tell if we make a mistake about something.

C: Deal.

I: Do you know why we are talking today?

C: Well, I know that my mom was upset about some bruises I had. She wanted to know how I got them. I guess she wanted me to talk to you about that.

I: Ok. I understand that sometimes it's easier to talk to someone else about something.

C: Yup.

Developmental Assessment

This phase encompasses assessment of the child's skills and knowledge with regard to various developmental spheres. As is evident from this passage of dialogue, the child demonstrated that her skills were developmentally congruent. She appeared to be functioning age-appropriately with regard to tasks and concepts both discussed and observed. The child made a spiral using different markers to demonstrate color identification. She also exhibited congruency of concepts and offered her understanding, which was developmentally appropriate. Following is a brief excerpt:

I: Tell me how old you are.

C: I'm eight.

I: What grade are you in?

C: Third.

I: Tell me about school.

C: Well, I like my teacher, and I like it when we do art.

I: How about other subjects? Math? Do you like math?

C: Not really.

I: Are you learning multiplication?

C: I guess so.

I: Can you tell me what 2×2 equals?

C: Four.

I: That's right.

C: We aren't doing hard stuff yet.

I: Ok. Do you like adding or multiplying?

C: Doesn't matter. I can do both as long as it isn't too hard.

I: I see. Ok. What about with English—are you learning about opposites?

C: What do you mean?

I: Sometimes we talk about different meanings that words have that may be opposite like good and bad.

C: I get it.

I: Can you explain how good and bad are opposites?

C: Sure. One means good, and one means bad. They mean different things.

I: Are there other words like good and bad that are opposites?
C: Yes.
I: What about right and wrong? Are they like good and bad?
C: Yup. Good and right are the same, and bad and wrong go together.
I: OK. I told you that my job is to talk to kids. Well, sometimes we talk about things that may be good or bad. It's ok to talk about both kinds of things with me—good or positive as well as bad or negative. Can you give me an example of something good or positive?
C: Well, something good is me getting to come here and draw.
I: Ok. Can you tell me something bad or negative?
C: I have a spelling test tomorrow, and that's bad because I don't like spelling tests and I have to practice spelling when I get home.
I: Thank you for telling me that. I don't like tests either.

Fact Finding

Reflective listening and repeating back the child's words are paramount throughout the process. As well, a question continuum is used to facilitate elicitation of information. Although open-ended prompts are promoted as best practice with regard to eliciting free recall and a narrative, it is not always prudent to offer an open-ended prompt. At times, more focused, albeit not suggestive or leading prompts, are encouraged. These prompts are then followed up by open-ended prompts such as "tell me more" or "I am not sure if I understand will you please explain what you mean." The use of open-ended prompts and sequencing of questions will vary according to the individual interview and the child.

As she interacted with the interviewer and began to describe what led up to the acquisition of the bruises, the child began to draw a picture that she described as the basement next door (Figure 16.1).

In the picture, she depicted her best friend's two brothers. She drew them sitting on the sofa. She drew herself sitting on a separate chair in the same space. She discussed that the boys were playing video games when she and her friend went into the basement. The child said that after a little bit Mrs. R. (her friend's mother) told her friend that the piano teacher had arrived, and her friend left the basement to take her lesson. The child sat in the chair and watched the brothers play video games. The child said that after a few minutes the boys switched the channel and began to watch a "sexy" show. The child said that the boys were making rude comments about what they were watching, which she described in the following way. She disclosed that on the television a man and a woman were kissing and getting undressed and touching each other. She said they must have been in a bedroom because they were sitting on a bed. The child reported that while the three were watching the television, the oldest brother told her to come over and sit on the couch. The child said she told him no and said, "I don't want to." She said that she began to feel uncomfortable and wanted her friend to come back downstairs. The child said that she tried to get up from the chair to go upstairs, but the older boy got up from the couch and grabbed her arm and tried to pick her up by holding one arm and one leg. She said that must be how she got the bruises. The child disclosed that the older boy was strong and mean. She said that he tried to get on top of her while he was trying to pull her down. She said that the boy touched her over her clothes on her private parts, but she kicked him to make him stop and to prevent him from pulling down her pants. The child said that she told him to leave her alone. She said he was mad, and he cursed

Figure 16.1 Fact finding/disclosure drawing of experience in boys' basement

at her. She said that the boy told her she was going to be sorry for kicking him "in the nuts" and she'd better not tell anybody anything. Her friend came downstairs to the basement and asked what they were doing. The boy said they were wrestling and then went back and sat on the couch. The younger brother had switched the television back to the video game. The child said that she and her friend went upstairs, but she didn't feel like playing. The child expressed that she was not sorry she kicked the boy, but she offered that she is afraid of what he might do to her the next time she goes over to the house. She said that is why she didn't want to go to the dinner after the soccer game.

Excerpts from Fact Finding are as follows:

I: We've been talking about different things. You told me that you were coming here to talk to me about some bruises that your mom said you have. Can you tell me about that?

C: Well, I had some bruises on my arm and leg. My mom saw them when I got dressed for soccer after school the other night.

I: Uh huh. What about the bruises?

C: My mom wanted to know how I got them. I didn't fall or anything.

I: Ok. Can you tell me about the bruises?

C: I probably got them when I was next door.

I: I'm not sure I understand. What do you mean?

C: I was at my best friend's house after school because my mom was working. She lives next door with her family.

I: So you were next door with your best friend after school because your mom was at work.

C: Yup.

I: Who was in the house?

C: My best friend, her two brothers, and me.

I: Anyone else?

C: My best friend's mom, Mrs. R. She was cooking dinner. She gave us a snack and a juice box. She told us to do our homework and then we could go and play in in the basement when we were done because she was busy in the kitchen.

I: Ok, so after you ate your snacks and did your homework, then what?

C: We went into the basement to watch a movie and play, but my friend's two brothers were sitting on the couch playing video games so we couldn't watch TV.

I: What did you do?

C: We played with her stuff, but then her mom called her upstairs because she had to take her piano lesson. The teacher comes to their house.

I: So what did you do while she went upstairs to take her piano lesson?

C: I stayed in the basement with her brothers because her mother told me to.

I: So you stayed in the basement with the two boys. Tell me about them.

C: What do you want to know?

I: Are they older or younger than you?

C: One is 12, and the other is 15. Sometimes they're nice, and sometimes they're mean.

I: How were they on the day you are describing?

C: Well, the 12-year-old was not nice, and the 15-year-old was bugging me.

I: He was bugging you?

C: Yes. He wanted me to sit on the couch with them, but I said no and I sat on the other chair. Then the 12-year-old turned on a sexy movie.

I: What do you mean?

C: There was a man and a woman, and they were sitting on a bed and kissing and stuff. They were taking off their clothes, and when you take off your clothes when someone else is there it's sexy.

I: So there was a man and a woman taking off their clothes and kissing each other while sitting on a bed?

C: Yes, that's what I saw.

I: What happened next?

C: Well, I'm not supposed to watch that kind of stuff. My mom won't let me. I didn't want to watch it. J (the 15-year-old) told me again to sit on the couch. I said no. I was going to go upstairs even though Mrs. R. had told me to stay in the basement, but J got mad at me, and he came over to where I was sitting, and he tried to pick me up from the chair.

I: So J tried to pick you up?

C: Yup. He is big.

I: Then what?

C: He tried to pick me up by my arm and leg, and I slid onto the floor. He was trying to get on top of me, but I was pushing him away and telling him to get off of me.

I: Where was the other brother, K?

C: He was still sitting on the couch watching the sexy movie. He was laughing and laughing because he thought it was funny that J was trying to get on top of me.

I: What happened next?

C: J was trying to touch me on my private parts, and he was trying to kiss me. Yuck.

I: Ok.

C: J tried to pull my pants down, but I didn't let him. He was trying to do what they were doing in the sexy movie. He was trying to kiss me, and he was trying to take off my

clothes, and he was touching me all over just like on the TV, but he couldn't get his hands in my pants because I had on my leggings.

I: Ok. You said that J was trying to pull your pants down.

C: Yes. He tried to pull my pants down so he could touch me on my private parts, but he didn't get my pants down. I was trying to push him away, and I was telling him to stop. He kept touching me over my clothes. I kicked him. Here, I'll show you.

The child began to make another drawing in which she drew herself and J (Figure 16.2).

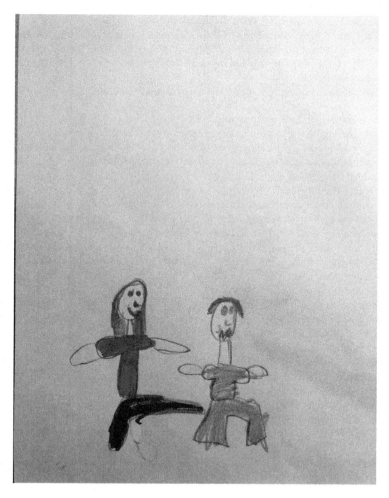

Figure 16.2 Drawing of child defending herself and invoking superhero powers/empowerment

She explained that in the drawing she was kicking him. She said that she wanted to draw how she kicked J "in the nuts." She said that her older sister had told her what to do if anyone ever tried to do something like touch her or hurt her. The child proceeded to depict herself standing next to a figure she identified as J. She stated, "This is me kicking him in the nuts." The child reported that "he won't try that again because he knows I know how to stop him." The child stated, "I should have kicked him first before he tried to grab me."

I: Can you tell me about the drawing you just made?

C: Yes, this is me, and this is J. (Child pointed to the figures as she spoke about them). I'm kicking him in the nuts.

I: You kicked him?

C: Yes, I kicked him in the nuts.

I: You kicked him in the nuts? What do you mean?

C: I kicked him in the private parts really hard, and he was mad. My sister told me to do that if someone bothers me. She said it would hurt and make them stop. My sister calls boys' private parts nuts and my dad said it's ok to say that, but my mom doesn't like us saying that.

I: Tell me about the drawing you just made where you are kicking J.

C: I did.

I: Can you tell me about it again so that I understand what all you drew?

C: J was wearing blue jeans and an orange shirt from school. His school colors are orange and black. I'm wearing what I had on that day. I remember because I had leggings on that were black and I wore my red shirt because it was red ribbon week and we were told to wear red that day.

I: What's red ribbon week?

C: It's got to do with saying no to drugs.

I: Ok. Tell me again what you are doing in the picture.

C: I am kicking J in the nuts. Well, I have my leg up in the picture. but it's not touching his nuts. That's me going to kick him. I made a mistake and started to draw me standing on both legs. but I erased it and made my leg go out like I am kicking him because that's what I did.

I: What else can you tell me about the drawing?

C: I changed J's mouth. At first I made him smiling, but then I drew his mouth mad because he got mad when I kicked him. See his mouth? It looks mad.

I: Anything else? How about your face?

C: I'm smiling because I kicked him.

I: What do you mean?

C: I'm like a superhero because they have powers and they can take away power too. The drawing shows me taking care of myself like a ninja.

I: What do you think about drawing yourself like a ninja or a superhero?

C: They kick their way out of bad situations. Superheroes are cool. Girls can be superheroes. I'll use my power to take down anyone that tries to hurt me again.

As a caveat, understanding the terms and associations that a child uses for body parts, rather than the interviewer ascribing a name for such, helps with fact finding. Ascertaining this information during the phases of developmental assessment or anatomy identification provides understanding for how a child references sexual and non-sexual body parts, which can be very helpful during the fact-finding phase since this provides understanding with regard to the child's language. If a child introduces a term that has

not been previously utilized for a sexual body part, for instance, or that does not seem to correlate with what the child has already stated, the interviewer would want to explore the usage of the newly offered term to assess whether it is the child's terminology or if it came from someone else. The child's statement "in the nuts" is an idiosyncratic utterance that correlated with how the child identified male genitalia earlier (although not excerpted here) in the interview. The acquisition of information or details including core, peripheral, and idiosyncratic contributes to the establishment of credibility and helps in the assessment of suggestibility as was explained earlier in the chapter as well as grounding the disclosure within the child's experience.

Use of Drawing

The child made two drawings that were related to what she disclosed. She depicted the setting (basement) and the location (couch and chair), and she included the people (two boys and herself) who were present. The drawing seemed to provide a catalyst for disclosure as she spoke about what took place. She provided information related to the drawing that was situational and contextual. The use of imagery appeared to function as a stimulus, and she offered episodic details that appeared to be based upon the incident rather than generalized knowledge or script (memory) pertaining to known information. She provided material stemming from personal experience that was supported by idiosyncratic utterances.

The child provided core information (being in the basement with the two boys watching the TV) as well as peripheral details including how J grabbed her and tried to lift her by the arm and leg, which caused her to slide to the floor. The child provided information about the television program and what she observed. The situational, contextual, core, and peripheral details were revealed via the child's narrative. Additional details were provided when the child was asked to clarify or explain her narrative and her statements. The child was able to provide a description of the teenagers. She explained how the two boys had different hair color but similar eyes. She described their different heights and weights and what they were wearing (this exchange was not excerpted). She attempted to include such details in her drawing as well as the colors of the boys' clothing and the surroundings including the carpet and the furniture in the basement. Drawings that include such details in conjunction with the child's statements are helpful for investigative purposes. Drawings may eventually be used as evidentiary material in court proceedings.

Drawing enabled a means for disclosure and contributed to enhanced verbalization by the child, which included details and salient information related to the incident. Empowerment was exhibited by her use of the media to communicate how she handled the situation and how she would protect herself if in the future someone tried to harm her.

Closure (dialogical excerpts)

The interview concluded positively as the child seemed to be empowered by her drawings and her disclosure. She stated that she will use her powers to take down anyone that ever tried to hurt her again.

I: Is there anything we forgot to talk about or maybe I forgot to ask?
C: I don't think so.
I: I appreciate you coming here today.

C: I liked that I could draw.

I: Is there anything else you want me to know?

C: It was fun because I got to draw.

I: We are almost done talking. Do you have any questions?

C: I don't think so.

I: What would you do if something like this happened again?

C: I would use my superpowers to take down anyone that ever tried to hurt me again. I'm good.

I: Okay. Thank you for meeting with me today.

Table 16.1 The Common Interview Guideline Component Phases and Central Elements

Central Elements	Integration of Drawing
RAPPORT BUILDING	
Engage	**Develop comfort**
Promote comfort, trust, active participation	Icebreaker
Empower	Promote trust
Provide choice = control	**Engagement**
Encourage	Verbally and non-verbally
Correct, disagree, challenge authority	**Media**
Clarify misperceptions	Stimulates participation, conversation
Establish	Connotes child-friendly process
Address standard operating procedure	Choice = empowerment/control
Expectations	Stimulus to explore topics
Truth, no guessing, say I don't know	Bridge to fact-finding
Emphasize	
Accuracy, honesty	
Assess suggestibility	
DEVELOPMENTAL SCREENING/SKILLS ASSESSMENT	
Assess skill level in various spheres	**Artistic Developmental Levels**
Cognitive, social, emotional, linguistic	Correlate with developmental
Ability to interact	capabilities
Language, tasks, style	**Assess strengths/weaknesses**
Evaluate comprehension	**Assess ability to follow directives,**
Assess interactive patterns	**remain on task**
Adaptation of communication/interactive	Ability to attend, focus
patterns	**Practice and role play**
Concepts	
Spatial relationships	
Prepositions	
Colors/Numbers	
Developmentally congruent tasks	
Assess Congruency of concepts	
Truth/lie, real/pretend, right/wrong, good/bad	

Assess competency
Practice and role play
Issue of mistake

ANATOMY IDENTIFICATION

Identification of body parts Demonstration aid
Sexual and non-sexual Client generated product
Sensory reference Externalization/Distance
Explore different touches Objectification

FACT-FINDING

Question continuum Disclosure drawings
Non-leading questions Corroboration of Facts
General to specific Details
Details Core, peripheral, situational, and
Core, contextual, situational, idiosyncratic Contextual, idiosyncratic
Who, what, when, where, how Facts
Specific facts Charge enhancements
Corroboration of information Threats, force, bribes, coercion,
Collateral material rewards, use of media,
Charge enhancements pornography, photography
Explore alternative hypothesis Pictorial clarification
Credibility assessment Verbal confirmation

CLOSURE

Thank Child for participation Revisit
Leave door open for re-interview Clarify
Address concerns and questions Memory stimulus/trigger
Avoid false hopes Bridge
Address personal safety Re-constitution
Bridge to what happens next Review drawing(s)
End positively Identification details

Interview Summary

As has been discussed, the phases of the interview process are delineated sequentially, but the interviewer follows the child's lead; thus, essential elements or core components are addressed as they manifest in a fluid manner. Drawing was used as an open-ended prompt in the art therapy-based investigative interview or the CIG. The CIG, which is predicated upon rapport building, attunement to a child's developmental capabilities, fact finding, and minimization of re-traumatization (Cohen-Liebman, 1999, 2003; Gussak & Cohen-Liebman, 2001), appeared to provide the child with an ego syntonic means for disclosure of an experienced event. The use of imagery appeared to be a significant factor within the interview process. Imagery was related to stimulation of recall and memory resulting in enhanced fact finding or disclosure of information. In the composite interview, episodic details were disclosed pictorially as well as verbally, contributing

to understanding of the child's experience. Details regarding who, what, when, where, and how were provided. The composite interview demonstrated the facilitative effect of drawing when utilized as a primary resource within the interview process, which contributed to enhanced verbalization. Drawing appeared to provide the child with emotional support as it empowered her to disclose and master the experience as evidenced through her associations in combination with her graphic depictions.

Forensic relevance, as was discussed in the literature review, refers to information and the manner in which it is disclosed relative to an experienced event. Forensic relevance increases and is enhanced with the quantity as well as the quality of the information disclosed by a child within an investigative process. Facts or details including central, peripheral, contextual, situational, and idiosyncratic are considered as are types of memory with regard to how a child stores and recalls information. Whether information is episodic (referring to a personal experienced event) or script (generalized knowledge about a topic or previous knowledge about something) is considered and evaluated with regard to determining credibility. Similarly to the findings of a recent study (Cohen-Liebman, 2017), the use of imagery—whether mental, visual, or pictorial—enhanced memory recall and facilitated enhanced disclosure in the composite interview as noted above.

Conclusion

In keeping with the theme of the text and the shift from "at-risk" to a strength-based model, this chapter discussed an art therapy-based investigative interview process that fosters resilience and empowerment. Through a fact-finding process that incorporates the use of free drawing as an open-ended prompt, child victims and witnesses are encouraged to share their narratives of experienced events. The process is intended to safeguard the emotional well-being of children and adolescents while providing a forensically relevant platform for discussion of personally meaningful events that may be traumatic in nature, such as sexual abuse. As such, measures that "ensure that the investigation is an empowering experience that generates feelings of trust, self-worth and justice" are advocated and continue to be topics of study (Katz et al., 2014, p. 858). Katz et al. (2014) contend that emphasis has been focused on maximizing testimonial capability in an effort to help children retrieve and report information that is not only rich but also reliable. They contend that attention should be directed at "interviewing tactics" that not only enhance testimony but also "modify" interviews to attend to children's emotional needs (Katz et al., 2014, p. 859). In the composite vignette, as demonstrated through dialogical excerpts and narrative passages, the use of drawing and imagery shifted the child's perspective and thereby altered the dynamic from victim to superhero (her metaphor) endowed with power and strength.

The CIG, an art therapy-based investigative interview process, yields a distinct and complex investigative method that is sensitive to the parameters of clinical interviewing while adhering to forensic interviewing principles and practices. The CIG offers an investigative approach or a fact-finding method that is informative yet supportive and legally compliant yet clinically responsive (Cohen-Liebman, 2016). Drawing and the use of imagery is fundamental to the process and the facilitation of fact finding and disclosure of information that is accurate and reliable (Cohen-Liebman, 2017). The CIG is unique in that it blends fundamental tenets associated with art therapy, including the relationship, or dialogical component and the creative process (art-making) with a forensically oriented approach.

Exploring the use of the CIG as a means to interview and gather information from victims and/or witnesses that have experienced or been exposed to traumatic experiences is recommended. Continued study of the CIG will build upon recent research that situated the CIG as a dynamic and interactive process that is grounded in fact finding, imagery, and relationality (Cohen-Liebman, 2017). Drawing as an open-ended prompt within the CIG seemingly contributed to enhanced fact finding or disclosure of event-specific (forensically relevant) information. Expanding the use of the CIG to youth engaged in matters that merit investigation will hopefully support the use of drawing as a means to facilitate the fact-finding process within a safe and supported milieu. The CIG may also lend itself to other applications in which forensically relevant information or fact finding is the goal, such as when expressive language may be compromised or in the investigation of elder abuse.

Within an investigative interview format, the facilitative effect of drawing has the potential to offer support, promote empowerment, and enhance disclosure for children and youth and other individuals who have experienced or witnessed interpersonal violence or other forms of trauma. Further research may lead to acceptance and understanding of the CIG, an art therapy-based investigative interview process, and provide an alternative to traditional verbal techniques for the facilitation of information pertaining to experienced events when investigation is warranted.

References

American Academy of Child and Adolescent Psychiatry. (1990). *Guidelines for the evaluation of child and adolescent sexual abuse*. Washington, DC: Author.

American Professional Society on the Abuse of Children. (2002). *Practical guidelines: Investigative interviewing in cases of alleged child abuse*. Chicago, IL: Author.

Anderson, J., Ellefson, J., Lashley, J., Miller, A. L., Olinger, S., Russell, A., & Weigman, J. (2010). CornerHouse forensic interviewing protocol: RATAC. *Thomas M. Cooley Journal of Practical and Clinical Law, 12*(2), 193–331. Retrieved from www.cornerhousemn.org/images/CornerHouse_RATAC_Protocol.pdf

Barlow, C. M., Jolley, R. P., & Hallam, J. L. (2011). Drawings as memory aids: Optimising the drawing method to facilitate young children's recall. *Applied Cognitive Psychology, 25*(3), 480–487. https://doi.org/10.1002/acp.1716

Brooks, C. M., & Milchman, M. S. (1991). Child sexual abuse allegations during custody litigation: Conflicts between mental health expert witnesses and the law. *Behavioral Sciences and the Law, 9*(1), 21–32. https://doi.org/10.1002/bsl.2370090104

Carnes, C. (2000). *Forensic evaluation of children when sexual abuse is suspected*. Huntsville, AL: National Children's Advocacy Center.

Ceci, S. J., & Bruck, M. (1995). *Jeopardy in the courtroom: A scientific analysis of children's testimony*. Washington, DC: American Psychological Association. https://doi.org/10.1037/10180-000

Cheit, R. (2014). *The witch hunt narratives: Politics, psychology and the sexual abuse of children*. Oxford, England: Oxford University Press.

Cohen-Liebman, M. S. (1999). Draw and tell: Drawings within the context of child sexual abuse investigations. *The Arts in Psychotherapy, 26*(3), 185–194. https://doi.org/10.1016/S0197-4556(99)00013-1

Cohen-Liebman, M. S. (2002). Intro to art therapy. In A.P. Giardino & E.R. Giardino (Eds.), Recognition of Child Abuse for the Mandated Reporter, (3rd edition). St. Louis, Missouri: G.W. Medical Publishing.

Cohen-Liebman, M. S. (2003). Drawings in forensic investigations of child sexual abuse. In C. Malchiodi (Ed.), *Handbook of art therapy* (pp. 167–179). New York, NY: Guilford Press.

Cohen-Liebman, M. S. (2016). Forensic art therapy. In D. Gussak & M. Rosal (Eds.), *The Wiley Blackwell handbook of art therapy* (pp. 469–477). Chichester, England: Wiley-Blackwell.

Cohen-Liebman, M. S. (2017). *Drawing and disclosure of experienced events in an art therapy investigative interview process with school aged children: A qualitative comparative analogue study* (Doctoral dissertation). Retrieved from ProQuest Dissertations and Theses database.

Conte, J. R., Sorenson, E., Fogarty, L., & Rosa, J. D. (1991). Evaluating children's reports of sexual abuse: Results from a survey of professionals. *American Journal of Orthopsychiatry, 61*(3), 428. https://doi.org/10.1037/h0079264

Cronch, L., Viljoen, J., & Hansen, D. (2006). Forensic interviewing in child sexual abuse cases: Current techniques and future directions. *Aggression and Violent Behavior, 11*(3), 195–207. https://doi.org/10.1016/j.avb.2005.07.009

Davison, L. E., & Thomas, G. V. (2001). Effects of drawing on children's item recall. *Journal of Experimental Child Psychology, 78*, 155–177. https://doi.org/10.1006/jecp.2000.2567

Driessnack, M. (2006). Draw-and-tell conversations with children about fear. *Qualitative Health Research, 16*(10), 1414–1435. https://doi.org/10.1177/1049732306294127

Everson, M. D., & Boat, B. W. (2002). The utility of anatomical dolls and drawings in child forensic interviews. In M. L. Eisen, J. A. Quas, & G. S. Goodman (Eds.), *Memory and suggestibility in the forensic interview* (pp. 383–408). Hillsdale, NJ: Lawrence Erlbaum Associates.

Faller, K. C. (1993). *Child sexual abuse: Intervention and treatment issues.* Washington, DC: Department of Health and Human Services.

Faller, K. C. (2003). *Understanding and assessing child sexual maltreatment.* Thousand Oaks, CA: Sage Publications.

Faller, K. C. (2007). *Interviewing children about sexual abuse: Controversies and best practice.* New York, NY: Oxford University Press.

Faller, K. C. (2014). Forty years of forensic interviewing of children suspected of sexual abuse, 1974–2014: Historical benchmarks. *Social Sciences, 4*(1), 34–65. https://doi.org/10.3390/socsci4010034

Gould, J. W., & Stahl, P. M. (2009). The art and science of child custody evaluations. *Family and Conciliation Courts Review, 38*(3), 392–414.

Gross, J., Hayne, H., & Drury, T. (2009). Drawing facilitates children's reports of factual and narrative information: Implications for educational contexts. *Applied Cognitive Psychology, 23*, 953–971. https://doi.org/10.1002/acp.1518

Gussak, D., & Cohen-Liebman, M. S. (2001). Investigation vs. intervention: Forensic art therapy and art therapy in forensic settings. *American Journal of Art Therapy, 40*(2), 123–135.

Harris, S. (2010). Toward a better way to interview child victims of sexual abuse. *National Institute of Justice Journal, 267*, 12–15. Retrieved from www.ncjrs.gov/pdffiles1/nij/233282.pdf

Harris-Williams, M. H. (2010). *The aesthetic development: The poetic spirit of psychoanalysis: Essays on Bion, Meltzer, Keats.* London, England: Karnac Books.

Hinz, L. D. (2009). *Expressive therapies continuum: A framework for using art in therapy.* New York, NY: Routledge.

Hoffman, C. D. (2005). Investigative interviewing: Strategies and techniques. *The International Foundation for Protection Officers.* Retrieved from www.ifpo.org/wp-content/uploads/2013/08/interviewing.pdf

Jenny, C., Crawford-Jakubiak, J. E., & Committee on Child Abuse and Neglect. (2013). The evaluation of children in the primary care setting when sexual abuse is suspected. *Pediatrics, 132*(2), 558–567.

Jolley, R. P. (2010). *Children and pictures: Drawing and understanding.* Oxford, England: Wiley-Blackwell.

Katz, C. (2014). The dead end of domestic violence: Spotlight on children's narratives during forensic investigations following domestic homicide. *Child Abuse & Neglect, 38*(12), 1976–1984. https://doi.org/10.1016/j.chiabu.2014.05.016

Katz, C., Barnetz, Z., & Hershkowitz, I. (2014). The effect of drawing on children's experiences of investigations following alleged child abuse. *Child Abuse & Neglect, 38*(5), 858–867. https://doi.org/10.1016/j.chiabu.2014.01.003

Katz, C., & Hamama, L. (2013). "Draw me everything that happened to you": Exploring children's drawings of sexual abuse. *Children and Youth Services Review, 35*(5), 877–882. https://doi.org/10.1016/j.childyouth.2013.02.007

Katz, C., & Hershkowitz, I. (2010). The effects of drawing on children's accounts of sexual abuse. *Child Maltreatment, 15*(2), 171–179. https://doi.org/10.1177/1077559509351742

Kempe, A. (2007). *A good knight for children: C. Henry Kempe's quest to protect the abused child.* Booklocker.com, Inc.

Lamb, M. E., & Brown, D. A. (2006). Conversational apprentices: Helping children become competent informants about their own experiences. *British Journal of Developmental Psychology, 24*(1), 215–234. https://doi.org/10.1348/026151005X57657

Lamb, M. E., Hershkowitz, I., Orbach, Y., & Esplin, P. W. (2008). *Tell me what happened: Structured investigative interviews of child victims and witnesses* (Vol. 36). Hoboken, NJ: Wiley.

Lamb, M. E., Orbach, Y., Hershkowitz, I., Esplin, P. W., & Horowitz, D. (2007). A structured forensic interview protocol improves the quality and informativeness of investigative interviews with children: A review of research using the NICHD investigative interview protocol. *Child Abuse & Neglect, 31*(11), 1201–1231. https://doi.org/10.1016/j.chiabu.2007.03.021

Lamb, M. E., & Thierry, K. L. (2005). Understanding children's testimony regarding their alleged abuse: Contributions of field and laboratory analog research. In D. M. Teti (Ed.), *Handbook of research methods in developmental psychology* (pp. 489–508). Malden, MA: Blackwell Publishers.

Leclerc, J. (2006). The unconscious as paradox: Impact on the epistemological stance of the art psychotherapist. *The Arts in Psychotherapy, 33*(2), 130–134. https://doi.org/10.1016/j.aip.2005.07.002

Leclerc, J. (2012). When the image strikes: Postmodern thinking and epistemology in art therapy. In H. Burt (Ed.), *Art therapy and postmodernism: Creative healing through a prism* (pp. 367–378). London, England: Jessica Kingsley.

Lusebrink, V. B. (1990). *Imagery and visual expression in therapy.* New York, NY: Plenum Press.

Lyon, T. D., Ahern, E. C., & Scurich, N. (2012). Interviewing children versus tossing coins: Accurately assessing the diagnosticity of children's disclosures of abuse. *Journal of Child Sexual Abuse, 21*(1), 19–44. https://doi.org/10.1080/10538712.2012.642468

Macleod, E., Gross, J., & Hayne, H. (2013). The clinical and forensic value of information that children report while drawing. *Applied Cognitive Psychology, 27*(5), 564–573.

Malloy, L. C., Brubacher, S. P., & Lamb, M. E. (2011). Expected consequences of disclosure revealed in investigative interviews with suspected victims of child sexual abuse. *Applied Developmental Science, 15*(1), 8–19. https://doi.org/10.1080/10888691.2011.538616

Mathews, B., & Collin-Vézina, D. (2017). Child sexual abuse: Toward a conceptual model and definition. *Trauma, Violence, & Abuse*, 1–18. https://doi.org/10.1177/1524838017738726

Miller-Perrin, C. L., & Perrin, R. D. (2013). *Child maltreatment: An introduction* (3rd ed.). Thousand Oaks, CA: Sage Publications.

Myers, J. E. (1998). *Legal issues in child abuse and neglect practice* (Vol. 1). Thousand Oaks, CA: Sage Publications.

Naumburg, M. (1987). *Dynamically oriented art therapy: Its principles and practices.* Chicago, IL: Magnolia Street Publishers.

Nicol, A., La Rooy, D., & Lamb, M. E. (2017). Evidence-based and developmentally appropriate forensic interviewing of children. In L. Dixon, D. F. Perkins, C. Hamilton-Giachritsis, & L. A. Craig (Eds.), *The Wiley handbook of what works in child maltreatment: An evidence-based approach to assessment and intervention in child protection* (pp. 239–257). West Sussex, England: John Wiley & Sons.

Olafson, E. (2012). A call for field-relevant research about child forensic interviewing for child protection. *Journal of Child Sexual Abuse, 21*(1), 109–129. https://doi.org/10.1080/10538712.2012.642469

Orbach, Y., Hershkowitz, I., Lamb, M. E., Sternberg, K. J., Esplin, P. W., & Horowitz, D. (2000). Assessing the value of structured protocols for forensic interviews of alleged child abuse victims. *Child Abuse & Neglect, 24*(6), 733–752. https://doi.org/10.1016/S0145-2134(00)00137-X

Patterson, T., & Hayne, H. (2011). Does drawing facilitate older children's reports of emotionally laden events? *Applied Cognitive Psychology, 25*(1), 119–126. https://doi.org/10.1002/acp.1650

Pipe, M. E., Lamb, M. E., Orbach, Y., & Esplin, P. W. (2004). Recent research on children's testimony about experienced and witnessed events. *Developmental Review, 24*(4), 440–468. https://doi.org/10.1016/j.dr.2004.08.006

Poole, D. A. (2016). *Interviewing children: The science of conversation in forensic contexts.* Washington, DC: American Psychological Association.

Poole, D. A., & Lamb, M. E. (2003). *Investigative interviews of children: A guide for helping professions.* Washington, DC: American Psychological Association.

Robbins, A., & Sibley, L. B. (1976). *Creative art therapy.* New York, NY: Brunner, Mazel.

Salmon, K., Pipe, M. E., Malloy, A., & Mackay, K. (2012). Do non-verbal aids increase the effectiveness of "best practice" verbal interview techniques? An experimental study. *Applied Cognitive Psychology, 26*(3), 370–380. https://doi.org/10.1002/acp.1835

Salmon, K., Roncolato, W., & Gleitzman, M. (2003). Children's report of emotionally laden events: Adapting the interview to the child. *Applied Cognitive Psychology, 17*(1), 65–79. https://doi.org/10.1002/acp.845

Sapp, M. V., & Vandeven, A. M. (2005). Update on childhood sexual abuse. *Current Opinion in Pediatrics, 17*(2), 258–264.

Sternberg, K. J., Lamb, M. E., Davies, G. M., & Westcott, H. L. (2001). The memorandum of good practice: Theory versus application. *Child Abuse & Neglect, 25*(5), 669–681. https://doi.org/10.1016/S0145-2134(01)00232-0

Sternberg, K. J., Lamb, M. E., Hershkowitz, I., Esplin, P. W., Redlich, A., & Sunshine, N. (1996). The relation between investigative utterance types and the informativeness of child witnesses. *Journal of Applied Developmental Psychology, 17*(3), 439–451. https://doi.org/10.1016/S0193-3973(96)90036-2

Thoresen, C., Lønnum, K., Melinder, A., & Magnussen, S. (2009). Forensic interviews with children in CSA cases: A large sample study of Norwegian police interviews. *Applied Cognitive Psychology, 23*(7), 999–1011. https://doi.org/10.1002/acp.1534

Toth, P. (2011). Comparing the NICHD and RATAC child forensic interview approaches: Do the differences matter. *APSAC Advisor, 23*, 15–20.

Wadeson, H. (2010). *Art psychotherapy* (2nd ed.). Hoboken, NJ: John Wiley & Sons.

Resilience of Youth Overcoming Divorce-Related Stressors

ROBYN SPODEK-SCHINDLER

Activist Sheryl Sandberg conceptualizes resiliency by saying, "I think we build resilience to prepare for whatever adversity we'll face. And we all face some adversity—we're all living some form of Option B" (Ignatius, 2017).

Divorce-Related Stress in Childhood

Resilience is a trait often highlighted amongst children. People are quick to talk about how children overcome obstacles and have superior inner strength. For example, a child impacted by acute physical trauma from a sports-related injury will typically continue playing that sport without hesitation or resistance; a child who goes through an emotional trauma, such as losing a parent, is more likely to grieve and move forward quicker than many adults. Within my ten-plus years in the field of art therapy, this has shown to be especially true for the children I see who are coping with the concept of divorce. Some may ask, "Is divorce *really* that traumatic that it requires some type of resilience?" And my answer is, undoubtedly, yes.

According to Potter (2010), nearly half of first marriages in the U.S. end in divorce and, within that group, half involve a child. Divorces were at a particular peak during the 1980s, and, although divorce rates have slowed down a bit, they are still occurring often enough that the majority of clients I encounter/meet with are coping with a divorce. According to the 2016 census through the National Center for Health Statistics, there were over 2.2 million marriages and approximately 827,261 divorces or annulments. Despite this not being "half of all marriages" as historically noted, many families have been affected by divorce (Center for Disease Control and Prevention, n.d.).

Salvador Minuchin, a renowned family therapist, crafted a Family Stress Model based in structural family theory (Pardeck, 1989). Minuchin's model suggested the family system is liable to various stressors (Vetere, 2001). Internal developmental changes and external social-related pressures can tax the family system. The strength of a family is evident through the coping, restructuring, and resolve employed by the family. Transitional stress within the family unit can have a significant effect on its youngest members (Pardeck, 1989). Events such as a death of a family member, a

family divorce or separation, or even the planned departure of a child/sibling can promote transitional stress.

> In addition to the trauma of divorce itself . . . divorce related transitions often involve geographic moves, the addition of step siblings, and a new set of extended family members. Divorce followed by remarriage can involve the introduction of parent figures with multiple roles and overlapping relationships. Taken together, these divorce-related factors have a direct impact on the life courses of children and may be especially challenging for the adolescent who is simultaneously involved in critical developmental transitions.
>
> (Hines, 1997, p. 375)

Positive growth is possible as a result of the transition with familial support and greater awareness. Children need assistance in overcoming transitional stressors. Support received may become integrated for adaptive coping skills and a protective factor for future stressors. Potter (2010), on the other hand, noted the negative outcomes for children following divorce. Younger children experienced a decline in psychological well-being prior and after the divorce proceedings. Adolescents, while showing improvement leading up to and following the divorce, showed greater decline in the longer-term trajectories.

I work in a private practice setting with children, ages 3 through 21, who struggle with various issues such as anxiety, depression, bipolar, poor self-esteem, and family-related issues. Most of the families I serve are middle class, representative of diverse races. One in three families that seek out my counseling services are dealing with a current or past divorce. No two families are the same, and therefore no two divorces are the same; however, self-esteem-related issues are commonly experienced.

Children involved in divorce experience their own "Option B," as Sandberg (Ignatius, 2017) noted. It can be crushing to watch your family come apart, whether it is an amicable divorce or a tumultuous one. Children often do not have a say in the separation of their parents. They can often lose their voice in the planned families. This can be potentially damaging to a child's self-esteem.

Divorce is often experienced as a crisis or major loss (Rutledge-Drake, 1990). Bryner (2001) examined the associated losses, noting, "divorce comprises a series of transitions or stages for both adults and children." These stages are similar to the stages Elisabeth Kübler-Ross described for patients with terminal illnesses: denial, anger, bargaining, depression, and acceptance (p. 202). During the anger phase, parents will often solicit assistance, and children will often withdraw, act out, struggle academically, or experiment with substance abuse. These signs are what I refer to as the parental "wakeup call." It is usually here that parents will recognize their child is not coping well with the changes taking place within their family.

Children may not cycle through all of the other phases or stages listed once they are in treatment. The anger stage persists and can often intensify before resolution begins. With consistent treatment and parent engagement, children eventually reach "acceptance." Bryner (2001) postulated that acceptance does not occur until they are older. However, many children are able to understand why acceptance is an important goal with feasible steps. As children get older, according to Bryner (2001), they are more emotionally mature and therefore may be able to see the potential benefits of their parents' divorce, such as their parents' overall happiness. Creating a secure sense of self and strengthening the ego is a large part of the groundwork necessary to initiate treatment.

Children of divorced families learn many behaviors in their hypervigilant awareness of the conflicts at home. Children may learn destructive traits such as distrust from their parents and reenact problematic tendencies into their interpersonal relationships (McDermott, Fowler, & Christakis, 2013).

Ego development persists until young adulthood. Erik Erikson (1950) described ego development through stages across a lifetime and specifically spoke to the various ages of children in regards to their level of ego development. Children from birth to three years are categorized in the Trust versus Mistrust stage (Erikson, 1950). This early period establishes the dependence on the primary caregiver and subsequently the trust in the caregiving expected (Gray, 1999). This first stage has the potential to shape a person for the rest of their lives, according to some:

> Because parents are usually the first and most important caregivers in a child's life, the parent-child relationship forms the early basis for a child's developing sense of trust. . . . Children who develop stable attachments to caretakers expect to have good relationships with others, behave in ways that are likely to encourage this, and adopt a trusting orientation toward people. Conversely, children who witness the breakdown of the parental marriage and who are exposed to poor parental models of interpersonal behavior might have more difficulty trusting others in adulthood, having learned that distrust may in some cases be justified.
>
> (King, 2002, p. 643)

Typical progression through psychosocial stages of development will aid interpersonal relatedness. As each stage is "completed," there is the possibility of taking a successful path to move on to continued healthy ego identity formation—or the other end of the spectrum being a path that generally may lead to dysfunction and despair. Children who are faced with divorce or separation are typically suffering from low self-esteem—this may possibly include self-blame or guilt regarding their family situation—and repressed emotions such as anger, sadness, or anxiety. When a divorce occurs early on in development, there is increased likelihood that subsequent issues will later emerge in adolescence and adulthood (King, 2002, pp. 643–644).

As children progress toward Erikson's (1950) Industry versus Inferiority stage, which is typically ages 5 to 12, children take on more responsibility at home and school by being tasked with chores and assignments, learning how to "master" something with pride. Divorce or separation disrupts expected gains of this stage. In my practice, children at the start of therapy may struggle with a sense of inferiority. Parents may become too consumed by the divorce and overlook the child's accomplishments. Praise and recognition can aid in greater self-competency. In contrast, if an eager-to-please child continues to be denied recognition, they may then lose a very important building block needed to establish positive self-esteem (Gray, 1999, p. 445). The typical separation from the parents in later adolescence, while expected for individuation, may be more problematic for those in nontraditional family compositions (McCurdy & Scherman, 1996).

Three case vignettes describe treatment of the symptoms commonly observed in children of divorced families. In conjunction with psychotherapy, art therapy supported the development of coping skills. Three specific effects seen include the ability to express their own viewpoints, manage the conflicted feelings surrounding familial changes, and decrease maladaptive behaviors. Psychotherapeutic treatment provides a means to voice the needs of youth managing divorce. According to Moses (2013), younger children tend to blame themselves for their parents' divorce, citing their own bad behavior. These

children also tend to regress and exhibit more negative behaviors. Once a child is of school age, they develop a deeper understanding of why they are affected by their parents' separation, and they may often feel that the parent who has been removed from the home has rejected them. School-aged children may exhibit psychosomatic symptoms, such as stomachaches, instead of openly stating what is bothering them. Lastly, adolescents may show frequent changes in their mood, appearing to be depressed or show signs of anxiety. Given their age and understanding they also may choose a parent to favor or align with while blaming the other parent for the divorce.

Words are often unable to express the child's sadness, anger, and confusion. By using art and art-making processes, many children were able to not only express raw emotions but also reveal the feelings beneath the surface. Some parents are able to manage consistency in family routines and expectations keeping things "as they were." Despite parental assurance, children are perceptive to the anticipated and feared changes that result from separations in the family. For some families, the conflicts are so intense that they could not even occupy the same space. Some could not even be on the same email chain. One family rejected any joint communication whatsoever; all questions or significant updates needed to be sent in separate email messages. Regardless of specific details surrounding these different divorces, there is commonality among the reactions of the children.

Amanda: A Case Vignette

Amanda, a ten-year-old Caucasian cisgender girl, was referred by her mother due to continued emotional-related obstacles. Amanda's mother believed the majority, if not all, of Amanda's current issues were the result of the family's divorce. In addition to the perceived divorce-related feelings, Amanda was withdrawing socially. Her self-esteem, as reported by mom, was low. I worked with Amanda regularly through the age of 13 and continued seeing her for additional therapy sessions as needed throughout her early adolescence.

Amanda's parents divorced after years of fighting and unhappiness. Amanda was one of two children; she had a younger brother. Both children, as per their mother's description, witnessed arguments varying in severity. What made Amanda's case more unique was that after the divorce was final, her father made clear his desire to see and interact with only his son—while making little to no mention of seeing Amanda. Her mother would often speculate that her father felt more comfortable doing "guy things," and perhaps this is part of why he made no effort to salvage a relationship with Amanda. The few times that the father was brought in for sessions, he would state that he does try but that perhaps she did not see it. This dynamic echoed a classic "he said/she said" scenario, common to family disputes with escalated emotions. From Amanda's initial display of being quiet yet clearly angry, more authentic feelings of sadness and desperation eventually appeared. Self-esteem-related issues emerged within our weekly sessions as well as more severe expression of self-hatred.

According to Lansford (2009):

> [Y]oung children may be less capable of realistically assessing the causes and consequences of divorce, may feel more anxious about abandonment, may be more likely to blame themselves and may be less able to take advantage of resources outside the family to cope with the divorce.
>
> (p. 143)

Feelings of abandonment escalated, creating resentment and ultimately ending Amanda's relationship with her father. Through Amanda's artwork, she was able to explore various aspects of the divorce, her relationship with her parents, and her own self-concept. Her artwork was profound. As I was able to watch Amanda grow, her issues changed as she continued to mature and develop.

Although she was technically in the Industry versus Inferiority stage (Erikson, 1950), I also believed that I had received Amanda toward the end of her shame-filled Initiative versus Guilt stage: *What did I do to make my father stop loving me? Why does he love my brother more than me? Was the divorce my fault?*

Figure 17.1 highlights one of the first drawings created in treatment. The provided directive suggested showing what it was like living at home with your mother and father before the divorce. The resulting image appears to reveal possible fear and frustration

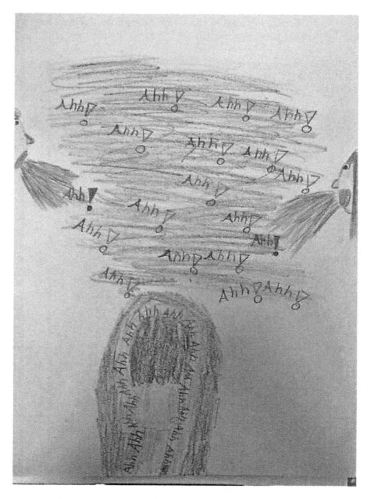

Figure 17.1 Amanda's drawing of life with her parents

as Amanda is seen surrounded by her parents' anger. As with many of the post-divorce children I see, Amanda was feeling trapped. She was stuck in the volatile relationship that her parents were now trying to escape while she herself had no escape. The composition of this piece is also worth noting. Amanda's parents are drawn in the periphery in silhouette, which may indicate her desire to keep their presence limited within this scene. She appears to be much lower than her parents and is illustrated with her back turned, suggesting her own perspective could be that she is beneath or "less than" in regard to her relationship with her parents.

It became unclear as to whether Amanda understood her emotions. She would often defensively use the word "fine" to describe how she was feeling, and, when asked for an alternate descriptor, she would state "good." I invited Amanda to create images for five specific feelings. In Figure 17.2, she created depictions of named feelings. The two most invested feelings were sadness (blue, top right) and anger (red, top left). Perhaps Amanda was relating most to these emotions at that time. When I explored her depictions of sad and angry as opposed to the other feelings, she replied that she did not realize she did that and could not say why.

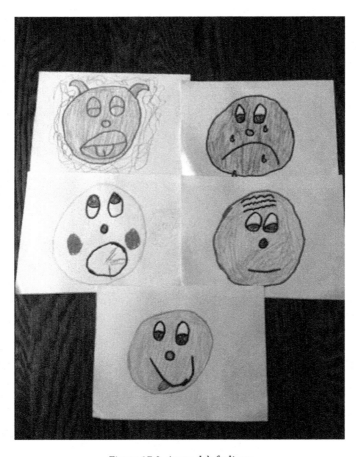

Figure 17.2 Amanda's feelings

As we continued to work through feelings surrounding her parents' divorce and strong negative views toward her father, both myself and her mother tried many times to explain to Amanda why it was important for her to have an open mind about her relationship with father. However, Amanda continued to express her anger toward her father, albeit in positive outlets such as art. I believed it was important for Amanda to continue releasing whatever anger she felt, especially toward her father, seeing how she was refusing communication with him. If she was unable to communicate her anger directly to him, I felt she needed to express her feelings in other ways. "Throw the paint," the example seen in Figure 17.3, is where I have children create a pie chart of specific examples of each of their various emotions. When they "throw the paint," they are to become that specific emotion as best they can and be in that moment that is creating that emotion. For Amanda, the anger slice (red) was specifically related to her father, while her worry slice (orange) was referring to taking tests and getting grades. For example, when Amanda was getting ready to throw her red, I asked her to remember the last thing that her father did that made her feel angry. Almost as though we were doing a guided imagery, I would say to her, as a grounding exercise, to remember where she was, what she saw and heard, and so on. Once Amanda assured me she was "in the moment" in her mind, she could then release the paint ball and "throw the paint."

Amanda spoke openly about her feelings that her father never paid her any positive attention. She had felt that the only type of attention she received from her father was yelling, which, she shared, she often did not understand the reason for. In one particular session, she stated that she used to "sneak" around the house "quietly" with the hopes that her father would not hear her and, therefore, she would not get yelled at. When

Figure 17.3 Amanda's throw the paint exercise

I asked if Amanda would like to see her father, she stated, "I would be happy if he came to see [my brother] because he wants to see him, but I don't want to see him."

When Amanda shared these sentiments, tears welled up in her eyes. Although Amanda was attempting to keep up a strong front through the divorce, it became clear through our work together that she cared a great deal more about the lack of attention and love afforded by her father. Even though Amanda had also verbalized that she did not trust or love her father, without working through these issues it was possible that Amanda would not be able to establish trusting relationships later in life, such as dating or developing intimate relationships with partners.

> The poorer parent-child relationship could result in offspring becoming more distrustful of their parents. Thus pathways through which parental divorce may affect offspring trust include the disruption of parent-child ties and offspring apprehension about the permanence of relationships resulting from witnessing the breakdown of the parental marriage. . . . Changes following divorce may negatively impact children's other relationships that further increase apprehension regarding the permanence of relationships.
>
> (King, 2002, p. 643)

Looking back on Amanda's first session, she had stated, "I would like to tell my dad how angry he makes me, but I don't." She had appeared saddened not just by that statement but, I believe, by the lack of confidence she held in expressing her feelings to her father. It became clear during our sessions that she was intimidated by her father and not willing to show and express her true thoughts and feelings. Amanda's self-esteem noticeably grew within our time together. Through her artwork, she was able to vocalize various feelings regarding her past and more current experiences. Amanda progressed, sharing how she had eventually become able to text and email her father emotional statements that had previously remained undisclosed. With greater validation, Amanda owned her feelings, establishing a stable level of confidence. She was also able to explain her own understanding of, and possible acceptance of, the divorce. Using her first image, the "trapped" drawing in Figure 17.1 where her parents are arguing around her, Amanda was later asked to imagine that she could change the drawing to how she would look now that her parents' divorce was final. She explained it would have been an image of her, on a couch, with her feet up saying, "Ahhhhhh," in a relaxing tone because, she stated, she was much happier after the divorce. Eventually, Amanda would join sports teams and increase her sociability at school. Her overall demeanor changed, and, according to her mother, less sadness and anxiety was reported.

According to Pufall and Unsworth's (2004) *Rethinking Childhood*, "about two years after a separation, families tend to stabilize, and both adults and children are functioning at about the same level as those from intact families" (p. 180). In my experience, and specifically through the families I am highlighting in this chapter, this is not the case. Many of the families endure long court proceedings; some lasting as long as one to three years. Most report that acceptance and resolution can be achieved two or three years after the divorce is finalized.

Jolie: A Case Vignette

A 14-year-old Caucasian, cisgender female, Jolie, had been referred to art therapy by her mother due to complications from the parental divorce and specifically Jolie's anxiety

toward her father. Although her parents were separated at the time we began sessions, Jolie reported that she often felt as if she and her father had always had a distant and strained relationship. He was an older man going through possible early stages of dementia (or related memory medical conditions) and battling what appeared to be alcoholism (based on statements from Jolie and her mother). According to Jolie, while on family vacations, she would often enjoy time with her mother while dad "golfed" or socialized among his own friends. She explained to me how she had a very fun childhood but recollected most fondly about her time with her mother. When dad was brought up, she replied with, "He was never really there." She never felt as if she really got to know him. Jolie compared her non-existent relationship with her father to the strong relationships of her peers and their fathers. This divorce provided relief to Jolie because she would often worry about his actions when he drank, creating moments of panic and stress. Years into her therapy, it was revealed that Jolie's father was not, in fact, her biological father. When Jolie was made privy to this information, she again felt additional relief. Jolie used music, writing, and art as a way to express, cope, and heal. She began her therapy by answering questions through minimal words and shrugs, but, if she was given an outlet other than verbalizing, she opened up tremendously. As Jolie wrote:

> Whenever I get home it's like a war zone. My dad is always complaining about something my mom forgot to do or something he didn't like. I'm always scared that they will start fighting when my friends are over.

At the start of my treatment with adolescents, I have them fill out their own informational forms, which include many questions about home life and about self-esteem. One section provides a long list of descriptors, and the adolescent is asked to circle which words they would use to describe themselves. Jolie circled: "worthless," "inadequate," "a nobody," "stupid," "ugly," "wrong," and "useless," among others. It was clear based on her initial presentation that she was struggling a great deal with self-esteem. Jolie's severely diminished self-esteem was seemingly exacerbated by the fear-inducing relationship with her father. In another section of her paperwork, Jolie wrote: "I am scared of my father and my house. I would like to be more confident so I could stand up to my dad."

While the disclosure aligned with the developmentally appropriate period identified as Identity versus Identity confusion (Gray, 1999), Jolie's negative sense of self would warrant substantial reworking in treatment. A more secured sense of identity coupled with feelings of sameness would improve psychological functioning and yield more positive growth (Chen, 2010).

In Figure 17.4, Jolie created her "two dads," one depicting her perceptions of her actual father and the other projecting a fantasy father. She spoke quietly, as she was very timid at the beginning of treatment. She stated that she always wanted a father whom she could spend time with; have fun with; and, especially, someone to "make her happy when she is sad." Through Jolie's artwork, she was slowly able to articulate words for her feelings. She viewed her own father as very selfish and never involved in her life. For Jolie, it was always easier for her to communicate these ideas through artwork rather than words. She would often clam up and withdraw with pressured questioning. Art-making and creative writing consumed the majority of the sessions in the first six months, enabling Jolie to express herself authentically, without fear of judgment or possible repercussions.

Jolie did not always choose to respond to her father via text or email, but, when she did, her father's typical response as stated by Jolie was, "Jolie, I know these aren't your

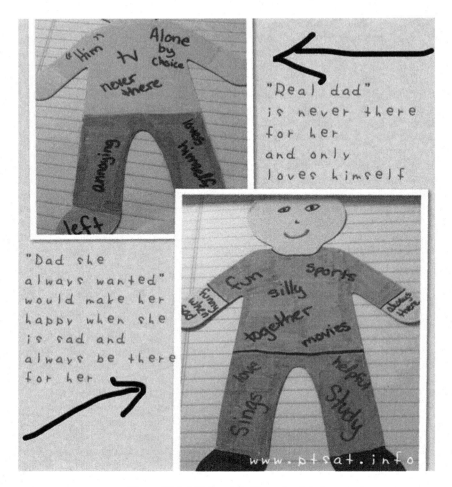

Figure 17.4 Jolie's real dad/imagined dad

words. This is your mom not you." For Jolie, this idea that her father was not believing her own words was devastating. Young adolescents often struggle to find and promote their own voices. Children and teens are often told by their parents that no matter what they do or say the parent will believe them and trust them. That type of understanding and unconditional love appeared to be lost in Jolie's relationship with her father. For Figure 17.5, I directed Jolie to use her passion for art and music not only to find her own words but to believe in herself as she expressed them. In the above piece, Jolie was given several possible songs to choose from, all based on the music she had previously voiced liking. She chose a popular song by *The Band Perry*. The song lyrics were printed out, and she was asked to recreate the song to be about her life and what she was going through. Jolie included some very strong and emotional statements such as, "you blame your faults on the ones who love you most." When discussing her lyrics, she explained that she actually imagined that she was singing to her father when writing them. In

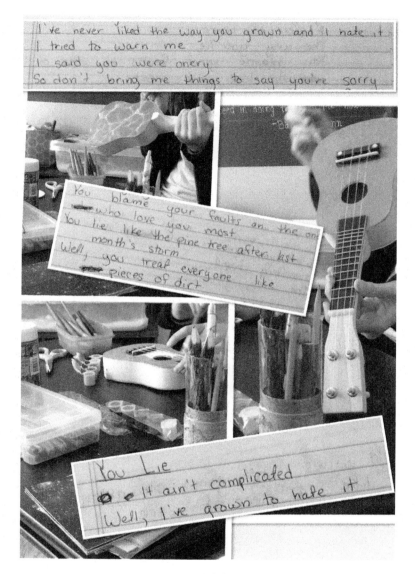

Figure 17.5 Jolie's lyric change

them, Jolie expressed the hopelessness experienced after her father had manipulated her attempts to share her own feelings.

In Figure 17.6, I suggested scrapbooking, as adolescents often engage positively with this directive. Scrapbooking can be seen as similar to the art of collage in that items/ images/words are already created and you, the client, are simply choosing the items you relate to or that work for the directive given. These types of artistic styles are often seen as an alternative to verbal communication.

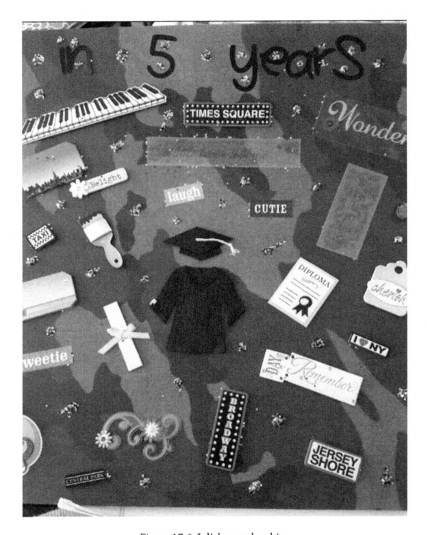

Figure 17.6 Jolie's scrapbooking

Collage may be used to join multiple visual or textual items to create a focus for "associations and connections that might otherwise remain unconscious." A researcher takes this artistic process further by systematically identifying reoccurring themes and, in the process, gives form to ideas, intuitions, feelings, and insights that may escape rational thought processes (Chilton & Scotti, 2014).

Collage can aid in decision making (Gussak & Rosal, 2015) while the act of searching through different images, stickers, and words can also have a somewhat calming effect on a person. I believe that a person may see this as a mindless activity, in which they turn pages of a magazine or look through a box of images. But as any psychotherapist would wonder, does a person's subconscious come through and choose for them?

If we try to understand these descriptions using the framework provided by our knowledge of the mind and brain, then we are led to the conclusion that the creative process arises from the unconscious rather than occurring as a conscious process. The person is typically in some type of reverie or dissociative state when the mind wanders freely, and thoughts and images float around without censorship. During this fluid time, the brain is probably working feverishly, despite the subjective sense of reverie and relaxation (Andreasen, 2011).

Typically, I will suggest certain themes for pages of a scrapbook such as:

- Family.
- Friends.
- School.
- Likes.
- Dislikes.
- Feelings.
- Worries.
- My future.
- My goals.
- Who am I?

Presenting the idea of scrapbooking provides a more accessible entry into art-making for those that might be showing trepidation. According to Chilton and Scotti (2014), the physical acts of cutting items, gluing, and adding writing or drawings to the collage can be empowering for the client.

For Jolie, I suggested the benefits of a "Future page." Jolie's anxiety increased when the future was discussed. Her legs would shake, and she would become silent for some time. For this exercise, I had Jolie create a future scene. The intention was to broaden Jolie's viewpoint of her future, expanding it beyond her current stressors related to her family. Jolie feared her dad's behavior would affect her socially and possibly even academically. Jolie was a wonderful student who enjoyed school and participated in many extracurriculars, showing talent in various areas of the arts. She stated in her writing, "Whenever I am around you [Dad] I am scared. Even when I'm not around you I'm scared. You always drink and lose your temper. Even if it's not with me, it scares me." This fear was crippling for Jolie, at times leading to panic attacks. But when she was creating her own future on the page, she was able to focus on a more integrated outlook, honoring both negative and positive aspects. She eventually included other areas of her life such as her relationship with her mother and even her maternal grandparents. She created her dream college life, traveling, exploring music and art, and reminders to maintain a positive outlook about herself. Her father was not included in her 'future' page because, as Jolie said, she only wanted to include the positive.

I supported Jolie's goal to hold the positives close to her and do her best to remove or change the negatives. Over time, Jolie evolved through her artwork and her writing. She was maturing emotionally as she increasingly began to understand and accept herself. In Figure 17.7, seen above, Jolie was given the directive of creating an image to depict her life journey, including the past, present, and future. She was asked to imagine what positives she would be taking with her from her past and present for her future journey and also what negatives would she be leaving behind. Jolie was invited to illustrate this in any way she chose, which gave her a great amount of artistic freedom. She created clearly defined boundaries between what she hoped to hold on to versus what she needed to

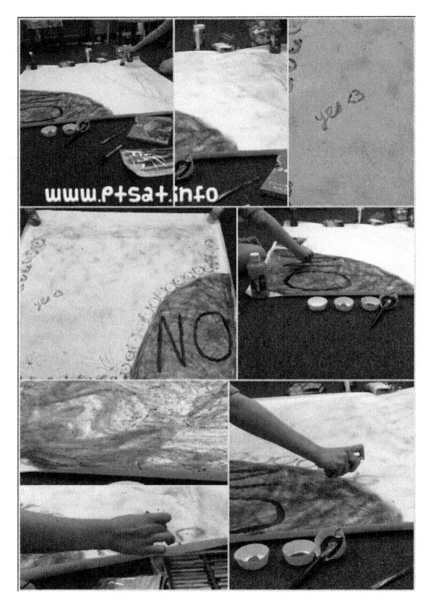

Figure 17.7 Jolie's life journey

abandon. In Jolie's artwork, the "NO" gray area was filled with anger and exhaustion and, in Jolie's words, everything that her father had done to cause her pain and anguish. Jolie had recently experienced panic attacks caused by abrupt intrusions by her father. These seemed to occur when Jolie requested time to herself. She experienced verbal attacks by him, either via text or phone calls, including constant accusations of Jolie "lying to him."

Also experienced were threats made by her father, such as him showing up without notice and being told that she could not stop him. Through Jolie's art and writing, she developed a whole new confidence. This was seen in the size of the negative, or "let it go," area, which was substantially smaller in the composition. The larger, brighter area was everything Jolie said she had to look forward to, such as her music, going to college, her boyfriend, friends, her family "who love her so much," a new apartment with mom, etc. That positive, take-with-me side of this piece showed Jolie just how much positivity she had in her life. She was able to verbalize that, for so long, she was only willing to look at the negative because it hurt her in such a way, but, seeing the two side-by-side, she declared that her positive side was much more impressive than she imagined.

In a letter that Jolie wrote to her father in one of our sessions, a letter that was created with no intention to be sent, Jolie included at the very end: "One last thing. This is not my mom talking; it's my voice." Self-esteemed appeared to be restored, as Jolie articulated her own feelings with conviction.

Paul: A Case Vignette

Paul was a nine-year-old Caucasian, cisgender male.+ Paul was referred to me by his mother due to changes she had noted in his behavior and emotional state as her divorce with his father began. Paul grew up with two parents in the law enforcement profession. As his parents began their heated separation and eventual divorce, Paul's reaction was one of sadness and guilt. He was not made aware that a major cause for his parents' divorce was his mother's supposed infidelity. Paul's father, as a result, would not communicate easily with the mother, and Paul was often put in the middle of conversations and situations. He withdrew often, putting on a brave face when necessary but revealing a great deal of inner turmoil and sadness. He, especially in the beginning of his therapy, felt that the divorce was somehow his fault.

Paul's father harnessed a great deal of anger toward Paul's mother, and Paul unfortunately received the discharge. Paul's parents were unable to communicate with me about their son on the same email chain, as they could not tolerate being in the same room with one another and had two very different ways of parenting Paul. As a result of this, there was a great deal of confusion and increased depression and anxiety symptoms from Paul. Interparental conflict during childhood has consistently resulted in negative and long-term outcomes for adjustment (Lansford, 2009). When Paul spoke about his parents' relationship, pre- and post-divorce, he was very much aware of the disdain that existed between his mother and father. Paul, at times, would even state directly to me "how am I supposed to figure out what I'm doing when they can't figure out what they are doing."

> Social research tells us that children are better off with the influence and presence of both parents in their lives, absent extraordinary circumstances. It is important for both parents to be mindful of this and to strive to create a parenting plan that provides this for their children. Hand-in-hand with encouraging and facilitating a meaningful relationship with the other parent is showing respect for the other parent. It is harmful to a child for either parent to make derogatory remarks about the other parent.
>
> (Moses, 2013, p. 35)

Considering the information provided about the parents' relationship, it was expected Paul was struggling with significant emotional distress. As an art therapist, I often

loosely use the House-Tree-Person (Hammer, 1980) assessment when first starting with a client. I find that it helps to open up communication, allows me to learn more about a client, and helps me look for possible areas of conflict. Paul's "House" drawing (Figure 17.8), displayed multiple areas of concern. The lack of a groundline was unusual for a child of his chronological age. This may suggest little or no contact with reality (Hammer, 1980). Perhaps someone going through a great deal of familial stress does not want to connect to his reality. His walls, which could be representative of his ego strength, appear to be solid, clear dark lines with no erasures, but the lines within the house suggested agitation with jagged and vertical lines. The absence of the drawn fireplace, despite its existence as revealed by Paul, could imply lack of psychological warmth within his life and may also indicate possible struggles with important male figures in his life (Horovitz, 2014).

The windows drawn in the suspected first floor of the home are visibly smaller than the others. This could be representative of psychological inaccessibility or a desire to prohibit others from seeing what is happening inside the home, which, in turn, could suggest arguments or other types of disputes that may have occurred in the home (Hammer, 1980). The excessive shading that Paul created on the roof of the house could be indicative of someone excessively seeking satisfaction in fantasy. Perhaps Paul was going through such difficulties in his reality with regards to his parents' divorce that he was preferring to live out more of a fantasy life. The window drawn on the roof also could indicate the same. One could furthermore propose that the excessive roof shading may have been Paul's way to more deeply reinforce or hold in all that had been occurring within the home.

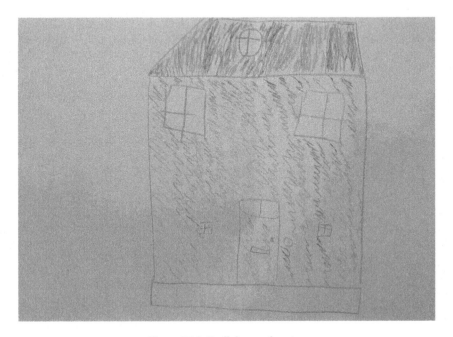

Figure 17.8 Paul's house drawing

Figure 17.9 Paul's divorce volcano

The children I work with are often asked to represent themselves among their parents' divorce through drawing. This is not an easy concept to put words to. In the above piece, Figure 17.9, which seemingly appears to be abstract, Paul was able to find his words. He created a volcano; each side of orange/yellow represents a parent, and the hot, black tar building up on the inside was understood to be Paul. Paul appeared to feel stuck, perhaps even trapped. He heard negative comments from each parent, and, although many other children that I have seen had lashed out with anger as a result of this, Paul did not. He kept almost all of his feelings inside, like his very own volcano waiting to erupt. He would have moments in sessions where he would become tearful but would then choke the tears back and push forward. It took a very long time for Paul to let down his guard and allow himself to feel in the moment. It also became clear early on that Paul was one of many children of divorce who felt torn between both parents, wanting love from them equally, seeking time with them each. In Pufall and Unsworth's (2004) *Rethinking Childhood*, it was found that "negative comments included feelings of being pulled both ways. 'I feel really sad, really upset. I felt like I was a ragdoll being pulled by both arms because they both wanted me.' (fifteen-year-old girl)" (p. 176).

I encourage my clients, with their parents' permission, to email me on days we are not meeting if something comes up or if they need assistance. I received an email from Paul—the first email I had ever received from him—where he wrote:

Two days ago I wasn't feeling good and I called my dad saying I wouldn't go for that day [meaning Paul would not be able to go and see dad on his designated day] or Friday so he said who will be watching [me] I said a babysitter. Then he [dad] said twice, "so you'd rather stay with a babysitter than with me?" then hung up on me.

And today I'm just stressed a little and I'm not goin to my dad's this weekend and I don't know what to say to him. Please respond."

This was a very important start in Paul's realization that he was receiving unnecessary pressure from his parents regarding their issues with each other. Paul was guilt-stricken and heartbroken by his father's reaction. He and I spoke about this for several sessions, during which time Paul often choose to manipulate clay, molding and moving it, ripping it and rolling it as he spoke about his feelings.

Sholt and Gavron (2006) highlight the benefits of clay work:

> Clay-work involves an intense and powerful tactile experience of touching and haptic involvement. Touch was identified as one of the first sensory responses to develop in humans Tactile contact is actually the first mode of communication that an infant learns. For humans, the early stages of life are dominated by oral and skin contact between infant and caregiver Thus, clay-work involves a very primal mode of expression and communication. Touch in claywork also requires body movements in endless opportunities for touching and modeling. Thus clay-work makes possible an entire non-verbal language or communication for the creator, through which his or her mental realm, emotional life, and primary object relations can be expressed.
>
> (p. 67)

While symptoms of anxiety were observably diminished when Paul played with the clay, his words spoke loudly about his regrets and fears of being hurtful, Paul rarely made anything out of the clay. It held a purely cathartic purpose for emotional release. It is important for children to recognize and accept the ambivalence and angst that accompanies divorce, and Paul required constant explanation regarding the uncertainty and frustration created by the unanswered questions of divorce. He expressed his anger by pounding and throwing the clay down. Sholt and Gavron (2006) suggest the aggressive use of hand movements or tools in clay work as expressing an aggressive regression.

Pufall and Unsworth (2004) found that one-third of children blamed themselves for the circumstances that led to divorce. When children speak about their parents' divorce, they often miss or long for time with the one parent who moved out of the family's home. This can lead to additional fears and added guilt, even to the point where the child may worry about the other parent moving out as well. This echoes Moses (2013) findings regarding self-blame among children of divorce.

Paul's father began not answering his calls, and, as a result, Paul's guilt became overbearing. He would talk about the difficulties in going from one home to the other. He wondered what holidays would be like for the rest of his childhood, how being on vacation would be so different, how he would never "watch TV as a family" again. These thoughts, coupled with his guilt, led to Paul asking real questions about his parents' divorce and to him wanting to know "why?" *Why did his parents' divorce? What was the cause? How are things going to be now?* We continued to utilize art as a venue to express these feelings and questions. He may not have been able to get the whole truth from his parents, but he did begin to work through his own feelings, specifically his guilt surrounding the divorce. He examined future positive and negative possibilities, and, with some help, Paul was able to focus more on the positives. For example, while initially worried about not having Christmas together as a family, he eventually warmed

up to the idea of having two places of comfort to go to, two Christmas trees to decorate differently, two homes for creating memories in, etc.

I believe Paul wanted to be relieved of his guilt and told that the divorce was NOT his fault. Paul requested a family session with mom and dad together to ask these questions, but Paul's parents refused to join together. Paul's request for that family session was a huge step in him finding his voice among his parents. Unfortunately, long-term work was not achieved as Paul's mother terminated therapy, believing Paul to have shown improvement.

Children of divorce are found to experience greater mental health challenges, lower academic achievement, and more conflicts in social relationships (Lansford, 2009). With greater support and intervention, children can manage the stressors of divorce. Despite the familial rupture, children of divorce, much like children who are faced with other various stressors, can access inspiring resilience. Resilience may come naturally for some, while for others it is a skill that must be honed. Teaching positivity and improving self-esteem, along with other building blocks of ego development, appear to assist in creating necessary skills for resilience. This idea goes along with a positive psychology approach; as noted in Rubin (2016), "a positive psychology approach assumes that the components of mental health—that is happiness, feeling better, being more productive in life—should all be goals in psychotherapy" (p. 250). This theory goes on to include that finding purpose and meaning in one's life and having a sense of independence promotes a happier and more fulfilled well-being. These more positive individuals are believed to be capable of better coping with issues as they arise and may overcome acute stress as a result.

Resilience among children of divorce appears to show itself in different ways for various ages and developmental stages. For example, children and adolescents who are able to communicate their thoughts and feelings, verbally or otherwise, appear to be capable of better overcoming obstacles related to a family's divorce and appear more likely to repair any ego damages while rebuilding much-needed self-esteem. Within my experience with this population, it is those who continue with consistent and continued therapy that see the most success in these areas. Eventually these children take off on their own, and they show clear signs that they can continue fostering positive ego growth and self-esteem without any regard to past issues within the family.

Recommendations

Working with children of divorce can be especially trying on the clinician. Parents will often attempt, purposely or accidentally, to push you into the middle of their separation, just as they do with the children. One must always be aware of any triangulation that is or could be taking place. I attempt to limit possible triangulation in several ways:

- **Consent from both parents at the start.** The paperwork that I give out before starting with a new client includes parental consent specifically of those going through or have gone through divorce. These state simply that both parents are in agreement of their child receiving therapy from me.
- **Communication.** Upon meeting with a parent or both parents before therapy begins, it is explained that both parents receive updates at the same time. This typically eliminates a good amount of he said/she said regarding you, the clinician. IF a parent decides to communicate with me privately on their own, I explain that our communication is always documented and if the other

parent, attorneys, or judges involved request communication paper trails, then everything is included for all to see.

- **Artwork.** Along with consent, I explain to the parents and child that the artwork created is almost always just for the child and will be up to the child if they decide to share that artwork with them. However, just like with typical psychotherapy confidentiality, there are specific times when artwork must be shared. This is specifically when I note anything distressing relating to hurting themselves, hurting others, or severe enough symptoms/content to warrant an increase in level of care.
- **Family sessions.** Family sessions will almost always have both parents present with regards to families of divorce. Under extenuating circumstances this can be overlooked, such as a parent living out of state, a parent waiving joint custody rights, or by request of the child. Family sessions within my practice occur as a request from any family member or can be requested by myself if it seen as needed in terms of the child's therapy and recovery.

Children in general require and typically thrive from structure in various environments. Art therapy, at times, should be no different. Therefore, I do believe using specific art therapy directives with children going through divorce can be beneficial. Specific directives that I recommend using include:

- House-Tree-Person Assessment (Hammer, 1980): This can be used as an initial assessment of the child, allowing the clinician to possibly see how the child is viewing their world around them. It can also serve as an estimate of the type of self-esteem or lack thereof that may be affecting the child. As mentioned, when using HTP, I do not follow all of the directions Hammer notes; for example, I do allow children to use markers or crayons instead of pencil if it is preferred.
- Family Drawing: I often couple this with the HTP assessment as an added drawing at the end of the assessment. I ask the child simply, "Now please draw a picture of your family, you can include whoever you consider to be your family that you'd like in the drawing." Most children will show their immediate family as they view it. Children going through divorce are often careful about where they place family members. For example, if a child places themselves close to their father while the mother remains further from them, that child could be communicating the type of relationship they have with the father or perhaps the relationship that they long for.
- Life Before Divorce and Life After Divorce: This directive works as a way for the clinician to observe how the child is viewing the changes taking place around him or her. It also assists in allowing the child to view the changes, both good and bad, that have taken place as a result of the divorce. This directive has been done both by using canvas and paint as well as paper and markers.
- Directives that allow a release of emotion: As art therapists we are typically aware that the art process itself can be quite helpful in releasing hard-to-express emotions. Working with these children, I will often take a step back and allow the cathartic use of the art to take over in assisting with releasing anger or guilt. The art, therefore, becomes the therapist for the child and I am simply facilitating the process. Some directives that work well here include but are not limited to: Throw the Paint, Clay manipulation, Song Lyric Change, Write a letter, and Scream Box.

- Throw the Paint: In an outdoor area, I have the child create a pie chart of emotions on a large piece of paper. I find that children can understand this idea even without previous knowledge of a pie chart, as most children know what a pizza pie looks like. It is explained that we are organizing their feelings into slices. The paper is then typically hung on a clothesline, and the child is asked to choose a paint color to represent each feeling. We then take sponges or wet paper towels formed into small balls and dip them into the paint. I explain that the idea is to throw the wet ball or sponge, covered in paint, to hit the desired area on their pie chart. I do this as a way to get them to focus on one particular emotion at a time, as opposed to just throwing wherever they want to. When the child "throws the paint," they are to become that specific emotion as best they can and be in that moment that is creating that emotion. I have the child go through each emotion, one by one, speaking about what makes them feel that way and how can they tell they are feeling that emotion. Lastly, we problem solve what they can do as a way to work through those emotions in a healthy way.
- Clay Manipulation: As a haptic activity, clay offers tactile experiences to process the conflicted emotions that come with the divorce.
- Song Lyric Change: Used more often with adolescents, the child chooses a song they relate to. It does not have to be about anything in particular, other than it being a song they know and appreciate. I then have the child change the lyrics to that song to be about what they are currently going through. This exercise can often create a flood of raw emotions, and so I will often go from this exercise to free painting as a way to help calm the child and ground them again.
- Write a Letter: Communication is critical, especially if one parent is less readily available during divorce. I explain that the letter serves only one purpose: "To allow you to express whatever it is that you never had the opportunity to express." It is explained that they are under no obligation to give the letter to anyone unless they choose to do so.
- Scream Box: Many children of divorced families deny their feelings. They will reply, "I am fine with it" or "it doesn't bother me." I have the child create a box, decorated however they want both inside and outside. The box is to be used as a keeper of screams: happy screams, sad screams, angry screams, etc. We work on actually screaming into the box based on how we are feeling. This will often help these children break down their barriers and get in touch with their true emotions.

In addition to directives, I stress the importance of choices. Children who are facing the world of divorce often feel devoid of choices. "Why don't I get a say in this? Why is it only up to you?" They feel as if they are losing control of everything, and this can bring on an abundance of anxiety, anger, and depression. As a result, I offer choices for just about everything that we do. From paper choices to paint color choices to choices about what we should do that day, choices offered in each session allow these children to regain a sense of control and identity. This assists in continuing to promote healthy self-esteem and ego growth. I always encourage parents to continue to support decision making at home as well with choices when possible.

References

Andreasen, N. (2011). A journey into chaos: Creativity and the unconscious. *Mens Sana Monographs, 9*(1), 42–53. https://doi.org/10.4103/0973-1229.77424

Bryner, C. L. (2001). Children of divorce. *Journal of the American Board of Family Practice, 14*(3), 201–210.

Centers for Disease Control and Prevention. (n.d.). *Provisional number of marriages and marriage rate: United States, 2000–2016* [Data file]. Retrieved from www.cdc.gov/nchs/data/dvs/national_marriage_divorce_rates_00-16.pdf

Chen, K., & Yao, G. (2010). Investigating adolescent health-related quality of life: From a self-identity perspective. *Social Indicators Research, 96*(3), 403–415.

Chilton, G., & Scotti, V. (2014). Snipping, gluing, writing: The properties of collage as an art-based research practice in art therapy. *Journal of American Art Therapy Association, 31*(4), 163–171. https://doi.org/10.1080/07421656.2015.963484

Erikson, E. H. (1950). *Childhood and society.* New York, NY: W. W. Norton & Co.

Gray, P. (1999). *Psychology* (3rd ed.). New York, NY: Worth Publishers.

Gussak, D. E., & Rosal, M. L. (Eds.). (2015). *Wiley handbook of art therapy.* West Sussex, England: John Wiley and Sons.

Hammer, E. F. (1980). *Clinical application of projective drawings* (6th ed.). Springfield, IL: Charles C. Thomas.

Hines, A. M. (1997). Divorce-related transitions, adolescent development, and the role of the parent-child relationship: A review of the literature. *Journal of Marriage and Family, 59*(2), 375–388. https://doi.org/10.2307/353477

Horovitz, E. G. (2014). *The art therapists' primer* (2nd ed.). Springfield, IL: Charles C. Thomas.

Ignatius, A. (2017, May). Above all, acknowledge the pain. *Harvard Business Review.* Retrieved from https://hbr.org/2017/05/above-all-acknowledge-the-pain?utm_campaign=hbr&utm_source=facebook&utm_medium=social

King, V. (2002). Parental divorce and interpersonal trust in adult offspring. *Journal of Marriage and Family, 64*(3), 642–656. https://doi.org/10.1111/j.1741-3737.2002.00642.x

Lansford, J. E. (2009). Parental divorce and children's adjustment. *Perspectives on Psychological Science, 4*(2), 140–152. https://doi.org/10.1111/j.1745-6924.2009.01114.x

McCurdy, S. J., & Scherman, A. (1996). Effects of family structure on the adolescent separation-individuation process. *Adolescence, 31*(122), 307–319. Retrieved from www.ncbi.nlm.nih.gov

McDermott, R., Fowler, J. H., & Christakis, N.A. (2013). Breaking up is hard to do, unless everyone else is doing it too: Social network effects on divorce in a longitudinal sample. *Social Forces, 92*(2), 491–519. https://doi.org/10.1093/sf/sot096

Moses, M. E. (2013). Helping children endure divorce. *Tennessee Bar Journal, 49*(1), 34–38.

Pardeck, J. T. (1989). The Minuchin family stress model: A guide for assessing and treating the impact of marital disruption on children and families. *International Journal of Adolescence and Youth, 1*(4), 367–377. https://doi.org/10.1080/02673843.1989.9747650

Potter, D. (2010). Psychosocial well-being and the relationship between divorce and children's academic achievement. *Journal of Marriage and Family, 72*(4), 933–946. https://doi.org/10.1111/j.1741-3737.2010.00740.x

Pufall, P. B., & Unsworth, R. P. (2004). *Rethinking childhood.* Piscataway, NJ: Rutgers University Press.

Rubin, J. (2016). *Approaches to art therapy: Theory and technique* (3rd ed.). New York, NY: Routledge.

Rutledge-Drake, C. (1990). *The relationship of ego strength and tolerance of ambiguity to divorce adjustment* (Doctoral Dissertation). Retrieved from https://ttu-ir.tdl.org/ttu-ir/

Sholt, M., & Gavron, T. (2006). Therapeutic qualities of clay-work in art therapy and psychotherapy: A review. *Journal of the American Art Therapy Association, 23*(2), 66–72. https://doi.org/10.1080/07421656.2006.10129647

Vetere, A. (2001). Structural family therapy. *Child Psychology and Psychiatry Review, 6*(3), 133–139. https://doi.org/10.1111/1475-3588.00336

Part III
Consequences of Global and Systemic Stress and Inequalities

18
Conflict and Displacement
Finding the Space for Creativity

ANNIE G. BONZ, SOFIA DEL CARMEN CASAS,
AND ASLI ARSLANBEK

This chapter briefly overviews how arts-based psychosocial support has a uniquely promising role to play in both identifying and building resilience in children and adolescents facing conflict and displacement, highlighting case studies from Iraqi Kurdistan and Turkey. The multidimensional aspects of healing and resilience for displaced children and families are integral in determining the most appropriate mental health interventions across various settings—from initial displacement to protracted settings of instability. The first case will present the approach of capacity building through the arts-based training of trauma counselors in a community-based organization in Iraqi Kurdistan. The second case will highlight the creation of an art therapy program, by a Turkish art therapist, in a community center that serves Syrian refugees living in Istanbul. What brings these two cases so powerfully together is that although in different countries, they are both born from a response to the most unprecedented humanitarian crises of our time, the Syrian refugee crisis. Drawing from the research and our collective experiences, we believe art therapy has a unique role to play in supporting and responding to these children.

Situating the Authors' Context

We (the authors of this chapter) are trained as art therapists and have worked in numerous international humanitarian settings, particularly conflict-affected and forced migration contexts, with children, families, and community-based organizations (CBOs) and non-governmental organizations (NGOs). We have pondered and struggled with this concept of resilience in children and adolescents as individual practitioners and have identified parallels across our work and experiences in approach and practice. The questions and ideas raised herein have been stimulated by observation and discussions with other therapists/clinicians and non-specialist practitioners in the mental health and psychosocial support sectors.

Conflict, Displacement, and Resiliency

By the end of 2017, a total of 68.5 million individuals were forcibly displaced across the world as a result of conflict, persecution, violence, and human rights violations (United Nations High Commissioner for Refugees [UNHCR], 2018a). Amongst

this overwhelming number, the crisis in Syria is recognized as the largest and most unprecedented humanitarian crisis of our time. Syrians account for the largest forcibly displaced population in the world, currently at 12 million people, which is half of the population of Syria before the start of conflict. More than 5.6 million individuals, including 2.3 million children, have fled Syria to seek safety and peace in Lebanon, Turkey, Jordan, and Iraq (UNHCR, 2018a). For the past seven years, this ongoing conflict has left staggering impacts on the mental health and well-being of its children and families.

Conflict and displacement place psychological and social stress on individuals, families, and communities. The state of being displaced means something is lost—an identity, a relationship, a family, and perhaps a community. These experiences of grief and loss may affect one's psychological well-being and potentially increase one's vulnerability to mental health morbidity (Betancourt, Meyers-Ohki, Charrow, & Tol, 2013). For children and adolescents, the process of displacement and the associated experiences of becoming a displaced person, refugee, or migrant must be negotiated alongside the developmental process of identity formation (Betancourt, 2005). Children, in particular, may miss the "magical, grounding, securing, and nurturing aspects of childhood" as a result of these adverse experiences (Gray, 2014, p. 169).

A recent systematic review of resilience and mental health in children and adolescents living in areas of armed conflict in low- and middle-income countries (LMIC) affirms the narrative across multisectoral fields focusing on resilience, highlighting that resilience is a complex and multifaceted process with "outcomes determined by a dynamic interaction between gender, developmental stage, phase of conflict, and other intra-individual and contextual variables" (Reed, Fazel, Jones, Panter-Brick, & Stein, 2012, quoted by Tol, Song, & Jordans, 2013, p. 11). Collectively, the studies indicate that resilience may be better defined as the interaction between time-variant and context-dependent variables rather than just a combination of risk and protective factors. Additionally, this body of research emphasizes the importance of parental support in reaching desired mental health outcomes. Aspects of parental support may be incorporated into family-based preventive mental health interventions and are showing promising acceptability across refugee communities (Fazel & Betancourt, 2018). This review introduces a "Resilience and Mental Health Model" (Tol et al., 2013, p. 2), which further builds on the work of previous research on resilience in children affected by armed conflict (Betancourt & Kahn, 2008). Research to date highlights the dynamic nature of resilience at various levels of the social ecology and across varying sociocultural contexts. This model highlights social ecological variables (individual, family-level, peer-level, and community-level) that may be predictors for mental health outcomes in the context of adversity, including promotive and protective factors (Patel & Goodman, 2007). Promotive factors are associated with more positive outcomes, while protective factors are associated with lower levels of psychological symptoms. This model focuses on predictors at various levels of social ecology in order to best understand resilience in children affected by armed conflict.

As part of this review, Tol et al. (2013) examined existing research regarding intelligence, creativity, and mental flexibility as protective factors. All three have been shown to contribute a protective effect when measured across indices of overall psychological difficulties. Creativity and mental flexibility were found to be protective for overall psychological difficulties in two small longitudinal (post-conflict) samples. Findings or "lessons" from this systematic review offer a thoughtful discourse for the types of interventions and programs needed for children in LMIC. First, we must understand

how outcomes are shaped across varying sociocultural contexts. Second, a supportive sociocultural context should be central in interventions that promote resilience. Interventions should carefully assess both the potential protective and negative impacts that resilience resources in the socioecological context (Tol et al., 2013). And finally, interventions should not solely focus on promoting resilience but should instead be integrated into a multilayered system of care.

A complementary model to consider is the Social-Ecological Framework for understanding the numerous stressors affecting the mental health of refugees (Miller & Rasco, 2004). Within that framework, distress among refugees is understood as stemming not only from the violence and destruction of war but also from stressful conditions linked to social and material conditions of everyday life following displacement. An ecological model of refugee distress includes risk factors at different points in time (pre-migration war exposure, perilous experiences of flight, and current post-migration stressors) and at different levels of the social ecology. Displacement-related stressors may be viewed as a mix of daily stressors, defined as events and conditions of daily life that are caused or exacerbated by organized violence, that arise out of the experience of armed conflict and migration.

As noted in Tol et al.'s (2013) Resilience and Mental Health Model and Miller and Rasco's (2004) Socio-Ecological Framework, there are multiple factors impacting an individual's resilience—including interactions across the family, community, and the broader society. A child's perception and understanding of the stressors and impacts of violence and armed conflict are greatly influenced by caretakers and parents and, as such, must be taken into careful consideration in establishing interventions for support. Additionally, building on inherent strengths in the community serves to protect and support children (Betancourt & Williams, 2008). Culturally sensitive interventions must be based out of an understanding of local cultural norms, including spiritual and religious beliefs, familial structures, perceptions of illness, and social connectedness within the community (Klingman, 2002). Understanding local concepts of illness and mental illness are essential and must be a core part of developing an effective mental health intervention (De Jong, 2002). In line with the Inter-Agency Standing Committee Mental Health and Psychosocial Support Guidelines in Emergency Settings (2007), local capacity should also be developed in the implementation of interventions, while incorporating local values and practices regarding psychosocial well-being and healing. Interventions should draw upon individual, family, and community resources, honoring the existing practices of healing and integrating them into structured supports, as appropriate.

Creativity and Resiliency

Creativity, at varying capacities, is an intrinsic quality of the human mind and experience. It is a trait that has been central to the development of civilizations, culture, and humanity and can be defined as the ability to think in novel, flexible, innovative, and useful ways (Metzl & Morrell, 2008; Jung, Mead, Carrasco, & Flores, 2013). As the neuroscience of creativity continues to advance, we understand more about what neural processes are taking place to lead to high or low creative functioning, as well as how it impacts our development and our capacity for resiliency. Creativity has been linked to an increase in self-esteem, self-awareness, coping skills, autonomy, sense of purpose, problem solving, imagination, positive identity formation, and future planning (Malchiodi, 2014; Prescott, Sekendur, Bailey, & Hoshino, 2008).

Resiliency can be understood through multiple models and approaches, including resilience as the capacity to overcome adverse experiences, resilience as the ability to reshape and bounce back, or resilience as a dynamic interaction between multiple variables over time (Metzl & Morrell, 2008). Drawing together these definitions of creativity and resilience, one can theoretically draw similarities between them. Wolin and Wolin's work in 1993 placed creativity as one of the seven types of resiliency in their mandala of resiliency: insight, independence, relationships, initiative, creativity, humor, and morality.

Interventions in Post-Conflict Settings

Once active conflict has stopped, or a child has been displaced to a place of safety, the actual process of healing and restoration may begin (Barenbaum, Ruchkin, & Schwab-Stone, 2004). However, displacement to a place of safety is rare, as refugees are increasingly in transit or in post-migratory settings of insecurity and instability (Fazel & Betancourt, 2018). Refugee children and families may face the diverse components of the acculturation process in several countries before finding a place where they can participate or contribute to their new community. Initial stages of restoration include provision of basic needs including shelter, food, and clothing, as well as basic healthcare. Provision of basic needs, both physical and psychological, should be integrated with mental health and psychosocial support (IASC, 2007). Additionally, the Convention of the Rights of the Child highlights that states are required to "take measures to promote children's physical and psychological recovery and integration" (United Nations General Assembly, 1989). Restoration means connecting individuals with the traditions and cultural practices that provided meaning before the disruption of conflict or war, as well as building social support and community connections to create a sense of belonging (Fazel & Betancourt, 2018). Restoration and connection means reorganizing the altruistic nature of the community to support each other, promoting normalcy in human relationships. As a means of restoring a sense of hope in youth, Betancourt references "meaningful engagement" in activities such as creative expression through the arts (Betancourt & Williams, 2008).

Caregiver mental health may mediate the types of social support available to the child. Ideally, the caregiver can serve as a "protective shield"; otherwise, in less optimal circumstances, the caregiver's inability to cope subsequently complicates the child's ability to manage stress (Betancourt & Kahn, 2008, p. 322). Family relationships add to the strength of this shield and can play a mediating factor as well. This is of particular importance in thinking through the types of interventions and supports needed for children in order to foster resilience.

Group interventions may serve to "invigorate exogenous protective processes by bolstering social supports and connectedness among war-affected youths and their caregivers, peers and larger community" (Betancourt & Williams, 2008, p. 322). As noted earlier in the chapter, group processes should somehow mirror the socioecological framework in which children and families reside to help promote and protect the existing systems of support. Group interventions can highlight the inherent creativity of children as they map out their daily lives and reflect on the simple actions and activities of surrounding families and communities. A recent systematic review (Bosqui & Marshoud, 2018) highlights the importance of focusing on the key therapeutic processes that improve the well-being and resilience of children, rather than focusing on intervention-specific effectiveness. Key therapeutic rapport may include "reflective practice, a safe environment to

express emotion, and no moralistic or judgmental behavior," all of which may be core components of an effective group intervention (p. 14). Similarly, understanding the protective aspects of inherent strengths and norms within communities and cultures are key in determining pathways for healing.

Children need safety and security throughout their daily lives and an opportunity to express themselves and play. Many non-governmental organizations have implemented programs of psychosocial support to address needs of children and families in conflict and post-conflict settings, with a focus on education, livelihoods, health, and psychosocial support programming. Psychosocial programming for children often includes environments of play, which may include art, drama, music, and other expressive arts activities. Increasingly, art therapy and other therapeutic creative arts interventions are integrated into protection and psychosocial programming in humanitarian response for children, youth, and families.

Cultural Competency/Sensitivity in Art Therapy

Bringing one's own sense of culture and environment is inevitable, but the approach to a new culture must be met with humility and sensitivity. Sue and Sue (2016) identified three key components of cultural competence, including self-awareness, knowledge, and skill. Rather than viewing culture as a "static concept," individuals may instead approach their new environment with cultural humility, which emphasizes "an interpersonal stance that is other-oriented rather than self-focused, characterized by respect and lack of superiority toward and individual's cultural background and experience" (Hook, Davis, Owen, Worthington, & Utsey, 2013, p. 353). Additionally, a commitment to learning, both intellectually and therapeutically, are key to grasping the underlying tones and nuances of a culture. Similarly, the power disparities and inequities are very much present in international contexts involving humanitarian relief and support in post-conflict settings. Talwar (2015) highlights the importance of making "social, cultural and historical frameworks" central to art therapy with clients by exploring the "embodiment, language, feelings, and memory of trauma" (p. 101). She introduces the term "critical consciousness" to encourage practitioners to critically examine their role, both in awareness of systemic power disparities across the world but also in developing empathy and a commitment to a social justice framework.

Ethical practice in these settings "demands compassionate professionals who recognize art therapy's uniqueness in a world of many equally complex orientations" (Kapitan, 2015, p. 110). Similarly, "reflection must go beyond emotional processing to include critical analysis and an understanding of oppression, social change, agency, power, and privilege" (Kapitan, 2015, p. 110). Kapitan argues we must "commit to people" rather than the cause or the anticipated outcomes and, in doing so, build relationships to better understand how our lives intersect with the transformation through art for our clients.

Case Vignettes

Case 1: Capacity Building in Iraq—Sofia Casas

Since the start of the unprecedented Syrian refugee crisis in 2011, over 250,000 Syrians have fled to neighboring Iraq (UNHCR, 2018b). The majority of these refugees are living in the Kurdistan region of Iraq, spread across nine refugee camps and settled within

urban areas (UNHCR, 2018b). Kurdistan, meaning "Land of the Kurds," is a semi-autonomous region in the Middle East uniquely bridging Syria, Iraq, Iran, and Turkey. This region and its people, the Kurds, have witnessed centuries of severe violence, distress, persecution, survival, and struggle. Iraqi Kurdistan, which also houses the capital, Erbil, has established itself as the safe haven on the front of both the oppressive and violent spread of the Islamic State in Iraq and the ongoing civil war in Syria. Thousands of refugees and internally displaced peoples (IDPs) of Iraq flood the porous borders of Iraqi Kurdistan seeking safe refuge (United Nations International Children's Emergency Fund [UNICEF], 2018).

Responding to the historical and current humanitarian needs of its land, a community-based organization, the Jiyan Foundation for Human Rights, was founded in 2005 by a Kurdish psychologist. The mission of the Jiyan Foundation is to support survivors of human rights violations, promote democratic values, and defend fundamental freedoms in Iraqi Kurdistan (Jiyan Foundation for Human Rights, 2014). Through their network of nine rehabilitation centers for survivors of torture, Jiyan, meaning "life" in Kurdish, has provided medical treatment and psychotherapeutic support to over 20,000 women, children, and men. With an ongoing focus of building the capacity of their 140 multilingual professionals, including psychiatrists, counselors, psychotherapists, and doctors, the Jiyan Foundation has built a team of trauma-focused and extensively trained clinicians practicing in clinics and refugee and IDP camps throughout Iraqi Kurdistan. The clients of these clinicians are the survivors of some of the most horrific atrocities of modern history, including extreme torture, violence, and displacement.

It is within this context that, in 2016, I co-facilitated a capacity building effort in Iraqi Kurdistan for the Jiyan Foundation for Human Rights, along with a second credentialed art therapist, Nancy Slater, both of us recruited by an international arts-based humanitarian organization. The programmatic focus of the training was to develop arts-based psychosocial support amongst a group of these dedicated trauma counselors in Iraq, who serve the refugee and IDP population across Kurdistan. The Jiyan Foundation identified the need for their counselors to be trained in nonverbal modalities in order to provide alternative, culturally adaptive, and developmentally appropriate therapeutic interventions, especially for children and adolescents. Thus, the overall goal was to introduce the use of trauma-informed, arts-based interventions into the already robust clinical skills of twenty counselors, identified and chosen by the Jiyan Foundation.

The training took place over the course of three stages, spanning a period of ten months. I traveled to Kurdistan three times, with each visit lasting one week. The core objective of the training was for the counselors to familiarize themselves with the use of art materials and begin to experientially explore how art-making could be ethically used in their clinical and community-based work, both in the health clinics as well as the refugee and IDP camps. Demographically and culturally, the 20 trainees identified as Kurdish, all of Muslim faith, except one who identified as Yazidi. Their ages ranged between 23 and 55. The group was comprised of ten males and ten females. The populations they served were Iraqi, Kurdish, and Syrian, who often spoke Arabic while the counselors primarily spoke Kurdish. It is important to note that the counselors also had extensive histories of trauma, displacement, and loss, with some of the trainees themselves living in refugee camps. Their own stories and experiences periodically came up during the experiential training through their artwork and subsequent sharing, as well as through the sharing of their clinical cases.

The format of each of the three stages of training, each lasting five days, included three full days and two half days of theoretical, practical, and experiential learning with

the counselors at a hotel in Erbil, as well as two half days of experiential practice running art-based groups with Syrian children at Qushtapa refugee camp, which is located on the outskirts of Erbil. Guided by the emphasis on sustainable local capacity building, as well as the belief in the counselors as experts in their homeland, the trainers only observed the counselors facilitating the groups and provided no direct service during these field visits. All meals during the week were had together within the hotel, where both the counselors and trainers stayed, which rapidly created and contributed to a closeness and sense of community. The energy of the group was playful, humorous, and incredibly supportive and empathic of one another.

The approach to the training of art therapy practices highlighted in this chapter was solely directed toward building capacity, with no provision of direct service by myself or any other visiting mental health practitioner. I am a Costa Rican-American art therapist, trained and credentialed in the U.S. Though a global citizen with experience living and working around the world for over ten years, until this training, I had never stepped foot in Iraq or Kurdistan. It is now widely understood that sustainability of practice and support is essential, ethical, and more effective; this is the case whether in long-term development programs or in humanitarian crises and particularly when providing psychosocial support to refugees (Bardot, 2018; Kalmanowitz, 2018). Therefore, building the capacity of local, community-based specialists and paraprofessionals who will continue to support their community is the ideal approach to be taken when providing mental health and psychosocial support. Furthermore, when working as a visitor, it is imperative in the growing field of global mental health and global art therapy to practice humility, self-awareness, and a contextual understanding of current and historical dynamics of power, identity, politics, and culture (Kalmanowitz & Lloyd, 2005; Moon, 2013).

The goals of the experiential training were for the counselors to have an introductory yet broad knowledge of art materials; art therapy principles and practices; how to apply and culturally adapt these new skills to their current cases, both individual and group; and how to use art for their own self-care and peer supervision. As the practice of art therapy continues to spread globally, especially in areas and countries currently with no formal art therapy institutions or graduate programs, the navigation of ethics and professional implications of training other mental health specialists, or non-clinicians in art therapy, is often controversial and complex (Bardot, 2018). On one hand is the need to respect and protect the field of art therapy and on the other is the recognition that there are communities of high need in the world, where art-based approaches to psychosocial support could provide a more culturally grounded, resiliency-based, and effective modality. There are tangible tools that can be taught in such a state of crises and emergency. However, in response to these insights and concerns, it became central to us in the training to deliberately use the terms 'art-making' and 'arts-based psychosocial support,' avoiding the term 'art therapy' as much as possible.

The counselors received supervision from a psychiatrist at their clinical site; however, the Jiyan Foundation identified further clinical supervision and training as a high need for their staff. After the end of the three-step training, the two art therapists volunteered to provide regular tele-supervision to the counselors on an ongoing basis. This supervision, though often inconsistent due to distance and technological challenges, offered a space for them to present cases and discuss the use of art-making in their clinical work. This, in turn, also provided support in achieving the outcome of successfully implementing an arts-based approach within the Jiyan Foundation. In order to further sustainably integrate the program into the organization and region, there is also a plan

to continue training more counselors, as well as a goal of eventually identifying staff who could be trained as trainers in this arts-based therapeutic approach.

Case 2: Community Center in Istanbul—Asli Arslanbek

As a citizen and resident of Istanbul, Turkey, I was a witness to the Syrian refugee crisis, where I began to see Syrian families living on the streets in 2013. There are over 3.5 million registered Syrian refugees in Turkey as of June 2018, which makes Turkey the host to the largest number of refugees in the world (UNHCR, 2018a). Syrian refugees have sought refuge since the onset of civil war in 2011, where they were initially accommodated in camps. However, when the number of refugees exceeded hundreds of thousands in 2013, families started to move into the cities where they could have more economic and social opportunities (Altıok & Tosun, 2018).

When I began my art therapy education in New York, I often remembered my encounters with Syrian families on the streets of Istanbul. I wanted to do something meaningful for these families who were now residents of my birth city. Upon researching about what initiatives I could utilize to serve Syrian refugees, I reached out to Shahla Raza, an Indian documentary film maker and an activist who founded Yusra Community Center. Located in Balat neighborhood of Istanbul where a large Syrian community currently resides, Yusra Community Center focuses on teaching Syrian children Turkish and also attending to their psychosocial needs. Each group of children attend the center for one to two years before beginning elementary school. Children who attend Yusra are between three and eight years old. The center is staffed by volunteers, and their curriculum includes Turkish and English classes, art classes, gardening, and playtime.

This community setting operates as a transitional place for Syrian children who had often not received formal education in Syria. These children are trying to cope with the challenges of learning a new language and harmonizing with a new culture in Turkey. With these thoughts in mind, I started organizing short-term art therapy groups for children at Yusra in 2016 when I came home to Istanbul for the summer break and returned several times in 2017 and 2018. During the spring and summer of 2018, I established a more structured, long-term creative arts program.

I met many Syrian children who were dealing with the trauma of experienced violence and loss of home, as well as having a hard time with adapting to a new environment. My role was not only to facilitate art therapy groups but also to help families navigate the Turkish bureaucratic system. I learned many of these families struggled to provide children with a structured environment at home, where parents provided firm boundaries and supervision. Those who started elementary school were often discriminated against and bullied by Turkish students. I began thinking about the potential of art-making in addressing the issues of living in a new community, empathy building, and conflict resolution. While focusing on these factors, it was also essential to design the art therapy groups in relation to the mission of Yusra—to support integration through teaching and provide a responsive and structured environment to help bolster the children's sense of safety. The children attending classes at Yusra were accustomed to calling the facilitators "teacher" and being given guided tasks and activities. Any attempts to adjust those boundaries had to be carefully timed and introduced, given the group would be easily disrupted if the familiar pattern was to be changed.

In order to make sure all 14 to 20 young children received the attention and care they needed in the creative space each day, I decided to recruit volunteers from the community. Following a month of recruitment, I formed a team of six psychology and sociology

students from Middle East Technical University (ODTÜ) who wanted to engage with the community and support children in the art-making process. Before we started sessions, I had two meetings with the volunteers in order to address how to effectively serve the children at Yusra. In our first meeting, I shared general information about art therapy and its use with individuals who had experienced violence and other traumatic events in their lives. We talked about art's capacity to hold space and how to facilitate this through having a non-judgmental but supportive presence and a respectful stance toward the child's process. We also talked about processing through art-making, and I provided them with a set of chalk pastels and a sketchbook so that they could record their own reflections. In our second meeting, we visited Yusra and met with the children during their play time. This meeting gave both the children and the volunteers a chance to engage with each other before sessions started. It also allowed me to see each volunteer's approach to children; who was more emphatic and attuned, who was avoidant, who allowed the child to explore, and who seemed more restrictive. Among six volunteers, two of them were psychology students and four were sociology students who hadn't had any academic or practical experience in holding creative spaces to promote healing or in working with children. However, due to their academic training, the sociology students had extensive knowledge and intuition about understanding and respecting cultures outside of their own. This allowed them to stay open-minded and curious in their interactions with the children. Before the onset of sessions, I tried to address the questions and concerns of volunteers, and throughout the course this program, I met with the volunteers every Friday to discuss children's artworks, talk about issues that arose that week, and share the next week's objectives. This communication informed and helped us become more attuned with one another.

The cultural differences between the Turkish facilitators and the Syrian community we served needed to be understood and accommodated in order to provide culturally sensitive services to the children. In addition, there had been instances in the past where children were pulled out of Yusra's program by their parents/caregivers due to cultural challenges in programming. Therefore, we paid utmost care in providing a safe and supportive environment through respecting values of the families. When children pointed out cultural differences, we used these instances to reflect back on their reactions and talk about how people might have different values. Respecting the value system and being mindful of these values when responding to children is essential in providing culturally sensitive services, and it was perhaps one of the central components of our work.

I planned the structure of the sessions based on the needs of children between the ages three and eight. I began each session with half an hour of group games and dances, followed by a mindfulness exercise to encourage grounding and a transition to art therapy. Dancing and games allowed children to release their energy, and mindfulness exercises helped them regain their focus and body awareness prior to art therapy. In order to address the needs of each age group, I separated this large group into two smaller groups for art therapy, ages three to five and six to eight years. While the younger children (three to five years) engaged in more tactile, process-based activities, the older ones (six to eight years) were introduced to collaborative art-making and concepts such as peace, sharing, or living together in their communities. The concept of peace specifically drew most of the children's attention, and they settled on the decision of a mosque being a place where they felt the most peace. These concepts were sometimes introduced and other times arose organically while we had a group discussion. The following cases provide examples of how art therapy can be used to help promote well-being in children who are forcibly displaced and are dealing with cultural barriers and family stressors.

HALA: A RESILIENT CHILD WHO USED ART FOR RECONCILIATION

Hala was a seven-year-old girl who fled from Aleppo, Syria, with her parents in 2015, when she was four years old. She was living with her parents and a younger brother in the same room in Istanbul where they cooked, slept, and lived. I first met Hala in the summer of 2017 when she joined the art therapy sessions at Yusra. While she was one of the most silent children that first year, Hala learned Turkish and took up the duty of translating for her non-Turkish speaking friends in summer of 2018. She presented as a content child who wanted to please her family and teachers. Every afternoon, as we walked into the room as a group of instructors, she would stand up from where she was seated at her table and greet us with a hug. However, there were also times when she appeared preoccupied. Sometimes she would share what was going on at home straight-away, "my father said I can't go to school this year because he doesn't want me to" or sometimes she would just give me a plain "I am bored, teacher" without expounding upon further details. In those times where she shared her disappointment about her father's reactions, I would acknowledge her frustration and say she had been brave for sharing about this.

Hala's artworks often explored these concepts of family dynamics. The first year I met her, she regularly drew house-like structures, where she drew perseverative circles or zig-zags inside the structure (Figure 18.1). I learned that she had recently started attending

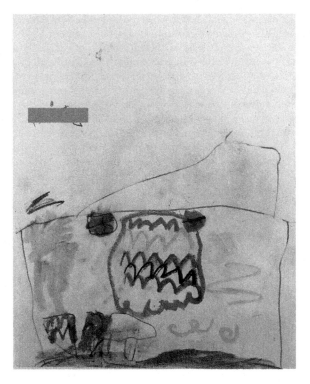

Figure 18.1 Untitled, 2017, Hala's drawing of a house (artwork from summer 2017)

the program and was less familiar with structured environments such as school where they follow certain routines. Furthermore, it appeared as though she had not previously received much exposure to art materials. Discovering the potential of materials through scribbles and random mark-making was one of the most prominent components of her art-making experience. She also was in the process of readjusting to following a daily schedule for the first time in her life; as such, her artworks exhibited unstructured scribbles and pressured lines, as well as attempts to create containment.

Hala continued discovering the theme of family and home in her artworks the following year as well; however, unlike the previous year, she drew more grounded structures to which she gave windows and a door (Figure 18.2). While timid in her expression and communication the first year, Hala became one of the most outgoing and proactive children in the group during the second summer together. She was one of the first children to respond when an activity was presented and became increasingly eager to share stories about her artwork as well. When she made art, she would often call me over, show me what she has done, and say "very beautiful" or "these colors are so nice." Her artwork exhibited her desire to communicate in a more organized fashion, as she seemed to have more deliberate mark makings and incorporated her perseverative marks in the formal elements of the pictures such as the rain or the door.

Hala drew a house with apparent harsh weather conditions outside and shared that there was a family living in this house with a grandmother, two siblings, and parents (Figure 18.3). She then said, "these are a happy family though, not like my family" while she made fists with both her hands and acted as if she was punching the air. In moments where she had a harder time explaining what she wanted to express, I would provide a fresh sheet of paper for her to try drawing her feelings. Yet, she would often decline this option and ask if she could help or assist me instead of drawing. Sometimes, she would

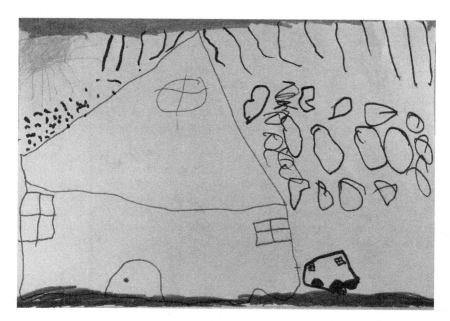

Figure 18.2 Untitled, 2018, Hala's drawing of "a house with a happy family"

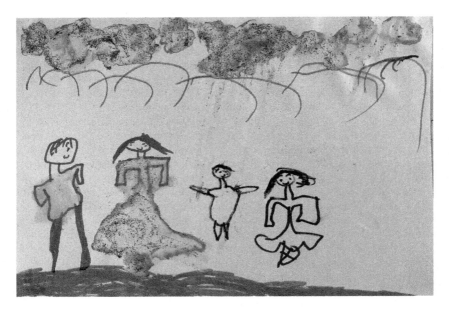

Figure 18.3 Untitled, 2018, Hala and her family "speaking about peace"

not propose to help but would stay quiet until she was ready to join the group again. Hala seemingly had days when she was not feeling well and struggled to express her internal state. I wondered whether her family situation could shed light into what was troubling her.

As reported by Hala's mother to the Director of the Yusra Community Center, Hala's father had a history of domestic violence including emotional and physical abuse toward his wife and children. His wife shared with the community center's director that her husband had been preventing her from coming to the center to attend women's classes and owning a cell phone. Hala later drew herself with her family "speaking about peace." It struck me how she seemed to inhibit her father's arms by drawing them so short, perhaps drawing him in an immobile state as an attempt to exert control over his violent nature.

In another image, Hala drew her family going to the mosque to pray together (Figure 18.4). In previous groups, all children including Hala drew a mosque to represent peace. Therefore, her symbolic attempt to bring her family together in a place associated with peace may have been her desire for reconciliation within her family. Moreover, Hala's drawings revealed her ability to use art to take control, resolve interfamilial conflicts, and recover. Positive perceptions of self and family can also support resilience and promote adaptation (Sirin & Rogers-Sirin, 2015).

A GROUP ARTWORK TO PROMOTE CONNECTEDNESS WITHIN THE COMMUNITY

In the following case, children were encouraged to create an imaginary community through a group art project. During the first week of groups, children appeared reluctant to share art materials, the art space, or even the attention of the instructors. By using

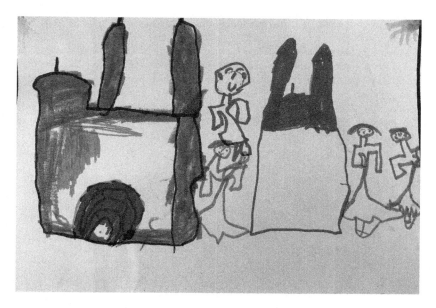

Figure 18.4 Untitled, 2018, Hala and her family "going to the mosque"

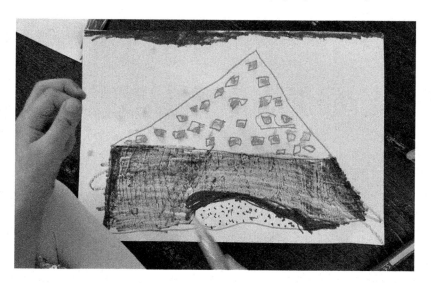

Figure 18.5 Untitled, 2018, Hala's drawing of "the big school" (elementary school)

positive reinforcement and assurances that they would all receive adequate amounts of materials, the children appeared to be more flexible in sharing. By the last weeks of groups, they became more accustomed to respecting each other's space and had more familiarity in sharing with others. As we approached an end to our eight-week art therapy program, it was time to engage them in a collaborative group artwork—building a

community with local materials, including milk cartons and other recycled craft materials (Figure 18.6).

Volunteers had a supportive presence through the process, both in providing children with assistance as they needed and through discussion about what they wanted to do with their piece. Before the onset of active art-making, we spent some time talking about what makes a community. While many of the children said a home is essential in creating a community, others said they would like to make a school or a grocery store. Once everyone had an idea about what they wanted to do, they chose a milk carton and painted or covered it with tissue paper (Figures 18.7 and 18.8).

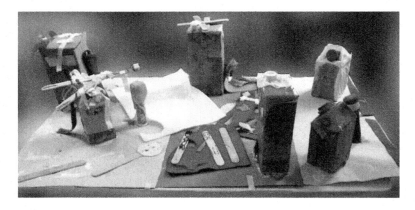

Figure 18.6 Building a community, 2018

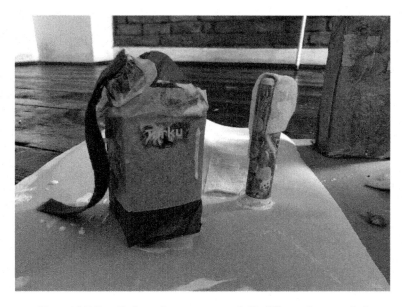

Figure 18.7 Details from the group artwork "Building a Community"

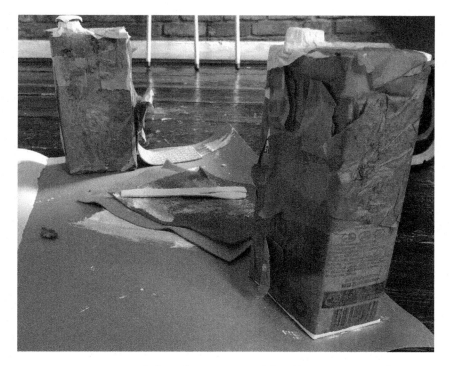

Figure 18.8 Details from the group artwork "Building a Community"

When everyone was finished decorating their piece, I put a large cardboard paper on the floor and invited the youth to position their structure somewhere on the paper (Figure 18.9). Those who didn't want to attach their artwork on the shared cardboard were given smaller pieces of separate cardboard; if they wished to connect with others, they were encouraged to bring their cardboard next to the shared one. Lastly, in order to bring this community to life, children made popsicle stick humans and practiced interactions between them. Interpersonal relationships between members of a community is correlated with individual's ability to cope with adversity and is an element of resiliency (Tol et al., 2013). This activity provided children with the opportunity to have individual space and come together to explore a new space as a community through artwork.

At the end of this two-month art therapy initiative, children's achievements were celebrated with an exhibition at the community center. Every child chose two pieces of art to exhibit, which were then framed and hung on the walls. Families were invited to learn about their child's artwork. On the day of the exhibition, each child was provided time and space to talk about their art and processes if they wished. Our program ending also corresponded with the end of the school year for Yusra, as almost half of the classroom was ready to start elementary school next fall. In our last session together, older children shared their excitement for "the big school" while hesitantly acknowledging their emotions about the end of program at Yusra. Throughout the two months of art therapy groups, the participating children had practiced creative self-expression and social

Figure 18.9 Children working on their group artwork "Building a Community"

skills, leading to an increased ability for affect regulation and emotional expression as well as adaptive behaviors in group.

Discussion

These two case vignettes serve to illustrate two tiers of arts-based psychosocial support that can be provided in the service of resiliency building in children and adolescents impacted by conflict and displacement. One case addresses the use of arts-based support for capacity building from a macro lens, and the other provides a closer look at direct services to children in a culturally and linguistically sensitive manner. Both cases share an approach of a guided effort to advocate and make space for creativity and the creative process as a psychosocial and community response to trauma, displacement, and loss.

The short-term art therapy interventions described in these vignettes represent an opportunity for recognizing "inherent strengths and norms" within the populations served. The perils and chaos of exposure to war, as well as the journey to safety, may be overwhelming and destructive to a child's sense of safety. However, creativity is an inherent protective factor and may promote a sense of normalcy. The artwork seen here represents the distinct need of the children and supporting adults to create and illustrate their surroundings. The frame of resilience in this artwork is in lived experience of chaos and uncertainty—but that frame includes color, centrality of images, and examples of life (including homes, families, clouds, the sun). Resilience may also mean acknowledging loss and finding ways in which to express components of loss.

Group interventions may provide youth an opportunity to experience protective processes, as well as strengthening the connectedness among the community (Betancourt & Williams, 2008). The group project of building a community in Case Vignette 2 presented opportunities for children to discuss what community means for them and

reflect it in a shared piece where they presented their everyday life. Through using milk cartons as structures of the living environment, children built the neighborhood they live in by creating houses, grocery stores, and a school. The socioecological framework identifies school and the surrounding community of the child to have a special role in emotional adjustment, and cohesive experiences within the neighborhood are associated with positive mental health (Betancourt, 2005). The resilience of a community is dependent on the available resources in the living environment (Cutter et al., 2008). Within this context, symbolic creation of these resources in the post-conflict setting can empower the children through allowing them to negotiate and control what they want to have in their new living environment.

Finding the space for creativity in the settings illustrated in this chapter is a dynamic and layered process. Space may be viewed as the dyad between trainer and practitioner, as seen in the case study from Iraq, as well as the direct interactions with youth (Case Vignette 2). Space may also be viewed as the environments in which creative arts are introduced—in a hotel in Erbil, a refugee camp, or a community center. Identifying the space to create and foster creativity requires attunement with the environment and an openness to seeing beyond our own cultural identities. The creation of the space for creativity also means building inclusivity in approach, especially in contexts involving conflict and displacement, where a sense of belonging and safety is markedly lost.

In times of displacement and forced migration, children compromise the secure and grounding aspects of childhood (Gray, 2014). Once resettled into a new and safe environment, the healing and restoration process begins. This process includes provision of basic needs; mental health services should be considered as a part of these needs in order to support children's psychological recovery (IASC, 2007; United Nations General Assembly, 1989). When addressing trauma and stressors of displacement, arts-based interventions are proven to be an effective treatment modality to address depressive and anxiety symptoms, decrease trauma symptoms, increase psychosocial functioning, and improve well-being (Möhlen, Parzer, Resch, & Brunner, 2005; Ager et al., 2011; Malchiodi, 2014). Moreover, creative interventions may contribute to the normalization of social conditions in the state of uncertainty. Through the creative process in a group intervention, children reclaim connection with the community and support systems prior to relocation.

Both case studies illustrate an emphasis on sustainability. In Iraqi Kurdistan, the pre-existing clinical structure of the organization lent itself to the rather seamless introduction of art-based interventions within the work. In Turkey, capacity building was also intentional, through the training of volunteers, who are on the path to becoming practitioners in the country. As art therapists who facilitate short-term interventions, questions of whether such programs benefit the community arise during the course of our work, as we know we will not be able to provide our services over an extended period of time. In these two cases, we depended on volunteers and community-based mental health professionals to provide both the cultural competency and continuity of the art therapy interventions. When someone volunteers to serve in their own community, that desire often stems from genuine care and willingness to engage. But how do we, as art therapists, channel this willingness into sustainable practice? Perhaps capacity building efforts of civil initiatives such as the Jiyan Foundation are a step in the direction of sustainable, ethical art therapy practice.

When designing and facilitating trauma-informed creative spaces and services, it is imperative to follow a culturally sensitive approach, calling upon the strengths, norms, and resources inherent to the family and culture of the community served. For example,

refugees are often offered mental health services that stem from Western theory that may not resonate with the local community, unless it is culturally adjusted by the intuitiveness of the clinician (Stauffer, 2008). When speaking about cultural norms and strengths, the concept of peace that arose in the second case vignette presents an example of how these concepts can differ based on the culture of origin. In one of the group discussions, children talked about what peace means and were encouraged to think of a peaceful place. All of the children in the group agreed that a mosque is where they feel peaceful. Some of the children drew their family going to the mosque, and some drew themselves inside the mosque when they were asked to draw this peaceful place. As this example demonstrates, inherent strengths of a culture, such as religious practices and belief systems in this case, can be presented as a protective factor for children who are affected by war and displacement (Ungar, 2012). Although cultural practices, belief systems, and social support are imperative for resiliency, the therapist must keep in mind that trauma often has ongoing impact on people's lives and a child might continue to face adversity due to intra-familial stressors.

With the clear benefit and need of art-based interventions amongst children and adolescents in conflict settings, we must think critically as to how the field and practice of art therapy can play a role in these places where there are not yet formalized art therapy institutions. In these settings, we recommend the omission of the term "art therapy" in training, capacity building, and program development, instead looking more to the use of "arts-based psychosocial support" or even simply the descriptive use of "art-making." By avoiding the use of "art therapy," we are ethically protecting and respecting the profession, acknowledging it as one that takes years of study and practice and cannot be taught in just a few sessions, weeks, or months. Additionally, in our experience, especially when working with paraprofessionals or non-specialists within communities, the term "therapy" can evoke much stigma and pathologization. In focusing on the process of art-making, we are instead able to connect on a creative and expressive level, meeting in the space of culture, instead of the often hegemonic, Western medicalized approach to therapy. This can open up ways of interacting that are less intimidating, more creative, and thus child and adolescent friendly.

Art Therapy Recommendations/Interventions

When taking into consideration the integration of arts-based mental health and psychosocial support, it is of utmost importance in any emergency or crisis situation to first assess the immediate safety and basic security needs of children, youth, families, and communities. This type of assessment, sometimes called a "rapid needs assessment" or "situational analysis" in international humanitarian settings, balances the perceived needs of those affected by emergency with the appropriate intervention. Per the IASC Intervention guidelines for Mental Health and Psychosocial Support in Emergency Settings (2007), a response should be complementary and interdisciplinary across a tier of supports—from basic security and shelter to community supports to focused non-specialized supports for individuals and families to specialized services provided by licensed practitioners. Art therapy may fall within the third tier of focused non-specialized supports, as well as the second tier for community and family supports. It is critical to consider whether or not the benefits of introducing creative arts activities to children will be in their best interest in displacement settings, as security concerns are ongoing and take precedence over any supportive interventions introduced by humanitarian organizations.

In providing short-term therapeutic supports, best practice is to develop supportive environments for children and create space for creativity through therapeutic art activities. The interventions may be facilitated by a licensed clinician but wouldn't be targeted at addressing a specific psychological symptom. Rather, group art therapy interventions may serve to generally decrease distress levels among children and promote play and imagination.

As much as possible, helpers and interpreters in these settings should be educated and informed of the impacts of conflict and displacement on children's minds and bodies. Often times, as noted throughout this chapter, supportive staff who worked alongside the art therapist were of the same community as the youth served in the interventions. The collective impacts of loss and grief are staggering and will likely influence the nonverbal and verbal behaviors of the helpers. Providing time for discussion and consultation, both before and after sessions, is one step in the healing process. Such discussions will likely provide an opportunity to discuss the goal of the intervention, the types of art materials, as well as possibilities of response among children. As supportive staff learn to identify and respond to the creative endeavors of the child, there is also an opportunity to highlight the resilience and strength of the children.

A key opportunity for promoting resilience among children in displacement settings is to be curious about their cultural backgrounds. If an art therapist can maintain a sensitive, open attitude to the nuances of culture, children will likely feel the freedom to express and create imagery reflective of their culture. We must utilize discretion in determining culturally appropriate interventions. Art therapists and other mental health professionals working in displacement settings have a huge responsibility to be thoughtfully aware of the types of interventions they implement with children; to discern the unspoken language of relationships outside of one's own culture, to appreciate and reflect on differences as well as likeness. We must develop a "more complex understanding of the culturally negotiated social experience that comprises art therapy and transform it with ethnorelative, multicultural lenses" (Kapitan, 2015, p. 110).

While one may address physical and emotional safety beforehand, it is expected to have instances which the therapist could use as learning opportunities. Especially when working along volunteers, the therapist must consider issues about competence and consistency as well as logistics of the art therapy space. Before the onset of art therapy interventions, the art therapist should make sure volunteers understand that they commit to serve for the whole duration of the program. Even after making such calculations, the therapist should predict absences and have the flexibility to accommodate instant changes in daily programing. The group leader should also assess safety concerns in the art space beforehand and ensure volunteers understand their responsibility to be mindful and responsible in mitigating these concerns.

Although the therapist may inform volunteers of how to provide a safe space for children in exploration of creative art materials, it is essential to pay attention to observe volunteers' interactions with children. This is especially important during the first few weeks in order to provide volunteers with feedback and support. If possible, it will be ideal to provide volunteers with an extensive overview of child safeguarding, introduction to impacts of trauma and displacement, and an introduction to art materials and therapeutic practices before the interventions begin. The therapist should make effort to recruit volunteers who share similar cultural backgrounds with the children they will serve in order to address the cultural aspects. Volunteers who intrinsically understands the cultural dynamics and value system can attune with the children better as well as inform the therapist about behavior, art-making process, and symbolism presented.

Recommendations for Capacity Building and Training

In order to support the local economy, as well as foster sustainability, it is ideal to source materials locally for training and programs. In addition to using local art brands, making use of found objects such as milk cartons, water bottles, sticks, pebbles, and other various materials will encourage the community to have autonomy in selection of materials and ensure sustainability of the program. The length of training can be as little as three consecutive days to several months spread out over time. Ideally, the space of the training should be conducive to art-making while feeling secure and supportive. However, it is important to maintain a sense of flexibility as often times the space in conflict settings, refugee camps, or community centers is out of one's control. Therefore, we recommend finding trauma-informed and creative ways to define the therapeutic space, such as the circle of fabric used in Kurdistan, introducing other ritual and routine, as well as using the inherently containing nature of the art object.

As we continue to respond to the need for arts-based psychosocial support, we must as a profession think of ways that both respect our field and protect it as we use its tools globally in some of the most high-need regions and settings. We recommend and encourage ongoing dialogue and debate on the ethical use of "art therapy" in trainings and capacity building and how we can best transmit the key concepts of therapeutic art-making while maintaining our integrity of practice and profession. We also must consider the reality of entering an environment for a short-term intervention—does this promote creativity, healing, and resilience if there are no sustainable solutions? Will children benefit from the opportunity to create, explore, and play, even if the intervention cannot be sustained over a longer period of time?

References

Ager, A., Akesson, B., Stark, L., Flouri, E., Okot, B., McCollister, F., & Boothby, N. (2011). The impact of the school-based Psychosocial Structured Activities (PSSA) program on conflict-affected children in northern Uganda. *Journal of Child Psychology and Psychiatry, 52*(11), 1124–1133. https://doi.org/10.1111/1469-7610.2011.02407.x

Altıok, B., & Tosun, S. (2018). *How to coexist? Urban refugees in Turkey: Prospects and challenges* (Policy brief 3–8). Retrieved from https://mirekoc.ku.edu.tr/wp-content/uploads/2018/10/ALTIOK-and-TOSUN-2018-How-to-coexist.pdf

Bardot, H. (2018). Art therapy training for relief workers to provide support and sustainability. *Journal of Applied Arts & Health, 9*(2), 157–169.

Barenbaum, J., Ruchkin, V., & Schwab-Stone, M. (2004). The psychosocial aspects of children exposed to war: Practice and policy initiatives. *Journal of Child Psychology and Psychiatry, 45*(1), 41–62. https://doi.org/10.1046/j.0021-9630.2003.00304.x

Betancourt, T. S. (2005). Stressors, supports and the social ecology of displacement: Psychosocial dimensions of an emergency education program for Chechen adolescents displaced in Ingushetia, Russia. *Culture, Medicine & Psychiatry, 29*(3), 309–340. https://doi.org/10.1007/s11013-005-9170-9

Betancourt, T. S., & Kahn, K. T. (2008). The mental health of children affected by armed conflict: Protective processes and pathways to resilience. *International Review of Psychiatry, 20*, 317–328. https://doi.org/10.1080/09540260802090363

Betancourt, T. S., Meyers-Ohki, S., Charrow, A. P., & Tol, W. A. (2013). Interventions for children affected by war: An ecological perspective on psychological support and mental health. *Harvard Review of Psychiatry, 21*(2), 70–91. https://doi.org/10.1097/HRP.0b013e318283bf8f

Betancourt, T. S., & Williams, T. (2008). Building an evidence base on mental health interventions for children affected by armed conflict. *Intervention* 6(1), 39–56. https://doi.org/10.1097/WTF.0b013e3282f761ff

Bosqui, T. J., & Marshoud, B. (2018). Mechanisms of change for interventions aimed at improving the wellbeing, mental health and resilience of children and adolescents affected by war and armed conflict: A systematic review of reviews. *Conflict and Health, 12*(15). https://doi.org/10.1186/s13031-018-0153-1

Cutter, S. L., Barnes, L., Berry, M., Burton, C., Evans, E., Tate, E., & Webb, J. (2008). A place-based model for understanding community resilience to natural disasters. *Global Environmental Change, 18*(4), 598–606. https://doi.org/10.1016/j.gloenvcha.2008.07.013

De Jong, J. (Ed.). (2002). *Trauma, war, and violence: Public mental health in socio-cultural context.* New York, NY: Kluwer Academic, Plenum Publishers.

Fazel, M., & Betancourt, T. S. (2018). Preventive mental health interventions for refugee children and adolescents in high-income settings. *The Lancet Child and Adolescent Health, 2*(2), 121–132. https://doi.org/10.1016/S2352-4642(17)30147-5

Gray, A. E. (2014). Dance/movement therapy with refugee and survivor children: A healing pathway is a creative process. In C. A. Malchiodi (Ed.), *Creative interventions with traumatized children* (pp. 169–190). New York, NY: The Guilford Press.

Hook, J. N., Davis, D. E., Owen, J., Worthington, E. L., Jr., & Utsey, S. O. (2013). Cultural humility: Measuring openness to culturally diverse clients. *Journal of Counseling Psychology, 60*(3), 353–366. https://doi.org/10.1037/a0032595

Inter-Agency Standing Committee. (2007). *IASC guidelines on mental health and psychosocial support in emergency settings.* Retrieved from www.who.int/mental_health/emergencies/9781424334445/en/

Jiyan Foundation for Human Rights. (2014, October 2). *Our mission.* Retrieved from www.jiyan-foundation.org

Jung, R., Mead, B., Carrasco, J., & Flores, R. (2013). The structure of creative cognition in the brain. *Frontiers in Human Neuroscience, 7.* https://doi.org/10.3389/fnhum.2013.00330

Kalmanowitz, D. (2018). Displacement, art and shelter: Art therapy in a temporary refugee camp. *Journal of Applied Arts & Health, 9*(2), 291–305.

Kalmanowitz, D., & Lloyd, B. (2005). Art therapy and political violence. In D. Kalmanowitz (Ed.), *Art therapy and political violence: With art, without illusion.* New York, NY: Routledge.

Kapitan, L. (2015). Social action in practice: Shifting the ethnocentric lens in cross-cultural art therapy encounters. *Art Therapy: Journal of the American Art Therapy Association, 32*(3), 104–111. https://doi.org/10.1080/07421656.2015.1060403

Klingman, A. (2002). Children under stress of war. In A. La Greca, W. K. Silverman, E. Vernberg, & M. C. Roberts (Eds.), *Helping children cope with disasters and terrorism* (pp. 359–380). Washington, DC: American Psychological Association.

Malchiodi, C. A. (2014). *Creative interventions with traumatized children* (2nd ed.). New York, NY: The Guilford Press.

Metzl, E., & Morrell, M. (2008). The role of creativity in models of resilience: Theoretical exploration and practical applications. *Journal of Creativity in Mental Health, 3*(3), 303–318. https://doi.org/10.1080/15401380802385228

Miller, K. E., & Rasco, L. M. (2004). An ecological framework for addressing the mental health needs of refugee communities. In K. E. Miller & L. M. Rasco (Eds.), *The mental health of refugees: Ecological approaches to healing and adaptation* (pp. 1–64). Mahwah, NJ: Lawrence Erlbaum Associates Publishers.

Möhlen, H., Parzer, P., Resch, F., & Brunner, R. (2005). Psychosocial support for war-traumatized child and adolescent refugees: Evaluation of a short-term treatment program. *Australian & New Zealand Journal of Psychiatry, 39*(1–2), 81–87. https://doi.org/10.1080/j.1440-1614.2005.01513.x

Moon, C. H. (2013). Developing therapeutic arts programs in Kenya and Tanzania: A collaborative consultation approach. In P. Howie, S. Prasad, & J. Kristel (Eds.), *Using art therapy*

with diverse populations: Crossing cultures and abilities. Philadelphia, PA: Jessica Kingsley Publishers.

Patel, V., & Goodman, A. (2007). Researching protective and promotive factors in mental health. *International Journal of Epidemiology, 36*(4), 703–707. https://doi.org/10.1093/ije/dym147

Prescott, M., Sekendur, B., Bailey, B., & Hoshino, J. (2008). Art making as a component and facilitator of resiliency with homeless youth. *Art Therapy: Journal of the American Art Therapy Association, 25*(4), 156–163. https://doi.org/10.1080/07421656.2008.10129549

Reed, R. V., Fazel, M., Jones, L., Panter-Brick, C., & Stein, A. (2012). Mental health of displaced and refugee children resettled in low-income and middle-income countries: Risk and protective factors. *Lancet, 379*(9812), 250–265. https://doi.org/10.1016/S0140-6736(11)60050-0

Sirin, S. R., & Rogers-Sirin, L. (2015). *The educational and mental health needs of Syrian refugee children.* Washington, DC: Migration Policy Institute.

Stauffer, S. (2008). Trauma and disorganized attachment in refugee children: Integrating theories and exploring treatment options. *Refugee Survey Quarterly, 27*(4), 150–163. https://doi.org/10.1093/rsq/hdn057

Sue, D. W., & Sue, D. (2016). *Counseling the culturally different: Theory and practice* (7th ed.). New York, NY: John Wiley & Sons.

Talwar, S. (2015). Culture, diversity and identity: From margins to center. *Art Therapy: Journal of the American Art Therapy Association, 32*(3), 100–103. https://doi.org/10.1080/07421656.2015.1060563

Tol, W. A., Song, S., & Jordans, M. J. (2013). Annual research review: Resilience and mental health in children and adolescents living in areas of armed conflict—a systematic review of findings in low- and middle-income countries. *Journal of Child Psychology and Psychiatry, 54*(4), 445–60. https://doi.org/10.1111/jcpp.12053

United Nations General Assembly. (1989, November 20). Convention on the rights of the child. *United Nations Treaty Series, 1577,* 3. Retrieved from www.refworld.org/docid/3ae6b38f0.html

United Nations High Commissioner for Refugees. (2018a). [Graph illustrations Trend of Registered Syrian Refugees]. *Operational Portal Refugee Situation.* Retrieved from https://data2.unhcr.org/en/situations/syria#_ga=2.125588618.167243194.1532096632-1302632346.1522706643

United Nations High Commissioner for Refugees. (2018b). *Syrian refugees in Iraq stats and locations 31 July 2018.* Retrieved from https://data2.unhcr.org/en/documents/details/65084

United Nations International Children's Emergency Fund. (2018). *Iraq humanitarian situation report August 2018.* Retrieved from https://reliefweb.int/report/iraq/unicef-iraq-monthly-humanitarian-situation-report-august-2018

Ungar, M. (2012). Social ecologies and their contribution to resilience. In M. Ungar (Ed.), *The social ecology of resilience: A handbook of theory and practice* (pp. 13–31). New York, NY: Springer Publishing.

Wolin, S. J., & Wolin, S. (1993). *The resilient self: How survivors of troubled families rise above adversity.* New York, NY: Villard Books.

19

Neither Here nor There

Art Therapy With Unaccompanied Adolescents Seeking Asylum in the United States

PATRICIA LANDÍNEZ GONZÁLEZ

The phenomenon of international migration affects all societies, bringing positive out-comes to individuals, families, and communities in countries of origin, transit, and des-tination. However, the lack of regular and safe channels for children and families to migrate are contributing to children and adolescents taking great risks, including deten-tion, family separation, physical and psychological harm, marginalization, discrimina-tion, and sexual and economical exploitation.

Around the globe, there are 68.5 million forcibly displaced individuals, among them 25.4 are refugees; half of the refugees are children below 18 years of age (UNHCR, 2018). The overall number of refugees increased from 10.4 million in 2011 to 15.5 million in 2016, (UNHCR, 2016). Yet, despite the magnitude of the situation, there is little research to assess the mental health outcomes among unaccompanied children and adolescents, and scarce evidence can be found about the use and effectiveness of art therapy with this population (Orr, 2007). This chapter will focus on art therapy treatment for adoles-cent boys who had traveled unaccompanied from Central America to the U.S. seeking asylum and international protection. Although, no brief case description can fully cap-ture the uniqueness of a typical journey experienced by any one of these young boys—and by no means the root causes and impact on the fabric of the everyday life of them and their families. This case study offers some insight about the complexity of the migra-tion experience, the legal framework that lays downs their rights, and key practical rec-ommendations about how art therapy has been beneficial to understand and provide care for asylum-seeking adolescents in short-term residential facilities located in the U.S. Three case vignettes are used to illustrate the potential of art therapy interventions to support children and adolescents deal with conflict and trauma. Prior to discussing their cases, key information regarding the global trends of migration, the legal frame-work that protects their rights as children, and information about the contributing fac-tors that forced them to leave their home countries to reach the borders of the U.S. are highlighted.

Unaccompanied Adolescents Seeking Asylum in the United States

In the midst of international migration and refugees' movements, there are chil-dren who travel by themselves, have been separated from both parents and other relatives, are not being cared for by an adult, and are facing particularly grave risks

(IAWG-UASC, 2016). UNICEF (2017) highlights that unaccompanied migrant children are the most vulnerable group among all migrants. Around 300,000 unaccompanied and separated children applied for asylum in 80 countries between 2015 and 2016, yet it is believed that the total number of unaccompanied children around the globe is much higher.

Over the past five years, the number of children traveling unaccompanied and apprehended crossing the United State-Mexico border, without permission, has dramatically increased from 4,059 unaccompanied children apprehended by the U.S. Customs and Border Protection in 2011 to 21,537 in 2013 and 68,541 in 2014. (UNHCR, 2014b). Between 2015 and 2016, 100,000 children were apprehended in the same border (UNICEF, 2017). Of the children arrested by immigration authorities in the in the first half of 2014, most came from Honduras (13,282), Guatemala (11,479), Mexico (11,577), and El Salvador (9,850). According to the UNICEF office in Mexico, the number of unaccompanied migrant children and adolescents who were detected by Mexican immigration authorities increased by 333% from 2013 to 2015; approximately three-quarters of all children referred were over 14 years of age, and two-thirds were boys (UNICEF, 2017, UNICEF, 2018).

From mid-April to May 2018, nearly 2,000 children were forcibly separated from their parents after the U.S. Department of Justice announced the "Zero Tolerance Policy for Criminal Illegal Entry" (Lussenhop, 2018;American Art Therapy Association,2018, June 20)). Child welfare and mental health professionals as well as human rights organizations and networks raised their voices to urge the U.S. government to stop this policy due to the long-term effects and psychological impact on children and adolescents after forced separation. Judges, the academia, and the American public protested and urged the U.S. government to stop this policy.

Some new phenomena started mid October 2018; approximately 7,000 to 9,000 people, including women and around 2,300 children, are walking more than 4,000 kilometers from their home countries of Honduras, Guatemala, and El Salvador to the border of the U.S. to seek asylum in the U.S. They are fleeing persecution, poverty, and violence in their home countries (UNHCR, 2018).

Unaccompanied children and adolescents are the most vulnerable group among all migrants. They have left their homes because of gang violence, sexual abuse, abandonment, or neglect and during the migration journey, they can be subjected to forced labor, drug trafficking, human trafficking, and sexual exploitation. The United Nations Human Rights Council in the report "Global Issues of Unaccompanied Migrant Children and Adolescents and Human Rights" (2017) observes children migrate to the U.S. since their rights have been violated. Children are fleeing for survival as they are confronted with harsh and life-threatening experiences; they are victims of gang-related and gender-based violence; they cannot fulfill their right to education and health; and they are repeatedly exposed to threats, intimidation, and insecurity in a lawless environment.

All countries that ratified the Convention on the Rights of the Child (CRC) signed their commitment to protect every child, everywhere; thus, a refugee or migrant child deserves as much state protection as domestic children do (Bhabha, 2014). Globally, under international human rights, notably established in the 1951 Refugee Convention, unaccompanied children are entitled to specific protection and standards of care (United Nations High Commissioner for Refugees UNHCR,1951). It is important to note that the U.S. signed the CRC on 1995 but is the only country that hasn't ratified it.

The U.S. Homeland Security Act of 2002 determined that the Office of Refugee Resettlement (ORR) within the Administration on Children and Families is responsible for providing care to children referred by immigration authorities (Graham, 2014; U.S. Department of Homeland Security. Homeland Security Act of 2002. PUBLIC LAW 107–296—NOV. 25;). Consistent with federal law, ORR/DUCS places children in the least restrictive settings. A network of state-licensed ORR-funded care providers offers classroom education, mental and medical health services, and reunification with a family member or another willing sponsor in the U.S. If the agency cannot find such a sponsor, the child remains in ORR custody. Most unaccompanied children are placed in deportation proceedings before an immigration judge, without the right to appointed counsel, in violation of their due process right. After the reunification, children and adolescents have no legal status in the U.S. and are generally not eligible for healthcare and most other public services (UNICEF, 2016).

The Committee of the Rights of the Child (CRC, 2012) recommends countries to adopt comprehensive human rights-based laws and policies to ensure that all children involved in or affected by international migration enjoy the full protection of the Convention in a timely manner, regardless of age, economic status, or documentation status of themselves or their parents, in both voluntary and involuntary migration situations, whether accompanied or unaccompanied. Based on equality and non-discrimination, all unaccompanied children outside their country of origin are entitled to international protection, regardless of their migrant status.

Understanding the Situation of Children in Their Country of Origin

Guatemala has one of the highest levels of inequality and poverty in the world; over 59% of all children and adolescents live in poverty, and 19.2% are extremely poor (UNICEF, 2015). The indigenous population is the most affected and has suffered systematic racism and discrimination. Most of the children that migrate to the U.S. come from Guatemala's extremely poor regions, often lacking access to the most basic services (Musalo & Ceriani, 2015).

While poverty and social exclusion continue to be important driving factors for migration, violence is the most prevalent factor. Honduras, Guatemala, and El Salvador, also known as the Northern Triangle, have the highest homicide rates on record (UNDOC, 2013). In both 2015 and 2016, El Salvador became the world's most violent country not at war. Honduras and Guatemala are also ranked amongst the highest for violence (UNICEF, 2016). The civil wars fought in the region between the 1970s and 1980s were largely funded by the U.S. (Rosenblum,2015). The surge of criminal organizations following the deportation of gangs' members back to the region and the presence of drug cartels that were pushed to central America as result of the closure of routes through Mexico are some of the roots causes of this violence (The United Nations Human Rights Council, 2016).

In Honduras, migrant children and adolescents experience violence at home. Seven out of ten Salvadoran children are suffering from violence in their homes (Center for Women and Refugee Studies, 2015). The presence of gangs increases their vulnerability through harassment, threats, and pressures to comply with or join the armed gangs (IACHR, 2015; American Immigration Council, 2014, July 10).

Amnesty International (2016) observed that although the migration flow from the Northern Triangle countries to the U.S. has always occurred, during the past decade

violence has become the key expulsion factor in El Salvador and Honduras. Since 1998, 9,881 Hondurans under the age of 23 have been murdered. Parents who have left for the U.S. have left behind thousands of Honduran children. Without parents to protect and support them, they are more vulnerable to gang violence and recruitment. In El Salvador, violence by gangs and organized crime has multiplied disproportionately, victimizing children and adolescents. The vast majority of victims are male and young; boys continue to be forcibly recruited by gangs and those who refuse are at risk of violent retaliation. Despite the dangers they may encounter during the traveling journey, adolescents prefer to travel to the U.S. a nation perceived as having higher standards of living and, above all, safety, education, and job opportunities.

As van der Kolk (2014) speculated, in our times it is difficult to separate trauma from politics as we cannot ignore the fact that the homeland determines the risks of developing traumatic stress, as well as access and quality of basic services.

The Migration Experience

Clinicians working with this population should be sensitively aware to the associated risks of migration, careful to avoid minimizing or overestimating the nature of the threats survived. The asylum seeker/refugee experience is best understood through delineated stages. Papadopoulos (2002) identified four phases of the migration experience, each being potentially traumatizing for refugees. The first phase, "devastating events," occurs when refugees experience actual violence against them that forces them to leave their homes. In the "anticipation phase," an individual starts to design plans to migrate, sometimes having to make quick, important life-changing decisions. Next is the "survival phase," when refugees are safe from physical violence but live in temporary shelters, short-term residential centers, or camps. During this stage, refugees experience confusion about the past and uncertainty about the future. Finally, during the "adjustment phase," refugees have to make extraordinary efforts to adjust to their new home in exile while grieving all that was left behind. During the migration journey, resettlement and acculturation process, children might experience several stressors and potentially traumatic events that affect their psychosocial well-being. Not to forget that in case of the refusal of asylum, children might experience even higher levels of psychological distress (Pieloch, Marks, & McCullough, 2016).

Migration impacts adolescent development substantially. When adolescents are confronted with uprooting, loss, and exposure to traumatic experiences, their psychological development can be hindered. Continued or cumulative exposure to stressors can have long-lasting impacts on adolescent's neurobiological development, physical health, and psychology. Some adolescents may experience a delay in cognitive development; disruption of children's neurobiology might compromise mental flexibility, memory, planning, attention, decision making, and impulse control. (Paris et al., 2018; Bloss (1979); Fong. & Earner (2007); Kimmel & Weiner (1985); Kinzie (2007); Mejia- Arauz, Sheets, & Villasenor (2012); Morris (2012); and Van Den Veer (1998)) Observational learning might be interrupted given that parents and caregivers are not present to act as role models or offer support in times of adversity (Arnett, 2000; Zubenko, 2002). Losses might also threaten the sense of identity, as they have to integrate many new sociocultural images. Moreover, the feeling that everything has changed, including their personality, might also affect their identity formation (Zubenko, 2002; Majumder, O'Reilly, Karon, & Vostanis, 2015; Levy-Warren, 1996).

Art Therapy in Practice: An Open Studio Art Therapy Group to Ensure Psychological First Aid Intervention

Typically, individuals affected by a tragic or traumatic event are suddenly struggling to cope with the loss and the disruption of their day-to-day routine. Individuals with a history of mental illness, past traumatic experiences, and limited family and social supports may be more reactive to trauma (WHO, 2013; Kirmayer, Lemelson, & Barad, 2007)

Van der Kolk (1987) asserts that trauma may occur when an individual loses a sense of having a safe place within or outside oneself to deal with frightening emotions and experiences. Some researchers suggest that asylum seekers and refugees are at substantial risk of developing post-traumatic stress disorder (Ter Heide, Mooren, & Kleber, 2016). In contrast, others (Bonanno, 2004; Papadopoulos, 2007; Pieloch, 2016) contest that too much attention has been given to the psychopathological consequences of traumatic events, yet individuals react normally to adversity, and many survivors do not develop any pathology after been confronted with great adversity.

Challenging the assumption that traumatic encounters are disturbing to everyone, Papadopoulos (2007) noted that most refugees and asylum seekers, after surviving immense adversity, tend to be resilient and resourceful. He advocates for a better understanding of the situation of the refugee population and invites mental health workers to focus on the strengths and other positive outcomes, rather than only identifying the pathological consequences and problems of the refugee population. Several authors argue that the concept of resilience has opened new avenues for understanding human behavior and the inherent coping mechanisms that, despite extreme traumatic experiences, allow human beings to survive without the development of pathology (Bonanno, 2004; Masten, 2014; Rutter, 1987; Prescott, Sekendur, Bailey, & Hoshino, 2008; Mohr 2014).

Since the late 1990s, the concept of resilience has received increased attention in the trauma literature, highlighting the ability to resurrect from adversity (O' Dougherty, Masten, & Narayan, 2013). For van der Kolk (2014), resilience has to do with agency. Masten (2014) notes that resilience does not come from rare and special qualities, but it is something inherent to the person and is part of the normative human resources in the one's mind, brain, and body; in families and relationships; and in communities. Shalev and Errera (2008) have concluded that there are many resilience trajectories and many ways in which survivors can fully or partially recover and ultimately return to an "ordinary" life. Yet, resilient survivors could be perceived as having scars and survivors with symptoms of PTSD as having open wounds. Finally, Papadopoulos (2007) observes that besides the negative effects, a traumatic event could possibly imply positive effects. He introduces a new trauma grid with three possible responses to adversity: negative reactions, resilience, and adversity activated development. This last concept refers to a positive response because of exposure to adversity, meaning that adversity exposes an individual's limits and might open new horizons beyond what have been previously planned or even imagined.

If loss and trauma are understood to be abnormal events for adolescents, intervention aims to create a safe space in which they can explore their feelings and emotions and start to integrate their experiences into their present life. Creativity provides the means to access a space, an interface between the inner world and external reality where children can play and discover a sense of self (Winnicott, 1975). Fitzpatrick (2002) studied the potential value of using art therapy as an intervention with Bosnian female

refugees in Australia, concluding art-making within a therapeutic relationship facilitates the process of remembering, mourning, and reconstructing experiences of trauma. She further explains that art can be understood as an external map of the internal world of the human being; thus, the art process and art product might offer the artist a valuable opportunity to look at and experience the world in a new way and to be challenged, moved, stimulated, and soothed.

Likewise, Johnson (1987) highlights the special role that art therapy plays in assessing early stages of treatment of psychological trauma. Art therapy enables children to revisit the trauma symbolically, thereby controlling emerging memories and integrating experiences without overwhelming them (Appleton, 2001; Lusebrink, 1989; Naumburg, 1958; Stronach-Buschel, 1990. Play and exploration, artistic and creative pursuits, and some form of involvement with others might help individuals deal with issues of helplessness and passivity created by exposure to traumatic events (van del Kolk, 1996).

Art therapy offers invitation and media to access traumatic images and memories, which, because of trauma, are neurologically encoded in visually dominated forms. Looman, 2006; observed that encouraging children to tell their stories through drawings provided them an opportunity to share their feelings and enabled practitioners to gain a better understanding of children's experiences, reactions, and coping mechanisms in response to difficult events.

Although the role of art therapy as a means of preventive intervention or early crisis intervention in the aftermath of psychological trauma is minimally documented, the art product and the art-making process can provide significant evidence of critical issues, emotional reactions, and coping patterns that ultimately enhance the understanding of individual reactions to traumatic experiences. Furthermore, creative interventions provide a temporary protective environment that allows adolescents to reveal and share their feelings, release tension, and explore new coping mechanisms at their own pace in times of crisis (Klingman, Koenigsfeld, & Markman, 1987; Riley, 1999).

Following, three case vignettes illustrate the potential of art therapy interventions to support children and adolescents deal with conflicted material and trauma. Themes found in the boys' artwork, together with their verbal expression and behavior, are discussed, particularly in relation to the role of art therapy in helping them deal with multiple stressors related to their past, present, and future situations.

Case vignettes are derived from clinical practice at a federally funded program providing short-term residential placement, education, health, and therapeutic support to unaccompanied children while waiting to be reunited with their sponsors in the U.S. An open studio approach enabled participants to explore materials freely. The open studio approach evoked a less fear-provoking experience. This approach countered the required, series of individual interviews where they were continually questioned, tested, and asked to precisely recount their migration journey.

At the start of each session, the rules and purposes of the group were reiterated, ensuring a sense of safety for newly arrived participants and existing group members. Most of the session was devoted non-directive art-making. Participants were given the option to take their work or store it in the group art portfolio. This facilitated a greater command of possession and trust for these involuntarily held participants.

Art therapy open group was offered as a safe space in which participants could express, graphically or verbally, anything they wanted to communicate about their past, present, or perspectives around their future. Individual art therapy was offered to some of the participants presenting observable manifestations of complex psychological distress.

Miguel: Art Therapy Utilized to Foster Resilience

Miguel was a 17-year-old cisgender boy from a very small town in south of Guatemala. He belonged to the K'iche' indigenous community and recently had migrated to the U.S. Up until a few weeks before his arrival, he had been living with his parental grandparents in Guatemala, helping with the farm and household chores. According to Miguel, he only attended school until the fourth grade. In our first encounter, Miguel appeared introverted, respectful, and obedient toward adults. He also seemed to have difficulties having a full conversation in Spanish. His native language was K'iche, a Mayan language spoken in the highlands of Guatemala.

In the first art therapy group, Miguel drew a colorful landscape (Figure 19.1.1). Miguel's first drawing suggests painful feelings related to his present situation and recent separation from his family and community. The rain clouds could be viewed as two tearful eyes. A wall of barbed wire interrupts the flying bird, which appears heavy and not grounded, trying to find its way—probably a place to land—and it seems to be hurt/burned in its chest. The sharp lines of the green grass and the clouds suggest that the bird might be entrapped inside a hostile and aggressive environment. Feelings of emptiness, frustration, and caught in transience, unable to either land or go back are suggested in this representation of his present experience.

Miguel was deeply engaged in the art-making process in the next session. Using clay, he created a colorful flower in a pot (Figure 19.1.2). The appearance of the pot/container suggests feelings of entrapment and uprooting as the plant is being transplanted. The

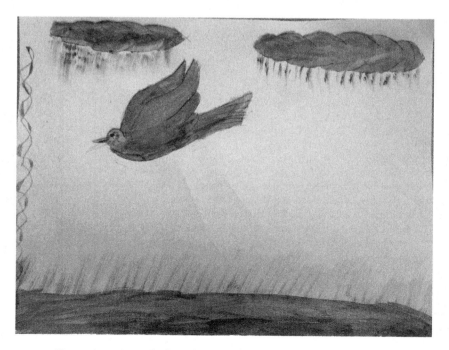

Figure 19.1.1 Miguel's bird drawing, first group session, regular pencil and tempera, 11 × 14

Figure 19.1.2 Miguel´s flower, second group session, clay and paint, 8 × 3

flower is strong and colorful and has a provisional solid base that supports it. Miguel might possibly have been communicating a pressing need to be held, to find a ground in which the flower could be nourished and continue to grow.

In the third group session, Miguel used pencil to depict a scene from New York City (Figure 19.1.3). He explained that over the weekend, he had been invited to visit Ground Zero in Manhattan. When he finished drawing, he described his experience about never having seen such large buildings before or using an escalator. He had difficulties describing his experience verbally and graphically; he did not know the words to describe the large buildings and escalators. However, what struck him the most was the survival tree, the only living thing that had survived the tragedy of 9/11. One can suppose that Miguel derived meaningful associations from his visit to Ground Zero—humans, like trees, have the capacity to survive despite intense adversity. At the beginning of the fourth and last group session, I gave Miguel a journal that had a drawing of a tree on its cover. He stated that he would like to draw what he thought would be the first page of his new journal (Figure 19.1.4). Drawing his hometown, he explained his grandparents' house, the town,

Figure 19.1.3 Miguel´s ground zero drawing, third group session, regular pencil, 12 × 16

Figure 19.1.4 Miguel´s hometown drawing, fourth group session, pencil and colored pencils, 12 × 16

local shopping, and the parking lot for the buses departing to the capital of Guatemala. The art allowed Miguel playfully to revisit positive memories from his hometown, perhaps symbolic of the land that provided soil and water for his earlier created flower. At the end of the session, we spent time searching for images and information about the U.S. state to which he was going to be released the next day.

An open studio art therapy offered an opportunity to experience a sense of safety; revisit memories of his life before his migration; reflect his strengths; and enhance self-esteem, self-achievement, and the confidence needed to function with normalcy.

Simon: Crisis Intervention in the Aftermath of Great Adversity

Simon was a 15-year-old cisgender boy who had lived with his grandmother, aunt, and younger siblings in Honduras. According to Simon, his mother had abandoned him when he was a young child. His aunt, the financial support for the entire household, died one year ago. Simon traveled to the U.S., hoping he would find a job to financially support his siblings and grandmother back in Honduras.

Simon participated quietly in four group sessions and three individual art therapy sessions. During the third group session, Simon created the flag of his home country and its five stars. In the middle of the flag, he wrote his nickname in bold letters and then covered them with red paint. Using green paint, he wrote "What you see, you do not ask about it" (Fig. 19.2.1).

Two weeks after Simon's arrival to the program, teachers were concerned about changes in Simon's behavior and requested individual art therapy. During the first

Figure 19.2.1 Simon's flag drawing, second group session, pencil and tempera, 11 × 14

individual session, Simon did not engage in the art-making process. Instead, he talked continuously. He began disclosing feelings of abandonment by this mother, adding, "My mother treated me like a dog. She left me in the hands of my grandmother and then she left. She did the same to my siblings." He said that he did not have any contact with his mother, but he knew she had other children.

Without prompting, he recounted his migration journey, leaving him tired and disoriented at the end of the session. He explained that he had traveled with a younger cousin for about 45 days, and they were robbed several times. At one point, he was lost for about a week, sleeping under bridges in Mexico. While in one of the homes for migrants in Mexico, the "coyote," or the migration "guide," sexually molested him. During the second individual session, I suggested that he could make a collage by selecting images from the magazines available in the art therapy room. He made a collage using seven images (Figure 19.2.2).

Images included: a portrait of President Obama and his wife, who Simon identified reflected his motivation to come to the U.S. a female angel, representing his deceased aunt; a female face representing the mother he wished to have had; a mother elephant caressing the head of its baby, representing the love of a mother that he longed for; a storehouse, which reminded him of his Honduran home; a black luxury car as an aspiring purchase for this future; and finally the image of a blue eye, saying that his life probably would have been different if he had been born with blue eyes. At the end of the session, he took his piece with him. Equipped with cardboard, glue, and the attuned presence of the therapist, Simon had condensed into one piece his past, present, and future, grieving losses and setting goals. It was astonishing to witness Simon's capability to consolidate and organize the losses and gaps he had experienced, together with wishes and hopes for his future.

Figure 19.2.2 Simon´s first collage, second individual session, magazine images, 12 × 16

In the third and last individual session, Simon chose to do another collage (Fig. 19.2.3). After carefully selecting the images in silence, he said that he had selected the pictures because he liked them or found them funny. However, he also said that he identified with the image of the dolphin. "The dolphin is like me, navigating in the deep sea with scars all over his body." Simon's artwork suggested loneliness, isolation, and emotional and physical pain. After four weeks in the short residential facility, Simon was discharged to a sponsor in another state.

The migration experiences described were extreme, and it was difficult to ascertain how long and how much his recent experience would impact his mental health and development. In addition to his hazardous journey, when he arrived in the U.S., he was challenged by other stressors: concerns for his family back home, deportation, and lack of information about the duration and outcome of the asylum-seeking procedure.

In individual art therapy, Simon created collages, and the freedom of manipulating images seemingly increased his sense of control over the past and present stressful events and helped to mitigate the tensions related to his current situation. Creative experiences counterbalanced the multiple losses experienced, providing a safe space. Furthermost, the most important experience for Simon may have been finding a safe space so that he could start integrating his recent migratory experience.

While pictorial indications suggested developmentally normative interests of graffiti, cartoons, and luxury cars for this adolescent, he was also forced to assume an adult role by being responsible for his younger siblings and grandmother. More time and space was needed to unravel the multiple traumas experienced during his migratory journey. However, Simon's expression indicates his recent migration prompted memories of unresolved trauma related to the abandonment by hssis mother. With hope, I believe

Figure 19.2.3 Simon's second collage, third individual session, magazine images, 12 × 16

that Simon will be given the opportunity to discover this potential far beyond what he has ever imagined in spite of the adversity experienced.

The use of imagery and sensorimotor experiences offered through material manipulation are potentially more effective for accessing traumatic images and memories (Appleton, 2001; Fitzpatrick, 2002; Stronach-Buschel, 1990; van der Kolk, 1996). After documenting six years of working with asylum seekers and refugees, Drozdek and Bolwerk (2010) conclude that early treatment is effective in a therapeutic setting to restore safety and aid expression to assimilate recent experiences. Several other authors (Johnson, 1987; Klingman et al., 1987; van der Kolk, 1996) have recognized early crisis intervention prevents symptoms of mental illness when traumatic events negatively affect perceptions about the world being safe and predictable. WHO (2013) recommends that, in the immediate aftermath of a disaster, the main objectives for mental health intervention should include the following: 1) provide safe and secure space for survivors; 2) help individuals find solutions to day-to-day issues; and 3) focus on the strengths of the individual and the community efforts to regroup and return the individual to normal functioning.

Fabio: Assessing Mental Health Needs

Fabio, 17 years old, had been born in Mexico and recently crossed the border when he began to participate in the open studio art therapy sessions. Fabio did not share any personal information outside of what he graphically expressed throughout four art therapy group sessions. No other psychosocial information was available.

At the start of the first group session, Fabio observed his peers. Then, he asked for a ruler. He started to make a frame by using the ruler and pencil, and he continued by drawing a cross in the middle of the paper, filling in the frame in brown marker (Figure 19.3.1). Working slowly in silence, he would stop drawing to observe others with caution and suspicion. At the end, he stated that he had drawn a cross because he used to go to church. Fabio had made extraordinary effort to keep perfect control of stroke. In the second group session, Fabio colored the cross and included his initials right in the middle. He then filled in the white space with heavily pressured dot marks. At the end of the session, he rapidly sketched a penis on a piece of paper. He solicited attention by intimidating his peers and throwing the paper around the table and accusing his peers of drawing the penis. He was reminded about the agreed rules of the group.

At first, I thought that Fabio's first drawing was related to some religious belief. However, when he placed his initials in the middle of the cross, I started to wonder about the meaning behind it. Was he provocative? Was he communicating something about death and sacrifice? Why was his drawing suggesting that the cross was lying in the middle of a graveyard? Is his drawing connected with his past in Mexico or his journey to the U.S.? Those and many other questions were unanswered. Individual treatment was not available at that time for Fabio. During the third session, Fabio painted the flag of his home country (Figure 19.3.2).

At the fourth and final session, Fabio stated he would prefer to sleep. I replied that the space meant to be used in whatever way they believed would be most beneficial for them and that if he strongly believed that what he most needed was to sleep, I would be happy to provide that space for him. After my remark, he decided to start drawing what he called "the human figure." When he showed his drawing to the group, other members laughed loudly (Figure 19.3.3.)

Figure 19.3.1 Fabio's cross drawing, first group session, regular pencil and markers, 8.3 × 11.7

Figure 19.3.2 Fabio's flag painting, tempera, 8.3 × 11.7

The last drawing made by this young artist presented psychotic-like characteristics. The drawing portrayed a fragmented and distorted representation of the reality. Displacement and condensation of different parts of the body were evident. The head seemed to be displaced to the torso; the eyes became the breast. The head had a transparency quality, and therefore the brain was visible. The hair seemed to be a projection of sturdy goose bumps, and the penis suggested a bunch of grapes. The arms and the legs seemed boneless and made of jelly, making the body unsteady. In addition, it seemed as if Fabio were confused, for he wrote the title of his piece below the drawing, first using the plural noun "Los" then erasing it and putting in the singular noun "El." It is difficult

Figure 19.3.3 Fabio's human body drawing, regular pencil, 12 × 16

to know if that inaccuracy was related to a low level of literacy, a sign of ego fragmentation, or just a simple error.

Verbal and nonverbal behaviors in conjunction with art-making, provides insight into the mental healthcare needs of asylum seekers and refugee populations. Fabio was referred for psychiatric evaluation.

Practical Considerations

The following practical considerations might be valuable to facilitate an open art therapy studio with unaccompanied adolescents from Central America seeking asylum in the U.S.

As they have recently gone through painful and hazardous experiences, it is paramount to install a safe place for them. Ensuring a sense of safety and comfort can be safeguarded by clearly informing them about the purpose of the group, providing the space to heal and thrive, and establishing rules of the group at the beginning of every session. It is possible that this population had limited or no access to mental health services in their home countries, and thus it is important to explain the concept of confidentiality in simple terms. Art therapist and members should be respectful and aware of differences on beliefs, religion, cultural views, and gender issues.

As adolescents in the residential care centers had scarce opportunities to experience autonomy, a non-structured art therapy approach should be favored. In every session, once the goal and rules are reiterated and understood by all, members of the group are introduced to available materials and are encouraged to explore and select the material they want to work with. Art therapists provide support and remain emotionally and physically present, without overwhelming them with many instructions or technical explanations. However, it is recommended to have an inventory of directives to assist those members who feel less threatened by having some directives and instructions. Art therapists should be flexible enough to follow the need of the group and the individuals as they unfold. Individual art therapy could be offered to some adolescents expressing complex psychological distress to support their healing process.

At the end of the session, members are encouraged to show their art pieces and say anything they want about it. Art therapists support group members to reflect on their experience by asking questions regarding the art product and process. Each group member decides what they want to do with their artwork: they can keep it, store it safely in the art room, or destroy it if they must.

Facilities and resources include the presence of an art therapist, preferably bilingual, and a suitable art room with organized art material at their disposal. If there is not a bilingual art therapist, the presence of a co-therapist translator should be available to ensure communication with members of the group in their mother tongue. It is important to have a referral system in place in case a member of the group needs specialized psychiatric or medical treatment.

Drawing, painting, collage, modeling clay, or crafting can be used by members as a means to communicate what they often have no words to describe. This approach supports the health of the adolescents, de-pathologizes the migrant adolescent, normalizes their reactions after their migration journeys and assists referral to specialized medical or psychiatric diagnosis and care if needed. Art therapists are encouraged to know more about the children's country of origin; their rights as children in the U.S, the contributing factors that cultivate victimization; and existing gaps, disparities, extreme violence, and discrimination that forced them to leave their home countries to reach the borders

of the U.S. Clinicians working with this population should be sensitively aware of the associated risks of migration and be careful to avoid minimizing or overestimating the nature of the threats survived.

Finally, it is my duty, as a mental health professional and child rights advocate, to ask all readers to ensure that policies and programs to protect and care for this population are designed, taking into consideration the best interests of the child. As mental health professionals, we are all aware of the importance of maintaining families together, and thus I advocate for children and adolescents from Central America to have access to their right to protection, to live in safety and be reunified with their families living in the U.S. In times of crisis, we should join our voices to ensure that immigration legislation respects family unity and the right to live in safety that all children and adolescents have, regardless of their home country or legal status.

Conclusion

Although, it was assumed that all participants potentially had had some exposure to a multitude of stressors during all phases of their migration, the art therapy interventions described in this chapter highlight that most asylum seekers hold capacity for resilience and resourcefulness, inviting professionals to consider that besides the negative effects, a traumatic event can be overcome and stimulate post-traumatic growth.

Regardless of their different life experiences and origins, art-making was an activity they were familiar with. While held in a residential care facility, the open art therapy studio allowed adolescents to experience the expansive potential of art-making that afforded freedom of expression and encouraged processing. Themes of the artwork focused primarily on feelings of being in the limbo, abandonment, loss, cultural identity, and uncertainty, as well as hopes and fears about their future.

Contemporary migration of unaccompanied children and adolescents is complex and challenges the legal, social, and mental health services in the host community; nonetheless, children and adolescents seeking asylum in the U.S. deserve culturally and age-appropriate clinical interventions to recover from exposure to extraordinary adversity in their home countries, throughout their migration processes, and following their arrival in the U.S.

The art therapy community ought to focus on developing more evidence about the effectiveness of art therapy in fostering resilience, preventing the development of symptomatology, and addressing particular needs of asylum seekers and refugees. Evidence-based findings would advocate for art therapy interventions to address the complex, severe needs of unaccompanied children and adolescents seeking asylum. Today, more than ever, mental health professionals must joint efforts to advocate for changes in policies and legislation that will ensure unaccompanied children and adolescents are not placed in detention, are not separated from their families, have their rights fulfilled, and are given the opportunity to grow in a safe environment.

References

American Art Therapy Association, Inc. (2018, June 20). *The AATA's statement on the traumatic impact of separating children from parents and caregivers* [Press release]. Retrieved from https://arttherapy.org/news-statement-separating-children-parents/

American Immigration Council. (2014, July 10). *Children in danger: A guide to the humanitarian challenge at the border.* Retrieved from www.immigrationpolicy.org/special-reports/children-danger-guide-humanitarian-challenge-border

Amnesty International. (2016). *Home sweet home? Honduras, Guatemala and el Salvador´s role in a deepening refugee crisis.* Retrieved from www.amnesty.org/en/documents/amr01/4865/2016/en/

Appleton, V. (2001). Avenues of hope: Art therapy and the resolution of trauma. *Journal of the American Art Therapy Association, 18*(I), 6–13.

Bhabha, J. (2014). *Child migration and human rights in a global age.* London: Princeton University Press.

Bonanno, G. A. (2004). Loss, trauma, and human resilience: Have we underestimated the human capacity to thrive after extremely aversive events? *American Psychologist, 59*, 20–28.

Bloss, J. (1979). *The adolescent passage.* New York, NY: International University Press.

Center for Women and Refugee Studies. (2015). *Childhood and migration in Central and North America: Causes, policies practices and challenges.* Retrieved from https://cgrs.uchastings.edu/sites/default/files/3_Exec_Summ_English_1.pdf

Committee on the Rights of the Child (CRC). CRC General Comment No. 6 (2005, September 1). *Treatment of unaccompanied and separated children outside their country of origin.* CRC/GC/2005/6. Retrieved December 6, 2014, from www.refworld.org/docid/42dd174b4.html

Committee on the Rights of the Child (CRC). *Report of the 2012 day of general discussion on the rights of all children in the context of international migration.* ONHCR Web Page. Retrieved from ttps://www2.ohchr.org/english/bodies/crc/docs/discussion2012/2012CRC_DGD-Childrens_Rights_InternationalMigration.pdf

Drozdek, B., & Bolwerk, N. (2010). Group therapy with traumatized asylum seekers and refugees: From whom it works and for whom it does not? *Traumatology, 16*(4), 160–167.

Fitzpatrick, F. (2002). A search for home: The role of art therapy in understanding the experiences of Bosnian refugees in Western Australia. *Art Therapy: Journal of the American Art Therapy Association, 19*(4), 151–158. doi:10.1080/07421656.2002.10129680

Fong, R., & Earner, I. (2007). Multiple traumas of undocumented immigrants—crisis reenactment play therapy. In N. Boyd (Ed.), *Play therapy with children in crisis* (pp. 408–425). New York, NY: The Guildford Press.

Graham, M. (2014, June). *Child migration by the numbers.* Retrieved from http://issuu.com/bipartisanpolicycenter/docs/bpc_immigration_task_force_-_child_/1?e=6794573/8445632

Inter-agency working group on unaccompanied and separated children IAWG-UASC. (2016). *Field handbook on unaccompanied and separated children.* Retrieved from https://childprotectionallianceblog.files.wordpress.com/2017/04/handbook-web-2017-0322.pdf

InterAmerican Commission on Human Rights ICHR. (2015). *Situation of human rights on Honduras.* Retrieved from www.oas.org/en/iachr/reports/pdfs/Honduras-en-2015.pdf

Johnson, D. (1987). The role of the creative art therapies in the diagnosis and treatment of psychological trauma. *The Arts in Psychotherapy, 14*, 7–13.

Kimmel, D. C., & Weiner, I. B.. (1985). *Adolescence: A developmental transition.* NJ: Lawrence Erlbaum Associates, Inc.

Kinzie, J. (2007). PTSD among traumatized refugees. In L. Kirmayer, R. Lemelson, & M. Barad (Eds.), *Understanding trauma: Integrating biological, clinical and cultural perspectives.* New York, NY: Cambridge University Press.

Kirmayer, L., Lemelson, R., & Barad, M. (2007). Inscribing trauma in culture brain and body. In L. Kirmayer, R. Lemelson, & M. Barad (Eds.), *Understanding trauma: Integrating biological, clinical and cultural perspectives.* New York. NY: Cambridge University Press.

Klingman, A., Koenigsfeld, E., & Markman, A. (1987). Art activities with children following a disaster: A prevented- oriented crisis intervention modality. *The Arts in Psychotherapy, 14*, 153–166.

Levy-Warren, M. (1996). *The adolescent journey: Development, identity formation and psychotherapy.* London: Jason Aronson Inc.

Looman, W. S. (2006). A developmental approach to understanding drawings and narratives from children displaced by Hurricane Katrina. *Journal of Pediatric Health Care: Official*

Publication of National Association of Pediatric Nurse Associates & Practitioners, 20(3), 158–166.

Lusebrink, V. (1989). Art therapy and the imagery in verbal therapy: A comparison of therapeutic characteristics. *Journal American Journal of Art Therapy, 28*, 2.

Lussenhop, J. (2018, June 19). The health impact of separating migrant children from parents. *BBC News*. Retrieved from www.bbc.com/news/world-us-canada-44528900

Majumder, P., O'Reilly, M., Karim, K., & Vostanis, P. (2015). "This doctor, I not trust him, I'm not safe": The perceptions of mental health and services by unaccompanied refugee adolescents. *International Journal of Social Psychiatry, 61*(2), 129–136. doi:10.1080/07421656.19 92.10758936

Masten, A. S. (2014). Global perspectives on resilience in children and youth. *Child Development, 85*, 6–20. doi:10.1111/cdev.12205

Mejia- Arauz, R., Sheets, R., & Villasenor, M. (2012). Mexico. In J. Jensen (Ed.), *Adolescent psychology around the world*. New York, NY: Psychology Press.

Mohr, E. (2014). Posttraumatic growth in youth survivors of a disaster: An arts-based research project. *Art Therapy: Journal of the American Art Therapy Association, 31*(4), 155–162. doi: 10.1080/07421656.2015.963487

Morris, K. (2012). Bereavement in children and young people. In J. Costello & P. Wimpenny (Eds.), *Grief, loss and bereavement: Evidence and practice for health and social care practitioners*. New York, NY: Routledge.

Musalo, K., & Ceriani, P. (2015). *Childhood and migration in Central and North America: causes, policies, practices and challenges*. Retrieved from http://cgrs.uchastings.edu/sites/default/files/Childhood_Migration_HumanRights_FullBook_English.pdf

Muss, R. (1962). *Theories of adolescence*. New

Naumburg, M. (1958). Art therapy: Its scope and function. In E. Hammer (Ed.), *The clinical application of projective drawings* (pp. 511–517). Springfield, IL: Charles C. Thiomas.

O'Dougherty, M., Masten, A., & Narayan, A. (2013). Resilience processes in development: Four waves of research on positive adaptation in the context of adversity. In S. Goldstein & R. Brooks (Eds.), *Handbook of resilience in children*. New York, NY: Springer.

Orr, P. P. (2007). Art therapy with children after a disaster: A content analysis. *The Arts in Psychotherapy, 34*, 350–361. doi:10.1016/j.aip.2007.07.002

Papadopoulos, R. (Ed.). (2002). *Therapeutic care for refugees: No place like home*. London: Karnac Books.

Papadopoulos, R. (2007). Refugees, trauma and adversity-activated development. *European Journal of Psychotherapy and Counseling, 9*(3), 301–312.

Paris, M., Antuña, C., Baily, C. D. R., Hass, G. A., Muñiz de la Peña, C., Silva, M. A., & Srinivas, T. (2018). *Vulnerable but not broken: Psychosocial challenges and resilience pathways among unaccompanied children from Central America*. New Haven, CT: Immigration Psychology Working Group.

Pieloch, K., Marks, A., & McCullough, M. (2016). Resilience of children with refugee statuses: A research review. *Canadian Psychology, 57*(4), 330–339.

Prescott, M., Sekendur, B., Bailey, B., & Hoshino, J. (2008). Art making as a component and facilitator of resiliency with homeless youth. *Journal of the American Art Therapy Association, 25*(4), 153–156.

Riley, S. (1999). *Contemporary art therapy whit adolescents*. London: Jessica Kingsley Publishers.

Rosenblum, M. (2015). *Unaccompanied child migration to the United States: The tension between protection and prevention*. Washington, DC: Migration Policy Institute. Retrieved from www.migrationpolicy.org/research/unaccompanied-child-migration-united-states-tension-between-protection-and-prevention

Rutter, M. (1987). Psychosocial resilience and protective mechanisms. *American Journal of Orthopsychiatry, 57*, 316–331.

Shalev, A., & Errera, Y. (2008). Resilience is the default: How not to miss it. In M. Blumenfield & R. Ursano (Eds.), *Intervention and resilience after mass trauma* (pp. 149–172). Cambridge: Cambridge University Press.

Shiromani, P., Keane, M., & LeDoux, J.

Stronach-Buschel, V. (1990). Trauma, children and art. *American Journal of Art Therapy*, *29*(11), 48–52.

Ter Heide, F. J. J., Mooren, T. M., & Kleber, R. J. (2016). Complex PTSD and phased treatment in refugees: A debate piece. *European Journal of Psychotraumatology*, *7*. doi:10.3402/ejpt. v7.28687

UNICEF. (2013). *Study on the follow-up to the implementation of the UN study on violence against children for the Caribbean.* Retrieved from https://srsg.violenceagainstchildren.org/sites/ default/files/publications_final/caribbean_study/caribbean_study_follow-up_to_un%20 study_2014.pdf

UNICEF. (2015). *State of the world's children: Reimagine the future.* Retrieved from www.unicef.org/ publications/index_77998.html

UNICEF. (2016). *Broken dreams: Central American children's dangerous journey to the United States.* Retrieved from www.justice.gov/eoir/file/888441/download

UNICEF. (2017). *A child is a child: Protecting children on the move from violence, abuse and exploitation.* Retrieved from www.unicef.org/publications/files/UNICEF_A_child_is_a_ child_May_2017_EN.pdf

UNICEF. (2018). *Data brief: Children on the move: Key facts and figures.* Retrieved from https:// data.unicef.org/wp-content/uploads/2018/02/Data-brief-children-on-the-move-key-facts- and-figures-1.pdf

United Nations High Commissioner for Refugees UNHCR. (1951). *Convention and protocol relating to the status of refugees.* UNHCR. Retrieved from www.unhcr.org/3b66c2aa10.pdf

United Nations High Commissioner for Refugees. UNHCR. (2014a). *Asylum trends, first half 2014: Levels and trends in industrialized countries.* Retrieved from www.unhcr.org/5423f9699. html

United Nations High Commissioner for Refugees—UNHCR. (2014b). *Report children on the run.* Retrieved from www.unhcrwashington.org/sites/default/files/1_UAC_Children%20on%20 the%20Run_Full%20Report.pdf

United Nations High Commissioner for Refugees. UNHCR. (2016). *Mid-year trends 2016.* Retrieved from www.unhcr.org/statistics/unhcrstats/58aa8f247/mid-year-trends-june-2016.html

United Nations High Commissioner for Refugees. UNHCR. (2018). *Global trends, forced displacement in 2017.* Retrieved from: https://www.unhcr.org/5b27be547.pdf. Produced and Printed by UNHCR (25 June 2018).

United Nations High Commissioner for Refugees. UNHCR. (2018, November 14). *Situation update: Response to arrivals of asylum-seekers from the North of Central America.* Retrieved from https://reliefweb.int/sites/reliefweb.int/files/resources/UNHCR%20Situation%20 Update%20on%20NCA%20EN%20-%2014NOV18.PDF

The United Nations Human Rights Council. (2017). *Global issues of unaccompanied migrant children and adolescents and human rights.* Final report of the Human Rights Council Advisory Committee. Retrieved from https://undocs.org/pdf?symbol=en/A/HRC/36/51=1

United Nations Office on Drugs and Crime, UNDOC. (2013). *Global study on homicide.* Retrieved from www.unodc.org/documents/gsh/pdfs/GLOBAL_HOMICIDE_Report_ExSum.pdf

U.S. Department of Homeland Security. (2002, November 25). Homeland security act of 2002. *Public Law*, 107–296. Retrieved from www.dhs.gov/homeland-security-act-2002

Van Den Veer, B. (1998). *Counseling and therapy with refugees and victims of trauma.* West Sussex, England: Wiley.

van der Kolk, B. (1987). *Psychological trauma.* Washington, DC: American Psychiatric Press.

van der Kolk, B. (1996). The body keeps the score: Approaches to the psychobiology of posttraumatic stress disorder. In B. van der Kolk, A. McFarlane, & L. Weisaeth (Eds.), *Traumatic stress: The effects of overwhelming experience on mind, body, and society.* New York, NY: The Guilford Press.

van der Kolk, B. (2014). *The body keeps the score: brain, mind, and body in the healing of trauma.* New York, NY: Penguin Books.

Waites, E. (1993). *Trauma and survival: Post-traumatic and dissociative disorders in women.* New York: W. W. Norton

Winnicott, D. W. (1975). *Jeu et réalité; l'espace potentiel* [Game and reality, potential space]. Paris: Gallimard.

World Health Organization. (2013). *Guidelines on conditions specifically related to stress.* Retrieved from www.who.int/mental_health/emergencies/stress_guidelines/en/

Zubenko, W. (2002). Developmental issues in stress and crisis. In W. Zubenko & J. Capozzoli (Eds.), *Children and disasters: A practical guide to healing and recovery* (pp. 85–101). New York, NY: Oxford University Press.

Making Artistic Noise
Amplifying the Voices of Court-Involved Youth

YASMINE AWAIS AND LAUREN ADELMAN

**The Artistic Noise art therapy project was supported by the New York City Department of Probation.

> The Family Court Tibetan Prayer Flag project was one of the first projects I completed at Artistic Noise. It is not the best work I've done but I believe it is the most inspirational. I was able to speak through art in a place [the courthouse] where many voices aren't given the opportunity to be heard. Years later, for unrelated reasons, I found myself in that [court] waiting room again, but now there was art and my time at Artistic Noise has taught me to equate that to peace.
>
> —E, participant in Artistic Noise

> My life was hard before I came to Artistic Noise. But now I really feel I have a sense of where I'm going. I feel like my life is coming together. I'm most proud of my first real art gallery exhibition at NYU. It was cool because my grandparents were there to see my work and I also sold all of my pieces. A lot of my mentors were there to support me, it felt like a big family with a lot of positive energy. Being in Artistic Noise, I have learned that it's ok to ask for help and that not everybody's out to get me. Artistic Noise can help you change your life if you are willing to put in the effort.
>
> —B, participant in Artistic Noise

This chapter describes the work of Artistic Noise, a non-profit organization that utilizes an interdisciplinary model of art therapists and teaching artists working together with young people who are incarcerated, on probation, or otherwise involved in the justice system. B's story above illustrates the impact that a community arts program based in the philosophy of positive youth development can have on a young person during their journey from incarceration back into their community. In this chapter, we briefly discuss the history of mass incarceration in the U.S. and the impact this has on young people, their families, communities, and society. We also explain how issue-based art education, positive youth development, and restorative justice practices can be used by art therapists and art educators working in community organizations focused on social justice practices. E's story above exemplifies the importance for young people to be the leaders and advocates for themselves and their communities and the way this can be accomplished through strong arts programs and community partnerships.

We use the term *court-involved youth*[1] in this chapter rather than terms such as *juvenile* or *youthful offenders*, focusing on the system instead of individualizing blame. Court-involved youth can be categorized into two groups. First are those who are

detained in residential or otherwise *locked* or *secure facilities*. These young people are heavily monitored and restricted by staff. The second group of court-involved youth are those engaged in *community corrections*. This method monitors youth within communities rather than behind walls, including alternatives such as *probation* or *parole*. Youth involved in the criminal and *juvenile justice systems* throughout the U.S. have often already been involved in systems such as schools, foster care, mental healthcare (Holman & Ziedenberg, 2006), and public housing (Ludwig, Duncan, & Hirschfield, 2001). These young people may be weary of those providing services because of negative experiences within these systems. Specifically, the Artistic Noise model promotes art therapy as a non-pathologizing form of providing support, which has been argued as a best practice for working with adolescents (Riley, 1999b; Sitzer & Stockwell, 2015).

Artistic Noise exists to bring the freedom and power of artistic practice to young people who are incarcerated, on probation, or otherwise involved in the justice system (Artistic Noise, n.d.a). Through visual arts and entrepreneurship programs in Massachusetts and New York, participants give voice to their experiences, build community through collaborative projects, and learn valuable life and job skills. Artistic Noise creates spaces where court-involved youth can be heard, seen, and supported on their path to adulthood. Rooted in the methods of issue-based art education and *restorative justice* practices to strive toward social justice, Artistic Noise programming offers opportunities for young people and communities to transform. According to Darts (2004), issue-based art education is enacted by those who purposefully "introduce the work of socially engaged artists. . . [and] open up educative spaces where the layers of socio cultural, political, aesthetic, historical and pedagogic complexities surrounding these works can be examined and explored" (p. 319). In other words, issue-based art education is the purposeful act of engaging students in social practice or socially engaged art-making (Finkelpearl, 2013; Helguera, 2011) rather than traditional art education models in which technical skills are often prioritized over content or concept. Restorative justice seeks to repair harm to communities rather than punish an identified offender. There are debates within the restorative justice community on its definition, whether it means offering alternatives to notions of punishment versus alternative to punishment itself (Rosenblat, 2015). For the purposes of this chapter, we use Zehr's 2004 definition (as cited in the Office of the State Attorney for the Fourth Judicial Circuit, n.d.) that describes restorative justice as "a movement to address the needs and roles of victims of crime, offenders, and communities, rather than the legalistic system that holds offenders purely in relation to violation of the state and law." In using a restorative justice model, young people are seen in relation to the larger community, and there is not necessarily a clear-cut line between offender and victim.

As the authors of this chapter, we have worked in the arts for many years. Lauren Adelman, an artist and art educator, co-founded Artistic Noise in Boston in 2001 with Minotte Romulus, a young woman who was incarcerated at the time, and Francine Sherman, a juvenile defender and photographer (Artistic Noise, n.d.b). Lauren was first introduced to the power of community-based arts organizations to create real social change and connect people with vastly different lived experiences while working with Potters for Peace in Nicaragua. Lauren has also taught in traditional public schools as a licensed teacher and as an educator at the Museum of Modern Art in their Community and Access Department running partnerships with adults and youth involved in the criminal justice system. As a white, upper middle-class woman, many aspects of Lauren's upbringing were far different than those of the young people she has worked with. Reflective of the statistics for youth involved in the justice system, the young people

who have participated in Artistic Noise have been predominantly Black and Latinx from communities that have historically been neglected by society.

Yasmine Awais is an art therapist who was employed with Artistic Noise. Yasmine came into the field of art therapy through her artistic practice, which included photographing incarcerated individuals and asking the subjects to engage in the process by writing directly on their photographs to re-tell their stories. As a first generation multiethnic Asian, Yasmine's experiences are also quite different than those of the youth who participate in Artistic Noise programs as she was never arrested, targeted by the police, or involved in the juvenile or criminal court systems. However, she shares experiences of being silenced and ignored, ones that the youth often express. As authors of this chapter and individuals dedicated to this work, we state our positionalities not for the psychotherapeutic concepts of transference (i.e., clients identifying with the therapist) and countertransference (i.e., therapists identifying with the client) but to explicitly acknowledge power and privilege inherent with us writing about and conducting social justice and restorative practice-based work.

The Problem With Mass Incarceration

In discussing issues of the justice system in the U.S., one must also name the existence of racial disparity within these systems. There is an over-representation of youth of color in arrests, placement in the justice system, and in long-term custodial settings. Black youth specifically are far more likely to receive harsher sentencing than their peers for incidents at school or within other youth-serving systems (Braverman & Morris, 2011). The U.S. has had a disproportionate amount of incarcerated people compared to its overall population (Collier, 2014). Despite increasing awareness of the prison industrial complex through books like *The New Jim Crow* (Alexander, 2010) and documentaries like *13th* (DuVerney, 2016), court-involved youth, and specifically those who are under 18 years of age, are often overlooked. One notable exception has been the media attention and public outrage regarding children being detained due to the migration crisis and subsequent policies aiming to deter individuals and families from seeking asylum or shelter in the U.S. (Dickerson, 2018). While national public attention on issues surrounding incarcerating young people is warranted, those living in the U.S. who have been historically incarcerated at high rates have been largely absent from public discourse.

The juvenile justice system can have a negative impact on young people, their families, and communities across the U.S. One such example is recidivism, or reoffending. In New York State, over 80% of the youth who are arrested for misdemeanors or minor infractions are rearrested before the age of 28 on felony-level charges (Corrections Association of New York, 2011). Hahn et al. (2007) conducted a systematic review of published articles that evaluated juveniles who were transferred to adult settings and found that this tends to increase rates of violence among those who were transferred. Similarly, research has shown that youth from "disjointed" neighborhoods are more likely to be justice-involved. "Paradoxically, research also shows that incarcerating large numbers of people from neighborhoods further destabilizes these neighborhoods" (Schiraldi, Schindler, & Goliday, 2011, p. 419).

Defining Youth

The U.S. juvenile justice system is bound by state guidelines, which creates unique challenges for service providers who must understand the rules and regulations of the state

in which they work. In other words, those who engage in this work must be cognizant that government policy, rather than chronological or developmental age, is the determinant factor in whether an offender is considered to be a child or an adult in a court of law. This reductionist definition of a child is in stark contrast to that of art therapists, who look to behaviors such as socialization, speech, and artistic skills as factors that assess an individual's developmental level. States first began making the distinction between adults and children in the court of law in 1899, and their involvement in determining the status of adults and juveniles, along with their capacity to act with intent, has been debated ever since (Burrows, 1946). Originally it was accepted that the state act as a "kind and just parent" for youth in the system (Ayers, 1997, p. 24). However, there have been changes in the way the juvenile justice system defines youth based on policy, as well as the manner in which a young person is perceived by society. From the 1920s until the late 1960s, juvenile court proceedings were informal and thought to be "personal and creative" rather than "legalistic and punitive" (Ayers, 1997). One landmark Supreme Court Case in 1964, *In re Gault*, ensured youth to be protected by the same basic constitutional rights as adults. This case is notable because it required the protection of juveniles, which were not assumed prior.

In New York, the majority of court-involved youth have been convicted for misdemeanors (Corrections Association of New York, 2011). Until 2019, New York and North Carolina were the two remaining states to automatically prosecute all 16- and 17-year-olds as adults. It should be noted that even within each state's laws dictating the age of which a person is considered a minor, they may still be tried as an adult depending on the charges, history, and services available (Sherman & Blitzman, 2011). This results in a lack of recognition of court-involved young people's unique and diverse needs (Corrections Association of New York, 2011). Specifically, when young people are being forced into an adult system, their cognitive and social developmental needs are not addressed because they are not in a system designed to treat their needs (Hahn et al., 2007).

Juvenile facilities most often fail to acknowledge the effect trauma has on decision making, specifically for young people. While juvenile facilities often expect youth to respond to systems of consequences and rewards to control their behavior, the concept that "behavior may be reactive to past victimization" has been overlooked (Beyer, 2011, p. 5). Approximately 50% to 75% of youth involved in the justice system require mental health services (Underwood & Washington, 2016). Specialized, non-traditional, and holistic services for youth identified with mental health needs have been found to be more effective in reducing recidivism, increasing active problem solving, improving school functioning, and improving parental life satisfaction for their caregivers than traditional services (Colwell, Villarreal, & Espinosa, 2012). Other resources identified for court-involved youth include services to accommodate those with limited English, resources for individuals with intellectual disabilities, medical services, and substance use services (New York State Office of Children and Family Services, 2016).

Another concern in working with court-involved youth is the lack of continuity of services from locked facilities to when a young person returns to their community. Maintaining consistency in services is particularly vital for the mental, behavioral, and physical health development of youth (Altschuler & Brash, 2004). The Office of Juvenile Justice and Delinquency Prevention (OJJDP) of the U.S. Department of Justice, Office of Justice Programs, notes that probation can be used as a prevention intervention as a way to monitor youth after community reentry as well as a penalty for violating a law after a court judgement. The OJJDP estimates 54% of the 716,100 juvenile cases were placed on

probation (OJJDP, n.d.). In New York City, young people convicted of a criminal offense often receive a sentence of probation rather than residential sentencing. Although youth previously served their sentences in residential facilities (sometimes referred to as *congregate care facilities* or *lock up*), the New York City Department of Probation has attempted to support youth on probation in the community through progressive, strength-based programming offered by outside service providers that augments supervision by a *probation officer* (PO). Artistic Noise has been one of the strength-based community programs partnering with the Department of Probation since 2012.

There has been a growing trend nationwide to look at alternative methods to best serve court-involved youth. Because youth may be treated as adults, diversion, after-care, and mental health services have been impacted (Justice Policy Institute, 2017). Harsher sentencing measures such as treating youth like adults has not been proven to work. In fact, it has been found that when young people are treated as youth or juvenile offenders, rather than adults, public safety is improved without significant cost to taxpayers (Justice Policy Institute, 2017). Using developmentally appropriate approaches and methods that are more strength based have been found to be beneficial for youth as a whole, as well as for those who are involved with the systems of juvenile justice, mental health, foster care, and specialist education (Sanders, Munford, Thimasarn-Anwar, Liebenberg, & Ungar, 2015). Positive Youth Development (PYD) is a strength-based approach that is adolescent specific. According to Catalano, Berglund, Ryan, Lonczak, and Hawkins (2004), positive youth development consists of a set of constructs that aim to achieve one or more of the following objectives:

- Promoting bonding, social competence, emotional competence, behavioral competence, and moral competence.
- Fostering resilience, self-determination, spirituality, self-efficacy, clean and positive identity, belief in the future, and pro-social norms.
- Providing recognition of positive behavior and opportunities for pro-social involvement.

Using a PYD approach with court-involved youth has many benefits, as it understands that all youth have strengths. In focusing on the strengths of youth through the way in which programming, mentorship, and the setting itself are implemented, youth will thrive (Lerner et al., 2011). Furthermore, Lerner and colleagues (2011) believe that employing a PYD lens when evaluating the juvenile justice system would allow policy makers to view youth as important stakeholders rather than a population to be controlled.

Considering the developmental needs of youth, Artistic Noise's staff of teaching artists and art therapists works with participants to create safe yet challenging spaces for creative expression through a strength-based PYD model. Using a variety of artistic media, youth explore themes such as friendship, loss, sexual violence, community, freedom, identity, and their dreams for the future. This format fosters critical thinking and problem-solving skills that are beneficial to teens. By collaborating with their peers, teaching artists, and art therapists, youth learn to follow a complex project through to fruition. In addition to addressing psychosocial needs through our art therapy programs, Artistic Noise also has an innovative Art, Entrepreneurship, and Curatorial program that employs young people returning to their communities from residential placement. This program focuses on job skills and future planning, which has been argued as a key requirement for court-involved youth (Altschuler & Brash, 2004).

A young person can begin working with Artistic Noise while incarcerated or while on probation. If they show an interest in continuing the relationship after release or while engaged through a probation workshop, an art therapist will meet individually with the young person to allow for a more seamless transition. Now, when a young person begins programming, they can engage in the art-making right away. Our most successful participants have transitioned from first working with us while in a locked facility to joining our Art and Entrepreneurship program upon release, allowing for the much needed continuity of care, mentorship, and involvement that can be overlooked when only focusing on one area of court involvement (i.e., detained or community-based programming).

Cost

From a public policy perspective, detaining court-involved youth has been a financial burden to society and individuals. It is difficult to identify exact figures due to the complexity of the criminal justice system, which involves the actual costs of detention and community corrections such as salary of the staff (i.e., correction officers, POs, etc.) and the services provided for youth such as meals, education, and healthcare. In 2013, *The New York Times* reported that New York City alone spent $167,731 to incarcerate one adult for a year (Santora, 2013). Services for young people can be far more expensive since their needs are greater. According to the 2014 Annual Report by New York State's Juvenile Justice Advisory Group, 1.9 million federal dollars were spent in New York on matters related to detaining and serving court-involved youth. The cost of detaining youth in the U.S. is estimated to be 7.9 billion to 21.47 billion dollars (Justice Policy Institute, 2014). These figures do not include the monetary cost to victims or the emotional costs to individuals and communities. Greenwood (2008) asserts that billions of dollars a year are spent based on costs associated with arrest, prosecution, incarceration, and treatment. To better understand these figures in comparison to how the state pays for education, in 2010, New York City spent an average of $18,500 per public school student while the state spent $266,000 on each incarcerated young adult, a ratio of about 1:14 (Simmonds, n.d.). However, community-based programs and those focusing on PYD cost less than the more punitive approaches, such as incarceration (Justice Policy Institute, 2017; Vera Institute of Justice, 2015).

Community Interventions and Treatment

Considering the financial costs of mass incarceration as a whole and treatment of young people involved in the juvenile and criminal justice systems, a question we raise is how to best support youth in the community both before and after incarceration or sentencing. There has been a growing trend away from detaining youth, resulting in a steady decline of detention admissions (New York State Juvenile Justice Advisory Group, 2014). Community-based programming has been promoted as more cost-effective than traditional incarceration or probationary services that primarily monitor youth (Robertson, Grimes, & Rogers, 2001).

Persons involved in either the juvenile or criminal justice systems can serve their sentences while incarcerated or in the community, often referred to as community corrections. Individuals engage in community corrections either after being discharged from a secure facility or if their sentence is strictly monitoring. Programs exist in both secure

and community settings, and those programs in community corrections occur in various locations: within homes, schools, community centers, or other environments not affiliated with a facility. Residential placement such as jail or lock-up detention facilities are not considered as effective as community programs; therefore, Greenwood (2008) and others (Lipsey, Howell, Kelly, Chapman, & Carrver, 2010) agree that community programs should be the first option. Underwood and Washington (2016) articulate, "instead of focusing on generating more evidence-based treatments to be used within the juvenile justice system, research seems to suggest that diversion programs and more community-based treatment services would be most beneficial to youth delinquents with mental health difficulties" (p. 10).

Favoring locked facilities over community-based programming is based in public management and neoliberal trends, which gained strong support during the Reagan administration in the 1980s. These non-effective yet popular ideas helped fuel politicians and the public to support "the war on drugs," "scared straight" programs, and other "tough on crime" initiatives such as boot camps and wilderness therapy programs (Dohrn, 2004; Greenwood & Turner, 2009; Henggeler & Schoenwald, 2011). These types of programs, along with transferring of youth to adult courts and surveillance (i.e., probation and parole) without links to supportive programming, have been found to be ineffective at best (Giroux, 2012; Greenwood & Turner, 2009; Paquette & Vitaro, 2014) and increase criminal behavior at worst (Henggeler & Schoenwald, 2011; Mowen, Brent, & Bares, 2017). A challenge with implementing community-based prevention models for youthful offenders is the public's desire to punish youth, conflating the idea that rehabilitation cannot occur without detention (Slobogin, 2011). The shift from rehabilitation to "get tough" policies in the 1980s was based mostly on the "superpredator" theories that the media and politicians pushed. While these predictions were unfounded and youth crime declined beginning in 1995, the damage was done, and policies were put into practice that has led to the large juvenile population and its overrepresentation of youth of color (Bell & Mariscal, 2011).

Youth-specific justice programming can take many forms, with an increased focus to reduce recidivism (Evans-Chase, Kim, & Zhou, 2013). While preventing youth from re-offending is attractive to politicians and communities in regard to measuring the success of community corrections programs, there may be better determinants of success. Rearrest rates are not always an adequate gauge of a young person's or program's success. For instance, young people of color are arrested disproportionately, oftentimes for status offenses such as homelessness, truancy, etc. Therefore, if youth of color are arrested more often than their white peers, then being arrested or rearrested can be a result of discriminatory practices rather than a measure of a program's effectiveness. The effects of the racialized practice of policing youth of color has been well articulated by Alexander (2010):

> When black youth find it difficult or impossible to live up to these standards—or when they fail, stumble, and make mistakes, as all humans do—shame and blame is heaped upon them. If only they had made different choices, they're told sternly, they wouldn't be sitting in a jail cell; they'd be graduating from college. Never mind that white children on the other side of town who made precisely the same choices— often for less compelling reasons—are in fact going to college.
>
> (p. 215)

A comprehensive evaluation of recidivism takes many years to complete. It has been recommended that instead of simply looking at the number of times a young person

returns to jail or violates probation, successful programs should also evaluate school attendance; employment; involvement in extracurricular activities; and quality of relationships with peers, family, and/or adult mentors (Lane, Turner, Fain, & Sehgal, 2007). Restorative justice models prioritize the repairing of community relationships that involve offenders acknowledging the way by which their offense harmed others (Ward, Gannon, & Fortune, 2015) and look to programs that lessen the chance of recidivism as a by-product rather than as the primary focus (Sellers, 2015).

Art Therapy in Locked Facilities and Community Settings

Art therapy has been promoted as valuable in the prison system (Johnson, 2008). Specifically, art therapists have been involved as service providers with detained adults in Riker's Island in New York City and Cook County Jail in Chicago as two examples. Art therapists working with incarcerated youth have been studied, including in the phenomenological experiences of juvenile boys (Persons, 2009), the impact on self-esteem (Hartz & Thick, 2005), and in practice-based research (Smeijsters, Kurstjens, Welten, & Willemars, 2011).

As a nonverbal based form of psychotherapy, art therapy may be more engaging to court-involved youth as it can be seen as more direct and accessible than traditional forms of verbal therapy (Persons, 2009). Art therapy allows for explicit expression for youth who may be resistant to traditional treatment methods as art therapists combine the verbal therapeutic process with art-making (Riley, 1999b; Rubin, 1984). Adolescents in general and court-involved youth in particular can have difficulties verbally expressing themselves, which can be interpreted as resistance in therapy. As noted previously, court-involved youth most likely have had social service involvement in addition to the juvenile or criminal justice system, which may lead to more skepticism toward adults seeking to "help." However, young people are inherently creative, allowing for rich, nonverbal communication (Riley, 1999a).

Art therapy can also provide a space for young people to take initiative and experiment with risk taking that is developmentally appropriate (Hinz, 2009). Feeling success and the ability to make actual change in the safety of the art studio can be what a young person needs to make changes outside the studio with peers, at school, within their homes, and in their communities. For example, a young person may have never used clay before and may be afraid of getting dirty or not doing something perfectly. In the art therapy studio, in taking a risk by using a new material, the young person can shape and change an object, which can be the antecedent needed for them to alter actions outside of the session.

Art therapy used with young people involved with the probation system has been implemented to present the idea of change, promote critical-thinking skills (Broom, 1999) and bolster self-esteem with incarcerated youth (Hartz, & Thick, 2005; Larose, 1987). These are concepts important to consider for a population that has been stigmatized by multiple identity labels, including psychological, educational, racial/ethnic, gender, and penal. While some art therapists continue to debate if "art as therapy" (i.e., focusing on materials and the process of making art as therapeutic) or "art psychotherapy" (i.e., prioritizing the verbalizations from metaphors, abstraction, and symbolization) as more effective, Hartz and Thick (2005) found that both approaches of art therapy were significant in improving self-esteem for young women in a secure detention facility. This was measured by an established scale, The Self-Perception Profile for Adolescents (SPPA), and a scale created for the study, The Hartz Art Therapy Self-Esteem Questionnaire (Hartz AT-SEQ) (Hartz & Thick, 2005).

Restorative Justice: A Theory-Based Approach

Most programs, particularly small non-profits, do not measure outcomes in ways that would qualify as evidence based (Greenwood, 2008) or have the funds available to purchase established evidence-informed methods. Lipsey et al. (2010) write that there are three other types of programs worth noting outside of evidence-based practices: research-based, pilot, and theory-based programs. Restorative justice programs fall under the theory-based model, which means that there has been peer-reviewed literature supporting the practice (Lipsey et al., 2010). Furthermore, restorative justice programs have been considered an effective method based on rigorous reviews (McGarrel, Olivares, Crawford, & Kroorand, 2000). The Campbell Collaboration, a well-known body that provides systematic reviews on social interventions, reviewed the Restorative Justice Conference (RJC), a specific type of restorative justice program (Strang, Sherman, Mayo-Wilson, Woods, & Ariel, 2013). The authors operationally defined RJC as practices where a trained facilitator met with the offender and victim in a face-to-face meeting, while the authors noted that restorative justice involves other types of practices as well. Ten randomized control trials were identified to review, and it was concluded that RJCs were highly cost effective, offending frequency was reduced, and victims' satisfaction was higher than those who were involved in traditional criminal courts (Sherman, Strang, Mayo-Wilson, Woods, & Ariel, 2015; Strang et al., 2013).

Restorative justice practices have been utilized in working with youthful offenders in the community (Lane et al., 2007), and there has been some writing on incorporating arts-based methods with restorative justice (Froggett, 2007). While research on restorative justice practices in conjunction with art therapy is lacking in literature, restorative justice and creative art programs have been utilized in facilities such as jails and have shown significant results in clinical outcomes with adults (Glowa-Kollisch et al., 2016). Artistic Noise uses its own highly routinized arts-based models founded in restorative justice principles, which includes implementing circles; providing high-quality art through issue-based art education; and collaboration between art therapists, teaching artists, and stakeholders (Awais, Adelman, Paul, & Buseman, 2014).

Amplifying Voices

To address the ongoing desire to provide community-based services, the New York City Department of Probation implemented a mental health initiative in 2012 for youth involved in community corrections. This initiative offered various mental health service options, which included art therapy and verbal therapy. Artistic Noise was one of the organizations selected to provide art therapy services. Arts-based programs have been identified as an effective way to engage youth who are often disengaged or otherwise unconnected to mainstream social institutions such as school or work (Thomas & Shihadeh, 2013). Art is concrete—there is a process required in the making of a final end product. When looking at this aspect from a PYD standpoint, this can produce feelings of competence and fosters resilience (Catalano et al., 2004). For some youth, creating something out of nothing, being able to engage in artistic risk taking through experimenting with materials, tools, or techniques and the process of trying, failing, and trying again, is most important. For others, the value lies in creating a final work that elicits pride, one that is aesthetically and technically powerful and can be publicly exhibited or sold. The act of exhibiting and even selling

artwork also aligns with the PYD principles of fostering self-efficacy, a positive identity, and recognition for positive behavior and provides opportunities for prosocial behavior (Catalano et al., 2004). It is not necessarily useful to argue whether the process or the product holds more significance but rather focus on the interplay and attention to both.

Art is a powerful tool to effect change on an individual and societal level, particularly when the artwork is shared. Artistic Noise does this by helping youth to tell their own stories to the public through public art exhibitions and advocate for themselves and their communities.

It is vital for the youth artists to tell their own stories rather than relying on others to speak on their behalf. Viewing works of visual art created by court-involved youth can allow the public to connect to and understand the artist without the artist being present. In this manner, the youth artists' stories can be told and retold in the public sphere even as they may still be removed from public life while incarcerated.

Bernardine Dohrn (2004) describes the importance of bringing girls' voices into the public realm, from an activist perspective:

> Notably absent from the record of a century of incarcerating girls has been the voices of the girls themselves. The experience of incarceration for adolescent girls— manifest in poetry, the arts, and in organized mobilizations to transform conditions of confinement- is now being articulated loud and clear by young women who have experienced the strip searches, the isolation, the separation from children and family, the stereotyping, and the brutal social control. They defy the paternalistic, racist, and patronizing generalizations. They speak for themselves.
>
> (pp. 303–304)

Figure 20.1 Installation view of Artistic Noise art exhibit, 2016

A Model of Collaboration

Art therapists working in and collaborating with communities that are not institutionalized or seen as traditional art therapy populations is not new (Moon & Shuman, 2013; Talwar, 2016; Timm-Bottos, 2006), but collaborating with artists is not as commonly documented. Art therapists provide unique skills and knowledge (Ottemiller & Awais, 2016), which can enhance the work that art therapists and artists already do as separate endeavors. In addition to art therapists and teaching artists collaborating, Artistic Noise partners with the justice system itself, such as the New York City Department of Probation, the Department of Corrections, Bronx Family Court, and the Office of Children and Family Services. While it may seem at odds to partner with systems that have policies and practices that incarcerate and effectively oppress young people, we found that collaborating within and outside of these systems has been powerful. Artistic Noise has rarely experienced the censorship one may expect when youth artists speak out against the injustices of the justice system. Three reasons may explain this: the cultivation of long-term relationships with community partners, partner's belief in the methods, and trust of the process.

Artists have a long history of working outside of the studio, as seen by those who engage in social practice (Finkelpearl, 2013; Helguera, 2011). Rachel Williams (2003) explains the vital role art plays in correctional facilities by allowing individuals to reclaim their sense of self. Writing about a mural project conducted with incarcerated women, she states, "[Art] can perform miracles in acts of healing, communication, meditation, ritual, and empowerment" (Williams, 2003, p. 151). Furthermore, "the arts can provide ways to reflect, empower, critique, and even transform" (Williams & Taylor, 2004, p. 51). The importance and power of art programming on an individual's and community's health continues once a young person returns home. A report of the Cultural and Social Well-Being in New York City found that low-income neighborhoods with cultural assets have an "18% reduction in serious crime rate" compared to low-income neighborhoods without these cultural resources (Stern & Seifert, 2017). However, it should be noted that a decrease in crime does not necessarily equate to a decrease in incarceration rates. Crime has been on the decline for years, while incarceration rates have been on the rise nationwide (Alexander, 2010).

Artistic Noise's partnership with the New York City Department of Probation allowed for the first hiring of a licensed and board-certified art therapist to co-facilitate workshops with teaching artists. While the workshops have always had therapeutic qualities, having a trained and licensed therapist working alongside teaching artists proved incredibly powerful and successful. The addition of a formalized art therapy program required a standardized intake process to work in partnership with the Department of Probation. This has been one of the multiple steps that take place before a young person engages in programming. Prior to intake, the PO determines which program is the best fit for each participant, which includes consideration of the program approach (i.e., art therapy, family therapy, etc.), ease of accessibility, and youth's interest (e.g., visual art, digital animation, creative writing). In the case of community corrections, once a young person has been matched with Artistic Noise, the art therapist conducts an intake. This intake occurs either at the probation office or at one of Artistic Noise's operating sites. The intake includes demographic, educational, and court-involvement questions as well as questions about prior history with therapy. Focusing on youth and working from a strengths-based approach, questions surrounding interests are also asked, including "Do you enjoy art, what mediums?" and "What is something you are proud

of accomplishing?" During the intake process, the art therapist assesses group readiness and additional services that may be useful, such as individual or family therapy. The intake developed for the probation partnership proved so effective that Artistic Noise has since incorporated it into all programming, with intakes being conducted at residential placement programs, such as on Rikers Island, as well as the community-based job skills training program.

Circles: Checking-In and Checking-Out

Programs rooted in restorative justice and PYD frameworks utilize circles. Circles are akin to what some art therapists use as a "warm up" exercise (Liebmann, 2004) to quickly assess a group before the session begins ("check-in") and before the group leaves the session ("check-out"). By gathering in a circle, the space is reclaimed for the duration of the time everyone is together, regardless of the location. The check-in and check-out circles are critical to working in incarcerated settings. This allows the participants to recognize that the space is now creative and safe, a stark contrast to the standard environment within a prison or detention center. Ending in a circle allows the young adults to re-enter the prison environment safely, indicating that the space that encouraged creativity, risk-taking, and expression has been closed. All of the Artistic Noise programs utilize this format, whether inside a facility or out in the community. Artistic Noise has conducted check-out circles on subway platforms, street corners, family court, and art galleries. In fact, some of our most powerful circles have been after our public exhibition openings in the galleries themselves with all of our participants, teaching artists, art therapists, and any gallery goers who are still present. Circles are not meant solely for youth participation but for community engagement as a whole.

It's My Law: Co-Facilitation and Restorative Justice

A rich facet of the work at Artistic Noise is co-facilitation. While co-facilitation can be challenging because it can require additional communication and preparation (Liebmann, 2004), when there is the right combination of skills, personality, and communication between the co-facilitators it can be a seamless collaboration. Interdisciplinary co-facilitation with an art therapist and a teaching artist can be especially powerful. While the act of creating art can be considered therapeutic, it is difficult to go beyond the inherent therapeutic qualities of art-making without co-facilitating with a trained art therapist. For example, Artistic Noise teaching artists have always advocated for our young people by attending court hearings, meeting with case workers, organizing public exhibitions, and maintaining strong interpersonal relationships. It wasn't until the hiring of licensed art therapists that individual art therapy sessions and directed psychosocial assistance with mental health, housing, and other issues were able to be addressed.

Similarly, while art therapists utilize art-making in their sessions, it is through the co-facilitation with an experienced art educator who has a strong personal studio practice where the curriculum design flourishes. Teaching artists have the technical skills to teach high-level art-making and the ability and training to create dynamic, approachable lesson planning. Pairing this with the clinical knowledge of an art therapist only deepens the work created. Having an art therapist co-facilitate allows the inclusion of therapeutic practices into the lessons themselves. When this works most effectively, the

different roles of the co-facilitators are not always apparent during a workshop. Instead, there will be a synergy in the workshop allowing high quality, expressive art to be created, while also attending to the participant's emotional needs.

NELSON[2]

Artistic Noise encourages teaching artists to use the preferred media in their own artistic practices with the youth. The *It's My Law* project was an altered book conceptualized by Alfred Planco, a book and mixed media artist. For this project, Alfred was the teaching artist, and Yasmine was the art therapist. This was part of a larger project to create artwork to be publicly displayed in the waiting rooms of family courts throughout

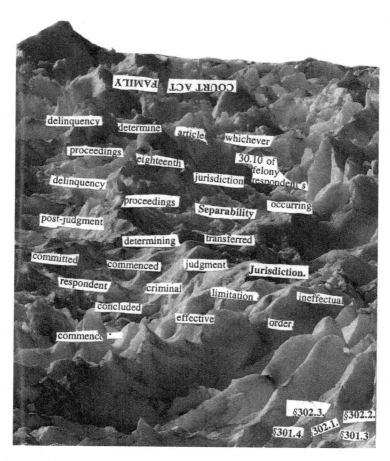

Figure 20.2 Alien Words Alien Land. Materials: mixed media collage. Description: "The message I pointed out in my work were words I didn't understand in the *Family Law* book. I put the title backwards to fit the rest of it."

New York City to support the efforts to improve the experience of people waiting for court. Artistic Noise partnered with the Bronx Family Court to enrich the public areas and courtrooms with visual art created by youth who had firsthand experience of the court's juvenile justice system. The youth involved in Artistic Noise's art therapy program in the Bronx, all of whom have spent time in this particular courthouse, used the main text from the New York State's Family Courts' Family Law: Family Court Act in their altered books. Through an in-depth artistic process, participants altered the pages to create a new book. *It's My Law* comes entirely from the probation section of *Family Law*, as all the participants who contributed were on probation. Within the pages of *Family Law* are the words, sentences, and paragraphs that directly affect the young people's lives. To create this altered book, the participants were given enlarged, photocopied pages of the original text and were invited to alter the pages in any way they desired. Some participants burned pages; others collaged using magazines and text.

The result of this process was therapeutic for the participants and thought provoking for the viewers to see that each youth artist was an individual, with diverse approaches and styles. The final project culminated in a published book, resulting in artworks that were complex, mature, and purposeful.

The pages from the probation section of *Family Court Act* that were not incorporated into *It's My Law* were used by the participants in a follow-up project called "book as object" project. Alfred and Yasmine asked the youth artists to treat the leftover stack of pages as an object and transform them into a sculpture. Nelson, a notably younger participant, had difficulties engaging with the other group members and would either antagonize them or retreat by putting his head down. Yasmine and Alfred interrupted his typical behaviors by giving Nelson a job, asking him to shred a stack of *Family Court Law* photocopied pages. Nelson loved working with the shredder, a non-traditional artist tool. He was able to literally destroy the law that implicated him. Furthermore, he

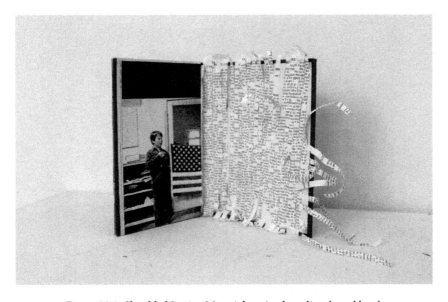

Figure 20.3 Shredded Justice. Materials: mixed media, altered book

took apart expectations that he had of art-making and that the facilitators had of him. Art-making was no longer boring but was exciting and destructive. Additionally, his ability to enjoy the process of shredding showed the facilitators that he was able to be engaged. After shredding each page, which took several sessions, he faced a pile of seemingly unusable garbage. Nelson then created order out of chaos by methodically gluing each shredded strip into an old, discarded book cover.

He was invested in this process and created a piece of art that he, his peers, and the facilitators were drawn to. The process and product of creating this work provided validation and self-regard.

The individual products of this collective project were put together to create a collaborative book that mimics the *Family Court Law Handbook* found on the desks of all lawyers and judges working in Family Court. Large-scale printouts of each page are on permanent display in the waiting rooms of the Bronx Family Court. This was a part of a larger project where Artistic Noise participants created many different works that are publicly displayed in the Bronx and Lower Manhattan Family Courts.

Tyra

When personnel at Bronx Family Court requested we create artwork to beautify the waiting rooms of their very stark building, no one had the foresight to know the impact it would make on the judges or our participants. The Bronx Family Court project involved training advanced participants of Artistic Noise's Arts and Entrepreneurship program to conduct brainstorming sessions with judges and other family court personnel. In one of our early brainstorm sessions, Tyra pulled Lauren aside and explained that one of the judges at the meeting, Judge Drinane, was the same judge who had sentenced her to long-term placement upstate years before. Tyra recalled that she acted out aggressively in the courtroom during sentencing. Previously, when Tyra faced Judge Drinane in family court, she was required to listen. In this case, the paradigm was now shifted with Tyra leading the discussion. This shift was consistent with Artistic Noise's restorative justice model.

Shortly after the brainstorm session, Tyra participated as a curator at an Artistic Noise public exhibition. Judge Drinane was in attendance, and Tyra gave her a 45-minute curatorial tour. In this gallery space, Tyra was the expert; unlike in the courtroom setting, she now had the mic and was positioned to manage the conversation. Even as the artwork relayed deep anger, the public display of powerfully evocative expression established a space for young people to be recognized for what they have to say and for their positive achievements. Additionally, it was powerful for a judge to engage with a young person after sentencing. So often judges see a young person in court and never know about the success stories of young people who do not appear again. Judge Drinane describes this experience:

> In court you see one limited side of a young person. Having this young woman give me a tour of the art works created by youngsters through their work with Artistic Noise reminded me how much we missed. As we stood in front of a beautiful drawing of an Indian woman, which was the curator's self-portrait, I was reminded how one-dimensional our judgements can be. She explained the portrait to me and how it reflected her wish to be a social worker who could help others. I thought of the young woman I had seen in court and the self-assured artist explaining the art works to me and was so glad Artistic Noise was a part of this young woman's life.
>
> (personal communication, April 19, 2018)

Discussion and Recommendations

Art therapy with court-involved youth can be challenging as they have largely had negative experiences in the juvenile justice system, in addition to, most likely, a myriad of other systems. We recommend a community-based approach that involves various stakeholders such as POs, family, friends, community members, and the young people involved. This approach is especially important while working with young people who are incarcerated. It is essential for youth to return to their communities with the resources and networks in place to ensure long-term success. Furthermore, co-facilitation between an art therapist and a teaching artist models communication and collaboration. The primary role of an art therapist in the Artistic Noise model is infusing a therapeutic perspective into all projects and workshops, enabling participants in need of more intense counseling access to individualized therapy with someone with whom they already have an established relationship. The main role of the teaching artist is focusing on the technical aspects of art-making, lesson planning, and the final product. This co-facilitation model also de-stigmatizes the therapy aspect, which can be off-putting for those who have had negative experiences with mental health providers in the past, as well as the art component, which can also be seen as intimidating. Artistic Noise also emphasizes that the level of art-making be of high quality, with its goal to be exhibited or shown to the public. When the work is exhibited publicly, the young people involved in the exhibition feel empowered and proud, and their voices are powerfully heard by those viewing the art.

We encourage using issue-based and socially engaged art curricula and restorative justice practices. We recommend including circles in groups for the purposes of structure and safety for all members—facilitators and group participants alike. When participants and staff become accustomed to and comfortable with circles, they are easily enacted even when more serious issues occur. In the circle, everyone has a voice, and everyone's voice is equal. Artistic Noise has utilized the familiar construct of circles with POs present when situations have arisen. Artistic Noise has also sadly sat in a circle when conveying to a close-knit group that a participant had died. With the co-facilitation of an art therapist and a teaching artist, the group is well equipped to handle more intense issues as they arise, whether these issues be what is happening in the news, the streets, or in our own program. We also recommend having co-facilitators of different gender identities, different races, and from diverse backgrounds. This way young people have a variety of adults with whom they are able to connect.

Being involved in the justice system can be incredibly stigmatizing. It is not uncommon to have a person who attended an exhibit comment with surprise on the quality of the artwork shown or on the speaking abilities of the artists. It is unfortunate and shameful that our society leads people to think that a court-involved young person may not be talented or articulate. There are many factors, some completely out of an individual's control, that can lead to justice involvement. The act of creating art can be incredibly liberating for a court-involved young person. Mass incarceration attempts to dehumanize people through various methods such as preventing individuals from voting, keeping up with current events, or interacting with family and friends. The act of creating art is in direct resistance to this: to create art is to be human (Dissanayake, 1980). By encouraging our participants to create art that is also a social critique of these systems, the art becomes an act of resistance.

Glossary

Community corrections: This overarching term refers to sanctions that occur outside of jail or prison settings. They are "generally operated by probation agencies (correctional supervision within the community instead of incarceration) and parole agencies (conditional, supervised release from prison)" (National Institute of Justice, n.d.).

Congregate facilities: The generic term for detention centers, training schools, and other locked residential units created specifically for juvenile offenders (sometimes called *congregate care facilities*).

Court-involved youth: We prefer to use this term rather than *juvenile* or *youthful offenders* as it humanizes the individuals, focusing more on the system rather than individualizing blame. Justice-involved youth is another preferred term. Juvenile delinquent is an outdated and unfavored term not used in this chapter to describe non-adult individuals who have been convicted of a crime. However, this term may be used in other texts.

Juvenile justice system: The penal system specifically for youth at or below the upper age specified by the state.

Juvenile offender: An adolescent or young person convicted of a crime. These individuals may be offered different forms of punishment or rehabilitation from their adult counterparts because of their developmental stage. *Youthful offender* is another term commonly used in policy and legal arenas; however, we use the term *court-involved youth* in this chapter.

Locked facility: A secure detention facility. See *lock up* or *congregate facility*.

Lock up: A secure detention facility. See *locked* or *congregate facility*.

Parole: An alternative to incarceration, offered to individuals after a partial sentence is served; an early release. This alternative is accompanied by supervision by a parole officer and often other mandates.

Probation: An alternative to incarceration, offered to individuals instead of a sentence to be served. This alternative is accompanied by supervision of a *probation officer (PO)* and often other mandates.

Probation officer (PO): Individual who provides supervision of an individual being monitored by probation.

Restorative justice: "A movement to address the needs and roles of victims of crime, offenders, and communities, rather than the legalistic system that holds offenders purely in relation to violation of the state and law" (Zehr, 2004, as cited in the Office of the State Attorney for the Fourth Judicial Circuit, n.d.).

Secure facilities: See *lock up* or *congregate facility*.

Youthful offender: See *juvenile offender*. This term is often used in policy and legal arenas; however, we prefer to use the term *court-involved youth* as it takes the blame off of the young people and puts it just in their system involvement.

Notes

1. The juvenile and criminal justice systems have specific terminology that readers not engaged in this work may be unfamiliar with. Please visit the glossary at the end of this chapter for basic definitions for italicized words.
2. All youth names used in this chapter are pseudonyms.

References

Alexander, M. (2010). *The new Jim Crow: Mass incarceration in the age of colorblindness*. New York, NY: The New Press.

Altschuler, D. M., & Brash, R. (2004). Adolescent and teenage offenders confronting the challenges and opportunities of reentry. *Youth Violence and Juvenile Justice, 2*(1), 72–87. https://doi.org/10.1177/1541204003260048

Artistic Noise. (n.d.a). *Our mission and purpose*. Retrieved from www.artisticnoise.org/our-mission-and-purpose/

Artistic Noise. (n.d.b). *Our story*. Retrieved from www.artisticnoise.org/history/

Awais, Y. J., Adelman, L., Paul, J., & Buseman, R. (2014, September). *Art as a bridge: Crossing the borders of artist educator therapist offender community member*. Panel presented at the conference of the Arcus Center for Social Justice and Leadership, Kalamazoo, MI.

Ayers, W. (1997). *A kind and just parent: The children of juvenile court*. Boston, MA: Beacon Press.

Bell, J., & Mariscal, R. (2011). Race, ethnicity, and ancestry in juvenile justice. In F. Sherman & F. Jacobs (Eds.), *Juvenile justice: Advancing research, policy, and practice* (pp. 111–130). Hoboken, NJ: John Wiley & Sons.

Beyer, M. (2011). A developmental view of youth in the juvenile justice system. In F. Sherman & F. Jacobs (Eds.), *Juvenile justice: Advancing research, policy, and practice* (pp. 3–23). Hoboken, NJ: John Wiley & Sons.

Braverman, P., & Morris, R. (2011). The health of youth in the justice system. In F. Sherman & F. Jacobs (Eds.), *Juvenile justice: Advancing research, policy, and practice* (pp. 44–67). Hoboken, NJ: John Wiley & Sons.

Broom, K. (1999). Art practice within the probation service. *Probation Journal, 46*(1), 31–36. https://doi.org/10.1177/026455059904600106

Burrows, A. (1946). The problem of juvenile delinquency. *The Journal of Educational Sociology, 19*(6), 382–390. https://doi.org/10.2307/2264018

Catalano, R. F., Berglund, M. L., Ryan, J. A., Lonczak, H. S., & Hawkins, J. D. (2004). Positive youth development in the United States: Research findings on evaluations of positive youth development programs. *The Annals of the American Academy of Political and Social Science, 591*(1), 98–124. https://doi.org/10.1177/0002716203260102

Collier, L. (2014). Incarceration nation. *Monitor on Psychology, 45*(9), 56.

Colwell, B., Villarreal, S. F., & Espinosa, E. M. (2012). Preliminary outcomes of a pre-adjudication diversion initiative for juvenile justice involved youth with mental health needs in Texas. *Criminal Justice and Behavior, 39*(4), 447–460. https://doi.org/10.1177/0093854811433571

Corrections Association of New York. (2011). *Youth in confinement* [Fact sheet]. Retrieved from www.correctionalassociation.org/resource/youth-in-confinement

Darts, D. (2004). Visual culture jam: Art, pedagogy, and creative resistance. *Studies in Art Education, 45*(4), 313–327. https://doi.org/10.1080/00393541.2004.11651778

Dickerson, C. (2018, September 12). Detention of migrant children has skyrocketed to highest levels ever. *The New York Times*. Retrieved from www.nytimes.com/2018/09/12/us/migrant-children-detention.html

Dissanayake, E. (1980). Art as a human behavior: Toward an ethological view of art. *The Journal of Aesthetics and Art Criticism, 38*(4), 397–406. https://doi.org/10.2307/430321

Dohrn, B. (2004). All Ellas: Girls locked up. *Feminist Studies, 30*(2), 302–324. https://doi.org/10.2307/20458965

DuVerney, A. (Producer & Director). (2016). *13th* [Motion Picture]. Netflix.

Evans-Chase, M., Kim, M., & Zhou, H. (2013). Risk-taking and self-regulation: A systematic review of the analysis of delinquency outcomes in the juvenile justice intervention literature 1996–2009. *Criminal Justice and Behavior, 40*(6), 608–628. https://doi.org/10.1177/0093854812469608

Finkelpearl, T. (2013). *What we made: Conversations on art and social cooperation*. Durham, NC: Duke University Press.

Froggett, L. (2007). Arts based learning in restorative youth justice: Embodied, moral and aesthetic. *Journal of Social Work Practice, 21*(3), 347–359. https://doi.org/10.1080/02650530701553724

Giroux, H. A. (2012). Collaterally damaged: Youth in a post-9/11 world. *Cross/Cultures, 145*, 591–617. https://doi.org/10.1163/9789401207393_036

Glowa-Kollisch, S., Kaba, F., Waters, A., Leung, Y. J., Ford, E., & Venters, H. (2016). From punishment to treatment: The "Clinical Alternative to Punitive Segregation" (CAPS) program in New York City jails. *International Journal of Environmental Research and Public Health, 13*(2), 182. https://doi.org/10.3390/ijerph13020182

Greenwood, P. (2008). Prevention and intervention programs for juvenile offenders: The benefits of evidence-based practice. *The Future of Children, 18*, 11–36. https://doi.org/10.1353/foc.0.0018

Greenwood, P., & Turner, S. (2009). An overview of prevention and intervention programs for juvenile offenders. *Victims and Offenders, 4*, 365–374. https://doi.org/10.1080/15564880903227438

Hahn, R., McGowan, A., Liberman, A., Crosby, A., Fullilove, M., Johnson, R., . . . Stone, G. (2007). Effects on violence of laws and policies facilitating the transfer of youth from the juvenile to the adult justice system: A report on recommendations of the task force on community preventive services. *Morbidity and Mortality Weekly Report: Recommendations and Reports, 56*(9), 1–11. https://doi.org/10.1016/j.amepre.2006.12.003

Hartz, L., & Thick, L. (2005). Art therapy strategies to raise self-esteem in female juvenile offenders: A comparison of art psychotherapy and art as therapy approaches. *Art Therapy, 22*(2), 70–80. https://doi.org/10.1080/07421656.2005.10129440

Helguera, P. (2011). *Education for socially engaged art: A materials and techniques handbook.* New York, NY: Jorge Pinto.

Henggeler, S. W., & Schoenwald, S. K. (2011). Evidence-based interventions for juvenile offenders and juvenile justice policies that support them. *Social Policy Report, 25*(1). Retrieved from www.srcd.org/sites/default/files/documents/spr_25_no_1.pdf

Hinz, L. D. (2009). *Expressive therapies continuum: A framework for using art in therapy.* New York, NY: Routledge.

Holman, B., & Ziedenberg, J. (2006). *The dangers of detention: The impact of incarcerating youth in detention and other secure facilities.* Retrieved from www.justicepolicy.org/uploads/justicepolicy/documents/dangers_of_detention.pdf

Johnson, L. M. (2008). A place for art in prison: Art as a tool for rehabilitation and management. *Southwest Journal of Criminal Justice, 5*(2), 100–120.

Justice Policy Institute. (2014). *$ticker $hock: Calculating the full price tag for youth incarceration.* Retrieved from www.justicepolicy.org/uploads/justicepolicy/documents/sticker_shock_final_v2.pdfwww.justicepolicy.org/research/index.html

Justice Policy Institute. (2017). *Raising the age: Shifting to a safer and more effective juvenile justice system.* Retrieved from www.justicepolicy.org/uploads/justicepolicy/documents/raisetheage.fullreport.pdf

Lane, J., Turner, S., Fain, T., & Sehgal, A. (2007). Implementing "corrections of place" ideas: The perspective of clients and staff. *Criminal Justice and Behavior, 34*(1), 76–95. https://doi.org/10.1177/0093854806288436

Larose, M. E. (1987). The use of art therapy with juvenile delinquents to enhance self-image. *Art Therapy, 4*(3), 99–104. https://doi.org/10.1080/07421656.1987.10758708

Lerner, R., Wiatrowski, M., Mueller, M. K., Napolitano, C. M., Schmid, K. L., & Pritchard, A. (2011). A vision for the American juvenile justice system: The positive youth development perspective. In F. Sherman & F. Jacobs (Eds.), *Juvenile justice: Advancing research, policy, and practice* (pp. 92–108). Hoboken, NJ: John Wiley & Sons.

Liebmann, L. (2004). *Art therapy for groups: A handbook of themes and exercises* (2nd ed.). New York, NY: Routledge.

Lipsey, M. W., Howell, J. C., Kelly, M. R., Chapman, G., & Carrver, D. (2010). *Improving the effectiveness of juvenile justice programs: A new perspective on evidence-based practice.* Retrieved from http://njjn.org/uploads/digital-library/CJJR_Lipsey_Improving-Effectiveness-of-Juvenile-Justice_2010.pdf

Ludwig, J., Duncan, G. J., & Hirschfield, P. (2001). Urban poverty and juvenile crime: Evidence from a randomized housing-mobility experiment. *The Quarterly Journal of Economics*, *116*(2), 655–679. https://doi.org/10.1162/00335530151144122

McGarrel, E., Olivares, K., Crawford, K., & Kroorand, N. (2000). *Returning justice to the community: The Indianapolis juvenile restorative justice experiment*. Indianapolis, IN: Hudson Institute. Retrieved from www.ibarji.org/docs/mcgarrell.pdf

Moon, C. H., & Shuman, V. (2013). The community art studio: Creating a space of solidarity and inclusion. In P. Howie, S. Prasad, & J. Kristel (Eds.), *Using art therapy with diverse populations: Crossing cultures and abilities* (pp. 297–307). Philadelphia, PA: Jessica Kingsley Publishers.

Mowen, T. J., Brent, J. J., & Bares, K. J. (2017). How arrest impacts delinquency over time between and within individuals. *Youth Violence and Juvenile Justice*, 1–20. https://doi.org/10.1177/1541204017712560

National Institute of Justice. (n.d). *Corrections & reentry*. Retrieved from www.crimesolutions.gov/TopicDetails.aspx?ID=28

New York State Juvenile Justice Advisory Group. (2014). *2014 JJAG annual report*. Retrieved from http://criminaljustice.ny.gov/ofpa/jj/docs/2014-JJAG-Annual-Report.pdf

New York State Office of Children and Family Services. (2016). *2016 annual report youth in care*. Retrieved from www.criminaljustice.ny.gov/ofpa/jj/jj-index.htm

Office of Juvenile Justice and Delinquency Prevention. (n.d.). *Youth (0 to 17) population profile detailed by age, sex, and race/ethnicity, 2014* [Data file]. Retrieved from www.ojjdp.gov/ojstatbb/nr2014/downloads/NR2014.pdf

Office of the State Attorney for the Fourth Judicial Circuit. (n.d.). *Restorative justice*. Retrieved from www.sao4th.com/about/programs-and-initiatives/restorative-justice/

Ottemiller, D. D., & Awais, Y. J. (2016). A model for art therapists in community-based practice. *Art Therapy: Journal of the American Art Therapy Association*, *33*(3), 144–150. https://doi.org/10.1080/07421656.2016.1199245

Paquette, J., & Vitaro, F. (2014). Wilderness therapy, interpersonal skills and accomplishment motivation: Impact analysis on antisocial behavior and socio-professional status. *Residential Treatment for Children & Youth*, *31*(3), 230–252. https://doi.org/10.1080/0886571X.2014.944024

Persons, R. W. (2009). Art therapy with serious juvenile offenders: A phenomenological analysis. *International Journal of Offender Therapy and Comparative Criminology*, *53*(4), 433–453. https://doi.org/10.1177/0306624X08320208

Riley, S. (1999a). Brief therapy: An adolescent invention. *Art Therapy*, *16*(2), 83–86. https://doi.org/10.1080/07421656.1999.10129669

Riley, S. (1999b). *Contemporary art therapy with adolescents*. Philadelphia, PA: Jessica Kingsley Publishers.

Robertson, A. A., Grimes, P. W., & Rogers, K. E. (2001). A short-run cost-benefit analysis of community-based interventions for juvenile offenders. *Crime & Delinquency*, *47*(2), 265–284. https://doi.org/10.1177/0011128701047002006

Rosenblatt, F. (2015). *The role of community in restorative justice*. Oxford: Routledge.

Rubin, J. A. (1984). *Child art therapy* (2nd ed.). New York, NY: Van Nostrand Reinhold.

Sanders, J., Munford, R., Thimasarn-Anwar, T., Liebenberg, L., & Ungar, M. (2015). The role of positive youth development practices in building resilience and enhancing wellbeing for at-risk youth. *Child Abuse & Neglect*, *42*, 40–53. https://doi.org/10.1016/j.chiabu.2015.02.006

Santora, M. (2013, August 23). City's annual cost per inmate is $168,000, study finds. *New York Times*. Retrieved from www.nytimes.com/2013/08/24/nyregion/citys-annual-cost-per-inmate-is-nearly-168000-study-says.html

Schiraldi, V., Schindler, M., & Goliday, S. J. (2011). The end of reform school? In F. Sherman & F. Jacobs (Eds.), *Juvenile justice: Advancing research, policy, and practice* (pp. 409–432). Hoboken, NJ: John Wiley & Sons.

Sellers, B. G. (2015). Community-based recovery and youth justice. *Criminal Justice and Behavior*, *42*(1), 58–69. https://doi.org/10.1177/0093854814550027

Sherman, F., & Blitzman, J. (2011). Children's rights and relationships: A legal framework. In F. Sherman & F. Jacobs (Eds.), *Juvenile justice: Advancing research, policy, and practice* (pp. 68–92). Hoboken, NJ: John Wiley & Sons.

Sherman, L. W., Strang, H., Mayo-Wilson, E., Woods, D. J., & Ariel, B. (2015). Are restorative justice conferences effective in reducing repeat offending? Findings from a Campbell systematic review. *Journal of Quantitative Criminology, 31*(1), 1–24. https://doi.org/10.1007/s10940-014-9222-9

Simmonds, M. (n.d.). The cost of juvenile justice. *The Way Home: Journeys Through the Juvenile Justice System*. Retrieved from www.juvenilejusticejourneys.com/the-cost-of-juvenile-justice/

Sitzer, D. L., & Stockwell, A. B. (2015). The art of wellness: A 14-week art therapy program for at-risk youth. *The Arts in Psychotherapy, 45*, 69–81. https://doi.org/10.1016/j.aip.2015.05.007

Slobogin, C. (2011). Commentary: A prevention model of juvenile justice. *Social Policy Report, 25*(1). Retrieved from www.srcd.org/sites/default/files/documents/spr_25_no_1.pdf

Smeijsters, H., Kil, J., Kurstjens, H., Welten, J., & Willemars, G. (2011). Arts therapies for young offenders in secure care—a practice-based research. *The Arts in Psychotherapy, 38*(1), 41–51. https://doi.org/10.1016/j.aip.2010.10.005

Stern, M. J., & Seifert, S. C. (2017). The social wellbeing of New York City's neighborhoods: The contribution of culture and the arts. *Culture and Social Wellbeing in New York City, 1.* Retrieved from https://repository.upenn.edu/siap_culture_nyc/1/

Strang, H., Sherman, L. W., Mayo-Wilson, E., Woods, D., & Ariel, B. (2013). Restorative Justice Conferencing (RJC) using face-to-face meetings of offenders and victims: Effects on offender recidivism and victim satisfaction. A systematic review. *Campbell Systematic Reviews, 12.* https://doi.org10.4073/csr.2013.12

Talwar, S. (2016). Creating alternative public spaces: Community-based art practice, critical consciousness and social justice. In D. Gussak & M. Rosal (Eds.), *The Wiley handbook of art therapy*. Oxford, England: Wiley-Blackwell.

Thomas, S. A., & Shihadeh, E. S. (2013). Institutional isolation and crime: The mediating effect of disengaged youth on levels of crime. *Social Science Research, 42*(5), 1167–1179. https://doi.org/10.1016/j.ssresearch.2013.03.009

Timm-Bottos, J. (2006). Constructing creative community: Reviving health and justice through community arts. *The Canadian Art Therapy Association Journal, 19*(2), 12–26. https://doi.org/10.1080/08322473.2006.11432285

Underwood, L. A., & Washington, A. (2016). Mental illness and juvenile offenders. *International Journal of Environmental Research and Public Health, 13*(2), 228. https://doi.org/10.3390/ijerph13020228

Vera Institute of Justice. (2015). *The price of jails: Measuring the taxpayer cost of local incarceration.* Retrieved from www.vera.org/sites/default/files/resources/downloads/price-of-jails.pdf

Ward, T., Gannon, T. A., & Fortune, C. (2015). Restorative justice-informed moral acquaintance resolving the dual role problem in correctional and forensic practice. *Criminal Justice and Behavior, 42*(1), 45–57. https://doi.org/10.1177/0093854814550026

Williams, R. M. C. (2003). *Teaching the arts behind bars*. Boston, MA: Northeastern University Press.

Williams, R. M. C., & Taylor, J. Y. (2004). Narrative art and incarcerated abused women. *Art Education, 57*(2), 47–54. https://doi.org/10.1080/00043125.2004.11653543

21

Fighting Isolation and Celebrating Gender Diversity

Art Therapy With Transgender and Gender Expansive Youth

BENJAMIN DAVIS

Much literature has highlighted the reality that transgender and gender diverse young people face significant health risks, many in dire need of therapeutic support (Becerra-Culqui et al., 2018; Connolly, Zervos, Barone, Johnson, & Joseph, 2016; De Pedro, Gil-reath, Jackson, & Esqueda, 2017; Kosciw, Greytak, Giga, Villenas, & Danischewski, 2016; Reisner et al., 2015). When compared with their cisgender peers, trans youth present with increased incidence of suicide, depression, anxiety, addiction, self-harm, substance misuse, eating disorders, HIV infection and other illnesses, homelessness, survival sex work, school refusal, and school dropout (Becerra-Culqui et al., 2018; Connolly et al., 2016; De Pedro et al., 2017; Kosciw et al., 2016; Olson, Schrager, Belzer, Simons, & Clark, 2015; Reisner et al., 2015). Given the proper support, however, transgender youth prevail as a resilient group who are both resourceful and adaptable (Breslow et al., 2015; Connolly et al., 2016; Durwood, McLaughlin, & Olson, 2017; Klein & Golub, 2016; Olson, Durwood, DeMeules, & McLaughlin, 2016).

Transgender youth are particularly vulnerable when they are members of other disempowered populations (James et al., 2016; Rider, McMorris, Gower, Coleman, & Eisenberg, 2018). Undocumented transgender immigrants may lack access to lifesaving medical care; others may be unable to alter documents to reflect their lived name and gender, exposing them to complex legal difficulties and increased threats to their safety. A gender expansive young person from a multistressed family may not have the psychosocial supports or family education necessary to move toward acceptance, nor adequate time to devote to support groups and community gatherings, leaving them isolated and with significant unmet need.

With limited (albeit growing) resources and specialists in the field, finding and affording appropriate care for transgender youth can be difficult. Some families are forced to relocate in search of more inclusive policies and schools, a financial burden that is untenable for most. Many families spend thousands of dollars each year traveling across the country and around the world to find relevant specialists who can assist in providing affirming and compassionate gender-affirming medical and mental health care. And while recent media attention and increased funding for assessment and intervention measures tailored to the needs of transgender youth have shed light on specific concerns for this population, racism, sexism, ableism, ageism, and heterosexism impact dynamics *within* the transgender community, highlighting continued gaps in accessible, culturally competent and attuned care. A white transman will experience an entirely

different reality than a transgirl of color. Access to supportive care is stratified by class, health insurance coverage, geographic location, and rapidly changing local rules and regulations. In most cases, a transgender person under the age of 18 will be denied medical interventions such as hormone therapy and surgery without parental consent, making family education essential to a young person's access to gender-affirming care. In some districts, transgender youth may be prevented from using their authentic names and gender pronouns in schools and other institutions, resulting in increased social avoidance and anticipated or actual bullying. Therefore, parental support and advocacy can afford young trans people numerous privileges inconceivable to trans youth without supportive adult figures.

Addressing feelings of isolation and increasing access to gender-affirming interventions are some of the most effective ways to address the critical needs of transgender youth communities, despite variations across geographic locations, racial groups, and social classes (American Psychological Association [APA], 2015; Durwood et al., 2017; Janssen & Leibowitz, 2018; Olson et al., 2016; Reisner et al., 2015). Fostering healthy coping skills can alleviate the stress associated with pervasive transphobia, medical trauma, social isolation, and ostracism (Austin & Craig, 2015; Singh, Meng, & Hansen, 2014). Clinical engagement for this population ranges from individual and family therapies to group interventions and community-based support activities. Culturally attuned and inclusive religious institutions, schools, and camps are known to significantly impact the safety and overall quality of life for many trans youth. These inclusive environments can be life changing and sustaining, particularly for youth with histories of bullying and social exclusion. They can provide accepting spaces and innovative activities through which trans people may develop and affirm their identities.

Art therapy is a modality that can offer trans youth an accessible format to articulate themselves, with interventions that include verbal and nonverbal engagement as well as limitless opportunities to self-express and to communicate through symbolism. In therapies that include only verbal interaction, gendered pronouns and descriptors can limit the expansive nature of identity, resulting in an either/or (male/female) paradigm that is unrelatable to many trans people whose identities may be more complex and varied than these qualifiers permit for. Art therapy, however, can work against restrictive terminology by probing the unending variations of color and shape to which we could not possibly assign a binary and static rubric. Terms such as *man, woman, masculine,* and *feminine* may be similar to *red* and *blue* when describing the experience of gender: important and prevalent but not inclusive of the full spectrum.

Art therapy allows for shades of grey not available in a binary gender construct, along with the ability to demonstrate and practice personal agency. By prompting clients to color outside the lines of prescribed gender roles and identities, art therapy can offer an opportunity for authentic exploration, validation, and mirroring. Active engagement in artistic creation can be particularly empowering for young people who are unable to take steps to change aspects of their bodies and lives one might as an adult. Art therapy can increase understanding and self-acceptance, and help children and adolescents to find strength and mastery despite feeling powerless over their bodies and their experiences within society at large. Whereas language-based activities can perpetrate and reinforce verbal erasure (Bauer et al., 2009), art therapy allows clients to *be seen* and *stay seen* by way of concrete and lasting artifacts. Verbal language is not necessary when exploring a young person's experience in an art therapy session, therefore not reducing their body or identity to a handful of restrictive terms. Instead, art therapy provides a language in which meaning comes in varied, limitless colors and textures. Self-definition becomes possible in this process wherein we witness, honor, and reflect the undefinable.

Gender-Affirming Language

My involvement in the field of transgender mental health and advocacy began in 2005 when I started working at an LGBTQ (lesbian, gay, bisexual, transgender, and/or queer) community center in a major city in the U.S. As a psychotherapist, advocate, and educator, I have participated in research and training across the country, and I have kept track of global progress in the field of transgender health through organizations such as the World Professional Association of Transgender Health (WPATH), of which I am a member, as well as trans-led initiatives that prioritize voices of transgender-identified clinicians, activists, and policy-makers. I have experienced great diversity among transgender people and have come to understand that language used to describe gender varies drastically. And while language has always changed and evolved over time, words used to describe transgender identities have been in major flux since the 1990s.

The word *transgender* is used to define people whose gender identity is different from that typically associated with their sex assigned at birth. Transboys and transmen are boys and men who usually were assigned female at birth, and transgirls and transwomen are girls and women who usually were assigned male at birth. *Gender nonconforming, non-binary, agender, gender diverse, genderfluid, genderqueer, gender creative* and *gender expansive* are terms used to identify a person whose gender identity is different from that typically associated with the sex they were assigned at birth and may also not align within a binary (male/female) gender construct. These individuals may identify with both, neither, or some of the perceived characteristics of men and women. In children, these identifiers may be self-assigned or used by a parent or caregiver.

Why is language so important to transgender youth? Nearly all supportive policies and practices urge clinicians, family, and friends to use the name and gender pronouns of the person's *affirmed gender* rather than the sex they were assigned at birth. MacNish (2015) notes that transgender adolescents have a strong desire to be seen as their core self, emphasizing the need for witnessing and validation of gender in addition to the general adolescent task of identity development. Using the correct name and gender pronouns for trans people, as well as mirroring the terminology they use to describe themselves, can signal seeing and believing. For these youth, this support can be lifesaving; use of a chosen name in multiple contexts affirms gender identity and reduces depression, suicidal ideation, and suicidal behavior (Russell, Pollitt, Li, & Grossman, 2018).

Gender identity refers to people's own understanding of who they are, entirely different from *sexual orientation* or *sexuality*, terminology used to discuss romantic and sexual attraction and partnering. Gender identity begins forming by the age of two, whereas sexuality and sexual orientation emerges much later, often with the onset of puberty (Janssen & Leibowitz, 2018). *Gender expression* denotes the ways in which a person indicates elements of masculinity and femininity through dress, hairstyle, and mannerisms. Sex assigned at birth, or *assigned sex*, is usually based on visual inspection of a newborn's external genitalia, but also includes other anatomic and physiologic elements of the body commonly used to designate someone as male or female, including chromosomes, hormone levels, and primary and secondary sex characteristics. While sex is generally assumed to be binary nature, bodies naturally exist with expected ranges of sex-specific criteria, therefore challenging the notion that there are two distinct categories of people, male and female. More and more research points to the complexity of biological sex and how an either/or (male/female) model is incomplete and reductive.

Social transition is generally understood to be the process in which a trans person begins to live with the name, role, and pronoun of their authentic self. *Gender-affirming*

medical interventions might be part of a *medical transition*, wherein trans people may take hormone blockers, hormone replacement therapies, and/or undergo surgery to align their body with characteristics of their identified gender, although there are a variety of ways in which one can medically transition, and many trans people seek no medical intervention at all. A *legal transition* refers to changing legal documents to reflect name and gender. It should be noted that access to medical transition is often heavily dependent on insurance coverage and legal inclusion requirements, a topic of significant debate within local and federal political administrations. Without inclusive policies, hormone therapy costs range from virtually nothing to a few hundred dollars monthly, and a gender-affirming surgery could cost from $10,000 to over $100,000, depending on numerous factors not systematically covered in the literature to date. Access to legal transition, including changing the legal gender marker on a birth certificate, can vary not only by state but by city and county, depending on local laws.

Coming out or *being out* as trans generally means that a person's trans experience is information they have decided to share with a select group. Being *outed* is an experience wherein a trans person's identity is shared without consent, either before the person transitions or long after. It should be noted that coming out as transgender and coming out as gay, lesbian, or another sexual identity are wholly different experiences. Living *stealth* is a term used to describe the experience of a trans person who is living as their authentic gendered self, choosing not to share their earlier experience of transition. This term should not be confused with being *in the closet*. For all gender and sexual minorities, it is critical that for whom, when, and how disclosure happens remain in the control of the person whose identity is being described. The experience of being *outed* without consent can be traumatic and dangerous.

In this chapter, *trans* is used to encompass all gender identities that do not fit the definition of *cisgender*, the word used to identify someone whose gender identity matches that which is commonly associated with their sex assigned at birth. Readers should note that *trans* may be too reductive a term and be mindful that, in this chapter, *trans* includes gender expansive, gender fluid, and non-binary youth, all of whom have varied experiences, needs, and concerns. In contrast, *cisnormative* refers to the traditional male-masculine versus female-feminine binary formula that has pervaded cultural expectations of identity. Given the rapidly changing landscape of language used to discuss gender and sexuality, it is always best to identify local trends and practices when working with these populations. Recommendations in this text are informed by its particular time and place.

Clinical Interventions for Transgender Youth

The most robust survey of trans populations at the time of this publication is the 2015 U.S. Transgender Survey (USTS), encompassing data collected from 27,715 trans individuals (James et al., 2016). While the study asked respondents to report retrospectively on their youth and adolescence, the research was limited to include only those above the age of 18 at the time of participation. Like other studies in the field, the report found that trans individuals were especially vulnerable to suicide and other mental health concerns. Forty percent of respondents had attempted suicide in their lifetime, nearly nine times the attempted suicide rate in the general U.S. population (James et al., 2016). In the year preceding the survey, seven percent had attempted suicide, nearly twelve times the rate in the general U.S. population (James et al., 2016).

Research samples that directly engage trans youth under the age of 18 have been limited in size. While The Williams Institute estimated that 150,000 trans youth were living in the U.S. in 2017 (Herman, Flores, Brown, Wilson, & Conron, 2017), there are significant issues in accounting for population data and demographic trends. Rarely do forms targeted at the general, non-LGBTQ public allow for any gender or sex selection apart from *male* or *female*. Trans youth who have been identified and counted in research are usually those receiving medical or mental health treatment, not accounting for entire segments of the population who do not engage in these services, live stealth, or whose parents do not allow for participation.

Yet the existing research on trans youth illustrates a sobering reality: prejudice and discrimination have profound effects on social functioning, education, and health. Olson and colleagues (2015) found that 35% of trans youth aged 12 to 24 reported depression symptoms within the clinical range. More than half of the youth in this study had thought about suicide at least once in their lifetime, and nearly a third had made at least one attempt. In a Canadian sample, 65% of trans youth 14 to 18 years old had seriously considered suicide in the past year (Veale, Watson, Peter, & Saewyc, 2017), and an Australian study of trans youth ages 14 to 25 found that 44% reported an anxiety disorder, 40% reported depression, and 38% reported suicidal thoughts (Smith et al., 2014).

Mental health concerns are not surprising given the hostility experienced by many trans youth. GLSEN's 2015 National School Climate Survey captured the experiences of 10,528 LGBTQ students aged 13 to 21. Of these respondents, over a third self-identified as not being cisgender, using language like transgender, non-binary, agender, gender-fluid, and genderqueer to identify themselves (Kosciw et al., 2016). In this sample, more than three quarters of trans students felt unsafe at school because of their gender expression. Over half of trans students had been prevented from using their affirmed name or pronoun in school, and 60% of trans students had been required to use a bathroom or locker room of their legal sex, rather than their affirmed gender. Students who experienced higher levels of victimization because of their gender expression were almost three times as likely to have missed school in the past month, had lower GPAs, were twice as likely to report that they did not plan to pursue any post-secondary education, were more likely to have been disciplined at school, had lower self-esteem and sense of school belonging, and had higher levels of depression than their peers (Kosciw et al., 2016). Seventy-seven percent of those in the USTS data set who were out or perceived as trans had experienced some form of mistreatment during their primary or secondary school years. Fifty-four percent were verbally harassed, 24% were physically attacked, and 13% were sexually assaulted because of being trans. Seventeen percent faced such severe mistreatment that they left school (James et al., 2016). When trans youth cannot safely learn or physically remain present in a school setting, they enter adulthood with far fewer resources and opportunities to succeed than their peers.

For many cultures around the globe, gender remains of utmost importance. Social, sexual, and occupational divisions exist between genders, making gender paramount above other characteristics like age, race, and ability. Gender is the first question we ask about when a baby is to enter the world, as if gender is the sole humanizing factor that crystallizes an ambiguous *it* into something capable of human bonds and relational identity. Unclear gender may have a dehumanizing effect, creating systems in which trans people are seen as ill, other, and suspect. Barbee (2002) examines the ways in which trans people are pathologized, attributing such harmful processes to deeply rooted binary notions of sex and gender, wherein *male* and *female* are distinct and absolute. Schilt and Westbrook (2009) conclude that "doing gender in a way that does not

reflect biological sex," or not being cisgender, "can be perceived as a threat to hetero-sexuality" (p. 442). To be unidentifiable as male or female, as they describe, disrupts cultural expectations regarding immutable aspects of biology, which may elicit anger, violence, and skepticism for fear of the trans person being tricky or deceptive. These responses can be deadly. The FBI documents that bias-motivated attacks based on gen-der identity increased from 33 incidents in 2013 to 130 in 2016 (U.S. Department of Justice Federal Bureau of Investigation, 2017). In 2017, there were 28 reported homi-cides of trans people in the U.S., a progressive increase from 2015 (Human Rights Cam-paign, 2018). Transwomen of color make up the vast majority of those killed.

Living as "other," isolated from peers and victimized by bullying, intimidation, and actual and anticipated violence, is no easy feat while also tasked with the developmen-tal milestones of childhood and adolescence. For trans youth, negative mental health outcomes are attributed to trauma, stigma, and minority stress, rather than an inher-ent predisposition for depression and other worrisome symptoms (Breslow et al., 2015; Hatzenbuehler & Pachankis, 2016). Minority stress models for transgender individuals include both distal (external) and proximal (internal) stressors. Breslow and colleagues (2015) identified anti-transgender discrimination as a distal stressor related to symp-toms of psychological distress, including suicidal ideation, anxiety, and depression, in addition to poor physical health outcomes. Internalized transphobia, or the ways in which transgender people might incorporate society's negative evaluations into their self-concept, is a proximal stressor that can lead to negative self-esteem. An additional proximal stressor is the expectation or fear of encountering future discrimination, a phenomenon identified as stigma awareness (Breslow et al., 2015). Trans identification is not caused by early childhood trauma or parental neglect. Conversion therapy has been shown to be harmful for trans individuals of all ages and can result in increased risk for depression and suicidal gestures, in addition to rupture within the family and further isolation (APA, 2015).

Affirming treatment for transgender youth should address the presenting symptoms, along with environmental interventions to decrease anxiety and the overall experience of social isolation and ostracism. Clinical interventions that foster resilience and con-nectedness have been shown to be effective for trans youth suffering from depression and anxiety (Austin & Craig, 2015; Beaumont, 2012; Kreiss & Patterson, 1997). Cogni-tive behavioral therapy (CBT) and dialectical behavioral therapy (DBT) models have been adapted for trans youth populations (Austin & Craig, 2015; Pardoe & Trainor, 2017), and group therapies addressing social anxiety and suicide prevention have been utilized. In schools, student clubs like GSAs (Gay Straight Alliances or Gender and Sex-uality Alliances), gender-inclusive training for faculty and staff, and classroom curricula honoring all students' experiences have been shown to decrease isolation and other neg-ative outcomes (Johns, Beltran, Armstrong, Jayne, & Barrios, 2018; Kosciw et al., 2016).

Exploring strength-based practice, Singh (2012) used critical theory and feminist paradigms in a qualitative study focusing on the resilience of trans youth of color. Examining these young people's ability to "bounce back" from challenging experiences with transphobia and racism, the researchers integrated a framework wherein power, privilege, and politics became integral to the treatment model. Singh et al. (2014) later synthesized this data, offering therapeutic interventions to support the resilience of trans youth and enumerating threatening factors that erode such resilience. Being able to define one's own gender, access supportive educational systems, connect with trans-affirming community, reframe mental health challenges, and engage with family and friends were all themes that supported resilience in this study. Threatening factors

included emotional and social isolation, healthcare barriers, employment discrimination, limited financial resources, and enforcement of cisnormative gender expression.

Other treatment models for trans youth focus on social transition and availability of gender-affirming medical interventions. Data from the research of Olson and colleagues (2016) support the clinical importance of accessible medical care and social affirmation, suggesting that trans children who had been allowed to socially transition showed no elevation in depression and only slightly elevated anxiety relative to population averages. Improved psychological functioning was correlated with the use of hormone blockers at the commencement of natal puberty (Olson et al., 2016). Growing evidence points to the conclusion that psychopathology is often avoidable and is much more prevalent in children who are prevented from transitioning or taking steps to be recognized as their affirmed gender.

Social, medical, and legal transition for a minor necessitates a degree of acceptance and commitment from parents or guardians, a reality rarely achieved overnight. The path to acceptance varies by household and family member and often requires education, time, and patience, involving multimodal interventions targeting the family's negotiation of safety, connection, and fluidity (Malpas, 2011). And while difficult to hasten, the need for parent engagement is dire. Klein and Golub (2016) analyzed the 2008 USTS data set to find that trans people with moderate or high levels of family rejection had significantly higher levels of suicide, while trans people with low or no family rejection experiences had significantly lower suicide rates. A Canadian sample of 16- to 24-year-olds showed a 93% reduction in reported suicide attempts for youth who indicated that their parents were strongly supportive of their gender identity and expression (Travers, Bauer, & Pyne, 2012). This research mirrors earlier work, which identifies that among LGBTQ people at large, family support and acceptance is a protective factor against suicide (Ryan, Russell, Huebner, Diaz, & Sanchez, 2010).

While family acceptance proves to be a strong predictive factor in the overall well-being of a young trans person, institutional and culture-wide transphobic beliefs and practices often cause significant distress, even if the child's immediate circle is affirming and engaged (Austin & Craig, 2015). National organizations like GLSEN, PFLAG, Gender Spectrum, and the Ackerman Institute's Gender & Family Project, among many others, work to provide psychoeducational training and gender-inclusive curricula for schools. In the last decade, major gains have been made in creating trans-inclusive religious community spaces and summer camps, among other cultural activities. The overarching goal of such programs is to create more welcoming environments for trans youth, increasing physical safety, social relatedness, and overall psychological well-being. These community-based interventions depathologize trans identities and emphasize the responsibility of community members to respect and welcome all.

Unfortunately, many policies and practices still exclude trans youth, and the effects are alarming. Following the 2016 U.S. presidential election, LGBTQ agencies and hotlines around the country reported an increase in concerns about healthcare, military inclusion, bathroom access, and physical safety (The Trevor Project, 2017). Suicidality and completed suicides reportedly multiplied following the election, as trans youth struggled to envision a future that included them (The Trevor Project, 2017).

Young trans people may have great difficulty accessing and using mental health services and other support systems, which can lead to further isolation and marginalization (Gridley et al., 2016; Olson et al., 2015). If these young people are able to establish a connection to care providers, their therapists must be mindful of the rigidity of cisnormative treatment models, gendered language and expectations, and a long history

of pathologizing gender nonconformity by mental health providers. For a transgender person entering mental health treatment, intake forms, bathrooms, and insurance policies, let alone diagnostic and treatment measures, are generally binary in structure and application. While therapists may not have the immediate ability to avoid these exclusionary systems altogether, awareness of them, paired with empathy and compassion for how their trans client might experience them, is meaningful.

The field of art therapy provides a range of strength-based approaches that offer young trans people less stigmatizing interventions, often met with less resistance than verbal modalities in which young clients are prompted to explain and defend their inner experiences to an adult therapist. Art therapy is uniquely positioned to disrupt social hierarchies, particularly through the physical relationship between artist or client and art-making materials (Fabre-Lewin, 1997). Art therapy is strength based, encouraging creative expression and authentic use of self.

Despite art therapy's utility and appropriateness as a mental health intervention, there is minimal published documentation on the efficacy of art therapy with trans youth. Beaumont (2012) suggests employing a compassion-oriented approach when working with trans clients in an effort to generate self-compassion through imagery and art-making, fostering greater resilience and positive coping skills such as mindfulness and self-soothing. The therapist's unconditional acceptance toward clients is an essential part of this approach (Beaumont, 2012). Babyatsky-Grayson (2014) implements an inclusive framework that highlights the strengths and creative aspects of young trans people as they attempt to understand their relationship to themselves and the world, while also acknowledging the importance of multidisciplinary care inclusive of medical professionals such as pediatric endocrinologists and primary care physicians. Schnebelt (2015) explores how art therapy can be utilized to facilitate empowerment, helping trans clients to discover a more genuine sense of self-identity. Art therapy can document the transition process and provide a visual method to articulate clients' inner experiences (Barbee, 2002; Maher, 2011).

Group art therapy offers clients an opportunity to connect with a peer group more understanding of their personal narratives, with the potential for visual and experiential mirroring. Oxendale (2017) utilized group art therapy as a venue for trans teens to explore identity and sense of self as they evolved in transition. The group setting allowed the teens to form new relationships as they examined their gender identities and sexualities. The age range in the group (13 to 17 years) fostered peer modeling and teaching while the clients explored topics including identity and sense of self, the transition process, support systems, the future, mindfulness, safety, self-love, and acceptance.

The existing literature suggests that art therapy can be a useful and particularly apt mental health intervention for trans youth. It can promote exploration of identity and foster psychological well-being through individual and communal art-making experiences that transcend the cisnormative verbal barriers of traditional therapeutic modalities.

Case Vignette: Making Art and Celebrating Together

The intervention documented here was conducted within the context of a psychosocial program supporting trans youth and their families. Located in New York City, The Ackerman Institute's Gender & Family Project (GFP) serves young people who identify as trans and gender expansive or whose families have begun to articulate the need for gender-related inquiry and exploration. At the time of this intervention in 2016, there

were 128 families actively engaged in programming. The median age of children in the group was 12 years old. Forty-nine percent of the families reported that their child was identified male at birth, and 51% had been assigned female at birth. Twenty-three percent of children identified as non-binary (or used another word, such as gender non-conforming or gender expansive), 37% identified as transgirls, and 40% identified as transboys. Sixty-eight percent of the program's youth were White, 18% Hispanic, 2% Black or African American, and 11% multiracial. Two percent of the youth were transracial adoptees, and 0% were Asian. Sixty percent of youth participating in the program had in some way socially transitioned, using their affirmed names and gender pronouns or having been integrated into their community in other ways that validated their identity. This demographic data suggest the heterogeneity of the population and, therefore, the children's varying social and emotional needs. I had been involved in the project since 2014 and had been known previously to some families due to my active role in the community throughout the preceding decade. At the time of this intervention, I served as GFP's Deputy Director.

Programming included the clinical services of psychological evaluation and family therapy, as well as community-based support and empowerment activities. Monthly group sessions were held for children as young as 5 and as old as 18, along with their parents and siblings. Community trainings were offered to related institutions and the young people's schools if they were not being affirmed within these settings. The program was entirely voluntary and financially accessible with sliding-scale fees, although children could not participate without parental consent and engagement, necessitating the delivery of services within the context of the family. For youth without such family support, referral was made to a partnering institution that was able to support the young person with education, food, and shelter as needed, in addition to psychosocial counseling and community support.

The primary intervention for GFP families was a monthly support group. When clinically appropriate, families were encouraged to attend two-hour group sessions each month, promoting continuity of care and familiarity among group members. Adult participation was usually limited to primary caregivers. As an art therapist facilitating the sessions for trans children and teens, I had already used art therapy within a group context. During each session, clients were offered art materials to work on individual and group projects. Making art was a ritualized activity in the group to promote multi-sensory engagement and expression, build cohesiveness, and provide lasting products for young people to track progress.

The act of creating art and the physical products that remain highlight the issue of privacy, of critical importance within the trans community in this case. The fact that there would be a visible record of each therapeutic session sparked discussion among GFP clinicians and staff. We wanted to ensure privacy and confidentiality, while also desiring to depathologize and demedicalize our work together, moving away from "treatment" and toward community engagement and integration. It was essential that there be both "closed" spaces for trans youth (and their closest family members), as well as more public spaces in which these young people could experience positive interactions with trusted allies.

The program welcomed socialization with extended family and the youths' cisgender friends at various times throughout the year. The annual winter holiday party, one such event, was an opportunity for art-making outside of the usual group context, integrating close family and friends. Within this frame, I aimed to provide the community a space in which to create art together while also celebrating gender diversity and trans

identities. The majority of families involved in the program routinely expressed exhaustion and frustration about navigating multiple clinical settings and specialists. It was important to offer an art-making experience that felt celebratory, rather than clinical or pathologizing, as I was deliberately working to move these youth away from feeling watched and analyzed. Pride was a particularly important theme during the holiday party in this case vignette, as the U.S. presidential election one month prior had rattled the trans community. Fear and panic were alive in the eyes of the youth and their parents. Whereas in previous years I had used photography and a picture frame directive to celebrate concepts of self and family, I was mindful here that photography and portraiture could be too exposing and anxiety provoking. Some families within the community had been targeted on social media by transphobic tormentors. Rumors and threats were quietly being discussed among parents, and the young people were well aware of heightened concern.

For this event, in consultation with colleagues, I developed a wall mural directive. I combined three pieces of colored mural paper to form a large rectangle, resembling the trans pride flag—pink, white, and blue—approximately 12 feet by 14 feet. I drew a large circle that spanned the height and width of the piece with the words "Our World, Our Community" written on top. The three colored bands of paper were then separated and placed for community art-making on three long tables that people could walk and sit around for easier access to the drawing spaces. Youth and their family and friends were invited to add to the mural throughout the party, using a variety of drawing media: crayons, oil pastels, colored pencils, and markers. Participants were told that the mural would be featured at a larger community holiday party to be held later that month at a prominent art gallery nearby. As the gallery party was open to colleagues in the field and other friends of the program, participants were instructed to not write their names or any other identifying information on the mural, although there were no other stipulations for involvement.

Approximately 40 young people added to the mural over the course of the 2-hour party (See Figure 21.1). They responded audibly with joy and surprise to see such a large rendition of the trans pride flag in their familiar group space. The outline of the circle created some structure, although the imagery created was largely spontaneous. Older teens found space to create carefully drawn figures and cartoons, while children as young as three scribbled gleefully with soft, shimmering pastels.

Images of anthropomorphic objects and animals can be seen throughout the mural. Hearts, peace signs, flowers, and rainbows are tucked away in corners, some carefully rendered, and others drawn more quickly, resembling doodles. Multiple images of mermaids and butterflies appear, possibly a symbolic depiction of transformation and duality. Just as the mermaid is half human and half sea creature, youth with limited language about gender may identify themselves as being part boy and part girl; some are known to even quantify those parts with percentages. The butterfly's metamorphosis is strongly suggestive of gender transition. Rocket ships and cars give the image life and movement, reminding viewers of transportation and travel. An older teen used the mural as an opportunity to create four mythical creatures embodying the identities of transgender, agender, nonbinary, and genderfluid beings. Using colors corresponding with pride imagery, this particular young transman discussed with me how important it was that people recognize the great diversity within the umbrella of "transgender." Leaving his mark through carefully articulated creatures, one with two heads, he was able to claim space for these lesser known ways of being.

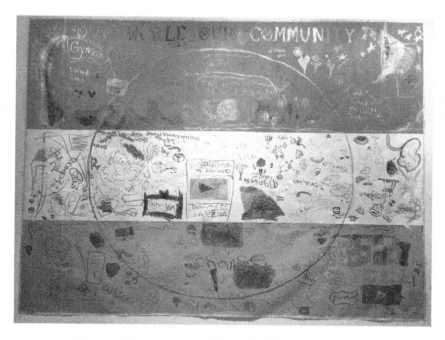

Figure 21.1 Full group mural, "Our World, Our Community"

The most dominant theme in the mural is the use of language. Many of the youth utilized the mural paper as an opportunity to write messages of hope and acceptance. "We the People" is written in an ornate font. Echoing the preamble to the U.S. Constitution in a moment of political duress, I understood this phrase as both a call for representation and also a bold statement of empowerment: *We are people. We are here. We cannot be ignored.* Another young person referenced a quotation from the 2007 *Bee Movie.* The sentence states: "According to all known laws of aviation, there is no way that a bee should be able to fly." Had the quotation continued, it would include, "The bee, of course, flies anyways, because bees don't care what humans think is impossible." Keeping in mind that the majority of trans youth must persist against strict rules about gender in order to live their authentic selves, often being told that their desires are impossible or untrue, I wondered how many youth in the room could relate to the quotation. These youth, despite adversity, fly.

The power of community strength and encouragement so clearly depicted in the literature on trans youth resilience was expressed in the group mural. Other examples of text on the piece stated, "Keep calm and learn about gender," "#TransPride," "Love and get loved back," "Treat others how you want to be treated," "A smile could go a mile," "Acceptance is protection," "Dedicated to life itself," "Love the world," and "Play." Are these commands or mantras? Are they meant for the artists themselves, their peers, or adversarial members of society? Are these assurances, reminders, or flashes of hope? Given the turmoil and hardship many of these youth had faced, I was impressed that this particular group of young people had integrated positive self-talk and affirmation. None of the youth took the opportunity to cross out or draw over their peers' work or

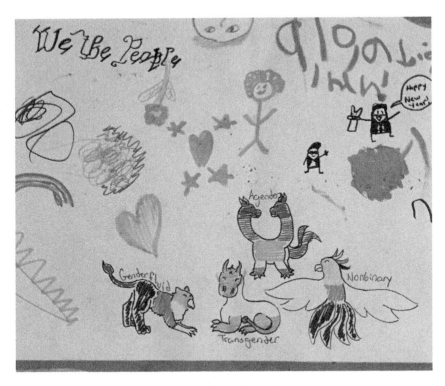

Figure 21.2 Mural detail, 1

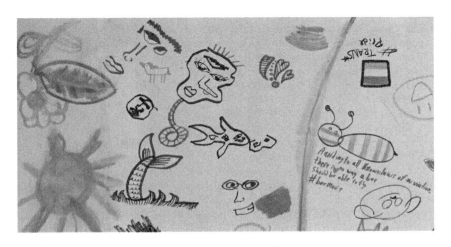

Figure 21.3 Mural detail, 2

vandalize the group project, evidencing the support and respect they had for each other, the space, and the shared experience of community art-making.

Depathologizing Transgender Youth

Placing artwork in a gallery speaks to its value, acceptability, and beauty. Yet the decision to elevate and display the artwork made in the holiday party setting was not obvious or uncomplicated. Over the past decade, trans youth have become part of public discourse. From news media coverage to pop psychology editorials, gender is a present topic in classrooms and dinner tables across the country. Once a community operating under the radar of most Americans, trans youth have been thrust into the spotlight—and under a microscope. To date, the excitement around and highlighting of the trans experience has neither normalized nor neutralized trans identities. While the increase in attention has certainly improved general awareness, so too has the conversation turned exoticizing, anxiety-provoking, and violent. Basic legal rights for trans individuals remain in jeopardy, while homicide rates continue to rise (Human Rights Campaign, 2018).

This duality, wherein trans people have become increasingly more celebrated and increasingly more at risk, is concerning. As a therapist and advocate for trans youth, I proceed with caution when considering public interventions. Sudden visibility can be confusing, frightening, and unintentionally over-exposing. When considering whether or not to display the group mural in a more public gallery setting, however, positive outcomes were likely. The artwork's creators were unidentifiable, artists were informed of the intent of the piece at the time of creation, and I was confident that my colleagues and I would be available and ready to process concerns if they arose.

Art therapy offers a unique form of witnessing, in which artists and their products are not only affirmed but also experienced and re-experienced through lasting creations. As Beaumont (2012) modeled compassion for trans youth with the goal being for them to enact and then embody self-compassion, the intervention using the gallery space was similarly intended to model and then integrate feelings of self-worth, mastery, and pride. Elevating the young people's work was an effort to depathologize and demonstrate the value of their experiences. In an era when access to affirming healthcare necessitates a diagnosis of Gender Dysphoria or Gender Identity Disorder and transphobic bigotry remains pervasive, claiming space within the gallery was an intervention to showcase health and wellness.

This *anti-pathologizing* approach was demonstrated via art-making in two main ways. First, participants made individual contributions to the community mural, rendered in pictorial or written form. Colorful rainbows, butterflies, hearts, and future-oriented messages dominate the mural. Participation, like many art therapy interventions, asked the young artists to demonstrate personal agency while at the same time promoting a process of self-definition. What emerged was a snapshot of a world where individuals were celebrated on account of their difference, and diversity was presented as inviting rather than threatening. The movie quotation about transcending adversity and defying expectations that was written on the mural offers a strong counter to cisnormative assumptions about the necessary alignment of sex and gender, as well as the necessary alignment between trans identity and psychopathology.

The second demonstration of anti-pathologizing is visible in the mural as a whole, an integrated and aesthetically pleasing product. The therapist's role in this context was to provide the setting and materials through which creative expression could be experienced as successful. The art-making experience was made accessible in its setup, scale,

choice of materials, and select interventions to provide containment: the enclosed circle, an organizing prompt and title, trans pride colors, as well as the shared information of intention for gallery viewing, asking the youth to bring respect and awareness into their practice. The final collaborative product highlights the community's role in affirmation and celebration, creating a space where trans youth are valued, rather than problematized, pathologized, and seen as "other."

Recommendations and Considerations

Trans youth are often made to feel like they are burdensome. Systemically, they represent a portion of society that is vulnerable to mental health issues, homelessness, and other poor health outcomes. In a world where gender serves as the primary organizer, a trans person can signal panic. They might stick out, not legibly male or female to an observer. Trans people can elicit a disorganizing and confusing response, often coupled with anger and heterosexist violence when labeling the trans person as deceptive. Schools, sometimes begrudgingly, now must adapt to include trans youth, working to change longstanding traditions of binary gender systems, from sports teams and bathrooms to pronouns and inclusive literature. Even within the most affirming family, a trans child can require costly specialists and medications, as well as precious time and energy. Aware of the realities of discrimination and violence, parents often fear the worst. Unintentionally, they may project pathology and "otherness" on their child.

Rendering a trans identity as tragic or unfortunate is not unique to parents. Educators and clinicians may unconsciously maintain a similar stance, enacting victimizing behaviors unintentionally. With their behaviors amplified by their positions of power, clinicians hold tremendous responsibility in the treatment of trans youth. Without malice, a provider may exhibit microaggressions or establish a dynamic in which the client is compromised and tasked as an educator, having to explain and defend their identity. Other providers unfortunately continue to uphold transphobic and shaming practices. Discrimination by healthcare professionals is linked to an increased risk for suicide attempts among trans people (Haas, Rodgers, & Herman, 2014). Treating a trans person without appropriate clinical specialization and supervision is unethical and can be dangerous. Addison (2003) emphasizes the importance of the clinician's own understanding of the cultural and systemic oppression faced by trans people, as well as their personal bias, which could affect the therapist-client relationship. Examination of a provider's own experience of gender and gender-based bias may illuminate the context in which they approach their work, particularly as it relates to trans youth.

Clinical attunement to young people's experience of their identity, as well as their encounters with previous medical and mental health professionals, must be explored so to bracket treatment that is relevant and culturally informed. Recommendations for working with trans individuals are, therefore, difficult to summarize, as interventions must depend on the youth's environment and experience of distress. Isolation and depressive symptoms should be managed differently than social anxiety or attachment concerns, as they would be with any other subgroup of the youth population. Impulse control, anger management, and high-risk behaviors should also be addressed accordingly.

However, whereas a treatment plan for a cisgender client may include relevant assessments of psychological functioning, peer integration, and family support, creating a treatment plan for a trans youth requires the clinician to first dutifully evaluate these external structures and systems for trans inclusivity. Most psychological measures are

based on binary sex assignment, which does not account for the experiences of trans youth or those who identify as non-binary. School-based health education curricula are rarely designed with trans students in mind. Thus, trans youth are rarely taught about their bodies and how to optimize their own health and safety. Clients may not be able to change their legal identification, which can hinder participation at a clinic or community event or even an educational field trip requiring them to show identification to gain access. When speaking with a client's parents or school representatives, clinicians must be mindful of who the child is "out" to. At times, it may be necessary to use a former name and pronoun to avoid creating a potentially unsafe home or school environment.

Even with the best intentions, clinicians may be overly focused on a client's transition, undermining the client's report of their primary concern, particularly when it is perceived to be unrelated to gender. This approach can seem reductive and dismissive to a young person. All too often, I speak with trans youth who sheepishly tell me that they are tired of talking about gender, wishing that people would recognize other aspects of their identity, their likes, and their talents. Yet ignoring the systemic oppression of trans people when addressing something seemingly distant from gender may set up a clinician to wrongly assume universality about the person's experience.

As mental health clinicians, we might become frustrated that we can't "fix" a problem, particularly when met with systems that don't include trans people or when we spend hours serving as case managers, tirelessly advocating in a role very different from how we may manage our other client populations. Adequate supervision might be difficult to find as we realize that our professional education only skimmed the surface of gender diversity. We might be fearful about the risk of crisis and self-harm or the profound suicide statistics, or we might assess the co-occurring stressors in a young trans person's life warrant a higher level of care than our practice provides, only to realize a lack of trans inclusive referrals and resources in our area. Some clinicians may feel conflicted and avoidant due to their own belief systems, religious or political. Conversely, new clinicians may be overly eager to intervene, stepping in as a "savior" without allowing space for clients to demonstrate their own resilient measures.

As clinicians, we must be mindful of what is clinically relevant and what might be our own personal curiosity. We must be humble about our lack of understanding so as to do no harm, committing ourselves to ongoing professional development and learning. Particularly when clinicians, family, and friends are all of cisgender experience, we should encourage trans youth to find trans community members to provide mirroring, modeling, and support. If we are trans ourselves, we may over-identify with our clients, generalizing our own personal experiences onto those of our clients, swimming in countertransference. Supervision must not be compromised at any cost.

It is imperative that in our pursuit to bolster the health of young trans people, we are not reductive in addressing their needs. Just as interventions must assess and include the supportive adults in the young person's life, so too must we be mindful of racial inequities and class disparities, largely impacting fundamental realities around safety and access to care. Trans youth from deeply religious homes and communities can be met with a range of responses from rejection to support and celebration. Even the experiences of trans youth with the same socioeconomic, racial, political, and religious upbringings can differ based on a host of factors such as the age of transition, their identity as binary or non-binary, male, female, or something else. Listen to the client's language and their definition of the problem, and ask about what is distressing and what isn't. For instance, many trans youth experience profound body dysphoria, heightening suicidality and risk of self-harm. But not all trans people feel that they were born in the "wrong body" or are

uncomfortable with all parts of their body, and to assume that they necessarily want or need to alter their body may be a mistake. In our enthusiastic attempts to support youth through transition, we may be reducing their experience along the lines of a "typical" trans narrative, not fully recognizing the complexity of the client's personal journey.

Clinicians should familiarize themselves with resources available for trans youth in their locality and learn how to access such services. When I began in the field in 2005, the vast majority of programs serving trans youth were targeted at the individual client, with the assumption that youth were coming from unaccepting homes and schools. Today, there is far more awareness regarding the importance of community support and engagement. Interventions have therefore focused more on the family and school than in previous decades, largely based on the success of programs such as the one presented in this case. However, trans youth without family support require significantly different interventions, including access to safe housing and education, food, primary healthcare, and financial support.

For the new clinician, I offer a few final strategies for therapeutic intervention:

- Consider the ways that you can signal respect and acceptance to a transgender person. They may have experienced multiple medical and mental health providers before you and may enter your office with fear of rejection based on previous bias and transphobia. Mental health systems are notoriously rigid in a binary understanding of gender. Even when all providers are warm and empathic, the client may have had to navigate a non-inclusive bathroom or intake form before they even entered your office. Acceptance can be signaled on a superficial level by using a correct name and pronoun and by mirroring the language the client uses to identify themselves. Listen to the client's goals for the future and ask about what certain labels and identifiers mean to them.

- Be curious about the role of gender for each client and how each client makes decisions about their gender, both publicly and privately. Consider how gender comes up each day for your client, be it regarding clothing choices to bathroom access to linguistic modifiers and pronouns. Is there space in your practice to create more ease around gender separation? If you have single-stall restrooms, create all-gender facilities rather than marking them as separate and solely for men or women. Similarly, consider your intake forms and paperwork. Use open-ended questions rather than check boxes, and consider prompting for a chosen name and pronouns.

- Acknowledge mistakes. Working with trans youth is new for many clinicians, and we will make mistakes, perhaps using the incorrect name or pronoun, referring a client to an unwelcoming specialist, or saying something transphobic, even if we didn't intend it to be hurtful. Apologize for these errors, and commit to not repeating them.

- Ask questions. It is appropriate and important to ask about someone's pronouns ("What pronouns do you want me to use? *He, She, They*, or something else? Can I use these with your parents? Your teachers?"). It is appropriate to ask about someone's name (I ask nearly all of my clients, "Is your legal name what you go by, or do you prefer something else?"). The therapeutic relationship depends on your client feeling comfortable in your office.

- Be extra mindful of privacy. Providing information that someone is transgender can make them vulnerable to social ostracism, taunting, and even physical assault. Thus, disclosure should always be determined by the person who is

self-identifying as trans. Privacy is also relevant in the treatment of trans youth because of the relatively small population size. If working in a small town or even a sizable city, it is likely that your transgender clients will know each other, as will their families. When discussing cases or referring to your work, it may be necessary to create composite vignettes, rather than speaking about specific individual situations.

- Make time for advocacy. Because of systemic transphobia and profound misconceptions about trans people, sometimes your role as a therapist may mean calling the school to discuss the importance of adult interventions around transphobic teasing and threats. Clinicians may also be called upon to write letters for medical and surgical treatments or to explain why someone might be traveling with a photo identification that looks very different from their current presentation. Consider your client's mental health in their environment, and understand that you may need to intervene outside of the clinical session.

- Continue to learn. The field of transgender mental health is rapidly growing. Language is changing, treatment models developing, and social awareness evolving. Seek out professional development and further learning opportunities to ensure that you are utilizing the best resources, practices, and policies. Similarly, keep an eye on local events and changes to trans peoples' legal rights and statuses.

- Practice *always* using respectful and inclusive language, not just when you know that you are in the presence of someone who is trans. Many trans people do not disclose their transgender experience and simply live as the people they are, not advising others that they were assigned at birth to a sex different from how they currently present. This is not meant to trick or deceive anyone but rather to keep the person safe, physically and emotionally. More often than not, you will interact with a trans person without knowing the details of their gender history. More often than not, their trans identity will not be relevant and need not be addressed.

- Make room for multiple trans narratives, including experiences of victimization, isolation, and hopelessness, as well as pride, empowerment, and leadership. Work to counter transphobic cultural norms by not problematizing trans youth or assuming that being trans is sad or unfortunate. If working with a family, consider the child's developmental readiness for exposure to parental disappointment and loss. Rewriting future expectations, dreams, and hopes takes time. Consider working with the parents and child separately until the parents are able to tolerate engaging in future-oriented empowerment work. If counseling a teen with resistant parents, consider working with the teen to acknowledge the slower pace of their parents. Often, by the time a trans person "comes out" and shares their identity with their parents, it has already been processed to some extent by the youth. This contrasts with the experience of the parent, who is hearing it for the first time, and may need time to process. Consider each family member's journey toward acceptance as separate, while engaging them in having compassion and empathy for each other.

- Within the context of art therapy, be mindful of the conclusions about gender drawn from clients' imagery. Consider thinking about symbolic representations of gender-stereotyped behavior for all children, trans and cisgender. The young person may be exploring themes of power, privilege, and safety, identifying

with a cultural stereotype rather than a specific gender identity. In general, try to consider sex, gender identity, gender expression, and sexuality as separate concepts. Work to create gender-inclusive art therapy practices by monitoring your own surprise or embarrassment as the young person selects art materials, colors, shapes, and designs, particularly when they may seem incongruent with their expected gender role. Ensure that there is a range of colors and content themes for all youth in your practice without delineating what is for boys and what is for girls.

When working with transgender youth, it is vital that clinicians understand the gendered dynamics at play. There are countless layers in which this conversation is relevant: internal to the young person, between the child and their family, where and how they experience gendered dynamics in their local community, and in the world beyond as youth engage in a more global conversation around gender inclusion and equity. To optimize therapeutic interventions, clinicians may find it helpful to first locate their own experience of gender bias and their own general expectations around gender. Continued professional development, supervision, and participation in trans-led community events will provide helpful insight about the future of trans youth and how to best prepare them to navigate a cisnormative world. Creating opportunities for peer-to-peer engagement and seeking out relatable adult role models can bolster individual and family therapies, while coordination with medical professionals and school systems can ensure access to affirming care and education.

The therapeutic use of art, untethered by language, may be invaluable when working with trans communities. As mental health treatment models evolve to include the diversity of transgender young people, art therapy is already situated to contain and express what words cannot. Through the act of creation, youth are able to actualize their inner experiences, without reducing or confining their expression to a list of preset terms. As art therapists, we have access to clinical methods beyond the reach of verbal language. Unique to our practice is the evaluation of symbols and their personal meanings. For transgender youth who are asked to fit themselves into bodies, schools, and social systems not fully set up for the expansivity of their experiences, art therapy serves as a culturally attuned modality, offering young people a unique space free from the pressure of definition.

References

Addison, D. (2003). Art therapy with gay, lesbian, bisexual, and transgendered clients. In S. Hogan (Ed.), *Gender issues in art therapy* (pp. 53–68). London, England: Jessica Kingsley Publishers.

American Psychological Association. (2015). Guidelines for psychological practice with transgender and gender nonconforming people. *American Psychologist, 70*(9), 832–864. https://doi.org/10.1037/a0039906

Austin, A., & Craig, S. L. (2015). Transgender affirmative cognitive behavioral therapy: Clinical considerations and applications. *Professional Psychology: Research and Practice, 46*(1), 21–29. https://doi.org/10.1037/a0038642

Babyatsky-Grayson, D. E. (2014). *Counseling transgender youth utilizing expressive art therapies* (Doctoral dissertation, American Academy of Clinical Sexologists). Retrieved from www.esextherapy.com/dissertationsDeborahEveBabyatskyGraysonCounselingTransgenderYouthUtilizingExpressiveArtTherapies.pdf

Barbee, M. (2002). A visual-narrative approach to understanding transsexual identity. *Art Therapy: Journal of the American Art Therapy Association, 19*(2), 53–62. https://doi.org/10.1080/074 21656.2002.10129339

Bauer, G. R., Hammond, R., Travers, R., Kaay, M., Hohenadel, K. M., & Boyce, M. (2009). "I don't think this is theoretical; this is our lives": How erasure impacts healthcare for transgender people. *Journal of the Association of Nurses in AIDS Care, 20*(5), 348–361. https://doi.org/10.1016/j.jana.2009.07.004

Beaumont, S. L. (2012). Art therapy for gender-variant individuals: A compassion-oriented approach. *Canadian Art Therapy Association Journal, 25*(2), 1–6. https://doi.org/10.1080/08322473.2012.11415565

Becerra-Culqui, T. A., Liu, Y., Nash, R., Cromwell, L., Flanders, W. D., Getahun, D., . . . Quinn, V. P. (2018). Mental health of transgender and gender nonconforming youth compared with their peers. *Pediatrics, 141*(5), 1–11. https://doi.org/10.1542/peds.2017-3845

Breslow, A. S., Brewster, M. E., Velez, B. L., Wong, S., Geiger, E., & Soderstrom, B. (2015). Resilience and collective action: Exploring buffers against minority stress for transgender individuals. *Psychology of Sexual Orientation and Gender Diversity, 2*(3), 253. https://doi.org/10.1037/sgd0000117

Connolly, M. D., Zervos, M. J., Barone, C. J., Johnson, C. C., & Joseph, C. L. (2016). The mental health of transgender youth: Advances in understanding. *Journal of Adolescent Health, 59*(5), 489–495. https://doi.org/10.1016/j.jadohealth.2016.06.012

De Pedro, K. T., Gilreath, T. D., Jackson, C., & Esqueda, M. C. (2017). Substance use among transgender students in California public middle and high schools. *Journal of School Health, 87*(5), 303–309. https://doi.org/10.1111/josh.12499

Durwood, L., McLaughlin, K. A., & Olson, K. R. (2017). Mental health and self-worth in socially transitioned transgender youth. *Journal of the American Academy of Child & Adolescent Psychiatry, 56*(2), 116–123. https://doi.org/10.1016/j.jaac.2016.10.016

Fabre-Lewin, M. (1997). Liberation and the art of embodiment. In S. Hogan (Ed.), *Feminist approaches to art therapy* (pp. 115–124). London, England: Jessica Kingsley Publishers.

Gridley, S. J., Crouch, J. M., Evans, Y., Eng, W., Antoon, E., Lyapustina, M., . . . McCarty, C. (2016). Youth and caregiver perspectives on barriers to gender-affirming health care for transgender youth. *Journal of Adolescent Health, 59*(3), 254–261. https://.doi.org/10.1016/j.jadohealth.2016.03.017

Haas, A. P., Rodgers, P. L., & Herman, J. L. (2014). *Suicide attempts among transgender and gender non-conforming adults.* Retrieved from https://queeramnesty.ch/docs/AFSP-Williams-Suicide-Report-Final.pdf

Hatzenbuehler, M. L., & Pachankis, J. E. (2016). Stigma and minority stress as social determinants of health among lesbian, gay, bisexual, and transgender youth: Research evidence and clinical implications. *Pediatric Clinics, 63*(6), 985–997. https://doi.org/10.1016/j.pcl.2016.07.003

Herman, J. L., Flores, A. R., Brown, T. N., Wilson, B. D., & Conron, K. J. (2017). *Age of individuals who identify as transgender in the United States.* Retrieved from https://williamsinstitute.law.ucla.edu/wp-content/uploads/TransAgeReport.pdf

Human Rights Campaign. (2018). *Violence against the transgender community in 2017.* Retrieved from www.hrc.org/resources/violence-against-the-transgender-community-in-2017

James, S. E., Herman, J. L., Rankin, S., Keisling, M., Mottet, L., & Anafi, M. (2016). *The report of the 2015 U.S. transgender survey.* Washington, DC: National Center for Transgender Equality.

Janssen, A., & Leibowitz, S. (Eds.). (2018). *Affirmative mental health care for transgender and gender diverse youth: A clinical guide.* New York, NY: Springer.

Johns, M. M., Beltran, O., Armstrong, H. L., Jayne, P. E., & Barrios, L. C. (2018). Protective factors among transgender and gender variant youth: A systematic review by socioecological level. *The Journal of Primary Prevention, 39*(3), 263–301. https://doi.org/10.1007/s10935-018-0508-9

Klein, A., & Golub, S. A. (2016). Family rejection as a predictor of suicide attempts and substance misuse among transgender and gender nonconforming adults. *LGBT Health, 3*(3), 193–199. https://doi.org/10.1089/lgbt.2015.0111

Kosciw, J. G., Greytak, E. A., Giga, N. M., Villenas, C., & Danischewski, D. J. (2016). *The 2015 national school climate survey: The experiences of lesbian, gay, bisexual, transgender, and queer youth in our nation's schools.* Retrieved from www.glsen.org/sites/default/files/2015%20National%20GLSEN%202015%20National%20School%20Climate%20Survey%20%28NSCS%29%20-%20Full%20Report_0.pdf

Kreiss, J. L., & Patterson, D. L. (1997). Psychosocial issues in primary care of lesbian, gay, bisexual, and transgender youth. *Journal of Pediatric Health Care, 11*(6), 266–274. https://doi.org/10.1016/S0891-5245(97)90082-1

MacNish, M. (2015). *Gender identity development* [PowerPoint slides]. Retrieved from www.lgbthealtheducation.org/wp-content/uploads/Gender-Identity-Development.pdf

Maher, A. L. (2011). *The use of art and interview to explore the transgender person's experience of gender transition: A phenomenological study* (Master's thesis). Retrieved from https://idea.library.drexel.edu/islandora/object/idea%3A3657/datastream/OBJ/view

Malpas, J. (2011). Between pink and blue: A multi-dimensional family approach to gender nonconforming children and their families. *Family Process, 50*(4), 453–470. https://doi.org/10.1111/j.1545-5300.2011.01371.x

Olson, J., Schrager, S. M., Belzer, M., Simons, L. K., & Clark, L. F. (2015). Baseline physiologic and psychosocial characteristics of transgender youth seeking care for gender dysphoria. *Journal of Adolescent Health, 57*(4), 374–380. https://doi.org/10.1016/j.jadohealth.2015.04.027

Olson, K. R., Durwood, L., DeMeules, M., & McLaughlin, K. A. (2016). Mental health of transgender children who are supported in their identities. *Pediatrics, 137*(3). https://doi.org/10.1542/peds.2015-3223

Oxendale, H. A. (2017). *Adlerian art therapy for treatment of gender dysphoric adolescents* (Master's thesis). Retrieved from http://alfredadler.edu/sites/default/files/Oxendale%20MP%202016.pdf

Pardoe, J., & Trainor, G. (2017). Transgender youths who self-harm: Perspectives from those seeking support. *Mental Health Today.* Retrieved from www.mentalhealthtoday.co.uk/transgender-youths-who-self-harm-perspectives-from-those-seeking-support

Reisner, S. L., Vetters, R., Leclerc, M., Zaslow, S., Wolfrum, S., Shumer, D., & Mimiaga, M. J. (2015). Mental health of transgender youth in care at an adolescent urban community health center: A matched retrospective cohort study. *Journal of Adolescent Health, 56*(3), 274–279. https://doi.org/10.1016/j.jadohealth.2014.10.264

Rider, G. N., McMorris, B. J., Gower, A. L., Coleman, E., & Eisenberg, M. E. (2018). Health and care utilization of transgender and gender nonconforming youth: A population-based study. *Pediatrics, 141*(3). https://doi.org/10.1542/peds.2017-1683

Russell, S. T., Pollitt, A. M., Li, G., & Grossman, A. H. (2018). Chosen name use is linked to reduced depressive symptoms, suicidal ideation, and suicidal behavior among transgender youth. *Journal of Adolescent Health, 63*(4), 503–505. https://doi.org/10.1016/j.jadohealth.2018.02.003

Ryan, C., Russell, S. T., Huebner, D., Diaz, R., & Sanchez, J. (2010). Family acceptance in adolescence and the health of LGBT young adults. *Journal of Child and Adolescent Psychiatric Nursing, 23*(4), 205–213. https://doi.org/10.1111/j.1744-6171.2010.00246.x

Schilt, K., & Westbrook, L. (2009). Doing gender, doing heteronormativity: "Gender Normals," transgender people, and the social maintenance of heterosexuality. *Gender & Society, 23*(4), 440–464. https://doi.org/10.1177/0891243209340034

Schnebelt, B. A. (2015). *Art therapy considerations with transgender individuals* (Master's thesis). Retrieved from https://digitalcommons.lmu.edu/etd/154

Singh, A. A. (2012). Transgender youth of color and resilience: Negotiating oppression and finding support. *Sex Roles: A Journal of Research, 68*(11–12), 690–702. https://doi.org/10.1007/s11199-012-0149-z

Singh, A. A., Meng, S., & Hansen, A. (2014). "I am my own gender": Resilience strategies of transgender youth. *Journal of Counseling & Development, 92*(2), 208–219. https://doi.org/10.1002/j.1556-6676.2014.00150.x

Smith, E., Jones, T., Ward, R., Dixon, J., Mitchell, A., & Hillier, L. (2014). *From blues to rainbows: The mental health and wellbeing of gender diverse and transgender young people in Australia.* Retrieved from www.beyondblue.org.au/docs/default-source/research-project-files/bw0268-from-blues-to-rainbows-report-final-report.pdf

Travers, R., Bauer, G., & Pyne, J. (2012). *Impacts of strong parental support for trans youth: A report prepared for children's aid society of Toronto and Delisle youth services.* Retrieved from http://transpulseproject.ca/wp-content/uploads/2012/10/Impacts-of-Strong-Parental-Support-for-Trans-Youth-vFINAL.pdf

The Trevor Project. (2017). *Spike in crisis contacts related to anti-trans rhetoric.* Retrieved from www.thetrevorproject.org/trvr_press/spike-in-crisis-contacts-related-to-anti-trans-rhetoric/#sm.00000yfbik5rcndnqztcz755g9bwd

United States Department of Justice Federal Bureau of Investigation. (2017). *Hate crime statistics.* Retrieved from https://ucr.fbi.gov/hate-crime/2017

Veale, J. F., Watson, R. J., Peter, T., & Saewyc, E. M. (2017). Mental health disparities among Canadian transgender youth. *Journal of Adolescent Health, 60*(1), 44–49. https://doi.org/10.1016/j.jadohealth.2016.09.014

22
School-Based Art Therapy
Filling the Void

MARYGRACE BERBERIAN

In an era where students face increasing and ever-changing mental health needs, school-based art therapy can provide an essential service. School shootings, terrorist attacks, gang violence, and political unrest permeate school walls, disrupting students' academic and/or social performance. These adverse large-scale events exacerbate the chronic stress that paralyze young people, often developmentally ill equipped to mitigate such insurmountable stress. Teachers and administrators are often the first to notice problematic symptoms, and schools can offer a safe, familiar environment for students to receive treatment. Cultivating creativity in students helps them develop skills to manage the complex issues they encounter (Robinson, 2015). The New York University Art Therapy in Schools Program, developed in 1997, provides school-based art therapy treatment for general education students who struggle with emotional and behavioral challenges. It features a tri-part model of intervention that supports students, teachers, and parents in their home communities.

Need for Mental Health Treatment

Between 13% and 20% of children in the U.S. have been diagnosed with a mental health disorder (Centers for Disease Control, 2013). According to the National Alliance on Mental Illness (NAMI, 2018), 50% of all lifetime cases of mental illness begins by age 14. One in every four to five adolescents met the criteria for a mental disorder with severe lifetime impairment (Merikangas et al., 2010). Inpatient admissions for mental health and substance abuse treatment increased by 18% between 2013 and 2017, with a rise of 39% in spending (Health Care Cost Institute, 2019). A mood disorder was the most common diagnosis for inpatient hospitalization for young people aged 1 to 17 years between 1997 and 2011, increasing over that time period by 66% for those covered by Medicaid and 88% for the uninsured (Pfuntner, Wier, & Stocks, 2013). In total, childhood mental disorders in the U.S. cost $247 billion each year (Perou et al., 2013).

Lack of access to affordable treatment has a long-term negative effect, but many communities are unable to provide sufficient outpatient mental healthcare. Challenges in accessing treatment stem from both structural and attitudinal factors, including costs, insurance restrictions, limited availability, and cultural beliefs and stigmas (Campo, Bridge, & Fontanella, 2015). In a 2017 study by Gallo et al., only 63% of those seeking

psychiatric treatment were able to schedule an appointment upon calling a clinic, and 19% of those unable to schedule were not provided with a referral for other resources. Most referrals were thwarted by the necessity of multiple calls, administrative paper-work, and several intake appointments before receiving care. It is therefore unsurprising that 50% of children ages 8 to 15 years who have a mental health condition do not receive treatment. Among young people in poverty, fewer than 15% receive services, and even fewer complete treatment (Kataoka, Zhang, & Wells, 2002). Poverty often adds other attitudinal concerns that hinder treatment, including self-blame, mistrust of the inequitable healthcare system, and fears of having a child who is diagnosed with a mental illness removed from the caregiver (Hodgkinson, Godoy, Beers, & Lewin, 2017). Mental health services may also be a "mismatch" for community members; care that does not adapt to cultural needs by providing attuned staff or interventions results in decreased treatment acceptance and fidelity (Ijadi-Maghsoodi et al., 2017, p. 225).

Poverty-related distress is consistently linked to poor mental health outcomes (Santiago, Kaltman, & Miranda, 2013). In a nationally representative sample, the lack of neighborhood resources, interpersonal support, and community and school safety were positively associated with current diagnosed mental disorders in young people aged 6 to 17 years (Dahal, Swahn, & Hayat, 2018). Stiffman et al. (2010) suggested a public health approach to pediatric mental health is most appropriate, noting that "strengths and problems of children and adolescents are based upon interactions between their internal genetic/ biological predispositions, as well as their family, community, school, and societal environments" (p. 120).

Schools are more often becoming the sole providers of mental health support for children (Berberian, 2017). A report by the Citizens' Committee for Children of New York (2013) advocated for more affordable, school-based mental health treatment, as New York city agencies can serve only 12% of school-aged children who need mental health treatment. Nationally, schools were found to be an "ideal place to leverage evidence-based mental health knowledge and make a transformative impact on the mental health landscape of this country" (Child Mind Institute, 2016, p. 1). Effective interventions within the school setting can address students' underlying issues, reducing or eliminating the need for special education services and clearing a path for academic learning. Mental health issues and the associated negative social and educational outcomes drive priorities for effective solutions (Murphy, Abel, Hoover, Jellinek, & Fazel, 2017).

Unaddressed mental health needs lead to negative outcomes in school performance (Child Mind Institute, 2016). When mental health symptoms emerge even in first grade, academic performance can diminish within two years (Murphy et al., 2014). Normative stress associated with later transitions to middle school resulted in substantial academic failure and behavioral risk for sixth grade students (Lane, Oakes, Carter, & Messenger, 2015). Students challenged by mental health issues struggle academically and achieve lower levels of educational attainment (McLeod, Uemura, & Rohrman, 2012). Alternatively, emotion regulation was positively associated academic success, productivity, and achievement scores (Graziano, Reavis, Keane, & Calkins, 2007).

Art Therapy in Schools

The pioneers of the art therapy profession formed their visions within the context of art education. In her groundbreaking work at the Wiltwyck School for Boys, Edith Kramer (1958) demonstrated the importance of her work as a skilled artist, teacher, and

therapist. In 1964, Margaret Naumburg, Edith Kramer, Rawley Silver, and Elinor Ulman presented their innovative work with children at the Ninth Symposium on Creative Arts Education, which was titled "Creativity for the Exceptional Individual" (Syracuse Herald-Journal, July 27, 1964). Lowenfeld later contributed greatly to this forum with his lectures, "Art Education Therapy" (Lowenfeld & Michael, 1982; Silver, 1986). Janet Bush (1997), an innovator in school-based art therapy, suggested that school-based art therapists can "meet the challenge of twenty first century by upgrading programs designed to assist youngsters at risk in their climb toward academic and emotional reconstruction" (p. 16).

The landmark adoption of the federal Education of All Handicapped Children Act of 1975, updated as the Individuals with Disabilities Education Act (IDEA) in 1990, mandated best practices for children with special needs. In 1997, related services, including therapeutic recreation and counseling were outlined in the IDEA (Sec. 602, paragraph 22). Subsequent documentation by the Office of Special Education and Rehabilitative Services (OSERS) in the U.S. Department of Education (2006, 2008, 2011) specified the following clarifications for Regulations for Part B of the (IDEA) (34 CFR §300.34):

> Related services can include artistic and cultural services that are therapeutic in nature, regardless of whether the IDEA or the Part B regulations identify the thera-peutic service as a related service. The Department's long-standing interpretation is that the list of related services in the IDEA and the Part B regulations is not exhaus-tive and may include other developmental, corrective, or supportive services (such as artistic and cultural programs, art, music, and dance therapy), if they are required to assist a child with a disability to benefit from special education in order for the child to receive FAPE [Free Appropriate Public Education]. As is true regarding consideration of any related service for a child with a disability under Part B of the IDEA, the members of the child's IEP Team (which include the parents, school offi-cials, and whenever appropriate, the child with a disability) must make individual determinations in light of each child's unique abilities and needs about whether an artistic or cultural service such as music therapy is required to assist the child to benefit from special education.
>
> (2011, p. 22)

The more recent Every Student Succeeds Act of 2015 advocated for "specialized instruc-tional support personnel" (SISP) including social workers, psychologists, and related service providers to be part of the comprehensive program to meet student needs. The inclusion of school-based art therapists as SISPs is regulated on the state level (Potash & Sutherland, 2016).

Research supports the use of art therapy in schools to help students overcome a vari-ety of academic, social, and emotional challenges. In the U.S., school-based initiatives have demonstrated substantial positive outcomes: improved self-concept (Rosal, McCulloch-Vislisel, & Neece, 1997); improved social interaction and cooperation (Boldt & Brooks, 2006; Coakley, 1997; Ziff, Pierce, & Johanson, 2012); increased problem-solving abilities (Pfeiffer, 1994; Fish, Dingee, & Neumann, 2000; Gibbons, 2010); increased self-competency and self-esteem (Garibaldi, 1995; Kay & Wolf, 2017; Sitzer & Stockwell, 2015); improved academic performance (Darrell & Wheeler, 1984; Wallin & Durr, 2002; Ziff, Ivers, & Shaw, 2016); and decreased disruptive behaviors (Coakley, 1997; Guzder, Paisley, Robertson-Hickling, & Hickling, 2013; Epp, 2008;

Freilich & Schectman, 2010; Froeschle & Riney, 2008; Spier, 2010). Other research has shown that the sense of safety and agency established by creative arts therapies in educational settings enables children to thrive (Landgarten, Tasem, Junge, & Watson, 1978; Bornmann, Mitelman, & Beer, 2007; Wahl-Alexander, 2015). A recent systematic review of more global, controlled studies in school-based art therapy noted positive outcomes for students struggling with classroom behavior, oppositional defiant disorder, separation anxiety disorder, and issues relating to locus of control and self-concept (McDonald & Drey, 2018). Art-making in schools supports resiliency, as the provision of pleasure and safety is coupled with the discovery of the potential to adapt, cope, and thrive (Dunn-Snow & D'Amelio, 2000).

Despite the proven benefits and legislative advances, only a few states offer sustainable, district-implemented art therapy services for general education students (American Art Therapy Association, 2011). In most other instances, programs for general education students rely on time-limited grants. Gonzalez-Dolginko (2018) advocated for the dissemination of evidence-based data of clinical school-based art therapy to overcome the bureaucratic impediments to widespread expansion.

Most mental disorders are diagnosed when children reach school age (National Academies of Sciences, Engineering, & Medicine, 2015). Disruptive, impulsive students who tend to externalize their distress generally receive attention that points to the need for treatment. Students who tend to internalize behaviors (e.g., depressive symptoms) often take longer to attract notice in classroom settings. When academic performance declines or maladaptive behaviors surface, underlying causative factors are revealed. Through art therapy, students disclose hidden trauma, including domestic violence or abuse, that has led to destructive behaviors such as substance abuse, sex work, eating disorders, and self-harm. School-based art therapy helps students organize the chaos of their internal worlds and their often less-than-favorable realities.

The school experience can promote mental health by molding, teaching, and evaluating proficiencies for skill building and interpersonal relations (Mallin, Walker, & Levin, 2013). Schools, an integral resource in the social ecology of resilience, "initiate meaningful resource-provision, reciprocate in contextually-relevant ways when children negotiate for supports, and advocate for life-worlds that prioritize children's well-being" (Theron, 2016, p. 88). School-based art therapy helps students cope with the psychological distress that impedes academic performance and healthy social-emotional development. Community and familial stressors can evoke overwhelming feelings of powerlessness, which can intensify in academic settings that demand focus on cognitive tasks. Empowered with a sense of agency, struggling students can find solace in the school day. They can discover strengths that have been concealed by feelings of "not being good enough" due to academic failures, social isolation, and lack of validation. Academic support was associated with greater executive functioning and increased global cortical thickness in the brain (Piccolo, Merz, & Noble, 2018).

Positive early childhood experiences are particularly crucial for immigrant-background students. Students in immigrant families make up 25% of the U.S. population ages zero to eight and even larger proportions in many states and localities (Park, McHugh, & Katsiaficas, 2016). The U.S. foreign-born population reached 43.7 million in 2016, nearly tripling to 13.5% from 4.7% in 1970 (Lopez, Bialik, & Radford, 2018). As schools strive to meet students' academic, sociocultural, psychological, and physical needs, those from immigrant backgrounds face the added burden of acute and chronic adversity. Suarez-Orozco et al. (2012) noted that "loss and separation from country of origin, family members, familiar customs and traditions; changes in social

class and/or socioeconomic status; exposure to a new physical environment and the need to navigate unfamiliar cultural contexts" can serve as catalysts for psychological distress (p. 7). This lack of connectedness can result in adjustment issues, difficulties with attachment, and social isolation. Negative social, psychological, and educational outcomes for immigrant-background students leads to heightened vulnerabilities and poor educational and life outcomes (Cherng, Sanzone, & Ahram, 2017). Academic challenges are more prevalent in students living in poverty (Cortina, 2014). Further, disproportionality—the higher rates of referral for special education services for students in marginalized racial groups—has been documented in schools for more than 40 years (KramarczukVoulgarides, Fergus, & King-Thorius, 2017).

Direct connections have found between participation in the arts and increased self-esteem; participants reported a feeling of being part of something larger, an ability to find deeper meaning in life, an increased capacity to build social relationships, and an enhanced self-awareness (Martin et al., 2013).Young people form and revise their identities based on affirmation and feedback from others in their circles (McGann, 2006). Art therapy increases self-awareness and the concept of self in the context of the group, culture, and/or society (Kalmanowitz & Ho, 2016). For immigrant-background students, creative expression promotes the safe disclosure of loss, separation, and trauma in the assimilation process (Rousseau, Lacroix, Bagilishya, & Heusch, 2003). The use of metaphor and symbol in visual expression aids negotiation of conflicted cultural values for immigrant-background students (Berberian, 2015). A school-based protocol for creative expression can aid the exploration and integration of identity for students displaced from their countries of origin (Beauregard, Papazian-Zohrabian, & Rousseau, 2017).

Art therapy can be more readily accepted by students in a school setting, where a sense of safety and support has already been established (Cortina & Fazel, 2014). The school-based art therapist builds trust quickly with students and families. High visibility in the school building enables the art therapist to become a familiar, trustworthy fixture of support. Factors of predictability and consistency ground students in a sense of safety for healing in school-based treatment (Field, 2016). Perry and Szalavitz (2017) considered schools a controlled, predictable environment for traumatized children to better regulate their sensitized and overreactive systems. Student perceptions of school connectedness are associated with improved emotional health (Kidger, Araya, Donovan, & Gunnell, 2012). Positive perceptions of the school climate (La Salle, Wang, Parris, & Brown, 2017) and school connectedness (Marraccini & Brier, 2017) were also associated with reduced suicidal thoughts and behaviors by students.

Engagement in creative expression, through its spontaneous exploration of varied materials, proves beneficial for students. In art therapy, students unpack the burdens of intrapsychic and external stressors. In this relationship of secured, attuned witnessing, the student repairs, re-creates, and restores the experiences of loss, victimization, and deprivation. Art therapy interventions address gaps in a student's emergent development by supporting fundamental demands: to be seen, cared for, and celebrated.

The NYU Art Therapy in Schools Program

In 1997, New York University (NYU) piloted two public-school-based art therapy programs in New York City. This initiative, one of the few in the nation, proved to be an effective modality for general education students struggling with emotional and behavioral challenges. Following the attacks of September 11, 2001, the New York City Department

of Education invited expansion of art therapy to schools in the city's Chinatown (Berberian, 2015). The nonverbal, metaphorical intervention of art therapy was found to be culturally aligned with Chinese values. In the years that followed, post-9/11 federal and local funding and private donors enabled the Art Therapy in Schools program to continue to serve struggling students in New York City. As a proactive, preventative service, the NYU Art Therapy in Schools Program has established a model of intervention for general education students challenged by emotional and behavioral difficulties.

School-based art therapy services provide accessible, free, long-term treatment for students. As students are a "captive" audience in the school milieu, treatment attendance is higher than in outpatient community treatment. Treatment at the school level enables the art therapists to serve as the central point of connection and communication for students, teachers, and parents, allowing for a comprehensive and accurate perspective on progress and impediments. The structure and benefits of school-based art therapy services are comparable to outpatient mental health programs. Treatment is trauma informed and involves case management to address student needs holistically.

In the Art Therapy in Schools Program, students are referred for services by teachers, parents, and even the students themselves through the Pupil Intervention Committee (PIC), which includes the art therapist, school counselor, psychologist, and social worker, among other related service providers at the school. As the program gains buy-in from the students and their families, school-based art therapy has become the most referred intervention to support mental health in the participating schools. All services are labeled "art therapy" rather than "expressive arts" or other names offered to avoid the feared stigma associated with mental health intervention. If the services are called "art therapy," students feel permitted to present issues of intense psychological distress to their teachers. The student may not feel able to present issues of self-harm, abuse, or domestic violence to an "expressive arts" teacher. Labeling the intervention as "therapy" also cultivates a willingness to receive mental health services in the future if warranted.

Once a referral is made, the art therapist discreetly observes the student in the classroom setting, where the challenges of managing academic and social engagement can be understood. A parent or legal guardian gives consent for the student to participate. The art therapist conducts an intake interview to discuss the student's strengths and developmental stressors and to articulate treatment goals. In the first session of treatment, the art therapist discusses confidentiality and shares the reasons for referral with the student. Weekly art therapy services are held for individuals, dyads, and groups for the academic year, providing a continuum of long-term care. Students of all grade levels generally respond enthusiastically to the additional support of school-based art therapy. For 45 minutes in the school day, students feel seen, heard, and supported through art therapy interventions. Teachers find the students less anxious, more positive, and better equipped to engage in academic learning when they return to class after scheduled sessions. Classmates often request art therapy services as they observe the positive changes in participants and hear stories of their experiences. Aside from a very few cases, there has been no refusal or stigma associated with school-based art therapy participation. Teachers and parents are engaged regularly to share feedback about progress. The art therapist often serves as mediator between the student, teacher, and parent, managing the parties' differing expectations. The art therapist can also help cultivate more social and emotional support in the school environment when familial stressors are exacerbated.

School-based art therapists can be "first responders," proactively solving problems through prompt assessment and intervention. Field (2016) wrote that trauma-informed

approaches in school settings change the response to disruptive or disengaged students, examining the underlying causes rather than the presenting symptoms. The following vignettes describe instances in which students' artwork reflected underlying conflicts.

Immediate Assessment and Responses for Students

LINA: A CASE VIGNETTE

During a group for students with behavioral concerns, Lina, a female, cisgender Latinx student, worked diligently on a clay mask. The directive was to create a mask of an imaginary creature, composed of human, animal, and/or fantasy qualities. Lina, however, opted to create a figure in her own likeness (Figure 22.1A). She was obese and relied on artificial means to beautify herself, with chemically treated hair, a full face of makeup, and synthetic nails. For three sessions, she carefully rolled thin coils of clay to apply as eyelashes to her mask. Lina seemed to rely on elaborate cosmetic enhancements to conceal the emptiness she felt inside.

On the back of the mask, Lina depicted the character's inner state by writing "Heart Less" and painting a sword-like object piercing a heart (Figure 22.1B). During the group discussion, Lina courageously jumped out of metaphor to describe how she had felt heartless when she encountered her birth mother, overtly high on a substance, while walking to school with her friends. She was both mortified and devastated by her mother's behavior. With Lina's knowledge and permission, the school-based art therapist contacted Lina's grandmother, her legal guardian, to alert her about Lina's feelings and experiences. Subsequently, Lina was able to receive more support through individual art therapy sessions.

WEI: A CASE VIGNETTE

School-based art therapy provides opportunities for disclosure when a child is in imminent danger. During an individual session early in treatment, Wei, a cisgender male 11-year-old from a Chinese immigrant family, created a drawing of a child being beaten and beating himself (Figure 22.2).

With contusions protruding from his head, the figure holds a stick that reads "Eat my poo poo." The seemingly same figure (dressed in identical clothes) is also beating his

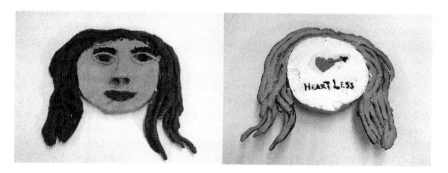

Figure 22.1A, 22.1B Lina's mask

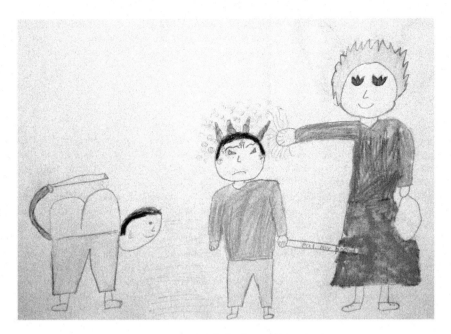

Figure 22.2 Wei's disclosure drawing

own bare buttocks. A figure drawn to the right has reddened eyes and lines radiating from her outstretched hand, suggesting she is the perpetrator. The art therapist was able to first use metaphor and then ask more direct questions about the motivation behind the drawings. Wei disclosed abuse at the hands of his female caretaker. Child protective services were called immediately.

Maya: A Case Vignette

In another case of neglect, Maya, a 14-year-old Latinx female cisgender student who had a trusting relationship with her art therapist, arrived at the start of the school day to report inappropriate touching by her mother's live-in boyfriend. Immediately, child protection was called. Upon investigation by caseworkers, Maya's mother was asked to either remove her boyfriend from the home or find alternative guardianship for Maya. The mother chose the latter, and Maya was sent to live with her aunt. In the art therapy session held immediately after her removal, Maya created this image with watercolor paint (Figure 22.3).

"I Hate You Mom!" are the dominant words on the page. She also wrote, "Why do you do this to me?" and "You ruined my life" and used the word "hate" repeatedly. While Maya was surely angered by her mother's choice to side with her boyfriend over her daughter, the emoji face signals sadness. Also, the meticulous execution of lettering with a watercolor-saturated brush demonstrates a significant level of control. The duality of anger and sadness is also evident in the mix of red and blue colors. Maya was able to receive individual, school-based art therapy in conjunction with the treatment provided by child protective services for the remainder of the school year.

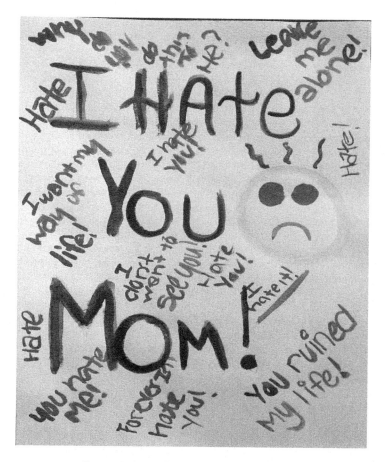

Figure 22.3 Maya's drawing about her mother

For the student living with chronic adversity, the responsiveness of a caring adult through long-term connectedness or relational continuity is an essential protective factor for health (Perry & Szalavitz, 2017). Siegel (1999) described a human need for "contingent communication" acquired through developing relationships, connecting with others, receiving affective attunement, and gaining a sense of coherence within the internal processes of the mind (p. 298). School-based art therapists provide a continuum of care in the school environment, wholly supporting students through the expected disruptions of grade changes and less predictable crises that pervade families and communities.

Immediate Assessment and Response for the Greater School Community

School-based art therapy addresses a broad range of challenges, including anxiety and depression stemming from both acute trauma and chronic issues of abuse, family conflicts, academic problems, identity formation, transitory living, addiction, and social

pressures. As described, school-based art therapy has been effective as a central mental health intervention, synthesizing the perspectives of the student, parent, and teacher. The establishment of art therapy services in the school building also allows for an immediate response when terrorizing events affect a community. A quick response is critical to preventing erroneous beliefs from becoming attached to the traumatic experience (James, 1989; Newgrass & Schonfeld, 2015). For example, the immediate processing of the 9/11 attacks with students corrected their misapprehension that many buildings fell, a notion derived from seeing footage repeated on news media.

Effective practices for communal engagement in art therapy include frameworks centered on empowerment, social justice, cultural considerations, and community relationships (Ottermiller & Awais, 2016). School-wide therapeutic intervention can reduce the isolation and fear caused by collective trauma. Community-based art therapy has been found to be an effective intervention for collective trauma to alleviate symptoms of psychological stress (Decosimo & Boland, 2017), increase self-efficacy (Ho, Lai, Lo, Nan, & Pon, 2017), mobilize support (Slone, Shoshani, & Lobel, 2013), offer interpersonal connection, and promote posttraumatic growth (Mohr, 2014).

Following the attacks of September 11, the author led school-wide interventions to help New York City public school students process their responses to the destruction and continuing fear of terrorist threats (Berberian, 2003, 2006, 2015; Levy, Berberian, Brigmon, Gonzalez, & Koepfer, 2002). At downtown schools, the anniversaries of September 11 were also difficult to endure. Anniversaries trigger collective emotional and cognitive reactions to the communal loss, as well as more individual experiences of grief and unpredictability. Pervasive fears were exacerbated by the continual threats of terrorism that plagued New York and other areas of the world. The concurrent start of the new academic term in early September added to the anxiety in the shared space of the school building. Examples of school-wide interventions follow.

SECOND ANNIVERSARY OF SEPTEMBER 11

As part of a school-wide art therapy initiative, a school in downtown New York created a Memorial Garden of Hope to commemorate the second anniversary of September 11. The art therapists developed a plan for coordinated classroom discussions in which students could share their thoughts and hopes for New York and people around the world. Because teachers in post-disaster communities often struggle with the intense emotions of students amidst their own grief (Ho, Potash, Lo & Wong, 2014), the art therapists distributed guidelines with scripted prompts for engagement. To create the garden, students were invited to draw or write their thoughts and expressions of hope on cardboard fence pieces. Teachers engaged in separate workshops to create flowers to honor the lives lost. This structured intervention provided concrete guidelines for the teacher facilitators, allowing the project to include all 900 students. It was also an opportunity to globally assess students. Teachers identified students who struggled in the discussions and art-making that followed. In its culmination, the installation of the fence in the school lobby became a testament of solidarity and safety in the school building, less than half a mile from Ground Zero (Figure 22.4).

FIFTH ANNIVERSARY OF SEPTEMBER 11

For the fifth anniversary, at a time of much global unrest, students, faculty, and staff at a downtown middle school were empowered to share their wishes for the future in a

Figure 22.4 Anniversary school-wide Memorial Garden of Hope

Figure 22.5A, 22.5B Anniversary school-wide weaving

project titled *Weaving Peace*. School art therapists and counselors led small-group discussions, inviting students to reflect on the events of September 11 and consider their aspirations for the future by drawing and writing them on long strips of paper. By articulating these intentions, students were able to take action and feel less passive and helpless (Figure 22.5A).

The intentions covered a wide spectrum, from the political to the poignant:

> I wish they'd find Osama . . . I wish for a happy life for my mommy . . . I wish the world would never come to an end . . . I wish that our leaders would be a model for peace, not violence . . . I wish no one would die . . . I wish that no one will attack the U.S. again so it would be safer . . . I wish that they would build new buildings and that the terrorists would not bomb them down . . . I wish that Bush would just stop the war . . . I wish to get into a good high school . . . I wish that the NYPD don't lose anymore officers . . . I wish the replacement towers are destruction proof and

they should stay that way forever . . . I wish Iraq won't attack us . . . I wish for lots of money for my family . . . I wish to make my mom proud . . . I wish to get a college degree . . . I wish my dad to live a longer life from cancer . . . I wish to become a scientist . . . I wish for better economic conditions. . . . I am wishing the dust didn't hurt my grandpa . . . I wish I got taller . . . I wish they saved more people . . . I wish my grandpa didn't die, so I would get to know more about him . . . I wish there were no more suicide bombers . . . I wish to have more friends this year . . . I wish I had my uncle still in my sight—RIP Uncle Jay . . . I wish for no more homework . . . I wish everything didn't go wrong . . . I wish for one million more wishes.

These strips were then woven through satin ribbons stretched across large 5' × 6' wooden stretcher frames (Figure 22.5B). The resulting fabric of running words and images expressed a collective voice imagining new possibilities. Intentions were intertwined and strengthened by solidarity.

RESPONSE AFTER THE NEW YORK 2017 TERRORIST ATTACK

On Halloween in 2017, a terrorist drove a rented truck down a bike lane on the west side of New York City, killing 8 people and injuring 11. Public school students in the schoolyard witnessed the attack and police activity that followed. Students were rushed back into the building and remained in lockdown for hours. Following the incident, parents and teachers observed students struggling to feel safe at both school and home. As the school was located near Ground Zero, school-based art therapy had been put in place after the September 11 attacks. School administrators, having seen the positive effects of the post-9/11 art therapy intervention, requested it to help cope with the aftermath of the 2017 incident.

Art therapists and graduate art therapy students conducted classroom workshops to meet with students and assess their coping. In structured art therapy workshops, students identified coping strategies to manage their thoughts and feelings. They created art using the metaphor of trees, taking inspiration from trees' resiliency and the strong roots that help them withstand storms. Students engaged in movement, writing, and art exercises to identify inner strengths. Figure 22.6A depicts the leaf of a student who

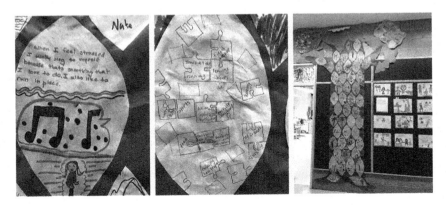

Figure 22.6A, 22.6B, 22.6C School-wide response to terrorist attack

wrote, "When I feel stressed I usually sing to myself because that is something I love to do. I also like to run in place." In another example, a child used pencil to carefully link puzzle pieces as she sorted through the things that brought her control and comfort. Students listed their sources of strength, including relationships with relatives and pets and activities such as fencing, field hockey, and working with technology (Figure 22.6B). The drawings were compiled into an installation of ten ceiling-height trees that showcased the strength of the school community (Figure 22.6C). The students were able to express their own strengths and learn adaptive coping skills from their peers. Teachers were also inspired by the imaginative ways students found solace in the face of community violence.

Students who exhibited more difficulties were invited to join long-term art therapy groups for the remainder of the academic year. For many, the terror and unpredictability of the attack triggered past experiences of trauma and loss. Parents also engaged in workshops led by art therapy staff to help manage symptoms at home. The school-based art therapy services reaffirmed the building as a safe, supportive place.

A sense of belonging is the strongest motivation to develop interpersonal relationships and seek group membership (Field, 2016). These structured school-wide initiatives expressed and normalized the feelings of fear and uncertainty while amplifying the hope held by the community.

PARENTAL INVOLVEMENT

For families in distress, parental involvement is a critical component to successful therapeutic outcomes. Positive parental engagement in children's mental health treatment is a key factor in the quality and effectiveness of care (Haine-Schlagel & Walsh, 2015). Parents are more likely to accept art therapy services within the familiar school setting, as they trust school staff to aid in their children's development. During communal trauma, schools can bring community members together, re-establish routines, organize aid, and distribute information (Ho et al., 2014). In post-disaster recovery and resilience building, community support of the kind offered by schools is sought more often than mental health interventions (Hanbury & Indart, 2013).

For children affected by war, terrorism, and conflict, school-based intervention has been shown to help families, as strong correlations were found between parental and child psychopathology (Slone & Mann, 2016). A recent meta-analysis of published family/parent training programs concluded that early intervention reduces behavior problems (Piquero et al., 2016). Extensive research indicates children with PTSD are largely affected by parental behavior (Yumbul, Wieling, & Celik, 2017; Vincent, 2009). Aisenberg and Ell (2005) related these findings to interdependent coping theory, whereby parental behavior affects children's emotional and cognitive responses to an event and subsequently to the parents' actions. The parents and children ultimately relate in a reciprocal and interdependent manner. In circumstances where parents have survived chronic traumatization, their fears are often transmitted or shared with their children, resulting in transgenerational trauma (Violence Policy Center, 2017). Additionally, adversities secondary to the traumatic event, such as homelessness and poverty, have a great impact on families and impair children's adaptation and development (Sriskandarajah, Neuner, & Catani, 2015).

In acute mental health treatment of young people, the clinician must actively support the parents. Mishne (2001) noted that "parents often know what they should do, and what they want to, but they may be paralyzed by internal or external inhibitions"

Figure 22.7 Art therapy workshops for parents

(p. 63–64). Art-based parental training has been shown to be effective in parent-child art psychotherapy (Gavron & Mayseless, 2018; Regev & Snir, 2014; Snir & Regev, 2018). Art-based parental training can effectively examine underlying fears, wishes, and conflicts through the artistic process (Shamri Zeevi, Regev, & Guttmann, 2018).

School-based art therapists lead parenting workshops based on the tenets of art therapy: creative processes and metaphors (Figure 22.7). Parents in familial distress often experience feelings of shame and failure. Art-making can diminish their anxiety about expressing their concerns. Metaphors are widely used in the parenting skills program, as they help to normalize struggles. In one workshop, parents painted flowerpots while discussing how best to support developing children. Some parents acknowledged wishing to hold their children close, almost smothering any chance for growth, while others explored their experiences of giving their children too much freedom and too little guidance. Parents were encouraged to engage their children in a planting activity in which they could talk about needs and preferences in their shared relationships. Soil and seeds were distributed along with talking points for children at each age level. The painted pot with its growing plant would also serve as a visual reminder to parents about topics discussed during the training, suggesting optimal development requires constant monitoring and care.

Art Therapy Support for School Staff

Grant support following the September 11 attacks allowed for art therapy groups for teachers and staff. The mental health of teachers is often neglected in school-based programs that address community trauma (Ho, Potash, Wong, 204). Just as children

Figure 22.8 Teachers creating during lunchtime art therapy groups

respond to the functioning of their caregivers, student behaviors reflect all that is emitted both verbally and nonverbally by educators. A distressed teacher cannot facilitate harmonious learning. Ideally, the enduring presence of the teacher in the life of a student develops through a sustained relationship that negotiates expectations with fairness, trust, and care (Song, Doll, & Marth, 2013).

In the NYU program, teachers engaged in weekly group art therapy sessions at lunchtime. The sessions offered teachers the chance to decompress, refuel, and restore balance. With bag lunches in tow, teachers would enter the nonjudgmental space of the art therapy room and find comfort and community while creating art (Figure 22.8).

Immersion in the creative process permitted candid dialogue about struggles in the classroom and personal challenges outside of school. With collective agreements of confidentiality, the art therapy room psychically held expressions of anxiety, frustration, rage, grief, relief, and joy associated with the demands of life and teaching complex students. The art therapist balanced the roles of facilitating clinician and collegial peer when prompting further introspection and offering guidance. Each year, the educators participated in an exhibition of their selected works.

Art therapy-based professional development for teachers enables consistent staff engagement. The art therapists lead workshops and trainings to better equip staff to understand students' artistic development and learn how art-making can improve classroom performance.

Recommendations

On the macro level, the American Art Therapy Association (AATA), the National Alliance of Specialized Instructional Support Personnel (NASISP), and school-based art therapists tirelessly advocate for the implementation of art therapy in public schools

across the U.S. School-based art therapists are encouraged to showcase the merits of the profession through parent workshops, professional development, and school-wide initiatives. Testimonials by art therapists, school mental health staff, and teachers at city and state hearings on public education help to raise the profile of school-based art therapy. As letters from constituents can influence government officials, the NYU program distributed sample letters to school communities to support the expansion of art therapy in New York State public schools.

On the micro level, the school art therapist must remain mindful when establishing a new role on the faculty. To initiate programming in a school or district, it is most effective to partner school-based art therapy services with a university or community-based organization; this capitalizes on the trust the institutions have already established. Generous effort should be invested in cultivating relationships with other school mental health practitioners to show that art therapy would complement rather than compete with existing services.

The art therapist can provide in-service trainings for staff. It is best to not to disguise art therapy services by calling them some other name in an attempt to avoid stigma associated with mental health interventions. Practitioners should share information about the scope and goals of art therapy with parents and teachers. Clinicians must also maintain guidelines for confidentiality; well-intentioned teachers and parents may be curious about the content of art therapy sessions, assuming the art reveals hidden answers. Art created in art therapy should be considered part of the treatment record and protected by HIPAA standards. It is helpful to engage both the parent and teacher in the student's treatment through a cooperative relationship.

As a mediator between parents and teachers, the school art therapist may have to negotiate conflict. While open lines of communication can help to support the student in need, the demands of each party can be contradictory and overwhelming. The push and pull of each side forces a great amount of negotiation and limit setting. Often this mediating role requires that the school art therapist confront both parents and teachers and challenge their decisions about the student's well-being. While the problems can often feel insurmountable, the rewards are evident in positive student outcomes.

The intimacy and confidentiality of art therapy treatment can be novel in school environments, which often showcase student achievement. Art created in sessions should be considered with great sensitivity and only displayed when requested by the students. In cases of expressively volatile work, the art therapist will need to confer with the student to discuss the potential vulnerabilities of having classmates view art created in sessions.

Full awareness of the academic culture is critical for the school-based art therapist. Administrators, teachers, and even parents may focus heavily on school performance. School personnel may prioritize academic success at all costs, which differs from the more holistic goals of the school art therapist. The therapist can respectfully offer psychoeducation to advocate for modifications in the classroom when social and emotional impediments are identified. By aligning with the classroom teacher, the school art therapist can devise classroom interventions that support academic performance while also cultivating emotional resilience.

Conclusion

Schools were originally established to teach. The work of educators in public schools has widened to include more than academics. Issues from home and social environments

often impede a child's academic performance. In order to learn, children may need help with their cognitive, behavioral, emotional, or social problems. Building capacity for resiliency in students requires attention to psychological well-being and interpersonal skills. School-based art therapy provides immediate, accessible intervention to address the acute and chronic stressors that impede the development of students. The NYU Art Therapy in Schools Program offers a model to support students as soon as mental health symptoms are noticed, cultivating collaboration between the student, teacher, and parent. Schools, as familiar and trusted centers in the community, are also well-equipped to deliver communal interventions when mass violence occurs. Structured, community-based art therapy interventions provide a venue for collective expression, normalizing responses, and identifying those in need of more intensive care. As students continue to face adversity in their families and communities, school art therapy cultivates creative solutions, providing a renewed sense of agency and resolution. Greater expansion of school art therapy in public education can help to address growing mental health needs.

References

Aisenberg, E., & Ell, K. (2005). Contextualizing community violence and its effects: An ecological model of parent-child interdependent coping. *Journal of Interpersonal Violence, 20*(7), 855–871. https://doi.org/10.1177/0886260505276833

American Art Therapy Association. (2011). *Model art therapy programs in K-12 schools.* Retrieved from www.americanarttherapyassociation.org

Beauregard, C., Papazian-Zohrabian, G., & Rousseau, C. (2017). Making sense of collective identity and trauma through drawing: The case study of a Palestinian refugee student. *Intercultural Education, 28*(2), 113–130. https://doi.org/10.1080/14675986.2017.129485

Berberian, M. (2003). Communal rebuilding after destruction: The world trade center children's mural project. *Psychoanalytic Social Work, 10*(1), 27–41. https://doi.org/10.1300/J032v10n01_04

Berberian, M. (2006). Hopeful visions: The faces of children. In Teachers College Press (Ed.), *Forever after: New York City teachers on 9/11* (pp. 73–84). New York, NY: Teachers College Press.

Berberian, M. (2015). Art therapy with Chinese American children in New York City. In S. L. Brooke & C. E. Myers (Eds.), *Therapists creating a cultural tapestry: Using the creative therapies across cultures* (pp. 25–56). Springfield, IL: Charles C. Thomas.

Berberian, M. (2017). Standing tall: Students showcase resiliency through body tracings. *Canadian Art Therapy Association Journal, 30*(2), 88–93. https://doi.org/10.1080/08322473.2017.1375734

Boldt, R., & Brooks, C. (2006). Creative arts: Strengthening academics and building community with students at risk. *Reclaiming Children and Youth, 14*(4), 223–227.

Bornmann, B., Mitelman, S., & Beer, D. (2007). Psychotherapeutic relaxation: How it relates to levels of aggression in a school within inpatient child psychiatry: A pilot study. *The Arts in Psychotherapy, 34*(3), 216–222. https://doi.org/10.1016/j.aip.2007.01.004

Bush, J. (1997). *The handbook of school art therapy: Introducing art therapy into a school system.* Springfield, IL: Charles C. Thomas.

Campo, J. V., Bridge, J. A., & Fontanella, C. A. (2015). Access to mental health services: Implementing an integrated solution. *JAMA Pediatrics, 169*(4), 299–300. https://doi.org/10.1001/jamapediatrics.2014.3558

Centers for Disease Control and Prevention (CDC). (2013). Mental health surveillance among children—United States, 2005–2011. *Morbidity and Mortality Weekly Report, 62*(2), 1–35.

Cherng, H. S., Sanzone, J., & Ahram, R. (2017). *Demographic change and educating immigrant youth in New York City.* New York, NY: Metropolitan Center for Research on Equity and the Transformation of Schools, New York University.

Child Mind Institute. (2016). *2016 Child Mind Institute Children's Mental Health Report*. Retrieved from https://childmind.org/report/2016-childrens-mental-health-report/

Citizen's Committee for Children of New York, Inc. (2013). *A prescription for expanding school-based mental health services in New York City public elementary schools*. New York, NY: Author.

Coakley, M. (1997). Using the arts in early intervention programs: Long term outcomes (Doctoral dissertation). *Dissertation Abstracts International: B: The Sciences and Engineering, 61*(2B).

Cortina, M. A., & Fazel, M. (2014). The art room: An evaluation of a targeted school-based group intervention for students with emotional and behavioral difficulties. *The Arts in Psychotherapy, 42*, 35–40. https://doi.org/10.1016/j.aip.2014.12.003

Dahal, S., Swahn, M., & Hayat, M. (2018). Association between neighborhood conditions and mental disorders among children in the U.S.: Evidence from the national survey of children's health 2011/12. *Psychiatry Journal*, Article ID 5914315. https://doi.org/10.1155/2018/5914315

Darrell, E., & Wheeler, M. (1984). Using art therapy techniques to help underachieving seventh grade junior high school students. *The Arts in Psychotherapy, 11*(4), 289–292. https://doi.org/10.1016/0197-4556(84)90027-3

Decosimo, A., & Boland, C. R. (2017). A chance to thrive, not just survive Ebola: A model for international psychosocial support programming in emergency and disaster settings. *Annals of Global Health, 83*(1), 77–78. https://doi.org/10.13140/RG.2.2.18641.53602

Dunn-Snow, P., & D'Amelio, G. (2000). How art teachers can enhance artmaking as a therapeutic experience: Art therapy and art education. *Art Education, 53*(3), 46–54. https://doi.org/10.2307/3193873

Field, M. (2016). Empowering students in the trauma-informed classroom through expressive arts therapy. *In Education, 22*(2), 55–71.

Epp, K. M. (2008). Outcome-based evaluation of a social skills program using art therapy and group therapy for children on the autism spectrum. *Children & Schools, 30*(1), 27–36. https://doi.org/10.1093/cs/30.1.27

Fish, B., Dingee, J., & Neumann, R. (2000, November). *Insight through art: A pilot program for school children in Cabrini Green*. Paper presented at the American Art Therapy Association Conference, St. Louis, MO.

Freilich, R., & Shechtman, Z. (2010). The contribution of art therapy to the social, emotional, and academic adjustment of children with learning disabilities. *The Arts in Psychotherapy, 37*(2), 97–105. https://doi.org/10.1016/j.aip.2010.02.003

Froeschle, J. G., & Riney, M. (2008). Using Adlerian art therapy to prevent social aggression among middle school students. *Journal of Individual Psychology, 64*(4), 416–431.

Gallo, K. P., Olin, S. S., Storfer-Isser, A., O'Connor, B. C., Whitmyre, E. D., Hoagwood, K. E., & Horwitz, S. M. (2016). Parent burden in accessing outpatient psychiatric services for adolescent depression in a large state system. *Psychiatric Services, 68*(4), 411–414. https://doi.org/10.1176/appi.ps.201600111

Garibaldi, D. (1995). Raising self-competence/self-esteem: A comparative study using art therapy intervention to raise self-competence and self-esteem in learning disabled and normally achieving third, fourth, and fifth grade students (Doctoral dissertation). *Dissertation Abstracts International, 56*(4B), 2324. Retrieved from www.worldcat.org/title/raising-self-competenceself-esteem-a-comparative-study-using-an-art-therapy-intervention-to-raise-self-competence-and-self-esteem-in-learning-disabled-and-normally-achieving-third-fourth-and-fifth-grade-students/oclc/190787864#borrow

Gavron, T., & Mayseless, O. (2018). Creating art together as a transformative process in parent-child relations: The therapeutic aspects of the joint painting procedure. *Frontiers in Psychology, 9*, 2154. https://doi.org/10.3389/fpsyg.2018.02154

Gibbons, K. (2010). Circle justice: A creative arts approach to conflict resolution in the classroom. *Art Therapy: Journal of the American Art Therapy Association, 27*(2), 84–89. https://doi.org/10.1080/07421656.2010.10129716

Gonzalez-Dolginko, B. (2018). Status report on art therapists in public schools: Employment and legislative realities. *Art Therapy, 35*(1), 19–224. https://doi.org/10.1080/07421656.2018.1459116

Graziano, P. A., Reavis, R. D., Keane, S. P., & Calkins, S. D. (2007). The role of emotion regulation and children's early academic success. *Journal of School Psychology, 45*(1), 3–19. doi:10.1016/j.jsp.2006.09.002

Guzder, J., Paisley, V., Robertson-Hickling, H., & Hickling, F. (2013). Promoting resilience in high-risk children in Jamaica: A pilot study of a multimodal intervention. *Journal of the Canadian Academy of Child and Adolescent Psychiatry, 22*(2), 125–130.

Haine-Schlagel, R., & Walsh, N. E. (2015). A review of parent participation engagement in child and family mental health treatment. *Clinical Child and Family Psychology Review, 18*(2), 133–150. https://doi.org/10.1007/s10567-015-0182-x

Hanbury, R., & Indart, M. (2013). Resilience revisited: Toward an expanding understanding of post-disaster adaptation. In S. Prince-Embury & D. H. Saklofske (Eds.), *Resilience in children, adolescents, and adults: Translating research into practice* (pp. 213–225). New York, NY: Springer Science + Business Media.

Health Care Cost Institute. (2019). *2017 health care cost and utilization report.* Washington, DC: Author.

Ho, R. T. H., Lai, A., Lo, P., Nan, J., & Pon, A. (2017). A strength-based arts and play support program for young survivors in post-quake China: Effects on self-efficacy, peer support, and anxiety. *The Journal of Early Adolescence, 37*(6), 805–824. https://doi.org/10.1177/0272431615624563

Ho, R. T. H., Potash, J. S., Lo, P. H. Y., & Wong, V. (2014). Holistic interventions to trauma management for teachers following disaster: Expressive arts and integrated body-mind-spirit approaches. *Asia Pacific Journal of Social Work and Development, 24*(4), 275–284. https://doi.org/10.1080/02185385.2014.92581

Hodgkinson, S., Godoy, L., Beers, L. S., & Lewin, A. (2017). Improving mental health access for low-income children and families in the primary care setting. *Pediatrics, 139*(1), e20151175. https://doi.org/10.1542/peds.2015-1175

Ijadi-Maghsoodi, R., Marlotte, L., Garcia, E., Aralis, H., Lester, P., Escudero, P., & Kataoka, S. (2017). Adapting and implementing a school-based resilience-building curriculum among low-income racial and ethnic minority students. *Contemporary School Psychology, 21*(3), 223–239. https://doi.org/10.1007/s40688-017-0134-1

James, B. (1989). *Treating traumatized children: New insights and creative interventions.* New York, NY: The Free Press.

Kalmanowitz, D., & Ho, R. T. (2016). Out of our mind: Art therapy and mindfulness with refugees, political violence and trauma. *The Arts in Psychotherapy, 49*, 57–65. https://doi.org/10.1016/j.aip.2016.05.012

Kramarczuk Voulgarides, C., Fergus, E., & King Thorius, K. A. (2017). Pursuing Equity: Disproportionality in Special Education and the Reframing of Technical Solutions to Address Systemic Inequities. *Review of Research in Education, 41*(1), 61–87. doi:10.3102/0091732X16686947

Kataoka, S. H., Zhang, L., & Wells, K. B. (2002). Unmet need for mental health care among U.S. children: Variation by ethnicity and insurance status. *The American Journal of Psychiatry, 159*(9), 1548–1555. https://doi.org/10.1176/appi.ajp.159.9.1548

Kay, L., & Wolf, D. (2017). Artful coalitions: Challenging adverse adolescent experiences. *Art Education, 70*(5), 26–33. https://doi.org/10.1080/00043125.2017.1335542

Kidger, J., Araya, R., Donovan, J., & Gunnell, D. (2012). The effect of the school environment on the emotional health of adolescents: A systematic review. *Pediatrics, 129*(5), 925–949. https://doi.org/10.1542/peds.2011-2248

Kramer, E. (1958). *Art therapy in a children's community.* Springfield, IL: CC Thomas Schocken Books.

Landgarten, H., Tasem, M., Junge, M., & Watson, M. (1978). Art therapy as a modality for crisis intervention: Children express reactions to violence in their community. *Journal of Clinical Social Work, 6*(3), 221–229. https://doi.org/10.1007/BF00760157

Lane, K., Oakes, W., Carter, E., & Messenger, M. (2015). Examining behavioral risk and academic performance for students transitioning from elementary to middle school. *Journal of Positive Behavior Interventions, 17*(1), 39–49. doi:10.1177/1098300714524825

La Salle, T. P., Wang, C., Parris, L., & Brown, J. A. (2017). Associations between school climate, suicidal thoughts, and behaviors and ethnicity among middle school students. *Psychology in the Schools, 54*(10), 1294–1301. https://doi.org/10.1002/pits.22078

Levy, B. A., Berberian, M., Brigmon, L., Gonzalez, S. N., & Koepfer, S. (2002). Mobilizing community strength: NY art therapists respond. *Art Therapy: Journal of the American Art Therapy Association, 19*(3), 106–114. https://doi.org/10.1080/07421656.2002.10129403

Lopez, G., Bialik, K., & Radford, J. (2018). *Key findings about U.S. immigrants*. Washington, DC: Pew Research Center. Retrieved from www.pewresearch.org/fact-tank/2018/11/30/key-findings-about-u-s-immigrants/

Lowenfeld, V., & Michael, J. A. (1982). *The Lowenfeld lectures: Viktor Lowenfeld on art education and therapy*. University Park: Pennsylvania State University Press.

Mallin, B., Walker, J. R., & Levin, B. (2013). Mental health promotion in the schools: Supporting resilience in children and youth. In S. Prince-Embury & D. H. Saklofske (Eds.), *The Springer series on human exceptionality: Resilience in children, adolescents, and adults: Translating research into practice* (pp. 91–112). New York, NY: Springer Science + Business Media.

Marraccini, M. E., & Brier, Z. M. (2017). School connectedness and suicidal thoughts and behaviors: A systematic meta-analysis. *School Psychology Quarterly, 32*(1), 5–21. https://doi.org/10.1037/spq0000192

Martin, A. J., Mansour, M., Anderson, M., Gibson, R., Liem, G. A. D., & Sudmalis, D. (2013). The role of arts participation in students' academic and nonacademic outcomes: A longitudinal study of school, home, and community factors. *Journal of Educational Psychology, 105*(3), 709–727. https://doi.org/10.1037/a0032795

McDonald, A., & Drey, N. (2018). Primary-school-based art therapy: A review of controlled studies. *International Journal of Art Therapy, 23*(1), 33–44, https://doi.org/10.1080/17454832.2017.1338741

McGann, E. P. (2006). Color me beautiful. *Journal of Emotional Abuse, 6*(2–3), 197–217. https://doi.org/10.1300/J135v06n02_12

McLeod, J. D., Uemura, R., & Rohrman, S. (2012). Adolescent mental health, behavior problems, and academic achievement. *Journal of Health and Social Behavior, 53*(4), 482–497. doi:10.1177/0022146512462888

Merikangas, K. R., He, J. P., Burstein, M., Swanson, S. A., Avenevoli, S., Cui, L., . . . Swendsen, J. (2010). Lifetime prevalence of mental disorders in U.S. adolescents: Results from the National Comorbidity Survey Replication—Adolescent Supplement (NCS-A). *Journal of the American Academy of Child and Adolescent Psychiatry, 49*(10), 980–989. https://doi.org/10.1016/j.jaac.2010.05.017

Mishne, J. (2001). Short-term psychodynamic treatment of children and adolescents. In B. Dane, C. Tosone, & A. Wolson (Eds.), *Doing more with less: Using long-term skills in short-term treatment* (pp. 57–86). Lanham, MD: Rowman & Littlefield Publishers.

Mohr, E. (2014). Posttraumatic growth in youth survivors of a disaster: An arts-based research project. *Art Therapy, 31*(4), 155–162. https://doi.org/10.1080/07421656.2015.963487

Murphy, J. M., Abel, M. R., Hoover, S., Jellinek, M., & Fazel, M. (2017). Scope, scale, and dose of the world's largest school-based mental health programs. *Harvard Review of Psychiatry, 25*(5), 218-228.https:// doi: 10.1097/HRP.0000000000000149

Murphy, J.M., Guzmán, J., McCarthy, A.E., Squicciarini, A.M., George, M., Canenguez, K.M., . . . Jellinek, M.S. (2014). Mental health predicts better academic outcomes: A longitudinal study of elementary school students in Chile. *Child Psychiatry and Human Development, 46*(2), 245–256. https://doi.org/10.1007/s10578-014-0464-4

National Academies of Sciences, Engineering, and Medicine. (2015). *Mental disorders and disabilities among low-income children*. Washington, DC: The National Academies Press. https://doi.org/10.17226/21780

National Alliance on Mental Illness. (2018). Facts on children's mental health in America. *NAMI: National Alliance on Mental Illness—Mental Health Support, Education and Advocacy*. Retrieved from www.nami.org

Newgrass, S., & Schonfeld, D. (2015). School crisis intervention, crisis prevention, and crisis response. In K. Yaeger & A. Roberts (Eds.), *Crisis intervention handbook: Assessment, treatment and research* (pp. 406–428). New York, NY: Oxford University Press.

Ottermiller, D., & Awais, Y. (2016). A model for art therapists in community-based practice. *Art Therapy: Journal of the American Art Therapy Association, 33*(3), 144–150. https://doi.org/1 0.1080/07421656.2016.1199245

Park, M., McHugh, M., & Katsiaficas, C. (2016). *Serving immigrant families through two-generation programs: Identifying family needs and responsive program approaches.* Washington, DC: Migration Policy Institute.

Perou, R., Bitsko, R., Blumberg, S., Pastor, P., Ghandour, R., Gfroerer, J., . . . Huang, L. (2013, May 17). Mental health surveillance among children—United States, 2005–2011. *Morbidity and Mortality Weekly Report, 62*(2), 1–35.

Perry, B., & Szalavitz, M. (2017). *The boy who was raised as a dog: And other stories from a child psychiatrist's notebook; What traumatized children can teach us about loss, love, and healing* (2nd ed.). New York, NY: Basic Books.

Pfeiffer, L. J. (1994). Promoting social competency in attention deficit hyperactivity disordered elementary-aged children. *ERIC, Resources in Education,* 1–92. Retrieved from ERIC database. (ED368120)

Pfuntner, A., Wier, L. M., & Stocks, C. (2013). *Most frequent conditions in U.S. hospitals, 2010: Statistical brief #148.* Rockville, MD: Agency for Healthcare Research and Quality. Retrieved from www.hcup-us.ahrq.gov/reports/statbriefs/sb162.pdf

Piccolo, L. R., Merz, E. C., & Noble, K. G. (2018). School climate is associated with cortical thickness and executive function in children and adolescents. *Developmental Science, 22*(1), 1–11. https://doi.org/10.1111/desc.12719

Piquero, A. R., Jennings, W. G., Diamond, B., Farrington, D. P., Tremblay, R. E., Welsh, B. C., & Gonzalez, J. M. (2016). A meta-analysis update on the effects of early family/parent training programs on antisocial behavior and delinquency. *Journal of Experimental Criminology, 12*(2), 229–248. https://doi.org/10.1007/s11292-016-9256-0

Potash, J., & Sunderland, L. (2016, March 30). Representing art therapy in the schools—NEA new business item D: Specialized instructional support personnel (SISP). In *Art therapy today.* Alexandria, VA: American Art Therapy Association. Retrieved from www.multibriefs.com. proxy.library.nyu.edu/briefs/aata/AATA033016.php

Regev, D., & Snir, S. (2014). Objectives, interventions and challenges in parent—child art psychotherapy. *Arts in Psychotherapy, 42,* 50–56. https://doi.org/10.1016/j.aip.2014.12.007

Robinson, K. (2015). *Creative schools: The grassroots revolution that's transforming education.* New York, NY: Penguin.

Rosal, M. L., McCulloch-Vislisel, S., & Neece, S. (1997). Keeping students in school: An art therapy program to benefit ninth-grade students. *Art Therapy: Journal of the American Art Therapy Association, 14*(1), 30–36. https://doi.org/10.1080/07421656.1997.10759251

Rousseau, C., Lacroix, L., Bagilishya, D., & Heusch, N. (2003). Working with myths: Creative expression workshops for immigrant and refugee children in a school setting. *Art Therapy: Journal of the American Art Therapy Association, 20*(1), 3–10. https://doi.org/10.1080/0742 1656.2003.10129630

Santiago, C. D., Kaltman, S., & Miranda, J. (2013). Poverty and mental health: How do low-income adults and children fare in psychotherapy? *Journal of Clinical Psychology, 69*(2), 115–126. https://doi.org/10.1002/jclp.21951

Shamri Zeevi, L., Regev, D., & Guttmann, J. (2018). The efficiency of art-based interventions in parental training. *Frontiers in Psychology, 9,* 1495. https://doi.org/10.3389/fpsyg.2018.01495

Siegel, D. (1999). *The developing mind.* New York, NY: The Guilford Press.

Silver, R. (1986). The Lowenfeld lectures: Viktor Lowenfeld on art education and therapy. *Art Therapy, 3*(2), 91. doi:10.1080/07421656.1986.10758830

Sitzer, D., & Stockwell, A. (2015). The art of wellness: A 14-week art therapy program for at-risk youth. *The Arts in Psychotherapy, 45,* 69–81. https://doi.org/10.1016/j.aip.2015.05.007

Slone, M., & Mann, S. (2016). Effects of war, terrorism and armed conflict on young children: A systematic review. *Child Psychiatry & Human Development, 47*(6), 950–965. https://doi.org10.1007/s10578-016-0626-7

Slone, M., Shoshani, A., & Lobel, T. (2013). Helping youth immediately following war exposure: A randomized controlled trial of a school-based intervention program. *The Journal of Primary Prevention, 34*(5), 293–307. https://doi.org/10.1007/s10935-013-0314-3

Snir, S., & Regev, D. (2018). *Parent-child art psychotherapy.* London, England: Routledge.

Song, S., Doll, B., & Marth, K. (2013). Classroom resilience: Practical assessment for intervention. In S. Prince-Embury & D. H. Saklofske (Eds.), *Resilience in children, adolescents, and adults: Translating research into practice* (pp. 61–71). New York, NY: The Springer Series on Human Exceptionality.

Spier, E. (2010). Group art therapy with eighth-grade students transitioning to high school. *Art Therapy, 27*(2), 75–83. doi:10.1080/07421656.2010.10129717

Sriskandarajah, V., Neuner, F., & Catani, C. (2015). Parental care protects traumatized Sri Lankan children from internalizing behavior problems. *BMC Psychiatry, 15,* 203. https://doi.org/10.1186/s12888-015-0583-x

Stiffman, A. R., Stelk, W., Horwitz, S. M., Evans, M. E., Outlaw, F. H., & Atkins, M. (2010). A public health approach to children's mental health services: Possible solutions to current service inadequacies. *Administration and Policy in Mental Health, 37*(1–2), 120–124. https://doi.org/10.1007/s10488-009-0259-2

Suarez-Orozco, C., Birman, D., Casas, J., Nakamura, N., Tummala-Narra, P., Zarate, M., & Vasquez, M. (2012). *Crossroads: The psychology of immigration in the new century.* Washington, DC: American Psychological Association.

Syracuse Herald-Journal. (1964, July 27). Symposium opens tomorrow at SU.. *Syracuse Herald-Journal.*

Theron, L. (2016). The everyday ways that school ecologies facilitate resilience: Implications for school psychologists. *School Psychology International, 37*(2), 87–103. https://doi.org/10.1177/0143034315615937

Vincent, N. (2009). Exposure to community violence and the family: Disruptions in functioning and relationships. *Families in Society: The Journal of Contemporary Social Services, 90*(2), 137–143.

Violence Policy Center. (2017). *The relationship between community violence and trauma.* Retrieved from http://vpc.org/studies/trauma17.pdf

Wahl-Alexander, Z. (2015). Practitioners' experiences creating and Implementing an emotional recovery and physical activity program following a natural disaster. *Strategies: A Journal for Physical and Sport Educators, 28*(2), 17–20. https://doi.org/10.1080/08924562.2014.1001102

Wallin, K., & Durr, M. (2002). Creativity and expressive arts in social emotional learning. *Reclaiming Children & Youth, 11*(1), 30–34.

Yumbul, C., Wieling, E., & Celik, H. (2017). Mother—child relationships following a disaster: The experiences of Turkish mothers living in a container city after the 2011 Van Earthquake. *Contemporary Family Therapy, 40,* 237–248. https://doi.org/10.1007/s10591-017-9445-7

Ziff, K., Ivers, N., & Shaw, E. (2016). ArtBreak group counseling for children: Framework, practice points, and results. *The Journal for Specialists in Group Work, 41*(1), 71–92. https://doi.org/10.1080/01933922.2015.1111487

Ziff, K., Pierce, L., Johanson, S., & King, M. (2012). ArtBreak: A creative group counseling program for children. *Journal of Creativity in Mental Health, 7*(1), 108–121. https://doi.org/10.1080/15401383.2012.657597

23

A Journey of Hope
Art Therapy With an Unaccompanied Minor

EILEEN P. MCGANN

The plight of unaccompanied minors from Central America seeking asylum in the U.S. is an international crisis that demands humanitarian response. In the last decade, the number of children crossing borders has drastically risen to an expected 75,000 in 2017 (U.S. Customs and Border Protection, 2016). The United Nations High Commissioner for Refugees (UNHCR) has been working with member states to provide protection for people worldwide, with special focus on the human rights of the child. The UNHCR has investigated why these children are leaving and what the specific factors are by geographic region in Central America. Reasons for moving and seeking asylum vary; for some, this comes by choice; for others, by force. While the promise of a better life, the need to escape persecution, environmental changes, or a shifting political system are all common reasons to leave home, the common denominator is to flee violence. Violence and grave danger are the realities that many young people continue to experience throughout their journey (Chavez & Menjívar, 2010; National Child Traumatic Stress Network, 2015). Many do not survive the journey, while others are apprehended at the U.S. border and placed in detention centers or residential care by the U.S. Office of Refugee Resettlement (United Nations International Children's Emergency Fund [UNICEF], 2016).

Common experiences of loss, hope, and survival are themes asylum-seeking youth in a residential facility often present. In these settings, trauma-informed therapeutic art interventions support youth to explore personal experiences of migration, displacement, seeking asylum, the meaning of home, community, safety, and hope. While refugee children are among the most vulnerable youth worldwide, they also possess incredible strength and resilience. Approaches to work with refugee youth must encompass an understanding of resilience, protective factors, and the positive growth and increased faith for many overcoming extreme adversities (Calhoun & Tedeschi, 1998; Papadopoulos, 2011; Powell, Rosner, Butollo, Tedeschi, & Calhoun, 2003).

Art therapy has been an essential component of treatment for many asylum-seeking youth. Therapeutic art interventions can provide an arena for exploration of trauma, cultural loss and adaptation, amplification of strengths, integration, healing, and connection with the community.

Unaccompanied Minors Seeking Asylum in the United States

In the last decade, there has been a mass exodus of children leaving their homes and family in Panama, Nicaragua, Costa Rica, Belize, Honduras, El Salvador, Guatemala, and Mexico to come to the U.S. Their journey is long and dangerous. Violence, political disenfranchisement, and dismal socioeconomic conditions have become life threatening, creating environments where relocation is the only sustainable option for young people envisioning their future. This crisis continues to escalate and is a focus of international concern.

Twice a recipient of the Nobel Peace Prize, the UNHCR is the leading organization for human rights of the child regarding protection, asylum, and the "fundamental principle of non-refoulement" (UNHCR, 2015, p. 2)—not sending any child back to the dangerous place from which they fled. A recent and comprehensive study by the UNHCR, Children on the Run (2015), examines the reasons why children flee, where they are coming from, and what their needs are. The UNHCR identified the Northern Triangle of Honduras, Guatemala, and Nicaragua as the most dangerous and violent area of Central America and the area from which the greatest number of children are on the run. Some children leave on their own accord, while others are sent by family members. Regardless of the country of origin and decision-making process, the most prevalent reason for leaving is to escape violence from organized crime and/or within the home. These children face terrible conditions: poverty, exploitation, violence, forced gang recruitment, and significant violations of basic human rights. They fear for themselves and their families and pursue a life that will afford them the opportunity for work, education, and reunification with family members (Carlson, Cacciatore, & Klimek, 2012; Chavez & Menjívar, 2010; Keller, Jocelyne, Granski, & Rosenfeld, 2017; Lusk & Terrazas, 2015; National Child Traumatic Stress Network, 2015; Raghallaigh & Gilligan, 2010; UNHCR, 2015; UNICEF, 2016).

More children than families are trying to cross borders (Rush, 2016; U.S. Customs and Border Protection [USCBP], 2016). In 2008, approximately 8,000 children were apprehended at the U.S. border. In 2014, the number rose to 69,000, and, in 2017, the estimates were at 75,000. These statistics do not include minors who are not apprehended at the border. Thousands die each year from brutal conditions of the journey (UNICEF, 2016).

The travel conditions for these children are arduous. Unaccompanied minors travel without protection of any dedicated adult. Crossing multiple borders intensifies the risks. Smugglers may abandon children along the way or sell them into slavery. The physical conditions of the trip are harsh and life threatening, filled with dangers from the environment. For many children with little or no money, the travel includes riding a freight train across Mexico. This train commonly referred to as "la Bestia," or "the beast," is extraordinarily dangerous: riding on top of or under the cars can result in losing limbs or falling to their death. Criminals are known to frequent the train, robbing, beating, mutilating, raping, and murdering. Being subject to brutal attack or witnessing others victimization, children live in fear on this journey (Chavez & Menjívar, 2010; National Child Traumatic Stress Network, 2015).

Once across borders, youth may be apprehended by the Department of Homeland Security (DHS) and placed in a detention center until their status is determined. If they are evaluated to be an unaccompanied minor, the Office of Refugee Resettlement (ORR) will take charge of their care (Chavez & Menjívar, 2010; ORR, 2015; USCBP, 2016). Placement in a detention center can have negative impact on the child. In a

study of the mental health of refugee children in the New York area, there was a high correlation between psychological distress and symptoms of depression, PTSD, anxiety, and length of detention. Significant trauma for the minor, from pre-migration, throughout the journey, and even upon arrival, frequently results in mental health symptoms that require careful consideration and therapeutic intervention. In evaluation and treatment, both the immediate and long-term needs of the child must be addressed (Keller et al., 2017).

Families at the Border

In 2018, over 2,700 children were forcibly separated from their parents by the U.S. Border Patrol. These parents were deported or placed in detention centers for crossing borders and their children, some as young as 18 months old, were removed from their care. Children removed from their parents then received the designation of "unaccompanied minor" and were placed in the foster care system under ORR (Holpuch & Gambino, 2018; Jones, 2018; Lind, 2018; Loria, 2018; Reilly, 2018; Robbins, 2018). Confused and afraid, these families experienced extreme distress and hardship. One mother reported the horror of her child being pulled away while breastfeeding, and a father from Honduras committed suicide after his son was taken from him (Loria, 2018).

The separation of migrant children from their parents at the U.S. border has drawn international attention and response ("UN rights chief slams 'unconscionable' U.S. border policy," 2018). News media have photographed children in detention centers and at the border. These visual testimonies are iconic and heartbreaking (Selk, 2018). Other news reports describe home-like settings with compassionate, trauma-informed therapeutic care for these children (Jones 2018; Jones & Ramos, 2018; Robbins, 2018). Regardless of the institutional care provided, forced separation from parents is detrimental to the physical, emotional, and psychological health of these children (The AATA Board of Directors, 2018; Stewart, 2018; Kraft, 2018; Pearle & Doom, 2018). Forced separation can lead to lifelong mental illness in children and also results in detrimental medical and health outcomes for their caregivers (Stewart, 2018).

There is consensus among medical and mental health professionals regarding the deleterious impact of forced family separation (Holpuch & Gambino, 2018; Jones, 2018; Jones & Ramos, 2018; Loria, 2018; Robbins, 2018). Leading mental health and human rights organizations, including the American Art Therapy Association, the American Academy of Pediatrics, the American Psychiatric Association, and the Office of the United Nations High Commissioner for Human Rights, have identified the forced separation of children from parents as inhumane, unconscionable, and with lifelong traumatic consequences (The AATA Board of Directors, 2018; Stewart, 2018; Kraft, 2018; "UN rights chief slams 'unconscionable' U.S. border policy," 2018).

Psychological Needs of the Child

Understanding the positive and negative psychological responses of the unaccompanied minor is essential. There is no one narrative that could account for the wide-ranging need of this population. The varied complex traumas and constant stressors young people experience prior to relocation impact their ongoing capacities and treatment needs. When the global community responds to political situations that cause people to become refugees, there is affirmation and a feeling of support and concern. When the global

community does not respond, or cuts off aid and support, the experience of feeling alone, abandoned, and afraid are likely to increase. And, if the larger community responds by forcibly separating children from their parents, the fear and trauma that follows are extreme and with lifelong consequences. Thus, it is the interactions between the larger community and the individual response that determine how a child may navigate their circumstance and what their psychological experience will be (Papadopoulos, 2011).

Papadopoulos (2007, 2010) outlines two areas of positive experience for the refugee. The first is resilience, an ability to manage and succeed in the face of great adversity. Resilience is a characteristic that is present within the person before becoming a refugee or experiencing trauma. With ongoing support and reinforcement, this individual quality is likely to increase and become solidified within the person. The second area of strength has been defined as "Adversity Activated Development"—the ability to maintain positive personal characteristics and develop additional strengths due to overcoming adversity. Here, the individual is transformed by the adversity and can experience post-traumatic growth: a positive change that develops from the struggle with life crisis or traumatic experience. Areas of growth may include changes in relationships, self-perception, and belief systems or philosophy of life. Increased appreciation for, and closeness to, others, along with an increased sense of opportunity and stronger belief in God, have been associated with post-traumatic growth (Calhoun & Tedeschi, 1998; Powell et al., 2003).

Many unaccompanied minors possess incredible resilience and a range of strong capacities, such as: intelligence, an ability to adapt to ever changing circumstances, determination, faith, and being future focused. Internal strengths, coping skills, and protective factors are just as important for therapists to acknowledge and understand as the distressing impact of trauma (Raghallaigh & Gilligan, 2010).

In any trauma work, the first and primary experience must be to establish a sense of safety and trust before trauma-focused therapy would occur (Ehntholt & Yule, 2006; Herman, 1992; van der Kolk, 2014). The needs of the child require ongoing reassessment. The therapist must carefully monitor the child's ability to tolerate sharing information about their life experiences, as there can be a propensity to become flooded emotionally by the traumatic disclosure. Some youth may shut down and withdraw from talking at all. Others may experience guilt and shame for surviving or witnessing and being unable to stop the pain or death of others, including family members. Feelings of loss and reconnecting with trauma can result in an emotional crisis, which then necessitates re-establishing a sense of safety and calm in the child before resuming further trauma-focused therapy (Ehntholt & Yule, 2006).

Impact on the Therapist

The therapist will bear witness to the experiences and narratives of asylum seekers. Secondary or vicarious traumatization can occur when the therapist is exposed for long periods of time or to intensely disturbing material from the people with whom they work (Herman, 1992). In a study by Lusk and Terrazas (2015), responses of professional caregivers who work with refugees from El Salvador, Honduras, Guatemala, and Mexico were explored. Listening to countless narratives of trauma and survival, these workers reported high levels of compassion fatigue and secondary trauma. However, high levels of satisfaction and gratification from their work were also reported. Having a perspective on the positive aspects of their work and engaging in healthy self-care practices impacted therapists' emotional well-being.

It is important for therapists to recognize and understand that there is a wide range of emotional and psychological experiences for refugee and asylum-seeking children. Traumatic reactions, fears, anxiety, depression, physical self-harm, as well as feelings of accomplishment, pride, inspiration, and hope occur. The tendency to polarize and simplify the work is not uncommon. However, polarization will deprive both the therapist and child the opportunity to experience growth and success:

> If we ignore the wider spectrum of responses, our own effectiveness as refugee workers will be diminished and we will need to expend more energy and resources to prop them up instead of facilitating the further development and deployment of the refugees' own existing and potential resources.
>
> (Papadopoulos, 2011, p. 6)

Kohli (2006) outlines the importance of understanding and considering what asylum-seeking children do not say or reveal in verbal narrative. Children who have been in war can remain silent to what they have experienced as a means of survival, protecting themselves and possibly their family. From a "psychological perspective, war silences children, and the silence is a way of dealing with deep disturbance—in some ways an attempt to survive intolerable loss" (p. 709). Green (2000), as cited by Kohli (2006), describes "unclear loss" for unaccompanied children. Not knowing what has happened to family who did not journey creates a loss that cannot be specifically identified or defined.

A positive perspective can also be taken regarding silence. Papadopoulos (2002) describes the healing process for the child during periods of silence:

> The maintenance of silence by refugees is seen to have protective functions, not necessarily pathological ones, in that it allows them a psychological space to reflect on their experiences, and make sense of them, before using their emotional energy to move on in their new worlds.
>
> (Kohli, 2006, p. 710)

Carlson et al. (2012) identify having a strong focus on the future as a factor that helps children experience hope and move forward. The authors provide an analysis of the protective factors that support unaccompanied minors who, despite traumatic exposure and experience, function at a high level. "Easy temperament, good coping skills and belief in a higher power or religiosity" (Carlson et al., 2012, p. 265) are individual protective factors. Extended family support and connection to a community organization, such as a church, school, or social group, are also significant protective factors. Religion and spirituality have been identified in other studies as particularly relevant to an increased ability to adjust and cope successfully. Faith that God, Mary the mother of Jesus, and the saints will guide, protect, and be with them always provides strong protective coping skills for unaccompanied minors of Christian faith (Raghallaigh & Gilligan, 2010).

Art therapy with refugee children has proven to be an effective and powerful intervention. With a focus on hope, art-based interventions developed by Yohani (2008) as well as Ugurlu, Akca, and Acarturk (2016) highlight the use of art therapy for alleviating anxiety and depression in refugee children. A more open art approach, using the process to develop a visual vocabulary by McGann (2014), can support trauma recovery, integration, healing, and acculturation for work with unaccompanied minors.

Stephen

My work with unaccompanied minors begins after ORR has placed them in residential care. The length of their placement and certainty of future is unclear. Acclimating to a new culture, language, and all that accompanies loss and transition are inherent in work with these minors. Many children have memories of home and *nostalgic disorientation*: a compounded emotional experience that manifests in a diffuse sense of loss (Papadopoulos, 2002). Art therapy is also a modality to explore strength.

Stephen is one remarkable young man whose experience illustrates the ways in which art therapy can be used to engage, heal, and help youth maintain hope. Stephen fled the Northern Triangle region of Central America and was apprehended at the U.S. border. He was placed with an agency that provided care for foster youth and refugee children. All children received a wide range of services including medical, religious, educational, and mental health treatment. Stephen was 15 when he was placed with the agency, highly traumatized and experiencing post-traumatic stress disorder. His course of treatment included: trauma assessment, Structured Psychotherapy for Adolescents with Recurring Chronic Stress (SPARCS), medical care, verbal therapy, group therapy, Trauma Focused Cognitive Behavioral Therapy (TF-CBT), psychiatric medication management, substance abuse counseling, education, recreation, and art therapy over a period of 22 months.

Meeting Stephen

Staff escorted a young man to my office. He had recently arrived at campus. Artwork was his main venue of communication: a notebook filled with demonic images, brutal and violent and exquisite in detail. The treatment team requested an art therapy consultation for support in understanding the meaning of his drawings, collaboration of care, and planning. We agreed to meet for an initial session and evaluate possible treatment goals. I am not bilingual nor was this young man—it seemed our work, if he were agreeable, would rely on translation and the art—a visual language we shared.

Stephen entered the room with his head averted, eyes down, seemingly trying to not make any eye contact while scanning the space. His discomfort was palpable; his fear overwhelmed me—this was a young man to meet with gentle caution. His clinician, Ms. M. introduced us, "This is Stephen, the young man I was telling you about. He is an artist." I introduced myself, welcomed him, and let him know that Ms. M. would help us with translation. He clearly deserved to be heard and understood, and I too wanted no feelings of unnecessary confusion in our time together.

He held a notebook filled with images. I let him know that we thought he might want to have some time to make art in this studio. Guarded, he looked up and into my eyes without much response. We made our way to sitting at the table, and he handed me his notebook. It was filled with demons, devils wielding machetes, axes, knives, and hammers; weapons of barbaric torture, with arms that extend, capable of reaching far and wide toward anyone or anything in their path. Some of the sketches were clear in detail with strong line quality; they were accurate, well formed, and highly realistic images. Other creatures did not have a clearly defined contour and were drawn floating, diffuse in a fugue state suggesting hallucinatory processes in connection to these visions. While unsure and fearful, Stephen appeared open to support and connection.

I did not offer him any drawing materials; his art suggested overstimulation leading into psychotic processes and hallucinatory states or flashbacks. As an intervention,

I brought out clay—an alternate expression in tactile modality to ground and release. Surprised and interested, he had not worked with clay before. Our work together had begun: a 22-month journey of discovery, sharing new experience in taking risks, trust, connection, and finding hope.

Stephen worked with the clay for over an hour, silent, focused, and with a comfortable grasp on the medium. The tactile connection grounded him. Working side by side, I modeled ways of sculpting the clay and turning the form into figures. As I practiced silent, deep breathing, he followed my lead. He was/seemed visibly relaxed, appearing more stable as his breath became slow and steady. He was sensitive to the environment and responded to nonverbal interventions. His figure transformed from a devil to an animal, of what species he was unsure. As we were ending this session, Stephen expressed being surprised by how calm he felt working with the clay and the amount of time spent in session. He agreed to come again, and our work in clay continued. A focus on the devil, good and evil, God, spiritual beliefs, life, death, and the search for hope were themes that would repeat. Ms. M. continued to be present in all sessions to provide language translation and participated in the art-making as well.

Over the next few weeks, his work in clay continued on this animal and its place in the environment. The identity changed from a demonic creature, a seven-headed dog that was the protector of the devil, to a headless form. Stephen's anxiety, pain, and

Figure 23.1 Clay animal in progress

overwhelming emotional distress were visible in the raw, self-inflicted wounds on his arm and in the art-making process itself. In session, we practiced slow, deep breathing to help ease his anxiety and physical tremors. He was experiencing flashbacks during the day and having difficulty sleeping at night. I did not allow him to take his clay creature back to the unit, as an intervention to keep the horrific visions away from him at night. We discussed him being able to use the art to explore and create anything he wanted but that I would be the protector here and not allow him to take out of session any images or materials that may cause him to feel distressed or be used for self-harm. The idea of protecting him from his own visions in the art was new to Stephen, and he appeared quite surprised but agreed with these terms.

The animal was left headless one week, as a flat plane with sharp scalloped edges. From this view, the creature appeared sliced at the neck, a horrific parallel to the murder and decapitation of his best friend, which occurred prior to him leaving home.

My intervention to use white clay, only hands and no tools, restricted use of paint, and the support of two therapists helped this young man be grounded and navigate the emotional intensity of his process. He maintained emotional regulation, stability, and relief at the end of this and successive sessions. For Stephen, this was a very important step in treatment, as he had previously been so easily flooded and dysregulated with extreme symptoms of post-traumatic stress disorder (PTSD).

Artwork was the unconscious supervisor in the sessions. Looking to the process and the imagery was a continuous guide for ongoing interventions. In some aspects, the art

Figure 23.2 Clay dinosaur completed

provided a buffer throughout sessions to the intimacy of working one to one with the intensity of the memories he was accessing.

When told he could create anything in art therapy but it would not go back to his room, Stephen appeared relieved. He seemed to need permission to separate from this monster and accepted interventions to keep him emotionally safe. As he worked, the feeling and atmosphere in the room was incredibly sad and felt full of longing. I sculpted a mother and baby bird, and Ms. M. created a horse. Stephen asked that the pieces stay together. I wondered out loud where the animals would live and playfully acted out with the clay. He laughed and looked at me in a quizzical manner then joined in on making an environment for them. He seemed to accept and ask in the metaphor that we be connected and form a community.

The following week, Stephen created a volcano, and at this juncture the work halted. He could not decide if the volcano should overflow, if the creatures could be safe, or if they were destined to die. Life and death, safety and terror repeated in his work as ongoing themes that spoke of his own experiences. In the metaphor, we explored relationships, value, and loss.

The sensory stimulation of the clay brought up other sensory memories, an implicit example of the body holding memories and how the art process helped to release them. Stephen spoke of early relationships, his mother, grandparents, and girlfriend; listened to music in session; and cried. His ability to feel upset and maintain emotional balance was critical and evidenced the movement toward an overarching treatment goal—to tolerate feelings without becoming triggered or overwhelmed. The balance between physical action in the clay, silence, talking, and close monitoring of his responses helped him do this.

As with many clients who start to share deep personal experiences, it is prudent to not push in any area of treatment but to let the child lead. When the art process is emotionally revealing, the talk may not be, and when there is more disclosure that follows the art, in turn the art may become more regulated. This rhythm of treatment provided a balance for his emotional openness and helped guard against flooding of memory. Throughout his course of treatment, ongoing collaboration between clinical team members, primary clinician, psychologist, nurse practitioner, and art therapist occurred weekly to monitor Stephen's daily functioning and ability to manage his emotions.

In subsequent weeks, Stephen came to session with work he started on the unit or in class. Respecting his need for structure and control as self-regulation, we spent time coloring together. The images he chose were telling in content and ranged from religious drawings to cartoon characters and young vulnerable figures. He presented me with several works as gifts that I hung up in the room. This bulletin board over time became his gallery of artwork. Validation and affirmation were essential components of our work; he needed to connect, be seen, celebrated, feel safe, and have hope. His gratitude was important to embrace and accept. I affirmed that he had much to offer others and that his contributions were of value—as was he.

Drawing upon his approach with structured images, I created some landscapes in session, leading him to follow by my visual example. This approach of leading the direction by art-making invited him to share more about his experiences. Stephen responded by creating landscapes of his home country and spoke of his family and what occurred before he left.

His disclosures were terrifying, revealed both in art and verbal therapy. The connection and memories of events at times caused him to undergo tremendous distress outside of sessions. Stephen became highly agitated, experienced flashbacks, had difficulty

Figure 23.3 Pooh bear hugging a heart

sleeping and nightmares, engaged in self-harming behaviors, and expressed suicidal ideation. As an intervention, a staff person was assigned to be with Stephen at all times to help support him and keep him safe. Meetings with clinician, psychologist, nurse practitioner who monitored his medications, and other program staff occurred daily to help evaluate Stephen's functioning and what interventions were needed. Art therapy provided Stephen with an arena to project some of his brutal memories.

In Figure 23.4, we see his work with animal stencils. The forms overlap in a violent and bloody scene. The alligator snaps the terrified looking horse in half at the waist. A brutal encounter, the use of stencils, and control from coloring appeared to help Stephen communicate a deadly experience. The image seemed to parallel his disclosure of a murder he had previously shared in session, which occurred while traveling on "the

Figure 23.4 Animal stencils

beast." Stephen witnessed a man sliced with a machete at the waist and thrown from the train into the river.

When he was unable to manage off the unit, I saw him in the crisis room. During these times, I brought scented lotion and dry structured materials for us to use. The lotions soothed him, and he associated the orange ginger with work in the fields; it felt good to him to recall being outside and home. The coloring sheets and stencils provided organization, distress tolerance, and distraction, essential interventions in trauma work. In one meeting, he colored an image of a lion in a fierce pose: although chained to the mountainside, the lion was pulling away with muscles taut and emphasized, held a ferocious facial expression with teeth bared, and had a red bloody head against a tan body. The animal seemed to repeat the violence he had experienced and his feelings of being trapped. I asked what this animal would need to feel unchained, to be free, to not be so alone. Stephen shrugged his shoulders and shook his head, his response communicating that he did not know or could not say in the moment. Trauma isolates, and the burden of knowledge and experiences should not be carried alone.

On many other occasions, I tried to engage Stephen in breathing exercises and guided imagery to help him feel calm. Sometimes he was receptive, and at other times he was not. In this session, he asked, "Why go to paradise when you only wake up to hell?" I spoke of not being able to change reality but being able to tolerate the moments one by one and that staff was here to support him. Stephen listened but did not respond verbally. When I reflected that he did not appear hopeful, he nodded, and we sat in silence. It was important to accept and validate his feelings of hopelessness in this moment.

The following week he was more stable. We met in the studio and, side by side, created landscape images. He spoke of his home country, life there and living in the mountains, recalling family and friends. The conversations became more personal and revealing and led to him disclosing, to his clinician, a trauma that he had never shared. By visually depicting his experiences in the metaphor through creating art, Stephen developed an emotional tolerance that led to verbal disclosure. The visual and verbal sharing allowed him to let go of the isolation and burden of his trauma. The integration of art and verbal therapy provided Stephen with multisensory expressions of his past and enabled him to feel safe and stable enough to disclose traumatic experiences. He visibly appeared calm in mood, with a significant decrease in symptoms and an increased ability to regulate affect and behavior.

When Stephen first came to the agency, he questioned the existence of God and asked why there was so much evil in the world. His drawings, at that time, were of demons and Santa Muerte, a Mexican folk saint who is considered to be the personification of death. At this point in treatment, following his relief after disclosure of a brutal trauma, Stephen's art shifted with a focus on positive, hopeful spiritual imagery. He created many drawings of crosses, hands praying, Madonna, rosary beads—images that suggested he was turning to religion as a means of support and seeking help from God (Figure 23.5). In this, Stephen expanded his arena for how and where he could access

Figure 23.5 Religious image

something to bring him comfort, self-soothe, and hope, all integral parts of emotional stability and trauma recovery. Outside of session, his sketchbooks and notebooks, which were previously filled with horrific demonic figures, now included youthful characters and spiritual connections.

When He Left . . .

Stephen was abruptly transferred to another facility across the country that was not therapeutic in design. There was no preparation for this; the move was upsetting and confusing for everyone. I turned to my own art-making to process the emotional intensity and pain of our work and let go of what I had been holding on to. Art therapists take in so much on a sensory, visceral level; it is critical that we use our own art to process and understand the imprints of trauma work that sit within us.

I painted a landscape to convey a brutal and vulnerable place (Figure 23.6). The splashes of silver and red paint across soft-toned land represented the silver metal of the train and trauma Stephen had experienced. Vulnerable to societal, sociopolitical, and institutional oppression, Stephen had limited ability to control life exposure to violence, traumatic experiences, and institutional decisions about his future.

His life experiences strongly contrasted my position of privilege and power, as a Caucasian American professional woman with access to freedom, family, safety, and resources. I felt a heightened awareness to the injustice of systems that had brought him to a place of oppression and vulnerability in juxtaposition to my unearned personal privileges. The deeply felt implicit impact of our cross-cultural encounters and power differentials was painful to bear. The size of the work, 2' × 4' was as wide as my arm span. In reflection, I saw this as representing as much as I could carry or hold onto. Relieved and exhausted after completing this painting, I continued to worry about Stephen's safety and well-being.

Figure 23.6 Landscape by art therapist

When Stephen Returned . . .

Several months later, we learned that Stephen would be returning. It had been determined that our agency was the best place for him as he had been highly engaged in treatment. In anticipation of his return, I created a series of collages to explore our relationship and questioned the next steps in treatment and my own fears of managing such intense therapy. My collages revealed figures in a landscape that were both beautiful and dangerous. I wondered what else I might come to know and if I could manage. Therapy has a life, dance, and rhythm of its own. Often the time between is held in suspension and the session resumes where the last meeting left off.

Our first encounter was highly emotional for Stephen, myself, and Ms. M. We met in the art therapy studio, had tea, and spoke about his departure and return. Stephen presented as anxious, visibly shaking, yet also expressed being very glad to be back. He appeared emotionally raw and confused. I encouraged Stephen to join me in slow, deep breathing to help him feel calm. He was receptive and responded well to the intervention. Stephen said he was not ready to talk about the other placement. During this check-in session, he questioned why he left, who were his protectors, if were there angels, and again spoke about good versus evil, god versus devil, life and death. Stephen expressed feeling betrayed and abandoned by God. He told us he had been afraid, experienced flashbacks from his trauma, and evidence of significant self-harm were visible on his arms. Looking through art books, an image of a mural led to him sharing that several family members, artists in his home country, had been targeted and killed by gang members. Stephen learned of this while at the other facility, and his feelings of loss and sorrow were palpable. This set the course for the next phase of treatment, loss and mourning along with a more focused connection in art therapy and with his clinicians. The journey of traumatic recovery is not a smooth one. Expectedly, Stephen's course of treatment involved both periods of stable functioning and times of distress, self-harm, and increased emotional instability.

The Notebooks

Outside of session, Stephen continued drawing as a strong coping tool and filled a multitude of notebooks. Some of the works were playful cartoon characters, decorative banners of his homeland, and images of sentimental romantic relationships. Mostly, however, his images were expressions of his internal struggles: demonic faces, violent scenes of brutality, distorted angry women, and prayers to God for help and salvation. Figures 23.7 and 23.8 are examples of the works that haunted him.

Stephen easily provided insights about his drawings and how art therapy helped him process thoughts, feelings, struggles, and hope. We reviewed the work he had done between sessions, and he told me what he felt and how the art helped him express that moment in time. Stephen articulated clearly that the art helped him to move forward after the release via imagery. Stephen described Figure 23.9, a clown face, as a man covering up feeling sad. He further described gang members from his home country that would dress as clowns to conceal their identity as they murdered. Providing him with sketchbooks and later review of the works helped him cope daily. The frequency and intensity of his self-harm abated. We candidly discussed how self-mutilation of cutting his arms had helped him manage his pain and how now the art could do this instead. Stephen agreed and said he wanted to show me another notebook of images that he created during his time away from the agency. In this other facility, he was alone and

Figure 23.7 Demon image with horns

Figure 23.8 Demon image screaming

Figure 23.9 Clown face

Figure 23.10 Sunset

frightened and used the art to express and try to contain his fears and anxiety. The images of people in this notebook included angry, sad, frightened faces; brutal weapons; and demonic figures. Overall, the art expressed pain. On one page, a sliver of glass was hidden beneath some tape. When I asked about this, Stephen said that he had used the glass to self-harm in the other facility. He appeared vulnerable and was looking for help. I wondered out loud if he wanted me to hold this for him, to keep him safe, and he agreed. The art therapy space held what he could not have with him, hallucinatory images and materials that were unsafe. His gratitude for support, resilience, and compassion were notable qualities in this young man.

An example of Stephen's compassion found expression in an image of a bird he created for a staff member whose pet had died. He asked me to work side by side with him to complete this as a gift. The joined approach supported him as he reflected on loss of

Figure 23.11 Portrait of woman

life in this sublimated image. His next artwork, of a sunset, revealed a more personal experience of loss. Stephen said this image was the beach he would go to each night, watch the sunset, and cry for his mother. She had migrated to the U.S. before him, to escape being killed. Stephen's hope, and our agency goal, was for his reunification with his mother.

Outside of session, he drew a portrait of a woman. He was very proud of this work and presented it to me as a gift. He said the image was of me. I understood our connection had deepened and accepted his drawing with much gratitude. At times he asked me what I saw in him and his art. It seemed that Stephen's attachment to me was maternal in transference and that he was seeking validation and praise. In giving me the portrait, I felt that he was telling me that he saw me as well. I felt a strong pull and countertransference in work with this young man, with feelings of nurturance, protection, and concern.

In subsequent sessions, he requested the iPad to listen to music and requested that Ms. M. and I create art alongside him, which became an ongoing pattern of our work. At times he was playful in his approach; he teased Ms. M. about her artwork and directed me to draw complex images for him to color. At other times he was melancholy.

Stephen selected songs that were from his homeland and painted landscapes of his country. He described home with a sense of longing. He missed his friends and living in the mountains and wondered what had happened to the people he left behind. Not knowing what happened to others created a diffuse sense of loss for Stephen. He also spoke of the brutality he survived. He spoke of his journey: vicious gang violence, the train ride on "the beast," murders he has witnessed. Stephen pulled up a film clip on the iPad to show me scenes from the movie Si Nombre. After a few moments, I intervened to have him turn this off; the film clip of forced gang initiation was highly disturbing to view. I feared he would become distressed, be triggered from the graphic, visual display of violence, and decompensate. He agreed but asked me to watch the movie before our next session. He wanted me to understand what he had experienced, how he had survived. It seemed very important to him that I be witness to what he lived. He wondered what I would think of him after seeing the movie. His statement suggested that he anticipated or feared rejection by me, a fear rooted in shame. I agreed to view the film and spoke with him about survival and the impact that trauma can have on people, particularly a young person who is alone. I asked him what he thought of forgiveness and what he wanted in his life now. Stephen said he wanted to find hope again.

Coming Together

In times of crisis as well as in times of his success, the clinical team gathered with Stephen to support him and/or celebrate with him. Meetings included any combination of the following staff who worked with him on a daily or weekly basis: primary clinician, psychiatric nurse practitioner who monitored his medication, health office staff, program director and support counselors for his living unit, educational staff, psychologist, crisis support team on campus, and art therapists. Throughout his treatment, symptoms of PTSD were closely monitored: hallucinations, flashbacks, self-harm, fears, irritability, and anxiety. Observations by different staff, along with Stephen's participation, helped to manage his medication needs, communicate behavioral expectations on his living unit, and guide verbal and art therapy interventions. As Stephen's functioning stabilized, he became more active in discussing his treatment needs. Sessions occasionally included his psychologist, with whom he met for TF-CBT. Together we processed his disclosures

in verbal treatment and work in art therapy. He was gratified by the collective support and requested that we come together, *like a family*.

Following one period of prolonged stability, Stephen requested a celebration with Ms. M. and me. We discussed several options and decided to cook a meal of foods from his home country together in the community kitchen. Rice, beans, salad, fish, and fruit were prepared. Stephen invited a peer, who was going to be discharged soon, to join us. The atmosphere was at times lively, full of laughter, and at other moments quiet and reflective. The two young men, who were from the same home country, spoke of swimming at the beach, diving for fish, foods that their family cooked, and people they missed. They described feeling free, having fun; shared feelings of loss and hope; and supported each other.

During periods of struggle, when Stephen was haunted by memories of trauma, his anxiety escalated, and he decompensated. Various manifestations of his psychological distress included verbal aggression toward staff and peers, difficulty sleeping, nightmares, self-harm, eating disturbances, and feeling hopeless. During one period of crisis, when Stephen again questioned the existence of God, why so many people suffered, and why he had endured so much trauma, I suggested a meeting with a religious staff person who could talk with him about God, faith, and his uncertainty. He agreed. Stephen, Ms. M., and I met with a Sister of Mercy who spoke with him in an open, compassionate manner. Stephen engaged in an intimate discussion about faith, fear, God, the devil, life and death, and his ambivalent desire to believe in God. The outcome was Stephen knowing he had the choice of what to believe. This perspective of choice being in his control seemed to empower him. In the months that followed this meeting, Stephen became more confident and steadfast in his expressed devotion to God, faith, and hope.

When a peer left the program, Stephen, along with others, walked the sanctuary garden labyrinth as a meditation and left a small stone in the center as a positive intention for this peer. It was common practice to have a goodbye gathering for youth leaving the program. He was in a place of reflection and growth. He spoke of acceptance and expressed hope for his future. He was incorporating what he had learned from treatment. His emotional stability was seen in his capacity to tolerate mixed emotions in the work. Stephen's requests to learn to integrate colors, have us work together, and employ symbols of balance and hope seemed to be a parallel process of his emotional regulation and management through art therapy. Each step forward was another on his path for healing. His ability to integrate varied emotional states during times of stress was revealed in one of his last artworks. Stephen created a yin-yang mandala and described the need for balance in stress and included his personal symbol of hope, a cross. Therapeutic gains through art therapy were notable for this resilient young man. Stephen, a youth of courage, stands as an example of so many asylum-seeking unaccompanied minors, the need for humanitarian response, and the role of art therapy in helping these children to cope, heal, and move forward with hope.

Discussion

The work with Stephen can serve to illustrate ways in which art therapy, in a collaborative therapeutic environment, can support and bring positive impact for asylum-seeking children. The consistent collaboration and integration of services, with clinician, psychologist, program staff, nurse practitioners, and Stephen, being an active and vocal participant, allowed for an inclusive and well-informed approach to his care. A range of equally critical factors that necessitated ongoing consideration and attention were

understanding and acknowledging his distress; actively engaging him in the process of healing; addressing the individual and societal trauma; and emphasizing his resilience, strength, and growth through adversity.

The length of treatment dictates interventions and therapeutic goals, and yet for many asylum-seeking children, the time we will have with them is unknown. Initial interventions often focus on immediate self-regulation, by using the art for distress tolerance, distraction, and coping, particularly when a child presents with acute trauma symptoms. Increased management of emotions and experiences will follow, with deeper and longer-term work to explore their trauma, journey, loss, and future.

Arriving to the residential treatment facility with profound experiences of violence, Stephen was highly traumatized and necessitated extensive interventions. Hallucinations, flashbacks, self-harm, and nightmares plagued this youth. Art-making provided a vehicle of expression for things he could not say or sustain discussion about. The early interventions in art therapy, of using white clay and deep breathing, focused on regulating his body responses, which is essential in trauma work (van der Kolk, 2014). Sometimes, the intervention was to just breathe . . . to sit side by side, hand on heart, and teach Stephen how to use his breath to self-regulate and calm his body and mind enough to feel safe. This exercise was employed several times in our work, and formed a connection of calmness, that, I believe, was viscerally remembered and accessed.

It was essential that Stephen tolerate his emotions without decompensating, and over time this was achieved. The use of sensory grounding clay work, breath exercises, and controlled works of stencils and coloring sheets helped Stephen balance the emotional intensity triggered by intrusive thoughts. These approaches also supported him, when, by conscious choice, he revisited his trauma and was able to do so without decompensating.

Interventions in the art were focused on the metaphor and our process of connection. While my own lack of bilingual capacity was a clear limitation, our strained verbal fluency facilitated the process and engagement in the arts. An intentional guiding by example, media approach, and joint art-making supported the development of a visual vocabulary (McGann, 2014) and sensory regulation through the arts.

After Stephen returned from his placement with another facility, his experiences in detention centers and the sociopolitical systems became an explicit part of our work together. Through notebooks filled with images, he shared many stories and ultimately asked me to hold a hidden piece of glass that he had previously used to self-harm. Art therapy helped Stephen transform internally directed rage and self-mutilating behavior into constructive expression and exploration of trauma. Rather than using his body as the platform for expression of intolerable anxiety, fear, and pain, he drew, painted, and sculpted images. Through discussion and art-making around the violence in his homeland, the cultural factors and disparity with my life experiences were openly addressed. Specific topics included living with my family in a safe environment and not having encountered gang violence or crossed borders. We acknowledged the differences and focused on his needs and care. In our therapeutic relationship, what became most important was that he be heard. His desire to be understood and have me know, see, and tolerate his journey enabled him to also tolerate these experiences. In return, his drawing my portrait outside of session seemed to convey that he was seeing me, internalizing the care and validation mirrored to him. Our joint efforts to communicate took effort and investment in the art, translation, and nonverbal exchanges. The effort was recognized as care and commitment and held value.

The sensitivity with which Stephen's primary clinician, Ms. M., helped us communicate through language translation was critical for ongoing clarity in verbal

communication in the initial session and through nearly two years of treatment. Additionally, her participation in sessions provided another layer of support and protection: he often said the three of us were *la familia*, and the buffer of the group seemed to help cushion the emotional intensity of the work. The emotional impact of work with asylum-seeking youth, and, in this case, Stephen parallels the findings of Lusk and Terrazas (2015) and Herman (1992) regarding vicarious traumatization from highly disturbing material. Stephen's trauma was more intense and severe than any long-term work I had experienced in over 30 years of practice as an art therapist. Parallel to his unprecedented trauma history, his ability to overcome adversity, engage in treatment, and have faith and inner strength also presented in ways that I had never experienced.

The professional caregiver is well advised to become familiar with the protective factors that help asylum-seeking children succeed. Personal meaning for each youth is important to explore as it may reflect unknown losses or a healing process (Papadopoulos, 2002). Silence of the past and the unknown, elements of psychological survival, can be a healthy defense and protective factor. Silence for refugees can provide a psychological space for reflection and understanding of their experiences (Kohli, 2006; Green, 2000). Art therapy inherently draws upon silence in sessions. Understanding the importance that silence may have for refugee children can help to inform the art therapist regarding interventions and themes of exploration. Stephen began treatment questioning the existence of God in the face of so much lived violence, death, and evil. His art portrayed his struggle, desire to believe, and rage around lack of protection. Religion is a strong protective factor for many refugee children, and, for Stephen, art therapy helped support his desire to maintain belief and faith.

The rosary beads Stephen drew at one point manifested in daily wear of rosary beads around his neck. He said the beads protected and guided him. Strings, beads, and any hard objects were no longer hidden to self-mutilate; he had moved from internal direction of anxiety and pain, loss, and fear to an external embracing of connection, calm, joy, and hope. As Stephen awaited reunification with his birth mother, he was processing the duality of life. He was emotionally stable, enjoying his daily successes, confident in his achievements, and had faith and hope in his future.

Conclusion

Work with refugee and unaccompanied asylum-seeking youth requires commitment to understanding complex political and social systems. The response to the plight of refugee children by the larger community, including the therapeutic community, will impact how the child is able to navigate their past experiences and new circumstances. Such complexities suggest that ideal treatment integrate a collaboration of mental health, physical, medical, and social services. Art therapists must acknowledge and understand positions of privilege and power in the dynamics of cross-cultural therapeutic relationships. The work with Stephen can help to illustrate ways of forming a therapeutic alliance and how engaging in art therapy can support asylum-seeking youth. Art-based interventions should be carefully monitored, and materials must be chosen on an individual basis. For some youth, the inclination to self-harm as a means of mediating trauma and coping with incredible anxiety will require ongoing monitoring by the therapist to ensure safety.

Understanding the brutal and pervasive exposure to violence, for so many of these children, is a critical factor in their course of treatment. Anticipated length of treatment is also a strong consideration for therapeutic care. Art therapists must consider

when in-depth exploration of past experience is helpful, and when focusing forward and drawing upon concrete coping strategies is the best approach. Of equal importance is viewing and working with the youth from a strength-based perspective and identifying protective factors that can help them sustain their hope and resilience. Recognizing both the positive and negative psychological responses of the child are critical in this complex work.

Recommendations for the art therapist include conscious monitoring of self for emotional and psychic impact of this work, attunement to signs of vicarious trauma, collaborating with other professional care givers, and enlisting external support. Assuming the role of ally and not rescuer is important for both youth and therapist to avoid the savior victim dynamics of trauma and promote a strong foundation of connection, which can help with future resiliency and self-sustaining coping skills.

Like so many other unaccompanied asylum-seeking minors, Stephen's journey and time in art therapy reveal both the worst of humanity—brutal, pervasive violence, evil acts of barbaric torture, loss, fear, and hopelessness—as well as the best of humanity—compassion, engagement, respect, love, commitment, validation, faith, and hope. I am grateful for the opportunity to know and work with these children and admire their courage, with special regard for Stephen, a young man who has taught us all so much and for whom I have much hope.

References

The AATA Board of Directors. (2018). The AATA's statement on the traumatic impact of separating children from parents and caregivers. *American Art Therapy Association*. Retrieved from https://arttherapy.org/news-statement-separating-children-parents/

Calhoun, L. G., & Tedeschi, R. G. (1998). Beyond recovery from trauma: Implications for clinical practice and research. *Journal of Social Issues*, *54*(2), 357–371. https://doi.org/10.1111/0022-4537.701998070

Carlson, B. E., Cacciatore, J., & Klimek, B. (2012). A risk and resilience perspective on unaccompanied refugee minors. *Social Work*, *57*(3), 259–269. https://doi.org/10.1093/sw/sws003

Chavez, L., & Menjívar, C. (2010). Children without borders: A mapping of the literature on unaccompanied migrant children to the United States. *Migraciones Internacionales*, *5*(3), 71–111.

Ehntholt, K., & Yule, W. (2006). Practitioner review: Assessment and treatment of refugee children and adolescents who have experienced war-related trauma. *Journal of Child Psychology and Psychiatry*, *47*(12), 1197–1210. https://doi.org/10.1111/j.1469-7610.2006.01638.x

Green, E. (2000). Unaccompanied children in the Danish asylum process. *Danish Refugee Council*. Retrieved from www.childmigration.net/files/DRC_Green_00.pdf

Herman, J. (1992). *Trauma and recovery: The aftermath of violence—from domestic abuse to political terror*. New York, NY: Basic Books.

Holpuch, A., & Gambino, L. (2018, June 18). Why are families being separated at the U.S. border? *The Guardian*. Retrieved from www.theguardian.com/us-news/2018/jun/18/why-are-families-being-separated-at-the-us-border-explainer

Jones, B. (2018, June 23). MercyFirst in Syosset gives shelter to children, including migrants. *Newsday*. Retrieved from www.newsday.com/long-island/nassau/family-separation-border-mercy-first-1.19382903

Jones, B., & Ramos, V. M. (2018, June 19). 8 kids separated from parents are now on LI, agency says. *Newsday*. Retrieved from www.newsday.com/long-island/immigration-separation-children-parents-1.19291938

Keller, A., Jocelyne, A., Granski, M., & Rosenfeld, B. (2017). Pre-migration trauma exposure and mental health functioning among Central American migrants arriving at the U.S. Border. *PLoS One*, *12*(1), 1–11. https://doi.org/10.1371/journal.pone.0168692

Kohli, R. (2006). The sound of silence: Listening to what unaccompanied asylum-seeking children do not say. *British Journal of Social Work, 36*(5), 707–721. https://doi.org/10.1093/bjsw/bch305

Kraft, C. (2018, May 8). AAP Statement opposing separation of children and parents at the border. *American Academy of Pediatrics*. Retrieved from www.aap.org/en-us/about-the-aap/aap-press-room/Pages/StatementOpposingSeparationofChildrenandParents.aspx

Lind, D. (2018, June 15). The Trump administration's separation of families at the border, explained: Why children are being sent to "foster care of whatever" while their parents are sent to jail. *Vox*. Retrieved from www.vox.com/2018/6/11/17443198/children-immigrant-families-separated-parents

Loria, K. (2018, June 19). Separating kids at the border mirrors a "textbook strategy" of domestic abuse, experts say. *Independent*. Retrieved from www.independent.co.uk/news/world/americas/us-border-families-separation-trump-administration-mexico-children-cages-domestic-abuse-damage-a8405901.html

Lusk, M., & Terrazas, S. (2015). Secondary trauma among caregivers who work with Mexican and Central American refugees. *Hispanic Journal of Behavioral Sciences, 37*(2), 257–273. https://doi.org/10.1177/0739986315578842

McGann, E. (2014). Developing a visual vocabulary. *ATOL: Art Therapy OnLine, 5*(2), 362–383.

National Child Traumatic Stress Network. (2015). *Working with unaccompanied and immigrant minors*. Retrieved from www.nctsn.org/content/working-unaccompanied-and-immigrant-minors

Office of Refugee Resettlement. (2015). *Unaccompanied alien children*. Retrieved from www.acf.hhs.gov/orr/programs/ucs

Papadopoulos, R. K. (2002). *Therapeutic care for refugees: No place like home*. London, England: Karnac Books.

Papadopoulos, R. K. (2007). Refugees, trauma, and adversity-activated development. *European Journal of Psychotherapy and Counselling, 9*(3), 301–312. https://doi.org/10.1080/13642530701496930

Papadopoulos, R. K. (2010). Enhancing vulnerable asylum seekers' protection. *Trainers' Manual*. Rome, Italy: International Organisation for Migration. Retrieved from https://asop4g.eu/wp-content/uploads/2019/01/EVASP-TrainersHandbook_Trauma-vulnerabilities.pdf

Papadopoulos, R. K. (2011). *A psychosocial framework for work with refugees*. Retrieved from www.southeastsafenet.eu/sites/default/files/3.pdf

Pearle, L., & Doom, J. (2018, June 27). Federal judge rules children, parents separated at border must be reunited within 30 days. *ABC News*. Retrieved from https://abcnews.go.com/Politics/federal-judge-rules-children-parents-separated-border-reunited/story?id=56192051

Powell, S., Rosner, R., Butollo, W., Tedeschi, R. G., & Calhoun, L. G. (2003). Posttraumatic growth after war: A study with former refugees and displaced people in Sarajevo. *Journal of Clinical Psychology, 59*(1), 71–83. https://doi.org/10.1002/jclp.10117

Raghallaigh, M., & Gilligan, R. (2010). Active survival in the lives of unaccompanied minors: Coping strategies, resilience, and the relevance of religion. *Child and Family Social Work, 15*(2), 226–237. https://doi.org/10.1111/j.1365-2206.2009.00663.x

Reilly, K. (2018, June 21). What's happening to the 2,300 children already separated from their parents? *Time*. Retrieved from http://time.com/5317117/what-happens-children-separated-family-border/

Robbins, L. (2018, June 20). Hundreds of separated children have been quietly sent to New York. *New York Times*. Retrieved from www.nytimes.com/2018/06/20/nyregion/children-separated-border-new-york.html

Rush, N. (2016). Welcoming unaccompanied alien children to the United States. *Center for Immigration Studies*. Retrieved from https://cis.org/sites/default/files/rush-refugee-UAC_0.pdf

Selk, A. (2018, June 18). "I wanted to stop her crying": The image of a migrant child that broke a photographer's heart. *The Washington Post*. Retrieved from www.washingtonpost.com/news/post-nation/wp/2018/06/18/i-wanted-to-stop-her-crying-the-image-of-a-migrant-child-that-broke-a-photographers-heart/?utm_term=.56e4f24eee82

Stewart, A. (2018, May 30). APA statement opposing separation of children from parents at the border. *American Psychiatric Association*. Retrieved from www.psychiatry.org/newsroom/

news-releases/apa-statement-opposing-separation-of-children-from-parents-at-the-border

Ugurlu, N., Akca, L., & Acarturk, C. (2016). An art therapy intervention for symptoms of post-traumatic stress, depression and anxiety among Syrian refugee children. *Vulnerable Children and Youth Studies, 11*(2), 89–102. https://doi.org/10.1080/17450128.2016.1181288

United Nations High Commissioner for Refugees. (2015). *Children on the run: Unaccompanied children leaving Central America and Mexico and the need for international protection.* Retrieved from www.unhcr.org/en-us/about-us/background/56fc266f4/children-on-t-e-run-full-report.html

UN rights chief slams "unconscionable" U.S. border policy of separating migrant children from parents (2018, June 18). *UN News.* Retrieved from https://news.un.org/en/story/2018/06/1012382

United Nations International Children's Emergency Fund. (2016, August 23). To escape gangs and poverty, Central American children making risky journey to U.S. *UN News Center.* Retrieved from www.un.org/apps/news/story.asp?NewsID=54734#

U.S. Customs and Border Protection. (2016). *Southwest border unaccompanied alien children statistics* [Data file]. Retrieved from www.cbp.gov/site-page/southwest-border-unaccompanied-alien-children-statistics-fy-2016

van der Kolk, B. (2014). *The body keeps the score: Brain, mind, and body in the healing of trauma.* New York, NY: Penguin Books.

Yohani, S. (2008). Creating an ecology of hope: Arts-based interventions with refugee children. *Child and Adolescent Social Work Journal, 25*(4), 309–323. https://doi.org/10.1007/s10560-008-0129-x

Art Therapy With Bereaved Youth

MARIA KONDRATIEV SOSSI

"The kingdom where nobody dies," as Edna St. Vincent Millay once described childhood, is the fantasy of grownups. We want our children to be immortal—at least temporarily. We can be more useful to children if we can share with them realities as well as fantasies about death. This means some uncomfortable moments. Part of each child's adventure into life is his discovery of loss, separation, nonbeing, death. No one can have this adventure for him, nor can death be locked in another room until a child comes of age. At the beginning the child does not know that he is supposed to be scared of death, that he is supposed to develop a fabric of evasions to protect himself, and that his parents are not to be relied upon for support when it really counts. He is ready to share his discoveries with us. Are we?

—Kastenbaum (1972, p. 38)

Losing a loved one has a profound effect on a person's life. A number of theories of loss and bereavement have been developed to make sense of this complex and universal experience, with our varied understandings of grief further shaped by background, culture, age, and relationships alike.

For a young child, however, death is an especially painful and often traumatic event, frequently leading to feelings of instability within their environment and themselves. The process of grieving and reconstruction can manifest in children through a myriad of ways, its effects taking on many forms that go unnoticed or mislabeled. Symptoms such as emotional dysregulation and regressive behaviors are often categorized as "acting out" (Corr & Balk, 2010; Zambelli, Clark, & de Jong Hodgson, 1994). Contrastingly, the seemingly adjusted performance of others may be viewed as proof of coping rather than that of masked pain and profound internal struggle (Corr & Balk, 2010; Zambelli et al., 1994). These effects are further dictated by the child's developmental stage, which plays a significant role in their behavior and understanding of the world around them.

Surviving caregivers often struggle with the monumental task of preparing, guiding, and supporting bereaved children through this overwhelming experience. In many instances, well-meaning caregivers are inclined to shield their children from painful truths related to death, consequently denying them their ability to mourn. In addition, the struggle of managing their own grief and adjusting to a new role can often eclipse attempts to remain emotionally available (Doka, 2000, 2002; Silverman, 2000). Despite efforts, children cannot be sheltered from pain related to loss; however, those who are given the opportunity to grieve in a supportive environment become able to cope and adapt.

Grieving children who are provided opportunities to express their emotions through creative approaches in art therapy are seen to exhibit improvements in their affect and functioning (Hill & Lineweaver, 2016; Zambelli et al., 1994). Developmentally appropriate for young people who may perceive verbal prompts as intrusive, art therapy instead allows for visual and symbolic expression of grief. Furthermore, art therapists informed by bereavement models can spontaneously engage the client in creative exploration of loss and restoration, promote self-regulation, and foster meaning making through art, play, and storytelling (Lister, Pushkar, & Connolly, 2008). Through this safe and projective modality, children are able to maintain a meaningful bond to their missing loved one.

This chapter carefully delineates intensive treatment with a family, tracking before and after a mother's death. It reveals the vastly different coping strategies of two siblings who are working to negotiate their profound loss. In the review of this case study, the role of one's cultural framework in understanding and coping with grief will be addressed. The presentation of detailed interactions and interventions highlighted within select sessions underscore the means by which the artistic medium allowed for a developmentally appropriate venue to process grief. Also examined is the important role of the therapeutic relationship in holding the space and bearing witness to the experience of the bereaved youth. Finally, I consider the implications of the clinician's own experience with loss and offer directives and techniques for future grief work.

Overview of Loss and Bereavement Theories

Death is a human inevitability and grief its surviving consequence. Grieving a loved one can encompass a myriad of emotions: shock, sorrow, anger, fear, anxiety, relief, peace, and sadness. The complex experience of bereavement has led to a number of theories espoused by clinicians in an attempt to understand the psychological reaction to life's greatest unknown.

Freud (1917/1957) was the first to write of the mourning process as a gradual withdrawal of attachment from the deceased loved one. Once distanced, he wrote, sufficient emotional energy would again be available to invest in new relationships. Evolving bereavement theories have built upon Freud's notion that grief occurs over a series of phases (Bowlby, 1980; Kübler-Ross, 1969; Worden, 2009). Kübler-Ross (1969) described five such sequential stages essential to bereavement: denial, anger, bargaining, depression, and acceptance. Bowlby (1980) later proposed a model for understanding the ways by which bereavement experiences arise from early attachment structures. His Attachment Theory made room for the presence of ambivalent feelings associated with the loss of relationships touched by conflict and complexity.

Dual Process Model

While much of the literature on bereavement concerns the completion of stages or tasks necessary to overcome loss (Archer, 1999), the Dual Process Model is a non-linear and lifelong paradigm examining the way by which ties to the deceased dictate one's course of coping and adjustment (Stroebe & Schut, 2010). Integrating cognitive stress and attachment theories, Stroebe and Schut (2010) describe a dynamic process of oscillation between confrontation and avoidance and between loss and restoration.

Through this series of fluctuations, one learns to self-regulate and cope with the pain of death. In fact, Stroebe and Schut (2010) postulate that people who show little or no oscillation adjust more poorly and become psychologically and physiologically exhausted. As one alternates between approaching and avoiding the loss, Stroebe and Schut (2010) assert that acute grief reactions eventually diminish in frequency, and focus turns instead toward reconciliation and meaning making.

Meaning Reconstruction Model

Similar to the Dual Process Model, the Meaning Reconstruction Model views the course of bereavement as unique, non-linear, and lifelong. Gillies and Neimeyer (2006) explain that the Meaning Reconstruction Model emerged from the belief that humans are inveterate meaning makers and define the process of meaning making as "sense making, benefit finding and identity change" (p. 54). When a loved one dies, the mourner's internal representation of the assumptive world is fractured necessitating an active exploration of the relationship to the deceased and ongoing redefinition of that relationship over time. Grieving entails an attempt to reaffirm an evolving self-narrative challenged by loss (Gillies & Neimeyer, 2006; Neimeyer & Burke, 2017). Consequently, meaning reconstruction is viewed as essential to healthy adjustment, with the loss event seen as an opportunity for growth (Neimeyer, 1998; Gillies & Neimeyer, 2006; Neimeyer & Burke, 2017).

Continuing Bonds

Unlike past theories that encouraged severing ties with the deceased, more current models prioritize maintaining the connection without engaging its negative effects. Building on Bowlby's work, Klass, Silverman, and Nickman (1996) stress the importance of continued bonds as these connections have the potential to provide comfort and relief. Worden (2009) concurred, proposing that grief work should include the following tasks: accepting the reality of loss, experiencing the pain or emotional aspect of the loss, adjusting to life without the deceased, and finding an enduring connection to the deceased while embarking on a new life.

Culture and Grief

The U.S. is comprised of many ethnic groups that have migrated from across the world, carrying with them an equal number of cultural systems. The social customs and values of these cultures of origin can continue to shape the beliefs and practices for immigrants adapting to a new country, as they provide a stabilizing framework with which to understand the world (Gupta, 2011). As such, culture and ethnicity play a crucial and defining role in the experience of death, loss, and grief.

Balk (2004) discusses the Euro-American concept of loss recovery as redefining and reintegrating oneself into life. However, it is important to acknowledge that many cultures do not place equal consideration on the individualistic self. Grief may rather be viewed as a communal experience, and, subsequently, personal recovery would not be emphasized (Rosenblatt, 2008). In a study of bereavement among the Chinese of Taiwan, the family unit was seen as attempting to collectively maintain its wholeness by retaining the status quo prior to the experienced death (Hsu, Kahn, Yee, & Lee, 2004). As such, the well-being of the family superseded that of its individual members.

In facing the death of a loved one, culturally informed worldviews can dictate the beliefs and behaviors of the person dying and those who grieve them. Therefore, it is vital for clinicians to become familiar with the framework related to death and bereavement among the ethnic communities they serve (Gupta, 2011; Rosenblatt, 2008). An awareness of the significance surrounding death-related practices is needed to provide culturally sensitive and effective services to those who remain. Above all, we must recognize the value of the mourner's capacity "to know their own realities, lives, and memories better than any observer, particularly an observer whose language and culture are different from their own" (Rosenblatt, 2008, p. 12).

Grief in Childhood

While death is universal, the experience of loss has been shown to be highly diverse and individualized; this is no truer than for the youngest members of our society. Unlike adults, children have a limited capacity to endure painful emotions such as grief (Corr & Balk, 2010; Pearlman, Cloitre, & Schwalbe, 2010; Wolfenstein, 1966). Due to this lowered tolerance for persistent and ongoing negative affect, bereaved youth tend to oscillate between intense and often polarizing reactions rather than sustaining high levels of a single emotion over time (Wolfenstein, 1966). They may cycle through a variety of feelings such as numbness, confusion, sadness, anger, fear, guilt, and loneliness (Corr & Balk, 2010; Webb, 2002). Consequently, children grieve intermittently to protect against these overwhelming and ever-changing feeling states (Corr & Balk, 2010; Pearlman et al., 2010; Wolfenstein, 1966).

A primary factor in childhood grief is the developmental stage at which the loss occurred, with the bereaved child's age and development bearing significant influence over the way their loss is managed. Young children, from two to five years of age, struggle with the notion that death is irreversible and inevitable (Webb, 2002). Youth at this stage may turn to magical thinking, with the perception that their own thoughts and actions were the cause of death (Pearlman et al., 2010; Webb, 2002). Young children may also develop anxiety related to secondary losses, which can include changes in routines, decreased familial support, and having to relocate to a new home (Corr & Balk, 2010; Webb, 2002; Zambelli et al., 1994).

From the ages of five to eight, children begin to develop a greater comprehension of death and often become curious about its nature. These children may exhibit denial, magical thinking, and internalized emotions associated with loss (Zambelli et al., 1994). At this stage, low self-esteem and acting out behaviors are likely in those who experience unwarranted guilt or feel unsafe in expressing emotions related to grief (Zambelli et al., 1994). Like their younger peers, children in this phase of development may regress and exhibit fears related to the possibility of their own death or that of a loved one (Pearlman et al., 2010).

As they approach nine and ten years of age, children adopt an increasingly sophisticated understanding of death. Subsequently, they require a more comprehensive and direct explanations about loss in order to feel a sense of mastery and control (Corr & Balk, 2010). Self-blame, guilt, worry, and fear persist during this stage (Pearlman et al., 2010).

Between their innate emotional oscillation and developmental-specific anxieties, bereaved children of all ages may be observed as either acting out or withdrawing into themselves. Some children will exhibit extreme emotional, behavioral, or physical

symptoms; others, meanwhile, can appear well-adjusted in the immediate aftermath of a loss but experience grief later in life as they encounter new stressors or reach new developmental milestones (Klass et al., 1996). In addition, prolonged negative emotions are more likely to endure when the nature of grief is complicated. Shear and Mulhare (2008) define complicated grief as a state in which acute grief is extended and accompanied by complicating thoughts, behaviors, and emotional dysregulation. Complicated grief may follow an anticipatory loss such as a terminal illness or a sudden traumatic death (Mannarino & Cohen 2011).

In general, the death of a loved one may inhibit the child's sense of autonomy and evoke feelings of powerlessness (Zambelli et al., 1994). It is essential for bereaved children to feel reassured that their physical and emotional needs will continue to be met after a death has occurred (Pearlman et al., 2010; Silverman, 2000).

Role of Parenting in Childhood Grief

Family dynamics and the quality of relationship between child and caregiver, along with the child's personality and coping skills, will further determine the grieving process (Corr & Balk, 2010; Pearlman et al., 2010). With help from their families, most children are able to integrate the painful experience of loss into their lives. However, they do not always receive this necessary support.

Bowlby (1979) details the common experience of children who, despite being aware of their loss, are somewhat unintentionally made to believe that their perceptions are invalid. This can lead to the creation of a painful experience for children who do not feel safe to express their grief. Bowlby (1979) observed that all too often, in an attempt to conform to the parent's wishes to protect the child from difficult truths, children repress impressions they know to be true; in turn, this results in an "inhibition of their curiosity, distrust of their own senses and tendency to find everything unreal" (p. 405).

Culture can also hold a significant influence within family dynamics and parenting styles. Danieli et al. (2015) found that when distressed, immigrant parents may adopt a numb or avoidant style, characterized by "pervasive silence and depletion of all emotions, [with] minimal tolerance to stimuli" (p. 168). This isolation and detachment are often accompanied by a conspiracy of silence, in which traumatic experiences are never discussed (Danieli et al., 2015; Danieli, Norris, & Engdahl, 2017).

Since the child's ability to overcome trauma and mourn is dependent on the presence of an authentic, emotionally available and encouraging adult who is able to tolerate the child's behavior and feelings (van der Kolk, 1996; Wolfelt, 1983), treatment may be necessary for children confronted by chronic familial distress or emotional withholding.

Art Therapy and Grief

In art therapy, most children engage in the playful and gratifying qualities integral to the modality while finding relief in being able to express themselves creatively (Goodman, 2005; Kramer, 1993; Lister et al., 2008 Worden, 2009; Zambelli et al., 1994). In addition to self-expression, the making of symbols or images can foster communication of both conscious and unconscious thoughts, feelings, and self-narratives, providing access into the child's internal and hidden world.

Research shows that grieving children who are given the opportunity to express their emotions through creative approaches in art therapy exhibit significant improvement

in their affect and overall functioning (Hill & Lineweaver, 2016; Zambelli et al., 1994). Sitzer and Stockwell (2015) note that because children are inclined to present with silence or oppositional behavior after trauma has occurred, verbal prompts may elicit stress, confusion, and be perceived as prying. As such, visual directives that promote emotional awareness and foster self-expression allow for the child to engage in necessary grief work in a paced and safe manner.

Grief as understood through the Dual Process and Meaning Reconstruction Models appears particularly suited to art therapy interventions. The regulating benefits of this creative modality can serve to support the fluctuating nature of the grieving process as espoused by the Dual Process Model; this holds no truer than with children, who by developmental necessity tend to oscillate like a pendulum. Similarly, Neimeyer, Baldwin and Gillies, 2006, proponents of the Meaning Reconstruction Model, argued that while some children coping with loss are able to identify and express their feelings and thoughts, others encounter great difficulty. Art-making prevails where words are not sufficient in expressing overwhelmingly painful emotions, and so "provides a way of remaking the self after a loss through exploring, expressing, and transforming feelings into visual images" (Malchiodi, 2007, p. 149). Art therapists informed by both models can spontaneously engage children in creative exploration of loss and restoration, promote self-regulation, and foster meaning making through expressive art, dramatic play, and child-led storytelling (Lister et al., 2008).

Case Vignette

Background Information

I am a senior art therapist working for a not-for-profit organization serving inner-city children in educational settings. It is in this capacity that I met siblings Annie and Harry, following their referral to the art therapy program offered at their elementary school. Annie was a ten-year-old girl in fifth grade with flat affect who appeared very shy. Meanwhile, Harry, a seven-year-old boy in second grade, presented as hyperactive, anxious, and disorganized. He was reported to have developed enuresis and was experiencing behavioral issues in class. Annie and Harry were Chinese and, along with their parents, immigrated to the U.S. from China when they were young. Throughout the entirety of their childhood, their mother had been fighting a 12-year-long battle with cancer. Art therapy services were recommended as a means of processing this significant illness.

In speaking with Annie and Harry's parents during an initial meeting, it was revealed that their mother's cancer had recently metastasized to her bones and brain. Her illness had become terminal. When sharing this information, their mother, Lifen, and father, Zhou, appeared to avoid directly addressing Lifen's diagnosis; rather, they directed discussion to her search for alternative treatment in China.

Lifen and Zhou explained that Annie and Harry had never been explicitly told about their mother's cancer or its progression and had avoided questions posed by the siblings while attempting to conceal their struggle from the children's school. They admitted that, despite a desire to protect Annie and Harry from the painful knowledge of the illness, hurtful words had been directed toward them in moments of stress and despair; at times, it had been stated that the children's poor behavior would directly impact the health of their mother. This led Harry to become anxious while Annie immersed herself in schoolwork as a way to cope. The parents also shared that additional responsibilities

and added pressure to succeed in school had been placed on the children during this trying time. Despite a lack of clear communication within the family unit, it was apparent that each member was absorbing the effects of this looming loss.

Both parents were encouraged to speak openly with Annie and Harry about Lifen's cancer and to support their children's emotional response. They were also urged to consider the impact of hurtful language on their children's self-esteem and well-being. Family art therapy sessions, in conjunction with individual art therapy for both Annie and Harry, were put in place as a means of providing an opportunity to acknowledge Lifen's illness, enhance communication, repair disruptions, and offer a safe and validating environment for the children to begin relinquishing the parentified roles forced upon them.

Family Art Therapy

In the first family session, the members made clay bead necklaces as a means of crafting tangible objects that would provide comfort in times of distress. Creating art together was intended to engender positive memories, reinforcing the sense of unity and connectedness so desperately missed. With agreement from both parents, a dialogue was facilitated allowing Annie and Harry to express their worries and concerns. Psychoeducation regarding anticipatory grief was also imparted to normalize feelings and to provide a shared language with which to process Lifen's illness.

When Harry's disorganized and self-critical behavior hindered his ability to follow instructions and stay on task during the art-making process, Zhou was redirected away from teasing his son and, instead, encouraged to show Harry his own bead-making technique. In this way, therapeutic interventions became opportunities to model new avenues of support and redirection. The value in this interaction was further reinforced when Harry later shared that he "really liked it when [his] parents help [him]."

In a following mother-daughter session, Lifen and Annie were invited to complete their beads in continued efforts to facilitate communication between parent and child. As they engaged in the art process, I articulated some of the concerns that Annie had expressed in a previous individual session regarding her mother's health. Annie had acknowledged feeling afraid of her mother's illness and avoided thinking about it by reading fiction at home. Lifen was able to listen, empathize, and validate her daughter's feelings. Mother and daughter sobbed and acknowledged the pain of anticipating death from the disease. Before transitioning from the art therapy space, Lifen and Annie were encouraged to release the painful feelings that had arisen in session by squeezing a ball of clay with all of their strength. Passing the clay between one another allowed for symbolic connectivity, while the sensory manipulation of the clay provided containment for their shared anguish.

Annie's Individual Art Therapy

Coping With Anticipatory Grief: Comfort Creatures

A few months into the school year, Annie's mother traveled to China to seek alternative cancer treatment. The move was abrupt, and the children were not offered a chance to say goodbye. In subsequent art therapy sessions, Annie appeared avoidant, presenting constricted affect and relying on superficial art forms. As an attempt to provide her with a sense of control and mastery, I invited Annie to sew a stuffed animal—or "comfort

creature"—to keep her company while her mother was away. Such value was placed on her initial piece that a second creature was sewn for her mother soon after. As treatment progressed, Annie began engaging in spontaneous play with the creatures. She developed a narrative about two sisters, one timid and the other courageous. It was this second sister, brave and optimistic, whom Annie chose to send to her mother in China.

The creation of these comfort creatures and ensuing play allowed Annie to loosen her defenses and gain newly developed agency in the complex relationship with her mother. Robbed of the opportunity to say goodbye to Lifen, Annie was able to create an alternative narrative for the departure. In her tale, Annie enabled the creatures to hug and express love before one was mailed to China, sending her mother strength and hope through her symbolic creature.

First Mother's Day After Loss

Without advance notice, Lifen returned home and died the following day. Annie blushed with anger and became highly anxious if her mother was mentioned in art therapy. In a pivotal session leading up to Mother's Day, Annie was invited to free draw or make personal symbols. Annie responded by depicting a girl's face with a sad expression, partially concealed behind long hair with a deep red streak resembling blood (Figure 24.1).

Figure 24.1 "Girl in Happy Land," 8 × 11, pencil and colored pencils on paper

The girl in the image was without a body and appeared suspended in front of a tombstone. A crown with a superimposed smiley face was placed on her head, its happy symbol an attempt to distract from the wearer's sorrowful appearance. When asked about her drawing, Annie said that she drew a girl in "happy land."

While avoidance was necessary for Annie to be able to cope with her mother's tragic death, it was also exhausting for her to maintain a happy appearance day after day. Art-making allowed Annie the opportunity to externalize the difficult feelings that arose as Mother's Day approached.

TERMINATION: LETTING GO

In anticipation of her upcoming graduation from elementary school, Annie was offered the opportunity to make a "time capsule box" and was given writing prompts encouraging reflection of the year's events. Annie eagerly shared positive memories and processed ambivalent feelings related to change but was quickly triggered when her retrospection turned to the loss of her mother. In response to her reaction, I suggested the creation of a memorial to place within the capsule. Included in this commemorative project was a poem for Annie's mother, compiled from cut-out words in magazines. During its creation, Annie cried and appeared to feel safe as she shared her pain. After reading the poem out loud, Annie placed it in her time capsule along with photos of her and her mother making art together during a family session.

Poem for Annie's Mom:

I tried to overcome sadness, tears and sorrow.
I lost my mom. I lost my family. It changed.
It was like climbing a mountain. There was darkness and worries about the future.
Collapse.
I am honoring the life of my mom.
With time I will heal. I will survive and recover.
I am letting go.
I will always have love.

Harry's Individual Art Therapy

COPING WITH ANTICIPATORY GRIEF

In our first meeting, Harry shared that he feared his mother would die, negating his parents' claim that he was unaware of his mother's illness. Unlike his sister's withdrawn presentation, he appeared disheveled, hyperactive and anxious and assumed a consistent look of confusion. Initially, Harry was rejecting and critical of both himself and me, stating that he was "stupid" and "messed up in the head" while simultaneously attributing feelings of anger and boredom to the art therapy experience. Eventually, Harry became absorbed in mixing modeling clay, utilizing the physical process to release his anxious and aggressive energy.

After taking notice of a feelings chart on the wall, Harry grew interested in identifying the various emotions it depicted. With some support, he was able to reveal the ones that resonated with him: "helpless," "confused," "angry," and "isolated." Over time, Harry began to identify his emotional state with increased comfort, returning to the feelings

chart at the start and close of each session. By the sixth session, Harry's growing ability to safely identify and verbally express difficult emotions had led to a significant decrease in hyperactive and disorganized behaviors.

FEELING IDENTIFICATION: FEELING BODY MAP AND MANDALA

To support Harry's emotional awareness, he was encouraged to map the feelings he frequently experienced onto a drawn body outline. He appeared calm in doing so and, following its completion, spontaneously shared that his mother had told him she was sick because she had given birth to him. The grounding activity enabled him to verbalize this wounding declaration and process the ways her words had hurt him.

The following session, Harry drew a robot floating in the sky with the intention of launching into space. The figure was trapped by a cloud of bats and seemed to signify a sense of impending doom. He added a "mother bat" to the colony and wrote the words "I am searching." The drawing appeared to illustrate Harry's desire for a nurturing mother figure while feeling surrounded by threats.

Harry shared that the robot felt "ignored," "frustrated," and "cheated," quickly connecting those words to his own emotional experience when witnessing his parents' arguments. Harry then asked if it was okay to cry, sharing that his father had told him crying was unhealthy. This opportunity for contained free drawing had allowed Harry to externalize overwhelming emotions and painful experiences while receiving the acceptance he so desperately sought.

THE HURRICANE AND WINDING ROAD

When Harry shared that his mom had unexpectedly returned home, he appeared dysregulated and anxious as he paced around the room. He created an expressive painting comprised of energetic brownish red and gray strokes that underwent multiple transformations. Similar to his use of modeling clay in the first weeks of treatment, the act of mixing colors supported Harry in being able to self-regulate and promoted regression in service of the ego. He reflected that it looked like a "winding road" or a "hurricane," adding that hurricanes are spinning and dangerous. Harry's spontaneous choice to paint served him in being able to communicate a sense of chaos and threat related to his mother's sudden return and the innate knowledge of her impending death.

"MY MOM IS IN HEAVEN"

Harry looked scared and confused at the start of our session following his mother's passing. He denied these feelings, however, and we sat together for a while in silence. Harry had experienced little control in his mother's departure, return, and death; it was important that he retain the right to share this intimate news. I eventually observed, "I sense that something is bothering you," to which Harry replied that his father had revealed that his mother "was in heaven." I told him I was saddened to hear that she had passed away and affirmed the love that Harry and his mother had shared.

When I offered permission for his grief by saying, "It's okay to be sad and to cry," he began to cry. To support his ability to self-soothe, I asked Harry to assist me in mixing watercolors. He began releasing the liquid paint into a bowl of clear water using a pipette, and we watched together as the tear-like drops dispersed. When I saw Harry in

the hallway later that day, rather than addressing me with his typical puzzled expression, he said "hello" with a smile.

Processing Grief

The sense of trust and security fostered in the therapeutic relationship prior to Lifen's death allowed Harry to be open and expressive in the weeks following this significant loss. After his mother's funeral, Harry engaged in drawing and painting projects that supported him in externalizing a range of emotions, including aggression. In one particular session, Harry drew an explosive volcano erupting inside of his body, seeming to convey embodied anger and a sense of chaos (Figure 24.2). This poignant image prompted Harry to share his father's view that there was "nothing" after death and disclose that he wanted to die. Harry's safety was assessed in session and a contract was co-created to keep him safe. Prompted by his mother's Buddhist funeral ceremony coupled with his father's denial of the existence of God, Harry began to explore his own beliefs regarding religion and the afterlife. He read biblical stories at home and asked many questions about heaven and hell in our sessions. During this time of reflection and grieving, Harry returned to a previous state of internalized anger and disorganization, revealed in his chaotic depiction of a boy wearing a jetpack, which appeared to be imploding from within.

In conversation within sessions, Harry struggled to find positive traits and memories associated with his mother. I reminded him of their family art therapy session and shared the encouraging words that Lifen had spoken about him. Harry stated that he was convinced his mother was in hell and had been punished because "she did not try to get better," later revealing that his father had cited her refusal to "take chemicals." In reinforcing that his mother did not become ill because she was bad, I explained that her

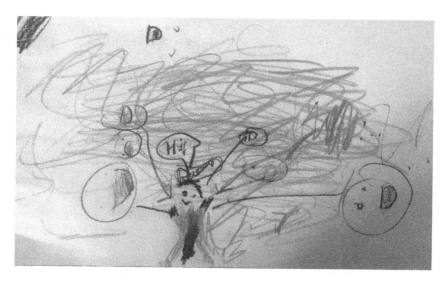

Figure 24.2 "Untitled," 8 × 11, colored pencils on paper

decision to avoid chemotherapy was made because the medicine would have caused her to become too sick to say goodbye. Presenting Harry with a different narrative than the one he had heard at home allowed him to mourn the fond memories he so deeply held.

In his final session before summer break, Harry accepted the suggestion of making a memorial for his mother. He created a poem using the letters of her name and affixed it to a glass heart layered with tissue paper. When held up to the light, the heart resembled a stained-glass window. Following its completion, Harry declared that he no longer thought his mother was in hell and shared that he knew she was not a bad person.

> *Lost*
> *Is nice*
> *Floating in heaven*
> *Every time I say something you know what I am mean. You understand me.*
> *Nice woman who gave birth to me.*

CONTINUED TREATMENT

Harry did not receive support services over the summer and was regressed when he returned to school. Upon resuming art therapy treatment, Harry began engaging in dramatic play with a handmade puppet who appeared to be a self-projection. In one session, Harry shared that his puppet was being visited by a ghost and made a drawing of the haunting.

I gifted the puppet a tea light candle for protection, and Harry was empowered to provide further safety by placing a blanket over the puppet. This "haunting" theme became prevalent in Harry's drawings as well. A penciled image of his deceased mother lying in a coffin with outstretched arms facilitated verbal disclosure of Harry's fear of zombies and revealed a poignant sense of unresolved grief.

Harry's ability to externalize his pain signified the process of separation from his deceased mother and the space to make new meaning.

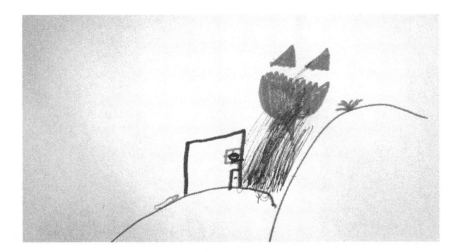

Figure 24.3 "Untitled," 8 × 11, pencil and markers on paper

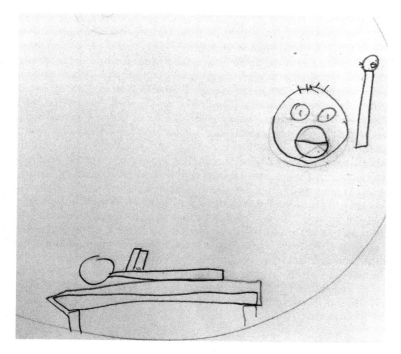

Figure 24.4 "Untitled," 8 × 11, pencil on paper

Following the creation of these drawings, Harry expressed his wish for an "angel ghost to watch over him." The delineation of these two states illustrated the polarity Harry experienced as he tried to incorporate both good and bad constructs of his mother. This ultimately allowed for a reformed narrative of his mother as a guardian "angel ghost" rather than a frightening zombie. Harry began verbally sharing his grief with increased frequency; speaking these feelings aloud enabled him to gain a sense of control in his own body, and he eventually stopped wetting his bed.

In ongoing sessions, Harry continued to process feelings of loss and anger surrounding his mother's death while deciphering the ways in which his father's pain had impacted his own. Harry became increasingly willing to tolerate verbal exploration of his feelings and eventually began attending group art therapy where he negotiated peer relationships and a desire for positive social bonds.

Discussion

Cultural Considerations

Stigma related to mental health services and ambivalence about soliciting help, as well as a general lack of affordable, accessible, and quality mental health resources within the community, had previously prevented Harry, Annie, and their parents from receiving appropriate support in dealing with their looming loss. Conveniently offered within the school setting, and often an effective treatment modality for those resistant to traditional

verbal methods, art therapy was perceived to be an accessible and approachable form of treatment. Furthermore, Lifen and Zhou appeared to value the opportunity for creative expression as a source of joy for both children.

Like many first-generation Chinese immigrants (Koo, Tin, Koo, & Lee, 2006), Lifen and Zhou were accustomed to suppressing their feelings and viewed their misfortune as a source of family shame. Promoting emotional catharsis alone in treatment would have been detrimental for a disconnected family in crisis. Research indicates that offering a sense of control is necessary to family grief work, especially for Chinese immigrants who are taught to restrain their emotions (Chan & Chow, 2006). Chan and Chow (2006) further explain that because feelings are often painted somatically in Chinese culture, it is helpful to stay in the metaphor by applying projective means like art-making to explore emotions in therapy. In our initial family session, for example, the shared act of beadmaking encouraged supportive interactions between family members while allowing for a sense of control and mastery through its creative and symbolic process.

The family's chronic conflict, along with their deep roots in Chinese culture, were important aspects to consider when engaging the children and family in treatment. In order to navigate the divergence in religious beliefs between Harry and Annie's parents, as well as between their Western and Eastern cultural influences, I encouraged the siblings to speak about their understanding of different belief systems and invited them to share their thoughts and impressions. Being curious and promoting a non-judgmental space for them to reflect freely was key in maintaining a culturally sensitive approach to treatment (Rosenblatt, 2008).

Processing Grief in Art Therapy

In the aftermath of a significant loss, children can begin to feel less secure in their environment and within themselves. Bereaved children may pass through a variety of intense and often overwhelming emotions, seeking external supports in their efforts to self-regulate (Corr & Balk, 2010; Pearlman et al., 2010; Wolfenstein, 1966). The self-soothing construction of Annie's comfort creature offered her a sense of safety; meanwhile, the physical process of mixing modeling clay and paint provided a containing release of Harry's anxiety and aggression. In both instances, art therapy interventions were aimed to alleviate stress and promote a sense of control and mastery.

Children are often seen to oscillate between avoidance and confrontation of their grief, as outlined by the Dual-Process Model (Stroebe and Schut, 2010). Providing a nonverbal and visual language for loss and trauma, art therapy allows young grievers to process their pain through the safety of this projective modality. Ultimately, this self-paced exploration can encourage and result in the verbalization of feelings.

For instance, Annie's drawing of a young girl in "happy land" suspended near a tombstone served as an expression of masked grief. Similarly, Harry's painting of a hurricane and winding road communicated feelings of chaos and fear in the days leading to his mother's death. Opportunities to externalize grief in this client-led manner supported the siblings' eventual capacity to verbalize their emotions through poetry.

Making sense of a loss and finding meaning within the experience of grief are central goals to the bereavement process, as recognized by the Meaning Reconstruction Model (Gillies & Neimeyer, 2006). Such growth and understanding can be fostered through creative approaches in art therapy, permitting the manipulation of existing narratives and creation of new ones. Annie's ability to stage a story in which her comfort creatures hugged farewell gave her the loving goodbye she herself was unable to receive. Likewise,

only in exploring the haunting existence of ghouls and zombies was Harry able to positively reframe his mother's spirit as an "angel ghost watching over me." These explorations of alternative realities through art-making and play allowed for a maintained, and perhaps strengthened, bond to the mother they so deeply missed.

Exploration of Grief in the Therapeutic Relationship

The therapeutic relationship developed within the sibling's art therapy treatment provided a validating space required for their oscillation of grief and exploration of loss. In containing Harry and Annie's fluctuating emotions and bearing witness to their suffering, I offered reflections without judgment while remaining present and attuned to their needs (Back, Bauer-Wu, Rushton, & Halifax, 2009). By allowing for Harry's initial resistance, demonstrated through his early critical assessments of the art therapy experience and myself, safety and acceptance was communicated: while he might reject me, I would not do so to him. Eventually, this dynamic encouraged a decrease in Harry's defensive posturing and led him to find control within the space and within himself.

Throughout treatment, I continued to foster this sense of control. As both Harry and Annie had experienced little power through their mother's illness and her death, it was vital to let them determine the content and manner of that which was shared in session. In this self-paced process, the siblings learned that it was safe to express emotions and gradually began externalizing their grief.

As Harry became increasingly comfortable in verbalizing his experience of loss, he expressed curiosity about death and engaged in a developmentally appropriate search for meaning. The trust established within the therapeutic relationship allowed for the opportunity to reconstruct the narrative surrounding Lifen's departure, which supported Harry and Annie in being able to make sense of her illness and, ultimately, her death.

Countertransference

Those who engage in grief work can serve as "wounded healers," denoting the way by which a therapist's personal history with loss can inform treatment and enhance empathy (Hayes, Yeh, & Eisenberg, 2007). When working with bereaved youth, however, continued examination of one's own countertransferential reactions within treatment is essential to minimize overidentification and maintain appropriate boundaries (Hayes et al., 2007). Talking through difficult cases with a supervisor or a colleague helps the clinician to recognize countertransferential issues and validates their work. In addition, it is important to remain self-aware and practice regular self-care to combat compassion fatigue.

During the course of Annie and Harry's treatment, I discovered a strong need to organize the art supplies after each session. The effort in holding the siblings' chaotic and fragmented emotional experience often left me feeling helpless and destabilized. As such, the process of organizing became a conscious ritual and grounding support.

Furthermore, the artwork created in session would often evoke in me a deep sadness, and I recognized within myself a sense of relief whenever their creative expression instead offered respite. Seeming to echo Annie and Harry's process, I experienced my own need to regulate or oscillate in order to rebuild and recharge while engaging in their profound grief work. I questioned whether I was joining in my clients' avoidance as a response to the intensity of the work or rather acting with clinical intent in allowing the siblings to dictate the pace of their treatment. Regardless of my impulse toward

avoidance, however, I remained cognizant of the moments in which space for direct dialogue surrounding their grief and loss was needed.

Recommendations

The following treatment considerations were found to be effective in this clinical encounter, as art therapy treatment served to mitigate the tensions of both confronting and avoiding the complex grief following parental death.

Structure and Containment

Creating a sense of structure and containment is critical in the beginning stages of treatment, particularly for bereaved children who may not be accustomed to expressing and sharing their emotions. Setting up a predictable routine at the start of the session, such as a quick drawing of the "here and now" in a personal sketchbook or a discussion about emotions using a feelings chart, will promote a sense of safety and predictability. Similarly, identifying plans for the following session while engaging in cleanup activities allows for closure and further investment. To accommodate avoidance, invite the child to illustrate embodied emotions by using color to represent feelings inside of a human figure. For a child who is hyperactive, the physical and product-driven process of using clay molds to create relief sculptures provides a sense of mastery and control. Furthermore, stampers or textured objects pressed into polymer clay form imprints made permanent through baking to suggest a sense of constancy. These types of process-oriented directives are non-threatening and can support a young client in establishing feelings of agency within the art therapy experience.

Affect Regulation

Being well attuned, flexible, and undemanding honors the grieving child's need for treatment to progress at a safe and comfortable pace. This process can take time—time

Figure 24.5 "Windows Book," 7 × 9, watercolor crayons, watercolors, and pencil on bound paper

afforded, in the case of Harry and Annie, through school-based art therapy interventions. The therapist must accept the child as he or she oscillates between the confronting and avoidant pursuits central to the bereavement process. Bereaved children experience a myriad of intense and overwhelming feelings, but when they are supported in being able to identify, communicate, and externalize their grief, they become better able to manage complex emotions. Applying creative interventions in order to support emotional identification and expression should be tailored individually to each child.

When he was flooded with emotion, Harry found the process of mixing colors self-soothing. Additionally, Harry was invited to create "paint factory" color swatches in his sketchbook. He labeled the various swatches to correspond with his affect, using this intervention to self-regulate when transitioning to or from his session. When Harry was motivated to free draw in his sketchbook, he scribbled and mixed colors in a regressive manner. To contain and validate these expressions, squares were cut out from inside of the sketchbook.

Exposing different layers of color and scribbles, the squares functioned as windows into his drawings. This intervention supported Harry's ability to regulate what he chose to reveal and what would remain hidden.

To better equip children with the tools to express repressed emotions, provisions for safety and opportunities for mastery are needed. Examples include:

- Stenciling, cutting, and sewing tactile fabrics in the creation of stuffed creatures to help soothe and comfort.
- Mixing paint colors to create and label "paint factory" swatches as a means of regulating emotions.
- Providing a battery-operated tea light to light up a safe space, fostering a sense of control in the presence of terrorized feelings.
- Sculpting and marbling polymer clay into worry stones or beads to promote grounding and mindfulness.

Family Support

Coaching caregivers on the ways to facilitate difficult conversations with their children is important during a period of family bereavement. Supporting caregivers by providing psychoeducation and working with the entire family in conjunction with individual therapy can improve communication between children and caregivers. This also includes providing resources for bereaved caregivers to better cope with their own grief, enabling them in turn to be emotionally present for their children.

Honoring Special Memories

As a method of honoring the deceased loved one, a symbolic memorial can give meaning to the life experience and allow for exploration of emotions related to the loss. Documenting significant moments with the deceased by creating a memory book or box, decorating a picture frame to hold a photograph of the loved one, or writing a poem are all effective interventions that can be facilitated with a grieving child or family. In cases of more complicated grief, the creation of a memorial might be a difficult and triggering task. Children like Harry and Annie may require support in finding something positive and meaningful to represent the complex bond with the departed loved one.

Grieving children may also seek a less concrete means of honoring the deceased. At Harry's request, common family routines such as sweeping the floor and dialogues about family trips became integrated into sessions as he processed what he missed most about moments shared with his mother. These interventions can result in less tangible yet equally poignant commemorations of the lost loved one.

Conclusion

"It is in *showing*, rather than the *telling*, that children can explore their understanding of life, death, grieving, and surviving."

(Fry, 2000 p. 126)

In working with Annie and Harry, it became quickly apparent that the tragic loss of their mother, coupled with a history of relational trauma, was an experience too difficult to access through verbal means alone. Important considerations throughout the length of treatment included the family's ongoing conflict, their shared Chinese identity, and a cultural framework in which topics surrounding death were communicated through metaphor or avoided altogether.

Art therapy appeared to meet the needs of the family by allowing for self-expression through art-making, dramatic play, and child-led narratives, as well as the opportunity to process themes that emerged through the safety of the artistic metaphor. These became pleasurable and effective interventions for Annie and Harry, empowering the siblings to communicate and externalize grief on their own terms. In turn, this process of externalization allowed for unarticulated thoughts and feelings about death to become less frightening and more manageable.

Both Annie and Harry experienced difficulty self-regulating—yet with vastly different presentations: the former was emotionally flooded and unable to function, while the latter was avoidant and appeared well adjusted. The provided materials and semi-structured directives enabled both brother and sister to self-regulate or vacillate between confrontation and avoidance pursuits central to the bereavement process. Simultaneously, the use of imagination to create restorative narratives promoted problem-solving skills and empowered the siblings to make meaning of their lived loss and new reality.

Grief is a journey on which we all must sadly embark; however, when one loses a parent before being afforded the chance to find themselves, the consequences are immeasurably profound. While bearing witness to the grief experience of a bereaved child can seem difficult beyond words, it is in those very moments—beyond words—that strength can be seen and hope can be found. For Annie, Harry, and so many others, the offering of support, safety, and a chance to honor their loved one can inspire growth through the pain of that loss.

References

Archer, J. (1999). *The nature of grief: The evolution and psychology of reactions to loss.* New York, NY: Routledge.

Back, A. L., Bauer-Wu, S. M., Rushton, C. H., & Halifax, J. (2009). Compassionate silence in the patient—clinician encounter: A contemplative approach. *Journal of Palliative Medicine,* *12*(12), 1113–1117. doi:10.1089/jpm.2009.0175

Balk, D. E. (2004). Recovery following bereavement: An examination of the concept. *Death Studies,* *28*(4), 361–374. https://doi.org/10.1080/07481180490432351

Bowlby, J. (1979). On knowing what you are not supposed to know and feeling what you are not supposed to feel. *The Canadian Journal of Psychiatry, 24*(5), 403–408. https://doi.org/10.1177/070674377902400506

Bowlby, J. (1980). *Attachment and loss: Loss, sadness and depression* (Vol. 3). New York, NY: Basic Books.

Chan, C., & Chow, A. (Eds.). (2006). *Death, dying and bereavement: A Hong Kong Chinese experience.* Hong Kong, China: Hong Kong University Press.

Corr, C. A., & Balk, D. E. (2010). *Children's encounters with death, bereavement, and coping.* New York, NY: Springer Publishing.

Danieli, Y., Norris, F. H., & Engdahl, B. (2017). A question of who, not if: Psychological disorders in Holocaust survivors' children. *Psychological Trauma: Theory, Research, Practice, and Policy. 9*(Suppl 1), 98–106. http://dx.doi.org/10.1037/tra0000192

Danieli, Y., Norris, F. H., Lindert, J., Paisner, V., Engdahl, B., & Richter, J. (2015). The Danieli inventory of multigenerational legacies of trauma, part I: Survivors' posttrauma adaptational styles in their children's eyes. *Journal of Psychiatric Research, 68*, 167–175.

Doka, K. J. (Ed.). (2000). *Living with grief: Children, adolescents, and loss.* Washington, DC: Hospice Foundation of America.

Doka, K. J. (2002). Forward. In N. B. Webb (Ed.), *Helping bereaved children: A handbook of practitioners* (2nd ed.). New York, NY: The Guilford Press.

Freud, S. (1957). Mourning and melancholia. In J. Strachey (Ed. & Trans.), *The standard edition of the complete psychological works of Sigmund Freud* (Vol. 14, pp. 237–260). London, England: Hogarth. (Original work published 1917)

Fry, V. (2000). Part of me died too creative strategies for grieving children and adolescents. In K. J. Doka (Eds.), *Living with grief: Children, adolescents, and loss* (pp. 125–137). Washington, DC: Hospice Foundation of America.

Gillies, J., & Neimeyer, R. A. (2006). Loss, grief, and the search for significance: Toward a model of meaning reconstruction in bereavement. *Journal of Constructivist Psychology, 19*, 31–65.

Goodman, R. F. (2005). Art as a component of grief work with children. In N. B. Webb (Ed.), *Helping bereaved children: A handbook of practitioners* (2nd ed., pp. 297–322). New York, NY: The Guilford Press.

Gupta, R. (2011). Death beliefs and practices from an Asian American Hindu perspective. *Death Studies, 35*(3), 244–256.

Hayes, J. A., Yeh, Y., & Eisenberg, A. (2007). Good grief and not-so-good grief: Countertransference in bereavement therapy. *Journal of Clinical Psychology, 63*(4), 345–355. https://doi.org/10.1002/jclp.20353

Hill, K. E., & Lineweaver, T. T. (2016). Improving the short-term affect of grieving children through art. *Art Therapy: Journal of the American Art Therapy Association, 33*(2), 91–98.

Hsu, M. T., Kahn, D. L., Yee, D. H., & Lee, W. L. (2004). Recovery through reconnection: A cultural design for family bereavement in Taiwan. *Death Studies, 28*(8), 761–786. https://doi.org/10.1080/07481180490483391

Kastenbaum, R. (1972, December 23). The kingdom where nobody dies. *Saturday Review of Literature*, 33–38.

Klass, D., Silverman, P. R., & Nickman, S. L. (Eds.). (1996). *Continuing bonds: New understandings of grief.* Washington, DC: Taylor & Francis.

Koo, B., Tin, A., Koo, E., & Lee, S. (2006). When east meets west: Implications for bereavement counselling. In C. Chan & A. Chow (Eds.), *Death, dying and bereavement: A Hong Kong Chinese experience* (pp. 261–272). Hong Kong, China: Hong Kong University Press.

Kramer, E. (1993). *Art therapy with children* (2nd ed.). Chicago, IL: Magnolia Street Publishers.

Kübler-Ross, E. (1969). *On death and dying.* New York, NY: Macmillan.

Lister, S., Pushkar, D., & Connolly, K. (2008). Current bereavement theory: Implications for art therapy practice. *The Arts in Psychotherapy, 35*(4), 245–250. https://doi.org/10.1016/j.aip.2008.06.006

Malchiodi, C. A. (2007). *The art therapy sourcebook* (2nd ed.). New York, NY: McGraw-Hill.

Mannarino, A. P., & Cohen, J. A. (2011). Traumatic loss in children and adolescents. *Journal of Child and Adolescent Trauma, 4*(1), 22–23. https://doi.org/10.1080/19361521.2011.545048

Neimeyer, R. A. (1998). *Lessons of loss: A guide to coping.* New York, NY: McGraw-Hill.

Neimeyer RA, Baldwin SA, & Gillies J. (2006). Continuing bonds and reconstructing meaning: mitigating complications in bereavement. *Death Studies, 30*(8), 715–738. https://doi.org/10.1080/07481180600848322

Neimeyer, R. A., & Burke, L. A. (2017). Spiritual distress and depression in bereavement: A meaning-oriented contribution. *Journal of Rational-Emotive & Cognitive-Behavior Therapy, 35*(1), 38–59. doi:10.1007/s10942-017-0262-6

Pearlman, M. Y., Cloitre, M., & Schwalbe, K. D. (2010). *Grief in childhood: Fundamentals of treatment in clinical practice.* Washington, DC: American Psychological Association.

Rosenblatt, P. (2008). Recovery following bereavement: Metaphor, phenomenology, and culture. *Death Studies, 32*(1), 6–16.

Shear, M. K., & Mulhare, E. (2008). Complicated grief. *Psychiatric Annals, 38*(10), 662–670. Retrieved from http://ezproxy2.library.drexel.edu/login?url=https://search-proquest-com.ezproxy2.library.drexel.edu/docview/217060159?accountid=10559

Silverman, P. (2000). When parents die. In K. J. Doka (Ed.), *Living with grief: Children, adolescents, and loss* (pp. 215–228). Washington, DC: Hospice Foundation of America.

Sitzer, D. L., & Stockwell, A. B. (2015). The art of wellness: A 14-week art therapy program for at-risk youth. *The Arts in Psychotherapy, 45*, 69–81. doi:10.1016/j.aip.2015.05.007

Stroebe, M., & Schut, H. (2010). The dual process model of coping with bereavement: A decade on. *Omega: Journal of Death and Dying, 61*(4), 273–289. https://doi.org/10.2190/OM.61.4.b

van der Kolk, B. (1996). *Traumatic stress: The effects of overwhelming experience on mind, body and society.* New York, NY: The Guilford Press.

Webb, N. B. (Ed.). (2002). *Helping bereaved children: A handbook for practitioners* (2nd ed.). New York, NY: The Guilford Press.

Wolfelt, A. (1983). *Helping children cope with grief.* Muncie, IN: Accelerated Development.

Wolfenstein, M. (1966). How is mourning possible? *The Psychoanalytic Study of the Child, 21*, 93–123.

Worden, W. (2009). *Grief counseling and grief therapy: A handbook for the mental health practitioner.* New York, NY: Springer Publishing.

Zambelli, G. C., Clark, E. J., & de Jong Hodgson, A. (1994). The constructive use of ghost imagery in childhood grief. *The Arts in Psychotherapy, 21*(1), 17–24.

25
Learning From Mistakes in Adolescent Art Therapy

NICOLE BRANDSTRUP, GRETCHEN M. MILLER,
AND JORDAN S. POTASH

In this chapter, we present mistakes we made in adolescent art therapy, share response art created to understand why they occurred, and reflect on the lessons learned. Admitting to making mistakes in professional practice is not easy, but making them is a normal part of the helping service professions—and being human (Cooperberg, 2010; Hazler, 2002). In the course of regular supervision, therapists and art therapists discuss areas of concern, identify obstacles, and determine actions for further learning (Fish, 2016). Therapists generally avoid discussing errors outside of supervision or in public forums. The reasons for such omissions are multifaceted. Acknowledging mistakes may foster a sense of incompetence in the therapist, even though research suggests that doing so benefits the therapeutic alliance (Medau, Jox, & Reiter-Theil, 2013). Making such an admission may lead one's colleagues to doubt one's abilities and competencies. There may be worry that errors may be interpreted as negligent or unethical, which is particularly worrisome as ethical guidelines clearly state that there are consequences for concealing or not reporting ethical violations (AATA, 2013).

By publishing *Bad Therapy: Master Therapists Share Their Worst Failures*, Kottler and Carlson (2003) aimed to create a culture where mistakes could be tolerated and made into educational opportunities. Analyzing the results of 22 accounts of mistakes, they defined bad therapy as "when the client or the therapist is not satisfied with the result, and when that outcome can be traced to the therapist's repeated miscalculations, misjudgments, or mistakes" (p. 198). In order to make this conception more relevant to the unique features of art therapy, we view *bad art therapy* as art therapy that stagnates or fails as a result of when the art therapist:

- Misdirects art-making in a way that does not foster growth.
- Fails to maintain a safe studio environment.
- Taints the creative process, intervention, and interpretation of images with unresolved countertransference and unchecked assumptions.
- Disregards the creative process as a source of renewal, reflection, and reconnection.

There are several possible and unintended consequences of failing to share our professional mistakes as art therapists. The first is that ignoring mistakes perpetuates the idea of the perfect art therapist. Second, it fosters a culture of silence regarding our failings—a

stance that can be intimidating to students, new professionals, and even seasoned practitioners. Third, it inhibits creativity in planning interventions by making published case studies appear as pre-determined recipes, rather than as references. Further, it denies the healthy process of reviewing one's work, finding errors, discovering sources of the mistake, and becoming aware of alternative courses that others in the field can benefit from in their own development. Just as we expect clients to openly admit to mistakes in order to learn from them, so can we as professionals benefit from discussing ours.

Adolescent art therapy, in particular, presents many chances for clinicians to make mistakes from the initial meeting through the working stages (Price & Margerum, 2000). Such mistakes may derive from the intersection of adolescent developmental tasks, the adolescents' abilities to arouse evocative emotions in adults, and therapists unresolved adolescent issues (Rasic, 2010). Art therapists working with adolescents may find themselves reacting to their clients' defensiveness and challenges to authority, rather than addressing inferiority and doubt that arise in response to adolescent developmental stressors (Moon, 2012). All of these factors can impede the therapeutic alliance and in turn have negative consequences for treatment (de Haan, Boon, de Jong, Geluk, & Vermeiran, 2014; Hawley & Garland, 2008). The additional role of creativity and art-making, while offering much needed outlets for adolescents, also introduce their own opportunities for error in areas such as studio management, use of art materials, choice of directives, and interpretation. However, these potentialities are rarely recorded in the art therapy literature, especially in recent years. In writing on her countertransference with an artistically talented teenager, Klorer (1993) recounted how the gratification she received at seeing her client's developing talent prevented her in remaining attentive to his therapeutic needs. Riley (1999) dedicated an entire chapter in her book to "getting tangled up in adolescent treatment" (p. 218) and reflected on how she was not immune to the difficulties, doubts, and mistakes that work with adolescents can bring. Rather than privately learn from their mistakes to the benefit of their clients, both Klorer and Riley's public sharing offers all of us examples of cautionary tales, challenges of being an art therapist, and the growth that occurs from purposeful introspection.

In order to accept Kottler and Carlson's (2003) charge while also staying focused on unique aspects of art therapy, we each chose to focus on a mistake reflected in a different aspect of our work: managing materials, offering directives, and making interpretations. To enrich our learning, we created two pieces of response art: one on the mistake and the other on the lesson derived from it. Art therapists have encouraged creating response art for professional development to document countertransference (Fish, 2012; Moon, 2012); enhance therapeutic relationships (Franklin, 2010; Moon, 2009); and challenge biases related to racial, social, and cultural differences (Coseo, 1997). This self-reflective process enables art therapists to increase their self-awareness and develop their professional practice.

Mistakes in Managing the Art Studio—Nicole Brandstrup MA[2], LPCC, ATR-BC

At the end of an art therapy group in a locked community correctional facility for juvenile felony offenders, all of the young men participated in cleaning the studio. It was during this process that I noticed one pair of scissors was missing. Initially, I tried finding the scissors on my own after the group left the room. When I came up empty handed, I reported the incident due to the high security stakes. After the entire art room had been dismantled, all 44 males patted down, each adolescents' room searched, and

the rest of the building inspected, the scissors appeared in the collage box that both my colleague and I had already each checked. As a consequence for mishandling the scissors, I temporarily prohibited the group's use of scissors as it seemed that they could not be trusted.

Understanding the Mistake

After the scissors were found, I knew only part of my mistake had been corrected.

Working in a correctional facility demands safety and security be of the utmost importance. Art therapy necessitates vigilance, attention, and care for supplies—especially potentially dangerous ones. On the surface of this mistake, it is clear that I violated all three of Moon's (2012) principles for the adolescent art therapy studio: "1. The studio must be safe. 2. The studio must be predictable. 3. The studio must focus on making art in the service of establishing of relationships" (p. 148–9).

As my response art shows (Figure 25.1), I was trapped in a singularly, unwavering focus on the scissors that blocked my ability to see the incident from any other perspectives. Initially following the incident, I was angry at the residents for not taking good care of the supplies and turning everything in as I had asked them to do. I thought,

Figure 25.1 Nicole's mistake

"How could they do this to me?" I wanted to believe that the adolescents respected art therapy, the studio, the art materials, and me. I wanted to believe that the residents would not harm me or my professionalism. I wanted to believe that I mattered and art therapy mattered. Yet, that was not the core of the mistake. Looking back, it was easy to manipulate the story and trick myself into believing it was someone else's fault. The trap I created for myself lasted until I saw how I caused the incident.

Reflecting on the moments while searching on my hands and knees in the studio and at many other moments in the following days, I recognized that I felt extremely power-less. Showing oneself as an authority in adolescent therapy is recognized as one of the struggles for adolescent therapists (Sommers-Flanagan & Bequette, 2013). By not recog-nizing this aspect of the work, both physical and psychological safety in the therapeutic milieu become compromised. Therapists and clients may co-construct the relationship to allow for meaningful therapeutic expression, but it is the therapist's responsibility to ensure a safe setting for emotional expression (de Haan et al., 2014). Within art therapy, this is incredibly important as the studio environment itself must be physically safe in order to function as a container for creative exploration (Moon, 2012).

In truth, I was lax managing the scissors and did not follow proper procedures of sign-ing them in and out. I created an opportunity for the scissors to go missing and the result-ing stress and inconvenience for the entire agency. By unjustly prohibiting the group's future use of scissors on the premise that they could not be trusted, I compromised the therapeutic relationship by blaming the adolescents instead of taking responsibility for my part in the incident. My embarrassment was furthered when I saw how I closed myself off to feedback from colleagues about how to better manage the art materials. In retrospect, my arrogance perpetuated the error and limited my ability to make a sincere amends to those involved. By taking this stance, I was not respecting the art materials, studio, ado-lescents, or colleagues. In actuality, I was the one who used the art materials as a weapon.

Learning From the Mistake

I learned that managing supplies is much more than just counting and keeping an accu-rate inventory. Just as important is the level of respect and responsibility I communicate to the adolescents and my colleagues by how I offer, use, and care for the art materials. I learned that the adolescents I work with will only go as far as I allow them to go. They watch how I manage and respect the art materials in the art therapy studio. What I model communicates to the adolescents the level of physical and psychological safety present in the art therapy studio and if it is safe enough to take the risk to express their thoughts and feelings. My decisions and actions also communicate to my colleagues the degree of value I give my professional work. After all, the art materials are the very tools that make art therapy unique; they create a one-of-a-kind language for the adolescents to speak what is deep inside their hearts and minds.

Beyond studio management, that day I learned an intimate lesson about humility, empathy, and forgiveness. I wondered, "Is this similar to how the adolescents have felt when they have gotten into trouble in the past?" Do they look back at their choices and actions and ask, "If only I made a different decision." Suspending judgment and actively listening to myself and my art created space for me to see the similarities I share with the adolescents. Taking time to reflect on my mistake helped me learn these lessons. More so, it helped me to switch from focusing on myself to focusing on my clients. I decided to create a container to hold the lessons I learned about the management of studio sup-plies and myself (Figure 25.2). The box is covered in individual pictures of scissors with

Figure 25.2 Nicole's lesson

a ticket that says "admit one" as a reminder that I, as the art therapist, must be present, alert, and accountable for the management of the studio supplies in order to support the well-being of each adolescent in the group. The inside of the box reflects the shift I experienced from the dark emotions of my mistake to a calmer space once I sought out response art and supervision. As a result, I was able to increase empathy toward the adolescents by understanding the inner turmoil they often feel. Just like the adolescents, it was hard for me take in feedback that is true and hard to hear. It was also difficult to ask for help even when hiding seems like a good option.

Mistakes in Planning Art Interventions—Gretchen M. Miller, MA, ATR-BC, ACTP

This mistake is from an art therapy group with adolescent girls in a residential treatment program. I had thought it would be appropriate to introduce a directive about strengths, adapted from an art directive designed by Cohen, Barnes, and Rankin (1995). My intention was to use this as an opportunity to begin exploring concepts related to self-worth and resiliency, while supporting the group toward engaging in positive, healthy interactions with one another. These areas posed challenging for group members and were reflected in their outlined treatment goals. I thought the art task would be a refreshing and welcomed perspective to focus on the positive versus the negative labels or messages the girls were frequently delivering and/or receiving.

The session included creating two-dimensional paper stepping stones representing various strengths and to draw or collage a path of these strengths. The group immediately showed resistance after hearing the directive. Most of the girls verbalized they did not

feel comfortable identifying "good things" about themselves or how to identify a single strength, let alone a pathway created from many. Challenging the task or participation was common for these adolescents who were mandated to attend art therapy group. However, this time I felt uncertain how to navigate the group's oppositional reaction as the anxieties and frustration in the space (both the clients' and my own) were evident. Thoughts of abandoning my task and doing something completely different crossed my mind under the pressure of the opposition. I also considered what kind of message this would communicate about me as the facilitator and the issues related to power, control, and authority. Instead of giving up on the directive entirely, I was able to slightly stabilize and shift the energy of the group through inviting the girls to identify and create strengths they saw in one another, rather than finding and naming strengths for themselves. This adjustment appeared to bring some resolution, as it helped put some comfortable distance on the personal self-reflection. Some of the girls were able to engage with this change while other girls still would not participate and continued to display their opposition.

Understanding the Mistake

I identified three components that contributed to my mistakes: 1) failing to see the task in light of trauma-informed work, 2) not meeting the safety needs of clients with trauma, and 3) making the assumption that the strength-based task I planned and attempted to implement would best address the clients' needs.

These components were further influenced by the residential program milieu: a highly structured treatment design for these at-risk adolescent females. The residential treatment program's theoretical approach was rooted in cognitive and behavioral theory, often focusing on level systems and behavior modification to help manage disruptive behaviors, reinforce accountability, award "good" behavior, and affect positive decision making. However, there was an assumption that the adolescent needed to fit into this milieu, rather than the milieu fitting to the needs of the adolescent. According to Steele (2009), this stance does not provide the safety needed for traumatized youth and often results in the youth and their behavior being perceived as *problematic* when, instead, their trauma has been re-triggered by the environment.

In addition to concerns over power dynamics and a desire to focus on strengths, the task I chose did not support the underlying true need of this group. The task I was offering did not support sensory-based, implicit mid-brain development where the work of trauma often begins but instead focused on cognitive work based in the brain's neocortex. In addition, the adolescent brain uses the amygdala, rooted in feeling, instinct, and at the lower part of the brain stem, to process information instead of the brain's cortex that supports thinking, problem solving, and reasoning (Micsak, 2009; Roaten, 2011). My art directive and approach prematurely invited a cerebral approach. Cognitive interventions can be constraining when prompted to explore trauma related content. This part of the brain is often compromised due to trauma and can trigger avoidance reactions (Soma, 2013). My lack of knowledge and understanding of trauma-informed practice, coupled with my own preference to offer structured cognitive-based interventions, contributed to the group's failure.

Learning From the Mistake

To better understand my mistakes, I created response art privately in my home studio in the form of a box to hold a series of mini collages representing my errors

Figure 25.3 Gretchen's mistake

(Figure 25.3). To help process this experience further, I focused on the three components identified above that influenced my mistakes. After creating images for my mistakes and the container to safely hold them, a few weeks later I privately made additional response art, again in my home studio, about the lessons I learned (Figure 25.4). The idea of making an altered book served as a metaphor for transforming something in the past into new purpose and meaning for my current practice as an art therapist.

My primary lesson included gaining awareness about client needs related to trauma, particularly the limitations of cognitive-based interventions and what this approach can trigger. This included understanding my assumptions as the therapist, learning that

Figure 25.4 Gretchen's lesson

I needed to recognize client needs through a trauma-focused lens, and how to manage milieu expectations when working with at-risk adolescents in this setting. Reactions influenced by trauma were missed and instead focused on the manifestations of acting out behaviors. This experience humbled and reminded me to see the adolescent girls I was working with through a different lens that was not just about resistance or responding in opposition. I needed to remember that at the core of what is seen in their challenging behavior was the shattered emotional pieces of unresolved hurt, pain, and suffering from untreated trauma and they did not feel safe. The group's response of heighted arousal state, perceiving threat, and other actions of pushing away was not about the adolescent's need for power and control or rebellion. The response was about protection and survival and revealed my need to learn more about how to provide a better sense of safety for expressing the terror and powerless that the experience of trauma can trigger.

To do this, I needed to become more equipped to not only to treat trauma but become a voice for trauma-informed care and to advocate for youth facing these issues. As a result, I became committed to coursework about trauma and obtained trauma certification to strengthen my practice. This specialized training has provided me with the tools and knowledge to approach my art therapy work from the brain stem up and to be more thoughtful in understanding how to implement sensory-based art interventions before jumping right into cognitive processing.

Mistakes in Interpreting Client Art—Jordan S. Potash, PhD, ATR-BC, REAT, LCAT, LCPAT

While working in a private practice, I worked with a client who was fascinated with the former Soviet Union and the Communist Party. Throughout the two years that we worked together on anger and anxiety, he often picked topics that were socially unconventional, anti-social, or those that went against what he thought were my progressive worldviews. While drawing Stalin, he wanted my opinion on the merits of the dictator. At first, I gave a fairly neutral answer and invited him to share his ideas. Soon I found myself in a political debate on authoritarianism and democracy. When I stated that it could be uncomfortable for him to stay with upsetting feelings, he continued with historical references rather than personal ones. And when he switched the topic to politics, I tried to remind him of our treatment goals. He responded with a controversial view; I responded with the negative effect he was having on our relationship.

After finding myself becoming annoyed and the client becoming more distant, I decided to change the nature of my intervention. I allowed for silence and asked, "So, what are the benefits to being a dictator?" He looked up, seemingly stunned by the question and change in engagement. He told me about the material and sexual benefits of being a dictator and the feeling of power. I asked how his life would be different if he were a dictator. Other than the material and sexual, he told me it would be "just like any ordinary day." I added that it would be a shame not to enjoy those benefits given how much time he spends worrying. He told me that Stalin used to worry all the time. For the rest of the session, we wondered how he might be able to avoid Stalin's emotional fate.

Understanding the Mistake

Although I found a way to adjust my political position in the session, the situation became clearer later on when I privately created response art (Figure 25.5). In this image, the form in the bottom of the drawing symbolizes my client's shifting defenses, like tectonic plates, to protect himself from a more disclosing interaction. In between these defenses there were glimpses to the core of his authentic self. While it would have been easy to blame him, I was reminded that defenses exist for a reason. In this case, they may have been activated by my lack of awareness and insistent questions. For my part, I made the mistake of limiting access to my own internal source of empathy, not responding to him according to his presentation and unintentionally putting up barriers through the unconscious shifting of my own defenses. I literally blocked my ability to see him for who he was at that moment. These obstructions may better be depicted as emerging parts of the self. Schwartz (2003) describes each person as having multiple aspects but that only one can govern at a time. The times Schwartz gets in trouble as a therapist is when his critical part takes control over the empathic one. In this case, several parts of the critical me impeded the therapeutic relationship.

As my political part was triggered, I channeled it by forcing a therapeutic interaction as a way to stop the barrage. Hearing about the glorification of a murderous dictator and other non-progressive events were all difficult for me to endure. In the moment, I had to stay present, rather than use my position to advocate certain political beliefs. My client knew this and used it to derail conversation, observe how I handled anger, and protect himself from emotional expression. Instead of aligning my empathic part with his emotions, I paired my political part with his power part and in effect aligned my protective part with his protective part.

Figure 25.5 Jordan's mistake

In relation to the artist part of me, this client tested my personal ideas about aesthetics. His drawings of repeated stereotypes gave him a sense of mastery and substitute for communication. They protected him from his feelings by acting as both a filter and shield. They allowed him to express anger, frustration, and pain in a contained way while preventing him from feeling insignificant. Admittedly, appreciating stereotypic images in general was one of my ongoing areas of need for professional development. In addition to the actual image, I forgot about the role of metaphor in art therapy as a way to design interventions, observe creative process, and facilitate interpretation. I forgot the core messages that Moon (2012) offers on treating work with adolescents as performance art and on art therapists as *metaphoriticians*. In the multilevels of the image, I was stuck on the content of Stalin, rather than paying attention to the underlying feeling of power and powerlessness driving this particular image.

A final part that came to surface was my personal part. I had not given myself ample time to settle into therapist mode. I was running late for this session after having a disagreement with my spouse. When my client entered in a combative state, I continued to feel under attack due to unresolved issues with my spouse. The harassment I felt from my client only continued an unresolved personal state that fueled my countertransference.

At its core, I became too smug with this client. After two years of working with him, I thought I knew the pattern of his unconventional behaviors and how to work around them. I lost sight of who he was at that moment in time and therefore lost sight of the therapeutic relationship. When I lost this connection, I severed the bridge that connects that helping part of me to the expressive part of him.

Learning From the Mistake

From the second image created as response art (Figure 25.6), I realized that getting in touch with my empathic part allowed me to be a better *metaphoritician*. Instead of remaining as tectonic plates, the images in my picture developed into petals, and I began to see a gradual opening and unfolding, rather than an uncontrollable, unintentional shifting. For this client and for others, I need to be constantly aware of how various aspects of myself either impede or progress the therapeutic relationship.

When I can keep my parts—political, artistic, and personal—in order, there is space to connect with clients, no matter if that receptiveness is expressed overtly or symbolically.

Figure 25.6 Jordan's lesson

Foremost, I was reminded of the importance of honoring the therapeutic relationship. No matter one's theoretical orientation to art therapy, empathy is recognized as a key active ingredient in successful psychotherapy (Dil, Dekker, Van & Schalkwijk, 2016). No amount of skills, techniques, or interventions will matter if the relationship is impaired. My response reminded me of the importance in maintaining a state of openness and active curiosity. This case serves as a reminder to search for metaphors, one of the greatest tools that art therapists working with adolescents have at their disposal.

Discussion

Undertaking this process was informative, insightful, scary, and ultimately beneficial. We learned a great deal about how we admit to, process, and learn from our mistakes. Choosing to publicly admit our mistakes proved to be more difficult than we initially realized as it led to anxiety and self-doubt. Our worry centered on how we perceived our competency as professional art therapists and how our colleagues would view us. Once we were able to put those concerns aside, the process of creating response art allowed us to shed our concerns and emerge with a new sense of self-awareness and humble confidence.

We sought to document various aspects of adolescent art therapy to demonstrate the propensity for errors when using creative processes. Investigating studio management, directives, and interpretations reminded us of important adolescent developmental tasks pertaining to trusting adult relationships, recognizing brain development, and maintaining communication strategies. The response art helped us to see where we failed to recognize these aspects of adolescent art therapy but also pointed to parallels between our reactions and those typically displayed by adolescents such as doubt and defensiveness, both of which can impede relationships.

Doubt revealed itself as a sense of inferiority that perpetuated the mistakes. Brandstrup questioned her ability to manage dangerous materials, Miller was uncertain about designing directives, and Potash wondered about being able to guide accurate interpretations. Failure to address and cope with mistakes can arise from the discomfort therapists experience when feeling inferior. Response art provided a safe format for beginning to explore the sense of inferiority. Further reflection revealed the discrepancy between perception and reality. Sharing our art with each other helped us to identify this common element. As we regained a sense of ourselves and saw how our mistakes occurred, we were renewed in our work with a fresh perspective and a revitalized energy.

Just as adolescents can become defensive when challenged, we too noticed this tendency in ourselves. Brandstrup refused to accept help from her colleagues. Miller aimed to protect her role as an authority. Potash blamed the client for the negative quality of the relationship. Creating response art helped us each to recognize how shame can be a powerful motivator. Like adolescents who are very much influenced by peer perceptions, we found ourselves wanting to assert our viewpoints by attributing these dilemmas to others, such as client negligence or resistance. In essence, passing off responsibility to someone else to avoid personal accountability and judgment. In addition to protecting ourselves, we also felt pressure to safeguard the small profession of art therapy from ridicule or mistrust. Perhaps we were responding to pressures that our individual capabilities would reflect on the greater competency and value of art therapists as mental health professionals.

Learning these lessons increased our own professional development but—and perhaps more importantly—helped us to improve our future therapeutic relationships. At the time of the mistake and perhaps lingering for some time afterward, we wondered

if our clients doubted our abilities to act effectively in their best interest. Mismanaging, misdirecting, and misunderstanding may have diminished our helper role and affected the therapeutic alliance in the eyes of the adolescents. The mask of competence that we try so hard to present was now removed. The errors we describe throughout this chapter were not directly addressed with our clients and in reflection could have offered an opportunity to have a meaningful exchange about mistakes, being human, and foster a sense of reparation (Greenberg, 2016). Admitting our mistake to the youth we were working with could have modeled that it is natural for everyone to make errors, the value of making amends, and how we can all learn from our faults and missteps to improve decision making and better who we are. This acknowledgment could also have been an example to our adolescent clients that the therapeutic space we work in is safe to share their own mistakes and how they can learn from them (Cooperberg, 2010). Choosing to look at our mistakes through response art did increase our sensitivity in approaching our future work with clients and ourselves. Actively exploring these mistakes, rather than ignoring them, demonstrated humility and an opportunity to be better art therapists.

Conclusion

Given the tremendous benefit this process has had on each of us, we hope that it will have a larger effect on our profession. Art therapists can benefit from sharing mishaps and failed experiences alongside triumphs and "perfect" case studies. Sharing the successes only gives a partial picture. In addition to these admissions of missteps and oversights occurring in private supervision, we believe and invite art therapists to publicly share their mistakes and lessons they learned from them in presentations and publications. This can enhance not only individual professional development but also communal professional development. We need to know what does not work and why. We need to know so explicitly, rather than implicitly, by trying to understand what art therapists in our field are also *not* writing about, presenting, or saying.

The benefit of making response art related to our mistakes and the lessons gained reaffirmed the tremendous role that art-making can have as a way of learning, processing, and reflecting on our own professional development. In the busy environments of agency work, engaging in supervision can be a challenge and sometimes devolves into case reporting or program administration needs, rather than a unique opportunity for professional reflection, growth, and development. Personal art-making followed by purposeful reflection can be a supportive supplement to supervision and help manage feelings of burnout. Making art offered a safe venue to explore and manage this anxiety-provoking topic. More so, creating art invoked the artist willingness to address errors creatively—a mindset we can enlist when addressing errors in our professional practice as clinicians. By publicly sharing our process, with its difficulties and successes, we hope that others will be more willing to openly admit to and share their professional failings and, in so doing, discover opportunities for personal and collective growth.

Author's Note: This chapter was adapted from the authors' 2009 panel presentation, Transforming Past Mistakes into Future Lessons: Challenges of Art Therapy with Adolescents at the American Art Therapy Association annual conference in Dallas, TX.

References

American Art Therapy Association. (2013). *Ethical principles for art therapists*. Alexandria, VA. Retrieved from www.americanarttherapyassociation.org/upload/ethicalprinciples.pdf

Cohen, B. M., Barnes, M., & Rankin, A. B. (1995). *Managing traumatic stress through art*. Baltimore, MD: The Sidran Press.

Cooperberg, D. M. (2010). To err is human: Turning our mistakes into useful interventions. In S. S. Fehr (Ed.), *101 interventions in group therapy-revised edition* (pp. 227–331). New York, NY: Routledge.

Coseo, A. (1997). Developing cultural awareness for creative arts therapists. *The Arts in Psychotherapy, 24*(2), 145–157. doi:10.1016/S0197-4556(96)00063-9

de Haan, A. M., Boon, A. E., de Jong, J. T. V. M., Geluk, C. A. M. L., & Vermeiren, R. R. J. M. (2014). Therapeutic relationship and dropout in youth mental health care with ethnic minority children and adolescents. *Clinical Psychologist, 18*, 1–9. doi:10.1111/cp.12030

Dil, L., Dekker, J., Van, R., & Schalkwijk, F. (2016). A short-term psychodynamic supportive psychotherapy for adolescents with depressive disorders: A new approach. *Journal of Infant, Child, and Adolescent Psychotherapy, 15*(2), 84–94. doi:10.1080/15289168.2016.1163188

Fish, B. J. (2012). Response art: The art of the art therapist. *Art Therapy: Journal of the American Art Therapy Association, 29*(3), 138–143. doi:10.1080/07421656.2012.701594

Fish, B. J. (2016). *Art-based supervision: Cultivating therapeutic insight through imagery*. New York, NY: Routledge.

Franklin, M. (2010). Affect regulation, mirror neurons, and the third hand: Formulating mindful empathic art interventions. *Art Therapy: Journal of the American Art Therapy Association, 27*(4), 160–167. doi:10.1080/07421656.2010.10129385

Greenberg, B. (2016). The 10 most frequent mistakes therapists make. *Psychology Today*. Retrieved from www.psychologytoday.com/blog/the-teen-doctor/201604/the-10-most-frequent-mistakes-therapists-make

Hawley, K. M., & Garland, A. F. (2008). Working alliance in adolescent outpatient therapy: Youth, parent and therapist reports and associations with therapy outcomes. *Child Youth Care Forum, 37*(2), 59–74. doi:10.1007/s10566-008-9050-x

Hazler, R. (2002). Confusion, creativity, and credibility in therapy: Confronting therapist frailties and self-doubt. *Journal of Clinical Activities, Assignments & Handouts in Psychotherapy Practice, 2*(2), 35–44. doi:10.1300/J182v02n02_04

Klorer, G. (1993). Countertransference: A theoretical review and case study with a talented client. *Art Therapy: Journal of the American Art Therapy Association, 10*(4), 219–225. doi:10.1080/07421656.1993.10759016

Kottler, J., & Carlson, J. (2003). *Bad therapy: Master therapists share their worst failures*. New York, NY: Brunner Routledge.

Medau, I., Jox, R., & Reiter-Theil, S. (2013). How psychotherapists handle treatment errors—an ethical analysis. *BMC Medical Ethics, 14*(1), 50. doi:10.1186/1472-6939-14-50

Micsak, J. (2009). *Healing the inside child: Working with stressed and traumatized children and adolescents*. Paper presentation at the National Institute for Trauma and Loss in Children Childhood Trauma Practitioners Assembly, Grosse Point Woods.

Moon, B. L. (2009). *Existential art therapy: The canvas mirror* (3rd ed.). Springfield, IL: Charles C. Thomas.

Moon, B. L. (2012). *The dynamics of art as therapy with adolescents* (2nd ed.). Springfield, IL: Charles C. Thomas.

Price, J., & Margerum, J. (2000, July–August). Four most common mistakes treating teens. *Psychotherapy Networker*, 52–55.

Rasic, D. (2010). Countertransference in child and adolescent psychiatry—a forgotten concept? *Journal of the Canadian Academy of Child & Adolescent Psychiatry, 19*(4), 249–254.

Riley, S. (1999). *Contemporary art therapy with adolescents*. Philadelphia, PA: Jessica Kingsley Publishers.

Roaten, G. K. (2011). Innovative and brain-friendly strategies for building a therapeutic alliance with adolescents. *Journal of Creativity in Mental Health, 6*(4), 298–314. doi:10.1080/1540 1383.2011.630306

Schwartz, R. (2003). The critical parts of me. In J. Kottler & J. Carlson (Eds.), *Bad therapy: Master therapists share their worst failures* (pp. 49–56). New York, NY: Brunner Routledge.

Soma, C. (2013). When cognitive interventions fail. *National Institute for Trauma and Loss in Children.* Retrieved from www.starr.org/research/when-cognitive-interventions-fail

Sommers-Flanagan, J., & Bequette, T. (2013). The initial psychotherapy interview with adolescent clients. *Journal of Contemporary Psychotherapy, 43*(1), 13–22. doi:10.1007/ s10879-012-9225-5

Steele, W. (2009). Trauma informed care a history of helping: A history of excellence lessons learned since 1990. *National Institute for Trauma and Loss in Children.* Retrieved from www.mhcc. org.au/media/25383/steele-2009.pdf

Index